ABSTRACT
EXPRESSIONISM

ABSTRACT EXPRESSIONISM
A Critical Record

David Shapiro
and
Cecile Shapiro

PUBLISHED BY THE PRESS SYNDICATE OF THE UNIVERSITY OF CAMBRIDGE
The Pitt Building, Trumpington Street, Cambridge, United Kingdom

CAMBRIDGE UNIVERSITY PRESS
The Edinburgh Building, Cambridge CB2 2RU, UK http://www.cup.cam.ac.uk
40 West 20th Street, New York, NY 10011-4211, USA http://www.cup.org
10 Stamford Road, Oakleigh, Melbourne 3166, Australia
Ruiz de Alarcón 13, 28014 Madrid, Spain

First published 1990
Reprinted 1992, 1995, 1999

Printed in the United States of America

Typeset in Janson

A catalog record for this book is available from the British Library

Library of Congress Cataloging in Publication Data is available

ISBN 0 521 36493 0 hardback
ISBN 0 521 36733 6 paperback

For Deborah, Anna, Abby, and Lizzie

CONTENTS

List of Illustrations x
Preface xi

Introduction: A Brief History, *David Shapiro and Cecile Shapiro* 1

PART I • ORIGINS 31

Concerning the Beginnings of the New York School, 1939–1943;
 Interview with Robert Motherwell, *Sidney Simon* 33
"Everyone Knew What Everyone Else Meant," *Robert Goldwater* 46
The Club, *Irving Sandler* 48

PART II • THE CRITICAL RECEPTION 59

Towards a Newer Laocoon, *Clement Greenberg* 61
The American Action Painters, *Harold Rosenberg* 75
Statement and Letter to the Directors of the Museum of Modern Art,
 A Group of Artists 86
A Critique of Abstract Expressionism, *Leon Golub* 89
The New American Painting, *Alfred H. Barr, Jr.* 95
As the Critics Saw It 101
Narcissus in Chaos: Contemporary American Art, *Cleve Gray* 109
Happy New Year: Thoughts on Critics and Certain Painters as the Season
 Opens, *John Canaday* 119
Letter to the Editor Regarding Canaday's Criticism, *Dealers, Critics,*
 Artists 122
Reflections on the New York School, *Robert Goldwater* 126
The Critical Reception of Abstract-Expressionism, *Max Kozloff* 139
Re-evaluating Abstract Expressionism, *Gregory Battcock* 152
Residual Sign Systems in Abstract Expressionism, *Lawrence Alloway* 157
American Painting Since the Last War, *Peter Fuller* 169
Abstract Expressionism: The Social Contract, *Donald B. Kuspit* 182
Abstract Expressionism's Evasion of Language, *Ann Gibson* 195

PART III • THE ARTISTS AND THEIR CRITICS 213

WILLEM DE KOONING

Selected Chronology 215
What Abstract Art Means to Me, *Willem de Kooning* 219

De Kooning's Women; Interview with Willem de Kooning, *David Sylvester* 225
Review of an Exhibition of Willem de Kooning, *Clement Greenberg* 229
Willem de Kooning, *Dore Ashton* 231
Willem de Kooning, *Lawrence Alloway* 238
Interview with Willem de Kooning, *Harold Rosenberg* 241
De Kooning of East Hampton, *Hilton Kramer* 254

ADOLPH GOTTLIEB

Selected Chronology 257
My Painting, *Adolph Gottlieb* 261
Adolph Gottlieb: An Interview, *David Sylvester* 264
Adolph Gottlieb, *Barnett Newman* 270
Adolph Gottlieb at the Nierendorf Gallery (*Anonymous*) 271
Adolph Gottlieb, *Fairfield Porter* 272
Adolph Gottlieb, *Clement Greenberg* 273
Adolph Gottlieb and Abstract Painting, *Lawrence Alloway* 276

FRANZ KLINE

Selected Chronology 288
Franz Kline Retrospective Exhibition: Introduction, *Frank O'Hara* 291
Art Chronicle: Feeling Is All (Kline), *Clement Greenberg* 299
Franz Kline, *Dore Ashton* 300
Franz Kline: Painter of his Own Life, *Elaine de Kooning* 304
Kline's Estate, *Lawrence Alloway* 316
Kline's "Effulgent Abstractions," *John Russell* 319

BARNETT NEWMAN

Selected Chronology 322
The Sublime Is Now, *Barnett B. Newman* 325
Barnett Newman at the Parsons Gallery, [*T. B. H.*] *Thomas B. Hess* 329
Art Chronicle: Feeling Is All (Newman), *Clement Greenberg* 330
The Philosophic Line of B. Newman, *E. C. Goossen* 332
Barnett Newman: The Stations of the Cross and the Subjects of the Artist,
 Lawrence Alloway 336
Newman: Meaning in Abstract Art, II, *Harold Rosenberg* 344

JACKSON POLLOCK

Selected Chronology 351
My Painting, *Jackson Pollock* 356
An Interview with Jackson Pollock, *William Wright* 358
Art Chronicle: Jackson Pollock, *Clement Greenberg* 363
Jackson Pollock at Art of This Century (*Anonymous*) 364
Jackson Pollock: The Infinite Labyrinth, *Parker Tyler* 365
The Month in Review: Jackson Pollock, *Hilton Kramer* 368

viii CONTENTS

De Kooning on Pollock: An Interview, *James T. Valliere* 372
The Mythic Act, *Harold Rosenberg* 375
To Interpret or Not to Interpret Jackson Pollock, *Donald B. Kuspit* 382

MARK ROTHKO

Selected Chronology 392
The Romantics Were Prompted, *Mark Rothko* 397
Mark Rothko at Art of This Century (*Anonymous*) 401
Art: Mark Rothko, *Dore Ashton* 402
The New New York Scene, *Anita Brookner* 406
Mark Rothko's New Retrospective, *Max Kozloff* 408
Rothko, *Harold Rosenberg* 413
Mark Rothko, *Robert Carleton Hobbs* 418

Selected Bibliography 423
Index 434

ILLUSTRATIONS

Jackson Pollock, *Going West*, 1934–5 4

Thomas Hart Benton, *The Ballad of the Jealous Lover of Lone*
 Green Valley, 1934 5

Willem de Kooning, *Queen of Hearts*, 1943–6 6

Philip Evergood, *Through the Mill*, 1940 11

Edward Hopper, *Early Sunday Morning*, 1930 12

Arthur G. Dove, *Ferry Boat Wreck*, 1931 13

Stuart Davis, *New York Waterfront*, 1938 110

Willem de Kooning, *Door to the River*, 1960 220

Adolph Gottlieb, *Beasts*, 1945 262

Adolph Gottlieb, *Two Discs*, 1963 263

Franz Kline, *Palmerton, PA*, 1941 292

Franz Kline, *Mahoning*, 1956 293

Barnett Newman, *Covenant*, 1949 326

Barnett Newman, *Vir Heroicus Sublimus*, 1950–1 327

Jackson Pollock, *The She-Wolf*, 1943 356

Jackson Pollock, *Number 1, 1948*, 1948 357

Mark Rothko, *Subway (Subterranean Fantasy)*, ca. 1936 398

Mark Rothko, *Vessels of Magic*, 1946 399

Mark Rothko, *Red, Brown, and Black*, 1958 400

PREFACE

A N ART MOVEMENT may be said to have ended when it no longer attracts talented new adherents. This is true even when some of the original practitioners are still making works of the highest quality. Accordingly, Abstract Expressionism has come and gone. Once an art movement has departed in this way it becomes possible to examine it from a vantage not available earlier – a phenomenon of which some of the more recently published essays included in this volume are apt examples.

This collection is dedicated to an examination of the American manner of making art that became known as Abstract Expressionism. The major critical works are all in. The responses to Abstract Expressionism when it was fresh and evolving have been written. Comments since then come under the heading of art history.

Most of the pieces in this book were originally written for art magazines, intellectual journals, and museum or gallery catalogues. Few college and university libraries, even those with excellent periodical collections, have complete files of all of them, and even fewer collect exhibition catalogues. Serious arguments that help piece together a movement that began to trace its first patterns during World War II, moreover, appeared in obscure publications that are difficult to come by: *Tiger's Eye*; the one issue of *Possibilities* that Robert Motherwell edited with his friends; *It Is*, the publication of "The Club"; the Belgian periodical *Quadrum*; the Paris-based *Cimaise*; and so on. It is to bring some of these together and make them generally available that they are reprinted here.

The history we know about, that we study at school, is based on the records that happen to remain. We know little about the vast history that has not been recorded. In a parallel way the art history we study has been deduced from the works of art that remain, plus such written material as has been preserved. Our perception of the art work itself, as one of the critics included within these pages remarks, is affected by what has been said about it – both society's established view and the views of differing critics whose evaluations filter through.

The articles selected for anthologizing in this book include most of the important statements made about Abstract Expressionism. Its most influential critics are represented, though not always in proportion to

their impact. We have included essays that by tone and evaluation make clear their approval of Abstract Expressionism's contributions as well as others that deplore the mode. But readers ought not surmise that equivalent proportions pro and con were published during the period. Far from it. Abstract Expressionism appears to have made such a clean sweep during its heyday that it has not been easy to discover reasoned arguments attacking its assumptions. Published adverse criticism did not even amount to as much as ten percent. Had we limited ourselves, however, to a selection based on proportional representation, not only would we have had to omit the few published iconoclasts of the 1950s and 1960s – Leon Golub, Cleve Gray, John Canaday, the artists involved with the publication *Reality* – but we would also have been required to reduce the entire list of authors to those, such as Clement Greenberg, Harold Rosenberg, and Hilton Kramer, who were most prolific and influential. Moreover, much of the criticism of Abstract Expressionism's most assiduous commentators has been collected elsewhere and thus is readily available to readers who wish to pursue their views.

Our choice has been, rather, to include comments by each of the foremost Abstract Expressionist artists as well as to suggest the full range of critical evaluation, opinion, discussion, and opposition so that readers looking at the paintings themselves will find them brightly lit from as many angles as are needed to see them clearly. Long ago the late art critic Harold Rosenberg scolded American intellectuals for failing to study and write about the new American art. It is unlikely that even he hoped for the trickle of comment to become such a torrent. This collection attempts (to carry the metaphor a bit further) to pick out the sturdiest barques with the most clear-sighted pilots on that river of material so that they can continue to be available as companions and guides to the works themselves.

We gratefully acknowledge the assistance of the librarians of the Sherman Art Library at Dartmouth College, particularly Barbara Read and Claudia Yatsevich, for their cheerful help and resourcefulness in finding materials needed for this and other projects in which we have been engaged. To Elsie Reynolds, now retired, and Janet Wagner, reference librarians at the Axinn Library of Hofstra University, we offer our thanks once again for their generous assistance at earlier stages in the development of this book.

We thank Elizabeth Maguire, our first editor at Cambridge University Press, whose steadfast confidence in our proposal brought this book to life, and Beatrice Rehl, who has followed through.

We are indebted to all the authors, journals, publishers, museums, and foundations that have made this collection possible by granting permission to publish material and to reproduce artists' works.

David Shapiro and Cecile Shapiro

I celebrate myself and sing myself,
And what I shall assume you shall assume.

I sound my barbaric yawp over the roofs of the world.

WALT WHITMAN, "Song of Myself," *Leaves of Grass*

Now about American painters. Today yesterday or any day. How do they do it.
They do it like this.
When they paint it does not make any difference what gets upon the canvas, they are they and they feel that they are going to be they. Oh yes. They. They are they. That is what they look like and that is what they feel.

GERTRUDE STEIN, *Four in America*, 1934

No possible set of notes can explain our paintings. Their explanation must come out of a consummated experience between picture and onlooker. The point at issue, it seems to us, is not an "explanation" of the paintings, but whether the intrinsic ideas carried within the frames of these pictures have significance. We feel that our pictures demonstrate our aesthetic beliefs, some of which we, therefore, list:

1. To us art is an adventure into an unknown world, which can be explored only by those willing to take the risks.

2. This world of the imagination is fancy-free and violently opposed to common sense.

3. It is our function as artists to make the spectator see the world our way – not his way.

4. We favor the simple expression of the complex thought. We are for the large shape because it has the impact of the unequivocal. We wish to reassert the picture plane. We are for flat forms because they destroy illusion and reveal truth.

5. It is a widely accepted notion among painters that it does not matter what one paints as long as it is well painted. This is the essence of academism. There is no such thing as good painting about nothing. We assert that the subject is crucial and only that subject-matter is valid which is tragic and timeless. That is why we profess spiritual kinship with primitive and archaic art.

Consequently, if our work embodies these beliefs it must insult any one who is spiritually attuned to interior decoration; pictures for the home; pictures for over the mantel; pictures of the American scene; social pictures; purity in art; prize-winning potboilers; the National Academy, the Whitney Academy, the Corn Belt Academy; buckeyes; trite tripe, etc.

ADOLPH GOTTLIEB and MARK ROTHKO, "Statement," 1943.
Responding to *New York Times* critic Edward Alden Jewell's criticism of their paintings in the Federation of Modern Painters and Sculptors exhibition. Published in *The New York Times*, June 13, 1943.

INTRODUCTION:
A BRIEF HISTORY
David Shapiro and Cecile Shapiro

I

WHEN THE NEW ART FORM now known as Abstract Expressionism began to impinge on the consciousness of the New York art world at the tail end of the forties, it astonished most observers, so unprecedented did it appear in form and content. With hindsight and investigation its roots have been unearthed, enabling us to recognize sources in Surrealism; in Freudian theories of the twenties; in the art and politics of the thirties; and in the *Zeitgeist* of the forties. But when by the early fifties the first trickles of Abstract Expressionism – also known at various times as the New York School, the New American Painting, Action Painting, American-Type Painting – had turned into a flood of works in visage and intent deliberately and programmatically divorced from anything in the entire history of art East or West, art cognoscenti were deeply divided as to its legitimacy and value.

The new painting dispensed with recognizable images from the known world. Its surfaces were often rough, unfinished, even sloppy, with uneven textures and dripping paint. Violent, brutal, improvised, slapdash, it demanded attention yet offered no clue to the nature of the response expected. It had force, energy, mystery, yet its explosions seemed inchoate outpourings of expression to which viewers were provided no key.

It was an art that aimed to negate the art of America's recent past as well as that of more distant times and places. School-of-Paris abstraction as it had been developing for a generation or more under the influence of Picasso and Braque was rejected as thoroughly as the most prominent schools of American painting immediately preceding it: Regionalism, Social Realism, American Scene, and American abstraction. The tradition of art as communicator or as source of pleasure appeared to have been abandoned by an intensely individual school of painting, in which each artist had a distinct, immediately differentiable calligraphy. Yet all seemed to share certain assumptions: the need to explore the subcon-

1

scious, the value of the exploitation of chance; the capacity of paint to serve as a vehicle for emotional expression; the certainty that the times mandated an entirely new way of painting employing an individually developed style in a vehemently personal art divorced from, and irreconcilable with, the past.

Anyone familiar with modern art will, to be sure, discern in Abstract Expressionist painting traces of Kandinsky, Miró, Picasso; some of the naiveté of Klee; the two-dimensionality of the Cubists; splashes of color reminiscent of Matisse; rudimentary echoes of so-called primitive art. The notion that pure form and color, independent of object or design, · could evoke emotion had been enunciated by Kandinsky, a core tenet reaffirmed by elusive fragments of Kandinsky sometimes observable in their work.

Though the Abstract Expressionists rejected Surrealist forms because they were illusionist, they borrowed a central axiom, exploitation of the subconscious. In further differentiation from the Surrealists, they allowed the subconscious to spill over without the intermediary of narrative, forethought, known symbol, formal design, studied concept, or slick finish. Emotion was to flow from the artist directly onto the canvas, with the artist withholding conscious control and direction – the antithesis of art as artifice. Even by deciding to begin and then declare a work complete, the artist cannot help but apply basic volitional controls, of course, but the abdication of premeditation or planning resulted in totally new images.

Belief in the validity of inner experience, its authenticity considered more true and more real than objective fact and appearance, was nevertheless probably the essential shared notion among the Abstract Expressionists. The artist became, in a sense, only the conduit, the brush by means of which automatic writing transmitted emotion onto an external object, the painting surface. Its difficulty of access would thereby seem inevitable as well as intentional. By celebrating the individual inner cry "This is Me! Me! Me!" the Abstract Expressionist participated in the "exhilaration of an adventure over depths in which he might find reflected the true image of his identity," Harold Rosenberg wrote in the early fifties, revealing these artists as partaking of the last draughts of an extreme strain of Romanticism.[1]

Abstract Expressionism's avowed purpose is to express the self to the self. Just as certain songs by Luciano Berio use vocables indistinguishable as words, or as the composer Olivier Messiaen employed an invented mystical pseudo-language in his "Cinque Recants," these artists created a painting language comparable with speech in which sounds have

2 DAVID SHAPIRO AND CECILE SHAPIRO

no assigned meaning. Or, perhaps, meaning in Abstract Expressionist painting might better be compared with the mysterious, secret languages reportedly developed by certain identical twins, who understand each other perfectly but close out from comprehension everyone else.

It is a paradox that Mark Rothko, Barnett Newman, and Adolph Gottlieb, all first-generation Abstract Expressionists, nevertheless insisted on the importance of subject matter, but insofar as possible they expressed their subjects impulsively and without acknowledgment of a potential audience. Thus, although some paintings by each of these artists transmit a range of emotions to some of those who look at them, responses are not necessarily related to the emotions suggested by the titles of the works or the written comments of the artists. Communication via visual metaphor comparing two unknowns is unlikely to be effective, yet it may be that this very quixotic attempt tells us why serious critics have called the art and the artists "heroic." ("Shall I compare thee to a summer's day?" works because we have experienced summer days, although we do not know "thee." But suppose the speaker had compared "thee" to a "frumious Bandersnatch" when commenting to a person unfamiliar with Lewis Carroll?) In the typical Abstract Expressionist canvas the objective correlative (the actual event or object) to the emotion has been omitted. Feeling is free-floating, as ambiguous as a Rorschach blot, because it is not anchored in the experience of the spectator as well as the artist.

Yet if there are many who cannot "see" Abstract Expressionist paintings despite a willingness to experience them and a sophisticated art background, those who respond fully include the most impressive names among trained art viewers – artists, museum people, critics, and art teachers who spend most of their days with twentieth-century painting. Members of the art-loving, gallery-visiting public, collectors as well as people of modest means, have been enthusiastic about the paintings. Most men and women born since Abstract Expressionism became a factor in American art accept its legitimacy without question. Many of them, indeed, have been among its strongest supporters. Their most typical response, as one might expect, is sentient, sometimes paralleling the emotional release of the artist, sometimes conjuring unnamable but somehow satisfying emotions, and at other times, according to those who have experienced it, overwhelming "religious" feelings, most often in reaction to works by Rothko and Newman.

There is no doubt that this very American form, related in its improvisational characteristics to jazz (another quintessentially American contribution), was in its alienation, experimentalism, and hermeticism more

closely tied to the European *Zeitgeist* of the 1940s and 1950s than other American pictorial art of its time. One has only to recollect the alienation expressed by such writers as Albert Camus and Samuel Beckett, the Existentialism of Jean-Paul Sartre, the Theater of the Absurd, the *nouvelle vague* experimentation in the novel led by Alain Robbe-Grillet and Nathalie Sarraute to realize that the estrangement felt by the Abstract Expressionists was closer to French sensibilities than to the prewar imperatives that other schools of American art continued to explore.

What impelled this particular group of artists to embark on a journey of exploration and discovery? Some of them – Adolph Gottlieb, Mark Rothko, Philip Guston – had achieved a measure of success with their earlier styles. Others had rarely or never exhibited. Yet they shared a deep need to effect a change in the artistic climate of their time. They came from disparate backgrounds and took a variety of routes to their convictions. Pollock, Rothko (who was born in Russia), Motherwell, Guston, and Still had all been raised in the West; only Gottlieb and Newman had grown up in New York, where they all converged. Willem de Kooning had emigrated to New York from Holland; Franz Kline,

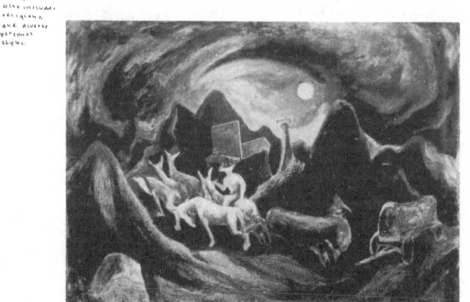

JACKSON POLLOCK, *Going West*, 1934–5. Oil on fiberboard 15⅛″ × 20¾″. National Museum of American Art, 1973.149.1. Smithsonian Institution. Gift of Thomas Hart Benton.

4 DAVID SHAPIRO AND CECILE SHAPIRO

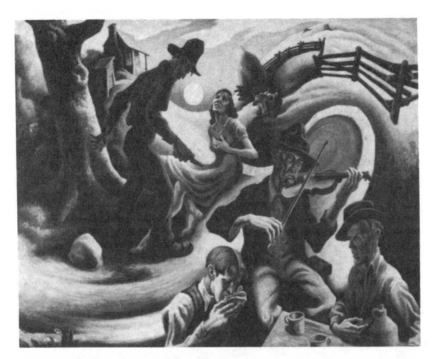

THOMAS HART BENTON, *The Ballad of the Jealous Lover of Lone Green Valley*, 1934. Oil and Tempera on canvas mounted on panel 41½″ × 52½″. Spencer Museum of Art, University of Kansas, Lawrence, Kansas. Museum purchase: Elizabeth M. Watkins Fund. (Photography by Jon Blumb)

from Pennsylvania – to speak only of differences in birthplace. Rothko, Guston, Gottlieb, and Newman were nominally Jewish. Pollock had initially been a follower of Regionalist Thomas Hart Benton; Guston had developed one of the finest Social Realist styles; de Kooning had struggled through dependence on Picasso – to suggest briefly their stylistic diversity. All of them, once living in New York, became familiar with the galleries and museums, the art magazines, and the currents running in the mainstream.

By the 1930s and early 1940s in New York City excellent examples of the art of every period in most cultures could be seen, and it can be argued that more modern art, much of it abstract, was being shown in public collections than virtually anywhere else in the world. From 1929 on the Museum of Modern Art mounted exhibitions emphasizing French modernism that set a high standard for others to follow. Soon thereafter the Solomon R. Guggenheim Museum, then known as the Museum of

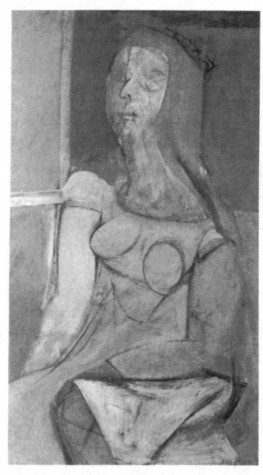

WILLEM DE KOONING,
Queen of Hearts, 1943–6.
Oil and charcoal on
fiberboard 46⅛″ × 27⅝″.
Hirshhorn Museum and
Sculpture Garden.
Smithsonian Institution. Gift
of Joseph H. Hirshhorn
Foundation, 1966.

Non-objective Art, showed in its funereal gray-walled, gray-carpeted space the works of Kandinsky, Klee, Mondrian, and their followers, including some young American nonobjectivists. The Museum of Non-objective Art even helped young artists with stipends. Under the patronage of Gugggenheim and the direction of Baroness Hilla Rebay, the assistance program was designed to encourage artists to work in non-objective styles. The allowance, most often $15 a month (easily worth more than ten times the sum's value today) was intended to cover art supplies. In exchange recipients were expected to show the Baroness examples of their work for criticism.

At New York University the Albert Gallatin Collection of Living Art

(now at the Philadelphia Museum of Art), canvases by Cézanne, Picasso, Seurat, Braque, Léger, Matisse, and Mondrian could be studied. These luminous names were joined in the permanent collection by modernists such as Dufy, Tchelitchew, Modigliani, Utrillo, and de Chirico. Beginning in 1929 the collection added American modernists, among the initial group Marsden Hartley, Man Ray, Karl Knaths, and William Zorach, later joined by younger Americans such as John Xcéron, Charles Shaw, George L. K. Morris, Susy Frelinghusen, and Gertrude Greene.

Anyone could visit these institutions freely, since none charged admission except the Museum of Modern Art, for which art students and artists could – and most did – purchase an annual pass for a dollar.

Outside the museums an influx of European emigrés, many fleeing Hitler and world war, stimulated the growth of new approaches to painting. Hans Hofmann had come from Munich via Paris to live permanently in the United States in 1930, first teaching in California, then opening in New York City and in Provincetown, Massachusetts, art classes where a high proportion of future abstractionists studied for long or short periods. His direct influence as an abstract painter was far outdistanced by his reputation as a teacher, and his Friday evening lectures in New York were well attended by a motley assortment of artists.

Never a permanent New Yorker, Marc Chagall worked there for a long time; Salvador Dali, then a serious Surrealist, arrived in 1940; Dadaist and Surrealist Max Ernst lived and exhibited in New York during a portion of the period. After arriving in New York André Masson, who had earlier invented a version of automatic writing, had a tangible impact on some of the younger painters who were to become Abstract Expressionists. The Chilean painter Matta (Roberto Echaurren Matta), the youngest of the Surrealist group, became closest of all to American artists. He too was involved with automatic writing but even more with the morphology of "psychic responses to life." He embraced the idea that "everyone would invent their own morphology."[2]

Piet Mondrian's arrival in 1940 had been preceded both by his disciplined rectilinear paintings in primary colors and by his theoretical writings, which had appeared in the magazine he and Theo Van Doesburg founded in 1917, De Stijl. Although Mondrian's painting forswore any manifestation of emotion, and to that extent was antipathetic to Abstract Expressionism, its strict nonobjectivity could not help but make it an exemplar. Yves Tanguy, a Surrealist, went to New York from France in 1939. Another French painter, Amédée Ozenfant, whose

Foundations of Modern Art had been published in 1931, opened a school shortly after he arrived, where he taught his post-Cubist version of modernism, Purism. Artists debated System and Dialectics of Art, Russian-born John Graham's book on aesthetics. Ossip Zadkine, a Russian sculptor who had lived in France made a considerable impact, in part because he took students, as did Kurt Seligmann, an emigré in 1939.

More European artists representative of various strains of modernism resident in New York before or during World War II could be cited, but the point is that their presence allowed a miscellany of young artists to become involved firsthand with advanced practitioners of an array of modern European movements. Keenly tuned to the city's art milieu, those who were to become the first generation of Abstract Expressionists participated in museum and gallery life and met representative Europeans then in the process of turning New York into a cosmopolitan cultural center for the first time. With them, and with each other, they engaged in endless disputation about theory and experimentation in paint.

The future Abstract Expressionists were ambitious and hoped to achieve the special kind of greatness possible for artists. They came to believe that artists were distinct orders of being, and each felt that he had the "call," the mission to become a true artist. Indeed, some of them claimed more for art than had ever been claimed before. Closely following remarks by art historian Meyer Schapiro, who in 1937 had pointed out that apologists for abstraction liked to compare it to mathematics, particularly to non-Euclidian geometry, which they viewed as "independent of experience," Newman carried the notion further saying that the new painter is the true revolutionary:

> [He is] the philosopher and the pure scientist who is exploring the world of ideas, not the world of the senses. Just as we get a vision of the cosmos through the symbols of a mathematical equation, just as we get a vision of truth in terms of abstract metaphysical concepts, so the artist is today giving us a vision of the world of truth in terms of visual symbols.[3]

This eagerness to scale the highest peaks was not peculiar to Newman, although even more than most of the Abstract Expressionists he embraced philosophic speculation. The language of an anonymous press release for a 1943 exhibition in which both Gottlieb and Rothko participated, that of the Federation of Modern Painters and Sculptors (an outgrowth of the League for Cultural Freedom and Socialism), assumes that art is central to life and the United States is central to the world.

8 DAVID SHAPIRO AND CECILE SHAPIRO

Today America is faced with the responsibility either to salvage and develop, or to frustrate Western creative capacity. This responsibility may be largely ours for a large part of the century to come. This country has been greatly enriched, both by the recent influx of many great European artists, some of whom we are proud to have as members of our Federation, and by the growing vitality of our native talent.

In years to come the world will ask how this nation met its opportunity. Did it nourish or starve this concentration of talent?

Since no one can remain untouched by the impact of the present world upheaval, it is inevitable that values in every field of human endeavor will be affected. As a nation we are being forced to outgrow our narrow political isolationism. Now that America is recognized as the center where art and artists of the world meet, it is time to accept cultural values on a truly global plane.[4]

Here is one answer, then, to the question posed some paragraphs back about the impetus behind the struggle to find a new way of painting: The Abstract Expressionists wanted to erase the past and invent an original culture. They hoped to achieve greatness by means of a revolutionary upheaval parallel to their revolutionary political sympathies, which were by the late thirties and early forties most often leftist, anti-Stalin, and inclined toward Trotsky. They were to be not the midwives of regenerated art but the first cause. They aimed to create something utterly unexampled, entirely their own, and yet completely American. If the spectator could not understand their canvases, Gottlieb and Rothko insisted, it was the artists' function "to make the spectator see the world our way – not his way."

"During the 1940s," Gottlieb wrote soon after Jackson Pollock's death,

a few painters were painting with a feeling of absolute desperation. The situation was so bad that I know I felt free to try anything, no matter how absurd it seemed; what was there to lose? Neither Cubism nor Surrealism could absorb someone like myself; we felt like derelicts.... Therefore one had to dig into one's self, excavate whatever one could, and if what came out did not seem to be art by accepted standards, so much the worse for those standards.[5]

But what to excavate, what to try in their desperation, was not easy to discover. It is one thing to be an autodidact; it is another to know what to

teach oneself. Although they insisted on a new *how*-to-say (style), they permitted themselves at first to plunder the past for their *what*-to-say (content, imagery). Pollock, Gottlieb, Rothko, Newman, and others turned for varying periods to mythology, particularly Greek myths and American Indian lore, in much the same way as Picasso for a time had turned to African art. "There is no such thing as a good painting about nothing," Gottlieb and Rothko maintained in a 1943 letter to *New York Times* art critic Edward Alden Jewell. "We assert that subject matter is crucial and only that subject matter is valid which is tragic and timeless. That is why we express spiritual kinship with primitive and archaic art." Once again they echoed but misinterpreted the art historian Meyer Schapiro, who had said something rather different in "The Nature of Abstract Art." There he had pointed out, not approvingly, that modern critics one-sidedly "relied on feeling to penetrate" primitive art, giving it "the special prestige of the timeless and instinctive."[6]

Primitive and archaic art, however, like all forms of art, are products of their time and place. Gottlieb and Rothko plucked the symbols of disparate cultures from their native fabric, with the result that their meanings and connotations were not available to the contemporary audience, whatever they may have meant to the artists. The borrowed symbols were rarely used literally in any case. They were taken out of context and abstracted or used as takeoff points for design. The artists allowed themselves the liberty because they saw their painting as "poetic expression of the essence of the myth" and as a "new interpretation of an archaic image." They believed that "the significant rendition of a symbol, no matter how archaic, has as full validity today as the archaic symbol then."[7] Extending and broadening the notion, Harold Rosenberg, embroidering Schapiro's insight, wrote that "a three-thousand-year-old mask from the South Pacific qualifies as Modern and a piece of wood on a beach becomes Art."[8]

The goal: a universal symbolism in a timeless art. Symbols removed from their cultural context, however, become merely abstracted signs or elements of formal design if the fragments borrowed are not integrated as symbols evoking newly relevant myths. Yet this period in the art of the founding fathers of Abstract Expressionism, although it failed to achieve most of its stated aims, helped prepare for the art that was to follow by breaking with twentieth-century pictorial content and the observed world. By rejecting all current art styles as starting points, by dismissing the recent past as a source of visual examples, they left themselves no choice but to explore their psyches, their inner vision, and a morphology of their own invention.

Their solipsism was not merely a matter of taste, however. It was, paradoxically, political as much as anything else. During the 1930s, when these painters were beginning their studies and careers, the aesthetics of American art were shaped by pressing social, political, and economic events that connected directly to the kind of art produced. The artists who came to be called Regionalists – with Thomas Hart Benton, Grant Wood, and John Steuart Curry their leaders and critic Thomas Craven their champion – embraced a conservative political and social position. They sought to recapture the values of America's agrarian past as they interpreted them. Their heroes were the farmers of the Midwest, where in their view the qualities that made America great grew as vigorously as the corn and wheat in the heartland. It was there that independence, industriousness, self-reliance, and individualism could thrive isolated from European thought, values, and wars. Their vision was not shared by many New York artists.

The Social Realists – painters such as Ben Shahn, William Gropper, and Philip Evergood – held Marxist views to one degree or another and on the whole supported the ongoing experiment in the Soviet Union. They

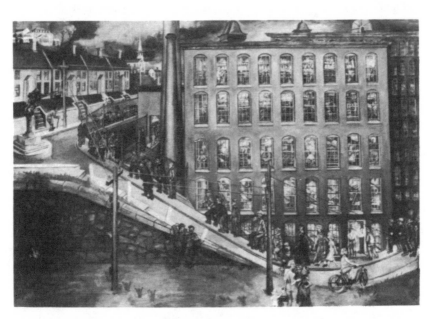

PHILIP EVERGOOD, *Through the Mill*, 1940. Oil on canvas 36″ × 52″. Collection of Whitney Museum of American Art, New York. Purchase 41.24 (Photo by Geoffrey Clements)

frequently made the theme of their art workers and the poor of America, and although their paintings were not always as insistently political as their orientation may suggest, images showing the working class as exploited but brave and capitalists as powerful yet greedy were intended as contributions to the class struggle, to the use of art as a weapon. They sought to end capitalism in the long run; they also proposed, in contrast to the other stylistic and ideological groupings, an immediate transformation of the system of art exhibition, distribution, and marketing.[9]

The organized group that called itself the American Abstract Artists and that included George L. K. Morris, Carl Holty, Byron Browne, and Balcomb Greene, followed the example of European abstraction as it had been developing in Paris. It was to this school that the Museum of Modern Art was then devoted, although not to its American counterpart. (The American Abstract Artists picketed the Museum of Modern Art in 1939 in protest against its neglect of American abstraction.)

Not organized into a formal group parallel to the American Abstract Artists were the artists who focused on the American scene. Probably accounting for the largest number of American painters, they included Paul Sample, Doris Lee, Waldo Pierce, Ernest Fiene, and Peter Hurd, all of whom tended to be illustrational and to portray scenes from American life in genre and landscape paintings largely unaffected by modernism. Neither the American Scene painters nor the abstractionists, as groups,

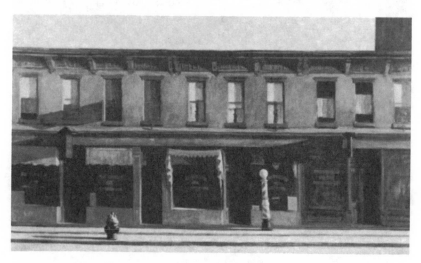

EDWARD HOPPER, *Early Sunday Morning*, 1930. Oil on canvas 35″ × 60″. Collection of Whitney Museum of American Art, New York. Purchase, with funds from Gertrude Vanderbilt Whitney. 31.426. (Photo by Geoffrey Clements)

12 DAVID SHAPIRO AND CECILE SHAPIRO

ARTHUR G. DOVE, *Ferry Boat Wreck*, 1931. Oil on canvas 18″ × 30″. Collection of Whitney Museum of American Art, New York. Purchase, with funds from Mr. and Mrs. Roy R. Neuberger. 56.21. (Photo by Geoffrey Clements)

were overtly political, although individuals within them were. A final subdivision among American painters of the period cannot be categorized easily, for some of the best painters were totally independent of groups or like-minded colleagues. Such artists as Arthur Dove, Charles Burchfield, John Marin, Edward Hopper, and Georgia O'Keeffe stood apart, without attracting followers or themselves following movements. Each of these varieties of art could be seen in New York, long the art center of the United States, drawing ambitious painters from every part of the hinterland.

Numerous artists, no matter their style, came to believe that capitalism had demonstrated its failure by its inability to cope either with the disastrous Depression or with the growth of fascism abroad. Conditions for artists, always marginal, had deteriorated further during the Depression. Few galleries survived the dearth of clients, and museums struggling to keep their doors open could spare scant funds for the purchases that help support art makers. During this period of burgeoning trade-union growth and of federal "make-work" employment, it was inevitable that leftist artists, of which there were a great many, would form an artists' union that insisted on the federal government's responsibility to initiate projects that would give work to artists.[10]

In December 1933 the Roosevelt Administration set up the Public

Works of Art Project, which in a few months' time employed more than 3,500 artists, who produced more than 15,000 works for public institutions. This short-lived initial project was eventually expanded by the New Deal into the Federal Art Project of the Works Progress Administration (WPA), which, unlike its predecessor, did not demand evidence of high professional qualifications from participants, although it did insist on a "pauper's oath" as a condition of employment. (A small group of accomplished professional painters and sculptors was exempted from the oath.) Many artists thought swearing to poverty demeaning, so much so that the oath became a recurrent source of friction, but within its first year the WPA Art Project employed 5,500 men and women who had some training and experience in creating paintings, prints, and sculpture. Additionally, the Treasury Department commissioned murals for public buildings, usually making its selection of muralists by means of public competitions that anyone could enter.[11]

Hundreds if not thousands of artists survived by means of these government-sponsored jobs. Work that brought in regular paychecks, furthermore, tended to make many artists feel less alienated from society, and gave them for the first time a sense of belonging to the real workaday world. Paid work siphoned off some of their bohemianism, some of their sense of disconnection from American life, and made them feel more closely allied with other working Americans. With artists viewing themselves as part of the economy rather than peripheral to it, and with art regularly being produced for public showing in public buildings, it is not hard to understand why so many of them believed that American art was headed for a renaissance that would rival that of fifteenth-century Italy.

More significantly, perhaps, artists who had traditionally in this century worked in large part disassociated from their peers now found themselves involved with groups in an artists' community created by the public projects. They were in frequent contact with one another, whether delivering work to supervisors, meeting to plan ways of complying with or evading some bureaucratic edict, or actually making their art within the confines of shared physical space. Increased socialization led to discussions, exchanges of ideas, and examination of a variety of aesthetic postures. By no means were these comings together all sweetness and light – quite otherwise, in fact – but such contact did offer effective experience with political interplay, strategical games, and exploration of visual concepts. The artists who invented Abstract Expressionism and experienced these special circumstances as members of federal programs include Pollock, de Kooning, Rothko, Gottlieb, Guston, Still, Gorky, Baziotes, and Brooks. Surely, the seeds of Abstract Expressionism were

sown then. (Newman, never on the Project, complained that his friends did not take him seriously as an artist because he had not been employed by the projects.)

This new community of artists was usually embroiled in conflict, in the main between the political right, as represented by the Regionalists, and the left, the Social Realists, although artists in both these camps employed easily accessible imagery and wished to communicate with wide audiences. Both factions disdained abstraction – the Regionalists abhorring it as effete and un-American; the Social Realists viewing it as an elitist flower of decadent capitalism.

Those who became Abstract Expressionists were at times allied with either one side or the other, but mainly with the Social Realists. Beginning in the late thirties and continuing during and after the Second World War, however, the future Abstract Expressionists began to find political activity futile, socially oriented art pointless. A host of factors combined to produce this climate, primary among them disenchantment with the Soviet Union, brought on particularly by the Moscow trials of 1936–38 and the 1939 Nazi–Soviet nonaggression pact and the invasion of Finland by the Soviets in 1939. The divorce of artists from a social role in the United States, the failure of Communist Party intellectuals to create a nourishing philosophy for political art, the attraction of more freewheeling Trotskyist art theories, the amelioration of the Depression and hence the source of much of their radicalism, and, finally, the inception of the Cold War, which in time solidified anti-Stalinism into anticommunism, also contributed.

Yet even while the future Abstract Expressionists came to believe in the futility of political activity and to feel free from any obligation to produce socially oriented art, many of them, particularly those who had been followers or members of the Communist Party, remained political beings. In divorcing their art from any obvious link with politics, they were adherents of two eminently political thinkers, Leon Trotsky and André Breton, who established a theoretical structure that had begun to emerge in 1937 with Meyer Schapiro's "The Nature of Abstract Art," originally published in the *Marxist Quarterly*.

By 1938 Trotsky and Breton had come by dissimilar routes to similar conclusions, Trotsky via leadership of the Russian Revolution and subsequent exile by Stalin, Breton by way of leadership of the Surrealist movement. (In 1930 Breton changed the name of his journal, *The Surrealist Revolution*, to *Surrealism in the Service of the Revolution*.) Outraged by Stalin's policies as well as by the concept of art as a weapon, Trotsky and Breton collaborated on "Manifesto: Toward a Free Revolu-

tionary Art." Published in the United States in the *Partisan Review* and in European Surrealist journals (with Trotsky's name until many years later replaced by that of Diego Rivera in order to protect the exile), this important manifesto calls for "complete freedom for art." Even if it were necessary, it says, to "build a socialist regime with centralized control, to develop intellectual creation an anarchist regime of individual liberty [must] from the first be established."[12] Creative individuals, in other words, were to be exempted from state controls of every kind even if restrictions were placed on other categories of people. Thus, the manifesto advocated centralized control for the masses, anarchism for artists.

Soon thereafter, in April 1940, a group of dissidents, led by Meyer Schapiro, broke away from the Depression-born broad organization called the American Artists Congress over the question of support for Finland, which had been invaded by the Soviets. The underlying issue, however, was the perception of Communist Party domination of the Congress. Subsequently, some of the dissenters joined the League for Cultural Freedom and Socialism, a "revolutionary league of writers and artists," which announced its agreement with Trotsky's manifesto.[13] The LCFS in turn gave birth to the Federation of Modern Painters and Sculptors, while the much larger American Artists Congress foundered, as did many other Popular Front organizations in which communists, fellow travelers, liberals, and middle-of-the-roaders had for a time worked together, a collapse attributable to continued Communist Party support of the USSR during the twenty-two months of the Nazi–Soviet nonaggression pact.

In 1939, about a year after the Trotsky–Breton essay appeared, granting "permission" for the politically minded artist to make an art free from social or political commitments, another seminal essay, this one by Clement Greenberg, appeared in the *Partisan Review*, the leading Marxist–Trotskyist intellectual journal. Not widely noticed at the time, it soon became familiar to the art world – discussed and anthologized. "Avant-garde and Kitsch" spelled out concretely some of the points made in the "Manifesto." It may be considered the manifesto for the art movement known today as Abstract Expressionism.

In "Avant-garde and Kitsch" Greenberg begins by saying that artists in Western culture, instead of academically repeating themselves, have produced something entirely new: "avant-garde culture." The "first settlers of bohemia – which was then identical with the avant-garde – turned out to be demonstrably uninterested in politics." The artist "emigrated from bourgeois society to bohemia," and in this migration

turned to "art for art's sake," in which subject matter or content became something to be "avoided like a plague." Further, "in search of the absolute," the avant-garde arrived at nonobjective art because it is trying, in effect,

> to imitate God by creating something valid in its own terms, in the way nature itself is valid, in the way a landscape – not its picture – is aesthetically valid; something *given*, increate, independent of meanings, similars or originals. Content is to be dissolved so completely into form that the work of art or literature cannot be reduced in whole or part to anything not itself.[14]

The artist's values are wholly aesthetic, Greenberg asserts, and in turning away from "the subject matter of common experience," the artist turns to "the medium of his own craft." This, in itself, becomes the subject matter. (The medium, as Marshall McLuhan was to say more than thirty years later, becomes the message.) The "expression" of the artist will become *more* important than "what is expressed." There is no other way, Greenberg argues, "to create art and literature of a high order."

There is no point, Greenberg continues, in expecting patronage from the masses, since they have always remained "more or less indifferent to culture." It is to the ruling class that the avant-garde turns. Since, he notes, it is impossible for a "culture to develop without social basis, without a source of a stable income," money has always been provided by an "elite among the ruling class of that society from which it [high culture] assumed itself cut off, but to which it has always remained attached by an umbilical cord of gold."

The avant-garde represents the opposite of kitsch; kitsch is the rear guard; it is debased. Kitsch is the "product of the industrial revolution which urbanized the masses of Western Europe and America and established what is called universal literacy." In the past culture belonged to those who had leisure and literacy. "But with the introduction of universal literacy the ability to read and write became a minor skill like driving a car," making it more difficult to "distinguish an individual's cultural inclinations, since it was no longer a concomitant of refined tastes."

Kitsch, then, is the devalued, watered-down version of high culture, repetitive and self-evidently academic, according to Greenberg. It takes different forms in different countries, so that it can be found in the Soviet Union, where the masses have been

conditioned to shun "formalism" and to admire "socialist realism." ... The native of China, no less than the South American, the Hindu, no less than the Polynesian, have come to prefer to the products of their native art, magazine covers, rotogravure sections and calendar girls.

But Kitsch, he says, is not merely conditioned: it is widely accepted because "there is no continuity between art and life." Kitsch is predigested, providing those lacking in high culture a shortcut to the enjoyment of art. Kitsch is synthetic; it imitates life.

Avant-garde art, on the other hand, is a new creation. It adds forms of life. By definition it is difficult. It *should* be difficult. Its difficulty guarantees that the masses will shun it and the elite support it. Thus, the reaction of the audience becomes a litmus test for the art. "Avant-garde and Kitsch," then, denies as high art the art of the recent past and serves as a guide to the forms for which it issues a call.

Whether or not one accepts Greenberg's philosophic, aesthetic, or sociopolitical formulations, the essay contains within its argument a powerful ploy (probably fortuitous) for enhancing the lure of difficult art: by making the enjoyment of recondite, hermetic art a cultural test, the avant-garde adds to its attraction – its difficulties become a barrier to be catapulted by people with upwardly mobile cultural aspirations. Who wants to be left standing outside the gardens of the elite? Who can admit to not understanding a mode if to do so is to be tagged "uncultured"?

Greenberg's notions stem from his interpretation of Trotsky's theories of culture. Trotsky's lines against "themes" in art can be understood as preliminary to Greenberg's advice that the avant-garde turn away from the subject matter of common experience. Greenberg's premise that art cannot be reduced to anything not itself, a commonplace in literary criticism, is another way of saying that art cannot be *reduced* to its theme. ("A poem should not mean/ But be," is the way Archibald MacLeish said it in 1926.) To be against themes per se, however, is to oppose not only immediate predecessors Social Realism, Regionalism, Surrealism, Precisionism, American Scene painting, and more, it may also be understood to preclude abstraction based on concrete phenomena. In fact, it stands against all preceding American painting.

Looking back in the late fifties, Greenberg spelled out the connection with Trotsky.

Abstract art was the main issue among the painters I knew in the late thirties. Radical politics was on many people's minds, but for these particular artists Social Realism was as dead as

American Scene. Though that is not all, by far, that there was to politics in those years; some day it will be told how "anti-Stalinism," which started out more or less as "Trotskyism," turned into art for art's sake, and thereby cleared the way, heroically, for what was to come.[15]

The Trotsky–Breton statement that art should *not* submit to discipline, that anarchist individualism is necessary to creative fulfillment, can be read as the basis for Greenberg's espousal of the Abstract Expressionist dissolution of content into form – which, of course, dissolves theme as well. His expression of the need of the avant-garde to create something "new," something unrelated to Platonic mimesis, may also be interpreted as a means of escaping from constraint, as Trotsky advised. Greenberg's ideas were extremely influential among the artists, eventually making him the revered and feared guru of Abstract Expressionism, a man who could make as well as break reputations by means of public comments or private introductions.

If Greenberg expanded the germ of Trotsky's idea of "complete freedom for art" into the basis for Abstract Expressionism, the second seminal theoretician and spokesperson was Harold Rosenberg. His key essay, "American Action Painters" (reprinted herein), appeared long afterward, in *Art News* in 1952, as the movement was in the process of sweeping everything before it. It was in this article that Rosenberg made his now famous remark that "what was to go on canvas was not a picture but an event." Although the line invites parody, such as Mary McCarthy's quip that you can't hang an event on the wall, its meaning is clear enough. Rosenberg is saying that the act – or the event – of making a picture takes precedence over what may appear on the canvas. The painting, he said, is no longer "the space in which to reproduce, re-design, analyze, or 'express' an object, actual or imagined." (This line alone, we believe, eliminates the pertinence of the past, including twentieth-century modernism, to the new art.) The canvas is now "an arena in which to act. The marks on the canvas would be the record and the result of the encounter between the artist" – who begins with no image in mind – and the "piece of material in front of him." It made no difference to Rosenberg whether we call this radically new mode, different in kind rather than degree, "abstract" or "expressionist" or "abstract expressionist" – what is essential is this art form's "special motive for extinguishing the object."

By reading one or both of these essays, or the Schapiro or Trotsky–Breton essays before them, or even by means of discussions among themselves, artists in New York became familiar with the ideas proposed,

and some incorporated them into their thinking. When Abstract Expressionism surfaced, the *Partisan Review*, by then enjoying an expanded and less parochial readership, supported this revolutionary and anarchistic mode of painting from its inception, publishing encouraging articles about the phenomenon by art people as diverse as Robert Goldwater, James Johnson Sweeney, Robert Motherwell, Hilton Kramer – and, of course, Clement Greenberg.

II

The United States had emerged from World War II as the dominant world power. It believed it had saved the world from fascism; it had invented the atom bomb; its industrial strength was huge and expanding, with more Americans employed than ever before. Optimism as well as productivity reached a peak, while abroad both victors and vanquished had only begun to rebuild. Henry Luce's announcement, in his magazines *Time* and *Life*, that this was to be the "American Century" seemed logical and desirable to most Americans. Not everyone bought Luce's notion of world dominance by the United States, but versions of his views on cultural imperialism were accepted in the art world as elsewhere. Museum trustees, virtually all fulfilling at least the minimal qualification of disposable wealth, had ties with industrial and political power. Museum directors and curators are habitually alert for anything new – discovery being one of the quickest routes to a reputation and its rewards – and, by training, museum people are obsessive collectors with a constant and irremediable itch to increase their holdings. After the war, money and curatorial influence were put to the service of the avant-garde critics and artists who saw the time as ripe for American art to seize the space formerly occupied by advanced European painting. The cultural lag had been eliminated, Clement Greenberg felt able to announce in 1948, when he asserted that "the main premises of Western art have at last migrated to the United States."[16] The United States was to become the world's cultural leader.

And so it did become with the first entirely new style of painting to debut after the Second World War, Abstract Expressionism. From *Encounter* in London to such short-lived little magazines as the *Tiger's Eye* in New York, it was championed and publicized by the new young art critics whose opinions appeared in a catholic diversity of periodicals. Leading art journals published frequent explanatory and laudatory pieces about the new painting. During the crucial years between 1948

and 1951 the *Magazine of Art*, the notable organ of the powerful American Federation of Art, published feature articles on de Kooning, Still, Motherwell, Rothko, Pollock, and Gorky. By 1950 *Art News* ceased frowning at the lusty young usurper, becoming more sympathetic than any other American art magazine.

The general magazine with the largest weekly circulation in the nation (and needless to say, often filled with kitsch), *Life*,[17] ran a long, full-color, heavily illustrated piece on Abstract Expressionism as early as 1948, before some of its star practitioners had even had the opportunity for solo shows, and at a time when some of the painters' exhibitions had not outgrown the category granted grudging reviews squeezed into an inch or two of print. The participants in the symposium in the penthouse of the Museum of Modern Art that *Life* organized and reported on were considerable figures in the art world – among them Columbia University professor Meyer Schapiro, since 1943 a member of the Acquisitions Committee of the Museum of Modern Art; Metropolitan Museum of Art Director Francis Henry Taylor; British critic Raymond Mortimer; H. W. Janson, Professor of Art at Washington University in Saint Louis; Alfred Frankfurter, editor and publisher of *Art News*; James Johnson Sweeney, long associated with the Museum of Modern Art and that year newly appointed advisory editor of the *Partisan Review*; James Thrall Soby, curator of paintings at the Museum of Modern Art; and Clement Greenberg. (All identifying titles are those held at the time.)

They focused their discussion of modern art on the new paintings of Jackson Pollock (by this time recipient of foundation support through the intervention of Sweeney), Willem de Kooning, Adolph Gottlieb, and William Baziotes. Works by *all* these painters had already been acquired by the Museum of Modern Art. Thus the forum may be viewed as a means of publicizing and justifying to the larger public choices already made by the Acquisitions Committee of the Museum.

In terms of influence Clement Greenberg's "Avant-garde and Kitsch" almost a decade before had been of greater import for intellectuals than the *Life* symposium, and his continued discussion, explication, and defense of Abstract Expressionism in the *Partisan Review*, *Commentary*, *The Nation*, and other intellectual and art publications was effective, reaching the audience that counted, many of whom took their cue from the critic. Harold Rosenberg became the other most published and best-known defender and promoter of Abstract Expressionism, although the two critics frequently differed in the pages of the journals for which they wrote. Both, however, were excited about the new work, both were friends of many of the artists and socialized regularly with them, and

both eventually owned collections of paintings that had come to them mainly as gifts from the artists. Both Greenberg and Rosenberg, too, attempted to learn more about the new painting from their conversations with the artists, with the result that one can hear echoes of the critics' comments in some of the interviews and writings of the artists and vice versa.

New York newspaper critics Edward Alden Jewell, Howard Devree, and John Canaday of the *New York Times*, Emily Genauer of the *New York World–Telegram* and *The Sun*, and Carlyle Burrows of the *New York Herald Tribune* were dubious about the new painting, often perplexed by it, and generally critical of its direction. They were writing, to be sure, for an audience rather less sophisticated about visual art. Even the critic Thomas Hess, before *Art News* changed its mind about the mode, wrote the brief review that follows, representative of one kind of derisive criticism:

> Barnett Newman, one of Greenwich Village's best known homespun aestheticians, recently presented some of the products of his meditations in his first one-man show. These are large canvases painted in one even layer of color (scarlet, yellow, blue, etc.) and on which runs a vertical line (or lines) of white or a contrasting hue. There are some terrific optical illusions: if you stared closely at the big red painting with the thin white stripe, its bottom seemed to shoot out at your ankles, and the rectangular canvas itself appeared wildly distorted. It is quite like what happens to a hen when its beak is put on the ground and a chalk line drawn away from it on the floor. However, very few spectators actually were hypnotized. But there is almost no interest for the average spectator. Newman is out to shock, but he is not out to shock the bourgeoisie – that has been done. He likes to shock other artists.[18]

In time critics who applauded the new art outnumbered its detractors, increasingly so as both critics and audience became more accustomed to it. It is also fair to infer that critics who found the new mode retrogressive, vapid, or meaningless, or who refused to accept its validity were gradually rejected for publication in the art magazines, if not the more general or scholarly press. The relative scarcity of published comment questioning either the premises or the products of these artists suggests that most editors preferred not to assign or accept articles doing battle with an art movement that had captured the art establishment. (When not acclamatory, much of the day-to-day reviewing of the new art was descriptive rather than evaluative. In this connection it should be recalled

that the fifties were the years of conformity and "togetherness," and that the first part of the decade was shadowed by the nefarious Senator Joseph McCarthy and his troop, with their red hunts and black lists. It is also worth noting that the Abstract Expressionist artists and McCarthy are not known to have attacked each other on any grounds. To this day such adverse criticism as did appear – some of the most representative of which is collected in the following pages – has rarely been cited in the hundreds and even thousands of articles and essays, with their multitude of footnotes, that have poured forth through the decades.

Such derogatory reactions as were published could evoke fevered protest. When John Canaday wrote a long piece (reprinted herein) attacking Abstract Expressionism as late as 1961, letters from academics, artists, and museum people questioned not only his views but his sanity and intelligence. One even threatened his life! More than 600 letters arrived at the *New York Times* in reaction to this single article, of which 52, both pro and con, were published.[19]

Notwithstanding, it is fair to say that after 1950 or so Abstract Expressionism enjoyed a quite consistently good press, and that paintings in the mode by its initiators as well as followers found enviable opportunities for exhibition and sale. It was the dominant mode of painting between 1950 and 1960, a fact reflected in the purchases made by museums and private buyers (rich enough to inhabit houses spacious enough for large canvases), as well as in the pages devoted to the artists and their work in art publications.

The art world, however, is a small one. In terms of collectors of contemporary art, it is even smaller. It is far narrower than, say, the world of books, which some three percent of Americans are said to buy regularly. A higher proportion, assuredly, *reads* books, just as numerous Americans visit art exhibitions. The actual purchasers of professional original art nevertheless constitute far less than one percent of the population, and those buying large nonobjective canvases are but a fraction of this tiny percentage. Necessarily, most of these collectors are museums, banks, or other corporate bodies, or unusually wealthy private individuals who typically are connected in one way or another with at least one museum or corporation. Sales for any given style can boom with so few as a couple of dozen active collectors, in contrast to books, for which a hundred thousand or more must vote with their dollars to make a best-seller, or films, for which a still greater number are required to make a movie a hit.

This is not to confuse quality with popularity, as no necessary connection links the two, but it is to say that a minuscule minority can

support an art that answers its needs, and this fraction can popularize it sufficiently among those who count to make it seem dominant. The connection between art and its patrons has been elucidated for centuries and is a familiar story to anyone knowledgeable about the history of art, but when in recent centuries art patronage became indirect, the connecting links became less obvious. Clement Greenberg hit the mark with his remark that art is connected with its patrons by "an umbilical cord of gold," and Max Kozloff is perceptive when he complains that "art writers have failed to understand the significance of most world art's alignment with the powerful" and that the "problems raised by art are themselves distorted whenever it is imagined that art is socially neutral."[20]

It is an irony that instead of reigning for a thousand years, as Adolph Gottlieb had predicted, Abstract Expressionism remained monarch for only a decade. As early as 1956 Leo Steinberg cast a somewhat disenchanted eye, noting that Abstract Expressionism was demonstrating "the impasse of expressionism settling into style and turning into habit. The raw, rash, rapid handling of paint is the Hofmannerism of our day."[21]

The artists, too, seem to have harbored ongoing insecurities about the mode they had invented. In 1958 at "The Club," the meeting place at which these artists discussed so much of their theory, a panel enlarged on the question, "Has the situation changed?" Art News published a series of artists' comments titled "Is Today's Artist With or Against the Past?" In 1959 the Club sponsored panel discussions on "What Is the New Academy?"[22]

Younger commentators grew bolder. In 1960 William Rubin remarked on the poor quality of "Abstract Expressionist or de Kooning style painting . . . by painters who have converted it into a formula and given it 'professional' finish and polish. . . . This happens only after style has passed its period of vitality, when the metaphor becomes the cliche."[23]

In the sixties even Greenberg concurred to a degree. Having revised his theories, he wrote an article titled "After Abstract Expressionism" in 1964 that foreshadowed (or paved the way for?) subsequent modes by saying that "the irreducible essence for pictorial art consists in but two constitutive conventions or norms: flatness, and the delimitation of flatness; . . . observance of merely these two norms is enough to create an object which can be experienced as a picture. . . . Not skill, training or anything else having to do with execution or performance, but conception alone."[24] Looking back in 1970 he decided that "Abstract Expressionism collapsed very suddenly back in the spring of 1962. . . . It is true that it had begun to lose its vitality well before that. . . . "[25] Harold Rosenberg

decided in 1962 that a new art mode was long overdue. "By all the presumed laws of vanguardism, no innovative style can survive for that length of time without losing its radical verve and turning into an Academy.... Thus for several years upon the closing of the galleries in the spring, Abstract Expressionism was, like Adonis ... prepared for burial."[26]

All revolutions fail, at least in the sense that the next generation wants or gets the entire package proposed by the original insurgents. Abstract Expressionism came out of a set of social, political, and cultural circumstances that bred few direct followers faithful to the mode. But this is not the same as saying that the hegemony of Abstract Expressionism has been without lasting effect. On the contrary, as Harold Rosenberg had predicted, the "tradition of the new" became established. Art forms came to be judged on the basis of their novelty, which itself became a standard for evaluating art. If what artists made seemed not to be art by accepted standards, then "so much the worse for those standards," in the words of Adolph Gottlieb.

What Abstract Expressionism had accomplished that would not fade away was its enlargement of the territory that our era defines as art; or put another way, art became de-defined, as Rosenberg maintained; or, in Lawrence Alloway's view, art required new definitions.[27] Dethroning Abstract Expressionism, American artists kept a whirlwind of immediately apprehendable "new" styles twirling, each in turn attracting museum adherents and a market. "Happenings," an early post-Abstract Expressionist phenomenon, may in fact stem from Abstract Expressionism, as Allan Kaprow claimed. He said that viewing Jackson Pollock's exhibitions created for him the "effect of an overwhelming environment" that inspired him to create his first environments, a notion Harold Rosenberg had explored by tracing art's separation of "the *action* [as in "action painting"] from the *painting*." First, Kaprow wrote, "make a *real* environment, then encourage appropriate action.... In the process the Happening ... developed." Even Claes Oldenburg, father of Pop art – antipodal to Abstract Expressionism except for its equal disclaimer of traditional intellectual, social, or aesthetic values – alleged kinship with Pollock, insisting that he used Pollock's "kind of paint to entangle the objects in my surroundings."[28]

After Abstract Expressionism everything could be art because art was whatever artists made: meticulous, vastly enlarged painted reproductions of photographs became art; home-made rag dolls became "soft sculpture"; banal illustration – if worked in oil or acrylic on canvas – became Pop art, as did comic strips made with the same materials. Random objects,

draped mountains, empty galleries, scribbled instructions, spray-painted subway trains, arrangements of lights or stones or tiles or dirt or sawdust – all are called art. The myriad mini-movements propelled to prominence in the wake of Abstract Expressionism could be detailed, but it suffices to note that few of them would have been acceptable occupants of the formerly exalted precinct – the sacred grove set aside for art – before the gates were opened and the fences burned.

In the same way that the revolution of free verse removed meter as a rule of poetry, so Abstract Expressionism discarded requirements for the expression of ideas or communication with the audience. The argument protracted over centuries as to whether the purpose of art is education or delight became moot, for since Abstract Expressionism the purpose of art has been neither. Art is now whatever its maker chooses to call art. It is made to please the maker. But just as Robert Frost found writing poetry without meter like playing tennis without a net, so too the need for making visual images that reflect and interpret the observed world has not vanished, although it is unlikely to flourish again in the forms familiar before the advent of Abstract Expressionism.[29]

Notes

1. Harold Rosenberg, "The American Action Painters," *Art News*, December 1952, p. 48; reprinted in this volume. This seminal essay describes the gestural painters such as Pollock and de Kooning primarily, but its ideas illuminate all the Abstract Expressionists and are still repeated by almost anyone discussing the style.

2. Max Kozloff, "Matta: An Interview," *Artforum*, September 1965, p. 25.

3. Barnett Newman, "The Plasmic Image" (unpublished manuscript), as quoted in Thomas B. Hess, *Barnett Newman* (New York: Museum of Modern Art, 1971), p. 39. His comment repeats an idea expressed in similar words by Meyer Schapiro in his 1937 review, "The Nature of Abstract Art," originally published in the independent *Marxist Quarterly*, of Alfred Barr's *Cubism and Abstract Art* (New York: Museum of Modern Art, 1936): "Just as the discovery of non-Euclidian geometry gave a powerful impetus to the view that mathematics was independent of experience, so abstract painting cut the roots of the classic ideas of artistic imitation. The analogy of mathematics was in fact present to the minds of the apologists of abstract art; they have referred to non-Euclidian geometry in defense of their own position, and have even suggested an historical connection between them." (Meyer Schapiro, *Modern Art, 19th and 20th Centuries* [New York: George Braziller, 1978] p. 186.) For a brief history of the *Marxist Quarterly*, see Alan M. Wald, *The New York Intellectuals* (Chapel Hill & London: University of North Carolina, 1987), pp. 152–4.

4. Quoted in part by Edward Alden Jewell in his column "End of the Season Mélange," *New York Times*, 6 June 1943, p. 9. The Federation of Modern Painters and Sculptors, sponsor of the exhibition, was founded in 1939 by artists who had broken away from the American Artists Congress on the grounds that it was dominated by the Communist Party. For more on the break, see note 10, below.

5. Adolph Gottlieb, "Statement," in "Jackson Pollock: An Artists' Symposium," *Art News*, April 1967, p. 31.

6. Adolph Gottlieb and Mark Rothko, "Statement," as quoted in Edward Alden Jewell, "'Globalism' Pops into View," *New York Times*, 13 June 1943, p. 9. Although Barnett Newman did not sign the statement, it later became known that he collaborated in its writing. See Schapiro's "The Nature of Abstract Art," especially pp. 200–1 for other borrowings.

7. Gottlieb and Rothko, ibid.

8. Rosenberg, "Action Painters," p. 49.

9. For more on this group, see David Shapiro, *Social Realism: Art as a Weapon* (New York: Ungar, 1973). The Abstract Expressionists, in common with all other groups except the Social Realists, had no quarrel with the structure of the art establishment in terms of the way art was supported, exhibited, promoted, and sold.

10. For more on the Artists Union, see Stuart Davis, "The Artist Today – the Standpoint of the Artists' Union," *American Magazine of Art*, August 1935, p. 476 (reprinted in Shapiro, *Social Realism*); Gerald Monroe, "Artists as Militant Trade Union Workers During the Great Depression," Archives of American Art *Journal*, Vol. 14, No. 1, 1974, pp. 7–10; Gerald Monroe, "Art Front," Archives of American Art *Journal*, Vol. 13, No. 3, 1973, p. 5; David Shapiro and Cecile Shapiro, "The Artists Union in America," in Philip S. Foner and Reinhard Schultz, eds., *The Other America* (London: Journeyman Press, 1985).

11. For information on the New Deal art projects, begin with Francis V. O'Connor, *Federal Support for the Visual Arts: The New Deal and Now* (Greenwich, Conn.: New York Graphic Society, 1969) and Francis V. O'Connor, ed., *Art for the Millions* (Boston: New York Graphic Society, 1975). See also Greta Berman, *The Lost Years: Mural painting in New York City under the Works Progress Administration's Federal Art Project* (New York: Garland Press, 1978); Edward Bruce, "Implications of the Public Works of Art Project," *Magazine of Art*, March 1934, p. 113; Edward Bruce and Forbes Watson, *Art in Federal Buildings* (Washington, D. C.: Federal Buildings, Inc., 1936); Elinor Carr, "The New Deal and the Sculptor," Ph.D. dissertation, New York University, 1969; Belisario R. Contreras, "Treasury Art Programs: The New Deal and the American Artist," Ph.D. dissertation, American University, 1967; Olin Dows, "The New Deal's Treasury Art Program: A Memoir," *Arts in Society*, Vol. 2, No. 4 (n.d.), pp. 51–88; Holger Cahill, *New Horizons in American Art* (New York: Museum of Modern Art, 1936); Richard D. McKinzie, *The New Deal for Artists* (Princeton: Princeton University, 1973); Marlene Park and Gerald Markowitz, *New Deal for Art* (Hamilton, N. Y.: Gallery Associates, 1977);

Marlene Park and Gerald Markowitz, *Democratic Vistas* (Philadelphia: Temple University, 1984); David Shapiro, ed., *Art for the People: New Deal Murals on Long Island* (Hempstead, N. Y.: Hofstra University, 1978); Karal Ann Marling, *Wall-to-Wall America* (Minneapolis: University of Minnesota, 1982).

12. André Breton and Diego Rivera, "Manifesto: Towards a Free Revolutionary Art," *Partisan Review*, Fall 1938, pp. 49–53. For a more extended discussion of the Breton–Trotsky article and its long-range ramifications, see David and Cecile Shapiro, "The Politics of Apolitical Painting," *Prospects* III (New York: Burt Franklin, 1977), pp. 175–214, reprinted in Francis Frascina, ed., *Pollock and After* (New York: Harper & Row, 1985). See also Annette Cox, *Art-as-Politics: The Abstract-Expressionist Avant-Garde and Society* (Ann Arbor: UMI Research Press, 1982); Clement Greenberg, "The Late Thirties in New York," *Art and Culture* (Boston: Beacon Press, 1961), p. 230; Serge Guilbaut, *How New York Stole the Idea of Modern Art* (Chicago: University of Chicago, 1983).

13. "Statement of the League for Cultural Freedom and Socialism," *Partisan Review*, Vol. 6, No. 4, Summer 1939, pp. 125–7. Signers of the statement included Clement Greenberg, George L.K. Morris, Fairfield Porter, Harold Rosenberg, Meyer Schapiro, and Parker Tyler. Among the seventeen who signed Schapiro's challenge to the American Artists Congress were Gottlieb and Rothko. For a discussion of the collapse of the American Artists Congress, see Gerald Monroe, "The American Artists Congress and the Invasion of Finland," Archives of American Art *Journal*, Vol. 15, No. 1, 1975, pp. 14–20. See also Lincoln Rothschild's rebuttal in the subsequent issue.

14. All the quotations above are from Clement Greenberg, "Avant-garde and Kitsch," *Art and Culture* (Boston: Beacon Press, 1961), pp. 3–21. Originally published in 1939 in the *Partisan Review*, the version published in the *Partisan Reader* (New York: Dial Press, 1946), pp. 378–9, incorporated many revisions, among them the omission of the following paragraph: "Capitalism in decline finds that whatever quality it is still capable of producing becomes almost invariably a threat to its own existence. Advances in culture, not less than advances in science and industry, corrode the very society under whose aegis they are made possible. Here, as in every other question today, it becomes necessary to quote Marx word for word. Today we no longer look toward socialism for a new culture – as inevitably as one will appear, once we do have socialism. Today we look to socialism *simply* for the preservation of whatever living culture we have right now."

 See Greenberg's essay herein, "Towards a Newer Laocoon," for his theories about flatness and purity.

15. Clement Greenberg, "The Late Thirties in New York," *Art and Culture* (Boston: Beacon Press, 1961), p. 230.

16. Clement Greenberg, "Art Chronicle: The Decline of Cubism," *Partisan Review*, March 1948, p. 369.

17. *Life*, 11 October 1948, pp. 56ff. Meyer Schapiro and Sidney Janis, the art dealer (not a participant in the symposium), headed the Acquisitions Committee of the Museum of Modern Art in 1943. See Michael Auping, ed.,

Abstract Expressionism: The Critical Development (New York and Buffalo: Abrams/Albright-Knox Gallery, 1987), p. 261.

18. Thomas B. Hess, "Barnett Newman," *Art News*, March 1950, p. 48.

19. "Letters," *New York Times*, 26 February, 5 March, 12 March 1961. See also, in the present volume, John Canaday, "Selections from *The Embattled Critic*," and the letter that follows. The protest letter to the *Times* signed by many artists and academics was initiated by the artist John Ferren and the art historian Irving Sandler. See Irving Sandler, *The New York School: Painters and Sculptors of the Fifties* (New York: Harper & Row, Icon edition, 1978), pp. 281–2.

20. Max Kozloff, editorial, *Art Forum*, December 1976, p. 7.

21. Leo Steinberg, "Month in Review," *Arts*, January 1956, p. 47.

22. Sandler, *The New York School*, p. 282.

23. William Rubin, "Younger American Painters," *Art International*, Vol. 4, No. 1, 1960, p. 25.

24. Clement Greenberg, "After Abstract Expressionism," *Art International*, Vol. 6, No. 8, October 1962, p. 30.

25. Clement Greenberg, "Avant-Garde Attitudes: New Art in the Sixties," *Studio International*, Vol. 179, No. 921, April 1970, p. 143.

26. Harold Rosenberg, "Art at Mid-Century," in Herbert Spencer, ed., *Readings in Art History*, 2nd ed., Vol. II (New York: Charles Scribner's Sons, 1970), p. 398.

27. Lawrence Alloway, *Topics in American Art Since 1945* (New York: Norton, 1975). His essays constitute an attempt to define the new art.

28. Allan Kaprow, "Jackson Pollock: An Artists' Symposium, Part I," *Art News* LXVI, April 1967, p. 60; Claes Oldenburg, ibid., Part II, pp. 27–66.

29. Art historians continue to explore Abstract Expressionism from a variety of approaches: literary, psychological, political, religious, economic, adding insights that may further open the values and meanings of Abstract Expressionist works. Among such art historians not heretofore cited are the following:

Ashton, Dore. *Out of the Whirlwind: Three Decades of Commentary* (Ann Arbor Mich.: UMI Research Press, 1987).
Buettner, Stewart. *American Art Theory, 1945–1970* (Ann Arbor, Mich.: UMI Research Press, 1981).
Calas, Nicolas. *Transfigurations: Art Critical Essays on the Modern Period* (Ann Arbor, Mich.: UMI Research Press, 1985).
Chave, Anna Carruthers. "Mark Rothko's Subject Matter." Ph.D. dissertation, University of Delaware, 1982.
Crane, Diana. *The Transformation of the Avant-Garde: The New York Art World, 1940–1985* (Chicago: University of Chicago Press, 1987).
Foster, Stephan C. *The Critics of Abstract Expressionism* (Ann Arbor, Mich.: UMI Research Press, 1980).
Gibson, Ann. "Theory Undeclared: Avant-garde Magazines as a Guide to

Abstract Expressionist Images and Ideas." Ph.D. dissertion, University of Delaware, 1984.

MacNaughton, Mary Davis. "The Painting of Adolph Gottlieb, 1923–1974." Ph.D. dissertation, Columbia University, 1981.

Merkert, Jörn. "Stylelessness as a Principle: The Paintings of Willem de Kooning," *Willem de Kooning: Drawings, Paintings, Sculpture* (New York: Whitney Museum of American Art, 1984).

O'Connor, Francis V. "The Genesis of Jackson Pollock." Ph.D. dissertation, Johns Hopkins University, 1965.

Rohn, Matthew Lee. "Visual Dynamics in Jackson Pollock's Abstractions." Ph.D. dissertation, University of Michigan, 1984.

Rubin, Joan Gassisi. "Frederick Church, Jackson Pollock and Christo." Ph.D. dissertation, New York University, 1983.

PART I

Origins

How does an art movement begin? Sidney
Simon's interview with Robert Motherwell
reveals aspects of Abstract Expressionism's
inception that might not have become known in any
other way. Irving Sandler's and Robert Goldwater's
essays on "The Club" give full reports from participants.
Written long after the events described, the pieces taken
together disclose essential bases of the mode.

CONCERNING THE BEGINNINGS OF THE NEW YORK SCHOOL: 1939–1943

An Interview with Robert Motherwell Conducted by Sidney Simon in New York in January 1967

imon: Since these discussions are concerned with the origins of the so-called New York School, I would welcome your detailed reminiscences of the period roughly from 1939 to 1943. What, for example, were the circumstances that led to your close association with Matta in 1940?

Motherwell: To give some idea of what must have taken place, I will have to emphasize the fact that my background up to 1940 had little to do with painting. Until then, I had known only one obscure American artist. My grown-up life had been spent in prep school and universities, involving various scholarly pursuits. It is true, on the other hand, that I drew and painted all my youth, so that I can't really say that I walked into the New York art situation visually naked, but I certainly had no professional experience at all.

Simon: Might we back-track a bit? You were at Harvard for a time, isn't that so? When was that?

Motherwell: The academic year of 1937–1938. I was a graduate student in the Philosophy department. That particular year, Arthur Lovejoy, who was a visiting professor, had a year-long seminar in the History of the Idea of Romanticism. When he discovered that I was interested in painting, he assigned to me Eugène Delacroix, whose journal had just been published in translation. Both Lovejoy and my Harvard mentor, David Prall, liked what I wrote well enough to suggest that I go to Paris

From *Art International*, Summer 1967. Reprinted by permission of Sidney Simon and *Art International*.

for a year and prepare it for publication. It was in May, 1938, that I went to France. After a short stay at the University of Grenoble to improve my French, which remained awful, I spent the rest of the time in Paris almost until the war began. There was an interlude at Oxford, in July 1939.

Simon: Had you yet decided on a career in painting?

Motherwell: No. Back in the States, I got a teaching job at the University of Oregon for one year, as a substitute for someone on sabbatical leave. I took the job so that I would have something to do while I was trying to make up my mind whether to continue my academic career or to become a painter – which I really longed to do, but did not know how to go about. During that year I met the composer, Arthur Berger, who advised me to go to New York and study with Meyer Schapiro at Columbia, while making up my mind. New York, he thought – and quite rightly – was much more of a center of art than the other places I had been. So I wrote to Columbia. They pointed out that I was unqualified technically to be in the graduate school of art history but were willing to take me, on probation.

Simon: Your contact with Meyer Schapiro is of course very well known.

Motherwell: I owe him a lot. When I came to New York I knew no one. By coincidence I lived near Schapiro. I began to paint a lot. Occasionally, because I didn't know anyone else who would be interested, I used to take my pictures and show them to him – I realize now, somewhat to his annoyance. I had no conception of how busy people are in New York. One day he suggested that what I really needed was to know some other artists. He knew most. He wanted to know whom I would like to meet. If it were possible, he said, he would arrange it.

Simon: Did he influence you about becoming a painter?

Motherwell: He felt strongly that I should become a painter and not a scholar – not that my scholarship was inadequate – but that my real drive was obviously toward painting. He asked me what American painters I liked; and I said I didn't know of any that I really liked or wanted to meet. And then he said, what about the Parisian Surrealists (who were most of them in New York in exile)?

Simon: Do you remember when exactly this conversation took place?

Motherwell: It must have been around Christmastime, 1940. I said that, judging from the little I had seen, I didn't like Surrealist painting either. What I had in mind was the work of Dali, the more literary kind. And he said, whether you like their painting or not, they are the most lively group of artists around. (They would have been in their 40's then.) They are highly literate; and, since you have an orientation toward

modern French culture, it could be good for you. So I said, from that point of view, fine. After some reflection, he arranged that I study engraving with Kurt Seligmann. (Seligmann spoke English very well.) He was learned, and, as we would say nowadays, "square." Although I was interested in learning engraving, the thing was really a pretext (which we both understood) to help me to enter a bit into the French milieu. After all, I couldn't just hang around. . . .

Simon: What kind of an impression did the Surrealists make on you? What were they like?

Motherwell: They were a real fraternity. Such as I have never seen before, or since, among artists. (Most of the artists I have known have as their best friends other artists, but it is a personal rather than an ideological relationship.) Surrealism was a complicated system of ideas and attitudes, having to do not only with art.

Simon: Since you found them such a close-knit group, was it hard for you to get to know them?

Motherwell: No. What I am trying to emphasize is their comradeship. To answer your question, through Seligmann – all the Surrealists appeared in his studio at one time or another – and his reciprocal visits to various studios (taking me with him) I not only met them, but also had an important, if minor, function to perform: I was an American. Most of them had been plunged straight into exile. There were lots of things that puzzled them, from the most minor things like – If you couldn't get olive oil, what other kind of cooking oil would serve as well? Why do Americans do this or that or the other thing? And being an American I was in a position to be helpful, to provide other frames of reference.

Simon: I take it from what you say that they had few real contacts with Americans?

Motherwell: They were artistically isolated on the whole. They knew that the American artists held off, either out of jealousy or out of lack of sympathy; or perhaps feeling threatened, or merely not being interested: I don't know. But I, of course, had nothing yet about which I could feel threatened. Not yet a painter, and being imbued in French culture, and regarding them as forming a distinctive part of this culture, I had great sympathy. And so I was useful to them in some ways. I think they liked me, too.

Simon: You would have met Matta about this time?

Motherwell: Yes. The first Surrealist I met and the only one who was close to my age was Matta. He was the most energetic, enthusiastic, poetic, charming, brilliant young artist that I've ever met. This would have been the spring of 1941.

THE NEW YORK SCHOOL, 1939–43 35

We tend to forget, in thinking about this period, that it was the end of the Depression. The war was about to begin; it had already begun in Europe. Most of the artists of my generation nearly all had been on the WPA, at $25 a week, or whatever it was. The WPA was heavily socially oriented; and those few artists who were attracted to modern or abstract art had a rough time. None had recognition. Most were poor, depressed, with considerable feelings of hopelessness, but determined nevertheless to carry on, in their respective aspirations.

For an enthusiastic person like Matta to appear – this had an extremely important catalytic effect. (Matta and I were both "foreigners" to the New York painting scene. Matta came from a different world, while I, an American, had never been forced to endure what my colleagues had.)

Simon: Can you recall the first time you met Matta?

Motherwell: I can't. I would imagine it was in Seligmann's studio. (The other possibility is that I met him through the Onslow-Fords. I can't remember. Gordon Onslow-Ford had something of the same relationship as I had to Matta – that is, we were both his admirers.) What I do remember is that Matta and I became friendly very quickly. By this I mean we met at least a couple of times a week, etc., during the spring 1941. He was married at the time to an American girl. I remember that he wanted very badly to get out of America for the summer. Seligmann had another pupil in engraving, a young girl, Barbara, who was the daughter of Bernard Reis, the art collector. It was finally aranged that the Mattas and the Seligmanns, Barbara Reis and I would all go to Mexico for the summer. Then, as you will recall, in May, Paris fell to the Germans. And the Seligmanns, both of whom were Swiss Jews, were worried about their relatives in Europe and so they decided they couldn't go. The Mattas, Barbara and I got on a boat and left for Mexico. On the boat was a young Mexican actress with whom I promptly fell in love, and soon after married.

Simon: How important do you feel this Mexican sojourn was for your artistic development?

Motherwell: It was important in a special sense. In the three months of that summer of 1941, Matta gave me a ten-year education in Surrealism. Through him, I met Wolfgang Paalen, a prominent Surrealist, who was living in Mexico City. At the end of the summer, the Mattas and Barbara Reis returned to New York. Maria and I settled near Paalen till nearly Christmastime. Paalen was an intellectual, a man widely read; and it was with him that I got my postgraduate education in Surrealism, so to speak.

By the time Maria and I returned to New York, we were already married. We took an apartment on Perry Street in the Village, not far from where Matta lived. One day, I recall, Matta and I went up to Columbia to see the mathematical three-dimensional objects (like very beautiful abstract sculptures) that are made by mathematicians, to show their concepts in three dimensions. In the subway, on the way back, there was a very attractive young woman, who spoke to Matta. Afterwards I asked who she was, and he said that she was the wife of a very good young American artist, Bill Baziotes. Come to think of it, he said, you ought to get to know Baziotes. He thought we would like each other. Matta had us to dinner, and we became friends on the spot.

Simon: Do you recall seeing Matta's first show in New York, at the Julien Levy Gallery? It opened in April 1940. This would have been a year before you met him.

Motherwell: No, I don't remember seeing it. My vivid feelings about his work were always the same. I loved his pencil drawings, but I never really liked his paintings. For me they were theatrical and glossy, too illusionistic for my taste. But I do think the drawings he made in those years – in the late 1930's and 1940's – are among the most beautiful, if not *the* most beautiful work made in America at that time. And there were hundreds of them. Matta, with all his worldliness and sociability, has always been a very hard worker, enormously productive.

Simon: How do Pollock, Busa and Kamrowski relate to the general situation that we have been discussing?

Motherwell: Well, here is where I have got to talk about what has always seemed to me the beginnings of what later became known as Abstract Expression. The thing that I want to establish (and I say this as a metaphor) is that Matta had an Oedipal relation to the Surrealists. He was, in the time we are talking about, only about 30 years old while all of the other Surrealists were in their forties. He was the loved son, the heir apparent; but he was also treated with a certain amount of suspicion, somewhat unfairly, because the last person to play his role was also Spanish speaking – I'm referring, of course, to Salvador Dali. The Surrealists at that moment hated Dali; and I think there was some suspicion that Matta might be ultimately another Dali. In any case, Matta certainly had a deep love–hate relationship with the Surrealists. At one moment when the hate relationship was more dominant, he wanted to show the Surrealists up, so to speak, as middle-aged grey-haired men who weren't zeroed into contemporary reality. He realized that if he made a manifesto by himself, or even if he had a beautiful show by himself, the Surrealists could say, well, he's a Surrealist and he's very talented; but if

there were a group who made a manifestation that was more daring and qualitatively more beautiful than the Surrealists themselves, then he could succeed in his objective of showing them up.

Simon: The possibility of succeeding in this I would say must have been rather dim. Would you agree?

Motherwell: Of course. The thing was that there weren't a lot of good painters around; or if there were we didn't know about them; so the problem was how to go about it. Matta came to me and Baziotes with the problem. Of course, I didn't know any American artists, though by this time I had got to know most of the European artists reasonably well. Baziotes, however, had been on the WPA for many years and perhaps was still on it at that time. So Matta said to Baziotes, are there some guys on the WPA who are interested in modern art and not in all that social realist crap? Baziotes said there are very few. He named Pollock, de Kooning, Kamrowski and Busa. And then Matta said to me, how can we make a manifestation? And I answered that the great manifestation in America had been the Armory Show, that perhaps we should hire an armory, or a big loft or something, and show *new* work. Matta said – quite properly – if we are going to make a manifesto against the Surrealists, the work has to have some group point, something more than simply personal talent. Then I said, you and I have talked for a year constantly about Surrealist theories of automatism and we believe that they can be carried much further. Since the three of us have been experimenting with various forms of automatism all winter, perhaps we could explain what automatism is to the artists Baziotes has named and see if they would be interested in some kind of collaboration. I suggested that perhaps we should even rent a place, a month in advance of the show, and all go there for a month and make this manifestation on the spot.

Simon: You make it sound like a quite feasible idea after all. I would be interested to know why it never came off.

Motherwell: Matta was all for it then. He was very enthusiastic, full of ideas, loved to see things start; but once they started, he often lost interest or got interested in something else. So what ulimately happened was that I, as the theoretician, and Baziotes, as the friend of the artists, were sent to explain all of this to them somewhat on our own. Matta, you see, retreated from the enterprise, which nonetheless was more personal to him than to us.

Simon: But you went ahead with the project anyway?

Motherwell: Yes. I asked Baziotes who he thought to be the most talented of his friends. Baziotes thought probably Pollock. He gives the impression of being very tough and he didn't know how receptive he

would be to the idea. I remember that Baziotes called up Pollock and we made a date to go and spend a whole afternoon with him. I talked, I guess, for four or five hours explaining the whole Surrealist thing in general and the theory of automatism in particular, which nowadays we would call a technique of free association. I showed Pollock how Klee and Masson made their things, etc. And Pollock, to my astonishment, listened intently; in fact, he invited me to come back another afternoon, which I did. This would be the winter of 1942.

Simon: Just how interested would you say Pollock was?

Motherwell: What I haven't said is that by this time I'd become friendly with Peggy Guggenheim (who either had or was about to marry Max Ernst and was very much part of the Surrealist milieu). I think a lot of Pollock's interest in me was not altogether in what I was saying, but in that I had a connection with Peggy Guggenheim. (In those days it was almost impossible for an unknown American artist to show in a first-rate modern gallery, such as Curt Valentin or Pierre Matisse.) And it turned out, in fact, that Peggy Guggenheim was the only one who recognized – because of the milieu she was in – the value of the new artists, and showed us with style and class, to her credit. But Pollock learned something, esthetically too. He was barely past the Mexicans and coming up to the Picasso of the 1930's.

Simon: You mentioned a second visit to Pollock.

Motherwell: That second visit I recall vividly. Pollock was living with Lee Krasner, who was a pupil and admirer of Hofmann, who lived only a few doors from them. I think it was at Lee's behest that Pollock took me over after dinner to see Hofmann. It was the first time I had met him, and I at once realized that my being 26 years old – Hofmann was already in his 60's – it would be impertinent for a young apprentice artist to tell him about what painting was. As it turned out, Pollock got drunk on a big jug of red wine, and we all had to carry him down four flights into the street and then up four flights to his place. It was a halluva job.

Simon: Did you see much of Pollock after that?

Motherwell: After several months, Pollock and I became somewhat friendly. He and his wife and I and my wife and the two Baziotes used to write automatic poems together, which I kept in a book. Unfortunately, this book is now lost, given away or stolen. I greatly regret that I have never been able to recover the poems which were inserted in the book for safekeeping!

Simon: After Pollock, which artist did you contact?

Motherwell: I think Peter Busa was the next. In those days Busa struck me as the epitome of the Italian artisan, gentle and charming. Just

married. I seem to recall that he was painting the female figure with the degree of abstraction of, let us say, Karl Hofer, or perhaps, Modigliani. After Busa, we called on Kamrowski, a depressed man who expressed an interest in our proposed project and did begin to work in these directions.

The last person to be visited – it was Pollock's initiative that took me to see him – was de Kooning. He had a loft around West 19th Street. In those days de Kooning was painting figure paintings in a direction that he developed jointly with Gorky and John Graham. De Kooning was also doing abstractions in a rather loose, and to me not very interesting manner. I think at this particular time his figure paintings were not wholly resolved. He had some inability to "finish" them. I remember that there were never eyes in the sockets. There were other details that baffled him. In any case, he wasn't particularly interested in what I told him; he became interested in automatism only much later.

Simon: Does Gorky figure in this at all?

Motherwell: Only to the extent that about two years later, Matta, on his own, converted Gorky to the theory of automatism. Gorky in those days wouldn't pay much attention to what we said, although I spent a whole evening at Peggy Osborn's house telling him all about Surrealism, about which, incidentally, he knew very little. This would be the spring 1942.

Simon: Would it be correct to say that an informal group of the artists you and Baziotes contacted ended up by meeting from time to time in Matta's studio in order to conduct certain experiments?

Motherwell: To be truthful I don't recall an awful lot about that. The meetings must have been separate. It was an awkward situation in that Matta was the guiding spirit. You have to remember that he was much more "successful," he was earning his living as an artist, he knew many famous collectors and artists very well, and he was part of the inter-national art-establishment. On the other hand, we were all loners, basically, ignored and neglected; so that he would, so to speak, flirt with us, but never abandon his other world for us. In the end, though he was the instigator of it all, the strongest relationships grew up among the American artists, because, in a way, we were left in the lurch by him and we made our own way.

Nevertheless, my conviction is that, more than any other single thing, the introduction and acceptance of the theory of automatism brought about a different look into our painting. We worked more directly and violently, and ultimately on a much larger scale physically than the Surrealists ever had. It was the germ, historically, of what later came to be called Abstract Expressionism.

Simon: Can you recall any of the early experiments you and the others made?

Motherwell: Let's see. The summer of '41 was in Mexico. Either the next summer or the one after, Peggy Guggenheim, who was by then married to Max Ernst, took a house for the summer in Provincetown. I and several other people followed. Matta was living nearby – he had a house in Wellfleet. Several times (in going to Peggy's for dinner) Max took me into his studio. There he had hung brushes from the ceiling on a cord so that they would just touch a canvas placed on the floor beneath. They would swing like a pendulum, making a kind of labyrinth on the canvas. Of course, this anticipated Pollock's drip style, but only in a very limited sense, i.e., limited to arcs. By comparison, what Pollock achieved was totally different, totally free.

We experimented rather freely. Together we would make what the Surrealists called the Exquisite Corpse. You know what that is?

Simon: Yes, of course. The paper is folded and each one does a different part of the figure.

Motherwell: Right. I remember that a conflict came up between Matta and myself. As I said earlier, I greatly admired his pencil drawings which were, roughly speaking, in the same vein as Miró – very comic and very plastic. When we began to play the Exquisite Corpse, I thought Matta would use this degree of abstraction, but instead he drew comically, very realistically. As in a Barney Google cartoon there would be a nose and, very carefully, a pimple on it, a couple of hairs coming out of it – very much in the style of present-day *Mad Magazine*. I expected that he would draw in a more inventive Klee or Miró way – more the way I tried to draw at the time. So the group drawings looked funny.

Simon: Was Pollock receptive at all to these various experiments?

Motherwell: I don't know. To be truthful, it always astonished me when he appeared. He said very little, and made it very clear, after the second session I had with him, that he didn't believe in group activities and would not join the proposed manifestation that we were going to have. At the same time, I think now, in retrospect, that he was much more ambitious than I realized. In those days, given my university background, I did things with a certain gratuitousness, with a love of doing things for their own sake. As an "amateur" in the English sense. Pollock had had a much more tormented, and, socially, a much more difficult life than I had. He was probably much tougher than I was, but didn't reveal this to me. He was certainly interested in getting in a functioning world. Peggy Guggenheim, rather than the Surrealists, was the real center of attraction to him, I think now.

THE NEW YORK SCHOOL, 1939–43 41

Simon: Peggy Guggenheim opened her gallery in November 1942. Exactly a year later she gave Pollock his first one-man show.

Motherwell: I don't remember exactly when Peggy became aware of Pollock, Baziotes and myself among the young American artists. But I do remember that she was going to put on the first international collage show that had ever been held in America. It was going to include all the names – Schwitters, Max Ernst, Cornell, Picasso, Braque, Miró, Masson, etc. And because she was benignly and generously interested in the three of us – you see, she suggested to me that we all makes some collages, and if they were any good (she reserved the right of judgment) she'd put them in the show. It was to have been the first chance for all three of us to show in a majro gallery with major artists. The idea both excited and intimidated us. One day, Pollock suggested to me – Pollock in a funny way was a very shy as well as a very violent man – he suggested in a reticent way that since neither of us had ever made a collage that we try to do them together. I liked the idea and we decided to do so in his studio. (He had been painting much longer than I had, and had a much more professional set-up than mine in terms of space, light and materials.)

And we did make our first collages together. He, I remember, burnt his with matches and spit on it. Generally, he worked with a violence that I had never seen before. As is well known, I took to collage like a duck to water. I showed my results to Matta, who liked them very much, but said that they are too little. "If you can do them that well little, you can do them bigger." He urged me to make some big ones. And I did. They became the core of my first show at Peggy Guggenheim's in October 1944.

Simon: To return to Pollock for a moment, what, in your opinion, led him to adopt the drip technique?

Motherwell: I have a theory about how Pollock came to work his way. Of course it's not demonstrable, but from everything I saw of him in those days and from looking at his work, I believe it to be true: when I met him he was just coming out from having been deeply influenced by the Mexican painters – I think, particularly, by Orozco. The only American painter he liked then – he told me so – was Albert Ryder. (In that famous early document by him which appeared in one of the art magazines – I actually wrote it for him on the basis of interviews – he says this specifically.) As you know he studied with Benton. What Ryder, Benton and Orozco all have in common is that they are all highly rhythmic, brutal and Expressionist painters. I am convinced that an intense, brutal rhythm was at the heart of Pollock's plastic understanding as well.

When I met him, as I say, he was just coming out of Orozco into

violent Picassos of the sort having to do with the drawings for Guernica. In those days Mary Callery had a collection of art devoted entirely to Picasso and Léger. It included Picasso's famous woman with a knife in her hand holding a rooster – a very brutal, beautiful picture. And I think Pollock's aspiration was to make his own version of that kind of Picasso – the Picassos of the mid-1930's. And he wasn't able to do it without making them look too much like Picasso. Pollock, by nature, was a convulsive man, a really violent man and a hard-drinking man. I think that at certain moments of despair and frustration, he would violently cross out his Picasso images, and, at a certain moment, some of them took on a beauty of their own. Part of the beauty of Pollock's work is the sense that underneath his beautiful surface there is a sea of swarming eels, lobsters and sharks. And I think that at a certain moment (it was perfectly natural), he realized that he didn't have to make the Picasso thing at all, but could *directly* do the crossing out or dripping, or what have you. . . .

But even in one of his very last shows, he returned to a version of a Picassoesque figure. I think a lot of Pollock's doubt – which doesn't seem to me strange at all – was that his gift was for something other than that what he really wanted to do. I have a feeling that in many artists, when they finally find their style, it's not what they originally wanted to do at all, but it turns out to be what they are best at doing. And it would be a foolish man who would do something else.

Simon: Your comments about Pollock bring to my mind the question of Masson. How much had you looked at Masson's work?

Motherwell: We all looked at Masson's work a lot. He was here. No one, it is true, knew him very well. To the best of my knowledge, he never learned a word of English. Also, he lived in the country, in Connecticut; the Surrealists, after they had been here a couple of years, tended to move to the country. Gorky, when he was picked up by the Surrealists, also moved to Connecticut. There was a regular enclave there.

Simon: Where would you have seen Masson's work?

Motherwell: He exhibited a lot. I can remember several one-man shows. He was a prolific, hard-working artist. Everyone would have been very aware of his work in terms of automatism, which is how his work is built. And many of us were also aware of some beautiful collages he had made much earlier – a fairly blank canvas with a few automatic lines and very often feathers or something like that pasted on – around 1927, or so.

Simon: What about Kandinsky's work?

Motherwell: I don't think most of us paid much attention to Kandinsky, with the exception of Gorky; but even in Gorky's case, the interest was much more technical, about edges, lines, etc., than in Kandinsky's

overall conception. I think that some historical things are, in a way, invented all over again. My personal conviction is that had Kandinsky never existed, Abstract Expressionism would look exactly the same way.

What I am saying is that at the particular moment in American art that we are talking about, *what was needed was a creative principle*. It is never enough to learn merely from pictures. When you learn merely from pictures, the result is bound to be somewhat imitative as compared to starting off with a real principle. In this sense, the theory of automatism was the first modern theory of creating that was introduced into America early enough to allow American artists to be equally adventurous or even more adventurous than their European counterparts. It was this that put America on the artistic map, so to speak, as authentically contemporary.

Simon: In this respect Peggy Guggenheim's gallery served a very practical function.

Motherwell: Yes. Look at the artists who showed at Peggy's – Baziotes, Pollock and myself – and a little later Rothko, Still and Gottlieb, and so on. Before that time, Gorky had a large underground reputation. Also Hofmann. But very few people had seen their pictures. Around 1945 Kootz came along and offered us money to paint – very little but enough to manage on. Many of the artists of what I think of as the second wave of Abstract Expressionism were impressed that we were making a mark, so to speak, and decided that it was time for them to start to move. And only *then* did they begin to examine seriously the principles on which our work was based – and in the process partly distorted them. Peggy always said she would go back to Europe when the war was over, and she did.

I remember some years ago talking to Rothko about automatism. He and I became friends in the mid 1940's. I told him a lot about Surrealism. He was one of the few American painters who really liked Surrealist painting, went to Surrealist shows, and understood very well what I was talking about. When he developed the style in the late 1940's for which he is now famous, he told me that there was always automatic drawing under those larger forms. When I talk about automatic drawing – the method we used – I don't mean doodling, something absent-minded, trivial and tiny. If we doodled – and perhaps you can say that we did – it was ultimately on the scale of the Sistine Chapel. The essential thing was to let the brush take its head and take whatever we could use from the results. And of course it was Pollock who became the most identified with this technique of working.

In his dripping, one could see most clearly and nakedly the essential nature of the process.

Simon: A new sense of scale, then, I take it, you feel was an essential factor in Abstract Expressionism – even in the 1940's?

Motherwell: I think that one of the major American contributions to modern art is sheer size. There are lots of arguments as to whether it should be credited to Pollock, Still or Rothko, even Newman. It's hard to say, probably Pollock, possibly Still....

Simon: Yes, what about Still in this connection?

Motherwell: I had never heard of Still, until he had his first show at Peggy's. Pollock had his in '43, Baziotes and I in '44, Rothko and Still in '45. I must say, it is to Still's credit – his was the show, of all those early shows of ours, that was the most original. A bolt out of the blue.

Simon: In what sense?

Motherwell: Most of us were still working through images toward what ultimately became Abstract Expressionism. Baziotes, Pollock and I all had some degree of figuration in our work, abstract as our work was; whereas Still had none. His canvases were large ones in earth colors. I don't suppose that they would seem so large now, but they did then. They mainly had a kind of jagged streak down the center, in a way like a present-day Newman if it were much more free-handed, that is, if the line were jagged, like lightning.

My belief is that Still's influence on Abstract Expressionism was strongest later on, in the very late '40s when he and Rothko met in San Francisco teaching in the same school. Rothko was deeply impressed with Still; and Rothko, in those days, was, in turn, very close to Newman. (I also think that they must have had some experience with Expressionism, which undoubtedly contributed a certain element to Abstract Expressionism.)

But the developments I have been talking about – automatism particularly – came out of Paris, and not out of either German or American Expressionism. I think the "Expressionist" part of Abstract Expressionism had to do with a certain violence native to the American character; I do not think it was the result of esthetic considerations. What, in my opinion, happened in American painting after the war had its origins in automatism that was assimilated to the particular New York situation – that is, the Surrealist tone and literary qualities were dropped, and the doodle transformed into something plastic, mysterious, and sublime. No Parisian is a sublime painter, nor a monumental one, not even Miró.

"EVERYONE KNEW WHAT EVERYONE ELSE MEANT"

Robert Goldwater

AGOOD DEAL OF THE SOCIAL HISTORY of American painting during the 'fifties belongs to "the Club," which, with its shifting addresses and renewals of attendance (it's up, or down, to the third artistic generation by now), has been a little like a floating crap game. At the beginning only those who were known to have nothing to do with the authorities were allowed to play; now it is the other way around, most of the uptown men won't come in the door.

But there has always been one thing true of the old pen-knife, no matter how often the blade and the handle got changed: No mention of names. The rule wasn't hard and fast, of course; it was in fact properly anti-traditional. The gods could be named (Picasso and Matisse, mostly, it used to be); and so could the demi-gods (Pollock and de Kooning, mostly). But no ordinary mortals, artists, that is, who might be present or have friends. The idea was to prevent riots. Let's not get personal or we'll have to go out on the sidewalk and settle it.

Maybe at the beginning there was some reason: Either you're with us or against us, and let's not break up the Roman square or the flying wedge (or whatever it was) by internal arguments. We've got enough enemies and let's not give anything away. We all need each other and let's accept the (human and perhaps moral) intention and not question the (painted and sculptured) performance.

The proceedings always had a curious air of unreality. One had a terrible time following what was going on. The assumption was that everyone knew what everyone else meant, but it was never put to the test; no one ever pointed to an object and said, see, that's what I'm talking about (and like or don't like). Communication was always entirely verbal. For artists, whose first (if not final) concern is with the visible and the

From *It Is*, No. 3, Autumn 1959. Reprinted by permission of *It Is* and Mrs. Robert Goldwater (Louise Bourgeois).

tangible, this custom assumed the proportions of an enormous hole at the center.

I wonder if more recently it hasn't led to worse. Given recent "successes," massive defense is not only no longer necessary, but positively harmful. It amounts to giving up the critical faculty, a refusal to make distinctions of quality. These then are left largely to the unfriendly, who don't really want to make them, so the friendly have to defend everything, and they really would rather not. And I wonder too, if it doesn't have something to do with the strange stylistic associations one sees these days in the "tenth street galleries" – a long way from the mutually exclusive groupings of the old days, a series of monogamies rather than the present promiscuity.

Of course what I am talking about – the naming of names – did go on at the Cedar Bar, and now it is scattered around. But is that really where it belongs?

THE CLUB
Irving Sandler

FOR NOSTALGIA-PRONE ARTISTS who frequented the Waldorf Cafeteria, the lectures at the "Subjects of the Artist" School and Studio 35, the Club and the Cedar Street Tavern, the decade following the Second World War was "the good old days." Uncontaminated by success, artists were supposed to have been purer then, more comradely and preoccupied with artistic matters. For others – the careerists – the social history of Abstract Expressionism, once it became important, has been something to rewrite. With an eye to future position, they have tried to change the past. Both attitudes (aggravated by natural lapses of memory) have led to myth-making, which, like any distortion of past events, saps them of authenticity. The following notes attempt to reconstruct what actually happened. They were culled from dozens of interviews, personal experiences, surviving records and printed memoirs.

Many of the artists who founded the Club met in the 1930s while on the Federal Art Project. Some got to know one another at meetings of the Artists' Union and the American Abstract Artists, or in Hans Hofmann's school, or in such restaurants as Romany Marie, the San Remo, the Stewart Cafeteria on 23rd and 7th Avenue and the one on Sheridan Square. During the war, the Waldorf Cafeteria on 6th Avenue off 8th Street became a popular late-at-night hangout for downtown artists. However, they were not comfortable there; whenever the weather permitted, they gathered in nearby Washington Square Park. The cafeteria was a cruddy place, full of Greenwich Village bums, delinquents and cops. The management did not want the artists; they were coffee drinkers who preferred to eat where the fare was better and cheaper (like the Riker's on 8th Street near University Place). To harass them, the Waldorf management allowed only four persons to sit at a table, forbade smoking, and, for a time, even locked the toilet. Therefore, a group of artists decided to get their own meeting place, and in the late fall of 1949, met at Ibram Lassaw's studio and organized the Club.

From *Artforum*, September 1965. Reprinted by permission of Irving Sandler and *Artforum*.

The Club was preceded a year earlier by the "Subjects of the Artist" School, but the School was not its parent body, as has often been claimed. The two were formed independently. The School was founded by William Baziotes, David Hare, Robert Motherwell and Mark Rothko, all of whom had had one-man shows at Peggy Guggenheim's Art of This Century Gallery between 1944 and 1946. With the exception of Rothko, the other three had been close to the Surrealist Government-in-Exile in New York during World War II. Clyfford Still participated in the initial planning of the School but did not teach; Barnett Newman joined the faculty somewhat later. To broaden the experience of the students, other advanced artists were invited to lecture on Friday evenings. These sessions were open to the public, and many of the artists who organized the Club either spoke or attended.

After one semester the School closed, and in the fall of 1949, Robert Iglehart, Tony Smith and Hale Woodruff — teachers at the New York University School of Art Education — and some of their students, notably Robert Goodnough, took over the loft, named it Studio 35, and continued the Friday evenings until April, 1950. Among those who lectured during the two seasons, 1948–49 and 1949–50, were Hans Arp, Baziotes, Nicholas Calas, John Cage, Joseph Cornell (who showed his films), Jimmy Ernst, Herbert Ferber, Fritz Glarner, Adolph Gottlieb, Harry Holtzman, John Hulsenbeck, Kees, Willem de Kooning, Levesque, Motherwell, Newman, Ad Reinhardt, Harold Rosenberg and Rothko. The final activity of Studio 35 was a three-day closed conference, April 21–23, 1950 — some six months after the inception of the Club. The proceedings were stenographically recorded, edited by Motherwell, Reinhardt and Goodnough, and published in *Modern Artists in America*, 1951. In the introduction to this book, the reason for the decline of Studio 35 is given: "These meetings ... tended to become repetitious at the end, partly because of the public asking the same questions at each meeting." The Club was to avoid this problem by limiting participation in its activities mainly to artists and by abstaining from any attempt at adult education.

According to a 1951 list, the charter members of the Club were Lewin Alcopley, George Cavallon, Charles Egan, Gus Falk, Peter Grippe, Franz Kline, Willem de Kooning, Ibram Lassaw, Landes Lewitin, Conrad Marca-Relli, E. A. Navaretta, Phillip Pavia, Milton Resnick, Ad Reinhardt, Jan Roelants, James Rosati, Ludwig Sander, Joop Sanders, Aaron Ben-Shmuel (who was at the first meeting but soon dropped out) and Jack Tworkov. They rented a loft at 39 E. 8th Street and fixed it up. The Club was governed by a voting committee, consisting of those charter

members who remained active and others it elected. By the end of 1952, some twenty more were added, including Leo Castelli, Herman Cherry, John Ferren, Philip Guston, Harry Holtzman, Elaine de Kooning, Al Kotin, Nicholas Marsicano, Mercedes Matter, Joseph Pollet, Robert Richenburg, Harold Rosenberg and Esteban Vicente. However, the dominant force in Club affairs was Phillip Pavia, who made up any financial deficit and arranged the programs.

All Club rules were determined by the voting committee without recourse to the membership. No policy established by one voting meeting was deemed to limit the actions of subsequent meetings. In fact, no one seemed to remember just what decisions had been made from month to month, and minutes were kept only sporadically. For example, as late as 1955, a sub-committee was appointed to define what a charter member was. To become a member, one had to be sponsored by a voting member and approved by the committee. A black-ball method was used; two negative votes (it had to be two because Lewitin always voted no) and a candidate was rejected, but this was occasionally ignored. New members were selected because of their compatibility and not because of how they painted. In the beginning, there was an initiation fee of $10 (sometimes waived for poorer artists), presumably to buy a chair, and monthly dues of $3; later, the dues was lowered to $10 or $12 annually.

Membership jumped quickly. By the summer of 1950, the original 20 had been tripled. An entry in the minutes a year later reads: "77 members + 11 deadheads." Most artists who came to be labeled Abstract Expressionists joined within a few months, including the faculty of the "Subjects of the Artist" School, Rothko excepted, although he appeared now and then at the beginning. Frequent attendance, however, was another matter. The regulars tended to be those who had met at the Waldorf, and their friends who lived south of 14th Street. In 1955, a voting meeting limited total Club membership to 150. Each member in good standing was permitted to bring guests or to write them notes of admission. But few outsiders, if persistent, were denied entry; it was usually sufficient to announce the name of the member who was supposed to have invited you. At first, guests came in free; later, there was a 50 cent charge, presumably paid by the member, not his guest, to emphasize the private character of the Club. Initially, only coffee was served. Drinking liquor was not the thing to do; besides, most members could not afford it. Subsequently, a bottle was bought to oil up the speakers, and still later, liquor was provided after the panels, the costs defrayed by passing a basket. Games were prohibited, but there was dancing.

The Club was formed to provide a place where artists could escape the

loneliness of their studios, meet their peers to exchange ideas of every sort, including tips on good studios and bargains in art materials (a perpetual topic). But there was a more compelling, though not always conscious, reason: mutual support. Reacting against a public which, when not downright hostile to their work, was indifferent or misunderstanding, vanguard artists created their own audience, mostly of other artists – their own art world. Further, for many, existing styles and their traditions – social and magic realism, regionalism and geometric abstraction – had lost their meanings, and new ones had to be discovered. Therefore, artists gathered to consider what such new values might be – and whether they constituted a common culture – and to find ways of describing and interpreting them. Their needs were urgent enough to keep "these highly individualistic artists together, their ideas criss-crossing and overlapping in a conflict that would tear apart any other togetherness," as Pavia put it. "They faced each other with curses mixed with affection, smiling and evil-eyed each week for years." (*It Is*, No. 5, Spring, 1960.)

The Club was meant to be private, and informal. At first, every member had a key and came when he pleased. Meetings were generally prearranged by phone calls on the spur of the moment. However, the Club soon took on a more public and formal character, first by inviting speakers (prompted by the Studio 35 sessions), and then by arranging panels. (This move was strongly, but unsuccessfully, resisted.) In keeping with its dual purpose, free-wheeling Round Table Discussions, limited to members, were held on Wednesdays (until 1954); on Fridays, lectures, symposiums and concerts were presented which were open to guests who were mainly critics, historians, curators, collectors, dealers and avant-garde allies in the other arts. The programs, organized by Pavia until the spring of 1955, by Ferren the following year, and by a committee headed by myself from 1956 to the end of the Club in the spring of 1962, became the major activity.

In assuming a semi-public function, the Club both reflected and contributed to the changed nature of the New York art scene. During the late forties, shows by Pollock, de Kooning, Still, Rothko, Motherwell, Kline and other Abstract Expressionists in the galleries of Peggy Guggenheim, Howard Putzel, Betty Parsons, Sam Kootz and Charles Egan, received growing recognition. Such critics as Clement Greenberg, Harold Rosenberg, Thomas Hess and Robert Goldwater called public attention to these exhibitions. What had been an underground movement came out into the open. Convinced that the art they were creating was more vital, radical and original than any being produced elsewhere, the artists themselves began to demand their just due from art officialdom, or, to put it

more accurately, to denounce discrimination. In 1948, a meeting called by artists at the Museum of Modern Art censured hidebound art critics in general and a statement issued by the Boston Museum of Contemporary Art attacking modernism. Again, in 1950, at the three-day conference at Studio 35, Gottlieb suggested that a jury which had chosen a show entitled "American Art Today, 1950" for the Metropolitan Museum be repudiated as hostile to modern art. A letter, signed by 18 artists, was sent to New York newspapers; this protest was widely publicized, and the signers labeled "The Irascible 18."

The fact that the Waldorf artists organized a club rather than choose a new restaurant, as had been the practice, indicates a change in attitude. However, it must be stressed that the Club never had a collective mission or promoted an esthetic program. It is true that the majority of its founders worked in abstract modes, but they were a diverse group with intents as irreconcilable as de Kooning's and Reinhardt's. It is also true that most of the abstract artists inclined to Expressionism. Naturally, their art became the main topic of discussion, particularly because each member insisted on talking about his own work and experience – a novel turn in advanced New York art-talk which in the past had focused on the School of Paris. Morever, the Abstract Expressionists generated a sense of excitement. As Goldwater remarked: "The consciousness of being on the frontier, of being ahead rather than behind, of having absolutely no models however immediate or illustrious, of being entirely and completely on one's own – this was a new and heady atmosphere." (*Quadrum*, No. 8, 1960.)

But the Abstract Expressionists abhorred all fixed systems, ideologies and categories – anything that might curb expressive possibilities. Extreme individualism was a passionate conviction: "We agree only to disagree" was the unwritten motto. Therefore, no manifestoes, no exhibitions, no pictures on the walls (size and placement might indicate a hierarchy), and, as much as possible, no names of contemporaries, lest through iteration some be made heroes and, as Goldwater quipped, to prevent riots. Pavia deserves special mention for keeping the Club neutral and preventing it from becoming the platform for any individual or group.

The early lectures covered many facets of modern culture. Among the speakers were philosophers William Barrett, Hannah Arendt and Heinrich Bluecher, composer Edgar Varese, social critic Paul Goodman, Joseph Campbell, Father Flynn of Fordham University, and art critic Thomas Hess. There were also parties held in honor of artists such as Alexander Calder, Marino Marini and Dylan Thomas. A selection of

events in 1951–52 denotes the range of artists' interests and esthetic positions:

Sept. 28: Martin James led an "Inquiry into Avant-Garde Art."

Oct. 12: Peter Blake spoke on "The Collaboration of Art and Architecture."

Nov. 9: "An Evening with Max Ernst," introduced by Motherwell.

Nov. 23: Lionel Abel lectured on "The Modernity of the Modern World."

Dec. 14: Abel again, on "Work or Free Work."

The following week, Hubert Kappel spoke on Heidegger.

Jan. 18: The symposiums on Abstract Expressionism, promoted by the publication of Thomas Hess' "Abstract Painting," began. The first panel, titled "Expressionism," consisted of Harold Rosenberg (moderator), Baziotes, Guston, Hess, Kline, Reinhardt and Tworkov.

Jan. 25: "Abstract Expressionism II": John Ferren (moderator), Peter Busa, Burgoyne Diller, Perle Fine, Adolph Gottlieb, Harry Holtzman and Elaine de Kooning (who sent a paper which was read).

Feb. 1: "Abstract Expressionism III": Martin James (moderator), George Amberg, Robert Goldwater, Ruth Field Iglehart, Ad Reinhardt and Kurt Seligmann.

Feb. 20: A conversation between Philip Guston, Franz Kline, Willem de Kooning, George McNeil and Jack Tworkov was moderated by Mercedes Matter.

March 7: A group of younger artists, Jane Freilicher, Grace Hartigan, Alfred Leslie, Joan Mitchell, Frank O'Hara and Larry Rivers was moderated by John Myers, continuing the discussion on Abstract Expressionism.

March 14: John Cage spoke on "Contemporary Music," introduced by Frederick Kiesler.

March 21: James Johnson Sweeney led a discussion on "Structural Concepts in Twentieth Century Art." The chairman was Peter Busa.

March 28: "The Purist Idea": Harry Holtzman (moderator), Paul Brach, John Ferren, James Fitzsimmons, Ad Reinhardt.

April 11: "The Image in Poetry and Painting": Nicholas Calas (moderator), Edwin Denby, David Gascoyne, Frank O'Hara, Ruthven Todd.

April 25: "The Problem of the Engaged Artist": John Ferren (moderator), Abel, Cage, Denby, Navaretta.

May 2: Dr. Frederick Perls spoke on "Creativeness in Art and Neurosis."

May 14: "New Poets": Larry Rivers (chairman), John Ashbery, Barbara Guest, Frank O'Hara, James Schuyler.

May 21: "Abstract Color Films": Lewin Alcopley (chairman), Ted Connant, Eldon Reed, Bill Sebring.

Of all the subjects discussed, the one that recurred most often and that created the hottest controversy was the problem of community, of defining shared ideas, interests and inclinations. Much as the Abstract Expressionists hated the thought of a collective style, its possible existence concerned them. Attempts to indicate a tendency had been made earlier, i.e., a show titled "The Intrasubjectives," with a foreword by Rosenberg, at the Kootz Gallery in the fall of 1949. The issue of group identity was also raised at the Studio 35 sessions in April, 1950. Gottlieb said, "I think, despite any individual differences, there is a basis of getting together on mutual respect and the feeling that painters here are not academic. . . ." Newman picked up this point, "Do we artists really have a community? If so, what makes it a community?" This question was central to the symposiums on Abstract Expressionism (Pavia called it "The Unwanted Title") at the Club in 1952. Eight panels were entitled "Has the Situation Changed?" in April and May, 1954 and another series had the same heading in January 1958 and February 1959. Four panels, "What is the New Academy?" in the spring of 1959 were con-

tinued in 17 statements by artists published in *Art News*, Summer and September, 1959. However, no consensus was ever arrived at.

Part of the difficulty in defining and clarifying shared ideas was the verbal style of the Club. Artists refused to begin with formal analysis, pictorial facts or the look of works. This approach might have implied that Abstract Expressionism was a fixed and established style whose attributes could be identified. Further the idea of style assumed that making a certain kind of picture was a primary aim. This, the Abstract Expressionists denied. Indeed, most adopted an unpremeditated method to avoid style. The problem of how and why an artist involved himself in painting was more exciting to them than the mechanics of picture-making. The consciousness of being on the frontier, of being on one's own, produced a new and heady atmosphere, but without models to fall back on, the sense of possible failure was intensified. These mixed feelings of elation, doubt and anxiety had to be communicated, partly because they fed into the work, and partly because the talk about them reassured artists that their essays into uncharted areas were not delusional.

Club members supposed that their peers understood how a picture "worked" in formal terms. Therefore, they tended to talk about the function of art, the nature of the artist's moral commitment and his existential role (but with little reference to Existentialism). That is, they tried to transliterate their creative experience rather than the art object. Conversation was treated as the verbal counterpart of the painting activity, and artists tried to convey what they really felt in both. This created frustrating difficulties, because such ideas can rarely be checked against specific works. As Goldwater wrote: "The proceedings always had a curious air of unreality. One had a terrible time following what was going on. The assumption was that everyone knew what every one else meant, but it was never put to the test; no one ever pointed to an object and said, see, that's what I'm talking about (and like or don't like). Communication was always entirely verbal. For artists, whose first (if not final) concern is with the visible and the tangible, this custom assumed the proportions of an enormous hole at the center." Self-confession did lead artists to take liberties with, and to strain language and logic, but there were compensations. What they had to say, they said directly (to the point of brutality), personally and passionately. At times, this resulted in incoherent and egotistic bombast, but more frequently, it led to original, trenchant and provocative insights. The verbal style of the Club also generated bitter personality conflicts, for, as Goldwater remarked, "Since the artist identified with his work, intention and result were fused,

and he who questioned the work, in however humble a fashion, was taken to be doubting the man." (*Quadrum*, No. 8, 1960.)

Some of the special flavor of the Club was caught by Jack Tworkov in an entry in his journal of April 26, 1952:

> The enthusiastic clash of ideas that takes place in the Club has one unexpected and, in my belief, salutary effect – it destroys, or at least reduces, the aggressiveness of all attitudes. One discovers that rectitude is the door one shuts on an open mind. The Club is a phenomenon – I was at first timid in admitting that I like it. Talking has been suspect. There was the prospect that the Club would be regarded either as bohemian or as a self-aggrandizing clique. But now I'm consciously happy when I'm there. I enjoy the talk, the enthusiasm, the laughter, the dancing after the discussion. There is a strong sense of identification. I say to myself these are the people I love, that I love to be with. Here I understand everybody, however inarticulate they are. Here I forgive everyone their vices, and I'm learning to admire their virtues. How dull people are elsewhere by comparison. I think that 39 East 8th is an unexcelled university for an artist. Here we learn not only about all the possible ideas in art, but learn what we need to know about philosophy, physics, mathematics, mythology, religion, sociology, magic. (*It Is*, No. 4.)

Despite the bluntness of the discourse at the Club, the panel format made it somewhat self-conscious and inhibited. The place for more informal and private conversation came to be the Cedar Street Tavern. Artists began to go to the bar when the panels got dull, or after them. Then, they started to gather there every night when the Club was not open. They arrived late and stayed late. In fact, there was an entirely different clientele in the daytime: New York University professors and students, and a group of horse-racing enthusiasts.

Unlike the Waldorf Cafeteria, the Cedar catered to artists. But its owners knew better than to make it look like an artists' bar, for this would have attracted the public and would have driven out the artists. Therefore, no paintings on the walls, driftwood, travel posters and other arty emblems of Greenwich Village bohemia. Nor did the management turn it into a neighborhood bar by introducing television. Artists were also attracted by the food which was fair and inexpensive, and by the fact that credit was extended when one got to know the owners. However, the move to the Cedar did reflect a new affluence – in the switch from coffee to alcohol. Like the Club, the Cedar's decor was neutral, interchangeable with thousands all over America, reflecting the artists' desire

for anonymity. There was nothing to distinguish it as an artists' hangout; in the front, a bar; in the rear, tables. At one time a drab green, the bar was "remodeled" in the late fifties and painted an equally nondescript grey.

Lower middle-class colorlessness became protective coloration. It shielded the artists from the "creative-livers," and the Beats, from Madison Avenue types who posed as bohemians after five o'clock, from the chic of all varieties who came slumming, and from Brooklyn and Bronx tourists who came to gape at the way-out characters. To further discourage these interlopers, the artists tended to dress soberly. Indeed, the Cedar typified a "no-environment" – de Kooning's term for the milieu of contemporary man – no nostalgia, romance or picturesqueness. It may also be, as Harold Rosenberg has suggested, that an artist could best engage in finding his personality in as neutral an environment as possible. The very name, or more accurately, misname – the Cedar Street Tavern, for a bar located on University Place – symbolized, unintentionally of course, the refusal of its customers to accept fixed categories. An establishment that could not get its own name straight must be the right place for a group that could never decide on a name for its club.

The idea of mounting an exhibition of the works of Club members – like a big salon – was raised many times, but was rejected because it might indicate a trend or position and curb the open character of the Club. However, in the spring of 1951, it was finally decided to have a show, but not under the direct auspices of the Club. A group of charter members with the help of Leo Castelli (who, among other things, put up the rent money) leased an empty store at 60 E. 9th Street (next door to the studios of Kline, Marca-Relli and Ferren), chose the arists and installed the show. Sixty-one artists were listed on the announcement of the 9th Street Show, which, in the main, read like a Who's Who of Abstract Expressionism. However, with the exception of Motherwell, painters who had been connected with, or close to, the "Subjects of the Artist" School (Baziotes, Gottlieb, Newman, Rothko and Still) did not submit canvases, a sign of their growing indifference to the Club by 1951. Most of the exhibitors did not think that the show would attract much attention, but it did. There was a large crowd on opening night, May 21, and the rest of the show was well attended (it closed on June 10). The 9th Street Show generated a sense of exultation, a feeling that something important had been achieved in American art.

After 1955, the year Pavia left the Club, the makeup of the Club changed. Older members began to attend less often, even though many continued to pay dues. The beginnings of this turn were evident as early

as May 1952, when a voting meeting was devoted to the topic of disbanding the Club because it had outlived its function. A younger generation took over, the "inheritors," as Rosenberg called them, but that is another matter.

The Critical Reception

THE FIRST ESSAY in this part, written before Abstract Expressionism had surfaced, nevertheless suggests a theoretical basis for the movement. The next group of essays respond to exhibitions of the art itself, and, in some cases, to criticism of the work. The pieces that conclude Part II look back on a recent past to evaluate and reevaluate it.

TOWARDS A NEWER LAOCOON

Clement Greenberg

THE DOGMATISM and intransigence of the "non-objective" or "abstract" purists of painting today cannot be dismissed as symptoms merely of a cultist attitude towards art. Purists make extravagant claims for art, because usually they value it much more than any one else does. For the same reason they are much more solicitous about it. A great deal of purism is the translation of an extreme solicitude, an anxiousness as to the fate of art, a concern for its identity. We must respect this. When the purist insists upon excluding "literature" and subject matter from plastic art, now and in the future, the most we can charge him with off-hand is an unhistorical attitude. It is quite easy to show that abstract art like every other cultural phenomenon reflects the social and other circumstances of the age in which its creators live, and that there is nothing inside art itself, disconnected from history, which compels it to go in one direction or another. But it is not so easy to reject the purist's assertion that the best of contemporary plastic art is abstract. Here the purist does not have to support his position with metaphysical pretentions. And when he insists on doing so, those of us who admit the merits of abstract art without accepting its claims in full must offer our own explanation for its present supremacy.

Discussion as to purity in art and, bound up with it, the attempts to establish the differences between the various arts are not idle. There has been, is, and will be, such a thing as a confusion of the arts. From the point of view of the artist engrossed in the problems of his medium and indifferent to the efforts of theorists to explain abstract art *completely*, purism is the terminus of a salutory reaction against the mistakes of painting and sculpture in the past several centuries which were due to such a confusion.

From *Partisan Review*, July–August, 1940. Reprinted by permission of Clement Greenberg.

There can be, I believe, such a thing as a dominant art form; this was what literature had become in Europe by the 17th century. (Not that the ascendancy of a particular art always coincides with its greatest productions. In point of achievement, music was the greatest art of this period.) By the middle of the 17th century the pictorial arts had been relegated almost everywhere into the hands of the courts, where they eventually degenerated into relatively trivial interior decoration. The most creative class in society, the rising mercantile bourgeoisie, impelled perhaps by the iconoclasm of the Reformation (Pascal's Jansenist contempt for painting is a symptom) and by the relative cheapness and mobility of the physical medium after the invention of printing, had turned most of its creative and acquisitive energy towards literature.

Now, when it happens that a single art is given the dominant role, it becomes the prototype of all art: the others try to shed their proper characters and imitate its effects. The dominant art in turn tries itself to absorb the functions of the others. A confusion of the arts results, by which the subservient ones are perverted and distorted; they are forced to deny their own nature in an effort to attain the effects of the dominant art. However, the subservient arts can only be mishandled in this way when they have reached such a degree of technical facility as to enable them to pretend to conceal their *mediums*. In other words, the artist must have gained such power over his material as to annihilate it seemingly in favor of *illusion*. Music was saved from the fate of the pictorial arts in the 17th and 18th centuries by its comparatively rudimentary technique and the relative shortness of its development as a formal art. Aside from the fact that in its nature it is the art furthest removed from imitation, the possibilities of music had not been explored sufficiently to enable it to strive for illusionist effect.

But painting and sculpture, the arts of illusion par excellence, had by that time achieved such facility as to make them infinitely susceptible to the temptation to emulate the effects, not only of illusion, but of other arts. Not only could painting imitate sculpture, and sculpture, painting, but both could attempt to reproduce the effects of literature. And it was for the effects of literature that 17th and 18th century painting strained most of all. Literature, for a number of reasons, had won the upper hand, and the plastic arts – especially in the form of easel painting and statuary – tried to win admission to its domain. Although this does not account completely for the decline of those arts during this period, it seems to have been the form of that decline. Decline it was, compared to what had

taken place in Italy, Flanders, Spain and Germany the century before. Good artists, it is true, continue to appear – I do not have to exaggerate the depression to make my point – but not good *schools* of art, not good followers. The circumstances surrounding the appearance of the individual great artists seem to make them almost all exceptions; we think of them as great artists "in spite of." There is a scarcity of distinguished small talents. And the very level of greatness sinks by comparison to the work of the past.

In general, painting and sculpture in the hands of the lesser talents – and this is what tells the story – become nothing more than ghosts and "stooges" of literature. All emphasis is taken away from the medium and transferred to subject matter. It is no longer a question even of realistic imitation, since that is taken for granted, but of the artist's ability to interpret subject matter for poetic effects and so forth.

We ourselves, even today, are too close to literature to appreciate its status as a dominant art. Perhaps an example of the converse will make clearer what I mean. In China, I believe, painting and sculpture became in the course of the development of culture the dominant arts. There we see poetry given a role subordinate to them, and consequently assuming their limitations: the poem confines itself to the single moment of painting and to an emphasis upon visual details. The Chinese even require visual delight from the handwriting in which the poem is set down. And by comparison to their pictorial and decorative arts doesn't the later poetry of the Chinese seem rather thin and monotonous?

Lessing, in his *Laokoon* written in the 1760s, recognized the presence of a practical as well as a theoretical confusion of the arts. But he saw its ill effects exclusively in terms of literature, and his opinions on plastic art only exemplify the typical misconceptions of his age. He attacked the descriptive verse of poets like James Thomson as an invasion of the domain of landscape painting, but all he could find to say about painting's invasion of poetry was to object to allegorical pictures which required an explanation, and to paintings like Titian's *Prodigal Son* which incorporate "two necessarily separate points of time in one and the same picture."

II

The Romantic Revival or Revolution seemed at first to offer some hope for painting, but by the time it departed the scene, the confusion of the arts had become worse. The romantic theory of art was that the artist

feels something and passes on this feeling – not the situation or thing which stimulated it – to his audience. To preserve the immediacy of the feeling it was even more necessary than before, when art was imitation rather than communication, to suppress the role of the medium. The medium was a regrettable if necessary physical obstacle between the artist and his audience, which in some ideal state would disappear entirely to leave the experience of the spectator or reader identical with that of the artist. In spite of the fact that music considered as an art of pure feeling, was beginning to win almost equal esteem, the attitude represents a final triumph for poetry. All feeling for the arts as métiers, crafts, disciplines – of which some sense had survived until the 18th century – was lost. The arts came to be regarded as nothing more or less than so many powers of the personality. Shelley expressed this best when in his *Defense of Poetry* he exalted poetry above the other arts because its medium came closest, as Bosanquet puts it, to being no medium at all. In practice this aesthetic encouraged that particular widespread form of artistic dishonesty which consists in the attempt to escape from the problems of the medium of one art by taking refuge in the effects of another. Painting is the most susceptible to evasions of this sort, and painting suffered most at the hands of the Romantics.

At first it did not seem so. As a result of the triumph of the burghers and of their appropriation of all the arts a fresh current of creative energy was released into every field. If the Romantic revolution in painting was at first more a revolution in subject matter than in anything else, abandoning the oratorical and frivolous literature of 18th century painting in search of a more original, more powerful, more sincere literary content, it also brought with it a greater boldness in pictorial means. Delacroix, Géricault, even Ingres, were enterprising enough to find new form for the new content they introduced. But the net result of their efforts was to make the incubus of literature in painting even deadlier for the lesser talents who followed them. The worst manifestations of literary and sentimental painting had already begun to appear in the painting of the late 18th century – especially in England, where a revival which produced some of the best English painting was equally efficacious in speeding up the process of degeneration. Now the schools of Ingres and Delacroix joined with those of Morland and Greuze and Vigée-Lebrun to become the official painting of the 19th century. There have been academics before, but for the first time we have academicism. Painting enjoyed a revival of activity in 19th-century France such as had not been seen since the 16th century, and academicism could produce such good painters as Corot and Theodore Rousseau, and even Daumier – yet in spite of

this academicians sank painting to a level that was in some respects an all-time low. The name of this low is Vernet, Gérome, Leighton, Watts, Moreau, Böcklin, the Pre-Raphaelites, etc., etc. That some of these painters had real talent only made their influence the more pernicious. It took talent – among other things – to lead art that far astray. Bourgeois society gave these talents a prescription, and they filled it – with talent.

It was not realistic imitation in itself that did the damage so much as realistic illusion in the service of sentimental and declamatory literature. Perhaps the two go hand in hand. To judge from Western and Graeco-Roman art, it seems so. Yet it is true of Western painting that in so far as it has been the creation of a rationalist and scientifically-minded city culture, it has always had a bias towards a realism that tries to achieve allusions by overpowering the medium, and is more interested in exploiting the practical meanings of objects than in savoring their appearance.

III

Romanticism was the last great tendency following *directly* from bourgeois society that was able to inspire and stimulate the profoundly responsible artist – the artist conscious of certain inflexible obligations to the standards of his craft. By 1848 Romanticism had exhausted itself. After that the impulse, although indeed it had to originate in bourgeois society, could only come in the guise of a denial of that society, as a turning away from it. It was not to be an about-face towards a new society, but an emigration to a Bohemia which was to be art's sanctuary from capitalism. It was to be the task of the avant-garde to perform in opposition to bourgeois society the function of finding new and adequate cultural forms for the expression of that same society, without at the same time succumbing to its ideological divisions and its refusal to permit the arts to be their own justification. The avant-garde, both child and negation of Romanticism, becomes the embodiment of art's instinct of self-preservation. It is interested in, and feels itself responsible to, only the values of art; and, given society as it is, has an organic sense of what is good and what is bad for art.

As the first and most important item upon its agenda, the avant-garde saw the necessity of an escape from ideas, which were infecting the arts with the ideological struggles of society. Ideas came to mean subject matter in general. (Subject matter as distinguished from content: in the sense that every work of art must have content, but that subject matter

is something the artist does or does not have in mind when he is actually at work.) This meant a new and greater emphasis upon form, and it also involved the assertion of the arts as independent vocations, disciplines and crafts, absolutely autonomous, and entitled to respect for their own sakes, and not merely as vessels of communication. It was the signal for a revolt against the dominance of literature, which was subject matter at its most oppressive.

The avant-garde has pursued, and still pursues, several variants, whose chronological order is by no means clear, but can be best traced in painting, which as the chief victim of literature brought the problem into sharpest focus. (Forces stemming from outside art play a much larger part than I have room to acknowledge here. And I must perforce be rather schematic and abstract, since I am interested more in tracing large outlines than in accounting for and gathering in all particular manifestations.)

By the second third of the 19th century painting had degenerated from the pictorial to the picturesque. Everything depends on the anecdote or the message. The painted picture occurs in blank, indeterminate space; it just happens to be on a square of canvas and inside a frame. It might just as well have been breathed on air or formed out of plasma. It tries to be something you imagine rather than see – or else a bas-relief or a statue. Everything contributes to the denial of the medium, as if the artist were ashamed to admit that he had actually painted his picture instead of dreaming it forth.

This state of affairs could not be overcome at one stroke. The campaign for the redemption of painting was to be one of comparatively slow attrition at first. Nineteenth-century painting made its first break with literature when in the person of the Communard, Courbet, it fled from spirit to matter. Courbet, the first real avant-garde painter, tried to reduce his art to immediate sense data by painting only what the eye could see as a machine unaided by the mind. He took for his subject matter prosaic contemporary life. As avant-gardists so often do, he tried to demolish official bourgeois art by turning it inside out. By driving something as far as it will go you often get back to where it started. A new flatness begins to appear in Courbet's painting, and an equally new attention to every inch of the canvas, regardless of its relation to the "centers of interest." (Zola, the Goncourts and poets like Verhaeren were Courbet's correlatives in literature. They too were "experimental"; they too were trying to get rid of ideas and "literature," that is, to establish their art on a more stable basis than the crumbling bourgeois oecumene.) If the avant-garde seems unwilling to claim naturalism for

itself it is because the tendency failed too often to achieve the objectivity it professed, i.e., it succumbed to "ideas."

Impressionism, reasoning beyond Courbet in its pursuit of materialist objectivity, abandoned common sense experience and sought to emulate the detachment of science, imagining that thereby it would get at the very essence of painting as well as of visual experience. It was becoming important to determine the essential elements of each of the arts. Impressionist painting becomes more an exercise in color vibrations than representation of nature. Manet meanwhile, closer to Courbet, was attacking subject matter on its own terrain by including it in his pictures and exterminating it then and there. His insolent indifference to his subject, which in itself was often striking, and his flat color-modeling were as revolutionary as Impressionist technique proper. Like the Impressionists he saw the problems of painting as first and foremost problems of the medium, and he called the spectator's attention to this.

IV

The second variant of the avant-garde's development is concurrent in time with the first. It is easy to recognize this variant, but rather difficult to expose its motivation. Tendencies go in opposite directions, and cross-purposes meet. But tying everything together is the fact that in the end cross-purposes indeed do meet. There is a common effort in each of the arts to expand the expressive resources of the medium, not in order to express ideas and notions, but to express with greater immediacy sensations, the irreducible elements of experience. Along this path it seemed as though the avant-garde in its attempt to escape from "literature" had set out to treble the confusion of the arts by having them imitate every other art except literature.[1] (By this time literature had had its opprobrious sense expanded to include everything the avant-garde objected to in official bourgeois culture.) Each art would demonstrate its powers by capturing the effects of its sister arts or by taking a sister art for its subject. Since art was the only validity left, what better subject was there for each art than the procedures and effects of some other art? Impressionist painting, with its progressions and rhythmic suffusions of color, with its moods and atmospheres, was arriving at effects to which the Impressionists themselves gave the terms of Romantic music. Painting, however, was the least affected by this new confusion. Poetry and music were its chief victims. Poetry – for it too had to escape from "literature" – was imitating the effects of painting and sculpture (Gautier, the Panassians,

and later the Imagists) and, of course, those of music (Poe had narrowed "true" poetry down to the lyric). Music, in flight from the undisciplined, bottomless sentimentality of the Romantics, was striving to describe and narrate (program music). That music at this point imitates literature would seem to spoil my thesis. But music imitates painting as much as it does poetry when it becomes representational; and besides, it seems to me that Debussy used the program more as a pretext for experiment than as an end in itself. In the same way that the Impressionist painters were trying to get at the structure beneath the color, Debussy was trying to get at the "sound underneath the note."

Aside from what was going on inside music, music as an art in itself began at this time to occupy a very important position in relation to the other arts. Because of its "absolute" nature, its remoteness from imitation, its almost complete absorption in the very physical quality of its medium, as well as because of its resources of suggestion, music had come to replace poetry as the paragon art. It was the art which the other avant-garde arts envied most, and whose effects they tried hardest to imitate. Thus it was the principal agent of the new confusion of the arts. What attracted the avant-garde to music as much as its power to suggest was, as I have said, its nature as an art of immediate sensation. When Verlaine said, "De la musique avant toute chose," he was not only asking poetry to be more suggestive – suggestiveness after all, was a poetic ideal foisted upon music – but also to affect the reader or listener with more immediate and more powerful sensations.

But only when the avant-garde's interest in music led it to consider music as a *method* of art rather than as a kind of effect did the avant-garde find what it was looking for. It was when it was discovered that the advantage of music lay chiefly in the fact that it was an "abstract" art, an art of "pure form." It was such because it was incapable, objectively, of communicating anything else than a sensation, and because this sensation could not be conceived in any other terms than those of the sense through which it entered the consciousness. An imitative painting can be described in terms of non-visual identities, a piece of music cannot, whether it attempts to imitate or not. The effects of music are the effects, essentially, of pure form; those of painting and poetry are too often accidental to the formal natures of these arts. Only by accepting the example of music and defining each of the other arts solely in the terms of the sense of faculty which perceived its effect and by excluding from each art whatever is intelligible in the terms of any other sense or faculty would the non-musical arts attain the "purity" and self-sufficiency which they desired; which they desired, that is, in so far as they were avant-

garde arts. The emphasis, therefore, was to be on the physical, the sensorial. "Literature's" corrupting influence is only felt when the senses are neglected. The latest confusion of the arts was the result of a mistaken conception of music as the only immediately sensuous art. But the other arts can also be sensuous, if only they will look to music, not to ape its effects but to borrow its principles as a "pure" art, as an art which is abstract because it is almost nothing else except sensuous.[2]

V

Guiding themselves, whether consciously or unconsciously, by a notion of purity derived from the example of music, the avant-garde arts have in the last fifty years achieved a purity and a radical delimitation of their fields of activity for which there is no previous example in the history of culture. The arts lie safe now, each within its "legitimate" boundaries, and free trade has been replaced by autarchy. Purity in art consists in the acceptance, willing acceptance, of the limitations of the medium of the specific art. To prove that their concept of purity is something more than a bias in taste, painters point to Oriental, primitive and children's art as instances of the universality and naturalness and objectivity of their ideal of purity. Composers and poets, although to a much lesser extent, may justify their efforts to attain purity by referring to the same precedent. Dissonance is present in early and non-Western music, "unintelligibility" in folk poetry. The issue is, of course, focused most sharply in the plastic arts, for they, in their non-decorative function, have been the most closely associated with imitation, and it is in their case that the ideal of the pure and the abstract has met the most resistance.

The arts, then, have been hunted back to their mediums, and there they have been isolated, concentrated and defined. It is by virtue of its medium that each art is unique and strictly itself. To restore the identity of an art the opacity of its medium must be emphasized. For the visual arts the medium is discovered to be physical; hence pure painting and pure sculpture seek above all else to affect the spectator physically. In poetry, which, as I have said, had also to escape from "literature" or subject matter for its salvation from society, it is decided that the medium is essentially psychological and sub- or supra-logical. The poem is to aim at the general consciousness of the reader, not simply his intelligence.

It would be well to consider "pure" poetry for a moment, before going on to painting. The theory of poetry as incantation, hypnosis or drug – as psychological agent then – goes back to Poe, and eventually to Cole-

ridge and Edmund Burke with their efforts to locate the enjoyment of poetry in the "Fancy" or "Imagination." Mallarmé, however, was the first to base a consistent practice of poetry upon it. Sound, he decided, is only an auxiliary of poetry, not the medium itself; and besides, most poetry is now read, not recited: the sound of words is a part of their meaning, not the vessel of it. To deliver poetry from the subject and to give full play to its true affective power it is necessary to free words from logic. The medium of poetry is isolated in the power of the word to evoke associations and to connote. Poetry subsists no longer in the relations between words as meanings, but in the relations between words as personalities composed of sound, history and possibilities of meaning. Grammatical logic is retained only in so far as it is necessary to set these personalities in motion, for unrelated words are static when read and not recited aloud. Tentative efforts are made to discard metric form and rhyme, because they are regarded as too local and determinate, too much attached to specific times and places and social conventions to pertain to the essence of poetry. There are experiments in poetic prose. But as in the case of music, it was found that formal structure was indispensable, that some such structure was integral to the medium of poetry as an aspect of its resistance.... The poem still offers possibilities of meaning – but only possibilities. Should any of them be too precisely realized, the poem would lose the greatest part of its efficacy, which is to agitate the consciousness with infinite possibilities by approaching the brink of meaning and yet never falling over it. The poet writes, not so much to *express*, as to create a thing which will operate upon the reader's consciousness to produce the emotion of poetry. The content of the poem is what it does to the reader, not what it communicates. The emotion of the reader derives from the poem as a unique object – pretendedly – and not from referents outside the poem. This is pure poetry as ambitious contemporary poets try to define it by the example of their work. Obviously, it is an impossible ideal, yet one which most of the best poetry of the last fifty years has tried to reach, whether it is poetry about nothing or poetry about the plight of contemporary society.

It is easier to isolate the medium in the case of the plastic arts, and consequently avant-garde painting and sculpture can be said to have attained a much more radical purity than avant-garde poetry. Painting and sculpture can become more completely nothing but what they do; like functional architecture and the machine, they *look* what they *do*. The picture or statue exhausts itself in the visual sensation it produces. There is nothing to identify, connect or think about, but everything to feel. Pure poetry strives for infinite suggestion, pure plastic art for the minimum. If

the poem, as Valéry claims, is a machine to produce the emotion of poetry, the painting and status are machines to produce the emotion of "plastic sight." The purely plastic or abstract qualities of the work of art are the only ones that count. Emphasize the medium and its difficulties, and at once the purely plastic, the proper, values of visual art come to the fore. Overpower the medium to the point where all sense of its resistance disappears, and the adventitious uses of art become more important.

The history of avant-garde painting is that of a progressive surrender to the resistance of its medium; which resistance consists chiefly in the flat picture plane's denial of efforts to "hole through" it for realistic perspectival space. In making this surrender, painting not only got rid of imitation – and with it, "literature" – but also of realistic imitation's corollary confusion between painting and sculpture. (Sculpture, on its side, emphasizes the resistance of its material to the efforts of the artist to ply it into shapes uncharacteristic of stone, metal, wood, etc.) Painting abandons chiaroscuro and shaded modelling. Brush strokes are often defined for their own sake. The motto of the Renaissance artist, *Ars est artem celare*, is exchanged for *Ars est artem demonstrare*. Primary colors, the "instinctive," easy colors, replace tones and tonality. Line, which is one of the most abstract elements in painting since it is never found in nature as the definition of contour, returns to oil painting as the third color between two other color areas. Under the influence of the square shape of the canvas, forms tend to become geometrical – and simplified, because simplification is also a part of the instinctive accommodation to the medium. But most important of all, the picture plane itself grows shallower and shallower, flattening out and pressing together the fictive planes of depth until they meet as one upon the real and material plane which is the actual surface of the canvas; where they lie side by side or interlocked or transparently imposed upon each other. Where the painter still tries to indicate real objects their shapes flatten and spread in the dense, two-dimensional atmosphere. A vibrating tension is set up as the objects struggle to maintain their volume against the tendency of the real picture plane to re-assert its material flatness and crush them to sil-houettes. In a further stage realistic space cracks and splinters into flat planes which come forward, parallel to the plane surface. Sometimes this advance to the surface is accelerated by painting a segment of wood or texture *trompe l'oeil*, or by drawing exactly printed letters, and placing them so that they destroy the partial illusion of depth by slamming the various planes together. Thus the artist deliberately emphasizes the il-lusoriness of the illusions which he pretends to create. Sometimes these elements are used in an effort to preserve an illusion of depth by being

placed on the nearest plane in order to drive the others back. But the result is an optical illusion, not a realistic one, and only emphasizes further the impenetrability of the plane surface.

The destruction of realistic pictorial space, and with it, that of the object, was accomplished by means of the travesty that was cubism. The cubist painter eliminated color because, consciously or unconsciously, he was parodying, in order to destroy, the academic methods of achieving volume and depth, which are shading and perspective, and as such have little to do with color in the common sense of the word. The cubist used these same methods to break the canvas into a multiplicity of subtle recessive planes, which seem to shift and fade into infinite depths and yet insist on returning to the surface of the canvas. As we gaze at a cubist painting of the last phase we witness the birth and death of three-dimensional pictorial space.

And as in painting the pristine flatness of the stretched canvas constantly struggles to overcome every other element, so in sculpture the stone figure appears to be on the point of relapsing into the original monolith, and the cast seems to narrow and smooth itself back to the original molten stream from which it was poured, or tries to remember the texture and plasticity of the clay in which it was first worked out.

Sculpture hovers finally on the verge of "pure" architecture, and painting, having been pushed up from fictive depths, is forced through the surface of the canvas to emerge on the other side in the form of paper, cloth, cement and actual objects of wood and other materials pasted, glued or nailed to what was originally the transparent picture plane, which the painter no longer dares to puncture – or if he does, it is only to dare. Artists like Hans Arp, who begin as painters, escape eventually from the prison of the single plane by painting on wood or plaster and using molds or carpentry to raise and lower planes. They go, in other words, from painting to colored bas-relief, and finally – so far must they fly in order to return to three-dimensionality without at the same time risking the illusion – they become sculptors and create objects in the round, through which they can free their feelings for movement and direction from the increasing ascetic geometry of pure painting. (Except in the case of Arp and one or two others, the sculpture of most of these metamorphosed painters is rather unsculptural, stemming as it does from the discipline of painting. It uses color, fragile and intricate shapes and a variety of materials. It is construction, fabrication.)

The French and Spanish in Paris brought painting to the point of the pure abstraction, but it remained, with a few exceptions, for the Dutch, Germans, English and Americans to realize it. It is in their hands that

abstract purism has been consolidated into a school, dogma and credo. By 1939 the center of abstract painting had shifted to London, while in Paris the younger generation of French and Spanish painters had reacted against abstract purity and turned back to a confusion of literature with painting as extreme as any of the past. These young orthodox surrealists are not to be identified, however, with such pseudo- or mock surrealists of the previous generation as Miró, Klee and Arp, whose work, despite its apparent intention, has only contributed to the further deployment of abstract painting pure and simple. Indeed, a good many of the artists – if not the majority – who contributed importantly to the development of modern painting came to it with the desire to exploit the break with imitative realism for a more powerful expressiveness, but so inexorable was the logic of the development that in the end their work constituted but another step towards abstract art, and a further sterilization of the expressive factors. This has been true, whether the artist was Van Gogh, Picasso or Klee. All roads led to the same place.

VI

I find that I have offered no other explanation for the present superiority of abstract art than its historical justification. So what I have written has turned out to be an historical apology for abstract art. To argue from any other basis would require more space than is at my disposal, and would involve an entrance into the politics of taste – to use Venturi's phrase – from which there is no exit – on paper. My own experience of art has forced me to accept most of the standards of taste from which abstract art has derived, but I do not maintain that they are the only valid standards through eternity. I find them simply the most valid ones at this given moment. I have no doubt that they will be replaced in the future by other standards, which will be perhaps more inclusive than any possible now. And even now they do not exclude all other possible criteria. I am still able to enjoy a Rembrandt more for its expressive qualities than for its achievement of abstract values – as rich as it may be in them.

It suffices to say that there is nothing in the nature of abstract art which compels it to be so. The imperative comes from history, from the age in conjunction with a particular moment reached in a particular tradition of art. This conjunction holds the artist in a vise from which at the present moment he can escape only by surrendering his ambition and returning to a stale past. This is the difficulty for those who are dissatisfied with abstract art, feeling that it is too decorative or too arid and "inhuman,"

and who desire a return to representation and literature in plastic art. Abstract art cannot be disposed of by a simple-minded evasion. Or by negation. We can only dispose of abstract art by assimilating it, by fighting our way through it. Where to? I do not know. Yet it seems to me that the wish to return to the imitation of nature in art has been given no more justification than the desire of certain partisans of abstract art to legislate it into permanency.

Notes

1. This is the confusion of the arts for which Babbitt [Irving Babbitt, *The New Laokoön: An Essay on the Confusion of the Arts*, 1910] made Romanticism responsible.

2. The ideas about music which Pater expresses in *The School of Giorgione* reflect this transition from the musical to the abstract better than any single work of art.

THE AMERICAN ACTION PAINTERS

Harold Rosenberg

J'ai fait des gestes blanc parmi les solitudes.

<div align="right">APOLLINAIRE</div>

The American will is easily satisfied in its efforts to realize itself in knowing itself.

<div align="right">WALLACE STEVENS</div>

WHAT MAKES ANY DEFINITION of a movement in art dubious is that it never fits the deepest artists in the movement – certainly not as well as, if successful, it does the others. Yet without the definition something essential in those best is bound to be missed. The attempt to define is like a game in which you cannot possibly reach the goal from the starting point but can only close in on it by picking up each time from where the last play landed.

Modern Art? Or an Art of the Modern?

Since the War every twentieth-century style in painting is being brought to profusion in the United States: thousands of "abstract" painters – crowded teaching courses in Modern Art – a scattering of new heroes – ambitions stimulated by new galleries, mass exhibitions, reproductions in popular magazines, festivals, appropriations.

Is this the usual catching up of America with European art forms?

From *Art News*, December 1952. Reprinted by permission of *Art News* and The University of Chicago Press.

Or is something new being created? . . . For the question of novelty, a definition would seem indispensable.

Some people deny that there is anything original in the recent American painting. Whatever is being done here now, they claim, was done thirty years ago in Paris. You can trace this painter's boxes of symbols to Kandinsky, that one's moony shapes to Miró or even back to Cézanne.

Quantitatively, it is true that most of the symphonies in blue and red rectangles, the wandering pelvises and birdbills, the line constructions and plane suspensions, the virginal dissections of flat areas that crowd the art shows are accretions to the "School of Paris" brought into being by the fact that the mode of production of modern masterpieces has now been all too clearly rationalized. There are styles in the present displays that the painter could have acquired by putting a square inch of a Soutine or a Bonnard under a microscope. . . . All this is training based on a new conception of what art is, rather than original work demonstrating what art is about to become.

At the center of this wide practicing of the immediate past, however, the work of some painters has separated itself from the rest by a consciousness of a function for painting different from that of the earlier "abstractionists," both the Europeans themselves and the Americans who joined them in the years of the Great Vanguard.

This new painting does not constitute a School. To form a School in modern times not only is a new painting consciousness needed but a consciousness of that consciousness – and even an insistence on certain formulas. A School is the result of the linkage of practice with terminology – different paintings are affected by the same words. In the American vanguard the words, as we shall see, belong not to the art but to the individual artists. What they think in common is represented only by what they do separately.

Getting Inside the Canvas

At a certain moment the canvas began to appear to one American painter after another as an arena in which to act – rather than as a space in which to reproduce, re-design, analyze, or "express" an object, actual or imagined. What was to go on the canvas was not a picture but an event.

The painter no longer approached his easel with an image in his mind; he went up to it with material in his hand to do something to that other

piece of material in front of him. The image would be the result of this encounter.

It is pointless to argue that Rembrandt or Michelangelo worked in the same way. You don't get Lucrece with a dagger out of staining a piece of cloth or spontaneously putting forms into motion upon it. She had to exist someplace else before she got on the canvas, and the paint was Rembrandt's means for bringing her here. Now, everything must have been in the tubes, in the painter's muscles, and in the cream-colored sea into which he dives. If Lucrece should come out she will be among us for the first time – a surprise. To the painter, she *must* be a surprise. In this mood there is no point in an act if you already know what it contains.

"B. is not modern," one of the leaders of this mode said to me the other day. "He works from sketches. That makes him Renaissance."

Here the principle, and the difference from the old painting, is made into a formula. A sketch is the preliminary form of an image the *mind* is trying to grasp. To work from sketches arouses the suspicion that the artist still regards the canvas as a place where the mind records its contents – rather than itself the "mind" through which the painter thinks by changing a surface with paint.

If a painting is an action, the sketch is one action, the painting that follows it another. The second cannot be "better" or more complete than the first. There is just as much significance in their difference as in their similarity.

Of course, the painter who spoke had no right to assume that the other had the old mental conception of a sketch. There is no reason why an act cannot be prolonged from a piece of paper to a canvas. Or repeated on another scale and with more control. A sketch can have the function of a skirmish.

Call this painting "abstract" or "Expressionist" or "Abstract-Expressionist," what counts is its special motive for extinguishing the object, which is not the same as in other abstract or Expressionist phases of modern art.

The New American Painting is not "pure art," since the extrusion of the object was not for the sake of the aesthetic. The apples weren't brushed off the table in order to make room for perfect relations of space and color. They had to go so that nothing would get in the way of the act of painting. In this gesturing with materials the aesthetic, too, has been subordinated. Form, color, composition, drawing, are auxiliaries, any one of which – or practically all, as has been attempted, logically, with unpainted canvases – can be dispensed with. What matters always is the

revelation contained in the act. It is to be taken for granted that in the final effect, the image, whatever be or be not in it, will be a *tension*.

Dramas of As If

A painting that is an act is inseparable from the biography of the artist. The painting itself is a "moment" in the adulterated mixture of his life – whether "moment" means, in one case, the actual minutes taken up with spotting the canvas or, in another, the entire duration of a lucid drama conducted in sign language. The act-painting is of the same metaphysical substance as the artist's existence. The new painting has broken down every distinction between art and life.

It follows that anything is relevant to it. Anything that has to do with action – psychology, philosophy, history, mythology, hero worship. Anything but art criticism. The painter gets away from Art through his act of painting; the critic can't get away from it. The critic who goes on judging in terms of schools, styles, form, as if the painter were still concerned with producing a certain kind of object (the work of art), instead of living on the canvas, is bound to seem a stranger.

Some painters take advantage of this stranger. Having insisted that their painting is an act, they then claim admiration for the act as art. This turns the act back toward the aesthetic in a petty circle. If the picture is an act, it cannot be justified *as an act of genius* in a field whose whole measuring apparatus has been sent to the devil. Its value must be found apart from art. Otherwise the "act" gets to be "making a painting" at sufficient speed to meet an exhibition date.

Art – relation of the painting to the works of the past, rightness of color, texture, balance, etc. – comes back into painting by way of psychology. As Stevens says of poetry, "it is a process of the personality of the poet." But the psychology is the psychology of creation. Not that of the so-called psychological criticism that wants to "read" a painting for clues to the artist's sexual preferences or debilities. The work, the act, translates the psychologically given into the intentional, into a "world" – and thus transcends it.

With traditional aesthetic references discarded as irrelevant, what gives the canvas its meaning is not psychological data but *role*, the way the artist organizes his emotional and intellectual energy as if he were in a living situation. The interest lies on the kind of act taking place in the four-sided arena, a dramatic interest.

78 HAROLD ROSENBERG

Criticism must begin by recognizing in the painting the assumptions inherent in its mode of creation. Since the painter has become an actor, the spectator has to think in a vocabulary of action: its inception, duration, direction – psychic state, concentration and relaxation of the will, passivity, alert waiting. He must become a connoisseur of the gradations among the automatic, the spontaneous, the evoked.

"It's Not That, It's Not That, It's Not That"

With a few important exceptions, most of the artists of this vanguard found their way to their present work by being cut in two. Their type is not a young painter but a reborn one. The man may be over forty, the painter around seven. The diagonal of a grand crisis separates him from his personal and artistic past.

Many of the painters were "Marxists" (WPA unions, artists' congresses) – they had been trying to paint Society. Others had been trying to paint Art (Cubism, Post-Impressionism) – it amounts to the same thing.

The big moment came when it was decided to paint.... Just *To Paint*. The gesture on the canvas was a gesture of liberation, from Value – political, aesthetic, moral.

If the war and the decline of radicalism in America had anything to do with this sudden impatience, there is no evidence of it. About the effects of large issues upon their emotions, Americans tend to be either reticent or unconscious. The French artist thinks of himself as a battleground of history; here one hears only of private Dark Nights. Yet it is strange how many segregated individuals came to a dead stop within the past ten years and abandoned, even physically destroyed, the work they had been doing. A far-off watcher, unable to realize that these events were taking place in silence, might have assumed they were being directed by a single voice.

At its center the movement was away from rather than toward. The Great Works of the Past and the Good Life of the Future became equally nil.

The refusal of Value did not take the form of condemnation or defiance of society, as it did after World War I. It was diffident. The lone artist did not want the world to be different, he wanted his canvas to be a world. Liberation from the object meant liberation from the "nature," society, and art already there. It was a movement to leave behind the self

THE AMERICAN ACTION PAINTERS 79

that wished to choose its future and to nullify its promissory notes to the past.

With the American, heir of the pioneer and the immigrant, the foundering of Art and Society was not experienced as a loss. On the contrary, the end of Art marked the beginning of an optimism regarding himself as an artist.

The American vanguard painter took to the white expanse of the canvas as Melville's Ishmael took to the sea.

On the one hand, a desperate recognition of moral and intellectual exhaustion; on the other, the exhilaration of an adventure over depths in which he might find reflected the true image of his identity.

Painting could now be reduced to that equipment which the artist needed for an activity that would be an alternative to both utility and idleness. Guided by visual and somatic memories of paintings he had seen or made – memories which he did his best to keep from intruding into his consciousness – he gesticulated upon the canvas and watched for what each novelty would declare him and his art to be.

Based on the phenomenon of conversion the new movement is, with the majority of the painters, essentially a religious movement. In every case, however, the conversion has been experienced in secular terms. The result has been the creation of private myths.

The tension of the private myth is the content of every painting of this vanguard. The act on the canvas springs from an attempt to resurrect the saving moment in his "story" when the painter first felt himself released from Value – myth of past self-recognition. Or it attempts to initiate a new moment in which the painter will realize his total personality – myth of future self-recognition.

Some formulate their myths verbally and connect individual works with their episodes. With others, usually deeper, the painting itself is the exclusive formulation, it is a Sign.

The revolution against the given, in the self and in the world, which since Hegel has provided European vanguard art with theories of a New Reality, has re-entered America in the form of personal revolts. Art as action rests on the enormous assumption that the artist accepts as real only that which he is in the process of creating. "Except the soul has divested itself of the love of created things ..." The artist works in a condition of open possibility, risking, to follow Kierkegaard, the anguish of the aesthetic, which accompanies possibility lacking in reality. To maintain the force to refrain from settling anything, he must exercise in himself a constant No.

Apocalypse and Wallpaper

The most comfortable intercourse with the void is mysticism, especially a mysticism that avoids ritualizing itself.

Philosophy is not popular among American painters. For most, thinking consists of the various arguments that TO PAINT is something different from, say, to write or criticize: a mystique of the particular activity. Lacking verbal flexibility, the painters speak of what they are doing in a jargon still involved in the metaphysics of *things:* "My painting is not Art; it's an Is." "It's not a picture of a thing; it's the thing itself." "It doesn't reproduce Nature; it is Nature." "The painter doesn't think; he knows." Etc., etc. "Art is not, not not not not ..." As against this, a few reply, art today is the same as it always has been.

Language has not accustomed itself to a situation in which the act itself is the "object." Along with the philosophy of TO PAINT appear bits of Vedanta and popular pantheism.

In terms of American tradition, the new painters stand somewhere between Christian Science and Whitman's "gangs of cosmos." That is, between a discipline of vagueness by which one protects oneself from disturbance while keeping one's eyes open for benefits; and the discipline of the Open Road of risk that leads to the farther side of the object and the outer spaces of the consciousness.

What made Whitman's mysticism serious was that he directed his "cosmic 'I'" toward a Pike's-Peak-or-Bust of morality and politics. He wanted the ineffable in *all* behavior – he wanted it *to win the streets.*

The test of any of the new paintings is its seriousness – and the test of its seriousness is the degree to which the act on the canvas is an extension of the artist's total effort to make over his experience.

A good painting in this mode leaves no doubt concerning its reality as an action and its relation to a transforming process in the artist. The canvas has "talked back" to the artist not to quiet him with Sibylline murmurs or to stun him with Dionysian outcries but to provoke him into a dramatic dialogue. Each stroke had to be a decision and was answered by a new question. By its very nature, action painting is painting in the medium of difficulties.

Weak mysticism, the "Christian Science" side of the new movement, tends in the opposite direction, toward *easy* painting – never so many unearned masterpieces! Works of this sort lack the dialectical tension of a genuine act, associated with risk and will. When a tube of paint is squeezed by the Absolute, the result can only be a Success. The painter need keep himself on hand solely to collect the benefits of an endless

series of strokes of luck. His gesture completes itself without arousing either an opposing movement within itself or his own desire to make the act more fully his own. Satisfied with wonders that remain safely inside the canvas, the artist accepts the permanence of the commonplace and decorates it with his own daily annihilation. The result is an apocalyptic wallpaper.

The cosmic "I" that turns up to paint pictures but shudders and departs the moment there is a knock on the studio door brings to the artist a megalomania that is the opposite of revolutionary. The tremors produced by a few expanses of tone or by the juxtaposition of colors and shapes purposely brought to the verge of bad taste in the manner of Park Avenue shop windows are sufficient cataclysms in many of these happy overthrows of Art. The mystical dissociation of painting as an ineffable event has made it common to mistake for an act the mere sensation of having acted – or of having been acted upon. Since there is nothing to be "communicated," a unique signature comes to seem the equivalent of a new plastic language. In a single stroke the painter exists as a Somebody – at least on a wall. That this Somebody is not he seems beside the point.

Once the difficulties that belong to a real act have been evaded by mysticism, the artist's experience of transformation is at an end. In that case what is left? Or to put it differently: What is a painting that is not an object nor the representation of an object nor the analysis or impression of it nor whatever else a painting has ever been – and that has also ceased to be the emblem of a personal struggle? It is the painter himself changed into a ghost inhabiting The Art World. Here the common phrase, "I have bought an O" (rather than a painting by O) becomes literally true. The man who started to remake himself has made himself into a commodity with a trademark.

Milieu: The Busy No-Audience

We said that the new painting calls for a new kind of criticism, one that would distinguish the specific qualities of each artist's act.

Unhappily for an art whose value depends on the authenticity of its mysteries, the new movement appeared at the same moment that Modern Art *en masse* "arrived" in America: Modern architecture, not only for sophisticated homes, but for corporations, municipalities, synagogues; Modern furniture and crockery in mail-order catalogues; Modern vacuum cleaners, can openers; beer ad "mobiles" – along with reproductions and articles on advanced painting in big-circulation

magazines. *Enigmas for everybody.* Art in America today is not only nouveau, it's news.

The new painting came into being fastened to Modern Art and without intellectual allies – in literature everything had found its niche.

From this isolated liaison it has derived certain superstitions comparable to those of a wife with a famous husband. Superiorities, supremacies even, are taken for granted. It is boasted that modern painting in America is not only original but an "advance" in world art (at the same time that one says "to hell with world art").

Everyone knows that the label Modern Art no longer has any relation to the words that compose it. To be Modern Art a work need not be either modern or art; it need not even be a work. A three-thousand-year-old mask from the South Pacific qualifies as Modern and a piece of wood found on a beach becomes Art.

When they find this out, some people grow extremely enthusiastic, even, oddly enough, proud of themselves; others become infuriated.

These reactions suggest what Modern Art actually is. It is not a certain kind of art object. It is not even a style. It has nothing to do either with the period when a thing was made or with the intention of the maker. It is something that someone has had the power to designate as psychologically, aesthetically, or ideologically relevant to our epoch. The question of the driftwood is: *Who* found it?

Modern Art in America represents a revolution of taste – and serves to identify power of the caste conducting that revolution. Responses to Modern Art are primarily responses to claims to social leadership. For this reason Modern Art is periodically attacked as snobbish, Red, immoral, etc., by established interests in society, politics, the church. Comedy of a revolution that restricts itself to weapons of taste – and which at the same time addresses itself to the masses: Modern-design fabrics in bargain basements, Modern interiors for office girls living alone, Modern milk bottles.

Modern Art is educational, not with regard to art but with regard to life. You cannot explain Mondrian's painting to people who don't known anything about Vermeer, but you can easily explain the social importance of admiring Mondrian and forgetting about Vermeer.

Through Modern Art the expanding caste of professional enlighteners of the masses – designers, architects, decorators, fashion people, exhibition directors – informs the populace that a supreme Value has emerged in our time, the Value of the NEW, and that there are persons and things that embody that Value. This Value is a completely fluid one. As we have seen, Modern Art does not have to be actually new; it only

has to be new to *somebody* – to the last lady who found out about the driftwood – and to win neophytes is the chief interest of the caste.

Since the only thing that counts for Modern Art is that a work shall be *new*, and since the question of its newness is determined not by analysis but by social power and pedagogy, the vanguard painter functions in a milieu utterly indifferent to the content of his work.

Unlike the art of nineteenth-century America, advanced paintings today are not bought by the middle class. Nor are they by the populace. Considering the degree to which it is publicized and feted, vanguard painting is hardly bought at all. It is *used* in its totality as material for educational and profit-making enterprises: color reproductions, design adaptations, human-interest stories. Despite the fact that more people see and hear about works of art than ever before, the vanguard artist has an audience of nobody. An interested individual here and there, but no audience. He creates in an environment not of people but of functions. His paintings are employed not wanted. The public for whose edification he is periodically trotted out accepts the choices made for it as phenomena of The Age of Queer Things.

An action is not a matter of taste.

You don't let taste decide the firing of a pistol or the building of a maze.

As the Marquis de Sade understood, even experiments in sensation, if deliberately repeated, presuppose a morality.

To see in the explosion of shrapnel over No Man's Land only the opening of a flower of flame, Marinetti had to erase the moral premises of the act of destruction – as Molotov did explicitly when he said that Fascism is a matter of taste. Both M's were, of course, speaking the driftwood language of the Modern Art International.

Limited to the aesthetics, the taste bureaucracies of Modern Art cannot grasp the human experience involved in the new action paintings. One work is equivalent to another on the basis of resemblances of surface, and the movement as a whole a modish addition to twentieth-century picture making. Examples in every style are packed side by side in annuals and in the heads of newspaper reviewers like canned meats in a chain store – all standard brands.

To counteract the obtuseness, venality, and aimlessness of the Art World, American vanguard art needs a genuine audience – not just a market. It needs understanding – not just publicity.

In our form of society, audience and understanding for advanced painting have been produced, both here and abroad, first of all by the

tiny circle of poets, musicians, theoreticians, men of letters, who have sensed in their own work the presence of the new creative principle.

So far, the silence of American literature on the new painting all but amounts to a scandal.

STATEMENT AND LETTER TO THE DIRECTORS OF THE MUSEUM OF MODERN ART

A Group of Artists

Statement

A GROUP OF ARTISTS have joined together to discuss their problems. The work of the members of this group is highly diverse in style and conception. Their kinship is a respect and love for the human qualities in painting. The following statement represents their concerted opinion.

All art is an expression of human experience. All the possibilities of art must be explored to broaden this expression. We nevertheless believe that texture and accident, like color, design, and all the other elements of painting, are only the means to a larger end, which is the depiction of man and his world.

Today, mere textural novelty is being presented by a dominant group of museum officials, dealers, and publicity men as the unique manifestation of the artistic intuition. This arbitrary exploitation of a single phase of painting encourages a contempt for the taste and intelligence of the public. We are asked to believe that art is for the future, that only an inner circle is capable of judging contemporary painting, that everybody else must take it on faith. These theories are fixed in a ritual jargon equally incomprehensible to artist and layman. This jargon is particularly confusing to young artists, many of whom are led to accept the excitation of texture and color as the true end of art, even to equate disorder with creation. The dogmatic repetition of these views has produced in the whole world of art an atmosphere of irresponsibility, snobbery, and ignorance.

We say, in the words of Delacroix: "The men of our profession deny to the fabricators of theories the right to thus dabble in our domain and at

From *Reality* (A Journal of Artists' Opinions) Vol. 1, No. 1, Spring 1953. By permission of Raphael Soyer.

our expense." We believe that art cannot become the property of an esoteric cult. We reaffirm the right of the artist to the control of his profession. We will work to restore to art its freedom and dignity as a living language.

Milton Avery
Isabel Bishop
Aaron Bohrod
Louis Bosa
Louis Bouché
Charles Burchfield
Nicolai Cikovsky
Gladys Rockmore Davis
Joseph De Martini
Alexander Dobkin
Guy Pène du Bois
Philip Evergood
Ernest Fiene
Joseph Floch
Xavier Gonzalez
Dorothea Greenbaum
Stephen Greene
William Gropper
Chaim Gross
Maurice Grosser
Robert Gwathmey
Joseph Hirsch
Edward Hopper

Karl Knaths
Leon Kroll
Yasuo Kuniyoshi
Joe Lasker
Sidney Laufman
Jacob Lawrence
Jack Levine
Oronzio Maldarelli
Reginald Marsh
Henry Mattson
Edward Melcarth
Paul Mommer
Sigmund Menkes
Henry Varnum Poor
Anton Refregier
Honoré Sharrer
Joseph Solman
Moses Soyer
Raphael Soyer
William Thon
Anthony Toney
Howard Warshaw
Sol Wilson

One of the last acts of John Sloan before his death was to join the Group.

Letter to Museum of Modern Art

A group of artists, in a recent discussion about trends and directions in art, have made a number of observations which we believe ought to be relayed to you for your consideration.

We have noted that abstract and non-objective art, both perfectly legitimate and worthy forms of expression, are in the way of becoming an academy carrying an esthetic weight.

We find that we have made this common observation, that the

Museum of Modern Art is coming to be more and more identified in the public eye with abstract and non-objective art. (This seems to be particularly true in the Mid-West.) Others cited your declared policy, that "the field of contemporary art is immensely wide and varied, with many diverse viewpoints and styles. We [The Museum] believe that diversity is a sign of vitality and of the freedom of expression inherent in any democratic society. We oppose any attempt to make art, or any opinion about art conform to a single point of view."

The greater number of our group have what might be termed the "humanist" outlook. That being our bent and our belief, we are acutely aware of the fast-spreading doctrine that non-objectivism has achieved some sort of esthetic finality that precludes all other forms of expression. This belief appears to pervade the schools, the museums, criticism, and as a result has a highly restrictive influence upon young artists.

We feel that this particular dogma stems very largely from the Modern Museum and its unquestioned influence throughout the country, that it is not due to an intentional slanting of exhibitions or publications, but is rather a matter of imbalance and emphasis.

In the light of the very admirable statement of policy quoted above, it would appear desirable that the non-abstract forms of art be given the same serious and scholarly consideration that the Museum has extended to abstract art recently, and to all forms of modern art in times past.

It might be pointed out in defense of our outlook that it is not an isolated or outmoded one. There appears to be in all creative fields a movement toward a return to the humanities. The universities throughout the country have begun to discover that the abstract sciences, technology and processes are not enough in education; that the purely operative individual is something less than an asset to society. There has been a strong revival of classical studies, a new emphasis upon those activities that tend to create stable values and moral and spiritual breadth.

The immensely increased art activity within the universities reflects this humanistic reawakening. Educational leaders, as well as artists and public, look toward the Modern Museum for direction. Thus, it is our feeling that the Museum should meet their need with a broad and well-considered program carrying out the democratic principles which it has stated so well.

We feel that a conference might help resolve some of the problems and principles involved here, and suggest that one be arranged.*

*Two conferences were subsequently held, but the Museum directors did not feel they were giving undue attention to non-objective art.

88 A GROUP OF ARTISTS

A CRITIQUE
OF ABSTRACT EXPRESSIONISM

Leon Golub

CONTEMPORARY AMERICAN AND EUROPEAN PAINTING has been increasingly identified as abstract expressionist in character. This dominance is apparent in exhibitions and critical literature, particularly in the reportorial journals, *Art Digest* and *Art News,* which attempt to document the art of our times. A major portion of critical space is devoted to the exponents of this development, celebrated as the logical and primary focus of the art of the immediate present.

The impact of these journals on younger artists is enormous, establishing trends and patterns of influence. This critique explores some metaphysical and formal suppositions of abstract expressionism as exemplified in the critical validation of this movement: (1) in regard to individual achievements (that is, the *capacity* for such achievements); (2) in relation to the general social arena. All subsequent quotations are from the November 15, 1953 *Art Digest* "Symposium: The Human Figure" – and the December 1, 1953 *Art Digest* and the December, 1953 *Art News* which discuss the "Younger European Painters" exhibition at the Guggenheim Museum. The purpose and nature of this exhibition – trends among younger artists – points up the dominance of abstract expressionism in "advanced" circles and the documentation (and formulation) of this role in the critical response of these journals.

John Ferren (*Art Digest*, November 15, 1953) states that "Abstraction gave us the fresh plastic truths of our time. Abstract expressionism gave a new range to the sensibility involving the whole, 'existential' man. Its humanism is implicit not explicit." James Fitzsimmons (*Art Digest*, December 1, 1953): "Had I been around when the 'old masters' of our times were 'younger painters,' I doubt that I could have been more excited about their work and more optimistic about the future of art than

From *College Art Journal*, Winter 1955. Reprinted by permission of Leon Golub and the *Art Journal*.

I am today when I look at the work of Soulages, Mathieu and Riopelle...."

This optimism is manifested at a time when the multi-variant range of innovation that introduced and maintained the modern movement in art has apparently narrowed into a relatively fixed style-appearance (uniform content – or, uniform rejection of specific content) that is influential on artists in widely separate locales. Abstract expressionism is an international style, perhaps the most generalized and widespread style that has appeared in this century. To what extent this style approaches anonymity – and paradoxically, in an extremely individualistic era, the intrinsic denial of individuated imagery – must be clarified in regard to the social role of the contemporary artist and any personal transcendence of general form expectations.

The writer would summarize the nature of abstract expressionism as follows:

1. the elimination of specific subject matters and a preference for spontaneous, impulsive qualities of experience.
2. the unfettered brush – discursive, improvisatory techniques – motion, motion organization, and an activised surface.

The artist substitutes for any normative sequence of concepts or experiences an impulse energy dramatized as "instinctual" to a preconscious state of mind. Actuality (purpose) is attained by abbreviated means through the "direct" impact of non-referential sensation. "Contact" becomes the meaning. Scratched, scribbled lines or ambiguous forms gesture an ambiguous reality when the artist cannot cope with the contradictory stereotypes of the culture.

The artist seeks an action that is pre-logical, pre-cognitive, and a-moral. Reversion or regression to primitive means, common to the childhood of the race or of childhood itself, can only be a romantic device, as modern man – for all his willful (and perhaps necessary) regressive hopes – must consciously seek and articulate what was once primitively experienced. If this expression cannot be directly achieved and if the sophisticated artist does not reach a residual primacy, his forms only simulate pre-conscious activization. Motion organization is then frequently allusive of the mannerisms and rocaille decoration of the eighteenth century and of the more recent Art Nouveau.

There are few common verbal equivalents of any such discursive

motion and as observer recognition is not constant (except on rather illustrative levels in regard to the artist's undetermined intent), descriptive comment tends to be hyperbolic. Especially peculiar to abstract expressionism is the terminological remoteness of the purposes attributed to it. The claims made for one painting could as easily typify works by other artists. James Fitzsimmons characterizes Mathieu's painting as a "vast black canvas on which white and scarlet tendrils coil and snap with extraordinary tension. This is the cosmic theater, the universe, the unconscious, the dark night within and around us in which primordial forces are engaged in a life-giving, life-destroying struggle that can only be witnessed at a remove; in dreams, in the photographs of astronomers and physicists and most evocatively, in art." If a critic purports such an explanation, he might well "see" those qualities in a painting. And while that painting might seem to intentionally characterize some such experiences, it might, also, very likely picture none of them, as it is not referential in its reduced state to such meanings in any specific fashion.

As Alfred Russell (*Art Digest*, November 15, 1953) writes: "The limitations of the non-objective idiom are its vastness, its lack of measure, its all-inclusiveness. It tends to equate all possible knowledge – especially intuitions of extra-spatial, non-Euclidian metaphors; the language of sign and symbol; the unconscious, and the laws of chance." There are no uniform or iconographic means (or for that matter, any notation corresponding to any scientific interpretation) through which the supra-formal aspects of such paintings could be defined. The ambiguities of abstract expressionism force the viewer to locate the extrinsic focus – in that the observer reacts through an allusive, self-referential perception. The observer does perceive variously accelerated or structured linear configurations; the attributes of these relations are so abstract, however, as to be incommensurable – these then can hardly be couched in metaphysical terms (unless the very negation of communicable content can be metaphysically construed).

The avoidance of content is not uniquely the problem of the abstract expressionist but is inherited from the abstract ideologies of the first decades of this century. Neo-plastic or constructivist artists sought (or seek) pure form, a non-idiosyncratic and universal art transcending the discordant images of the time. The abstract expressionists also deny any representative disorder, but their avoidance of the constructivist ideality and the irrational aspect of their "expressionist" bias points up an incapacity to avert some skirmished identification within a crisis situation.

This view may be clarified through regard of those "crisis" artists who retain referential associations in their work, e.g., Giacometti, Dubuffet,

Glasco. Robert Goldwater (*Art News*, December 1953) regarding the "Younger European Painters" exhibition states: "In its emphasis on abstraction the exhibition is surely representative of the most vital currents of European painting.... There are, of course, individual expressionists and objectively minded painters and sculptors of quality. But they remain individuals. (Giacometti – and how little realist he is! – who was supposed to be the new bell-wether, has only found a few pale imitators.)" A similar attitude regarding Giacometti as an isolated figure in respect to general trends is voiced by Herta Wescher (*Art Digest*, December 1, 1953). Giacometti is quoted as saying, "'I don't know how to do a head any more.... All I can make are these things.' ... Giacometti today is a solitary figure in Paris, detached from movements, programs or manifestos. He has found no disciples, and his art shows no evidence of derivations in his period. He would be very unlikely to have followers since his art is a continuous, groping search. It is a search in the face of fundamental and apparently irreconcilable human and sculptural issues."

Giacometti's uniqueness (an isolated position and in respect to the unusual quality and meaning of his work) might very well pin-point many of the critical issues of contemporary art. The quality of *certainty* (of role) is different in modern times. The culture is rich and diverse, but the artist is aberrant. The artist is not sure of his material – what he is to portray – or his purpose in so doing. Content is introspective and the prime reality acknowledged by the artist is reality of self.

The crisis in its most significant visual aspect concerns the rendering of a contemporary world picture. Picasso reordered the image of the time; distortions (of previously achieved ideologies) became the monumental and definitive visual equivalents of contemporary experience. These changes in the first decade of the twentieth century effected as abstraction, distortion, or gigantism, seen through a primitivist bias, are characteristic of the devaluation of the individual in society and in art. The loss of naturalistic discrete descriptions which originally designated the substantive and recognizable attributes of particular individuals or things was equivalent to a cultural dehumanization of man. Subsequently the twentieth century's overt exploitation of mass phenomena has become for some artists an interest in the irrational as a justification and as a source for creative differentiation. Klee and the surrealists worked from similar points of contact but through more intimate fantasy evocations. Subsequently the issue was raised at this level between those artists who confronted the dilemma through an idiosyncratic but heroically intense introspection – various expressionist or surrealist

attitudes – and their ideological opponents who abhorred what Gabo has termed the "cave mentality" and sought an engineered clarification of form that would transcend any involutional deviance. The expressionist, in a sense, wallowed in the mire of an orgastic harassment of self, while the constructivists sought to reconstruct the visual environment in terms of the de-personalized but mystic potentialities of the future.

The basic attitudes of abstract expressionism might almost be deduced from its name: expressionism refers as it originally did to violence, subliminal contents – an explosion of self; abstraction indicates general form inquiries, an avoidance of representational imagery and a commitment of visual impulse that is more "classic" or distanced (from any direct introspective impulsion). In a way, abstract expressionism wants a very good thing indeed – the intensity of personal commitment without the specificity such a view ordinarily entails. Gesture! if only to make an anonymous "contact."

The definition of a contemporary style depends on the artist's capacity to wrest coherent directives from the divergent choices available. The abstract expressionist theory of problematic psychic explorations is sufficiently generalized, provisional, and comprehensible to permit individuals to directly and immediately achieve a "style." These very factors, however (and one need only note the vast international output of abstract expressionist painting), also foster a situation in which it is almost impossibly difficult for an artist to define unique values beyond the common determinants of the style. Any dervish principle – that the prime elemental resources within the psyche have intense pictorial equivalents (or can even be tapped) – is still to be demonstrated. The abstract expressionists deal with spontaneity and although there are many levels of spontaneity, it remains doubtful whether these bravura skirmishings can evoke universals (of the type quoted from Fitzsimmons earlier) or point up elemental or instinctual processes and reactions. The question becomes *farcical*: what is the difference (and how can these differences be recorded) between a subliminal impulse, the cosmos, and a fanciful doodle?

The individualism of Renaissance art up through Picasso, Ernst, Miró, etc., has been discarded in abstract expressionism. This is one aspect of the experiential crises of the modern world. Only that rare artist who is iconoclastically remote survives with an intrinsic and personal art. If an art form becomes too "free-floating," that is, disassociated from representative contents, it may lose identification and become somewhat anonymous. Such anonymous objects have been functional in some collective cultures (wherein anonymity was a general social phenomenon integrated in the ways and means of the culture), but are certainly not in

evidence in the highly mobile, individualistic Western world – although the aggregates of power (social) and the mechanics of modern society certainly predispose towards anonymous responses.

In such a context, the withdrawal of particular (intrinsic) points of view would emphasize the dangers of anonymous or non-committal attitudes. Abstract expressionism is non-referential and diffuse; for all its practitioners' strenuous efforts, it is deficient in regard to any intense, ideational involvement of the artist. As was stated earlier – the quality of *certainly* is of such a nature today that the artist is "free-floating" in respect to the contradictory aspects of the culture or in regard to any personal point of view, which can only be achieved through a stringent and introspective demarcation of role.

Thomas Hess (*Art News*, December 1953) discussing Ad Reinhardt in respect to strongly reactive commitments writes, "Reinhardt's answer, characteristically would be mild but devastating laughter. Who's so tortured? Who's a cultural power?" Although the paintings of which Mr. Hess speaks are not abstract expressionist, Reinhardt's work has been previously associated with this movement. Regardless of this, however, and although the remark is a passing one, in a perhaps ironic context, that it was deemed worthy of being recorded is indicative of the incapacity of many modern artists to wrest out any uniquely definitive point of view – let alone gird themselves as did Giacometti – for a "search in the face of fundamental and apparently irreconcilable human and sculptural issues."

THE NEW AMERICAN PAINTING

Alfred H. Barr, Jr.

We are now committed to an unqualified act, not illustrating outworn myths or contemporary alibis. One must accept total responsibility for what he executes.

<div align="right">

CLYFFORD STILL, 1952

</div>

Voyaging into the night, one knows not where, on an unknown vessel, an absolute struggle with the elements of the real.

<div align="right">

ROBERT MOTHERWELL

</div>

There is no more forthright a declaration, and no shorter a path to man's richness, nakedness and poverty than the painting he does. Nothing can be hidden on its surface – the least private as well as the most personal of worlds.

<div align="right">

JAMES BROOKS, 1956

</div>

Art never seems to make me peaceful or pure. . . . I do not think . . . of art as a situation of comfort.

<div align="right">

WILLEM DE KOONING, 1951

</div>

The need is for felt experience – intense, immoderate, direct, subtle, unified, warm, vivid, rhythmic.

<div align="right">

ROBERT MOTHERWELL, 1951

</div>

Subject is crucial and only that subject matter is crucial which is tragic and timeless.

<div align="right">

MARK ROTHKO

</div>

Introduction from *The New American Painting: As Shown in Eight European Countries 1958–1959.* Published by The Museum of Modern Art 1959. All rights reserved. Reprinted by permission.

What happens on the canvas is unpredictable and surprising to me.... As I work, or when the painting is finished, the subject reveals itself.

WILLIAM BAZIOTES, 1952

Usually I am on a work for a long stretch, until a moment arrives when the air of the arbitrary vanishes and the paint falls into positions that feel destined.... To paint is a possessing rather than a picturing.

PHILIP GUSTON, 1956

The function of the artist is to make actual the spiritual so that it is there to be possessed.

ROBERT MOTHERWELL

O F THE SEVENTEEN PAINTERS in this exhibition, none speaks for the others any more than he paints for the others. In principle their individualism is as uncompromising as that of the religion of Kierkegaard whom they honour. For them, John Donne to the contrary, each man is an island.

Though a painter's words about his art are not always to be taken at face value, the quotations preceding this preface – like the statements printed further on – suggest that these artists share certain strong convictions. Many feel that their painting is a stubborn, difficult, even desperate effort to discover the "self" or "reality," an effort to which the whole personality should be recklessly committed: *I paint, therefore I am.* Confronting a blank canvas they attempt "to grasp authentic being by action, decision, a leap of faith," to use Karl Jaspers' Existentialist phrase.

Indeed one often hears Existentialist echoes in their words, but their "anxiety," their "commitment," their "dreadful freedom" concern their work primarily. They defiantly reject the conventional values of the society which surrounds them, but they are not politically *engagés* even though their paintings have been praised and condemned as symbolic demonstrations of freedom in a world in which freedom connotes a political attitude.

In recent years, some of the painters have been impressed by the Japanese Zen philosophy with its transcendental humour and its exploration of the self through intuition. Yet, though Existentialism and Zen have afforded some encouragement and sanction to the artists, their

96 ALFRED H. BARR, JR

art itself has been affected only sporadically by these philosophies (by contrast with that of the older painter, Mark Tobey, whose abstract painting has been deeply and directly influenced by Tao and Zen).

Surrealism, both philosophically and technically, had a more direct effect upon the painting of the group. Particularly in the early days of the movement, during the war, several painters were influenced by André Breton's programme of "pure psychic automatism ... in the absence of all control exercised by reason and outside of all aesthetic and moral preoccupation." Automatism was, and still is, widely used as a technique but rarely without some control or subsequent revision. And from the first Breton's dependence upon Freudian and Marxian sanctions seems less relevant than Jung's concern with myth and archaic symbol.

The artists in the exhibition comprise the central core as well as the major marginal talent in the movement now generally called "Abstract Expressionism" or, less commonly, "Action Painting." Both terms were considered as titles for this exhibition.

Abstract Expressionism, a phrase used ephemerally in Berlin in 1919, was re-invented (by the writer) about 1929 to designate Kandinsky's early abstractions that in certain ways do anticipate the American movement – to which the term was first applied in 1946. However, almost to a man, the painters in this show deny that their work is "abstract," at least in any pure, programmatic sense; and they rightly reject any significant association with German Expressionism, a movement recently much exhibited in America.

Action Painting, a phrase proposed in preference to Abstract Expressionism by the poet-critic, Harold Rosenberg, in an important article* published in 1952, now seems to overemphasize the physical act of painting. Anyway, these artists dislike labels and shun the words "movement" and "school."

The briefest glance around the exhibition reveals a striking variety among the paintings. How could canvases differ more in form than do Kline's broad, slashing blacks from Rothko's dissonant mists, or Pollock's Dionysiac *perpetuum mobile* from Newman's single, obsessive, vertical line? What then unites these paintings?

First, their size. Painted at arm's length, with large gestures, they challenge both the painter and the observer. They envelop the eye, they seem immanent. They are often as big as mural paintings, but their scale as well as their lack of illusionistic depth are only coincidentally related

*Harold Rosenberg, "American Action Painters," *Art News*, Vol. 51, December 1952.

to architectural decoration. Their flatness is, rather, a consequence of the artist's concern with the actual painting process as his prime instrument of expression, a concern which also tends to eliminate imitative suggestion of the forms, textures, colours and spaces of the real world, since these might compete with the primary reality of paint on canvas.

As a consequence, rather than by intent, most of the paintings seem abstract. Yet they are never formalistic or non-objective in spirit. Nor is there (in theory) any preoccupation with the traditional aesthetics of "plastic values," composition, quality of line, beauty of surface, harmony of colour. When these occur in the paintings – and they often do – it is the result of a struggle for order almost as intuitive as the initial chaos with which the paintings begin.

Despite the high degree of abstraction, the painters insist that they are deeply involved with subject matter or content. The content, however, is never explicit or obvious even when recognizable forms emerge, as in certain paintings by de Kooning, Baziotes, and Gottlieb. Rarely do any conscious associations explain the emotions of fear, gaiety, anger, violence, or tranquillity which these paintings transmit or suggest.

In short these painters, as a matter of principle, do nothing deliberately in their work to make "communication" easy. Yet in spite of their intransigence, their following increases, largely because the paintings themselves have a sensuous, emotional, aesthetic and at times almost mystical power which works and can be overwhelming.

The movement began some fifteen years ago in wartime New York. American painting in the early 1940's was bewilderingly varied and without dominant direction. The "old masters" such as John Marin, Edward Hopper, Max Weber, Stuart Davis, were more than holding their own. The bumptious Mid-Western regionalism of the 1930's, though still noisy, was dying along with its political analogue, "America First" isolationism. Most of the artists who during the decade of the Great Depression had been naïvely attracted by Communism had grown disillusioned both with the machinations of the party and with Socialist Realism. There were romantic realists who looked back nostalgically to the early nineteenth century, and "magic realists," and painters of the social scene such as the admirable Ben Shahn. The young Boston expressionists Hyman Bloom and Jack Levine had considerable success in New York, while from the Pacific coast came the visionary art of Mark Tobey and Morris Graves, reflecting Oriental influence in spirit and technique. There was also a lively interest in modern primitives, but no one discovered an American *douanier* Rousseau.

Late in the artistically reactionary 1930's, the American Abstract

Artists group had stood firm along with their allies, *Abstraction-Création* in Paris and Unit One in England. Working principally in rather dry cubist or non-objective styles, they did not seem much affected by the arrival in the United States of Léger, Mondrian and several Bauhaus masters. Quite other young painters, not yet identified as a group, were, however, strongly influenced by the surrealist refugees from the war, notably Max Ernst, André Masson, Marcel Duchamp (who had been the leader of New York Dadaism during World War I), the poet André Breton, and the young Chilean-Parisian painter Matta Echaurren. Equally important was the influence of the former surrealist associates, Picasso, Miró and Arp, who had stayed in Europe.

Chief among the supporters of the surrealist group in New York was Peggy Guggenheim whose gallery, "Art of This Century," opened in the autumn of 1942 and served as the principal centre of the *avant-garde* in American painting until the founder returned to Europe in 1947. Her brilliant pioneering was then carried on by the new galleries of Betty Parsons, Charles Egan and Sam Kootz. "Art of This Century,"gave one-man shows to Motherwell, Baziotes, Rothko and Still, and no less than four to Jackson Pollock. Arshile Gorky, the most important early master of the movement, showed at another (and prior) surrealist centre, the Julien Levy Gallery, with the poetic blessing of Breton.

The work of certain older American painters, notably Ryder, Marin and Dove, interested some of the artists, and for a time Rothko, Pollock, Gottlieb and Still were influenced by the symbolic imagery of primitive art, especially of the American north-west coast. All during this early period and afterwards, Hans Hofmann, a Parisian-trained German of Picasso's generation, taught the young inspiringly and became their *doyen* colleague, though with little obvious effect on the leaders.

Before 1950 most of the artists in this show had hit their stride. And they had won general, though usually reluctant, recognition as the flourishing vanguard of American painting, thanks to the courageous dealers just mentioned, enthusiastic critics such as Clement Greenberg, a handful of editors, teachers, collectors, and museum officials, and above all to their own extraordinary energy, talent, and fortitude.

They were not, however, a compact phalanx. Gorky had been a quite well-known but rather derivative painter for fifteen years before he found himself about 1943. Pollock and Baziotes, both born in 1912, worked in obscurity until 1942–3, when they emerged along with the youthful and articulate Motherwell. Pollock exhibited his first highly abstract pictures about 1945 and invented his "drip" technique in 1947. [Exhibitions early in 1959 confirmed that Pollock had painted abstract expressionist

paintings as early as 1937; and that Hofmann was using a drip technique as early as 1940.] By 1947, Rothko and Still, working some of the time in California, were developing their characteristic styles, Gottlieb was turning away from his "pictographic"forms, and Stamos, twenty years younger than they, had had his first show. In 1948, de Kooning, then forty-four, publicly entered the movement and quickly became a major figure; Tomlin was nearly fifty. Kline, Newman, Brooks and Guston, all mature painters, also transformed their art, Guston after having relinquished a brilliant success in a more realistic style. Since 1950, hundreds upon hundreds of American artists have turned to "abstract expressionism," some of them, like Tworkov, in mid-career, others like Hartigan and Francis while they were still students. Sam Francis is unique as the only expatriate in the show and the only painter whose reputation was made without benefit of New York, having moved directly to Paris from San Francisco where Still and Rothko had been honoured and influential teachers. Sculptors related to, and sometimes closely allied with, the painters' movement should be mentioned, notably Herbert Ferber, David Hare, Ibram Lassaw, Seymour Lipton, Theodore Roszak and David Smith.

The movement, after several tentative early years, has flourished in its maturity since about 1948, roughly the starting point of this show. Naturally, because of its dominance, it has aroused much resistance in the United States among other artists and the public, but it has excited widespread interest and even influenced the painting of some of its most stubborn adversaries. Others are staunchly resisting what has inevitably become fashionable. There will be reactions and counter-revolutions – and some are already evident. Fortunately, the undogmatic variety and flexibility inherent in the movement permits divergence even among the leaders; a few years ago, for instance, both Pollock and de Kooning painted a number of pictures with recognizable figures, to the dismay of some of their followers who had been inclined to make an orthodoxy of abstraction.

For over a dozen years now, works by some of these artists have been shown abroad, first in Europe, then in Latin America and the Orient. They have met with controversy but also with enthusiasm, thanks in part to artists working along similar lines, and to other champions.

To have written a few words of introduction to this exhibition is an honour for an American who has watched with deep excitement and pride the development of the artists here represented, their long struggle – with themselves even more than with the public – and their present triumph.

100 ALFRED H. BARR, JR

AS THE CRITICS SAW IT

N THE SPACE of a year, *The New American Painting* was seen in eight cities in eight countries. In each city the exhibition was held in the major institution associated with modern art and a catalogue ... was issued in the language of the country. It is not hard to imagine the quantity of journalism generated, nor the difficulty of assessing the response. It is true to say that the paintings created a sensation: whether enthusiastically, hesitantly, in the form of back-handed compliments, or of real hostility, it was acknowledged that in America a totally "new" – a unique and indigenous – kind of painting has appeared, one whose influence can be clearly seen in works of artists in Europe as well as in many other parts of the world. The quotations are necessarily brief. Elisions are not indicated, but we have tried not to distort any writer's main intent.

PORTER MCCRAY

The great reach of American painting becomes apparent when it not only comprises segments of reality dipped into vivid color by Hartigan, but also the severity of Barnett Newman, although the main influence lies in the direction of *Tachisme*. European influences are caught in the occasional appearance of painterly effects, particularly in absorbing surrealist motifs. Of Kandinsky, who means so much to European abstract painting, there is strikingly little, which is interesting because of the central position that the realization of spatial concept takes up in American painting. This in particular is its decisive character: the direct translation of unlimited space into the gesture of painting itself, whether into expanding form or the continual overflow and intermingling of forms; it is creation which tries for the domination of space. This impelling urge toward utter freedom and uninhibited statement frees this

style of painting of all symbolic sign language and allows it to reach the most spontaneous manifestation of emotion.

HELMI GASSER, *Neue Züricher Zeitung*, Zurich, May 23, 1958

It is not new. It is not painting. It is not American. There is no deep necessity, no inner torment, not even a serious formal research. Not one of these painters goes against the current. Not one of them is anti-conformist. There is no spiritual flight.

LEONARDO BORGESE, *Corriere della sera*, Milan, June 8, 1958

One should not forget that while on the Atlantic coast there was close contact with Europe, on the Pacific, in San Francisco, there were more diverse graftings: the totem poles of the Indians and the Mexicans' intricate baroque, the symbolic and ancient scripts of China and Japan. Such important and stimulating facts could not remain dormant in soil so rich. And the difficulties encountered by this new generation of painters in trying to pierce the indifference of the American public, the necessity of surviving as individuals without being crushed by the conformism of industrialized life, have added that charge of violence and of personal fury which each of these paintings conveys. It is like witnessing a ship-wreck and their fight for survival.

The rapidity and vigor of the results are astonishing. To be objective, I must say that American art derives from European art and is still sensitive to its cultural echoes, but nevertheless its character is so well defined, the images are so abundant and so permeated by the fantasy and motivations of American ideals, that one must admit it has by now the look of independence, decisively recognizable.

I feel that this process is taking place among these Americans with unexpected tenderness and lightness of touch, with a feeling of happiness, in spite of past anxieties. This recalls Matisse, and, less directly, Impressionism. Their creative talent is more free because they are not bound to traditions, to deep-rooted cultures, as our artists are. Therefore the American artists succeed in reaching a greater freedom, with results more pleasant, vibrant, and cheerful. We had been told that they were wild: we find instead a festive pictorial quality without dramatic shocks; including Pollock, who plunged deepest into the intricate web of pictorial experiments.

MARCO VALSECCHI, *Il Giorno*, Milan, June 10, 1958

I had resigned myself to not seeing the exhibition. But others did not resign themselves, and thus in rapid, improvised, and exhausting days, it was possible to move eighty-one canvases, packed in more than forty enormous cases, from Milan to Madrid. To judge the size of the trans-oceanic guests, a detail will suffice: to bring into the Museum two of the canvases, one by Jackson Pollock and one by Grace Hartigan, required sawing the upper part of the metal entrance door of the building the night before the inauguration.

Upon entering the room, a strange sensation like that of magnetic tension surrounds you, as though the expression concentrated in the canvases would spring from them. They are other myths, other gods, other ideas, different from those prevailing in Europe at present, and from that grayish and textured Parisian fog which also in this country of light and color today masks the polychromatic traditions.

Each picture is a confession, an intimate chat with the Divinity, accepting or denying the exterior world but always faithful to the more profound identity of conscience. The present painting is a mystery to many who wish to understand its significance without entering into its state, thereby committing an error as profound as he who wishes to attain the Moradas of Teresa de Avila by means of intelligence and not by means of Grace.

<div align="right">MERCEDES MOLLEDA, Revista, Barcelona, August 30, 1958</div>

In view of the large number of great talents, one can speak of an American School; for the first time in the history of art, personalities are emerging that are not influenced by Europe, but, on the contrary, influence Europe, including Paris. For nearly ten years Pollock has exerted his influence on the *avant-garde* of all countries. The appearance of his paintings in Paris and in Venice was a sensation; and since the young Sam Francis lives in Paris, he too is in the center of international interest. The unshakable fortress of the French School is shaken.

Pollock was a genius, but by European standards, one can easily count half of the other sixteen to be exceptional talents. They are painters without regard for the ready-made world. What they paint is real; it is the spectator himself who must have a certain amount of imagination in order to comprehend. Without an actual consciousness of the universe this is not possible. Here, there is no comfort, but a struggle with the elements, with society, with fate. It is like the American novel; something happens, and what happens is disquieting and at the same time pregnant with the future.

Robert Motherwell and Franz Kline stand apart from the rest. They paint gigantic symbols on the wall and call their proclamations *Elegy for the Spanish Republic XXXV* or *Accent Grave*. The paintings are hypotheses of what could come; but poems by Ezra Pound or the Spaniard Guillén are exactly as hypothetical if one starts with the limitations of one's own imagination. What makes these painters artists is the advance into a world which is not prefabricated, but for that reason is also not boarded up; on the contrary, it is so vast that one hardly dares to enter it. What is emphasized here? An event that starts like a poem by Ezra Pound and ends with a statute for the investigation of the space of the universe. Greece is not a European suburb any more.

They all use vast dimensions, not from megalomania, but because one cannot say these things in miniature. Klee was able to do just that; his world was not smaller because of it; he was a monk and wrote the psalter of our saeculum. Americans are world travelers and conquerors. They possess an enormous daring. One proves oneself in the doing, in the performance, in the act of creation. In the United States one speaks of Action Painting. We speak of Abstract Expressionism. This difference characterizes America as well as Europe. We cannot forget, we distill the conceptions of long experience instead of creating new ones. In any case, these young Americans stand beyond heritage and psychology, nearly beyond good and evil. In Europe we are a little bit afraid, confronted by such a lack of prejudice. Could it be that we are already in a state of defense?

WILL GROHMANN, *Der Tagesspiegel*, Berlin, September 7, 1958

Pollock must be given credit for creating, by colors and the movement of line, a dynamism which fascinates the eye. One feels that he has painted in a kind of ecstasy, supported, however, by authentic skill and by a highly developed gift as a colorist. Thus was his work created; a 'map' of modern life, a map in which areas of chaos are charted. Pictures consisting of angry, confused lines that are gradually acquiring order, the latter eloquently expressed by color. Consequently, the tension in Pollock's paintings contains an element of relaxation.

De Kooning's work is aggressive, filled with wrath and sometimes with repulsion. But it has dynamism and originality; his color as well, which sometimes makes startling contrasts. In this art, conflicts are expressed with a hardness and a temerity which involuntarily remind us of the hard-boiled mentality of modern American literature. Tomlin's work is

characterized by a dynamic kind of calligraphy and is therefore an example of the influence of Asian art, which is indeed considerable in America. Franz Kline paints angrily gesticulating signals suggesting danger, hostile barriers, and heads of prehistoric insects.

No matter how subjective their work may be, it has a communicative power because they live under the spell of their time, which is also our time, and because the projection of their personal tensions represents, to some extent, a projection of the spirit of our time, experienced by all of us.

UNSIGNED, *Nieuw Rotterdamse Courant*, Rotterdam, November 15, 1958

Primarily, it offers that climate of unconstraint which never fails to strike anyone traveling to the United States for the first time, and of which those of us who strolled this summer through the American Pavilion at the Brussels Fair could form some idea. For us, an avant-garde exhibition still retains a certain quality of provocation and unfailingly arouses a reaction from those who, without any justification one must add, see in it some sort of threat to traditional forms of expression. Two points to be remarked on: the feeling of sincerity produced by the work as a whole, and the intuitive sense generated in the spectator of an absence of gratuitousness.

R.M.T., *La Dernière Heure*, Brussels, December 7, 1958

One examines with consternation ink spots measuring two yards by two and a half; graffiti enlarged ten-thousand times, where a crayon stroke becomes as thick as a rafter; soft rectangles, formless scribblings, childish collections of signs; enough to make our own abstract painters blush for shame, exposed henceforth to the most humiliating comparisons.

UNSIGNED, *Le Phare*, Brussels, December 14, 1958

It is not only a question of bringing to the public's attention a few American names to slip in next to the 'Parisians', but – more profoundly – of coming to an interesting and opportune awareness of the 'modern adventure' in painting, thanks to the remarkable forms it is taking on the other side of the Atlantic. The seventeen painters chosen clearly define the amplitude of their experiments, from Barnett Newman's concise stripes, Rothko's simple constrasts and the thick black lines of Franz

Kline to Guston's semi-impressionist pink flickerings, Brooks' brilliant nests of color, and Sam Francis' rain of petals. We grasp the pleasure that Motherwell, for instance, or Tworkov takes in projecting himself into the formless; Grace Hartigan in producing street scenes of brilliant and clashing patches of color that recall the Fauves; Tomlin in marking out geometrical vibrations that are almost elemental signs. Baziotes, easily the most agreeable member of the group with his rather fragile mauves and greens, stands apart in his lack of frenzy. The two most feverish, and by the same token the most typical, are Willem de Kooning, with his grinning, flayed women, and the touching Gorky. We are dealing with a kind of painting that seems to refuse any frame, any imprisonment; which no longer takes anything into consideration. And which will have the greater difficulties growing old.

All of which emphasizes to an extreme degree the originality of the American scene – or more exactly, of the New York milieu. And yet this show enforces certain analogies. The roots of this art are European, and are called Fauvism, German Expressionism, Klee, Picasso, sometimes Matisse or André Masson's inspired Surrealism. In Europe we have returned by more or less brutal stops and starts to the notion of the 'object' and to the privileges of the *painting* treated as such; in the United States, ingenuous even in their surrealist revolt against the oppression of a mechanistic civilization and its utilitarian nonsense, men have discovered the facility and the strangeness of the very act of painting. There had to be this somewhat blind generosity to which Pollock bears witness to give to this anxiety its whole meaning. Thus develops a difficult and tentative dialogue, which constitutes the value of this century's painting.

ANDRE CHASTEL, *Le Monde*, Paris, January 17, 1959

Why do they think they are painters? We would end up by being, I won't say convinced – for the only greatness here is in the size of the canvases – but disarmed if we did not deplore the terrible danger which the publicity given to such examples offers, as well as the imprudence of the combined national museums in offering official support all too generously to such contagious heresies.

CLAUDE ROGER-MARX, *Le Figaro Littéraire*, Paris, January 19, 1959

Once inside the gallery you can't slide politely past this lot of pictures. If our aesthetic reactions are not numb, scenes of enthusiasm or distress,

dancing or denunciation are to be expected at the Tate. During my visit the public was quiet, though I have never seen so many young gallery-goers sitting down in a silent daze.

FREDERICK LAWS, *The Manchester Guardian*, Manchester, February 27, 1959

What cannot fail to strike any visitor, and strike him forcibly whether he is naturally inclined for or against this development of modern art, is an impression of size; of size, moreover, not merely in an inflatory sense, but as a natural assumption of scale which seems for once to fill, in the most acceptable manner, the Edwardian stateliness of the Tate's towering rooms. The paintings fulfill the demand of the galleries' dimensions, which are not proportioned for individual comfort or domestic relaxation, but for the expansive scale of the social occasion. Though the suggestion may not be readily acceptable in some quarters, it still seems worth remarking that paintings which can function in this manner appear eminently suitable for the public and social role which is so desperately looked for from the art of the present time, a role which can combine the so-called 'environmental' demands of architecture with the qualities of a personal statement. It must, however, be admitted that American painting has perhaps only unconsciously begun to satisfy the former requirement, its conscious pursuit being of the latter. But here again the quality of adventure, of individual striving, of hammering out modes of expression with a pioneering sense of independence, lends these personal utterances a forceful, easily communicable, vitality.

FROM OUR ART CRITIC, *The Times*, London, February 4, 1959

This is not art – it's a joke in bad taste: *Save me from the great string spider webs.*

HEADLINES IN *Reynolds News*, London, March 1, 1959

However often we may have heard of the size, the assurance, the headlong heedless momentum which characterize them all, we are still bowled over by these qualities when we are, as it were, physically involved in them. For involved we are, as if by some vast upheaval, not of Nature, but of our notion of human potentialities. When paintings of this sort were first shown at the Tate, in 1956, I made the error, as it now seems to

me, of judging them according to the canons of traditional aesthetics. They do not, in reality, relate to these aesthetics at all; or, if they do, it is as a result of what Mr Alfred Barr calls 'an intuitive struggle for order'.

JOHN RUSSELL, *Sunday Times*, London, March 8, 1959

NARCISSUS IN CHAOS
Contemporary American Art
Cleve Gray

T HE MODERN REVOLT against academicism is more than a century old, yet we are still flailing the horse that has long died. The new and the shocking in all arts are still so eagerly received that they are scarcely questioned so long as they are not academic. Branded as conservative and reactionary are any suggestions that order is intrinsic to art, that an artist has an obligation of aesthetic responsibility, that individuality should be disciplined. But if these standards are no longer reputable, what has replaced them?

The director of the most influential contemporary art museum in this country and his staff are making a collection of art that sets the standard of public taste. He has often been asked, on behalf of the public, how he makes his choices. To paraphrase his various answers, he tells us that he picks the work of artists who significantly reflect the age they live in, work which he believes will stand the test of time as unique and intensely imaginative expressions of individuality. One cannot argue with this aim, although it is one that presupposes vast knowledge. It presupposes, for one thing, a profound understanding of the relation of present-day American culture to Western civilization; and, even more, it requires ability to project into the future with a perspective developed only by time. On a lower plane, it also demands ability to distinguish between works of art that will have lasting meaning from those that are simply curious and irresponsible.

Undoubtedly the most respected art critics and museums in the United States have bet their chips heavily on a group called "avant-garde," a group composed of "abstract expressionists" and "action painters" in particular, and of non-objective artists in general. Leading painters in the group are Pollock, De Kooning, Motherwell, Still, Kline and Sam Francis,

Reprinted from *The American Scholar*, Volume 28, Number 4, Autumn, 1959. Copyright © 1959 by the United Chapters of Phi Beta Kappa. By permission of the publishers and Cleve Gray.

along with the older and influential teachers, Hans Hofmann and Stuart Davis. Paintings by members of this group were gathered together to represent United States art at the Brussels Fair. These painters have declared over and over, both in words and in paint, that they were not painting the visual world but rather their inner responses, that they were dealing with pure forms of vision and re-creating a new world, that they had replaced old types of art with the new art of their own unique symbols.

Stuart Davis typifies these thoughts in describing one of his own paintings: "Instead of the usual illusionist method, the emotions and ideas were equated in terms of a quantitatively coherent dimensional color-space system." The art critic Herbert Read gives further details about these intentions: "Modern man . . . will seek his ideal in some abstract harmony or in some symbol rising unaided from the depths of his unconscious."

This is a presumptuous program for an artist. It is presumptuous because it deliberately states that the visual declaration the artist makes is not about his conception of the visual world, but is only about his own

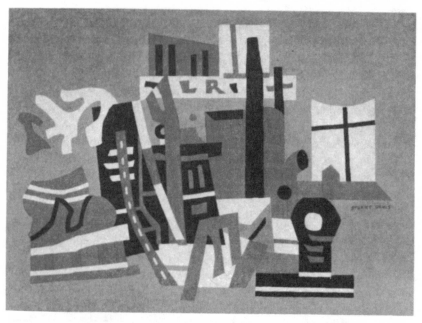

STUART DAVIS, *New York Waterfront*, 1938. Oil on canvas 22" × 30¼". Albright-Knox Art Gallery, Buffalo, New York. Room of Contemporary Art Fund, 1943. (Photo by Biff Henrich)

individuality. The artist assumes that his own ego and unconscious are worth contemplating, are more worthy of contemplation than the objective world. Yet he will admit to you in the very moment he sets his unique individuality before you that he is saying nothing more than, "Here I am!" To quote Hans Hofmann: "Everyone should be as different as possible. There is nothing that is common to all of us except our creative urge. It just means one thing to me, to discover myself as well as I can."

What is the origin of this egotism? One is tempted, at first sight, to find it in nineteenth-century Romanticism, but this association is false. The Romanticists of the nineteenth century looked into themselves in order to discover what men really felt, after a period in which feeling had been desiccated and sophisticated. The Romanticists were not only ready to abandon any introspection that was not borne out by common experience, but they used nature and history as touchstones by which to sort out the genuine from the fanciful. The Romanticists were, in a sense, conducting a new survey of human experience under conditions akin to scientific observation. But it is a far cry from their open and tentative results, couched in intelligible forms that all could criticize, to the esoteric pronouncements that modern artists seek to impose by fiat. As Clement Greenberg, critic and champion of the avant-garde, has said: "The image or object can be put back into art only by pastiche or parody."

The modern egotist is saying that, except for its parody, the object *must* be eliminated, that *we dare not* put the object back into the painting. This modern singularism-by-decree is something very different from the Romanticist's imaginative interpretation of self and nature seeking to communicate truth.

Most of us have a conception of the difference between an ordered and a disordered life; but few of us stop to consider what is meant by order and disorder in art. The word "order" has taken on many special and honorific connotations; but what it comes down to is methodical and harmonious relationships. Whether or not one is speaking of the church, of law, of the military, of grammar, or simply saying, "My refrigerator is out of order" or "My bank account is in good order," one means the same thing. Order is the working principles of organization and intrinsic authority. With reference to art, the meaning is the same; it can be emphasized by the relation of the words "art" and "articulate." Both words derive from *ars*, "to join." To articulate means to make clear and to function; it often refers to joints that operate or to speech that is distinct. Just so does the word "art" refer to the problem of expressing the burden of a new creation with clarity. This is accomplished by a working

relation of parts, and in the visual arts by an articulation of all the components that can be used for expression. The more imaginative and inclusive the use of these components is, the greater is the significant value of the work.

An artist has two different kinds of elements or components to articulate: the explicit parts, which are his lines, brushwork, color, form and the like; and the implicit parts, which are the various connotations and meanings implied and contained in the visual work. A painting or sculpture that consists simply of a vertical line has almost entirely eliminated the possibilities of implicit significance that enrich a work of art. A painting or sculpture that is mechanically realistic has eliminated most of the possibilities of significance inherent in the explicit parts. Actually, no work of art can make exclusive use of either of these two kinds of components without some reference to the other kind; but the character of the references and the degree of penetration into the relations between explicit and implicit expression determine the ultimate value of the work of art.

A sense of responsibility in life denotes respect for the obligation to act according to one's best intentions and powers. The artist's responsibility is no different. His obligation is to use the rich possibilities of his chosen art. We say a man is irresponsible if his actions are unrelated to standards of order. An irresponsible artist likewise holds himself not accountable to standards of visual reference. We judge whether the artist achieves responsible expression when we see how he uses visual references.

Academic art destroys the significance of individual expression by making unchangeable rules for the use of the explicit and implicit elements. But the reaction against academicism is no more worthy if it ignores or reduces possibilities of expression to insignificance. The more significant the expression, the greater the work of art. One may justly destroy old standards of order only if new standards replace them. The act of destruction by itself is not a creative act; it is irresponsible unless it prepares the ground for creation. Old standards give way to new ones only if the newer standards are more expressive and constructive.

The character of subject matter in painting bears directly upon the significance of the work of art because it helps determine the implicit component. Distinguishing his ideas from the classic idea that subject matter is real and belongs to the artist, the American avant-garde sculptor and painter will frequently describe how necessary it is before beginning work to spend a period of time in contemplation; and, if he has subject matter at all, this subject matter will be forced to disappear and to become his own reactions. Elaine de Kooning, painter, critic, wife of

Willem de Kooning, writes: "The main difference, then, between abstract and nonabstract art is that the abstract artist does not have to choose a subject. But whether or not he chooses, he always ends up with one." Creative will must apparently abdicate in favor of the creative accident. Subjective contemplation preceding work has long been characteristic of Oriental rather than Occidental art, developing from the philosophy of a world in disorder rather than an ordered universe. But, what is to the point, the Oriental artist always depicted reality. He never professed to give us a non-objective world. He invariably stated in his work that through the contemplation of visual reality he had passed to the high plane of spiritual unity, and that *his work showed this passage*. Indeed, that was its purpose.

It is related of Wu Tao-tzu, the Giotto of China, that one day he disappeared into his own painting of a landscape and was never seen again. In the contemporary American abstract expressionist action painting, it is the landscape that disappears into the artist. The unhappy spectator stares at an unintelligible vacuum.

It is a widespread cliché that in the twentieth century standards of order no longer exist, although Western civilization has always conceived of an orderly universe. Man in the Far East, perhaps because of a more brutal environment, has seen mainly the disorder of his personal life. As an artist he sought and found an escape in metaphysics; as a philosopher, possibly defending himself against a world in disorder, he dissolved his individual identity in the infinite oneness of the universe; whereas Western man, in a kinder, more submissive environment, attempts to dominate nature, forming it in his own image. Western man's identity is part of, even necessary to, all his metaphysical systems.

In twentieth-century America, the emphasis on the precious identity of the individual has been more intense than ever before. We place a priceless worth on the existence of every person. We feel a tremendous necessity to cultivate his physical and spiritual demands. We value a man's creations *according to the very degree of their individuality*.

Western civilization has from time to time turned to Greece as a period in which an ideal balance of creative individuality and individual responsibility was achieved. It is a telling fact that the Greek word for "idiot" (ἰδιώτηζ) has also the meaning "his own" or "private person." In other words, the individual becomes idiotic at the point where his experience is unrelated to a responsible conception of reality, the communal reality, and becomes entirely "his own." One may legitimately ask what is the relation to communal reality of the avant-garde artist. Harold Rosenberg, one of the first champions of action painting,

describes its process: "He [the artist] gesticulated upon the canvas and watched for what each novelty would declare him and his art to be."

It is, indeed, unnecessary for an artist to engage in communal activity outside his work. His communal activity is his work. His sense of communal responsibility ought to be present in the work itself, in the character of the aesthetic ideas communicated. Heaven forbid that the American artist should ever be required to communicate political ideas. But he should of his own accord feel the desire to use his freedom positively and constructively.

The painting of Jackson Pollock is today widely accepted in a great part of the world as being an important and highly individual contribution to art. Since his violent death, it has attained great monetary value, so that both aesthetic and financial judgment sustain it. It is extremely decorative and strong, and it possesses a degree of monumentality. Above all, it makes a kind of statement about the unlicensed freedom of an artist. But let us look further into the character of these attributes. After a long period of "classical" restraint surviving into the first half of the nineteenth century, the creative artists of Western Europe broke away from conventions of vision and technique, and they successfully established the artist's right to re-create visual reality according to conceptions that transcended ordinary visual experience. The assertion of the creative individual reached a Himalayan peak from 1900 to 1915. About 1915 destructive dangers, which are inherent in all revolutionary extremes, began to assert themselves. These were, perhaps, best typified by the Dadaists. The Dadaists clearly saw the result of the increased emphasis upon the individual's right to destroy his subject without re-creating a substitute. They saw that it led to a denial both of the validity of the subject and the necessity of the artist to create anything at all. Followed to its logical conclusion, this aesthetic declares that non-art is superior to art, that Marcel Duchamp should indeed abandon painting and devote his life to playing chess, and that, in the end, the most appropriate museum for modern art would be an empty building.

Since the first years of this century, therefore, little work of truly unique style has been achieved. There have been simply different exaggerations of different aspects of the already liberated imagination. *Most men who have worked in paint have not used the liberated language of their individuality to make constructive assertions.* They have climbed a familiar peak only to hear their own voices echo back, "I made it!"

It is ironical that the school of American art that calls itself the avant-garde, far from being ahead of its time, is rather drifting in a backwater

of ideas significant half a century ago. The initial shock value that gave the group a purpose has worn off. In fact, the so-called avant-garde is now a phase of the academicism it abhors. It works by unimaginative conformity with set rules. It is also ironical that this group is promoted as the reflection of the spirit of American individualism and action; for by neglecting the responsibility inherent in a communicative individualism, and by failing to recognize laws of order and expression, it has lost the only individuality it could claim for itself.

What I am saying is that although the best work of the contemporary non-objective painters, such as Pollock's, may be agreeably decorative, it is nothing more. Whether one displays oneself in dripped lines, in rectangular voids, in misty circles or in regulated squares is not important, because it expresses no defensible or disputable assertion. The artist who is so attracted to himself that he is content with his private shorthand, and the group that enjoys the contemplation of his narcissism will, one hopes, be replaced by artists who have learned the importance of human relations. And at this point I simply recall that Western civilization has developed because of its belief in ordered existence.

In relating contemporary American painting to the Western conception of the individual, it is informative to ask what kind of order, if any, Western philosophy finds in life today. It has been stylish to blame science for upsetting our conventional faith, leaving us without a standard of order. But the Western scientist is continuously remarking upon the order of the universe and constantly searching for its grand design. The design of the scientist, who is increasingly dominating our mode of thinking, gives emphasis to his conviction that the order imposed upon life may not be imposed entirely by metaphysics, as we have believed, but is rather the spontaneous process of nature; in fact, it is the *necessary* process for the maintainance of the natural development of life. Without this natural order, life would cease. Biologists, biochemists and astronomers agree that systems of life that lose their process of order give way to systems that can maintain themselves through their own innate order. Life exists because it is ordered; it is not ordered because it exists. Science is constructing still more reasons for the belief in an ordered universe.

To return to Pollock as an example of the best of the avant-garde group, it is helpful to review an aspect of his work which is often praised: its dancelike character. His work is praised for having been painted with bodily participation in the movement his canvases display. It is explained that he entered his creations physically in a new way. This achievement, action painting, is thus described by one of its first champions, Harold

Rosenberg: "The painter no longer approached his easel with an image in his mind; he went up to it with material in his hand to do something to that other piece of material in front of him. The image would be the result of this encounter ... the painter gets away from Art through his act of painting This work, the act, translates the psychologically given into the intentional, into a 'world' – and thus transcends it." Well, Michelangelo painted the Sistine Chapel painfully on his back, Renoir's last work was done in a wheel chair, and some Chinese painters of the "wild men" school used fingers instead of brushes; but this, I submit, should have not the slightest influence on our judgment of their value as works of art.

I doubt, moreover, if the word "rhythmic" is properly used in describing the movement in Pollock's or other abstract expresionists' works. Rhythm is, in essence, regulated by inherent law; rhythmic harmony represents an organized conception of proportions. The conscious use of disharmony only serves to accent measurement. Without bounds upon it, rhythm becomes mere flux – the word that better describes the type of movement abstract-expressionist action painting creates. For flux is unrestrained and unregulated. It may be compared to a stream of consciousness, possessing the materials of expression but for lack of precision not *artfully* expressive. This flux has gained its present prominence because of a mistaken belief that it is "justified" by psychiatry. But the unrestrained freedom necessary to psychiatric investigation has never been intended as an end in itself; it is rather a method used to achieve order out of chaos. Proust and Joyce kept order in their free associations and dealt with ideas which humanity shares, their work being, in consequence, neither narcissistic nor chaotic.

Similar considerations arise in discussing the emphasis placed upon the calligraphy of Pollock and others of the avant-garde. "Much has been said of the parallels between contemporary abstraction and Oriental esthetic, and Kline's bold strokes are among those having the nearest affinity to Eastern calligraphy," states the *Magazine of Art* in May of 1953. The word "calligraphy" is in this context improperly used. Oriental calligraphy refers to linear movement with inherent meaning. The civilization of the Orient has for centuries judged great calligraphy to be among the highest art forms. Painting technique in the Far East was founded on calligraphic movement. It should be obvious enough that a great difference exists between a calligraphy with implicit meaning behind every stroke and a would-be calligraphy without this inherent order. Tobey has also been hailed as an artist who has interpreted in Western terms the calligraphic character of Oriental art. He himself discusses this, saying:

"I have just had my first lesson in Chinese brush from my friend and artist Teng Kwei. The tree is no more a solid in the earth, breaking into lesser solids bathed in chiaroscuro. There is pressure and release. Each movement, like tracks in the snow, is recorded and loved for itself." This suggests a child's first attempts to imitate his parent's writing. Movement of this tentative kind and "loved for itself" is linear meandering.

It is poetic justice that the contemporary museum director, caught in the web of his own making, is all but required to exhibit the work of talented children because of its close relation to some contemporary painting. The work of children is praised, as it should be, for a quality of imaginative directness, but its exhibition in a museum is an inexpensive way of hedging one's bets. The museum director has so confused himself that he is no longer sure either of what to exhibit or what really constitutes a work of art.

I do not know whether it is truly possible for Occidental art to express itself in Oriental terms. Before attempting this, it would be advisable for the avant-garde to gain more than a superficial knowledge of what Oriental art really is. Principles of Chinese art are often quoted. The intelligent critic and painter William Seitz has written: "Thanks to the analogous concern of both the modern and the Oriental artist for life rhythm and dynamic resolution of antithesis, we have gained for the first time a sympathy with the attitude of the Chinese toward reality." Sensing that the first principle of Hsieh Ho, properly translated as "spirit's breath and life movement," a prime requisite of Chinese painting, is somehow different from our Western concept of rhythm and must not be translated as "rhythm," most contemporary Western abstract expressionist action painters have interpreted this principle of vitality essential to Oriental art as license to give way in their own work to violent caprice and eccentricity.

The fact that the breath of spirit and the movement of life must be present in a work of art means that the Far Eastern artist insists on a specific quality of life that makes the subject significant: its life. Indeed, objects that a Westerner calls inanimate, such as rocks, water, trees, have for the Oriental this quality of breath of spirit and life movement. All of disordered existence is pervaded with this vital force, yet it is not an ordering force; the Chinese artist does not search for an underlying structural order in the Western sense, but rather for nature's pervasive vitality. By losing himself in the magnitude of this vital force, the Chinese re-creates through his brush a visual representation of the appearance of this force as it manifests itself in objective reality. Nor is Oriental painting composed in the same manner as Western painting. A non-

Western conception of dynamic unity comes into play that is neither abstract expressionist flux nor Western geometric composition. But, above all, the purpose of great Oriental art is to bring about the passage of the human soul from actuality and its disorder to the unity of an all-pervading spirit beyond life.

We may, therefore, conclude that the object of all great art, Oriental or Occidental, is to elevate the spirit. Masterpieces of Western art achieve this end by an insistence on underlying structure, that is, order. Its source is metaphysical or, as science tells us, the fundamental requisite of life. Either way it is the order of life itself that exalts the Western soul. The painter's job is to find his way of interpreting this positive philosophy in visual terms. Many young American artists are working toward this goal, but they are not members either of the conservative realist or surrealist groups, nor are they part of the publicized avant-garde. In its honest effort to understand modern art, let us hope that the American public will soon be shown more of the constructive and less of the capricious.

HAPPY NEW YEAR
Thoughts on Critics and
Certain Painters as the Season Opens
John Canaday

THE NEW YEAR in these parts has so little to do with the first day of January and so much to do with the first Monday in September that Labor Day's Eve, which is tonight, would be a good time to ring the bells and blow the whistles while everyone wishes everyone else the best of everything for the next twelve months – including a lot less pother about abstract expressionism. With any luck, 1959–60 might even go down in history as the year abstract art in general accepted the responsibilities of middle age.

Kandinsky painted the first completely abstract composition half a century ago (forty-nine years, to split hairs), yet we are still talking about "the new art." Impressionism, a genuine scandal where abstract expressionism is a synthetic one, took less than half that many years to be born, to mature and to give way in its turn to the various innovations of post-impressionism. And a little quick arithmetic based on the birth and death dates of fauvism, cubism and surrealism as proselytizing movements should make the abstract expressionists feel embarrassed in their protracted adolescence. Fifty years is a long time to have remained so starry eyed, and some of the sparkle, examined at close range, is beginning to look distressingly like crow's feet.

There can be no objection to abstract expressionism as one manifestation of this complicated time of ours. The best abstract expressionists are as good as ever they were – a statement not meant to carry a concealed edge. But as for the freaks, the charlatans and the misled who surround this handful of serious and talented artists, let us admit at least that the nature of abstract expressionism allows exceptional tolerance for incompetence and deception.

From *The New York Times*, September 6, 1959. Copyright © 1959/1961 by The New York Times Company. Reprinted by permission.

The art of the French Salon, recognized as deadly, is the only school comparable in prolix mediocrity to the rank and file of abstract expressionist work today. Yet Salon art did require of its practitioners at least a manual talent for the imitation of academic disciplines, while anyone, literally, can paint in a kind of abstract expressionist idiom. Sweet innocence of technical fetters may even give the most unconsidered daub an individual character. Witness the highly personal work of Betsy the Ape, conspicuous not long ago in the newspapers, but the recipient of the silent treatment in the art magazines. Of course Betsy's work was not art, but it was certainly abstract and, in its own way, quite expressive of her own gay, outgoing self.

Yet the fact that a reasonable, if reprehensible, approximation of abstract expressionism can be executed in ten minutes by a novice with a large brush, is not sufficient explanation for so prolific a growth among painters who regard themselves as professionals. The question is why so many painters have adopted a form of art that should seem pointless except to the recondite, and why a large public is so humble in the face of an art that violates every one of its esthetic convictions. Bad painters we must always have, but how does it happen that we have them in such profusion in such a limited field, and why are we taking them so seriously?

The fault, I am afraid, lies quite directly with professors, museum men and critics, including this writer, who has functioned in all three capacities. In our missionary fervor for the best of it, we have managed to create the impression that all abstract art per se must be given the breaks on the probability that there is more there than meets the eye, while all other art per se must be regarded with suspicion on the probability that it isn't as good as it looks. Things have come to the point where it is amusing to dismiss the Renaissance with a quip, but dangerous to one's critical reputation not to discover in any second-rate abstract exercise some cosmic implication.

Ever since poor Ruskin ruined himself by accusing Whistler of throwing a pot of paint in the public's face and losing the libel suit that Whistler clapped on him, timid critics have been wiping the paint out of their eyes with a smile. But critics who think of themselves as adventurous have been even more responsible for an attitude that has changed art criticism from a rational evaluative process to a blind defense of any departure from convention, including pretentious novelties.

We suffer, actually, from a kind of mass guilt complex. Because Delacroix was spurned by the Academy until he was old and sick, because Courbet had to build his own exhibition hall in 1855 to get a

showing for pictures that are now in the Louvre, because Manet was laughed at, because Cézanne worked in obscurity, because Van Gogh sold only one picture during his lifetime, because Gauguin died in poverty and alone, because nineteenth-century critics and teachers and art officials seemed determined to annihilate every painter of genius – because of all this we have tried to atone to a current generation of pretenders to martyrdom. Somewhere at the basis of their thinking, and the thinking of several generations of college students who have taken the art appreciation course, is the premise that wild unintelligibility alone places a contemporary artist in line with great men who were misunderstood by their contemporaries.

Recognizing a Frankenstein's monster when they see it – and lately they can't miss it – some critics and teachers wail, "But what are we going to do? We can't go back to all those old Grant Woods again." Of course it is not a matter of going backward, but forward – somewhere. That we will go forward from abstract expressionism seems unlikely, since it is more and more evident that these artists have either reached the end of a blind alley or painted themselves into a corner. In either case, they are milling around in a very small area – which, come to think of it, may explain why they are increasingly under a compulsion to paint such very large canvases.

In the meanwhile, critics and educators have been hoist with their own petard, sold down the river. We have been had. In the most wonderful and terrible time of history, the abstract expressionists have responded with the narrowest and most lopsided art on record. Never before have painters found so little in so much.

LETTER TO THE EDITOR REGARDING CANADAY'S CRITICISM

Dealers, Critics, Artists

The Embattled Critic

THE following letter attacking me as art critic of *The New York Times* was printed on the art page on Sunday, February 26, 1961, without comment. It brought responses from more than 600 readers, with about 550 of them supporting me[1] – not all of these, however, for the right reasons from my point of view.

On the two subsequent Sundays, March 5 and 12, 1961, *The Times* printed fifty-two letters, pro and con, as a debate. In spite of their personal tone, which cannot be edited out, these letters can be read as an informal discussion of a critic's function and position today, and the selection given here, based on that made by *The Times*, is offered as such.

There are many more pro than con letters, partly to observe the proportionate relation of the letters that came in, but largely because the con letters did little but repeat the accusations made in the original letter. Some of the letters have been expanded to include portions of the originals that were edited out for reasons of space when published in *The Times*. There are a couple of changes in the titles of the signatories of the original letter, in one case at the request of the signatory, in another at the request of the institution with which he is connected.

<div align="right">JOHN CANADAY</div>

The original letter:

TO THE NEW YORK TIMES:

Reading Mr. John Canaday's columns on contemporary art, we regard as offensive his consistent practice of going beyond discussion of exhibitions

Reprinted from John Canaday, *Embattled Critic*, Farrar, Straus and Giroux, 1962. The letter appeared first in 1961 in *The New York Times*.

in order to impute to living artists en masse, as well as to critics, collectors and scholars of present-day American art, dishonorable motives, those of cheats, greedy lackeys or senseless dupes.

Here are some instances:

Sept. 20, 1959: "... a situation built on fraud at worst and gullibility at best has produced a school of such prolix mediocrity ..."

July 24, 1960: "The chaotic, haphazard and bizarre nature of modern art is easily explained: The painter finally settles for whatever satisfaction may be involved in working not as an independent member of a society that needs him, but as a retainer for a small group of people who as a profession or as a hobby are interested in the game of comparing one mutation with another."

Sept. 6, 1959: "But as for the freaks, the charlatans and the misled who surround this handful of serious and talented artists, let us admit at least that the nature of abstract expressionism allows exceptional tolerance for incompetence and deception."

"In the meanwhile, critics and educators have been hoist with their own petard, sold down the river. We have been had."

Sept. 11, 1960: "... for a decade the bulk of abstract art in America has followed that course of least resistance and quickest profit."

"There is not a dealer in town, nor a collector, nor a painter hoping to hang in the Museum of Modern Art who doesn't study each of Mr. Barr's syllables in an effort to deduce what he should offer for sale, what he should buy, or what he should paint ..."

Oct. 23, 1960: "... brainwashing ... goes on in universities and museums."

Mr. Canaday is entitled, of course, to the freedom of his opinions regarding works of art. We submit, however, that his terminology of insults is scarcely adequate to describe emerging art works and tendencies, and we scorn this waging of a polemical campaign under the guise of topical reporting.

If Mr. Canaday has a political or social or esthetic "position" or philosophy, let him state what it is and openly promote his aims. Every style and movement in art history contains examples of work by imitative or uninterested artists. To keep referring to these in order to impugn the whole, instead of attempting to deal seriously with the work of the movement, is the activity not of a critic but of an agitator.

JAMES S. ACKERMAN, *Professor of Fine Arts, Harvard University*
WILLIAM BARRETT, *Professor of Philosophy, N. Y. U.*
DONALD BLINKEN, *Collector*

WALTER BAREISS, *Collector*
BERNARD BRODSKY, M.D., *Collector*
JAMES BROOKS, *Painter*
JOHN CAGE, *Composer*
BERNARD CHAET, *Associate Professor of Painting, School of Art and Architecture, Yale University*
HOWARD CONANT, *Chairman, Dept. of Art Education, N. Y. U.*
STUART DAVIS, *Painter*
EDWIN DENBY, *Writer*
HENRY EPSTEIN, *Collector*
JOHN FERREN, *Painter*
ALFRED FRANKFURTER, *Editor and President*, Art News
PERCIVAL GOODMAN, *Architect, F.A.I.A.*
ADOLPH GOTTLIEB, *Painter*
JACK M. GREENBAUM, *Collector*
MR. & MRS. I. HAROLD GROSSMAN, *Collectors*
DAVID HARE, *Sculptor*
BEN HELLER, *Collector*
THOMAS B. HESS, *Executive Editor*, Art News
HANS HOFMANN, *Painter*
SAM HUNTER, *Director, Rose Art Museum, Brandeis University*
KENNETH KOCH, *Writer*
WILLEM DE KOONING, *Painter*
STANLEY KUNITZ, *Poet*
KERMIT LANSNER, *Writer*
BORIS LEAVITT, *Collector*
ERLE LORAN, *Painter and Teacher*
ARNOLD H. MAREMONT, *Collector, Chicago*
ROBERT MOTHERWELL, *Painter*
E. A. NAVARETTA, *Poet and Critic*
ALBERT H. NEWMAN, *Collector*
BARNETT NEWMAN, *Painter*
RAYMOND PARKER, *Painter*
PHILLIP PAVIA, Sculptor, *Editor*, It Is
GIFFORD PHILIPS, *Collector, Publisher*, Frontier Magazine
WILLIAM PHILLIPS, *Editor*, Partisan Review
FAIRFIELD PORTER, *Art Critic*, The Nation
DAVID A. PRAGER, *Collector*
HAROLD ROSENBERG, *Writer*
ROBERT ROSENBLUM, *Assistant Professor, Dept. of Art and Archaeology, Princeton University*

BARNEY ROSSETT, *Publisher, Grove Press*
IRVING SANDLER, *Writer and Critic.*
KENNETH B. SAWYER, *Art Critic*, Baltimore Sun
DAVID SMITH, *Sculptor*
WHITNEY S. STODDARD, *Professor of Art*
MEYER SCHAPIRO, *Professor, Dept. of Art History and Archaeology,
 Columbia University*
PAUL WEISS, *Professor of Philosophy, Yale University*

Note

1. [*Editors' note*] Many of the letters in support of Canaday were written by artists, and as might be expected, most worked in modes other than abstract expressionism. An abstract painter, Cleve Gray, wrote that it was a delight to read Canaday's criticism because it is "founded on knowledge, constructed with thought and expressed in clear English." Harry Sternberg, a realist, expressed outrage at the "vulgar, vitriolic attack" from authors who have "had a long period in which they have dominated the written pages of art discussion." Edward Hopper offered that he believed John Canaday "the best and most outspoken art critic *The Times* has ever had," while Karl Knaths thought that what "distinguishes John Canaday is honest opinion." George Schreiber, also an artist, condemned "the incredible aesthetic tyranny which the signers as a group have imposed on American creative thought," and the sculptor William Zorach congratulated *The Times* on having a critic who knows that "art did not begin this morning nor will it end tomorrow." Isabel Bishop counseled open-mindedness: "I think that Mr. Canaday should be listened to rather than quarreled with. And I think this about Mr. Hess [Editor of *Art News*], too."

REFLECTIONS ON THE NEW YORK SCHOOL

Robert Goldwater

NEARLY TWENTY YEARS have passed since Jackson Pollock had his first one-man show at The Art of This Century, and more than ten since Willem de Kooning made his debut at Charles Egan's Gallery. It is fifteen years since Arshile Gorky fused his long experiments into the influential style of his last years, and so became the partial prophet of a later achievement. And it is of course much longer since these men, and many others, both painters and sculptors, whom we (sometimes wrongly) account in succeeding artistic generations, began to work, and to work out the characteristic personalities by which they are known today.

This bit of chronology should be kept in mind, for its immediate implication is indeed correct: not only is there the New York School that has burst into popularity, influence, and affluence; not only has it had time to flower, to grow from indifference to prominence, from oppression to dominance; but it also has had time to change and develop, to evolve and alter and expand, to spread and succeed, to attract followers and nourish imitators. It has lived a history, germinated a mythology and produced a hagiology; it has descended to a second, and now a third artistic generation. This history, whose superficial aspects are those of other twentieth century styles, has in many ways contradicted the image of the New York School – the image it has had of itself, and even more the image its exegetes have given to the public – and so has presented it with peculiar and poignant problems. One of the results has been that recently, coincident with its notoriety, and in the midst of multiplying adepts, its old masters have begun to declare that it is not, nor indeed ever was, a school, perhaps not even a movement, and certainly not a style.

From *Quadrum* (Brussels), No. 8, 1960. Reprinted by permission of Louise Bourgeois (Mrs. Robert Goldwater).

The illustrations of this article are eloquent (even if necessarily partial) evidence of this diversity. Once we accept some degree of abstraction as given (and abstraction applies as well to other times and places), further characteristics common to a group style are difficult to discover. This is the more true since that style is supposed to speak through form alone, and small differences therefore take on added meaning. It is true too, precisely because among the younger members of the group (if group there be) the simple acceptance of abstraction has replaced the defiant assertion of abstraction that was the older men's reaction to the schooling and the artistic ambience of their youth. Thus for the artists themselves, specialists within a language that is their mother tongue, whose rudiments others must still learn to decipher, slight distinctions have important connotations. All this suggests what is indeed sometimes loudly proclaimed – that there are no common denominators, that any generalizations must be so broad as hardly to be meaningful. Each artist asserts his own existence, denies shared characteristics and insists that he is simply himself. Such insistence is the more pronounced because written commentary and criticism have not quite kept abreast of the decade's rapidly changing climate. Though the growth of the movement is recognized, and the spread of its influence beyond New York acknowledged (and still occasionally deplored), pressure from an even now laggard popular taste still forces some of the friendliest description toward a belligerent tone that suggests a defensive attitude. Where the artists maximize, the journalists have minimized differences, as though, in another context and concerning other artists, it were necessary to suggest that representation is acceptable too, and that artists who paint flowers (Renoir, Van Gogh, Matisse), are not simply floral artists – and so somehow really all alike. And as a concomitant, criticism has too often produced apologies in the guise of eulogy.

The history of the movement is relevant both to its present status of wide acceptance and its view of itself. In the background of its formative years were combined two separate and, in most ways, antithetical experiences: first, the Federal Art Project of the WPA (the government's economic assistance program), which during the thirties was literally essential to the continued existence of most of the artists who, sometime after 1945, were to become "abstract expressionists" (as well as to many others whose styles were to evolve differently); and second, the arrival in New York, during the early 'forties, of an important group of School of Paris artists (and writers), most of them in or on the fringes of the Surrealist movement. Externally, these two group events had a very different impact, each important in its own way.

While the Federal Art Project enabled artists to go on functioning as artists, and while for the sake of simple bread and butter, it was desirable to have its support (to be "on the Project"), it hardly provided a luxurious existence. Nor did it, as has sometimes been suggested, really convey – either to the artists it barely fed or to the public, which on the whole endured rather than enjoyed the little it saw of its post-office and hospital decorations – the impression that art had suddenly become essential to American society. (This was instead the optimistic hope of dedicated administrators in the arts, who saw the Project as a first step in an increasing program of governmental support of the arts in and for themselves rather than of artists as the unavoidable objects of public assistance; in the heady atmosphere of the time the dangers of such a development were hardly considered, and in any case it never took place.)

The Project did however produce a double-faceted awareness among the artists. Treated as members of a needy craftsman's group, rather than as individuals, they became conscious of common interests and problems, and were forced to live with each other as they never had before. Here undoubtedly is one of the sources of that extraordinary gregarious intimacy (in New York, and during summers on Long Island) that has been the paradoxical accompaniment of the New York School's assertion of individual uniqueness.

More important, the experience of the depression years suggested to the artists that however marginal an afterthought art was to others it was essential to them. Society treated them as craftsmen out of work; they put their pride in the core of art that was more than craft. They became aware that to continue to function on the margin was not only possible, but perhaps even desirable since this sort of existence gave rise to a certain valuable concentration on the work and a sense of esthetic community that in turn produced an invaluable intensity of feeling. Brought face to face with the fact that their art was a non-viable economic commodity, but absolved by the general state of affairs from seeking the causes in art itself (since the whole of society was finding it hard to market its skills), the non-sale of these works in the future (the fifteen years of struggle that preceded the present boom), would hold no terrors for them, nor reflect in any way on the value of their art nor on themselves for being artists. In a generally Puritan tradition of society this was a valuable gift.

The presence of the European artists in America, although on the surface a very different social phenomenon, had similar effects. It is certainly true, as has been said, that their actual appearance in New York

had a tremendous impact, even though their relation to the larger artistic community just described was tangential at best. To see, occasionally to talk with, Mondrian, Masson, Ernst, Tanguy, Léger, Lipchitz, Duchamp, among others, was, so to speak, to join the School of Paris, to join, that is, on to the central creative tradition of twentieth-century art, and through it to become part of the series of artistic revolutions that went back to Cézanne and Manet.

Even in the 'twenties there had never been as many expatriate painters and sculptors as writers. In the 'thirties isolation from Paris had intensified provincialism, both in painting fact and painters' feelings. The dominant "American scene" styles (those of Benton, Curry and Wood were the most notorious) that faithfully mirrored the political isolationism of the period, tried with dismal failure to make an asset of ignorance. The artists who remained in touch with European developments were only the more conscious of their distance from the center, and their time-lag. Lifted from the accidents and distractions of the context of their creation, the works illustrated in the latest *Cahiers d'Art* seemed to have a focus and a concentration missing from their own diluted existence. Now in the 'forties, both before and after the United States went to war, it was Paris, from which there was so little news, that appeared separated from the new center, where styles and personalities continued to evolve. New York had become an international artistic capital.

The predominantly Surrealist group that had arrived, international in character, "bohemian" in a self-confident, intensive fashion possible (after so many depressing years), to none of the New York artists, living *as if* they had no money worries, with at best a very different, more theoretical concern for social problems, had this in common with the artists who had experienced the WPA: they too existed on the margin of society, though it was perhaps a brighter margin, having nothing to do with those trade-union problems that bedevilled so many of the Americans. Moreover, as the latest issue of a long line of romantics, they accepted this situation as a condition of creativity, and made of it a positive virtue, so they were immediately at home – or as little at home – as they had been in Paris or in London. They carried with them a warmth of feeling, an intensity and concern for matters esthetic, a conviction of the rightness of their own judgments and an unconcern for any others. Artists of considerable reputation, they transmitted a sense of being at (or simply of being) the artistic center. This feeling, though it was not always entirely justified, was of the greatest value to the American artists who came into contact with them, teaching an entirely unfamiliar self-

confidence which external events seemed to justify. New York was at the head of the procession, there was nowhere else to look for standards or models. The conviction of the European group of the importance of art even in the midst of cataclysm, for all that it was partly expressed through annoying poses, was sincere and contagious. It was the proper accompaniment of their Surrealism, with its reliance upon the intuitive promptings of creation, and its trust in the subconscious impulse as the best artistic guide; it was a point of view that the American *avant-garde* of the time (most of them adherents of the American Abstract Artists) who based themselves upon careful post-Cubist or even more measured post-Mondrian deliberations, had not yet experienced. The antithetical attitudes of group mission and highly personal inventiveness fused in a sense of discovery and revelation that has been one of the lasting inheritances of the New York School.

Thus from strangely incompatible sources the New York artist learned to trust himself. He no longer had to look to the extra-artistic world for approval, since this was ruled out from the start; nor did he have to seek to join a distant central tradition, since this had come to him. He had learned to live with and to rely upon his own kind. And the spirit of the cenacle carried on beyond the artists' studios. The conscious attempts to transport the Paris café (Dôme or Flore) across the water of course failed, but in time its equivalent inadvertently arose in the several bars around east Eighth Street (notably the Cedar St. Tavern) and in "The Club," whose migratory, amorphous but always positive spirit has had various physical homes within the same area. It continued in the galleries too: at first at the The Art of This Century and Julien Levy's; then at Betty Parsons' and Charles Egan's (who so caught the fire of artistic intransigeance characteristic of the years from 1945 to 1955, that he himself became its best embodiment, suspicious alike of all but the most dedicated artist or potential buyer); at the Peridot and the Stable, and briefly in the Tenth Street galleries. It has been suggested that this self-reliance, this self-sufficient but gregarious existence (which for much of the time has been economic as well as esthetic) is the artists' equivalent of those professional associations in which doctors, lawyers or engineers talk to each other in a language of common assumption and connotation, that laymen find difficult to follow. However this may be, it has been one of the great strengths of the New York School, now partially dispersed by the impact of success.

This setting explains something of that sense of excitement under whose pressure the New York School first came into being and whose presence has continued to color its existence. The feeling of almost daily

discovery has marked other schools in the history of modern art, but it has rarely been present in America, which has more usually been engaged in matching what others have already invented. With it went the absorption of the Surrealists' employment of accident or chance as part of the creative attitude. Much has been made of the artist's supposed loss of control over the process of creation and his deliberate abandonment of conscious methods of work. Sympathetic critics (and often the artists themselves) have repeatedly stated or implied that the artist was simply a kind of medium through which the work brought itself into being. I believe that these factors have been overstressed, or rather that they have been given wrong emphasis. The consciousness of being on the frontier, of being ahead rather than behind, of having absolutely no models however immediate or illustrious, of being entirely and completely on one's own – this was a new and heady atmosphere.

That it was difficult to breathe at first is shown by that stage of mythological suggestion, too vague to be called subject-matter, but still deliberately present, which many artists, most notably Rothko, went through before arriving at their own styles of "abstract expressionism." Seen historically, these "signs," "pictographs" and symbolical nuclei, which tended toward the American Indian, the oriental or the generally primitive, were a sea-change on the more personal symbols of Surrealism. The Freudian reference, still present with Gorky, was now replaced by suggestions that were more generalized than truly ambiguous in the manner of the classic "paranoiac" image, with overtones that were social, or cultural, rather than psychological and often meant to bring to mind a native American past. If this was perhaps the inheritance, now transformed, of earlier depression days, it was also part of the process of increasing self-reliance that was shortly to be complete.

The brief need for the use of these symbols indicates, among other things, that independence came hard. So too in a different way does that phase of thick, reworked paint surface, heavy impasto and incrustation which for many of the older generation seems also to have been a necessary preliminary to a clear style. The pictures of this phase, most of them executed in the early 'forties and often containing the kind of symbolism just mentioned, reveal the artists' working process, the stages of development in the work, with less differentiation, less sureness and immediacy than is developed later; but the incorporation of this revelation into the final effect led toward subsequent freedoms.

The atmosphere of discovery being new to American artists, they made the most of it; but it was not new to the modern tradition. Their consciousness of it, their pleasure in it, and the theories erected around it

are proof that they really joined and led that tradition. The interaction between work and artist as the work grows under his hand (which in a broad sense began when tempera was replaced by the technique of oil), has been an integral part of the creative process at least since Redon and Gauguin; the sense that the artist adds to, rather than copies the world of nature is a central part of twentieth-century tradition. And the use of the happy accident has an even longer history. But with the exception of some "scientific" experiments of the early Surrealists (of the dream notation and "exquisite corpse" variety), the modern artist, no less than the romantic of the last century who was guided by "inspiration", has always retained control of his medium and method. The choice was his, and the "happy accident" was deliberately accepted – or rejected. This has been just as true of the New York School. Both the eulogists and the detractors who have made subconscious, unguided action its central principle have taken a part for the whole – the eulogists out of sympathetic enthusiasm, the detractors out of the shock of unfamiliar appearance. Often they have been misled by a figure of speech. The "struggle with the canvas" is a suitably intensified rephrasing of Cézanne's "inability to realize" and was similarly attributed either to technical incompetence or conversely to dedication, according to one's point of view. The wish for the appearance of accident is a continuation of Delacroix's desire to keep the insight and freshness of the first sketch. The "drip method" was (it is, I believe correct to refer to it in the past tense), precisely, a method designed to do just that. Pollock's long-arm strokes as he poured paint upon flat canvas were quick decisions ("inspirational" decisions), and in a way athletic, but they were decisions made out of long experience as to just what visual rhythms would result from the muscular feel of his motion. As such they were as artistically controlled as the more usual brush movements from the wrist or elbow. With Pollock pent-up energies were released rapidly, almost instantaneously. For the slower artist there is a deliberation on the work as it proceeds; and if, alone in his studio with that work, he chooses to personify it, and so to describe his procedure as a dialogue between himself and his work, this is but a natural projection. It remains true that at every stage the work is what he has made it.

In this way creative freedom, which involves choice, has, through a very human mixture of pride and humility, taken on the exclusive name of chance. It is not that the artist refuses responsibility for what he does (except for an occasional rhetorical protest); it is rather that this has been his way of stressing that his freedom is continuous as the work progresses, that he is bound by no one else's predetermined patterns.

Accident becomes incorporated into method. This is all the more evident since one of the other main emphases of the New York artist has been on the struggle to create, that is to say, to be the master of his intention (if one abandons onself to the arms of chance there is no struggle). Style and technique are to be kept in strict subordination; his aim as artist, rather than as craftsman painter or sculptor, is always paramount, and it is perhaps in this connection that the school's "expressionist" label is the most meaningful.

The liberation of the New York School was given an unfortunate emphasis in the term "action painting," the tag that has become best known to the public. Here was an epigrammatic description that stressed the artist's freedom as a creator, and the risks involved in a creation dependent upon continual, unprepared choices for whose outcome there are no prior guarantees. It transformed the American artist into an existentialist hero (and the post-war popularity of existentialism contributed to its success), living at a heightened level of unremitting decision, and compelled to more poignant choices than any other modern artist had ever been forced to make. The work's meaning lay not in the result, but in living the uncompromising process – or so at least went the literary refrain.

If this was an oversimplified summary, aggressive toward the public – the presumably uncomprehending public – it was sympathetic toward the artists. It gave dramatic emphasis to the American's unfamiliar and heady role of discoverer, and if it made him seem unique when he wasn't quite, this was only natural in the newness of his circumstances. If, following a bent of modern criticism that grows in part (but in part only!) from the relatively subjective nature of modern art, it failed to distinguish between process and result and between artist and subject (indeed insisted that they were identical), it called attention to the inventive, problem-solving aspects of painting and sculpture, and their materiality, hitherto largely unsuspected by both public and intellectual, and particularly appealing to the American pragmatic tradition. It was nevertheless misleading, since it suggested that the work itself was unimportant, to be examined only by philistines. As in the progressive schools, it was the *being* an artist that counted. The critics neglected to note that works continued to be finished, and preserved.

For the artists, at the time, the unspecified suggestion of political, or at least social concern contained in the word "action" had its importance. Out of their experiences in the depression and the war, and out of their contact with Surrealism, came a continuing concern for the "morality" of their art and their "total commitment" to it. But this was art without

subject-matter in the conventional sense, projecting its message by the direct impact of form and structure and their generalized associations. They wished to avoid the errors of subject-matter alone, so recently taught by the painters of the "American scene" and "social significance," and equally the errors of the calculated production of fine "objets d'art" for the public's tasteful enjoyment. They were the very conscious heirs of a century of artistic change in which every new style was a step toward truth and somehow linked with social, as well as artistic, progress. They and their art were part of this morality.

They were also, during the decade 1945–55, and especially during its first five years, a small and embattled minority, misunderstood and unappreciated. (*The Magazine of Art*, early in 1948, was the first art periodical to illustrate their works, and to praise them.) In the peculiar perspective of the time, which tended to confuse spatial and temporal distance, the sequence of styles and generations, of initial suffering and ultimate fame, was not quite clear, and in turn made unclear the role they saw themselves playing, and their relation toward a possible public.

The result of all this was that they adopted an attitude at once uncompromising and possessive. Contrary to the European artist, who, with equal integrity, has tended to dismiss the work, once finished, into a public existence having little more to do with him, the members of the New York School were at this time retentive toward their creations. They seemed to view them as extensions of themselves, whose understanding was given to few. The appreciation of others somehow compromised the work's existence, as if, after the manner of primitive belief, something of its vigor was drawn into the eye of the observer; popularity was suspect, and success (not yet achieved) a major crime. (How different the atmosphere today!) Since the artist identified with his work, intention and result were fused, and he who questioned the work, in however humble a fashion, was taken to be doubting the man.

These attitudes were a particularly intimate application of "le style c'est l'homme," and they had their consequences. In characteristic American fashion, public acceptance came with a great rush; where before the burden of proof had been upon the artist, now it lay with the spectator, and the artist was given the benefit of the doubt, if doubt there was. The enthusiasts, accepting the premise that the work was purely a mediating term between artist and observer, were now generous where before they had been hesitant, and allowed themselves to be carried along by the artist's energy and conviction. The artist's "something to say" was taken literally and the work, freighted with the burden of a precise philosophy, was too often looked through rather than at. By adopting

134 ROBERT GOLDWATER

this attitude the spectator negated the artist's great success in restoring the primacy of the visual, and the pure pleasure and power of visual effects, and obscured for himself the infectious and commanding quality which is one of the great achievements of abstract expressionism.

To make the work itself the bearer of emotion – this goal was not attained without dedication and struggle. Criticism has commonly stressed that this battle (which is a battle for control) is evident in the finished work, and that the sum-total of these works, mirroring the artist's internal combat, adds up to an atmosphere of crisis. But if for a moment one ignores intentions, looks at this art historically, as it were, from the outside rather than the inside, and allows the art to speak for itself, as it so eloquently does, it is evident that one of the principal characteristics of the New York School has been its great sensuous appeal. With certain exceptions (of whom de Kooning is the most obvious) this is a lyric, not an epic, art. The inhibiting problems of abstract freedom are many – and it may be mentioned by contrast that they have in the past helped to produce a great deal of geometric, renunciative art – whatever they are they have here been conquered in the outcome. Judged by their finished works, as they are best judged (and as they judge each other), here are artists who like the materials of their art: the texture of paint and the sweep of the brush, the contrast of color and its nuance, the plain fact of the harmonious concatenation of so much of art's underlying physical basis to be enjoyed as such. They have become fine craftsmen with all the satisfaction that a craftsman feels in the controlled manipulation of his art, and all his ability to handle his medium so that his pleasure is transmitted to the beholder.

This concentration upon sensuous substance is something new to American art: to the extent that the Abstract Expressionist is a materialist (as he has been called) and views his art as more than pure vehicle, to that extent he is not simply an Expressionist. It may be that the members of the New York School have been able to enjoy themselves and so please others because unlike the School of Paris they had no tradition of "well-made pictures" and *la belle peinture* to react against. Their "academy" was one of subject-matter, of realism and social realism, rather than the European one of clever, meaningless, manipulative skills, so that they have been able to rediscover the pleasures of paint. They have thus been able, as David Sylvester has said, "to be sensitive without being esthetic," and have "avoided a gratuitous beauty or charm without at once producing its opposite." Writers abroad have often mentioned a so-called *école du Pacifique*, a "school" which has been constructed from some few painters born on or working on the West

Coast. The implication has been of an exotic art born of a marriage of two distant cultures, and therefore of a totally different character from that of any art continuing the Western tradition. The fact is that there is no such school, but simply some painters whose forms and techniques are basically Western, but who have been influenced by a rather romantic reading of Eastern mysticism into underplaying their medium to the point of denial. This is one of the marks which distinguishes their work, characteristically pale and gentle, from the vitality and energy of the New York group, which, incidentally, like New York itself, includes artists from everywhere.

Robustiousness is the typical tone of the New York paintings. But not to the exclusion of all else. Criticism, both in the United States and in Europe, but especially abroad, has overemphasized the "unfinished" character of this art. Responding more to a preconceived notion of the untutored American than to the works themselves (compare the French image of American literature), it has singled out the sensuous aspect (sometimes in praise and sometimes in blame) as almost its unique quality. Now it is perfectly true that the sense, the feel, of the artist's handwriting is something he consciously tries to preserve. The process shines through the result (this too is good "romanticism"), and lends it freshness and impact. But whether it is the dripping paint can, the loaded brush, or the slashing palette knife that is thus consciously brought to mind in the observation of the finished work, this remains an art of harmonies as well as of contrasts. The over-all effects may be large and strong, but details are subtle and soft; there are pastel colors and graduated modulations, and the small stroke and the tiny area must be noted within the sweeping line and the frequently immense size. It can be as silent with Rothko as it is voluble with de Kooning; as brooding with Clyfford Still as it is active with Jackson Pollock; as reduced with Kline as it is exploding with Hofmann. It is an art which is as often delicate as it is powerful, and indeed in the best work is both at once.

There are several reasons (other than the myth of the Savage American) for calling attention to these visual facts. Because of its character, and the nature of its origins, the School's recent successes have brought with them new problems. For the older artists, not the least of these is how to preserve that sense of mission in the midst of hostility which was so important to the intensity of the first small group and to the integrity of its work; for the younger artists, it is how that original state of mind can be handed on in retrospect. It is undeniable that certain artists of the School (some younger, some older) have attached themselves to the

more obvious suggestions of method alone. Some, bemused by the free-wheeling talk of a few of the founding fathers, and even more by excessive philosophizing literary commentary, have been carried away by a program of ostensible complete freedom, and a presumed method of no-method; the result has been either confusion or emptiness. Others have analyzed their elders only too well and have produced works "in the manner of." Often these are initially appealing paintings, possessing, besides the construction, the brush-stroke and the palette of their models, an ease, a finish and a self-assurance missing in the originals. They are engaged in making handsome works of art which possess everything but the urgent purpose (its revolutionary morality), from which the style originally grew and which in the hands of its masters prevents it from being "style." In this they have merely acted as have followers everywhere. Because of the School's abstraction the distinction between creator and imitator is particularly hard to define; because of its expressionism its definition is essential. We are, however, finally reminded that the only valid definitions are based on the appearance of the works themselves and that it is from them that we must make our interpretative guesses of purpose and intention. Nevertheless the existence of such minor works confirms the vitality of the school as a whole; there are no followers without creative leaders.

Such leadership is not confined to the older "established" artists, nor does it depend upon a new kind of lonely existence in an ivory loft or the self-consuming heat of a cold-water flat. It must be said that there has been exaggerated insistence upon intuitive, isolated individuality, which pictures creation as a kind of narcissistic struggle that excludes both reflection and observation, and denies that we are here dealing with a group effort. But a style has indeed been created – and why not? – as the Fauves, the Cubists, the Dadaists created a style, though this [is] looser and includes more varied manners, by the incessant interplay of individual imagination, personal reflection and mutual observation. This is a month-to-month, often week-to-week, evolving process, in which the members of the group have each other's paintings and ideas under constant scrutiny. To recognize this unceasing give and take is to deny neither individuality nor creativity; on the contrary, it reaffirms both, as it reaffirms a continuing awareness of an outside world. It recognizes that there are the strong and the weak, the creators and the followers, and that as the artists themselves well know, their measure is neither success nor productivity. There are those few whose consistent individuality is heightened by the constant interchange and those more numerous who

(wittingly or more often unwittingly) succumb to the trend of the season or the year. In the locution of the artists themselves, the creative spirits are those who "have something to say."

The phrase emphasizes what is obvious, that however closely knit the artistic community, art is not produced from art alone, that the manipulation of materials, while it may occasionally be a starting point, is even, or perhaps especially, in an art largely abstract, not nearly enough by itself. But in recognizing that the artist needs "something to say," we must not distort the meaning of this description, as the device of language makes it so easy to do. The work is not transparent medium, it is, itself, what the artist has to say, and we must always come back to it. He is not merely a craftsman, neither is he merely a metaphysician; he is not simply a nature-lover (or interpreter), neither is he only an abstract composer. He is all these things at once, and to categorize his work is to impoverish öur vision of it. Except as technical device there is neither nature-into-abstraction, nor abstraction-into-nature; and where the device is not transcended there is hardly any art. Nor is there art, however abstract, which does not refer to visual, as well as to emotional experience, though it need recall no specific objects. The artist has come to speak of the work's "tension," by which he means its vitality as an organism. That arises as much from its (however generalized) relation to an outside world of shared experience (a part of which is art itself) as it does from any purely internal construction. Herein lies the richness of the work. Out of it grows the coherence and the multiple individuality of the New York School.

THE CRITICAL RECEPTION
OF ABSTRACT-EXPRESSIONISM

Max Kozloff

WHAT WE FEEL about visual works of art is in great measure conditioned by what has already been said about them. Past aesthetic responses maraud among our present artistic experiences, and are part of our cultural baggage, operating for good or evil upon our perceptions of the works themselves. The whole problem of the appropriateness and substance of those perceptions – within an intellectual continuum – was first broached in this country in the late 'forties. As a current of the modern sensibility, Abstract-Expressionism indelibly affected our civilization; as a stimulus to criticism, it marked a drama whose oppositions are so coherent as to have launched our present tradition. Incredibly complex in itself, mingling Cubist, Surrealist and Expressionist elements in a reprise of twentieth-century art, the movement demanded from its observers a largeness of spirit, broadness of reference and subtlety of vocabulary which themselves were tokens of creation. While this catalyzed attention to the nature of art, it compellingly threatened and altered the reality of the actual objects. And this too has become part of our legacy.

Perhaps the dilemma was intimated very early by some of the artists themselves. Here are two painters, prime movers of the time, voicing some of their anxiety about the consumption of their work:

> *Adolph Gottlieb*: Any conclusion can apply to any work of art.[1]
> *Mark Rothko*: A picture lives by companionship, expanding and quickening in the eyes of the sensitive observer. It dies by the same token. It is therefore a risky and unfeeling act to send it out into the world. How often must it be impaired by the eyes of the vulgar and the cruelty of the impotent who would extend their affliction universally.[2]

From *Arts Magazine*, December 1965. Reprinted by permission of Max Kozloff.

What I want to do here is to sketch and gauge this "affliction." And, conversely, to ask what kind of enduring companionship between art and criticism has resulted from the gallons of ink spilled, and the passion incited, by Abstract-Expressionism. How can the issues it raised be evaluated in the light of our present short perspective?

On the face of it, the task is multiple. There are, to begin with, two well-known branches to the New York School, roughly characterized by their active or passive physical presences, which in turn have strained the critical apparatus in two opposing directions. Secondly, within each of these branches, exemplified by Barnett Newman on the one hand and Jackson Pollock on the other, there existed a climate of ideas, a psychological and stylistic mesh, which could and did lead quite logically to mutually antagonistic conclusions. *Ambiguity*, of concept, execution, role and meaning, became a touchstone of comment as it never was before. Some of the polemics which arose, as much with us now as then, have to do with the work of art as self-expression, and as vehicle of historical consciousness; the nature of aesthetic crisis and moral content in art; and finally, overarchingly, the function and identity of criticism itself. It is a tribute to the New York School that it enormously heightened the relevance of all these questions.

In recounting the critical story in this limited space, I must omit some rather interesting facets. For example, negative opinions of Abstract-Expressionism offer revealing glimpses of the cultural condition of the 'fifties, but they also tend to be monotonous and cliché-ridden, even when they weren't uttered by unqualified writers. The substance of the arguments of such people as Herbert Read, Kenneth Clark, Ernst Gombrich, Hilton Kramer or Frank Getlein is that avant-garde painting was a regression to an impulsive, anarchic mentality, essentially alien to all pictorial order or comprehensibility. These objections were at least more topical than the rancid attacks against abstraction which were by and large inapplicable to an art often quite figurative. So brutish did the work appear that the drama critic Robert Brustein could complain that "The result is a pictorial parallel to the mumbling Method performance and the stammering San Francisco novel – an exercise in non-communication."[3] Surely, more is involved here than the offended sensibilities of literary and rationalistically minded people. There was indeed a widespread indigation, even fury, against the current of anti-art in New York painting and the claims made for it (in one quarter) as an extra-aesthetic, almost existential experience. In this respect, the sore point of negative response was the drip method of Pollock and various chance techniques

which were exaggerated and misconstrued as a total abdication of conscious will.

To go back to the beginning of Abstract-Expressionism's *critical* history, then, is to start at a point roughly around 1945. One sees two schools of thought separating themselves with remarkable distinctness, as they proceed to cut up the aesthetic turkey into white and dark meat. I am referring to the programs – one hesitates to call them merely critical observations – of Clement Greenberg and Harold Rosenberg. Greenberg stood essentially alone as a representative of the formalist point of view; Rosenberg, more philosophical and political in his approach, was seconded by the powerful aid of Thomas Hess, editor of *Art News*. The oppositions between these two camps are strong and clear, but they have been insisted upon so monotonously in recent years that a good deal of the underlying agreement between them has been obscured.

There is, to begin with, a fundamental reiteration that art must be a form of self-discovery and revelation. No matter how much a staple of the modern tradition since Manet, this principle was never more passionately articulated than in New York during the late 'forties. In retrospect, it can be seen how necessary this was in an atmosphere where the precedents were overwhelmingly European, and where the nascent identity of a number of American artists was in a fragile and uncertain state. The spectacle of a tiny group of artists, forging a coherent style in the face of great odds, enlisted the support and confirmed the dogma of politically oriented critics who could transfer their earlier left-wing dialectics to an embattled aesthetic minority. For the villain, in the view of both men, was a Philistine, implacably middle-of-the-road society, without any historical and cultural consciousness. As early as 1947, Rosenberg could say of a show which included Gottlieb, Motherwell and Baziotes that "Their nostalgia is ... for a means, a language that will formulate as exactly as possible what is *emotionally real* to them as separate persons.... Art is the country of these painters ... the standpoint for a private revolt against the materialist tradition that does surround them."[4] For his part, Greenberg believed that art is the embodiment of emotion, and of the painter's self. The painters must *find* themselves. And in his early reviews in *The Nation*, there is a tense, compassionate tone, almost in the manner of an aesthetic progress report, through which the writer oversees, as it were, the path of each artist in successive shows, to arrive finally at some ultimate distillation of his potentialities – or the defeat of those potentialities. For example, he observes of Gorky in 1946 that "On occasion he still relapses into

dependence on Miró.... Yet the chances are now that he has discovered what he is, and is willing to admit it, that Gorky will soon acquire the integral arrogance that his talent entitles him to."[5] Gorky in fact became the test case for both the writers: the formalist seeing in his eclecticism no more than an immensely gifted celebration of French taste, and the other, a sequence of impersonations that constituted his legitimate, if ironic artistic personality.

But Rosenberg was prepared to give all this a Freudian edge: "Action painting," he wrote, "has to do with self-creation or self-definition or self-transcendence; but this dissociates it from self-expression, which assumes the acceptance of the ego as it is."[6] In other words, the capacity of the artist to fulfill himself can only be achieved by some nullification or chastisement of his consciousness. While Greenberg would agree that distance has to be traveled in the process of artistic realization, arrival might symptomize the triumph of the *superego*, which is a re-created purified form of consciousness. At a certain point, the critical faculty of the artist becomes the whole pivot of activity, and it is then that a note of urgency enters the dialogue.

Common to both positions, and crucial to an understanding of the whole critical ambiance of Abstract-Expressionism, is the famous concept of *crisis* – a catchword whose potency has by no means diminished even in the present. A sense of heightened conflict or change had not been absent from occasional comment in the past – but it was hardly associated, as it is now, with the beginning and not the decline of a movement; nor was it couched in terms at once so pessimistic and exalted. Crisis, for Greenberg, has a very distinct meaning. On an everyday, practical level, he signifies by the word the public indifference to culture, the triumph of *Kitsch*, the isolation of the avant-garde and, above all, its lack of power. "The alienation of Bohemia in 19th century Paris," he writes, "was only an anticipation; it is in New York that it has been completely fulfilled."[7] Yet, from this and other statements, one gets the impression that it is the writer's own minority voice, quite as much as the artists', which is the point at issue.

On a deeper level, "crisis" was the most fitting expression of Greenberg's evolving concept of the contemporary painter's problematical relation with the tradition of modern art. For him, the decisive critical task is to sense the original *within* the continuous; and whereas past achievements must be acknowledged, nothing, by contrast, could be given to the present situation, which is viewed as a traumatic process of birth. Doubtless some of the strain that comes through in his writings of the 'forties was a result of his need to legitimize this struggle in

the light of previous struggles while conferring upon it uniqueness and an unprecedented measure of relevance. And the value by which he eventually judges at least the initial appearance of this originality is ... ugliness! It is a quality lacking in Gorky and Motherwell, but amply rewarding in Hofmann, Still and Pollock. By ugliness Greenberg means some unexpected optical awkwardness, or even grossness, without whose presence safe taste is not vanquished. Surely, here was one more realization that modern art collapses conventional distinctions between ugly and beautiful, distinctions now transferred out of the realm of the primitive and the expressionist into a play of pure forms. In point of fact, there are two considerations in Greenberg's system: first his espousal of potent ugliness as the guarantee of a successful work of art perceived as a unity, no matter how shocking; and second, his announcement of the artist's credentials – that is, his self-critical awareness of being in the mainstream of modern art.

That which fulfills the program of Greenberg under the title "ugly" is paralleled in Rosenberg's ideas by the notion of "risk" (in his famous article, "The American Action Painters," 1952). When Rosenberg says that "there is no point to an act if you already know what it contains"[8] – referring here to the creative act of the artist – he breaks down the self-knowledge of any conception which dictates execution. The whole course of picture-making is an open-minded one, whose very freedom imposes an unprecedented burden of decision. As he says:

> In terms of American tradition, the new painters stand somewhere between Christian Science and Whitman's "gangs of Cosmos." That is, between a discipline of vagueness by which one protects oneself from disturbance while keeping one's eyes open for benefits; and the discipline of the Open Road of risk that leads to the farther side of the object and the outer spaces of the consciousness.... The test of any of the new paintings is its seriousness – and the test of its seriousness is the degree to which the act on the canvas is an extension of the artist's total effort to make over his experience.... By its very nature, action painting is painting in the medium of difficulties.[8]

Or, at another point:

> ... Action painting is the abstraction of the moral element in art; its mark is moral tension in detachment from moral or aesthetic certainties; and it judges itself morally in declaring that picture to be worthless which is not the incorporation of a genuine struggle, one which could at any point have been lost.[6]

Thus, Hess also can remark of Pollock's art that it is "the turbulent process of the artist identifying his painting with himself, and then fighting to bring it out."[9] And he can say in 1951 that "de Kooning's solution has been to make the *crisis* itself the hero of his art ..."[9] Not merely are these judgments designed to elevate the feverish insecurity which the writers saw in the works and deduced from the behavior and words of the artists themselves, but to acclaim the revolutionary overthrow of a merely aesthetic attitude. "The apples," says Rosenberg, "weren't brushed off the table in order to make room for perfect relations of space and color. They had to go so that nothing would get in the way of the act of painting.... The new painting has broken down every distinction between art and life."[8] (Later Robert Rauschenberg, with considerably more justice, would claim that he himself had tried to squeeze in between the two.)

By insisting on the lack of purity in the art under discussion, Rosenberg was probably indicating its origins in many contradictory sources. But he was also welcoming its anti-art character. Yet, if the *painting* was in the medium of difficulties, so was his theory. Aside from the circumstances that there were no visual or comparative criteria by which to judge successful artistic acts, aside from the fact that creation is always a risky business, there could be no adequate explanation of how this art came into being. On one hand, the critic would like to cut off Abstract-Expressionism from the history of art, since the latter is only the record of past choices, but on the other, he is pleased to envisage the artist as a hero who has the awesome task of re-making history, and whose every step is taken in the inhibiting consciousness of such a role. Not that Rosenberg himself is interested in history in the slightest, or in its restrictions upon the possible. For him, the New York School represents a collective strike into the "Unknown" which is so far removed from its time and place as to operate on some metaphysical level of responsibility. It is never quite clear whether this revelation of the "act" signifies the end of orthodox art, or the most art-concerned (because it is exclusively self-involved) behavior on the part of the painters. Surely this is the same difficulty that besets his concept of the "tradition of the new," which is by his own definition an unstable quality doomed to repeating itself. For one cannot determine the "new" by an intellectual absolute, but only on constantly shifting comparative and empirical grounds.

Nevertheless, there were distinct attractions to Rosenberg's thesis. He was quite ready to admit, for instance, that "in turning to action, abstract art ... offers its hand to pantomime and dance," a prediction that came true, even if its author has not shown himself ready to endorse its present

implications. And certainly, there is ample recognition of such basic constituents of Abstract-Expressionism as its automatism, and its empathetic appeal. "A stroke of pigment ... 'works' within us in the same way as a bridge across the Hudson. For the unseen universe that inhabits us, an accidental blot or splash of paint may thus assume an equivalence to the profoundest happening."[8] Recently, there have been so many attacks against his celebrated conception of the canvas as an arena upon which to act (how can you hang an event? asked Mary McCarthy) that it is necessary to reclaim the care with which he restated the idea in 1957.

> If the ultimate subject matter of all art is the artist's state or tension ... that state may be represented either through the image of a thing or through an abstract sign. The innovation of Action Painting was to dispense with the *representation* of the state in favour of *enacting* it in physical movement. The action on the canvas became its own representation. This was possible because an action, being made of both the psychic and the material, is by its nature a sign – it is the trace of a movement whose beginning and character it does not in itself ever altogether reveal ... yet the action also exists as a "thing" in that it touches other things and affects them.[10]

This is a clear recognition of the ambiguity of two-dimensional art as it represents three-dimensional sensations, and of the power of an inert presence to recollect mobile forces. Although the chief illustration of Rosenberg's formulation was de Kooning, these remarks came forth in an article on Hans Hofmann.

By and large, what is most individual in the work of these two critics is their emphasis on the pressure by which works of art are created, and by which they must be felt. Both are in agreement that there is a moral element in the experience which makes up a great deal of its content. Further, they intuit and spell out a notion of crisis and struggle that marks a distinct change in the history of criticism. Rosenberg, whose interests are as much literary as artistic, seems to have arrived at his theory of action painting by grafting together ideas from Sartre, something of Dada,[11] and more conventional Expressionist notions of empathy. Greenberg, too, owes much to France, but to the lessons of the Cubists and Matisse more than French intellectual history. To this he adds an analytical zeal, rooted in sense-data, which smacks of American empiricism. (But the whole is ultimately tinctured by Idealist philosophy such as Croce's, which makes his work both self-contradictory and authoritarian.)

Actually, his overarching influence has been the example set by teachings and work of Hans Hofmann. It explains the whole tenor of

Greenberg's approach that he should have been most affected by the one painter among those in New York who had gone out of his way to discuss the sheer mechanics of art. As a German linked with Kandinsky, and committed to French aesthetics as early as Fauvism, and as an effective pedagogue, Hofmann was like a walking compendium of modern art. Essentially, he stands for an awareness of the reciprocity of all elements within the picture frame, so that one is not focused on the shape or definition of any one thing, but on how it *relates* to or is affected by its colleagues. Only in this area of relationships can meaning be effected, and high art achieved. And he carries this doctrine so thoroughly and self-consciously into his work that he is most schematic when he is trying to be most spontaneous. It is very hard after all to absolutize the relative, and Hofmann winds up by generalizing it.

In making a case for Hofmann's art, Greenberg is simultaneously at his most complex and least persuasive. He says that Hofmann's "Cubist trauma ... is responsible for the distractedness of his art in its abstract phase. Without the control of a subject in nature, he will too often impose Cubist drawing upon pictorial conceptions already complete in themselves ... yet his best pictures are precisely those in which his painterly gift, which is pre- and post-Cubist, has freest rein."[12] At other points, though, he complains of "Hofmann's illegitimately sculptural, overloaded effects, and his tendency to push a picture too far, in an old-fashioned attempt at synthesis of drawing and color." But he can also conclude that "paint is wielded with a disregard of 'construction' that represents the most inspired possession of it."[12] One might say that it was Hofmann's dualism, in addition to his working in many different styles, that elicited the critic's ambivalence; but there are other reasons that go back to his earliest writings.

Greenberg was the only serious practicing critic in the mid-'forties; he was the first to respond sympathetically to Abstract-Expressionism; he was the lone champion of Pollock for many years; and he has provided some of the most enduring judgments of the New York School – at its inception or at any other time. For dignifying the painting effort, giving it support when support was badly needed, and raising the standards of critical inquiry, his work has indebted all future writers. And yet, his own expectations were remarkably unsuited to evaluating the phenomenon with which his name is associated. One can perhaps see why in his use of that curious phrase I have already quoted, "Cubist trauma." For Greenberg, the great moment in twentieth-century Western art was 1907–10, when the space in Cubist painting oscillated between the depicted flatness of the facet-planes and an affirmation of the literal surface. Successive

developments, including "Synthetic Cubism," opted for a flat, constructional and, in his opinion, decorative solution. That was why there was such a drastic need to transcend the stultifying effects of late Cubism, to whose tenets he rather weirdly enlisted even the biomorphic Miró. In theory, a painterly reaction would have been the proper counterforce, but Greenberg had strong reservations about this in particular. In 1951, he wrote of Soutine that "his attempt to wrest from paint matter itself what other artists got from *relations* was, as far as Western tradition was concerned, utterly exotic and largely futile."[13] Hofmann, therefore, was an artist of compelling ambition in his attempt to stabilize a virulent, emotive paint-handling by Cubist structures. He magnetizes the writer by the grandeur of his theme, but also frightens him by his quasi-regressive procedures. (Even though he had to admit that the main event in postwar painting was a transition to a newer and looser notion of the easel picture.) In this respect, the "Cubist trauma" is Greenberg's own, and the theme of unrequited admiration pervades writings that wanted to change the art in question, but did not quite know how.

If we go back to Greenberg's first contacts with the emerging movement, another and just as significant resistance manifests itself. Here he is delivering himself of some characteristic doubts on the occasion of an exhibition, fittingly called "A Problem for Critics," which Howard Putzel organized in June 1945, and which included Masson, Miró, Pollock, Matta, Rothko, Gottlieb:

> Until recently abstract painting in this country and elsewhere was governed by the structural or formal or "physical" pre-occupations that are supposed to exhaust the intentions of cubism and its inheritors. Now there has come a swing back toward "poetry" and "imagination," the signs of which are the return of elements of representation, smudged contour lines, and the third dimension. Images, no longer locked to the surface in flat profile, reappear against indeterminate, atmospheric depths. Exhibited emotions give the spectator something to hang his interest on. There is nothing aesthetically wrong in this per se, but it does at this moment entail a certain return to the human, all-too-human, too obvious emotion, and academic subterfuges. The novelty and apparent importance of his subject tend to keep the artist from realizing the conventionality of his methods. Instead of exploring the means of his art in order to produce his subject matter, he will hunt about for new "ideas"; under which to cover up the failure to develop his means.[14]

Given this suspiciousness about poetry and imagination, it is no surprise that Greenberg, in December of 1947, questioned "the importance this

school (Rothko, Still and Newman) attributes to the symbolical or 'metaphysical' content of art; there is something half-baked and revivalist, in a familiar American way, about it."[15] That there were literary associations, Surrealist techniques and dramaturgical implications in Abstract-Expressionism was a fact that could be devaluated only by a man who focused entirely on one single concern. In this case, it was the "purity" of the painter's vision, as he ostensibly purged his art of all elements foreign to the theory of abstract relations.

A recurring phrase in Greenberg's work of the time is the proviso that anything can be art *if it works*, giving us to understand how precious little he himself would consider the area in which a new picture could "work." There was something irreversible – although never explicitly designated – about the course painting was supposed to be taking. Eventually, this began to be formulated in broad terms as a systematic renunciation – first of extra-pictorial concepts, but more importantly, of the formal devices, such as shading, which stood in the way of a post-Cubist style. It was therefore possible for him to stigmatize facility and painterly brio as impeding modernist "progress." Now the painters themselves – especially Gottlieb and Kline – were arguing against the same thing, but more through their love–hate relationship with the European tradition (which seems to have been more or less endemic) than through any dialectic about future necessities. One of the distinctions that Greenberg makes is between great *painters*, who are, of course, admirable people, and great *artists*, who win his real loyalty. In the end, he is able to decide that true spontaneity is solely a matter of conception, and he stigmatizes, as conventional and passé slickness, the virtuosity which distinguished most of the New York School painters and was so intimately bound up with what they wanted to do. Pollock is exempted from this judgment because "his bad taste is in reality simply his willingness to be ugly in terms of contemporary taste."[16] But after 1950, de Kooning is seen as regressing back into a hopeless attempt to establish a European grand manner. (And with him, of course, all those that he has influenced.) Greenberg's ultimate designation of Rothko and especially Newman as the harbingers of the future is logical in terms of his own propensities, as well as correct as historical prognosis. And even if they weren't the only progenitors of a post-Cubist style (the whole School might be said to have worked toward that), and even if Newman's transcendence of the geometric cannot be linked with Impressionism, they are given the importance which future developments have borne out.

Thomas Hess's 1951 book, *Abstract Painting: Background and American Phase*, cannot be said to have exerted an influence comparable

to the articles of his colleagues. It was the earliest book on the subject, however, and, as its title indicates, it was a flattering and quite justified attempt to identify and legitimize Abstract-Expressionism as part of its great European past. Hess emphasizes the confluence of abstraction and Expressionism as the chief trait of contemporary American painting. And he is at pains to underline its complex metaphorical vision of landscape, and cityscape. In addition to being sensitive to the special qualities of environment that it evokes, he wishes to illuminate the ambiguity he thinks is a factor of the whole style. On de Kooning, his particular hero, he frequently has perceptive things to say: "Each unit of the picture insistently refuses to surrender either its action through imagined space, or its emphatic adherence to the plane of the surface; either its freedom in a completely bounded, curving contour, or its weight as a matter-filled body."[9] But his interest in how one experiences the work kinesthetically led him either to repetition of the obvious or fanciful similes whose humanism strikes too dramatic a note. De Kooning's contribution is "his ability to give pulse and motion to the unrecognizable, to endow the abstract form with tragedy or laughter, and on its own terms."[9] He concludes, with Picasso, that there is no such thing as abstract art, and agrees with Rosenberg on the fundamental conception of criticism.

Here, then, are the lines of the great argument, as put forth by their most forceful representatives. Greenberg's comment is essentially compressive, Procrustean: lopping off those qualities of the art which didn't fit into his field of vision. Rosenberg's program is so elastic that it might improperly apply to any visual interpretation. In this sense, Rosenberg bears out Gottlieb's remark about the possibility of any conclusion, while Greenberg, for his part, devotes himself to paring away from his conclusions anything that might be considered an affliction of the vulgar – in Rothko's sense – if not the cruel. There are technical problems that still remain to be treated adequately, such as the definition of space in much of the work, and the complexities of color, that criticism is still no closer to dealing with today (although Hess is particularly good on de Kooning's color). But the more resounding difficulties of each position have to do with limitations of intellectual stance.

There is no provision in Greenberg's ideology for translating analysis into some record of feeling; indeed the absence of any connection between the two repeats the same failing of the work of Dr. Barnes earlier, and of formalist criticism in general. It is hard to accept the apprehension of two forms working together in space as an account of an emotional experience, that is, of the final, aesthetic end of the work. On the other hand, one never gets the impression that his fascination for personalities

and philosophical schemes has ever led Rosenberg to examine individual pictures, or that they exist for any other purpose than to illustrate a rhetorical field theory. Far from being a call to engagement, his criticism removes him to that role of stranger which he once decried. Paradoxically, neither man possesses enough detachment to let the work enter fully into his responses as the product of a sensibility different from his own. For all their verbal recognition of his individuality, they are not prepared to tolerate the "otherness" of the artist. And this is why their account of the Abstract-Expressionist personality rings so falsely. Greenberg, with his hostility toward Surrealism, does not even mention Pollock's revolutionary drip method in the latter's 1949 show;[16] and Rosenberg does not see in such automatist procedures impersonalized means to stimulate the personal. The whole correspondence between the mode of feeling, as symptomized by the effect of the canvas, and the supposed inner state of the artist is therefore misrepresented. Often enough, there is no such correspondence, and the Expressionist fallacy that posited an internal anguish and "tension" in the creator was just as wide of the mark as the formalist stricture that ignored its conventionalized content in the work.

Yet, after noting these deficiencies, one is re-impressed by the intensity with which a significant art was followed and upheld during the period of its inception and through its point of maximum vitality. Other critics have since appeared on the scene – William Rubin, Lawrence Alloway, William Seitz, Leo Steinberg, Sam Hunter and Meyer Schapiro – who have done much to synthesize the various cross currents of response and bring to them welcome shades of cultural sophistication. They have minimized some of the earlier mistakes. But the point of freshest human impact of fullest combat had been passed, to be remembered mainly in some of the most vivid partisan writing in the history of criticism.

Notes

1. Adolph Gottlieb, "Artists' Sessions at Studio 35" (1950), in *Modern Artists in America*, New York, 1951.

2. Mark Rothko, *The Tiger's Eye*, No. 2, December 1947.

3. Robert Brustein, "The Cult of Unthink," *Horizon*, Vol. 1, No. 1, September 1958.

4. Harold Rosenberg, "Introduction to Six American Artists," *Possibilities*, No. 1, Winter 1947–48.

5. Clement Greenberg, *The Nation*, May 4, 1946.

6. Harold Rosenberg, "A Dialogue with Thomas B. Hess," catalogue of the exhibition "Action Painting," March 5—April 13, 1958, The Dallas Museum for Contemporary Arts.

7. Clement Greenberg, "The Situation at the Moment," *Partisan Review*, Vol. 15, No. 1, January 1948.

8. Harold Rosenberg, "The American Action Painters" (revised), in *The Tradition of the New*, New York, 1959.

9. Thomas B. Hess, *Abstract Painting: Background and American Phase*, New York, 1951.

10. Harold Rosenberg, "Hans Hofmann: Nature in Action," *Art News*, May 1957.

11. Recently a source has been suggested by Robert Motherwell for the concept of action painting: "At that time [the mid-forties], I was editing 'Dada' proofs of Hulsenbeck's which ultimately appeared in the Dada anthology as 'En Avant Dada.' ... Harold came across the passage in proofs in which Hulsenbeck violently attacks literary aesthetes, and says that literature should be action, should be made with a gun in the hand.... Harold's notion of 'action' derives directly from that piece." "An Interview with Robert Motherwell," *Artforum*, Vol. IV, September 1965.

12. Clement Greenberg, *Hans Hofmann*, Paris, 1961.

13. Clement Greenberg, "Soutine" (1951), *Art and Culture*, Boston, 1961.

14. Clement Greenberg, *The Nation*, June 9, 1945.

15. Clement Greenberg, *The Nation*, December 6, 1947.

16. Clement Greenberg, *The Nation*, February 19, 1949. Though, in fairness, it should be pointed out that Greenberg considered the name "drip" inaccurate and wanted to substitute for it "pouring and spattering." Hofmann is given earliest credit for this method, but the implications of Pollock's extreme exploration of it are left undiscussed.

RE-EVALUATING
ABSTRACT EXPRESSIONISM

Gregory Battcock

EVERYBODY HAS BEEN COMPLAINING about Henry Geldzahler's *New York Painting and Sculpture: 1940–1970* but few have taken issue with the aesthetic claims revealed in these paintings that represent two decades of Abstract Expressionist art. Instead, most critics have confined their remarks to the anthology's table of contents; they have, especially, bemoaned the absence of one artist or another.

The New York Times' critic did attempt to direct his evaluation of the exhibition to the larger historical issues involved but his accusation that Henry Geldzahler imposed a "... fixed historical shape and a fixed order of significance on a period of art history ..." is tautological, if not, when examined under different light, encomium. The *Times'* reviewer moves rapidly from grand historical accusations to trifling queries concerning omissions and the "... exact nature of the critical criteria ... employed...."

Geldzahler's introductory essay to the catalog is not exactly a major document in the history of art criticism but it does serve to delimit the curator's intentions: "The Metropolitan Museum's Centennial celebration has created the opportunity to see the shape of our recent tradition."

In light of the exhibition I should like to consider some problems that have, perhaps only recently, emerged from the lower depths of the Abstract Expressionist aesthetic. The exhibition has given the opportunity to see the shape of our recent tradition and, upon close examination, that shape may not be nearly as noble and honorable as many have claimed.

I agree with Harold Rosenberg's assertion which appears elsewhere in the catalog that: "What makes any definition of a movement in art dubious is that it never fits the deepest artists in the movement...." Rather than attempt another definition of Abstract Expressionism, I will

From *Arts Magazine*, December 1969–January 1970.

begin by outlining some of the more readable characteristics of the movement. They include (from Pollock and Frankenthaler) innovations concerning the way in which the materials themselves are put together. The Abstract Expressionists learned to apply paint to the canvas in a variety of ways, other than direct application with an ordinary brush. Paint was dripped, stained, poured, thrown and smeared onto the canvas.

A second characteristic is the peculiar reduction, in paint, not of depth, but of point of view. The viewer is, in a sense, liberated from the tyranny of point of view and within a very limited range he is free to interpret as he will. The fact that many Abstract Expressionist paintings could be mistakenly hung upside down is proof. Indeed, in the exhibition's catalog, at least one Abstract Expressionist picture is printed upside down. Freedom from viewpoint resulted in another freedom. The Abstract Expressionists joined their creative colleagues in the other arts to reduce their reliance upon formal narrative sequences and upon literary allusion.

Probably the most important feature is seen in the new involvement by both painter and viewer with the procedures and materials of painting itself. This characteristic is perhaps the most representative of the typically Existentialist aesthetic that fathered all authentic artistic activity of the 1940s and 1950s.

The fact is that many Abstract Expressionist artistic developments were considered, by many contemporary critics, legitimate and vital contributions toward the development of a viable visual language for a time that was badly in need of one. Existentialist man questioned his psychological and sociological conditions and detected hypocrisy, incongruity and antinomy therein. The artist of the period was engaged in a re-evaluation of aesthetic expectations and found numerous aesthetic conventions in need of revision.

As a result, the artist required a direct confrontation with the materials and processes of painting itself – a reasonable artistic endeavor and an essential aesthetic decision. Beginning in the 40s and continuing throughout the 50s, many people working in other fields were concerned with a re-examination of the environment and the identification of persons, object and roles found therein. The painter of the period illustrated within his paintings his infatuation with the objective paraphernalia of painting itself.

The Abstract Expressionists did not shy from direct confrontations with Existentialist philosophic development of the period. They knew that scientific methods alone could insure the authenticity of anything other than the HERE and the NOW. Little was known about painting itself.

A painting is paint and canvas, and perhaps color. So what about it? What does it matter? It matters little unless we are able to witness the interaction between the known factors, between the paint and the canvas. It was inevitable that artists of the period would provide an art style that illustrated the existential confrontation between determinable factors in a clear, factual way.

It is this aspect of Abstract Expressionist painting that is emphasized in Henry Geldzahler's show, and rightly so. Abstract Expressionist painting is seen as an unavoidable development conditioned by the harsh necessities of Existentialist philosophic realizations and their resultant demands. The result is a logical, realistic and necessary art style of huge empty spaces, blobs of paint, stretches of bare canvas, drips, smears, open forms, running paint and transparent overlays; and they all became part of a visual lexicon that served to illustrate the facts in the art of painting. "Letters in art are letters," wrote Ad Reinhardt. Other Abstract Expressionist painters referred to their paintings as: "it is."

Today we are much more likely to say: "Lettuce in art is lettuce." Instead of "it is" we are more likely to ask: "So what?"

"So what?" is one question that Abstract Expressionism cannot easily answer. In 1952 Harold Rosenberg wrote: ". . . the Vanguard artist has an audience of nobody."

According to today's needs, definitions, expectations and questions, Abstract Expressionism appears to have been a big to-do about very little indeed. It is to the credit of Henry Geldzahler that he did not attempt to inject a meaning to Abstract Expressionism that was not originally intended. It is true that some contemporary critics viewed Abstract Expressionism in much the same way today's critics view the new Anti-Art school. Harold Rosenberg wrote: "The new painting has broken down every distinction between art and life." However, it is clear now that there are enormous differences between the two schools. The main difference is one of broad social commitment – a quality noticeably lacking in the "let them eat cake" aesthetic of Abstract Expressionism. Despite claims to the contrary, the mainstream art of the 1940s and 1950s remains a critic's art rather than an art of rebellion. Today art criticism is still suffering from the phantasmagoric outpouring of critical debris from the earlier period.

To this day, only critics read art criticism – everybody else has been burned once too often by the purple prose of art critics determined to give meaning to a few Existentialist blobs of red paint or to a couple of stripes.

If Abstract Expressionist painting succeeded in knocking out criticism,

it was even more successful in convincing the art public that there was nothing for them in art. They went right back to Doris Day and Mantovani with the comfortable feeling that they were missing nothing. The typical sensibility that had been carefully cultivated to believe in beauty, justice and the flag – the virtues upon which all values thrived and upon which morality and logic prospered – was in no condition to get anything out of a color field. The Abstract Expressionists, who had failed at significantly awakening the national consciousness with the social illustrations they were painting during the 30s, had become accustomed to working without benefit of an appreciative audience. They were convinced of their inability to deeply arouse a sense of national indignation and to create an environment of moral inquiry.

Thus, for them it was easy to get along without the expectation of ultimately attracting a broad audience. Why not concentrate upon the extravagant details of deliciously refined philosophical speculation and their resultant aesthetic realizations? They threw manners to the wind and catered to those confident, well-fed sensibilities that could get around without the burden of good conduct. Such sensibilities belonged to the rich and the brilliant and not, certainly, to the middle classes.

Such is the art that is admirably illustrated in Henry Geldzahler's anthology of visual documents at the Metropolitan Museum. It is an art style of extravagance: of waste, emptiness and exquisite sensual stimulation. It has little to do with anything of consequence and, amazingly enough, is all the more impressive because of its vacuity. Abstract Expressionism is viewed as an outrageous abdication, by the artist, of his traditional commitments. Like the *Capriccio* and *Veduta* painter of 18th century Venice, the mid-20th century New York Abstract Expressionist turned his back upon the prevailing moral, social, cultural and ethical crises of a society hell-bent upon its own destruction. The enormous unsolvable problems of today had their fruition in the 50s. The artists of the period gave us beautiful smudges of black oil paint, jagged fields of orange, drips of brown and green, etc.

Henry Geldzahler has offered no apology for the artist who has rejected the demands made upon him by a crumbling society. Instead, he *emphasizes* it and concentrates on just those artists who were most arrogant and abusive to their social reality. That is why there is no Marisol, or Nevelson, nor any black artists' work. He has spotlighted the decadence, glamour, romanticism, poetry and arrogance of the Abstract Expressionists, which is at once exhilarating and frightening.

The exhibition consists, however, of more than Abstract Expressionists. Minimal artists have been included, who are most representative of

what the movement was all about. They represent an attempt to bring sanity and purpose back to art. Minimal art, itself, was not a particularly astonishing example of a popular, committed and socially responsible art but it was a necessary step for art in its return to earth.

RESIDUAL SIGN SYSTEMS IN ABSTRACT EXPRESSIONISM

Lawrence Alloway

APROBLEM that reciprocally involved both subject matter and formality engaged the Abstract Expressionist painters of the middle and late forties. It was how to make paintings that would be powerful signifiers, and this led to decisions as to what signifiers could be properly referred to without compromising (too much) the flatness of the picture plane. The desire for a momentous content was constricted by the spatial requirement of flatness and by the historically influenced need to avoid direct citation of objects. Something of this train of thought can be seen in Barnett Newman's reflections on the role of the hero image in sculpture. He pointed out that the heroic was no longer directly available to the sculptor and hence, though he does not say so, to the painter. Therefore, he argued, the human gesture, freed of anatomy, could be used to signify the human presence.

> Herbert Ferber, by removing this mock hero, has reevoked the naked heroic gesture. Hanging his powerful line on and over pure space, he has succeeded in freeing himself from this hero, so that the gestures of his images move in free splendor, thus enabling each of us to fill the open masses with our bulky selves to become our own personal heroes. Ferber's skeletal line, by the majesty of its abstract freedom, touches the heroic base of each man's own nature.[1]

There is some reason to think, if one considers Ferber's naive sculpture of the period, that Newman is doing the best he can for a friend and that perhaps the real subject is Newman's own work. Certainly in his paintings the bands of color seem to have a comparable symbolic function, indicating in terms of verticality the basic human posture. In addition, an important group of large paintings includes bands that are

literally close to human scale. The term "gestural" is commonly applied to Abstract Expressionism with reference to conspicuous brushwork, but the term is also applicable to those of Newman's paintings in which the whole work has a gestural function. The tall lines and the man-sized area are a kind of gestural condensation of "the naked heroic gesture."

In 1948 Newman wrote: "we are freeing ourselves of the impediments of memory, association, nostalgia, legend, myth, and what have you, that have been the devices of Western European painting."[2] In later statements Rothko and Still confirmed the renunciatory mode. Rothko rejected "memory, history, or geometry,"[3] and Still dismissed "outworn myths and contemporary alibis."[4] Common to these three artists in the late forties is, therefore, an idea of art as the outcome of essentializing doctrine: art is what is left when surface detail and secondary ideas have been scraped away. These statements have been taken pretty much at face value, but actually there is more to be said.

For instance, it is notable that the renunciations demanded have a definite cultural context. Newman wrote: "that here in America, some of us, free from the weight of European culture, are finding the answer by completely denying that art has any concern with the problem of beauty and where to find it."[5] This can be compared to Still's statement: "the fog has been thickened, not lifted, by those who, out of weakness or for positions of power, looked back to the Old World for means to extend their authority in this newer land."[6] These statements clearly set the renunciations of the artist into the traditional contrast of two continents, which originated in the 19th century as part of the attempt to encourage national arts in America. The typology includes contrasts of dedication (America) and exhaustion (Europe), vitality and elegance, honesty and learning. As Benjamin T. Spencer has pointed out, when writing about America, "Emerson resorted to metaphors which implied primal energies rather than mature ideologies," such as "a colossal youth" or a "brood of Titans."[7] It is significant that the claim to be free of the (European) past should be argued in terms of a 19th-century (American) idea.

What is the meaning of this old defense of newness? It relates to a dominant theme of Newman's early writing, namely, the connection between primitive art and American art. In 1944 he wrote about Pre-Columbian stone carving and on "The Arts of the South Seas" exhibition at The Museum of Modern Art.[8] In each case Newman takes a primitive art form that is associated with America, or is at least non-European. In addition, he takes early, if not the first, artists and discusses their work as part of "the metaphysical pattern of life."[9] Contemporaneously with his Indian and Pacific pieces, he applied notions derived from primitive art

to the work of his contemporaries. In the catalogue *The Ideographic Picture*, he defines "a new force in American painting that is the modern counterpart of the primitive art impulse."[10] Of the eight artists in the show, four were Newman, Ad Reinhardt, Rothko, and Still. (Americanness here is identified with primal energies and should not be confused with the later artist-as-coonskinner image of Harold Rosenberg which trivialized the theme of national identity.) The exhibition that followed "The Ideographic Picture" at Betty Parsons' Gallery was by Theodoros Stamos, and again Newman wrote the catalog.

> Stamos is on the same fundamental ground as the primitive artist who never portrayed the phenomenon as an object of romance and sentiment, but always as an expression of the original noumenistic mystery in which rock and man are equal. Stamos is able, therefore, to catch not only the glow of an object in all its splendor but its inner life with all its dramatic implications of terror and mystery.[11]

Thus, America is both newer than Europe and older: to the extent that it is newer it is free from a late culture's habits of elaboration and attenuation; but it is older because artists have not lost their access to primal (i.e., young) energies and intuitions. These ideas, securely based on 19th-century precedents, suggest that the tablet of the Abstract Expressionists had not been wiped as clear as was supposed. A similar situation exists in these artists' treatment of mythology. As early as 1943 Rothko stated: "if our titles recall the known myths of antiquity, we have used them again because they are the eternal symbols upon which we must fall back to express basic psychological ideas."[12] And, again, "we seek the primeval and atavistic roots of the idea rather than their graceful classical version," renewing in oneself "the primeval and predatory passions from which these myths spring."[13] On the same occasion, Gottlieb said that he was aware of "denying modern art" by placing "so much emphasis on subject matter" but "the mechanics of picture making has been carried far enough."[14] (At the time of the broadcast at which they spoke Gottlieb was in the third year of his pictographic period.)

Four years later, Clement Greenberg wrote, apropos of the pictographs: "Gottlieb is perhaps the leading exponent of a new indigenous school of symbolism which includes among others Mark Rothko, Clyfford Still, and Barnett Benedict Newman."[15] Here then are several open avowals of the mythology that marked one group of Abstract Expressionists in the forties before it was subsumed into less explicit forms. Gottlieb's "denial of modern art" as a formal system has the same basis as Newman's

polemic against geometry. Writing in 1958, he declared: "Only an art free from any kind of the geometry principles of World War I, only an art of no-geometry can be a new beginning."[16] What he was after, for himself and on behalf of American painters, was "a new image based on new principles.... It is precisely this death image, the grip of geometry that has to be confronted."[17] Malevich is expressly mentioned as representative of the limits that American artists, strengthened by their primitive roots, had to transcend.

Greenberg's description, though he soon dropped it, of New York painting as "a new indigenous school of symbolism" is very much to the point. Abstract Expressionism achieved a new alignment of the existing styles of modern art and found a way of painting that maintained flatness without any diminishment of signification. If it is not evident from the art, though I believe it is, there is ample verbal evidence in the written and recorded statements of the artists of their conviction that art was a projection of their humanity. Art's value was to be derived from its success in embodying great thoughts and enduring themes. However, the sententious aspect of Abstract Expressionism was gradually lost sight of and as early as 1959 E. C. Goossen, referring to Gottlieb, discussed "how then to keep the physical presence of the painted surface alive, sensually immediate and materially present, while wielding the immateriality and illusion of space behind it."[18] This expressed well the pictorial problem of reconciling the picture plane with the spatial implications of color, but it confers prime value on this matter. What has happened is that Gottlieb is being interpreted in terms of "the mechanics of picture making." It is true that by this time Gottlieb was out of his pictographs, so that the evocation of universal patterns and motifs was reduced. Beyond this, however, Goossen's language is typical of the estheticizing analysis of Greenberg himself, whom Goossen is following, and the later writing of William Rubin and Michael Fried.

Goossen's stress on syntax at the expense of signification reveals a bias that characterizes American criticism at large. As the imagery of the myth-makers became flatter and larger, with fewer internal episodes, the level of symbolism was less and less discussed. What had been an antiabstract art was turned into another kind of abstract art, but one with a coloristic rather than a geometric base. The abstract potential of Newman, Rothko, and Still was exaggerated at the expense of other readings, including connections between their earlier and later work. It is crucial to remember in this respect that these three artists were late starters; though they began weakly, their early work is far from being student work. It may be clumsy, but it is not empty or uninformed.

Newman's and Rothko's biomorphic imagery and Still's troglodytic imagery, for example, were the product of men who had reached their forties. Though there are real morphological changes in their work of the late 1940s, the Abstract Expressionists can hardly be expected to have started entirely anew at that time of their lives. As suggested above, even the topic of renewal by renunciation should not be taken literally but as a cultural reflex. Thus the tendency of criticism to concentrate exclusively on the later work has led to a neglect of its sources. The problem to consider is whether the reductive mode, initiated in New York 1947–50, necessarily acts to exclude meanings or whether the declared concerns of the early forties may not persist in condensed and elliptical forms.

Newman wrote his article on the Sublime in the same year that he painted the first and second pictures called *Onement*. The verbal and pictorial statements coincide exactly, but not all the ideas in the article have their origin at that moment. Aspects of Newman's primitivism are certainly carried into this fresh context. Similarly with Still, the chronology of his work is obscure but it is at least clear that he had painted numerous fully characteristic paintings by 1952 when he made the rejective statement quoted above. Rothko's statement dates from 1949, the year in which he established his mature format of stacked edge-to-edge forms, but the original article in *The Tiger's Eye* is not illustrated by such work. The accompanying illustrations show patchy, free-form paintings, with internal incidents and vertical divisions as well as horizontal.[19] The announced rejection of "memory, history, or geometry" therefore does not necessarily entail the high level of unity of the mature work as has been assumed.

It is possible that the stress on renunciation may have been intended to cool some of the more ardent of the mythological references, but, in fact, this could only be a secondary motive. The subjects of renunciation and rebirth have their iconographical value, as in a text Rothko wrote for Still's first exhibition in New York in 1946:

> It is significant that Still, working out West, and alone, has arrived at pictorial conclusions so allied to those of the small band of Myth Makers who have emerged here during the war. The fact that his is a completely new facet of this idea, using unprecedented forms and completely personal methods, attests further to the vitality of this movement.
>
> By passing the current preoccupation with genre and the nuances of formal arrangements, Still expresses the tragic-religious drama which is generic to all Myths at all times, no matter where they occur. He is creating new counterparts to replace the old mythological hybrids who have lost their

pertinence in the intervening centuries. For me, Still's pictorial dramas are an extension of the Greek Persephone Myth. As he himself has expressed it his paintings are "of the Earth, the Damned, and of the Recreated."

Every shape becomes an organic entity, inviting the multiplicity of associations inherent in all living things. To me they form a theogony of the most elementary consciousness, hardly aware of itself before the will to live – a profound and moving experience.[20]

As the paintings of Newman, Rothko, and Still became simpler in format they did not lose in complexity of content. Although various elements were dispensed with, what remained was a great deal more than nothing. The parts that they kept were, in fact, maximized and presented emphatically. The more art is simplified the more potent what is kept can become; this is obvious but the rhetoric of 20th-century art gives more prestige to the act of giving up than holding on. What characterizes the work of the Abstract Expressionists from the late forties on is precisely the significative magnitude of their austerities. I am connecting early texts with later paintings not to circumscribe the paintings by a genetic theory but because I know of no better way to account for their special resonance. If we compare paintings by Frank Stella and Ellsworth Kelly with those of the Abstract Expressionists, it becomes evident that a dimension of allusion, an aura of content, has been suspended by the later artists. They certainly take off from positions given by Newman and Rothko, but the field of color, the holistic imagery, and the expanded scale of the canvas no longer imply momentous content. The allusions of the Expressionists are not present simply because of the intensity of the older artists' feelings compared to the reduced passion of the younger generation; the allusions are present as a set of specific cues, to which Newman's Sublime text is one basic source.[21]

In the 18th century the Sublime was an additional esthetic category, as was the Picturesque; both were added to the existing criterion of Beauty in recognition of the expanded awareness of the period. Similarly in the 1940s, the Sublime was regarded as an addition to European "modern art" in which geometry was (unfairly) equated with what is known and measurable. In both its 18th- and 20th-century usages Sublimity was an index of the expansion of esthetic limits. Some of the formal properties described by Edmund Burke, to take his *Philosophical Enquiry Into the Origin of Our Ideas of the Sublime and the Beautiful* as a summarizing text, fit American painting very well.

On "Uniformity" as a cause of the Sublime Burke writes:

if the figures of the parts should be changed, the imagination at every change finds a check; you are presented at every alteration with the termination of one idea, and the beginning of another; by which means it becomes impossible to continue that uninterrupted progression which alone can stamp on bounded objects the character of infinity.[22]

Appropriate to the Sublime, according to Burke, are "sad, fuscous colors, as black, or brown, or deep purple."[23] Rothko's mulberry paintings or Still's black ones come to mind, as well as Newman's observation on "the revived use of the color brown ... from the rich tones of orange to the lowest octave of dark browns,"[24] colors that connote the "majestic strength of our ties to the earth."[25] The concept of "artificial infinity" as symbolized by uninflected works and color in a somber range does not exhaust the correspondences between the Sublime esthetic and American painting. Burke observed that "extreme light ... obliterates all objects, so as in its effects to resemble darkness,"[26] which is a better way of describing the effect of a dark painting by Rothko than most of his critics have arrived at. And, of course, light itself is part of an expressive tradition that includes the paradox of dark in light described by Burke and radiance as an image of revelation. Rothko's avoidance of complementary colors and of black-and-white tonal contrasts gives his paintings an other-worldly look, raising Neo-Platonic memories of light as the energy of the Creator. Burke also considered as a source of Sublimity the effect on the spectator's mind of being dominated by an immense object. This can be related to Newman's statement, "the large pictures in this exhibition are intended to be seen from a short distance."[27] Finally, Sublimity, as defined originally by Longinus, was regarded as "the echo of a noble mind."[28] That is to say the Sublime is not reached by rule; it is a projection of the artist which is not equated with emotional self-expression, a view that accords well with the Abstract Expressionist self-image of the artist's role in the world.

It is significant that of the Abstract-Expressionist generation, it is the three artists we are concerned with here who have entertained environmental ambitions. Pollock in 1947 may have opened the way with his version of the death-of-easel-painting topic which led him to propose paintings halfway between easel and wall.[29] Rothko painted three groups: the first done in 1958–59 for the Four Seasons Restaurant and now in the Tate Gallery; the Harvard murals, 1961–62; and the Rothko Chapel, as it is called, painted 1966–68. Newman painted *The Stations of the Cross*, 1958–66. Still has not done any ensembles like these but

his exhibitions (Buffalo, 1959; Philadelphia, 1963) are constructed units. Still has written:

> These works are a series of acts best comprehended in groups or as a continuity. Except as a created revelation, a new experience, they are without value. It is my desire that they be kept in groups as much as possible and remain so . . . So I am in the strange position of seeking an environment for the work, and the small means wherein I'll be free to continue the "act."[30]

He was referring to an exhibition at the Parsons Gallery when he wrote, but clearly he had in mind cross-referential sequences on larger than gallery scale. These unitary schemes imply content by format, thus ascribing an expressive function to the environmental display itself. For instance, in the Rothko Chapel there are three triptychs, a form of picture with unbreakable associations to Christian art, and to number symbolism. The paintings of *The Stations of the Cross* are not decodable as specific episodes in Christ's Passion, but they do as a total of 14 contiguous works, allude to the event as a whole. Incidentally there are 14 paintings in the Rothko Chapel (the three triptychs and five singles) and at one point Rothko contemplated indicating their location on the outside of the Chapel by numbers, a clear reference to *The Stations*.[31]

Reviewing a Rothko exhibition in 1961, Robert Goldwater singled out for praise "the small chapel-like room in which have been hung three of the mural series of 1958–59."[32] Later Rothko really painted a chapel: it was first announced as a Roman Catholic chapel for St. Thomas University; subsequent plans changed it to an interdenominational chapel at Rice University; it ended up attached to the Institute of Religion and Human Development, a part of the Texas Medical Center. The Institute combines ecumenical religious and interdisciplinary studies with good works (hospital training and family counseling). The Chapel bears neither the name of the donors (the John de Menils) nor that of a saint: it is named for the artist, as if the Sistine Chapel were to be called the Michaelangelo Chapel. In Newman's *The Stations* the number 14 is a symbol as well as a reckoning and there is in addition a sequential pattern. The first six and the Eighth Stations are more related to each other than to the Seventh; the Ninth, Tenth, and Eleventh are white; the Twelfth and Thirteenth are mainly black; and the last is the whitest. The order of *The Stations* is the chronological order in which they were painted, suggesting that the subject is not only the biblical event but the artist himself. The Christian hero and the artist as hero are related as type

and antitype in the Testaments, a view of *The Stations* that fits both specific comments by the artist and his exalted notion of the role of the artist. Newman reasoned that

> the first pilgrims walked the Via Dolorosa to identify them-
> selves with the original moment, not to reduce it to pious
> legend; not even to worship the story of one man and his
> agony, but to stand witness to the story of each man's agony;
> the agony that is single, constant, unrelenting, willed – world
> without end.[33]

It is Christ's connection to mankind that Newman stresses. As to Newman's expectations of the artist, the prime text is his early article, "The First Man Was an Artist": "Speech was a poetic outcry rather than a demand for communication. Original man, shouting his consonants, did so in yells of awe and anger at his tragic state, at his own self-awareness and at his helplessness before the void."[34] The artist for Newman is one who renews man's original act of defiance. In *The Stations* and in the Rothko Chapel what has happened is that the traditional iconography and layout of Christian art have been usurped by purely artistic values. By this I do not mean an estheticization of religious art so much as an assertion of the heroic stance of the artist within the traditional themes. In Rothko's case, a certain religiosity is also present which emotionally repeats the motive of the domination of culture by the artist.

The topics that contributed to Abstract Expressionism include mytho-logy, biomorphism, and the heroic state of being an artist. This cluster is often given schematically in the early works, but developed and fused in the later works of Newman, Rothko, and Still. It should perhaps be pointed out that the recognition of a genetic unity in a group does not eliminate the members' empirical diversity as artists, as men. These artists had in common an avoidance of the basically naturalistic accep-tance of the world as it comes that marks de Kooning's and Kline's art. The high claims made on behalf of art by Newman, Rothko, and Still are the outcome of personal experience and of a traditional view of the function of art. Art does not reflect life nor is it separated from society, it is conceived as a model of behavior; it has an exemplary moral function. The art of the Sublime painters, or the field painters, is decidedly an art for the educated, both in terms of the social responsibility of being an artist and in terms of the issues to be dealt with as subject matter.

In the use of ideographs and pictographs the artists showed a con-scious recognition of the long-term potency of linguistic systems. Signs have a certain persistency that elongates their usage far past their original

communication situation. There are many signs learned in our culture and assumed to be almost natural owing to absorption and repetition. These reinforced systems carry meanings and values that we have forgotten learning, as one forgets having had to learn one's first language. In American art of the forties and fifties these residues of earlier doctrines and ideas included mixed organic imagery,[35] an inventory of information systems (such as ideographs), and a rediscovery of the expressive power of size. It is notable that scale is not present as a factor in earlier 20th-century painting, though it entered esthetics in the 18th century. Color, too, in its revelatory aspect, reentered painting, drawn from popular association with religious visions and mysterious light sources. There was, of course, nothing popular about the way this color symbolism was used by the artists, who subjected it to a searching and original reorganization. The presence of these available, historically rooted residues is essential to the continuity of culture. One of the ways in which the artists discussed here are unlike de Kooning and Kline is the fact that their paintings evoke if not a timeless realm, at least one of long duration with a slow rate of change. Witness the continuity of terror as a subject of both primitive and recent artists, for example. Contrary to the notion therefore that these Abstract Expressionist artists started with the minimum, the truth is that they incorporated complex layers of cultural allusion into their art. In a real sense, Newman, Rothko, and Still were History Painters by inclination but Abstract painters by formal inheritance. That is why the work is remarkable, for the diversity of residual signs that are successfully bound into their art.

Notes

1. Barnett B. Newman, *Herbert Ferber*. Betty Parsons Gallery, 1947.

2. Barnett B. Newman, "The Ides of Art, 6 Opinions on What is Sublime in Art?" *The Tiger's Eye*, 6, 1948, pp. 51–53.

3. Mark Rothko, "Statement," *The Tiger's Eye*, 9, 1949.

4. Clyfford Still, *15 Americans*, The Museum of Modern Art, New York, 1952.

5. Newman, *Sublime*.

6. *Paintings by Clyfford Still*, Albright-Knox Art Gallery, Buffalo, 1959.

7. Benjamin T. Spencer, *The Quest for National Identity*, Syracuse, 1957.

8. *Pre-Columbian Stone Sculpture*, Betty Parsons Gallery, 1944; *Northwest Coast Indian Painting*, Betty Parsons Gallery, 1946; "Las Formas Artisticas

del Pacifico," *Ambos Mundos*, June, 1946, pp. 51–55 (reprinted in *Studio International*, February, 1970, pp. 70–71).

9. Newman, *Northwest Coast Indian Painting*.

10. Barnett B. Newman, *The Ideographic Picture*. Betty Parsons Gallery, 1947.

11. Barnett B. Newman, *Theodoros Stamos*, Betty Parsons Gallery, 1947. See also Newman's "La Pintura de Tamayo y Gottlieb," *La Revista Belga*, 4, 1945: Gottlieb's capacity to handle mythology is said to link him with "the North American primitives."

12. Adolph Gottlieb, Mark Rothko, WNYC broadcast, October 13, 1943, on "The Portrait and Modern Art."

13. Ibid.

14. Ibid.

15. Clement Greenberg, "Art," *The Nation*, December 6, 1947. In 1945 an unsigned note in the catalogue of the Rothko exhibition at Peggy Guggenheim's Art of This Century Gallery described the artist as occupying "a middle ground between Abstraction and Surrealism." (The writer was probably Howard Putzel.)

16. Barnett B. Newman, *The New American Painting*, The Museum of Modern Art, New York, 1959, p. 60.

17. Ibid.

18. E. C. Goossen *Monterey Peninsula Herald*, May 12, 1954.

19. Rothko, *The Tiger's Eye*, 9.

20. Mark Rothko, *Clyfford Still*, Art of This Century Gallery, 1946. Typically Still separated himself, in retrospect, from Rothko, by stating that: "Appropriation by 'Myth-makers' group in New York at this time led to misinterpretation of meaning and intent of the painting" (*Paintings by Clyfford Still*).

21. Newman, *Sublime*. For a more detailed comparison of Burke and American painting, see the author's "The American Sublime."

22. Edmund Burke, *A Philosophical Enquiry Into the Origin of our Ideas of the Sublime and the Beautiful*, II, ix.

23. Burke, II, xiv.

24. Newman, *La Revista Belga*, 1945.

25. Ibid.

26. Burke, II, xiv.

27. Barnett B. Newman, Typescript, Betty Parsons Gallery, 1951.

28. Longinus, *On the Sublime*, IX, 2.

29. Francis V. O'Connor, *Jackson Pollock*, The Museum of Modern Art, New York, 1967, p. 40.

30. Clyfford Still, Letter to Betty Parsons, September 26, 1949.

31. Information kindly given to me by Jane Dillenberger.

32. Robert Goldwater, "Reflections on the Rothko Exhibition," *Art*, March, 1961.

33. Barnett B. Newman, Statement, *The Stations of the Cross, Lema Sabachthani*, Solomon R. Guggenheim Museum, 1966.

34. Barnett B. Newman, "The First Man Was an Artist," *The Tiger's Eye*, 1, October, 1947, pp. 57–60 (reprinted in Guggenheim International Award exhibition catalogue, Solomon R. Guggenheim Museum, 1964, pp. 94–95).

35. See the author's "The Biomorphic '40s," *Topics in American Art Since 1945*, 1975, pp. 17–24, for comments on the significative aspects of biologically derived images.

AMERICAN PAINTING SINCE THE LAST WAR

Peter Fuller

T THE OPENING of the Whitney's Biennial on Valentine's Day, the Director, Tom Armstrong, handed out "Biennial, I love you" buttons. (The word "love" was represented by a small heart.) The button was symptomatic of the fashionable kitsch which characterised much of the show: it might also have been read as a sign of the failure of criticism to respond with anything other than narcissistic complacency to the growing crisis within the American Fine Art tradition.

The Biennial demonstrated that the succession of "mainstream," postwar, Late Modernist movements, beginning with Abstract Expressionism and flowing on through Post-Painterly Abstraction, Pop Art, Minimalism, and Conceptualism had definitively come to an end. It could be seen to have expired in the ineptness of Ellsworth Kelly's steel cut-outs, the blandness of Brice Marden's and Robert Mangold's evacuated formalism, or the unspeakable banality of Richard Serra's all-black walls. Such work lacks even significant development of stylistic features. It signifies nothing but its own expansive vacuity. It is the product of professional artists who have nothing to say and no way of saying it.... The crisis in America, however, has a peculiar importance because, since 1945, American art practice and ideology have dominated Late Modernism wherever it has manifested itself throughout the world. What is happening (or failing to happen) in the New York art world at the moment is affecting the way that certain painters are working (or failing to work) in Buenos Aires and New Delhi, not to mention London and Paris.

The history of modern art is that of the Fine Art professionals in the era of monopoly capitalism and a mega-visual tradition. Until 1914, the rapidly-developing capitalist world order contained within itself an inherent promise, that of evolution into a new world in which the problem of need had been solved, the means of production fully socialised

From *Art Monthly* (London) May–June 1979, by permission of Peter Fuller.

and, through advanced technology, nature had been put completely at the service of men and women. As Fine Artists became progressively prised apart from immediate service of the bourgeoisie some of them – the "avant garde" – struggled, often without fully realising what they were doing, to express through images a new way of seeing and representing the world appropriate to their conception of this promised land; hence the great upsurge of classical modernist movements at the beginning of the century. Inevitably, these too were shaped by the national conjunctures within which they arose. But Cubism, in particular, offered a half-promise of an entirely new set of representational conventions distinct from the visual ideology of the old bourgeois academies and salons.

Of course, the half-promise was never realised. The vision of the avant-garde was shattered and annihilated; the new world never came into being. Instead, the horrors of the twentieth century, the First World War, the Depression, Fascism, Nazism, Stalinism, and Second World War, the Holocaust, and national struggles against imperialism, succeeded each other. As this saga of atrocity and historic tragedy unfurled, Fine Artists found themselves almost unable to respond. The hope of a new way of representing the world seemed to have been destroyed by history itself. Never had the old visual conventions seemed more irrelevant; Dada was able to capitalise upon this by celebrating the professional Fine Artist's redundancy. Meanwhile, the ubiquitous mega-visual tradition became ever more swollen. Professional Fine Artists were thus marginalised and rendered impotent: they seemed to have been stripped of an area of experience appropriate to their practice, of their visual means, and of their social function alike. The imagery of the unconscious, dreams, and fantasy seemed the last territory Fine Artists could claim as their own – hence the Surrealist episode. After that, they were bereft of both subject and content for their work, and the tradition became progressively more *kenotic*, or self-emptying. Soon after the Second World War, modernist Fine Art in France declined and fell; in Britain it barely survived, despite Government subsidy....

The conflagration in Europe in the 1940s saw the fragmentation of much of the modernist tradition as survived there. Many of the Surrealists fled to America. Some of those American painters who were later known as Abstract Expressionists were sympathetic to and influenced by the Surrealist initiative, especially by that part of it which had moved furthest from fantastic verisimilitude. But there were major differences between the Americans and these Europeans. Those differences played their part in determining the character of that curious epilogue to the

European professional Fine Art traditions which was played out in post-Second World War America.

After the war, not just in New York, but in many centres in Europe and America a number of artists turned spontaneously to a variety of late "expressionism." They were driven by what they felt as the necessity of bearing witness to their experience of that terrible moment of history through which they had lived. They bravely attempted to *force* the materials and surviving conventions of their respective traditions in such a way that – despite their historic crisis – they could vividly and meaningfully refer to experience beyond the experience of painting again. The Cobra movement writhed through several European capitals; "Monster Painting" sprang up in Chicago; in London, Auerbach and Kossoff, followers of Bomberg, produced some extraordinary works; and, in New York, there was Abstract Expressionism. Although they produced the most powerful images made by any post-war Fine Art professionals, all these short-lived eruptions, without exception, must be deemed failures. Paint proved peculiarly resistant to that which these artists were attempting through it. Nowhere was this more true than in New York.

Many of those who came to be known as Abstract Expressionists had worked in the Federal Art Project. They were acutely aware of the difficulties involved in attempting through painting to make imaginative, empirical representations of, and to relate meaningfully to, the world. It was just these difficulties which they sought to transcend. They were looking for a route back to reality, much as an analysand does, through an exploration of their own subjectivity. They sought to create visual equivalents not just for dreams, or immediate perceptions, but also for a wide range of experiences including anguish, hope, alienation, physical sensations, suffering, unconscious imagery, passion and historical sentiments. They had little in common except their diverse and desperate desire to seize hold of this new subject matter.

Gorky complained that the "emphasis on the mechanics of picture-making has been carried far enough." Gottlieb, Newman and Rothko jointly declared: "there is no such thing as good painting about nothing. We assert simply the subject as crucial." According to de Kooning, "Painting isn't just the visual thing that reaches your retina – it's what is behind it and in it. I'm not interested in 'abstracting' or taking things out or reducing painting to design, form, line and color." Later, he dismissed "all this silly talk" about the components of the picture, and insisted that the *woman* "was the thing I wanted to get hold of." This attempt necessarily involved new kinds of pictorial space and a quest for

new pictorial forms; but that was secondary and was not, initially at least, pursued for its own sake.

The "Moment of Abstract Expressionism" when the attempt to annex a new area of experience seemed realisable was soon over. It lasted from c. 1945 until the middle of 1953, though some artists who produced significant work in this period, notably Hofmann, Kline and Rothko, continued to develop subsequently. Pollock is symptomatic of the courageousness of what the Abstract Expressionists tried to do and of the enormity of their failure. He was a highly-skilled professional Fine Artist who sought to realise a historical vision through his painting. He studied under Thomas Hart Benton, one of the most prominent and accomplished of the American Regionalists. Pollock's earliest known works are emotive but nostalgic evocations of rural America. Later, he became dissatisfied with both the ideology and the representational conventions of Bentonism: he was involved in the Federal Arts Project, and worked briefly with Siqueiros, the Mexican muralist. Picasso's *Guernica* powerfully influenced him. But his struggle to take his standards from the future, to create a vision of the world not as it had been, but in a state of actual historical becoming, was shattered by the historical experience of the Second World War. Cut off from the past and the future, Pollock's vision, almost against itself, became increasingly confined within the "universal" imagery of psychosis and infantilism. Berger wrote about his "breakthrough" into the now famous "all-over" drip paintings of 1946–1948; "these gestures might be passionate and frenzied but to us they could mean no more than the tragic spectacle of a deaf mute trying to talk." Pollock "finally in desperation ... made his theme the impossibility of finding a theme."

Pollock had come to find the old skills of the Fine Art professionals useless and had abandoned them; but the moment of history in which he lived was such that he could not avail himself of the visionary consolations of the "avant-garde." In his personal life, he was increasingly subsumed by alcoholism and depression. In the 1950s, he went through long periods in which he did not paint at all, and expressed doubts as to whether he was saying *anything* through his art. When he did paint, he seemed to be struggling desperately to regain some way – any way – of meaningfully representing his perceptions and experiences through his painting. But he was unable to do so. He died at the vortex of a ferocious despair which he could never satisfactorily depict.

Pollock was an extreme instance, but his failure epitomises that of a movement which had begun with such high expectations in the mid-1940s and which so quickly dissolved into alcoholism, suicide, and

formalism. The new subject matter eluded these artists; they could find no convincing pictorial means of mastering it, and yet the history of the tradition within which they were working was such that they felt there was nowhere else for them to go. There were, of course, ruptures and divisions within the movement, and some painters came closer than Pollock to finding a way through. In 1949/50, de Kooning made some exceptional paintings – *Ashville, Attic,* and *Excavation* – which seem to combine something of the actuality of the other, a woman, and which yet pulsate with the artist's sensuous responses to her. De Kooning wrenched Cubist devices to hint at a new kind of "subjective object" in which the skin of the paint itself begins to represent that which is depicted. At the same time Motherwell was exploring a new way of expressing an individual response to history. In the midst of so much despair, Hofmann was doggedly endeavouring to affirm his belief in the sensuous and joyous – he would have said "spiritual" – potentialities of men and women, and, through his explorations into the mechanics of the picture space, devising some relatively effective new visual metaphors to this end. Rothko had begun to chronicle his struggle to overcome feelings of absence, alienation, exile and despair: the narrative of this battle against suicidal depression runs on through his work of the sixties into the fearful "negative spaces" of the grey monochromes he made before taking his own life. But, despite their occasional "moments of becoming," even these great artists failed. History had deprived them of representational conventions valid even for a single class view; although they tried, they could not transcend their own subjectivity. Their intentions necessarily remained opaque: a route that had seemed like a potential escape from the historic crisis confronting the professional Fine Artist splintered into a myriad of cul-de-sacs at the end of each of which was a solipsistic cell and often an early grave. (By the time of Pollock's fatal car crash, Gorky had already hanged himself; Kline was to drink himself to death within six years; by 1965, David Smith, the Abstract Expressionist sculptor, had died following a car crash; and in 1970, Rothko slashed his veins and bled to death on his studio floor.)

This, at least, was the internal history of Abstract Expressionism – or rather the repeated pattern of those individual histories that were lived out within it; but, in its relations to the outside world, Abstract Expressionism was anything other than a desperate initiative which ended in failure. American critics repeatedly described it as the glorious birth of an American national art, "The Triumph of American Painting" (the sub-title of Irving Sandler's book on the subject). Thus Berenice Rose, of the Museum of Modern Art, writes "what is ultimately im-

portant is that Pollock's work and his achievement, opened art to a new set of possibilities for everyone; it was largely responsible for creating the confidence that became the basis for the sudden strength of American art in the quarter century following the Second World War." The dichotomy between the reality of the movement, and the way in which it has been interpreted, can only be understood when Abstract Expressionism is situated in relation to *history*.

During the 1940s, America went through a period of unprecedented economic expansion. (By 1950, industrial production was twice what it had been in 1939; agricultural output half as much again.) The Second World War had weakened the industries, economies and cultures of America's enemies and allies alike. The US emerged from the conflagration as unquestionably the dominant power in the West. Her political and cultural influence spread with the extension of her markets throughout the world. The 1950s were, of course, the "Cold War" era, with its witch-hunt against "Reds" at home, and its unremitting propaganda against the Soviet bloc nations, and their cultures, overseas.

As far as visual traditions were concerned, the truth was that the majority of those producing static visual images in America, were advertising artists or new professionals working within one or other strand of the burgeoning mega-visual tradition. They, like their counterparts in the USSR and Eastern Europe, were engaged in the production of lies under rigorous controls from above. The controllers of the Eastern Socialist Realists were the Party, and a repressive state apparatus; those of Western mega-visual advertising artists the giant corporations of monopoly capitalism and their agents.

The most perceptive apologists for corporate American capitalism saw that the decisive comparison between Socialist Realism and Western advertising could be evaded and a significant propaganda point scored in the "Cold War" if the residual professional Fine Art tradition was given cultural centrality. The very internal crisis of that tradition was an advantage, since a seemingly abstract art could readily be elevated as an emblem of "terrible freedom"; in its very confusion, Abstract Expressionism was manifestly unregulated and imaginatively free – which the dominant mega-visual advertising art was not. Thus it could be seen to contrast sharply with the Soviet visual tradition.

The precise mechanisms through which, from the mid-fifties onwards, Abstract Expressionism was engineered into its improbable position of cultural enthronement have been at least partially chronicled in Eva Cockcroft's pioneering and still too little known article, "Abstract

Expressionism, Weapon of the Cold War," *Artforum*, June 1974. A central role was played by the Museum of Modern Art (MOMA), a Rockefeller-backed institution, also bank-rolled by other corporate families. Cockcroft sketches the career trajectories of key MOMA personnel through various political and cultural agencies and establishes MOMA's overtly political intentions, specifically in its international exhibitions programme, the purpose of which was – as Russell Lynes puts it in his book on MOMA – "to let it be known especially in Europe that America was not the cultural backwater that the Russians, during that tense period called the 'Cold War,' were trying to demonstrate that it was." Almost inevitably, the CIA was also active in the inflation of the alleged "triumph" of Abstract Expressionism: Thomas W. Braden, a former MOMA executive secretary, supervised CIA cultural activities in the early 1950s. He admitted that enlightened members of the bureaucracy fully realised the propaganda value of marshalling "dissenting opinions" with "the framework of agreement on cold-war fundamentals." Braden and his colleagues, wherever possible, supported the "avant-garde" rather than the "realists."

The assimilation and elevation of Abstract Expressionism was not, however, achieved without a bitter struggle on the part of conservative, anti-corporatist elements within the ruling class. The story of Representative George Dondero's campaign to smear abstract art as a communist plot is well-known; Rockefeller's men fought back with all the considerable resources available to them. For example, Alfred Barr, a key figure in the elaboration of the early ideology of Late Modernism and the first director of MOMA, wrote an article in the *New York Times Magazine* in 1952 called, "Is Modern Art Communistic?" in which he tried to identify realism with totalitarianism and to make out that abstract art was on "our side."

The ideological laundering of Abstract Expressionism was underwritten by the explosion of the art market in the 1950s. By the middle of the decade *nouveau riche* collectors began to show themselves ready to imbibe the propaganda posing as criticism with which Abstract Expressionism had been surrounded. Thus, in 1955, *Fortune* magazine reported that the "art market is boiling with an activity never known before." It listed as "speculative or 'growth' painters" de Kooning, Pollock, Motherwell, Still, Reinhardt, Kline, etc.

The "triumph" was clinched in the late 1950s and early 1960s by a succession of promotional exhibitions (largely emanating from MOMA) which toured Europe uncritically celebrating the new American art. It

may be difficult for an American reader, even now, to grasp the effects of this kind of cultural imperialism. In Britain, a weak, indigenous Fine Art tradition was effectively swamped.

Although the massive resources which were injected into the inflation of Abstract Expressionism as a propaganda weapon came from *outside* the movement itself, I am not trying to argue that it was a completely passive, wholly innocent victim, or that it was *entirely* at odds with the social function to which it was put. Max Kozloff has traced the close parallel between "American cold war rhetoric" and that melange of existentially-flavoured individualism which characterised Abstract Expressionist discourse (*Artforum*, May, 1973). The very political "neutrality" claimed by some Abstract Expressionists rendered them peculiarly vulnerable to penetration by prevailing ideological trends. Abstract Expressionism grew consciously on the mutilated corpse of European modernism, and drew some of its energy from "New World" artistic nationalism. Similarly, individualistic attempts to penetrate the amnesiac clouds of a lost, personal past, proved compatible with unrealisable yearnings for a mythic national past, a fathomless American cultural history. But despite all this, I still believe that early Abstract Expressionism was a peculiarly ill-suited emblem for Imperial America: no single artist had fully succeeded in imaginatively grasping and visually representing the new areas of experience which the pioneers of the movement had promised to open up. They had faced an arguably impossible task, but they had failed nonetheless. If they had succeeded, their work would have been even more inappropriate: *what* they failed to express convincingly was, by and large, a profound disillusionment, an historic despair. There were many reasons why so many of the Abstract Expressionists took their own lives. One was undoubtedly the use of their flawed but courageous paintings as ideological embellishments for a state within which they felt themselves to be rebels, aliens, and exiles rather than heroes. Most of them knew that whatever they had achieved, or failed to achieve, it could *not* be paraded as "The Triumph of American Painting," and yet it was.

While the ideological and commercial inflation of Abstract Expressionism gathered strength, its internal aesthetic crisis deepened. These simultaneous processes led to the proliferation and rapid decadence of the movement. During the 1950s, in New York at least, Abstract Expressionism changed from a desperate search into a style, an *art oficiel*. More and more painters produced more and more paintings which got bigger and bigger and emptier and emptier. Tenth Street Abstract Expressionism became a received mannerism, the manipulation

of a given set of formal devices in a way which signified nothing. Evidences of this sea-change were evident early in the decade. Irving Sandler refers to "the acceptance of American foreign policy by hitherto dissident intellectuals," a process which "prompted many to call for a rapprochement with Middle America, even extolling its stability, propriety and other bourgeois values." This, he points out, was the theme of a much publicised symposium, "Our Country and Our Culture," published by *Partisan Review* as early as 1952. Most of the contributors saw in American democracy "not merely a capitalist myth but a reality which must be defended against Russian totalitarianism." The editors asserted that many intellectuals no longer accepted alienation as the artist's fate in America: they had "ceased to think of themselves as rebels and exiles" and they wanted "very much to be part of American life." Many believed that American culture had at last "come of age."

The problem for the triumphalists was always that of disguising the failure of Abstract Expressionism and its subsequent immanent collapse. There had always been those on the periphery of the movement, like Ad Reinhardt, who appeared to wish to reduce Abstract Expressionism to "pure" painting, i.e., to a non-referential art for art's sake. This position, and its derivatives, became dominant. The critics, too, were writing that the search for a new subject matter itself was of no importance; they chose to celebrate the various formal devices which happened to be thrown up through that struggle.

For example, Clement Greenberg, who was to become the most powerful "tastemaker" for the art institutions in the 1960s, began his career as an apparent advocate of cubistic forms in painting. In the late 1940s, however, he somewhat reluctantly came to acknowledge the strength of what he called the "painterliness" of Abstract Expressionism. But Greenberg always looked at Abstract Expressionism in a blinkered way; he commented solely on what Gorky would have called "the mechanics of picture-making," of which he was an acute observer. In effect, he was indifferent to "The Moment of Abstract Expressionism," to the struggle for subject and meaning. He did to Abstract Expressionism what Harnack had once done to Christianity. He divided it into husk and kernel, and then proceeded to call the kernel the husk and to ignore it. As Harnack had rejected the eschatology of Christianity, Greenberg designated the "symbolical or metaphysical content" of Abstract Expressionism as something "half-baked." The end of the world may not have taken place in the first century but it was the belief that it would that fired the early Christians; the symbolical content of Abstract Expressionism may never have become clear and manifest, but it was the yearning to realise it

which was of the essence of the movement. Greenberg refused to acknowledge this. For him, "the purely plastic or abstract qualities of the work are the only ones that count." Thus, he inverted the Abstract Expressionists' conception of themselves: for Greenberg, one might say — parodying the quotations from the Abstract Expressionists made earlier — there is no such thing as a *good* painting *about* anything. He asserts quite simply that the subject is irrelevant. He is interested only in the visual thing that reaches the retina; there is nothing behind it, or in it. For him, painting becomes "talk about line, color and form." He may thus have championed Pollock; nonetheless, he ticked him off for his "gothicness," "stridency," and "paranoia," which allegedly "narrowed" his art.

Greenberg at least had the advantage of what he would call a "good eye" and a clear pen. An army of art world bureaucrats and institutional historians translated his formalist insights into dogmas. For William Rubin of MOMA, for example, Pollock's paintings were "'world-historical' in the Hegelian sense" but only because he "articulated his canvases with 'all-over' webs of poured paint," just as for Barbara Rose the *real* importance of Pollock was that his drip paintings could be read as "the first significant change in pictorial space since Cubism." These critics pay no attention to the meaning of Pollock's painting, to its relation to his personal anguish, let alone his historic despair. They treat such things as contingencies fit only for discussion by journalists and psychoanalysts. What Gorky had so impatiently dismissed was thus coming to be revered by these critics as the *only* aspect of the work worth attending to. In this way, the lie could be maintained; Berenice Rose, also of MOMA, could come to write of poor, tortured Pollock that he established "with absolute authority an original American art, one free of provincialism and rich with possibilities."

By the end of the 1950s the exhaustion of Abstract Expressionism could no longer be disguised. If the myth of the miracle of post-war American painting was to be sustained a new initiative was needed. In 1958, Alfred Barr cooled his support of Abstract Expressionism, and urged artists to rebel against their elders. Significantly, Barr, too, was involved in the manufacture of Jasper Johns. Until 1958, Johns was an obscure artist who had inserted certain Dada-esque representational components into what was essentially a modified Abstract Expressionist style. That year, he was given a one-man show by Castelli; before it opened, the decision had been taken to put him on the front cover of *Art News* (hitherto a partisan Abstract Expressionist publication). MOMA immediately purchased examples of his work. Johns's most characteristic paintings were to be based on the American flag and on maps of North

America. He was the unwitting catalyst through which the art of Imperial America could apparently be revived. (If that sounds like an exaggeration, one should remember that as late as 1959, the London *Times Literary Supplement* wrote, "Abstract Expressionism radiates the world over from Manhattan Island, more specifically from West Fifty-Third Street, where the Museum of Modern Art stands as the Parthenon on this particular acropolis.") Where once there had been Abstract Expressionism, now there could be Pop.

Abstract Expressionism apparently received its *coup de grâce* in 1962, in part through the dip in the stock market of that year. From this point on, "triumphant", "mainstream" American painting splits into two primary branches. One of these was Pop Art – the progeny of the Johnsian adaptation of Abstract Expressionism. Pop was a sensationalist, and conspicuously engineered moment: nonetheless, the way in which it succeeded Abstract Expressionism itself illuminates the creative bankruptcy of the American Fine Art tradition at this time, its inability to constitute any genuinely imaginative view of experience or the world. Pop was recognition by certain Fine Art professionals of the fact that they had been eclipsed by and were dependent on the products of practitioners within the mega-visual tradition: indeed, photo-realism, Pop's immediate stylistic successor, was to be nothing more than mimicry of photographs in paint.

The other primary strand of Late Modernism was the formalist abstraction of the 1960s. In 1962, Greenberg himself finally abandoned his advocacy of Abstract Expressionist "painterliness." (For some time he had been emphasising those whom he now designated "post-painterly" – the second- and third-generation followers of the movement.) He wrote that "the only direction for high pictorial art in the near future" was the "repudiation of virtuosity in execution or handling" within the context of "the kind of self-critical process that ... provides the infralogic of Modernist art." The goal of this process, he maintained, was "to determine the irreducible working essence of art and of the separate arts." That "irreducible" essence turned out to be a formal device: "more and more of the conventions of the art of painting have shown themselves to be dispensable, unessential. It has been established by now, it would seem, that the irreducibility of pictorial art consists in but two constitutive conventions or norms: flatness and the delimitation of flatness." He considered that "the observance of merely these two norms is enough to create an object which can be experienced as a picture." Thus "the ineluctable flatness of the support" was "the only condition painting shared with no other art" and hence that to which "Modernist Painting

oriented itself ... as it did to nothing else." Representation and more specifically illusion were held suspect as contradicting flatness. "Visual art," Greenberg wrote, "should confine itself exclusively to what is given in visual experience and make no reference to other orders of experience." Departures from the norm of flatness were to be "strictly optical" and not of the perspectival Old Master sort "into which one could imagine oneself walking."

Today, in 1979, Greenberg claims that his rhetoric was misunderstood; he says that his account was descriptive rather than prescriptive, that he had no particular brief for "flatness" or for abstraction over representation. He says that he was merely speaking of the character of the "best" art of his time, as he found it. Nonetheless, Greenberg's critical project shared determinants with (and to a certain extent was itself a determinant of) the development of "mainstream," abstract, American Late Modernism in the 1960s, its reduction precisely to formal and imaginative *flatness*. I have already suggested that the origins of this *kenosis* are to be found in the displacement of Fine Artists by new kinds of visual professional of the mega-visual tradition. But "mainstream" American Late Modernism contrived to *celebrate* that kenosis, to fetishise it, idealize it, and elevate it as another episode in the continuing "triumph." In fact, after Abstract Expressionism, those "mainstream" Fine Artists who were not mimicking the mega-visual professionals found that they were without an area of experience to which they could meaningfully refer at all. The post-painterly abstractionists – e.g., Frankenthaler, Louis, Noland, Stella, and Olitski – so lavishly supported by battalions of critics, art institutions, and art magazines, thus reduced painting to commentary on itself.

They attempted to produce works whose only value was "given in visual experience", i.e., they sought to give visual pleasure of a kind which was dissociated from considerations of meaning, truth, or history. The "self-critical" programme on which such painters embarked left intact only painting's decorative function. The decorative can be used in such a way that it transcends itself: the purely visual then becomes a symbol for something else. Rothko and Newman, for example, attempted to use it in this way. But this possibility was specifically eschewed in the Late Modernist aesthetic. The purity of painting was allegedly ruptured by contagion with any other "orders of experience."

The view that "flatness," embellished only by "optical" illusions rather than deep recessive space, was in fact the timeless "essence" of painting was, however, the opposite of the truth. "Flatness" was rather a highly specific characteristic for free-standing painting which arose in a parti-

cular historical moment (as Greenberg's present interpretation of his past "rhetoric" seems to acknowledge). Historically, the Fine Art tradition seems to have had far more "essential" elements than this: one of them was the search for *meaning* through visual forms. Flatness – and, indeed, the "delimitation of flatness" – were characteristic of many decorative arts other than painting, e.g., carpets, ceramics, and wall-covering design, in which meaning was not sought. Greenberg was in effect positing as the goal or "essence" of the Fine Art tradition, its dissolution. . . .

By the 1960s, at the high point of monopoly capitalism, *globally* the old professional bourgeois Fine Art traditions were falling into a malignant decadence, the characteristic manifestation of which – flattening of forms, emphasis on outline and pattern, etc. – were, however, paraded in America as progress. (The "rediscovery," and consequent cultural and financial revaluation of indigenous decorative arts – especially certain Amerindian blankets, women's patchwork quilts, and New England painted furniture – has much to do with this relinquishment of even the attempt to constitute a world view through "mainstream" Fine Art practice.)

ABSTRACT EXPRESSIONISM: THE SOCIAL CONTRACT

Donald B. Kuspit

THIS ESSAY IS IN RESPONSE to an article by Peter Fuller in which he launches an attack on modern American art as a whole and Abstract Expressionism in particular.[1] While the grounds for this attack are not always clear, it does manage to raise fundamental questions about Abstract Expressionism. Despite the air of an arbitrary diatribe verging on the preposterous – confirmed by Fuller's gross ignorance of the American scene, his possession of the worst of clichés about it – Fuller does restore an earlier sense of Abstract Expressionism as a controversial art. This is valuable, for it puts the art sufficiently in doubt for us to feel compelled to renew our faith in it. Perhaps more is at stake than had been previously assumed, in a dimension previously unexplored yet signaled by the art. Beyond all his facile generalizations, anti-Americanism and anti-capitalism – verging almost on the order of mechanical reflexes – Fuller manages to restore a traditional criterion of artistic value, namely, the way an art reflects the society in which it appears. The psychological significance of Abstract Expressionism has been readily taken for granted – it has been assumed that its speaking in gestural tongues has profoundly personalistic implications – but the way it demonstrates the social contract has hardly begun to be articulated. The authenticity of Abstract Expressionism has never been measured by this criterion and, whatever else Fuller is telling us, he seems to be shouting that it is time that this be done. There is no way we can refuse him an answer without undermining the credibility of Abstract Expressionism.

What Fuller in effect does is locate Abstract Expressionism within a cultural logic which has previously not been thought to impinge on it, making us realize that this logic forces us to reconceive the subjective logic that Abstract Expressionism has been consistently thought to exemplify. The core of Fuller's argument is presented through an examination of the intentionality of Pollock's art. "Pollock," writes Fuller, "is symp-

From *Arts Magazine*, March 1980. Reprinted by permission of Donald B. Kuspit.

tomatic of the courageousness of what the Abstract Expressionists tried to do and of the enormity of their failure. He was a highly-skilled professional Fine Artist who sought to realize a historical vision through his painting." Carrying this line of thought forward into a general discussion of the Abstract Expressionist, Fuller asserts:

> They were acutely aware of the difficulties involved in attempting through painting to make imaginative, empirical representations of, and to relate meaningfully to, the world. It was just these difficulties that they sought to transcend. They were looking for a route back to reality, much as an analysand does, through an exploration of their subjectivity. They sought to create visual equivalents not just for dreams, or immediate perceptions, but also for a wide range of experiences including anguish, hope, alienation, physical sensations, suffering, unconscious imagery, passion and historical sentiments. They had little in common except their diverse and desperate desire to seize hold of this new subject matter.

Returning to Pollock, Fuller argues that:

> ... the moment of history in which he lives was such that he could not avail himself of the visionary consolations of the "avant garde." In his personal life, he was increasingly subsumed by alcoholism and depression. In the 1950s, he went through long periods in which he did not paint at all, and expressed doubts as to whether he was saying *anything* through his art. When he did paint, he seemed to be struggling desperately to regain some way – any way – of meaningfully representing his perceptions and experiences through his painting. But he was unable to do so. He died at the vortex of a ferocious despair which he could never satisfactorily depict.

At the center of this argument – which reduces personal failure to a symptom of social failure – is the assumption that Abstract Expressionism, particularly as it is exemplified by its most exemplary figure, was unable to realize any kind of historical vision because the primary historical vision of avant-garde art, the vision of a utopian world, was no longer available, and if it was, it would no longer be viable. It had been refuted by history itself, by the reality of 20th century socio-political experience. No other social vision was available, although Fuller seems to be calling for an apocalyptic vision of capitalist social failure, in effect hoping that the Abstract Expressionists would have created such a vision, on the assumption that historically they were in a position to do so. That is, they were located in the capitalistically most advanced country in the

world, and were possessed of a visionary talent which should have seen through the veneer of well-being with which American society masked its exploitive, strictly contractual, basis. They should have apocalyptically punctured the veneer, not retreated in the face of it to their subjective lucubrations, although such a retreat is in effect an acknowledgment of the hollowness of the capitalist promise, if not a turning of capitalist materialism back on itself. For Fuller, the alternative subjectivity, an update on an old-fashioned transcendental spiritualism, never has the strength to actively confront, whether materially or idealistically – i.e., whether revolutionarily or prophetically – the sheer qualitative and quantitative weight of capitalism. Instead of threatening capitalist control and methodology, the Abstract Expressionists retreated to a world of private methods and a seeming loss of control which became the emblem of an inner freedom, which, simply because it was inner rather than outer, was an absurd illusion. In other words, for Fuller, the Abstract Expressionists retreated to a dubious fantasy world of ineffectual feeling because they could not develop a sufficiently strong reality principle. Unable to face up to the reality of the world they lived in and indirectly acknowledged in their personal suffering, they created a world of their own which for all its artistic novelty was not able to free them from their suffering – was not able to heal the wound inflicted by a life in capitalist society. The alternate world of art no longer existed as a utopian reproach to the real world of life, but as a cesspool draining negative feelings about society, which, backed up, became negative feelings about oneself – a questioning of one's own character as a social being. For this reason, Fuller argues, Abstract Expressionism ultimately became, to use his word, "kenotic" or self-emptying: this in effect is Fuller's unacknowledged understanding of automatism.

In any case, Abstract Expressionism shares in the general American development of what Fuller, in perhaps his best formulation, called "the mega-visual." That is, for all its seemingly transcendental subjectivity – its universality – Abstract Expressionism is sufficiently American to think big. While never spelling out what he means by the mega-visual – although by giving Hollywood a monopoly on it he seems to suggest that it is solely a matter of quantity – it seems fairly clear, from his wide-ranging use of the term, that he means it to be a matter of quality as well. The mega-visual means not simply the big picture – the expansive new grandeur emblematic of America's megalomaniac sense of significance – but the heroically entertaining image. Art as the grandest entertainment – this is the idea at the core of the mega-visual, and like all entertainment the mega-visual functions in one of two ways, which often unite. The

entertaining is simultaneously a distraction from reality – Fuller says that the mega-visual develops in disassociation "from the material conditions of life" – and a false consciousness which blurs real conflicts in the haze of a teleologically presupposed harmony. For Fuller, the modernist emphasis on painting for the sake of painting, on the exploration of "pictorial conventions" for their own sake, is at once the instrument and final form of false consciousness artistically mediated. In assuming the possibility of an ultimate pictorial harmony, however abstract and "critical," modernism creates a false consciousness of painting. That is, it assumes a facile "higher" reconciliation of art and reality symbolized by art's reconciliation with its own reality, and at the same time it dismisses the possibility of conceiving art as a significant reaching out to or reflection of social reality. The supposedly higher reconciliation with reality is at once an illusion and the putting off of the very possibility of realistic reconciliation, whether in the most simplistic or dialectically complex way. Thus, one might say that the mega-visual is an authoritarian articulation of the modernist pretension to artistic transcendence, which in itself is an authoritarian version of the idea of art's autonomy.

While Fuller does acknowledge that "Motherwell was exploring a new way of expressing an individual response to history," and grants the Abstract Expressionists their "occasional 'moments of becoming,'" on the whole he believes that "history had deprived them of representational conventions valid even for a single class view; although they tried, they could not transcend their own subjectivity," and as a result "splintered into a myriad of cul-de-sacs at the end of each of which was a solipsistic cell." The problem here is Fuller's expectation of *representational* conventions, as though they alone were capable of mediating a social outlook. He implicitly denies abstract conventions and abstraction's power of communicating sociality. He assumes only one method of communication; all others are mute and ultimately incomprehensible for him. Thus it is that he can quote his adopted mentor, John Berger, another facile, overgeneralizing Marxist: describing Pollock's 1947–50 all-over drip paintings, Berger asserts that "these gestures might be passionate and frenzied but to us they could mean no more than the tragic spectacle of a deaf mute trying to talk."[2] Pollock, continues Berger, "finally in desperation . . . made his theme the impossibility of finding a theme." There is, admittedly, a groping for meaning – but not for theme – in Pollock. It is possible to conceive the paint itself, refusing us any ready images and making those we extract suspect, as the theme, without making a modernist analysis of it, but instead noting that it relates to conventions of handling. Such connotations imply the objectification of

an attitude – extravagantly subjective insofar as it seems to dismiss reality while rendering it or, to put it another way, the articulation of a dialectical moment, in which subjective and objective inextricably condition one another. The moment we understand the unresolved quality of Pollock's all-over drip paintings to be indicative of a dialectical intentionality, we can begin to understand the superiority of the abstract conventions he taps into to the representational conventions accessible to him – particularly those of the social realists. For such conventions either force us toward the objective, in a premature determination of it, or else lead toward, if not entirely effect, a facile bifurcation into objective and subjective, i.e., content and style. Such bifurcation, with its automatic assumption of content being an objective matter and style a realm of subjective implications, is another, more perverse species of false consciousness. Thus, Fuller mechanically assumes that Pollock's style is necessarily subjective. Not being able to conceive subjectivity as an objective content, or rather a content with implications for the nature of objectification, because it does not satisfy his canon of objectivity, which implies direct referentiality or easy mediation, Fuller dismisses Pollock's all-over paintings as without any social objectivity. Marxist though he may be – and I find his Marxism too superficial and specious to be worth the name – he is not a dialectician, subtle or unsubtle. His dogmatism precludes a dialectically subtle awareness. In all fairness, this may be in part because he assumes, unconsciously, that in a capitalist society subject and object bifurcate and are irreconcilable – the individual's world separates into private and public realms, with only the most distinct and certainly unclarified relationship between them. But this idea goes contrary to dialectical expectation, which assumes a steady if unstable connection between subject and object – their indissoluble reciprocity. Not truly respecting this reciprocity, Fuller is not truly a Marxist, or else he is a vulgar Marxist, allowing, when its suits him, for cultural superstructures which reflect no social reality but are privately accessible, as though privacy, and the notion of person it co-implies, were not social constructs.

Is there anything in the literature surrounding Pollock that might give us a clue to a social reading of his art? C. L. Wysuph, in his introduction to the psychoanalytic drawings of Pollock, repeats what is common knowledge about Pollock but which has been given little attention.

> At 16, Pollock enrolled in Manual Arts High School in Los Angeles, and before the year's end was expelled for having taken part in the publishing and distribution of two broadsides

attacking the faculty and the school's overemphasis on sports. He returned to the school in 1929, but within the first month was in trouble again with the Physical Education department. From his letters, we learn that Jackson had come "to blows" with the head of the department, had attended Communist Party meetings during his expulsion, had showed an interest in Oriental philosophy, and had stated that people "frightened and bored" him.[3]

Perhaps in typical adolescent fashion, Pollock seemed to have difficulty accepting authority. He particularly felt compelled to challenge the most conventional American authority, that presumably epitomized the American way of competitive fair play and worship of winning – the authority that insisted that life was a game, not to be taken seriously yet energetically played. One was to be a sport – sporting in one's attitudes, sporting in one's commitments – shallow yet game, lively within the limited system of rules and conventions. Resentment of physical education requirements is not new, nor is the adolescent pursuit of social and personal revolution. Indeed, one might argue that Pollock was already facing the most crucial choice of his art, as Fuller might conceive it: should the art move in a social direction or in a personal direction? Should it be objective or subjective? The question assumes the lack of reconciliation of the directions, and even the necessity for this lack of reconciliation, as though in a decadent capitalist society one is forced either to play the game wholeheartedly or withdraw from it completely to the subjective sidelines. And yet the objective and subjective possibilities clearly arise out of common ground: both are premised on rebellion against and rejection of social authority, which insists that one cannot take a serious, questioning stand about either social or personal matters – which assumes them to be settled matters. This shallow attitude, which inevitably arises when there is no questioning, was altogether inimical to the attitude of aggressive doubt which led Pollock into the depths, an aggressive doubt which took its start from a disbelief in authority, which simply asked of one that one played the game with no questions asked about its nature. Even those who see Pollock choosing the subjective side, and gaining authority in subjective matters, and who in no way could conceive of such matters as on the sidelines of social life – who see Pollock as a Hercules at the crossroads choosing the virtuous path (sometimes this choice is presented as that between abstract and representational art, or between mytho-poetic and social realist art) – miss the point that Pollock's subjective orientation is rooted in rejection of social authority, with its superficial demands and sense of life. If this is correct, what

it means is that in taking the subjective turn, Pollock was also being socially revolutionary – directly not simply indirectly. For the key element in Pollock's subjective turn, its starting point, is the complete rejection of social authority. This remains the touchstone of Pollock's subjective revolution whatever the sense of the subjectivity achieved, i.e., whether it be said that Pollock's art bespeaks Jungian ideas or is, more generally, psycho-mythic. The either/or postulation, which sees Pollock's art as becoming either social or representational or personal and abstract, misses the dialectical connection of the two.

This is a surprise in Fuller's case, for we expect a Marxist to be a dialectician, not simply a materialist. It is less of a surprise in those who see Pollock plunging the psychological depths, for they neither want to imagine a return from such depths – so happy are they to find an artist swimming underwater in the unconscious who can hold his breath for an unexpectedly long time – nor do they believe the surface of life is as interesting and important as its depths. They want an art of extreme situations, of a constant emergency situation, as though that alone is redemptive in a boring world – better to be frightened than bored, to know one's anxiety than to will it away into disillusionment with the world. Yet it is only the dialectical recognition of Pollock's subjective side that prevents us from misreading it as rank subjectivism, as a decadent pursuit of rare subjective sensation, as Fuller seems to imply. Moreover, dialectical recognition is the only kind that permits us to understand how Pollock, for all his defiance of authority, assimilates it – makes it part of his art's own authority.

Thus, from a dialectical point of view, not only does a psychological reading of Pollock's art imply its socially revolutionary meaning, but the famous pure physicality of Pollock's painting – a physicality seemingly developed in the most casual way yet ultimately, more than any cultural considerations, the source of his paintings' commanding presence – can be said to be the result of an *Aufhebung* of the physical that Pollock encountered in his adolescence. This is suggested by his sense of the picture as an arena in which the artist physically, even gymnastically, performs. Think of the famous film of Pollock painting, where the physical act of painting counts as much as the painting itself. Certainly these images of Pollock "educating" us to his own lived body as well as the lived body of the painting is one of the sources of body art. And certainly the physical act of painting, so determined to be as energetic as the painting itself, reflects a sporting attitude to painting as well as produces a sporting painting. Moreover, the authority the artist thereby acquires, over against the authority of works, makes him seem significant

beyond any of his manifestations in his works, so that he becomes a kind of social force as well as an artistic presence. From this point of view, Pollock was struggling to enter the social arena by making painting a vigorous revolutionary gesture, whose sheer physicality was enough to disrupt the social order, with its superficially harmonious surface. Harold Rosenberg's description of Pollock's paintings as a kind of performance in the social arena – an intervention in social events – is far from wrong, if not altogether right in that it misses the fact that Pollock means to intervene with his physical person as well as his gesturing art. One thinks of Joyce's description, in *Portrait of the Artist as a Young Man*, of the revolutionary gesture that Stephen Daedalus inadvertently made in conversation with his girlfriend, and of the surrealist sense of the ultimate surrealist act as a terrorist gesture of arbitrary murder in the densely packed arena of a crowd. To this one adds Pollock's sense of painting as a disruptive social performance, an argument, as it were, not so much for a painting as for a revolutionary artistic presence in the world, where the artistic is the revolutionary, in however impacted a form. And Pollock means to free the impacted revolutionary in the artist – an intention which he means to be more than utopian, if less than socially constructive.

What I am arguing for, then, is a change in the by now standard conception of Pollock as a martyr to his own psychology – as a kind of Laocoön caught in the coils of his own suffering, and of his art as a kind of subjective Gordian knot which no objective sword can cut. I use these metaphors to suggest that the interpretation which views Pollock's art strictly in terms of its psychodynamics has become, in Kant's sense, rhapsodic. It is time to interpret Pollock's art in terms of its social dynamics, however dialectically disguised these may be. The Communist Party side is as active in Pollock's art as the Oriental philosophy side. Indeed, there is the same abstract messianic urgency – the same sense of forcing necessity, social and artistic – in Pollock's art as in early Communist ideology. There is the same abstract sense of the need for a revolution, and the same abstract sense of its possibility. The visionary need for a new kind of social and artistic authority necessarily formulates itself in abstract terms, for it involves a modal logic, not simply the logic of the given. The abstract is the necessary vehicle of the apocalyptic, which carries with it a new sense of necessity and possibility and the abandonment of an old actuality. The apocalyptic represents the over-throwal of the shallow surface of life by the depths of possibility, struggling for a wider vision than can be contained on the surface and so unsettling and finally disrupting it altogether. Whether the apocalyptic

vision can ever realize itself does not matter; and in fact it was never meant to be realized. It displays itself as the fullness and energy that is in the depths, periodically announcing to life and society and art the necessity for and possibility of their own renewal, a renewal never completely actualized. The apocalypse, in other words, is a lure into the future, a revitalization of the future, a renewal of its meaning as fullness rather than emptiness – as owned by life rather than death. Apocalyptic art always proposes more than it can offer, and in Pollock we have apocalyptic art par excellence, the exemplary apocalyptic art of the modern period, bringing to fruition the seed that Kandinsky planted. Indeed, it is Kandinsky – and the debt Abstract Expressionism owes him has been acknowledged only in the most half-hearted way – because of the repression the modernist conception of art has instigated, as epitomized by Clement Greenberg's essay on Kandinsky and William Rubin's account of the influences on Pollock and Abstract Expressionism, an account which goes against the testimony of such artists as Gorky,[4] who first, in the modern period, saw the artist as an active social force by reason of his spiritual energy.

What Kandinsky showed us was that abstraction need not be merely surface decoration, but the artistic unconvention that could imply depth of meaning with a rawness and directness that no representational art, whatever its methods, could begin to fathom. Abstraction meant to enter the depth that representationalism could only suggest, as a nuance of the surface of objects. As such, abstraction worked against the charisma of surface by disrupting the order which created it and which it reflected, particularly the hierarchical ordering of space and the objects in them. In Pollock, with the realization of the all-over picture – presaged in Kandinsky – we find the collapse of hierarchical values synonymous with the sense of immersion in the depths. At the same time, for all its disorder, a surface is created and held together, but one which, because it is differentiated according to no single principle, does not achieve singularity as surface, and so always suggests the loss of surface and the plunge into the depth. This is true of Pollock's *The Depth*, and of most of his other paintings, after 1947, whether the figurative implications or not. One might say that in Pollock the dialectic between shallowness and depth – between a surface that is constantly betraying itself and a depth that is emerging or else submerged like a lost Atlantis, i.e., a depth that is archaeologically trying to restore itself – creates a sense of apocalypse, a sense of apocalypse which dominates the paintings and which can be interpreted socially. For it is to be understood in the same sense in which Gottlieb and Rothko proposed an art of the timeless and tragic – not in

and for itself, but in defiance of American society, which was all too concerned with things temporal and banal. The problem is how to get out of the mode of everydayness into the mode of authenticity – this is an apocalyptic shift, and in art this shift is represented by the turn to a dynamic abstraction. That Pollock offers us the most dynamic abstraction since Kandinsky shows us just how thoroughly apocalyptic his art was, how desperate he was to escape from American ordinariness, its lure of banality. Calling the apocalyptic attitude elitist does not change its meaning, for the fact is that American society does not answer the need for meaning, for a sense of the profundity of life.

Ever since Gauguin asked the questions *Whence Come We? Where Are We Going? Who Are We?* the best modern art has been symbolist in intention, in the sense of trying to find depth of meaning in an increasingly secular and banal world. In Pollock we have a kind of ultimate symbolist statement: the meaning is not in the lost totems blurred in the mists of paint nor in the world never explicitly depicted, but in the very energy that seeks meaning. Both old and new totems – Pop art in a sense showed us the new ones, those of a self-banalizing secularity – suffer an apocalypse in Pollock, who abides only by the implication of depth of meaning that comes from the actuality of sustained energy. Pollock struggled to sustain his energy – hence his performances – in order to sustain the feel of possible meaning that goes by the name of depth. As long as the energy seems absolute and consistent, the depth will seem possible if inconsistently present, uncertainly there. The authority of the energy gives the depth the authority of authentic possibility, giving the art more social implication – making it a contract with the future of the life-world – than it would ever have if it presented us, with whatever grandeur or pessimism, an image of the known world.

Just as Rothko's early, pre-field paintings show strong signs of the apocalyptic, so Pollock's work "after" Benton, Siqueiros, and Rivera – including the psychoanalytic drawings – shows strong signs of an apocalyptic mentality, of a social contract with a future world and, simultaneously, a falling one. The field paintings make this mentality explicit. The de-centering, even dis-locating effect of the field bespeaks the raw, apocalyptic sensation of being thrown into existence, in the Heideggerean sense. The sense of being in an apocalyptic situation permits this metaphysical experience of raw thrownness (reflected in the handling of the paint). At the same time, the field also bespeaks the falling world that makes the sensation of thrownness – falling – possible. But the very lack of firm footing in the field of existence and the world becomes the opportunity for an energetic reworking of necessity into

possibility. That is, the sense of fate accompanying the apocalyptic experience generates an energy which seems capable of counteracting the authority of fate itself as well as articulating the apocalyptic experience. We are all fated to have a surface, and fate makes a mockery of the center(s) and locations we construct on that surface, but the energy with which surface is given implies enough of a contradiction of surface to suggest, if not to give, depth. The self-contradiction converts the manifest into the latent, and it is important to see that this conversion, in and of itself, is socio-politically charged, for it denies the imposed, "fated" order that is one way of saving surface from itself. When energy, not order, emerges from surface – when the sense of the whole is countermanded by the energy that makes it possible – fate (necessity) seems overcome, and with it the authority that sustains surface, i.e., that "socializes" it.

The field paintings are at once regression in the service of the ego and the negation in which the negation of the negation is prepared. Thus, when Wysuph asserts that "rather than the overt political and social statements of Benton, Siqueiros and Rivera, he [Pollock] must have felt the need to express a more interior reality,"[5] he misreads the meaning of Pollock's shift to all-over abstraction, as well as the meaning of interior reality as such, which he absolutizes and conceives in disjunction from exterior reality. He in fact even seems to think of interior reality as a repression of exterior reality, much as exterior reality is conventionally conceived as the repression of interior reality. Pollock rejects the conventional conceptions of exterior and interior reality by means of his abstraction which is simultaneously both. (One might even describe it, on a theoretical level, as a new kind of subjective Cubism, creating an ambiguity of subjective and objective which decodes the conventional conceptions of both, and mocks the conventional conception of their bifurcation.) Pollock's abstraction moves beyond any shallow ideology which means to predetermine exterior or interior reality, and thereby convey the whole of reality's meaning, presumably making reality itself "whole," i.e., wholly exterior or interior. Pollock rejected the art of Benton, Siqueiros, and Rivera because he realized that their ideological orientations, however heroic and grand, were nonetheless premised on the unquestioned conventional secular assumption of the ultimate banality – and therewith non-apocalyptic character – of the world. Such an assumption takes the form of a pseudoapocalyptic hierarchization of the world into the separate exterior and interior realms: the everyday stability of the world depends on the absolutization of this hierarchical assumption. Benton, Siqueiros, and Rivera, from this point of view, never successfully fused the subjective-mythic and socio-political aspects of

their art, as Pollock did. In general, the apocalyptic vision of reality assumes the non-hierarchical if unstable unity of exterior and interior realities, to the point at which they seem undifferentiated. This unity – essentially that of the profane and sacred (one might say the struggle for sanctification in the face of being inevitably overwhelmed by the ordinary, including the ordinariness of paint) – is demonstrated as a *fait accompli* in Pollock's abstractions.

Pollock's mature paintings, then, are jeremiads against the prevailing shallowness – the shallowness which denies dialectical unity, and which must be resisted in the name of a possible depth of implication. His works express an apocalyptic intention which insists on the open reconciliation of the social and personal, and refutes any effort to set up separate realms of being in dubious communication with one another. The insistence on unity of being is in and of itself a political act, for it interferes with the functioning of advanced society, which depends upon the separation and hierarchization of the social and personal, establishing a scheme of priorities which seems to allow the autonomous functioning of each but in fact cripples the whole of being. The conventional demand for non-dialectical "positiveness" is exactly what leads to the bifurcation of America into a realm of shallow everydayness and a realm of such flagrantly expressive, hyperventilating art as Pollock at first glance seems to offer, a realm of expression so exaggeratedly free it seems to verge on the arbitrary. Pollock, then, does offer a utopian vision, but one quite different from either what Fuller expected or what was offered earlier in this century's art. The only reason I can see for not accepting the apocalyptic character of Pollock's paintings is that one has been taken in by the political appropriation of Abstract Expressionism for American imperialist purposes so well described by Eva Cockcroft in her article on "Abstract Expressionism, Weapon of the Cold War."[6] The assumption that the marginal freedom articulated by Abstract Expressionism has anything to do with the mainstream of conventional life in America can only issue from absolute naiveté or a cunning desire to whitewash American dailiness.

Notes

1. Peter Fuller, "American Painting Since the Last War," *Art Monthly* (May–June 1979), pp. 6–13; (July–August 1979), p. 6–12.

2. Quoted by Fuller, *Art Monthly*, May–June 1979, p. 8.

3. C.I. Wysuph, *Jackson Pollock: Psychoanalytic Drawings* (New York, 1970), p. 12.

4. Rubin has, incidentally, written about the Gorky–Kandinsky connection, but not the Pollock–Kandinsky connection. The Kandinsky connection – perhaps only an affinity – has not gone unacknowledged, but it has not been sufficiently analyzed on a theoretical as well as visual level. While the term "Abstract Expressionism" was originally used (by Alfred Barr) to describe Kandinsky's art, the use of it to describe the American Abstract Expressionists remains unclarified in import. Neither a convergence with Kandinsky's imagery nor expectations from art are implied, and yet it is such a convergence which would give full weight to the term. Moreover, Kandinsky remains defamed by Greenberg because he did not pass through the alembic of French Cubism on his way to non-objectivity – as though the Abstract Expressionists passed through the French Cubist filter and it "purified" them.

5. Wysuph, p. 12.

6. Eva Cockcroft, "Abstract Expressionism, Weapon of the Cold War," *Artforum*, June 1974.

ABSTRACT EXPRESSIONISM'S EVASION OF LANGUAGE

Ann Gibson

HE CONVICTION that language is basic not only to the expression of thought but to its *formation* has occupied an important place in modern studies. By 1924, for instance, Edward Sapir had written, "It is quite an illusion to imagine that one adjusts to reality essentially without the use of language and that language is merely an incidental means of solving specific problems of communication or reflection. The fact of the matter is that the 'real world' is to a large extent built up on the language habits of the group."[1] Although there has been an increasingly open interest among artists throughout the last two decades in the use of linguistic theory as a model for artmaking, this was less common in America at mid century. By 1949, when Sapir's *Selected Writings* was published, there was, in fact, a strong resistance among a certain group of artists – the Abstract Expressionists – to the idea that language was inextricably meshed with every mode of apprehending the world and therefore, of course, to the idea that what their works represented could be put into words.[2]

The Abstract Expressionists' resistance to interpretation was remarked upon by their critics, both friendly and hostile. It was also expressed by the avoidance of recognizable images in their work and in their refusal to explain, except in the most general terms, what the work "meant." Some felt, with Clyfford Still, that "to interpose any literary allusion is to establish a serious block to communication."[3] Others, like David Smith, called for a "return to origins, before purities were befouled by words." "There were no words in my mind when I made it [my sculpture]," said Smith in a radio talk in 1952, "and I am certain there are no words needed to understand it. As far as I'm concerned, after I've made the work I've already said everything I have to say."[4] In 1944, Barnett Newman wrote of Adolph Gottlieb's paintings: "It is gratuitous to put into a sentence the stirring that takes place in these pictures."[5] One of the most verbally reluctant of the Abstract Expressionists, Mark Rothko, wrote to Newman in 1947 that the real reason he did not want to write a

From *Art Journal*, Vol. 47, No. 3, Fall 1988. By permission of Ann Gibson. [*Editors' note:* This issue of the *Art Journal* is devoted to Abstract Expressionism.]

statement about his art for the magazine *Tiger's Eye* was that "I have nothing to say in words which I would stand for," adding, "I am heartily ashamed of the things I have written in the past."[6] If anything, Rothko's antipathy to expressing himself in words increased in severity over the years. In 1954 he wrote that "forewords and explanatory data" cause "paralysis of the mind and imagination."[7] Jackson Pollock's few statements focused more often on his own experience than on critical practice, but his stance was similar to Still's and Rothko's. "*She Wolf*," he explained, "came into existence because I had to paint it. Any attempt on my part to say something about it, to attempt explanation of the inexplicable, could only destroy it."[8] Seymour Lipton wrote, "It is false to use literary means to convey the sense of reality, the mysteriousness, the transcendent, which alone is the realm of the artist."[9]

This determination to avoid correlating visual with verbal meaning was, of course, the complement to paintings and sculptures whose "difficulty" or opacity to existing methods of interpretation was remarkable even for experts. In the foreword to a catalogue of an early group show of Abstract Expressionist painting and sculpture at his gallery in Washington, D. C., David Porter wrote that the highly personal work he showed was largely incommunicable to the average viewer.[10] By 1950 Jackson Pollock had received sufficient recognition to be included as one of six painters representing America at the Venice Biennale. Despite his international status, critics would still resentfully describe paintings such as *Number 1. 1948* as "an elaborate if meaningless tangle of cordage and smears, abstract and shapeless."[11] Not all comments on the unintelligibility of this art were hostile. Marius Bewley, in an essay on Louise Bourgeois's suite of etchings, *He Disappeared into Complete Silence* (published 1947), wrote that for him, they expressed a situation in which the communication language offers doesn't work; one in which meaning is there but remains necessarily private.[12] Another favorably inclined observer, The Museum of Modern Art's Alfred Barr, Jr., did not call such apparently unexplainable works "meaningless," but remarked that their content "is never explicit or obvious even when recognizable forms emerge." "The painters insist," he reported, "that they are deeply involved with subject matter or content [yet], as a matter of principle, do nothing in their work to make 'communication' easy."[13] Barr was probably thinking not only of the impenetrability of the work but also of statements like that made by Baziotes in 1949: "I have *a horror of being easily understood*. For the modern artist, an easy understanding – an easy acceptance – would be a sensation akin to those great waving movements of the hand on the seismograph as it heralds the coming of death. All is

lost! he'd cry, and like Hamlet he would wish 'to die, to sleep.'"[14]

Opponents of the Abstract Expressionists viewed the artists' refusal to chart the meaning of their work as elitist or just plain contrary. To a degree both charges may be true. But also operating was the influence of a number of mutually reinforcing arguments denying that language should be used to criticize or articulate visual art. Given their number and the cultural authority these arguments wielded, it is not surprising that artists in a position to be aware of them elected to avoid "decoding" their work to make it easy to understand.

In the last decade and a half, scholars have been more determined than ever to flush out the Abstract Expressionists' reasons for the evasion of language. Three major explanations have been advanced. The first is centered on the position so categorically stated by the critic Clement Greenberg. By 1940 Greenberg had formulated his belief that each medium (painting, sculpture, poetry) must establish its excellence through an exploration of its own limits (thus implying the irrelevance of verbal interpretations of the visual arts).[15] Donald Kuspit has discussed Greenberg's basis for this proposition in Kant as well as its precedents in Roger Fry, Clive Bell, and T. S. Eliot.[16]

Irving Sandler, T. J. Clark, Serge Guilbaut, Fred Orton, Griselda Pollock, and others have emphasized a second reason: the association of realism with the totalitarianism of Hitler and Stalin. Even American Social Realism's narrative accessibility began to suggest a connection between the propagandistic explication of a painted or sculpted text and totalitarian control.[17]

A third reason, also pointed out by Sandler, developed by Paul Rodgers and others, and often noted by the artists themselves, was the Abstract Expressionists' suspicion of the literary basis of French Surrealism as it was conceived by the Surrealist leader André Breton. They identified Surrealist discourse with the descriptive pictorialism and lack of painterly vigor they saw in the illusionistic forms of Pavel Tchelitchew, Yves Tanguy, and Salvador Dali.[18] These they rejected, adopting the silent, gestural aspect of Surrealism – automatism – ostensibly for its plastic possibilities alone.[19]

Robert Motherwell wrote in 1944 that he preferred to think of the Surrealists' technique of "psychic automatism" as "plastic automatism," especially as it was practiced by Masson, Miró, and Picasso. When one contrasts one of Motherwell's works from about this time, such as *Joy of Living*, with that of one of the Surrealists who worked with a more traditional style, such as Tanguy's *Many Have Lived*, one can see what

Motherwell meant when he said that the automatism he prefers is a matter more of form than of content.[20] Tanguy's evocation of a space that may be entered – where paint becomes solids that are distinct from voids and where strange objects call to mind forms or substances such as slate, bone, mist, and wood – is strikingly denied by Motherwell's painting. Motherwell's space may be read, but not entered, and his paint retains its identity as wash or scumble. Where Tanguy draws the viewer into his psychic world with the vacuum of his limitless horizon, Motherwell merely supplies his audience with a map in the upper right-hand corner. The difference in attitude implied by these two techniques is a key to the Abstract Expressionists' attitude towards the autonomy of the viewer. Tanguy offers to transport viewers imaginatively into his painting, to lead them illusionistically by the hand. Motherwell, less patriarchal, is not so willing to serve as a guide. If there are natural or manmade structures to be understood in the Abstract Expressionist's painting, observers must determine the analogies themselves. Motherwell supplies the materials, but will not take the responsibility for their mimetic transposal into bone or sand. He will not, in other words, say what they mean.

These three bases of anti-intentionalism would perhaps have been sufficient in themselves to persuade the Abstract Expressionists that it was improper to state their aims. But there were four *additional* powerful influences, whose import in this regard has been less discussed in Abstract Expressionist literature. These are: 1) a judgment expressed by Carl Jung; 2) a New Critical tenet; 3) a Russian Formalist concept; 4) and an attitude central to Existentialist philosophy, most likely to be familiar to American artists as it was stated in the work of Jean-Paul Sartre. When these are understood in addition to the first trio of prohibitions, it becomes easier to see how the strength of the combined forces working against verbal explication for the Abstract Expressionists made suspect the dynamic interplay of word and image.

Jung wrote in *Modern Man in Search of a Soul* (available in English by 1933) that there was a qualitative difference between the power of the "psychological" artist who was aware of the relationship between his intention and his product, and that of the "visionary" artist who was directed by dark primordial drives within his psyche to produce work whose meaning he could not divine:

> The primordial experience, is the source of [the visionary artist's] creativeness; it cannot be fathomed.... In itself it offers no words or images.... Being essentially the instrument for his work, he is subordinate to it, and we have no reason for

> expecting him to interpret it for us.... A great work of art is
> like a dream; for all its apparent obviousness it does not
> explain itself and it is never unequivocal.[21]

Jung's claim that a great work of art is like a dream recalls a Freudian precept: that only what is repressed can be symbolized.[22] And as Lionel Trilling told his readers in 1940, Freud believed that these inner meanings of dreams are their intentions. Freud, however, wrote Trilling, did not have an adequate conception of artistic meaning. Unlike dreams, according to Trilling, art has no single meaning, because the meaning of a work cannot lie in the author's intention alone; it lies also in its effect.[23] As Trilling suggests, Freud's authority in aesthetic matters was in question by the forties. Jung's importance as an influence on many American artists began to overshadow that of Freud's in these years. *Modern Man in Search of a Soul*, for instance, was actively promoted at the California School of Fine Acts by the painters David Parks and Elmer Bischoff in the late forties and early fifties, at the time that Clyfford Still, Mark Rothko, and Ad Reinhardt were teaching there.[24] Adolph Gottlieb was more interested in Jung than in Freud in the years when he was beginning his Pictograph series. Like Jung, he understood the equivocal nature of symbols in art and used their impenetrability to protect his intentions: "I wanted to use ambiguous symbols for my own purposes, to prevent people giving them interpretations I didn't mean."[25] Jackson Pollock's Jungian analysis has been the subject of numerous publications.[26] By Jung's criteria, Pollock marked himself a visionary painter when he claimed in 1947, "When I am in my painting I am not aware of what I'm doing.... The painting has a life of its own."[27] David Smith, too, struck a Jungian note when he told an interviewer, "I have no conscious premise while working of *why* I am working, what it is I am making, or whom it is for."[28]

Clement Greenberg's dismissal of artists' intention indicates his lack of attention to the difference between a painter's intention and its realization.[29] Some scholars such as Richard Wollheim have criticized such indifference towards the ways artistic intention may be articulated as failing to open a work to understanding.[30] Others, such as Donald Kuspit, analyzed Greenberg's attitude in this matter, noting that he followed T. S. Eliot here. Kuspit has concentrated, however, on Greenberg's sympathy with Eliot's dissociation of sensibility – the separation of thought and feeling – rather than on Greenberg's agreement with Eliot's New Critical stance against intentionalism. But Eliot's insistence that

"poetry is not a turning loose of emotion, but an escape from emotion; it is not the expression of personality, but an escape from personality" is closely related to a fundamental proposition advanced by proponents of the New Criticism, the dominant literary theory in the United States in the forties and fifties.[31]

Eliot's desire to escape from emotion would not have appealed to many Abstract Expressionists. (Mark Rothko, for instance, once fumed at Selden Rodman, "I'm interested only in expressing basic human emotions – tragedy, ecstasy, doom, and so on."[32]) One must suspect, however, that Eliot's impact in this regard, which helped to shift critical emphasis from the poet to the poetry, was a significant factor in forming the atmosphere in which the Abstract Expressionists refused to submit to or offer an exegesis of their work.

The New Critical principle, the "heresy of paraphrase," most persuasively paralleled the Abstract Expressionists' attitude. As it was developed by Cleanth Brooks in the forties and presented in *The Well-Wrought Urn* in 1947, "the heresy of paraphrase" stood for the rejection of the idea that the thought in a poem could be stated in other words; Brooks and his New Critical colleagues claimed that the real, or essential structure of a poem, which was its meaning, could not be represented in any way other than it was in the poem itself.[33] New Critics like Monroe C. Beardsley and W. K. Wimsatt extended this tautological reasoning into the realm of intention, holding that factors exterior to a work of art could not play a significant part in the interpretation of its meaning. In their landmark essay, "The Intentional Fallacy" (*Sewanee Review*, 1946), Beardsley and Wimsatt had pointed out that whatever an artist might say about what he meant his or her work to mean was beside the point. Whatever could not be extracted from the work by a close reading was not relevant. This contention is echoed, implicitly or explicitly, by the attitude of the Abstract Expressionists. As the sculptor Herbert Ferber observed, it was wrong "to castigate artists on the basis of their character, personality, sincerity, and so on. We can only look at a work," Ferber declared, "and decide whether it is exciting, adventuresome, or pragmatic."[34]

That Greenberg was in accord with this precept, he demonstrated in review after review, describing with enthusiasm the evolution of the appearance of what we now call Abstract Expressionist work but avoiding any discussion of those vaguely stated concepts the artists themselves had insisted were crucial: subject matter. For Greenberg, the most important art did not have subject matter. He saw the avant-garde

arriving at nonreferential, "nonobjective" art, "Art for art's sake." When this happens, he explained in 1939, "subject matter or content becomes something to be avoided like the plague."[35] "In general," he wrote in 1940, "painting and sculpture in the hands of the lesser talents – and this is what tells the story – become nothing more than ghosts and 'stooges' of literature. All emphasis is taken away from the medium and transferred to subject matter."[36] Reflecting his New Critical orientation, he would later write, "all paintings of Quality ask to be looked at rather than read."[37] For Greenberg this meant that although language could describe a work's physical appearance and thus estimate its merit, the interaction of words with vision to develop or disseminate meaning could only lower the aesthetic quality of the result. Although specific connections between Greenberg and New Critics remain to be established, parallels between his ideas and those of Wimsatt and Beardsley suggest that such an investigation would yield some striking correspondences.

How much did the Abstract Expressionists know about the New Criticism? New Criticism developed in America in the thirties and forties, becoming established orthodoxy in college classrooms by the 1950s. Many of the first generation Abstract Expressionists, however, if they had college experience, had it in the twenties, as did Mark Rothko at Yale and Barnett Newman at City College. Some, like Jackson Pollock and Willem de Kooning, did not go to college. How, then, did their attitude towards verbal articulation come to follow New Critical theory so closely? Was their only association with it through art criticism? Or, in other words, how was it that they refused to provide statements of intention that could be used to interpret their work at the very moment that the New Critics (or art critics cast in that mold, like Clement Greenberg) were refusing to take such statements into account?

There was a general awareness of New Criticism in intellectual circles where writers, painters, and sculptors mixed, although many of the connections among painters and writers in the forties are yet to be explored. One such circle surrounded the *Tiger's Eye*, an avant-garde periodical edited by Ruth Stephan. Stephan's associate editor for the second and third issues was Barnett Newman. The third issue of *Tiger's Eye* carried an advertisement for a sister journal, that bastion of New Criticism, the *Sewanee Review*, announcing articles by such prominent New Critics as William Empson and W. K. Wimsatt.[38] But less circumstantial is the position of the *Tiger's Eye's* editorial staff. They were so convinced that interpretation of art was wrongheaded that they published the following guidelines in their first (October 1947) issue:

The *Tiger's Eye* has the following convictions that will guide its publication of art:

That a work of art, being a phenomenon of vision, is primarily within itself evident and complete;

That the study of art remains an afterthought to the spontaneous experience of viewing a work of art;

That too close an association between art and the profession of art criticism creates a marriage of hypocrisy for neither the artist nor the critic are [*sic*] motivated by altruism towards each other;

So it is our intention to keep separate art and the critic as two individuals who, by coincidence, are interested in the same thing, and any text on art will be handled as literature.[39]

New Critics, however, were not the Abstract Expressionists' only source for advice against the pitfalls of interpretation. Certain aspects of Russian Formalism may also have filtered down to the Abstract Expressionists, acting as a further incentive to avoid explaining their work, incentives whose parallels with New Criticism have not gone without notice.[40] Robert Penn Warren and Cleanth Brooks come especially close to the Russian Formalists, particularly to Roman Jakobson and Viktor Zirmunskij. Brooks's aforementioned stance, for instance, against the heresy of paraphrase is like Jakobson's and Zirmunskij's assertion that content exists only as it is embodied in form. Changing its form (paraphrasing a poem in critical prose or describing a painting in words) changed, for these Russians and Americans alike, its content.[41]

Some American artists in the 1940s were aware of the tenets of Russian Formalism.[42] Louise Bourgeois had been introduced to Russian Constructivism in her student days by Paul Colin; Hedda Sterne saw her first show of shaped Constructivist paintings in Bucharest as a child.[43] Ad Reinhardt's aphorisms, such as "ART IS ART. EVERYTHING ELSE IS EVERYTHING ELSE. ART-AS-ART. ART FROM ART. ART ON ART," and "ART OF ART," expressed an aversion to interpretation that was at least as radical as Zirmunskij's and Brooks's.[44] It is unlikely that Wassily Kandinsky's idea that shades of color "awaken in the soul emotions too fine to be expressed in prose" escaped the attention of many American artists, especially Arshile Gorky, David Smith, de Kooning, Pollock, or Hans Hofmann.[45]

It has generally been held, however, that such affinities as those exhibited between Russian Formalist ideas and American art such as Reinhardt's and Newman's cannot be ascribed to actual cross-fertilization, but are the result of convergence rather than influence.[46] But as we learn

about friendships among Russian and American artists connections begin to surface. Barnett Newman, for instance, wrote the Art of This Century catalogue for the Constructivist Theresa Zarnower. A leader of the Constructivist movement in Poland, Zarnower edited the avant-garde publication *Blok* in Warsaw. Although Zarnower was opposed to the purism of certain formalist tenets, she was in a position to know them firsthand and to convey information about them to American artists.[47] David Smith was friendly with the Russian sculptor David Margolis and his brother, the painter Boris Margo, who would recite verses by the Russian Futurist poet Vladimir Mayakovsky in the Cedar Bar at the tops of their voices. In a quieter mood, the brothers would translate the Russian poetry into English for Smith and his wife, the sculptor Dorothy Dehner. Over sandwiches and beer the Margolis brothers would explain the double and triple implications of words in poems like "The Last March," implications whose loss in translation made English renditions inferior to the original.[48]

The Abstract Expressionists had another link to Russian Formalism in the fiercely enthusiastic painter and collector John Graham. A close friend of David Smith, Willem de Kooning, and Arshile Gorky, Graham boasted of his personal friendship with the same Mayakovsky whose verses the Margolis brothers recited for the Smiths. Graham had known Mayakovsky before his (Graham's) final flight from Russia in 1920.[49] Graham was also linked to Mayakovsky through his friend the painter David Burliuk, who had helped Mayakovsky in the founding of the Moscow faction of the Russian Futurists. A friend of a number of artists in the Abstract Expressionists' social circle, such as Milton Avery, Burliuk felt close enough to Graham to write the introduction to the catalogue to Graham's show at the Dudensing Galleries in 1929.[50] As early as 1913, Burliuk had written that "the greatest crime against genuine art" is "all this talk about content."[51] Graham's appreciation of Russian Formalism, along with his self-appointed role as the missionary of modernism, provided a channel of information from Russia to American artists. Its flow of ideas would have supported the injunctions against intentionalism of which they were already aware.

Russian Formalism and New Criticism exhibited a significant similarity to a third and newer development in critical thinking: Existential criticism. The Existentalist's view of intentionality differed from the injunctions voiced by Brooks and Reinhardt, but it did imply, as did New Criticism, that the meaning of a work is not synonymous with the artist's intention. Jean-Paul Sartre wrote of Giacometti's sculptures, shown in America at

the Pierre Matisse Gallery in 1948, that Giacometti had made the viewer responsible for bringing the images to life. In thus placing his emphasis on the relationship between the viewer and the work rather than on relationships among parts of the work itself, Sartre avoided intentionalism without adopting New Critical or formal criteria. Sartre's choice of the viewer as the arbiter of meaning would have been acceptable to de Kooning, who said regarding this problem in 1950, "I think there are different experiences or emotions. I feel certain parts you ought to leave up to the world."[52]

The idea that a work of art might be made with no specific intended meaning for an audience was further elaborated in 1952 by Harold Rosenberg, a personal friend of Sartre's as well as of many Abstract Expressionists. In his now-famous article, "The American Action Painters," he responded to his own rhetorical question, "What is a painting that is not an object nor the representation of an object nor the analysis of it nor whatever else a painting has ever been – and that has also ceased to be the emblem of a personal struggle?" Rosenberg answered, "the act itself is the object.... The painting is only a ghost."[53] The idea that the art object is only a vehicle to enable the artist to perform a transition, as Rosenberg put it, "to the farther side of the object and the outer spaces of the consciousness,"[54] paralleled Sartre's use of the novel to effect his own transition from the old and still quasi-ideal Husserlian version of intentionality. Radically, Sartre asserted that we do not see only mental images; we also see the material and the physical directly.[55] His insistence on the moral necessity of a confrontation with the concrete matter of actual existence (whose "profusion" and "excess" is responsible for the sensation that stands as the title of La Nausée) follows this new understanding of intentionality. For Sartre, the real meaning of intentionality was the idea of a direct perceptual confrontation that opens us up to the outside world, that exposes us, making us vulnerable to whatever is outside.[56] This view of *intending* as the process of its own realization is like Rosenberg's definition of Action Painting. It implies that perception, like Sartre's novels and like Abstract Expressionism, is a very different thing for the subject – that is, for the artist – from what it is for those who would describe or analyze it. For the artist, as Rosenberg put it, "the work, the act, translates the psychologically given into the intentional, into a 'world' – and thus transcends it." For most of the "action" painters, he wrote, "TO PAINT is something different from, say, to write or to criticize.... Language has not accustomed itself to a situation in which the act itself is the 'object.'"[57]

Although Existential criticism diametrically opposed New Criticism

and Russian Formalism on the issue of criticism as biography, it concurred with these other systems in questioning the value and authority of interpretation that claimed to represent the artist's intentions "in other words." The conjunction of all these proscriptions against the use of language to describe intention also acted, however, to prevent the use of language as a tool to analyze and develop meaning in painting and sculpture. For the reasons discussed in this paper, most artists and critics held that Abstract Expressionism was uninterpretable.

This resulted in what could be called the fallacy of "objectivism" in one of two forms: the reduction of subjectivity either to the in-itselfness of observed fact (Greenberg's stance) or the identity of act and object – the identity, that is, of the process of making and the thing made (Rosenberg's Action Painting). In either case, the range of possibilities between the subjectivity of the artist's intention and the objective achievement of his work was denied.[58] One might consider, following Paul Ricoeur's line of reasoning, that Greenberg's and Rosenberg's stances correspond to the "neutral" attitude towards the object assumed (for different reasons) by science and phenomenological religion respectively. Both disengage intention from what is intended (the object – the painting or sculpture), thus disallowing consideration of the validity of the object itself.[59] The evasion of intentional language by the Abstract Expressionists did, in any case, create a vacuum that was occupied by these two systems of criticism (Greenberg's and Rosenberg's), each of which narrowed the implications of the work to a significant degree.

These artists merged individual style with universal convictions to attain what some regard as a grandeur no longer possible or desirable in today's postmodern world. It may be maintained that the avoidance of language is at least part of what enabled them to produce the dense multivalence of their work – that this is what has enabled it to retain for a newer generation the allure of the Other, elusive and unavailable to reason and language.

One may also observe, however, that the evasion of language prevented a number of artists and critics contemporary with them from attempting the reflective reconstruction of the genesis of the works, through which they might have perceived alternatives to the personal modes they established from 1947 through 1952. In these years, Rothko, Newman, Still, Pollock, Reinhardt, and de Kooning established their mature styles, with which they remained identified for the rest of their careers. They elaborated largely with those styles, restricted by the Catch-22 that guaranteed their integrity only so long as they avoided explaining their

work in any but formal or existential terms. In doing so, did they deprive themselves of what some have described as the fundamentally oppositional process of verbal thinking? To refuse to verbalize, it may be argued, is to refuse to grasp the oppositions, differences, and negations that make the world "take shape" for our purposes.[60]

It is no wonder then that, given the number and persuasiveness of the arguments against considering intention in discussions of art, so many artists and scholars in the generation of the Abstract Expressionists denied intention any validity at all in determining the significance of the art object. The limits of these systems, however, have led recent scholars to compare more closely the relation of the artists' statements with those of thinkers in other fields and with images in the work itself.[61] Their investigations have revealed some of the gaps in discussions that dismiss intention along with other factors apart from those that can be adduced by an examination of a work itself. One can consider, after all, that to concur with an artist who holds that his intention is immaterial is to walk backwards into the intentional fallacy oneself.

Forty years later we have begun to feel that if consciousness is *not* altogether formed by language, perhaps it cannot profit by attempting to escape it either. I would suggest that the solution to the problem of the relation of intention to meaning in Abstract Expressionism, absent as it is from the artists' statements as they are framed, should not be sought solely in the works or in their reception alone, either. Rather, it may be located at the intersection of these areas, in the play of language with what eludes it, and will involve the imaginative reconstruction of the choices not made; that is, the concepts forgone, emotions unexpressed, and issues untreated, as well as those present in the work.

Notes

1. Edward Sapir, *Selected Writings in Language, Culture, and Personality*, ed. David G. Mandelbaum, Berkeley, 1949, p. 162.

2. Although this paper is based on the premise outlined above, convincing arguments have also been made for the primacy of nonverbal thinking in the visual arts. I have attempted to formulate some of these in regard to specific paintings by Barnett Newman, Clyfford Still, Mark Rothko, and Ad Reinhardt in "Monochrome Malerei in Amerika seit 1950," *Kunstforum*, 88 (March 1987), pp. 114–26. For a justification of the nonverbal position in regard to more recent painting, see: Joseph Marioni, "Gegenwärtig-Sein," in *Günter Umberg*, exh. cat., Frankfurt am Main, Städtische Galerie im

Städelschen Kunstinstitut, 1985, pp. 31–43. One might consider also in this regard Jean-François Lyotard's idea that music and art deal with an order of experiences not available to words, that figural forms in music and art are "gaps" in verbally accessible reality, and that when these figures are presented as if they were communicable in words, as Lyotard has suggested, one is in the presence, not of an explanation, but of an ideology; see: "Notes on the Critical Function of a Work of Art," *Driftworks*, New York, 1984, pp. 69–70.

3. From a letter by the artist excerpted in *Tiger's Eye*, 7 (March 1949), p. 60.

4. David Smith, in *David Smith*, ed. Garnett McCoy, New York, p. 71; speech given on WNYC, October 30, 1952, transcript in David Smith File, Library, The Museum of Modern Art.

5. Barnett Newman, "Adolph Gottlieb," New York, Wakefield Gallery, February 7–19, 1944, n. pag.

6. Mark Rothko to Barnett Newman, n.d., Barnett Newman Papers, Archives of American Art, Washington D.C., Smithsonian Institution, Roll 3481.

7. Quoted in Dore Ashton, *About Rothko*, New York, 1983, p. 134.

8. Jackson Pollock, in Sidney Janis, *Abstract and Surrealist Art in America*, New York, 1944, p. 112.

9. Seymour Lipton, undated statement in the Seymour Lipton Papers, Archives of American Art, Smithsonian Institution, Washington, D. C., Roll D-386.

10. Porter's show included William Baziotes, Adolph Gottlieb, Jackson Pollock, Louise Bourgeois, Richard Pousette-Dart, and Mark Rothko. David Porter, "Foreword," *Personal Statement: A Painting Prophecy – 1950*, exh. cat., Washington, D. C., David Porter Gallery, 1945, n. pag.

11. Douglas Cooper, review in *The Listener*, July 6, 1950; reprinted in Francis V. O'Connor, *Jackson Pollock*, exh. cat., New York, The Museum of Modern Art, 1967, p. 53.

12. Louise Bourgeois Papers, Archives of American Art, Smithsonian Institution, Washington D. C., Roll 54.

13. Alfred Barr, "Introduction," *The New American Painting* (cited n. 3), p. 17.

14. William Baziotes, "The Artist and His Mirror," *Right Angle*, 3 (June 1949), p. 33.

15. Clement Greenberg, "Towards a Newer Laocoon," *Partisan Review*, 6 (Fall 1940).

16. Donald Kuspit, *Clement Greenberg*, Madison, Wis., 1979, pp. 19, 36, 169–70.

17. Irving Sandler, *The Triumph of American Painting*, New York, 1970, pp. 5–12; T. J. Clark, "Clement Greenberg's Theory of Art," *Critical Inquiry*, 9 (September 1982), pp. 139–56; Serge Guilbaut, "The New Adventures of the Avant-Garde in America: Greenberg, Pollock, or from Trotskyism to the New Liberalism of the 'Vital Center,'" *October*, 15 (Winter 1980), pp. 61–78, and *How New York Stole the Idea of Modern Art*, Chicago, 1983,

pp. 25–29, 38–39; Fred Orton and Griselda Pollock, "Avant-Gardes and Partisans Reviewed," *Art History*, 4 (September 1981), pp. 305–27.

18. For instance, in 1948 Barnett Newman characterized the use of paint to evoke the illusion of other substances, such as flesh or velvet, as a "beauty-cult." European art failed to achieve the sublime in part because of its "blind desire to exist inside the reality of sensation (the objective world whether distorted or pure)." Newman saw European culture in "the grip of the *rhetoric* of exaltation as an attitude . . . caught without a sublime content, and unable to move away from the Renaissance imagery of figures and objects except by distortion [Surrealism; Expressionism] or by denying it completely for an empty world of geometric formalisms [Neoplasticism]"; "The Sublime is Now," *Tiger's Eye*, 6 (October 1948), pp. 51–53.

19. Sandler (cited n. 17), pp. 34–41; Paul Rodgers, "Towards a Theory/Practice of Painting: Abstract Expressionism and the Surrealist Discourse," *Artforum*, 18 (March 1980), pp. 53–61.

20. Robert Motherwell, "The Modern Painter's World," *Dyn*, 6 (November 1944), p. 13.

21. Carl G. Jung, *Modern Man in Search of a Soul*, trans. W. S. Dell and Cary F. Baynes, New York, 1966 [1933], pp. 164, 171.

22. Ernest Jones, "The Theory of Symbolism," 1916, in *Papers on Psychoanalysis*, 5th ed., Boston, 1961, p. 97.

23. Lionel Trilling, "Freud and Literature" (originally "The Legacy of Sigmund Freud: Literary and Aesthetic," in the *Kenyon Review*, 2 [1940], pp. 162–68), reprinted in *The Liberal Imagination*, New York, 1948, pp. 47–49.

24. Mary Fuller McChesney, *A Period of Exploration: San Francisco 1945–1950*, exh. cat., Oakland, The Oakland Museum Art Department, 1973, pp. 21–22.

25. Adolph Gottlieb, in "American Exhibit Scores" in *The American Weekend* (April 18, 1959), p. 12, quoted in Mary Davis MacNaughton, "Adolph Gottlieb: His Life and Art," *Adolph Gottlieb: A Retrospective*, exh. cat., Washington, D. C., Corcoran Gallery of Art, 1981, p. 38.

26. One of the most recent of these, Donald Gordon, "Pollock's 'Bird,'" in *Art in America*, 68 (October 1980), pp. 43–53, contains in its endnotes a bibliographic guide to earlier material on Pollock and Jung.

27. Jackson Pollock, "My Painting," *Possibilities*, 1 (Winter 1947/48), p. 84.

28. Selden Rodman, *Conversations with Artists*, New York, 1961, p. 128.

29. This was suggested by Yve-Alain Bois, in "Ryman's Tact," *October*, 19 (Winter 1981), p. 101.

30. Richard Wollheim, "Criticism as Retrieval," *Art and Its Objects*, 2nd ed., Cambridge, 1980, pp. 185, 191–93.

31. For Kuspit on Greenberg and artistic intention, see: *Clement Greenberg* (cited n. 16), pp. 168–73; for Eliot, Greenberg, and the dissociation of sensibility: ibid., pp. 106–12; for the quotation from Eliot, see: "Tradition

and Individual Talent," in T. S. Eliot, *Selected Essays, 1917–1932*, New York, 1932, p. 10. Greenberg's New Critical leanings have not gone without parenthetical observation; Benjamin Buchloh, for instance, noted "the normative aesthetics of Greenberg's formalist 'new criticism,'" in "Michael Asher and the Conclusion of Modernist Sculpture," in *Theories of Contemporary Art*, ed. Richard Hertz, Englewood Cliffs, N. J., 1985, p. 233.

32. Rodman (cited n. 28), p. 93.

33. Cleanth Brooks, *The Well-Wrought Urn*, New York [1947], 1975, pp. 196–214.

34. Herbert Ferber, at the "Waldorf Panel 1: The Spontaneous and Design," *It Is*, 6 (1965), p. 57.

35. Clement Greenberg, "Avant-Garde and Kitsch," *Partisan Review*, 6 (Fall 1939), p. 35.

36. Greenberg (cited n. 15), p. 298.

37. Clement Greenberg in *Barnett Newman: First Retrospective Exhibition*, exh. cat., Bennington College, Bennington, Vt., May 4–May 24, 1958.

38. The fact that a painter like Pollock may have preferred Herman Melville and Dylan Thomas to New Critical favorites such as Ezra Pound and Wallace Stevens suggests that the New Criticism was hardly the sole source of the anti-intentionalist stance. Pollock owned Dylan Thomas's *Collected Poems* and also recordings of Thomas reading that he played frequently (Francis V. O'Connor and Eugene Thaw, *Jackson Pollock*, 4 vols., New Haven, 1978, vol. 4, p. 196). He also admired Melville. Not coincidentally, perhaps, Jung (cited n. 21, p. 154) considered Melville's *Moby Dick* to be the greatest American novel, placing it in the category of "visionary" works of art. For the literary preferences of a New Critic such as John Crowe Ransom, see: Max I. Baym, *A History of Literary Aesthetics in America*, New York, 1973, p. 252.

39. *Tiger's Eye*, 1 (October 1947), p. 76.

40. Scholars such as Victor Erlich, Frederic Jameson, Barbara Korpan, and Serge Doubrovsky have noted points of contact between Russian Formalist thought and Anglo-American New Criticism.

41. For Jakobson's and Zirmunskij's views on this matter, see: Victor Erlich, *Russian Formalism*, New Haven, 1965, pp. 186–91.

42. Maurice Tuchman has suggested that among American artists, Ad Reinhardt, David Hare, and George Rickey were aware of Suprematist and Constructivist tenets; see: "The Russian Avant-Garde and the Contemporary Artist," in *The Avant-Garde in Russia, 1910–1930*, exh. cat., Los Angeles County Museum of Art (1980), p. 118. By 1953, Victor Erlich had published "The Russian Formalist Movement," *Partisan Review*, 20 (May–June), in which he noted (p. 293) that words were for poets what colors were for painters.

43. Jean Fremon, "Louise Bourgeois," *New Observations*, 50 (September 1987), p. 50; Hedda Sterne, interview with the author, New York City, May 12, 1988.

ABSTRACT EXPRESSIONISM AND LANGUAGE 209

44. Ad Reinhardt, "25 Lines of Words on Art," *It Is*, 1 (Spring 1958), p. 42.

45. Gail Levin, "Miró, Kandinsky, and the Genesis of Abstract Expressionism," in Robert Carleton Hobbs and Gail Levin, *Abstract Expressionism: The Formative Years*, Ithaca, N. Y., 1978, pp. 32–38, and 40, n. 4.

46. Erlich (cited n. 41), pp. 271–75.

47. Barnett Newman, *Theresa Zarnower*, exh. cat., New York, Art of this Century, April 23–May 11, no year given; but Melvin Lader, "Peggy Guggenheim's Art of This Century: The Surrealist Milieu and the American Avant-Garde, 1942–1947" (Ph.D. diss., University of Delaware, 1981), p. 429, notes that Zarnower's exhibition was in 1946.

48. This was sometime between 1935 and 1939. (Dorothy Dehner, telephone interview with the author, October 24, 1985.) David Margolis remembers that not only were David Smith and Dorothy Dehner good friends of his and Margo's, but that Arshile Gorky was, too. They would speak with these artists about Russian aesthetics, an area in which the Margolis brothers felt Russian thinkers were ahead of those in America. Margolis knew Pollock (he had been at the Art Students League), Rothko, and Newman. (David Margolis, telephone interview with the author, October 24, 1985.)

49. Marcia Allentuck Epstein, *John Graham's System and Dialectic of Art*, Baltimore, 1971, p. 11.

50. Ibid., p. 25. For Burliuk's close relation to Milton Avery in the early forties, see the letters from the Averys to Louis and Annette Kaufmann, Mr. and Mrs. Louis Kaufmann Papers, Archives of American Art, Smithsonian Institution, Washington D. C., Roll 1119.

51. Quoted in Erlich (cited n. 41), p. 44. For Burliuk's relation to Mayakovsky, see also his periodical *Color and Rhyme*, published from the 1930s through the mid 1960s, which contains many reminiscences of Mayakovsky. See especially: Mike Gold, "Burliuk: Father of Russian Futurism, 1942," *Color and Rhyme*, 37 (1958), pp. 8–9, and the (unnumbered) issue of *Color and Rhyme* (1966), an 80th birthday celebration for Burliuk containing much biographical information. I wish to thank Andrew Masullo for calling my attention to *Color and Rhyme*.

52. Willem de Kooning, statement in "Artists' Sessions at Studio 35 (1950)," *Modern Artists in America*, New York, 1952, p. 16.

53. Harold Rosenberg, "The American Action Painters," *Art News*, 51 (September 1952), pp. 48, 49.

54. Ibid.

55. Fritjof Bergmann, "Sartre on the Nature of Consciousness," *American Philosophical Quarterly* (April 1982), p. 158.

56. In his interpretation, Sartre departed from the view developed by Husserl, who believed that intentionality was the apprehension of an object by consciousness, and that in the process of referring to an object, human consciousness endows it with meaning. For a discussion of Husserl's conception, see: Donn Welton, "Intentionality and Language in Husserl's Phenomenology," *Review of Metaphysics*, 27 (December 1973), pp. 260–97.

210 ANN GIBSON

57. Rosenberg (cited n. 53), p. 48. Rosenberg's elusive description of action painting might be studied with Michel Foucault's later description of a "statement" – as a discourse whose subject should not be regarded as synonymous with the author who formulated it – in mind. "To describe a formulation *qua* statement," wrote Foucault, "does not consist in analysing the relations between the author and what he says (or wanted to say, or said without wanting to); but in determining what position can and must be occupied by any individual if he is to be the subject of it"; *Archaeology of Knowledge*, trans. Alan Sheridan, New York, 1972, pp. 95–96. In other words, as Alan Sheridan has commented, this kind of discourse is not about objects; rather, it constitutes them; see: Alan Sheridan, *Michel Foucault: The Will to Truth*, London, 1980, p. 98. It is almost uncomfortably tidy that whenever Abstract Expressionists did comment on their work, they most often entitled that verbal formation a "statement."

58. For a discussion of these ways of short-circuiting the dialectic, see: Theodor Adorno, *The Jargon of Authenticity*, trans. Knut Tarnowski and Frederic Will, Evanston, Ill., 1973 [1963], esp. pp. 113–21.

59. As contrasted with science and faith, however, Ricoeur suggested that philosophy (to which I would add, art history), *must* confront the question of the validity of the object. The philosopher-historian expresses concern for the cause, for the genesis and function of the object because he or she cares about the object, and expects that from the study of it something valid will address itself to him or her; Paul Ricoeur, *Freud and Philosophy*, trans. Dennis Savage, New Haven, 1970, pp. 27–31.

60. See Frederic Jameson, *The Prison House of Language*, Princeton, 1972, pp. 163–65, for a discussion of the verbal and oppositional nature of perception.

61. Some of these, in addition to the contributors to this issue of *Art Journal*, are Anna Chaeve, Anne Edgerton, Evan Firestone, Robert Hobbs, Rosalind Krauss, Joan Marter, Harry Rand, Elizabeth Langhorne Reeves, Roberta Tarbell, Judith Wolfe, and Sally Yard.

The Artists
and
Their Critics

SIX ARTISTS, generally acknowledged as leading exponents of Abstract Expressionism, are singled out for inclusion in this part. The choice is to some extent arbitrary, as a roster limited to six individuals is bound to be. Initially, Arshile Gorky, William Baziotes, Robert Motherwell, James Brooks, Philip Guston, Clyfford Still, Ad Reinhardt, Hans Hofmann, and half a dozen other painters were considered as well, but space does not allow room for all those who merit inclusion.

In making our choices among the major Abstract Expressionist painters we have attempted to reflect art history, not revise it. Thus, it seems to us that Willem de Kooning, Adolph Gottlieb, Franz Kline, Barnett Newman, Jackson Pollock, and Mark Rothko were and continue to be the mode's most visible highlights.

In Part III, a chronology for each artist is followed by a statement by each about his work, usually in the form of an explicit written credo, sometimes as an implied one elicited by an interviewer. Thereafter, remarks by diverse critics published in a variety of American and European periodicals or catalogues are presented in chronological order, beginning in 1943.

SELECTED CHRONOLOGY

1904	Born Rotterdam, Holland.
1916	Apprenticed to commercial artists; enrolls evening classes Academie voor Beeldende Kunsten en Technische Wetenschappen in Rotterdam; remains eight years.
1920	Introduced to *de Stijl* and *Jugenstijl* artists.
1924	Studies at Academie des Beaux-Arts, Brussels, and Van Schelling design school, Antwerp.
1925	Returns to Rotterdam; completes studies at Academie there.
1926	Emigrates to United States.
1927–35	Works as free-lance commercial artist.
1934	Joins Artists Union.
1935	Employed by WPA Federal Arts Project; removed when it is learned he is not a U.S. citizen.
1936	Included, "New Horizons in American Art," exhibition of works from WPA Arts Projects, Museum of Modern Art.
1937	Designs mural for Hall of Medicine, New York World's Fair.
1941	Designs murals for United States Maritime Commission for *S. S. President Jackson*.
1942	Included, "American and French Paintings," McMillen Gallery, New York, selected by John Graham.
1943	Included, group show, Bignou Gallery, New York.
1944	Included, "Abstract and Surrealist Art in America," Mortimer Brandt Gallery, New York, selected by Sidney Janis. Participants include William Baziotes, Adolph Gottlieb, Mark Rothko.
1948	First solo show, Egan Gallery, New York; also 1951. Teaches, summer, Black Mountain College. Museum of Modern Art acquires *Painting, 1948*. Included, "Annual

	Exhibition of Contemporary American Painting," Whitney Museum of American Art; also 1949, 1950, 1951, 1952, 1953, 1954, 1956, 1959, 1963, 1965, 1967, 1969, 1972.
1949	Included, "The Intrasubjectives," Kootz Gallery, New York, organized by Harold Rosenberg and Samuel Kootz.
1950	Solo show, "XXV Venice Biennale," curated by Alfred H. Barr, Jr.
1950–1	Teaches at Yale University School of Fine Arts.
1951	First Prize, "International Exhibition of Contemporary Painting," Carnegie Institute. Included again 1955, 1956, 1958, 1961, 1964, 1970. Included, "Ben Shahn, Willem de Kooning, Jackson Pollock," Arts Club of Chicago; "Abstract Painting and Sculpture in American," Museum of Modern Art; "First São Paulo Bienal," organized by International Council, Museum of Modern Art; also in 1953. Logan Medal and purchase prize, "Sixtieth Annual American Exhibition," Art Institute of Chicago.
1953	Solo show, Sidney Janis Gallery; also 1956, 1959, 1962, 1972. First retrospective, School of the Museum of Fine Arts, Boston.
1954	De Kooning and each of the following have solo show: Ben Shahn, Ibram Lassaw, Gaston Lachaise, David Smith, "XXVII Venice Biennale," organized by Museum of Modern Art. Included, "Younger American Painters," Solomon R. Guggenheim Museum.
1955	Solo show, Martha Jackson Gallery, New York. Included, "The New Decade: 35 American Painters and Sculptors," Whitney Museum of American Art.
1956	Included, "XXVIII Venice Biennale," organized by Art Institute of Chicago.
1957	Solo show, Leo Castelli Gallery. Included, "American Paintings: 1955–1957," Minneapolis Institute of Arts.
1958–9	Included, "Nature in Abstraction," Whitney Museum of American Art, circulated nationally; "The New American Painting," organized and circulated by International Council, Museum of Modern Art, to Switzerland, Italy, Spain, West Germany, Holland, Belgium, France, England and finally, Museum of Modern Art, New York.
1959	Included, "New Images of Man," Museum of Modern Art; "Documenta II," Kassel, West Germany.
1960	Elected to National Institute of Arts and Letters.

1961	Solo show, Paul Kantor Gallery, Beverly Hills, California. Included, "American Abstract Expressionists and Imagists," Solomon R. Guggenheim Museum.
1962	Included, "American Vanguard," organized by United States Information Agency; circulated Austria, Poland, Yugoslavia, England. Included, "Art Since 1950," Seattle World's Fair, also shown Brandeis University and Institute of Contemporary Art, Boston; "International Exhibition," Stedelijk Museum, Amsterdam; "Biennial Exhibition of Contemporary American Painting," Corcoran Gallery, Washington, D. C. Two-person show with Barnett Newman, Allan Stone Gallery, New York.
1963–64	Solo show, Allan Stone Gallery, New York; also 1971. Included, "Painting and Sculpture of a Decade, '54–'64," Tate Gallery, London; "Within the Easel Convention: Sources of Abstract Expressionism," Fogg Museum, Cambridge, Mass.
1965	Included, "New York School: The First Generation, Paintings of the 1940s and 1950s," Los Angeles County Museum of Art.
1967	Included, "Two Decades of American Painting," organized by International Council, Museum of Modern Art; shown in Australia, Japan, India. Included, "Six peintres américains: Gorky, Kline, de Kooning, Newman, Pollock, Rothko," M. Knoedler & Cie, Paris.
1968	Solo show, M. Knoedler & Cie, Paris; also 1969.
1968–9	Retrospective, Stedelijk Museum, Amsterdam, organized by Museum of Modern Art, circulated to Tate Gallery, London; Museum of Modern Art, New York; Art Institute of Chicago; Los Angeles County Museum of Art.
1969	Solo show, "XVII Festival dei Due Mondi," Spoleto. Included, "New York Painting and Sculpture, 1940–1970," Metropolitan Museum of Art; "Painting in New York, 1944–1969," Pasadena Art Museum.
1970	Begins life-size sculpture.
1972	Solo show, Baltimore Museum of Art.
1974	Solo shows: Walker Art Museum, Minneapolis, circulated nationally; Richard Gray Gallery, Chicago.
1975	Awarded Edward MacDowell Medal. Solo shows: Galerie des Arts, Paris; Fourcade-Droll, New York, also in 1976, 1977, 1986.

1976	Solo show, Stedelijk Museum, Amsterdam; circulated to West Germany, Switzerland, France. Included, "The Golden Door: Artist Immigrants of America, 1876– 1976," Hirshhorn Museum and Sculpture Garden, Smithsonian Institution.
1977	Included, "Documenta VI," Kassel, West Germany. Circulating solo exhibition of sculpture, painting, drawing, and lithography organized by the Arts Council of Great Britain. Solo show, organized by International Communication Agency of the United States and the Hirshhorn Museum and Sculpture Garden; circulated nationally.
1978	Solo shows: Solomon R. Guggenheim Museum; Hesingen Kaupungin Taidekokoelmat, Helsinki; Carnegie Institute, Pittsburgh.
1981	Retrospective, Guild Hall, East Hampton, New York.
1983–4	Two circulating exhibitions, one of paintings, the other of drawings, organized by Whitney Museum of American Art.
1987	Included, "Abstract Expressionism: the Critical Developments," Albright-Knox Gallery, Buffalo.
1987–8	"Postwar Paintings from Brandeis University"; circulated nationally by the American Federation of Arts.

WHAT ABSTRACT ART MEANS TO ME

Willem de Kooning

THE FIRST MAN who began to speak, whoever he was, must have intended it. For surely it is talking that has put "Art" into painting. Nothing is positive about art except that it is a word. Right from there to here all art became literary. We are not yet living in a world where everything is self-evident. It is very interesting to notice that a lot of people who want to take the talking out of painting, for instance, do nothing else but talk about it. That is no contradiction, however. The art in it is the forever mute part you can talk about forever.

For me, only one point comes into my field of vision. This narrow, biased point gets very clear sometimes. I didn't invent it. It was already here. Everything that passes me I can see only a little of, but I am always looking. And I see an awful lot sometimes.

The word "abstract" comes from the light-tower of the philosophers, and it seems to be one of their spotlights that they have particularly focussed on "Art." So the artist is always lighted up by it. As soon as it – I mean the "abstract" – comes into painting, it ceases to be what it is as it is written. It changes into a feeling which could be explained by some other words, probably. But one day, some painter used "Abstraction" as a title for one of his paintings. It was a still life. And it was a very tricky title. And it wasn't really a very good one. From then on the idea of abstraction became something extra. Immediately it gave some people the idea that they could free art from itself. Until then, Art meant everything that was in it – not what you could take out of it. There was only one thing you could take out of it sometime when you were in the right mood – that abstract and indefinable sensation, the esthetic part – and still leave it where it was. For the painter to come to the "abstract" or the "nothing," he needed many things. Those things were always things in life – a horse, a flower, a milkmaid, the light in a room through

From *Statements by Six American Artists*. The Museum of Modern Art, New York, *Bulletin*, Volume XVIII, No. 3, Spring 1951. All rights reserved. Reprinted by permission.

WILLEM DE KOONING, *Door to the River*, 1960. Oil on Canvas 80″ × 70″.
Collection of Whitney Museum of American Art. Purchase, with funds from the
Friends of the Whitney Museum of American Art. 60.63. (Photo by Geoffrey
Clements)

a window made of diamond shapes maybe, tables, chairs, and so forth.
The painter, it is true, was not always completely free. The things were
not always of his own choice, but because of that he often got some new
ideas. Some painters liked to paint things already chosen by others, and
after being abstract about them, were called Classicists. Others wanted to
select the things themselves and, after being abstract about them, were
called Romanticists. Of course, they got mixed up with one another a lot
too. Anyhow, at that time, they were not abstract about something which
was already abstract. They freed the shapes, the light, the color, the
space, by putting them into concrete things in a given situation. They *did*

220 WILLEM DE KOONING

think about the possibility that the things – the horse, the chair, the man – were abstractions, but they let that go, because if they kept thinking about it, they would have been led to give up painting altogether, and would probably have ended up in the philosopher's tower. When they got those strange, deep ideas, they got rid of them by painting a particular smile on one of the faces in the picture they were working on.

The esthetics of painting were always in a state of development parallel to the development of painting itself. They influenced each other and vice versa. But all of a sudden, in that famous turn of the century, a few people thought they could take the bull by the horns and invent an esthetic beforehand. After immediately disagreeing with each other, they began to form all kinds of groups, each with the idea of freeing art, and each demanding that you should obey them. Most of these theories have finally dwindled away into politics or strange forms of spiritualism. The question, as they saw it, was not so much what you *could* paint but rather what you could *not* paint. You could *not* paint a house or a tree or a mountain. It was then that subject matter came into existence as something you ought *not* to have.

In the old days, when artists were very much wanted, if they got to thinking about their usefulness in the world, it could only lead them to believe that painting was too worldly an occupation and some of them went to church instead or stood in front of it and begged. So what was considered too worldly from a spiritual point of view then, became later – for those who were inventing the new esthetics – a spiritual smoke-screen and not worldly enough. These latter-day artists were bothered by their apparent uselessness. Nobody really seemed to pay any attention to them. And they did not trust that freedom of indifference. They knew that they were relatively freer than ever before *because* of that indifference, but in spite of all their talking about freeing art, they really didn't mean it that way. Freedom to them meant to be useful in society. And that is really a wonderful idea. To achieve that, they didn't need *things* like tables and chairs or a horse. They needed ideas instead, social ideas, to make their objects with, their constructions – the "pure plastic phenomena" – which were used to illustrate their convictions. Their point was that until they came along with their theories, Man's own form in space – his body – was a private prison; and that it was because of this imprisoning misery – because he was hungry and overworked and went to a horrid place called home late at night in the rain, and his bones ached and his head was heavy – because of this very consciousness of his own body, this sense of pathos, they suggest, he was overcome by the drama of a crucifixion in a painting or the lyricism of a group of people sitting

quietly around a table drinking wine. In other words, these estheticians proposed that people had up to now understood painting in terms of their own private misery. Their own sentiment of form instead was one of comfort. The beauty of comfort. The great curve of a bridge was beautiful because people could go across the river in comfort. To compose with curves like that, and angles, and make works of art with them could only make people happy, they maintained, for the only association was one of comfort. That millions of people have died in war since then, because of that idea of comfort, is something else.

This pure form of comfort became the comfort of "pure form." The "nothing" part in a painting until then – the part that was not painted but that was there because of the things in the picture which were painted – had a lot of descriptive labels attached to it like "beauty," "lyric," "form," "profound," "space," "expression," "classic," "feeling," "epic," "romantic," "pure," "balance," etc. Anyhow that "nothing" which was always recognized as a particular something – and as something particular – they generalized, with their book-keeping minds, into circles and squares. They had the innocent idea that the "something" existed "in spite of" and not "because of" and that this something was the only thing that truly mattered. They had hold of it, they thought, once and for all. But this idea made them go backward in spite of the fact that they wanted to go forward. That "something" which was not measurable, they lost by trying to make it measurable; and thus all the old words which, according to their ideas, ought to be done away with got into art again: pure, supreme, balance, sensitivity, etc.

Kandinsky understood "Form" as *a* form, like an object in the real world; and an object, he said, was a narrative – and so, of course, he disapproved of it. He wanted his "music without words." He wanted to be "simple as a child." He intended, with his "inner-self," to rid himself of "philosophical barricades" (he sat down and wrote something about all this). But in turn his own writing has become a philosophical barricade, even if it is a barricade full of holes. It offers a kind of Middle-European idea of Buddhism or, anyhow, something too theosophic for me.

The sentiment of the Futurists was simpler. No space. Everything ought to keep on going! That's probably the reason they went themselves. Either a man was a machine or else a sacrifice to make machines with.

The moral attitude of Neo-Plasticism is very much like that of Constructivism, except that the Constructivists wanted to bring things out in the open and the Neo-Plasticists didn't want anything left over.

222 WILLEM DE KOONING

I have learned a lot from all of them and they have confused me plenty too. One thing is certain, they didn't give me my natural aptitude for drawing, I am completely weary of their ideas now.

The only way I still think of these ideas is in terms of the individual artists who came from them or invented them. I still think that Boccioni was a great artist and a passionate man. I like Lissitzky, Rodchenko, Tatlin and Gabo; and I admire some of Kandinsky's painting very much. But Mondrian, that great merciless artist, is the only one who had nothing left over.

The point they all had in common was to be both inside and outside at the same time. A new kind of likeness! The likeness of the group instinct. All that it has produced is more glass and an hysteria for new materials which you can look through. A symptom of love-sickness, I guess. For me, to be inside and outside is to be in an unheated studio with broken windows in the winter, or taking a nap on somebody's porch in the summer.

Spiritually I am wherever my spirit allows me to be, and that is not necessarily in the future. I have no nostalgia, however. If I am confronted with one of those small Mesopotamian figures, I have no nostalgia for it but, instead, I may get into a state of anxiety. Art never seems to make me peaceful or pure. I always seem to be wrapped in the melodrama of vulgarity. I do not think of inside or outside – or of art in general – as a situation of comfort. I know there is a terrific idea there somewhere, but whenever I want to get into it, I get a feeling of apathy and want to lie down and go to sleep. Some painters, including myself, do not care what chair they are sitting on. It does not even have to be a comfortable one. They are too nervous to find out where they ought to sit. They do not want to "sit in style." Rather, they have found that painting – any kind of painting, any style of painting – to be painting at all, in fact – is a way of living today, a style of living so to speak. That is where the form of it lies. It is exactly in its uselessness that it is free. Those artists do not want to conform. They only want to be inspired.

The group instinct could be a good idea, but there is always some little dictator who wants to make his instinct the group instinct. There *is* no style of painting now. There are as many naturalists among the abstract painters as there are abstract painters in the so-called subject-matter school.

The argument often used that science is really abstract, and that painting could be like music and, for this reason, that you cannot paint a man leaning against a lamp-post, is utterly ridiculous. That space of science – the space of the physicists – I am truly bored with by now. Their

lenses are so thick that seen through them, the space gets more and more melancholy. There seems to be no end to the misery of the scientists' space. All that it contains is billions and billions of hunks of matter, hot or cold, floating around in darkness according to a great design of aimlessness. The stars *I* think about, if I could fly, I could reach in a few old-fashioned days. But physicists' stars I use as buttons, buttoning up curtains of emptiness. If I stretch my arms next to the rest of myself and wonder where my fingers are – that is all the space I need as a painter.

Today, some people think that the light of the atom bomb will change the concept of painting once and for all. The eyes that actually saw the light melted out of sheer ecstasy. For one instant, everybody was the same color. It made angels out of everybody. A truly Christian light, painful but forgiving.

Personally, I do not need a movement. What was given to me, I take for granted. Of all movements, I like Cubism most. It had that wonderful unsure atmosphere of reflection – a poetic frame where something could be possible, where an artist could practise his intuition. It didn't want to get rid of what went before. Instead it added something to it. The parts that I can appreciate in other movements came out of Cubism. Cubism *became* a movement, it didn't set out to be one. It has force in it, but it was no "force-movement." And then there is that one-man movement, Marcel Duchamp – for me a truly modern movement because it implies that each artist can do what he thinks he ought to – a movement for each person and open for everybody.

If I *do* paint abstract art, that's what abstract art means to me. I frankly do not understand the question. About twenty-four years ago, I knew a man in Hoboken, a German who used to visit us in the Dutch Seamen's Home. As far as he could remember, he was always hungry in Europe. He found a place in Hoboken where bread was sold a few days old – all kinds of bread: French bread, German bread, Italian bread, Dutch bread, Greek bread, American bread and particularly Russian black bread. He bought big stacks of it for very little money, and let it get good and hard and then he crumpled it and spread it on the floor in his flat and walked on it as on a soft carpet. I lost sight of him, but found out many years later that one of the other fellows met him again around 86th street. He had become some kind of a Jugend Bund leader and took boys and girls to Bear Mountain on Sundays. He is still alive but quite old and is now a Communist. I could never figure him out, but now when I think of him, all that I can remember is that he had a very abstract look on his face.

DE KOONING'S WOMEN

Interview with Willem de Kooning

David Sylvester

SYLVESTER: Are you conscious of your European formation?
De Kooning: No, I'm not conscious of it at all. That is all over.
It's not so much that I'm an American; I'm a New Yorker. You
know, I think we have gone back to the cities and I feel much more in
common with an artist in London, you know, or Paris. It is a certain
burden, this American-ness. If you come from a small nation, you don't
have that. When I went to the Academy and I was drawing from the
nude, *I* was making the drawing, not Holland, do you see what I mean?
Now it is getting a little bit of a bore; I feel sometimes that an artist must
feel like a baseball player or something, a member of a team writing
American history.

Sylvester: When you started to paint the Women, you were doing
something much more overtly figurative than any of the other so-called
action painters or abstract expressionists had been doing. You must have
felt you were out on a bit of a limb?

De Kooning: Yes, they attacked me for that, certain artists and
critics, but I felt this was their problem, not mine. I don't really feel like a
non-objective painter at all. Some painters feel they have to go back
to the figure, and that word "figure," that becomes such a ridiculous
omen. In a way, if you pick up some paint with your brush and make
somebody's nose with it, this is rather ridiculous, when you think of it,
theoretically or philosophically. It's really absurd to make an image, like
a human image, with paint, today, since we have this problem of doing or
not doing it. But then all of a sudden it becomes even more absurd not to
do it. So I fear that I'll have to follow my desires.

Sylvester: That's to say, when you started to do the Women, it wasn't

From *Ramparts*, Vol. 7, No. 71, 1969. Recorded in 1960 at the BBC. Reprinted by
permission of David Sylvester.

225

because you'd made a theoretical decision, as some painters have, to "return to the figure"? It was just a desire?

De Kooning: Yes. It had to do with the female painted through all the ages, all those idols. And maybe I'd been stuck to a certain extent, couldn't go on. And it did one thing for me: it eliminated composition, arrangement, relationships, light – I mean all this silly talk about light, color and form, you know – because there was this thing I wanted to get hold of. I put it in the center of the canvas because there was no reason to put it a bit on the side. So I thought I might as well stick to the idea that it's got two eyes, a nose and mouth and neck.

So I got to the anatomy and I felt myself always getting flustered. I really could never get hold of it; it always petered out. I never could complete it. And when I think of it now, it wasn't such a bright idea; but I don't think artists have particularly bright ideas. Matisse's "Woman in Blue," "Woman in a Red Blouse," or something – what an idea that is! Or the Cubists – when you think about it now, it is so silly to look at an object from many angles. It's good that they got those ideas because it is enough for some of them to become good artists.

Sylvester: Why do you think it is especially silly to paint the Women?

De Kooning: It is a thing in art that has been done over and over; you know, the idol, the Venus, the nude. Rembrandt wanted to paint an old man, a wrinkled old guy – that was painting to him. He got an idea about painting, he thought he wanted to paint this guy with the wrinkles, you know what I mean? Now the artists are in the state of a belated age of reason. They want to get hold of things, like Mondrian; he was a fantastic artist but now when we read his ideas and his idea of neo-plasticism, you know, pure plasticity, it's kind of silly, I think. Not for him. But one could spend one's life having this desire to be in and outside at the same time. He could see a future life and a future city – not like me, I am absolutely not interested in seeing the future city. I'm perfectly happy to be alive now.

Sylvester: While you were actually painting the Women, were you troubled by the absurdity of doing this thing again which had been done so many times before?

De Kooning: Oh yes, it became compulsive in the sense of not being able to get hold of it and the idea that it really is very funny, you know, to get stuck with a woman's knees, for instance. You say, what the hell am I going to do with that now, you know what I mean, it's really ridiculous, and it may be that it fascinates me that it isn't supposed to be done. I knew there are a lot of people, they paint a figure because they feel it ought to be done, because since they're a human being themselves, they

feel they ought to make another one, a substitute. I haven't got that interest at all. I really think it's sort of silly to do it. But like I said before, at the moment you take this attitude, it's just as silly not to do it. One has to have one's own convictions.

Sylvester: When you were painting them, you said, you found the problem of having to deal with a very specific subject stopped you from having to worry about aesthetic problems in the painting? It stopped you from having to think too much about problems of picture-making?

De Kooning: Well, yes, but in another way it became a problem of picture-making, because the very fact that it had a word connected with it – "figure of a woman" – made it more precise. Perhaps I am more of a novelist than a poet; I don't know; but I always like the word in painting, you know.

Sylvester: You like the forms to be identifiable?

De Kooning: Well, they ought to have an emotion of a concrete experience. I mean, like I am very happy to see that grass is green. At one time, it was very daring to make a figure red or blue: I think now it is just as daring to make it flesh-colored. I found that out for myself.

Content, if you want to say, is a glimpse of something, an encounter, you know, like a flash. It's very tiny – very tiny, content. When I was painting those figures, I was thinking about Gertrude Stein, like they were ladies of Gertrude Stein, like one of them would say: "How d'you like me?" Then I could sustain this thing all the time because it could change all the time; she could almost get upside down, or not be there, or come back again, she could be any size. Do you understand? Because this content could take care of almost anything that could happen, you know; and I still have it now from some fleeting thing – like when one passes something.

Sylvester: But the impact? You weren't concerned about getting a particular kind of drama or a particular kind of feeling?

De Kooning: No. When I look at them now, they look vociferous and ferocious, and I think it had to do with the idea of the idol, the oracle, and above all the hilariousness of it. I do think that if I don't look upon life that way, I won't know how to keep on being around.

Sylvester: So there was no question of any sort of attempt to make a comment on the time or the...?

De Kooning: No. Oh, maybe it turned out that way, and maybe subconsciously when I'm doing it, but I couldn't be that corny.

Sylvester: In one of the first studies, you put the mouth on in collage?

De Kooning: Yes, that helped me. I cut out a lot of mouths. First of all, I felt everything ought to have a mouth. Maybe it was like a pun,

DE KOONING'S WOMEN 227

maybe it's even sexual or whatever it is, I don't know. But anyhow I used to cut out a lot of mouths and then I painted those figures and then I put the mouth more or less in the place where it was supposed to be. It always turned out to be very beautiful and it helped me immensely to have this real thing. I don't know why I did it with the mouth. Maybe the grin – it's rather like the Mesopotamian idols, you know, they always stand up straight looking to the sky with this smile, like they were just astonished about the forces of nature, you feel, not about problems they had with one another. That I was very conscious of; and it was something to hang on to.

Sylvester: Because the mouth always stayed pretty much the same?

De Kooning: I wouldn't know what to do with the rest, you know, with the hands maybe, or some gesture, and then in the end I failed, you see. But it didn't bother me because I'd give it up in the end, and I felt it was really on accomplishment. I took the attitude that I was going to succeed and I also knew that this was just an illusion.

Sylvester: Do you feel that the paintings are failures?

De Kooning: The paintings? No, I never was interested how to make a good painting. For many years I was not interested in making a good painting like you could say, "Now this is really a good painting or a perfect work." I didn't want to pin it down at all. I was interested in that before but I found out it was not my nature.

Sylvester: What makes you feel that a painting is finished? When do you leave a picture alone?

De Kooning: Well, I always have a miserable time over it. But it is getting better now.

Sylvester: But what's the criterion – what is the point where you know you can stop the painting?

De Kooning: Oh, I really – I just stop. I sometimes get rather hysterical and because of that I sometimes find a terrific picture. As a matter of fact that's probably the real thing but I couldn't set out to do that. I set out keeping in mind that this thing will be a flop in all probability and, you know, it sometimes turns out very good.

REVIEW OF AN EXHIBITION OF WILLEM DE KOONING

Clement Greenberg

DECIDEDLY, the past year has been a remarkably good one for American art. Now, as if suddenly, we are introduced by Willem de Kooning's first show, at the Egan Gallery, to one of the four or five most important painters in the country, and find it hard to believe that work of such distinction should come to our notice without having given preliminary signs of itself long before. The fact is that de Kooning has been painting almost all his life, but only recently to his own satisfaction. He has saved one the trouble of repeating "promising." Having chosen at last, in his early forties, to show his work, he comes before us in his maturity, in possession of himself, with his means under control, and with enough knowledge of himself and of painting in general to exclude all irrelevancies.

De Kooning is an outright "abstract" painter, and there does not seem to be an identifiable image in any of the ten pictures in his show – all of which, incidentally, were done within the last year. A draftsman of the highest order, in using black, gray, tan, and white preponderantly he manages to exploit to the maximum his lesser gift as a colorist. For de Kooning black becomes a color – not the indifferent schema of drawing, but a hue with all the resonance, ambiguity, and variability of the prismatic scale. Spread smoothly in heavy somatic shapes on an un-crowded canvas, this black identifies the physical picture plane with an emphasis other painters achieve only by clotted pigment. De Kooning's insistence on a smooth, thin surface is a concomitant of his desire for purity, for an art that makes demands only on the optical imagination.

Just as the cubists and their more important contemporaries renounced a good part of the spectrum in order to push farther the radical reno-vation of painting that the fauves had begun (and as Manet had similarly excluded the full color shade in the eighteen sixties, when he did his most revolutionary work), so de Kooning, along with Gorky, Gottlieb,

From *The Nation*, April 24, 1948. By permission of Clement Greenberg.

Pollock, and several other contemporaries, has refined himself down to black in an effort to change the composition and design of post-cubist painting and introduce more open forms, now that the closed-form canon – the canon of the profiled, circumscribed shape – as established by Matisse, Picasso, Mondrian, and Miró seems less and less able to incorporate contemporary feeling. This canon has not been broken with altogether, but it would seem that the possibility of originality and greatness for the generation of artists now under fifty depends on such a break. By excluding the full range of color – for the essence of the problem does not lie there – and concentrating on black and white and their derivatives, the most ambitious members of this generation hope to solve, or at least clarify, the problems involved. And in any case black and white seem to answer a more advanced phase of sensibility at the moment.

De Kooning, like Gorky, lacks a final incisiveness of composition, which may in his case, too, be the paradoxical result of the very plenitude of his draftsman's gift. Emotion that demands singular, original expression tends to be censored out by a really great facility, for facility has a stubbornness of its own and is loath to abandon easy satisfactions. The indeterminateness or ambiguity that characterizes some of de Kooning's pictures is caused, I believe, by his effort to suppress his facility. There is a deliberate renunciation of will in so far as it makes itself felt as skill, and there is also a refusal to work with ideas that are too clear. But at the same time this demands a considerable exertion of the will in a different context and a heightening of consciousness so that the artist will know when he is being truly spontaneous and when he is working only mechanically. Of course, the same problem comes up for every painter, but I have never seen it exposed as clearly as in de Kooning's case.

Without the force of Pollock or the sensuousness of Gorky, more enmeshed in contradictions than either, de Kooning has it in him to attain to a more clarified art and to provide more viable solutions to the current problems of painting. As it is, these very contradictions are the source of the largeness and seriousness we recognize in this magnificent first show.

WILLEM DE KOONING

Dore Ashton

E VER SINCE THE INDUSTRIAL REVOLUTION, when the mass media
were born, the artist has been prey to popularizers. Their mission
is to reduce the large figure into rapidly grasped dimensions.
Willem de Kooning, because of his international renown, has suffered
more than most painters from the pitiless simplifications of the press. He
has been pursued, interviewed, misquoted, misunderstood, and widely
misrepresented.

Of course the simplicist phenomenon is not reserved for painters alone.
A striking instance recently was the response in the popular press (which
nowadays includes "class" as well as certain little magazines) to Jean-
Paul Sartre's autobiography *The Words*. Writers both in the United
States and Europe quoted certain of Sartre's double-edged ironies as
though they were not ironic but merely flat statements. They insisted on
reading him on a single level. Sartre was obliged to grant an interview to
correct misunderstandings. The essence of his interview was a discreet
plea to be read as the complex, contradictory, uneasy man that he is –
that any artist is.

De Kooning might have made the same plea. Most of his working life
has been an elaborate contest with contradiction, a contest not so easily
condensed. In a sense, de Kooning as a painter and Sartre as a writer –
men of the same generation – have pursued similar courses. Sartre, as he
emerges in his autobiography, is an heroic challenger of the sacred – in
his case, the sacred position of the writer in Western Civilization. He
does not deny the strong basis in literary tradition from which he springs,
but seeks to combat its suffocating consequences. If he writes in *The
Words*, "I have often thought against myself," he explains in the inter-
view that it is not a confession of masochism. Rather, "that is how one
should think: revolting against everything 'inculcated' that one may have
within oneself."

From the catalogue essay of the Smith College Museum of Art, April 8–May 2, 1965.
Reprinted by permission of Dore Ashton and the Smith College Museum of Art.

231

De Kooning has done no less. For this we have the testimony of his works. He has been a consistent challenger of the sacred position of the painter. He has been an unrelenting inquisitor into the meaning of history and his own existence. He has pondered the traditions which formed him and revolted against everything "inculcated." He has thought against himself in the subtle sense that Sartre uses this phrase, and the summaries of these thoughts and counter-thoughts are his paintings.

Because of his ceaseless questing, de Kooning's *oeuvre* is pitched in widely differing keys. His moods have ranged from tender to satiric, from lusty to angry, from sensuous to austere, from classical to rococo. His strong personality shows in unmistakeable traits evident from the beginning, but variations are wide. Too often de Kooning has been read exclusively as a painter of gesture, as though the gesture itself were singularly significant. But though de Kooning's peculiarity of touch, and his reflexive, quirky lines are identifiable throughout his work, there is more, much more to his image.

De Kooning's gesture is only one of the characteristics to which we must look. As Henri Focillon points out in his beautiful essay "In Praise of Hands," although "the hand means action: it grasps, it creates, at times it would even seem to think," finally, "the artist's eye, which has followed the shapes of things and has judged their relative density, performed the same gestures as his hand." It is de Kooning's eye, his mind, as much as his hand, which shapes the distinctive images that are his paintings.

That mind has been consistently preoccupied with the major 20th century revolution in painting: the revolution in the way space is appre-hended. De Kooning's signal achievement is not his greatly magnified, expressionist brushwork (which has a long history) but rather, his clear, idiosyncratic statement of a special kind of space.

If there is any doubt of this, de Kooning himself dispels it in one of his few published statements, "The Renaissance and Order." It is largely devoted to a discussion of spaces – Renaissance spaces which, as he says, were for events that always took place on earth, "this large, marvelous floor" that the painter worked on. He groups artists from the distant past to Giacometti because "they had a peculiar way of measuring." Those artists, he says, are on a "train track going way back to Mesopotamia."

As he clearly indicates throughout this essay, de Kooning is concerned with the spaces where things happen. But he is a 20th century painter, and well-informed, and things do not happen as they did during the Renaissance. Much of this history of de Kooning's work is a history of argument with Renaissance conventions. He admires the sense of place,

the "idea that the thing the artist is making can come to know for itself how high it is, how wide and how deep it is," because it comes from man's own image. But he also shares the modern artist's imperative to chart new spaces.

Whatever happens in a de Kooning painting happens in the peculiar spaces he has invented – the habitable spaces of his imagination. In certain of his small pencil or charcoal drawings for example, he places a human figure on a white ground as though it were nowhere. Yet, on some part of the page his hand arabesques, describing a light, looping line that eloquently declares that the occasion is specific. The figure exists in an environment and that environment is one known to the artist intimately.

As a painter who knows the value of history, de Kooning sought to understand the recent history of paintings thoroughly. He restlessly tried out cubism, surrealism, and even the formal abstraction practised by a small American avant-garde during the 1930s. When his hand could not capture the nuances of his visions, he shifted gears and attacked from an entirely different position. When, as in the early years, a certain melancholic nostalgia seeped into his paintings – the tender pinks and yellows receding behind a portrait bust – he doubled back to express its contrary. As he said in 1951, "Some painters, including myself, do not care what chair they are sitting on. It does not even have to be a comfortable one. They are too nervous to find out where they ought to sit."

The portraits done in the late 1930s and early 1940s for instance, indicate not only de Kooning's awareness of the analytic method of the cubists, in which parts are often considered separately before they are treated in relation to the whole, but also show his search for a way of amplifying picture space.

Already the peculiarities of his style announce themselves forcefully. Space is made ambiguously expansive by means of the slight blurs and partial erasures in and around the figures. A kind of double-register vision is established when de Kooning dims and softens features as he does in the "Portrait of Max Margulis." In such earlier works, he began experimenting with dislocations of perspectives, placing for example a pink plane behind a pale green plane, interrupting the outline of each, and suggesting a continuous space between them. By leaving open areas in both color planes and activating lines, de Kooning states an ambiguity which is to be developed later into a full-fledged, characteristic style of indicating the multiple possibilities of focus. Fixed perspective is decisively abandoned in favor of a fluid, shifting montage of variously suggested spaces.

In a very special way, de Kooning took up a signal controversy raging

since the 19th century – the quarrel between Ingres and Delacroix: linear versus painterly painting – and resolved it.

By 1943 de Kooning already knew the full power of his curving line that inflected his rapidly shifting emotions. His impatient hand also experimented with abrupt breaks in the surface (the slice of the knife cutting a plane clean off from its context). This willed abstraction is evident in a few portraits reminiscent of Egyptian encaustics, rendered in fairly conventional terms yet located in oddly interrupted spaces.

Toward 1948, when de Kooning began to paint his dipping and seething lacquer paintings, the vertiginous spaces were in every sense original. His curving line is fully exploited. The interruptions and disruptions become logical within new terms: amorphous shapes, their outlines bleeding from behind the surface; whimsical light darting over and under, and flailing out; visual rhythms in the unending sequences that signify complete activity. The piled-up detail, the rocking movements, the snap of the lines and the structural underpinning are typical of de Kooning's mature observations concerning the jostling, crowding confusion of existence.

In the black-and-white paintings of that year, de Kooning displays the hand that has long followed the shapes of living forms. In "The Little Attic" for instance, there is a perfect balance between the curving shapes with their memory of biological dynamics, the mechanical or the geometric. The thickness or thinness of line deftly indicates the amount of vitality symbolized and the nature of that vitality.

De Kooning's "intimations of unease," in Sartre's phrase, were made explicit in the startling series known as "Woman." In these extravagantly assertive paintings, de Kooning took back the figurative pretext and gave expression to unprecedented vulgarity. If latitude of interpretation is any index, the "Woman" suite is rich in suggestion. Nearly all the critics remarked the ritualistic character of the larger-than-life females, their eyes starting, their breasts heaving, their gestures wildly demonic. De Kooning had, in fact, painted women in the past with faintly ritualistic intonations. Certain of the earlier imaginary portraits seem like parodies of playing-card queens.

In the larger "Woman" paintings, de Kooning carries his concern with detail and shifting focus to an extreme point. He had always allowed details to absorb him, and often worked with notes, much as an author would, saving a phrase here or there for the proper occasion. In these paintings, there is a strong sense of the sundering technique. He uses a vignette method: limbs are given in terms of landscape – they can be vast; the eye can imagine them as painted space. They can be specific: the eye

can be moved by the fleshiness of their pink articulation, by the roundness conferred by over-riding line. They come together and form a semblance of a woman, or they ride apart, an expression of abstract fury. Chiefly, though, the eye is assaulted by the frenetic vigor of de Kooning's sense of life, for the spaces this woman inhabits are dynamic, they invade her, qualify her (blue for sky, green for grass). Like her protagonist, she is too nervous to know where to sit.

Not long after the first cycle of "Woman," landscape began to consume the figure. Doubling back again, as he had so often before, de Kooning sought a more rigorous expression. He initiated rather stern composing, emphasizing the sharp cut of straight planes and minimizing the baroque, curvilinear flourish. Here the spaces open out to suggest the complex features of a total environment, with the large proportions of emptiness that take up so much of our vision. Sky and sea, the dominant features of de Kooning's East Hampton residence, assert themselves. The animal heat and closed chambers suggested in the "Woman" series are carried away by strong, large elements.

In subsequent paintings, de Kooning's challenge to the factitious in the sacred Western tradition; his accusation of false elegance; his struggle with the void; his perpetuation of his prideful gesture; his pointed equivocation are plainly spelled.

In "Suburb in Havana" for instance, the great sweep of blue certainly stands for sky, the yellow below, for some lowland terrain. But in the upper left, de Kooning proposes a different perspective, a new space which relates to the V-shaped form below. With a brown sweep of the brush, he makes a *repoussoir* that sits on the very base foreplane of his canvas. The blue interior, cutting into the landscape – a well of color that can be read either as a surface form or as a receding form – immediately offers another perspective. Relating to the white emptiness at lower left, the blue is an abstract notation, reminding us that it is not only landscape which moves de Kooning, but a vision of some specific spaces he has negotiated. No one could climb about in his suburb, for it is de Kooning's very own, but one can follow his imagination in it.

Many of the landscape-like abstractions are redolent of conflict. Even the most beautifully pink and yellow areas are not without malaise. Every dazzling turn of his huge brush holds the danger, the excitement that can be compared to that of an audience when the girl on the flying trapeze is tossed from one performer to the other. Between those trapezes is the dread void.

It is in these paintings that de Kooning, challenger of the sacred, is most readily identified. He mocks dependence on beauty of material by

using rude paints (oils from tubes stretched to their limits with vegetable oils). He satirizes "painterly" painting by exaggerating his stroke to breathtaking proportions. The paint is laid on swiftly with a six-inch brush, and the inevitable short-stop shock when it terminates is like a caricature of "directional" stroking.

Nevertheless, at the same time de Kooning mocks, he praises. He pays his debt to the traditions which nourished him. Timbre, texture, continuity and discontinuity are manipulated deftly to produce complexity behind the ostensible simplicity.

His real achievement in these later landscapes is the clear description of his own spaces. They are splendid spaces, extending broad and far, dipping back beyond the horizon, inviting the eye to wander.

In describing these spaces, de Kooning reactivates an orderly tradition of illusion. Despite the tone of bravura, a lingering feeling of respect for the Renaissance masters who calmly measured out their spaces remains. De Kooning is often concerned with depth, rhyming color, symmetry, balance and other traditional qualities. Where his willful temperament appears – in the convulsive stroke and its screeching stop; in the multi-color sweeps of dirty brushes or in wild accidents that spray themselves wantonly over the picture – he is still not submitting to chaos. Standing behind him at all times is the memory of that train back to Mesopotamia.

Recently, de Kooning has taken up the woman again, this time in a relaxed, often rococo manner. Boucher, Tiepolo and a host of sensualist painters who celebrated the splendors of the flesh, echo through these largely improvisational works. In a few of the smaller studies, there is a deliberate theatrical atmosphere – the women enter with the studied élan of actresses. Their pink, ochre and pale green tints are picked up with special lighting. Their heads are tilted coquettishly, their bodies often dissolve into a flourish of powder pink.

In these lilting studies, there is little left of the ritual goddess. An acerbic thrust is still felt in the swift delineation of special traits: a sharp eye; the thrust of a hand covering a face like a mask; a bony cage for a stalk of a neck. But the general impression is one of lightness, tenderness. Like Picasso, who could wax sentimental over saltimbanques and then paint assassins with angry, mutilating strokes, de Kooning can switch from the fury of the earlier women to the brimming sentiment expressed in these. Skidding lines, foaming swirls of paint, eminently light-hued colors remind us of the vitalistic urgency of the earlier women, but the chorus-girls of today are part of the mortal world, not of the theodicy.

It is in his volatile shifting from mood to mood that de Kooning's nervous strength lies. As I said in the beginning, a large figure must not be

oversimplified. It is probably not yet time to discuss his role historically. But this can be said: De Kooning has epitomized the expressionist style of abstraction endemic to the United States. He has restored the possibility of dealing with the human figure, opening the way to a host of younger artists. He has given a system of drawing which, when studied closely, is as complex and complete as any of the systems broached in earlier Western art. He has extended the painterly tradition by means of singular innovations. Above all, he has kept the possibility for painting discourse open, both for himself and others.

WILLEM DE KOONING
Lawrence Alloway

I
T IS A CURIOUS FACT of the New York art world that artists in their 30s don't mind having retrospectives (Rauschenberg and Johns, for instance, at the Jewish Museum), but older artists are very sensitive about it. Exhibitions of artists in the 1903–13 age group, that is to say the men usually called "Abstract Expressionists," are subject to endless qualification. Museum shows of these artists, no matter how extensive, have to be presented as tentative and partial samples of the iceberg, to protect the artist from feelings of completion and exhaustion. The de Kooning exhibition at the Museum of Modern Art [March, 1969] lists 147 items in the catalogue and covers thirty years, but there is the standard warning not to take all this as a retrospective. It is, to quote the catalogue, just "a look at the artist in mid-career." Is "mid-career" honestly the right term for an artist who will be 65 next month?

De Kooning's presence at the Modern, whether one regards the show as a retrospective (which is my inclination) or a glimpse, is the welcome realization of a lengthy project. New York museums have been overusing guest directors for their exhibitions, inviting outside people to arrange shows well within the capacity of their curatorial staffs. However, inviting Thomas B. Hess, editor of *Art News*, to do the de Kooning show was absolutely correct; he not only knows more about the artist than anybody else; he is the only person likely to have persuaded the artist to go through with a big museum show (the Modern had been trying for years). Hess's modesty in the acknowledgements and introduction to his catalogue [*Willem de Kooning* (New York, 1968)] should not deceive anybody as to the centrality of his role.

The catalogue is rich in information about the artist, his work, his life style, his milieu. In a text that has space for the artist's relation with his dealers, however, I miss any discussion of de Kooning's immense influence on young artists in the 1950s. This was either a power play on his part, or a toleration of the role of king when it was pressed on him;

From *The Nation* magazine/The Nation Company, Inc., 1969. By permission of the author and *The Nation*.

238

whichever it was it calls for discussion. The other lacuna is that Hess is less precise about the flattening of de Kooning's forms in the late fifties and early sixties than on any other matters pertaining to the man he regards as "the most important painter at work in the middle of our century."

My experience of the show was very different from my expectation. De Kooning's paintings and drawings, seen in different places, a few at a time, over years, had left me with an image of a painter who possessed a wide range for handling several subjects. Seeing all the work together has the effect of reducing somewhat the gritty particularity of individual paintings and periods. When the paintings are gathered only footsteps apart, not even the confused hanging that is normal at the Modern can blot out an emergent unity. The correspondences that become visible seem more binding than the differences between various periods, though Hess lists fifteen from 1934 to 1965: equivalences grow between black-and-white paintings and the ones in color, between the images of women and the abstractions. Early and late works become symbiotic instead of antagonistic siblings.

Consider the famous paintings of *Women*, 1950–54. I remembered them as plastically solid figures heroically dominating the maelstrom of paint through which they loomed. By comparison, the women painted after 1964 seemed like Fragonard, say, compared to Rubens. In the context of thirty years of work, however, the "Women" that struck one as so violent appear now pretty much in accord with the rest of the painter's work; they are part of a rococo empire. The all-over curve of the line, the scatter of color, are now seen to pulverize the central image, so that the plasticity of the Grand Manner, which once seemed brilliantly preserved, is virtually effaced. Thus the early *Women* are not so different from the soft, shallow paint ripples of the later paintings. In both periods the image is diffused into the picture surface, flattened and gesturized simultaneously. Top patterns of line and floating patches of color are constant.

Criticism of de Kooning has generally dwelt on his art as an open-ended process. To quote Hess: "Joining impossibles is a de Kooning method" and "to finish meant to settle for the possible." The artist is seen to be involved in an existentialist dilemma in which he successfully resists all those forces that reduce the complexity of life to the simplicity of a convention; that is, to art. Still, all de Kooning's revisions and abandonments do issue, ultimately, in paintings. That these bear the signs of

sweat and contradiction is evident, but what does this mean in terms of the paintings? His anxiety, struggle, irresolution and abrupt conlusions converge in a style of improvised painterliness. There is no need, when speaking formally about de Kooning, to get involved in the simplistic dialogue between critics who think that painting must be flat and those who think it need not be. We do not have to think in terms of either de Kooning or Morris Louis. It is not that de Kooning fails to paint flat enough; on the contrary, his forms are always sucked flat against the canvas, as by a powerful vacuum cleaner. His forms are monotonously stuck, squashed, multiplied, and disintegrated across the flat plane of the canvas. To change the metaphor, his flatness has an aggressive and defamatory character, as of insects glued to the windshield of a car.

De Kooning's art is glutted with potential meanings, what Hess describes as his receptivity to "all possibilities." In practice this shows in brush work that is sometimes the record of visual perception, sometimes haptic or mnemonic (as when he draws with his eyes closed), sometimes iconographic (alluding to Ruben's flesh painting or to a pin-up girl's breasts). The surface that results from these multileveled signs tends to be diffuse and disjunctive. The same level of probability is in all the paint marks and this becomes oppressive. Of course, de Kooning is not open to everything. The possibilities that get into his pictures are only the ones that he is aware of and thinking about. He is associational and permissive, which is an attitude, a structure. His art demonstrates a principle that can be compared to disjunctive syntax (poor *but* honest, this *or* that). Of a painting his critics can say: turn the landscape sideways and it's a woman; it's a woman, it's East Hampton, it's paint. De Kooning's color, except when monochromatic, has a similar interchangeability.

He is certainly right to act as if there were no universal system by which his art, or anybody else's, can be regulated. On the other hand, his refusal to accept an arbitrary form or system, however improbable, as a means by which to create art seems to have left him in the air. To be Robinson Crusoe on an island of his own creation from scratch repels him. He seems obsessed by the quest for an authentic self, but is far too sophisticated to embrace a belief that would confer a sense of authenticity on him. He is like a Nietzsche who has read Wittgenstein and had the bad fortune to believe him. Each of his paintings becomes, then, an example of complexity, a cluster of ways to go and of things that might have been, and why not? For all his vigor and wit, de Kooning's position has the effect of making his pictures, early and late, run together in a melee of suspended possibilities which, instead of celebrating freedom, perpetuates indecision.

240 LAWRENCE ALLOWAY

INTERVIEW WITH WILLEM DE KOONING

Harold Rosenberg

De Kooning: I am an eclectic painter by chance; I can open almost any book of reproductions and find a painting I could be influenced by. It is so satisfying to do something that has been done for 30,000 years the world over. When I look at a picture, I couldn't care less for when it was done, if I am influenced by a painter from another time, that's like the smile of the Cheshire Cat in *Alice*; the smile left over when the cat is gone. In other words I could be influenced by Rubens, but I would certainly not paint like Rubens.

I was lucky when I came to this country to meet the three smartest guys on the scene: Gorky, Stuart Davis and John Graham. They knew I had my own eyes, but I wasn't always looking in the right direction. I was certainly in need of a helping hand at times. Now I feel like Manet who said, "Yes, I am influenced by everybody. But every time I put my hands in my pockets, I find someone else's fingers there."

Rosenberg: You once said that you could not draw like Rubens because you were too impatient. You said that you could draw a foot as accurately as Rubens, but that you didn't have the patience. Do you remember that? that –

De Kooning: I don't remember, but I could very well have said it. I also think that maybe I don't really have the talent for that kind of drawing. I think that certain talents come into being at certain times, but that doesn't make them dead or alive.

Rosenberg: I suppose nobody in our period could paint a detailed tableau of figures in the manner of the Renaissance?

De Kooning: I think there might be people who could do that. For example, the Spanish painter Sert, who made the murals at the Waldorf Astoria. He was no Rubens, but he was a remarkable painter. He just didn't have as great a talent as Rubens.

Rosenberg: You think there could be someone like Rubens today?

From *Artnews*, September 1972. Reprinted by permission of *Artnews*.

De Kooning: I would say there is no reason why there couldn't be. George Spaventa and I were open-minded, and we thought there was no reason why, after 40 years of power, maybe one or two Russian artists would be gifted in the kind of painting that the Russian government demanded. We went to the Russian exhibition at the New York Coliseum with open minds. It turned out to be terrible painting – awful; the kind of painting done in this country in 1910 for the *Saturday Evening Post*.

Rosenberg: Illustration?

De Kooning: Not that so much, because you could say that Rubens is an illustrator too. I felt that making portraits of Lenin and Stalin and workingmen and genre – there was no reason why someone couldn't be very good at it. But they were not good at all. I had thought that maybe after being under pressure, which you slowly get used to, they might have found a way. But it seems that the Russian pressure wasn't the right kind.

Rosenberg: But that's the idea that there are limits on what people can do in certain cultural situations.

De Kooning: Yes, I guess; to come back to Rubens and to Sert, there must be something in the idea that a certain kind of art can only exist at a certain time.

Rosenberg: That would be the point, wouldn't it? – A kind of historical pressure works against some forms of creation, though not necessarily in favor of something else?

De Kooning: I take that for granted. But that's why I said before that I am an eclectic painter, and that I could be influenced by Rubens, but I would not paint like Rubens. The smile without the cat. For example, I object strongly to Renaissance drapery. There is so much cloth involved in that period – it looks like an upholstery store. To paint like that would drive me crazy. The drapery covered so many sins. Whenever the painter came to a difficult part he put another piece of cloth over it. That was the style, and it came to a high point...

Rosenberg: You once said you were opposed to any kind of esthetic an artist might have before he produced his work. I believe you were talking about Mondrian and the fact that the Neo-Plasticists tried to work out an esthetic in advance. You said that, at the turn of the century, "a few people thought they could take the bull by the horns and invent an esthetic beforehand." You had the feeling that such a program is a form of tyranny. It interferes with the freedom of the artist.

De Kooning: Well we can go back to Russia. That's probably why good art did not come about there. You can't build an esthetic beforehand. They have canons of art, an Academy.

Rosenberg: The Russians believe in an Academy, and they believe that

art is a definite kind of work for which there are canons. The most admired artists in Russia are called Academicians. But what you were talking about was a modern Academy...

De Kooning: I remember that when I was a boy, on a cigar box they had "The Modern Age," the age of freedom and enlightenment, together with the great modern inventions. There was a blacksmith, bare-chested, with a leather apron, and a sledge-hammer over his back, which was considered a modern tool. And the wheel of progress was the biggest gear you ever laid eyes on – it certainly wasn't something that was made by a computer. Those symbols were a Romantic way of expressing the feeling of freedom.

Rosenberg: Impressionism is very much involved with that – horse racing, ballet, all those things.

De Kooning: I think Cubism went backwards from Cézanne because Cézanne's paintings were what you might call a microcosm of the whole thing, instead of laying it out beforehand. You are not supposed to see it, you are supposed to feel it. I have always felt that those beautiful Cubist paintings exist in spite of the Isms.

Rosenberg: If you start with an idea...

De Kooning: But they didn't. They were influenced by Cézanne and they could never have the patience to do all that again, once they knew what he was doing. But he didn't know.

Rosenberg: They were influenced not so much by the pictures as by their analysis of the pictures. If you were influenced by Cézanne's pictures you would start imitating his look or style. But the Cubists didn't do that. They analyzed the pictures, and made rules out of what they found in their own minds.

De Kooning: They made a superstructure, and for young people – I'm not being derogatory – for young people that was marvelous. It is unbelievable to think that men in 1910 or '11 could do such fantastic things, yet I don't think theirs was a particularly great "idea." It resulted in marvelous pictures because it was in the hands of fine artists. It depends on who was doing it. As a matter of fact, Cubism has a very Romantic look, much more than Cézanne has. Cézanne said that every brushstroke has its own perspective. He didn't mean it in the sense of Renaissance perspective, but that every brushstroke has its own point of view.

Rosenberg: What's amazing is the problems artists in the early 20th century were able to conceive. Instead of painting so that the result would look impressive, they brought to light all sorts of problems. That's what has led to the idea of the desperation of painting. Because if painting

isn't desperate – if it isn't in a crisis – why should it have so many problems? Simple responses don't count anymore, or being talented. Modern artists have genius for perceiving problems.

De Kooning: It is interesting that the late Baroque artists were so empty. There is Bernini's Minimalness. He was a virtuoso of genius – terrific. You look at it and it doesn't say a thing. It says nothing about the enormous amount of work. If I ever saw Minimalism, there it was. It says nothing. Like a saint's gesture, looking upwards to heaven.... It takes your breath away to see that done with such grandeur – and not say anything.

I don't want to defend myself, but I am said to be Cubist-influenced. I am really much more influenced by Cézanne than by the Cubists because they were stuck with the armature. I never made a Cubistic painting.

Rosenberg: Suppose you have the idea that you'd like to paint a tableau of a tree with people or cats sitting under it. Isn't it true that, while you are painting, you must see yourself come into it? The action of painting has to catch the totality of object and subject. You cannot think it out beforehand. Isn't that why you mentioned Wittgenstein's saying, "Don't think, look!"? Then you go farther, "Don't look, paint!"

De Kooning: That's right! There is this strange desire which you can't explain. Why should you do that? I think I like it because of the ordinariness, so I am free of an attitude, in a way. Of course, that in itself is an attitude, but it would help me in my work, I think The landscapes I made in the 1950s, such as *Parc Rosenberg*, were the result of associations. But I had a vast area of nature – a highway and the metamorphosis of passing things. A highway, when you sit in a car – removed ... Now I'm having the same difficulty. You might say that I'm going backwards by wanting to paint a tableau and not just the mood of it, a kind of double take. In contrast, one might paint something holy, like Barney Newman with his measurements and those divisions of colors (though the word "division" is a bad word). It was fascinating when Annalee [Newman] showed me his studio.

Rosenberg: You are talking about the linoleum on his painting wall, those squares?

De Kooning: Yes. I had thought that the linoleum would be squared off in feet – 1 foot, 2 feet, and so on. So that you could say, this canvas is 8 feet, 6 inches. But I found the squares to be 9 inches, and it's hard to measure by 9 inches. Ten is 1 with a zero. Nine is a mysterious number, because we stop there, and then we repeat the digits. In Europe there is the decimal system, but here the measure is twelve inches, with an eighth of an inch and a sixteenth of an inch....

Rosenberg: Well, one could do a simple calculation. Ten of those squares would be 90 inches.

De Kooning: Sure. But 9 is also a holy number. There is the mystery about why it is 9 – and then 1-zero, and start over again. This is contrary to our usual measurement system.

Rosenberg: Based on tens.

De Kooning: Everything is based on tens, but then it isn't based on tens but on the human foot. That's 12 inches, and then the inch is divided into the half-inch, and then the quarter inch, the eighth inch. It is a peculiar thing. There is the great invention of the Egyptians of a rope with twelve knots, which make a right angle – 3 + 4 + 5. Barney was interested in the Cabala, I was told.

Rosenberg: Tom Hess found evidence of that.

De Kooning: Before I knew that I wondered why he bought linoleum with 9-inch squares.

Rosenberg: You think it was on account of the sacredness of the number 9? Maybe he couldn't find linoleum with 12 inch . . .

De Kooning: Oh, come on. There are so many linoleums with a foot-square design. Or he could have painted one. I wouldn't even paint the squares; I would just make marks on my wall.

Rosenberg: Why then did he want that linoleum?

De Kooning: Because he wanted it in 9 inches, as a thing to measure with. So I wondered what he wanted the number 9 for. Then, later, they found his interest in the Cabala. That was why, I felt, he wanted 9 inches. He could have had any measurement he wanted. He could have said, "why not?"

Rosenberg: You mean 9 didn't mean anything to him in particular?

De Kooning: Not particularly. He just liked it I guess. Actually paintings in the dimensions of 9 are hard to place in an ordinary room, because most rooms are only 8 feet 6 inches high. As for me, I like squarish forms. So I make paintings 7 to 8; 70 by 80 inches. If I want it bigger, I make it 77 by 88 inches. That is kind of squarish. I like it, but I have no mystique about it. Also, I like a big painting to look small. I like to make it seem intimate through appearing smaller than it is.

Rosenberg: Usually, the opposite is the case. Artists want small paintings to look big.

De Kooning: I can see that, if you really make a small painting. But if I make a big painting I want it to be intimate. I want to separate it from the mural. I want it to stay an easel painting. It has to be a painting, not something made for a special place. The squarish aspect gives me the feeling of an ordinary size. I like a big painting to get so involved that it

becomes intimate; that it really starts to lose its measurements; so that it looks smaller. To make a small painting look big is very difficult, but to make a big painting look small is also very difficult.

I'm crazy about Mondrian. I'm always spellbound by him. Something happens in the painting that I cannot take my eyes off. It shakes itself there. It has terrific tension. It's hermetic. The optical illusion in Mondrian is that where the lines cross they make a little light. Mondrian didn't like that, but he couldn't prevent it. The eye couldn't take it, and when the black lines cross they flicker. What I'm trying to bring out is that from the point of view of eyes it's really not optical illusion. That's the way you see it.

In a book on optical illusion there was an illustration with many lines drawn in a certain way. There were two parallel lines, then little lines like this and little lines like that from the other side. The figure looked narrower in the center than on the top and bottom. I don't call that an optical illusion. That's the way you see it. It looks narrower in the center.

Rosenberg: You see it that way, but if you measured it, it would be different. That's the illusion.

De Kooning: But in painting, that's the most marvelous thing you can do. That's the very strength of painting, that you can do that. It is "optic" naturally, because you have to have eyes to see it. All painting is optic. If you close your eyes you don't see it. But if you open your eyes with your brain, and you know a lot about painting, then the optical illusion isn't an optical illusion. That's the way you see it.

Rosenberg: The way you see something doesn't mean necessarily that that's the way it is. That business of putting a stick in water so that it looks as if it's broken...

De Kooning: Well it is. That's the way you see it.

Rosenberg: What do you mean, it is broken? If you pull it out of the water it's not broken.

De Kooning: I know. But it's broken while it's in the water.

Rosenberg: The break is an illusion...

De Kooning: That's what I am saying. All painting is an illusion. Mondrian gives you one kind of illusion, whatever you call it, tension... He calls it "dynamic equilibrium," or "clear plasticity." I don't care what he calls it. That's the way you see it. You have the illusion of this horse. I feel it, but that's the way I see it.

Rosenberg: In that case he is an illusory painter in regard to you.

De Kooning: To me, a cow by Courbet is no more illusory than Mondrian is. I know how it's painted...

Rosenberg: You can do what you wish with a picture. Once after a

meeting with art teachers at the University of Kentucky we were standing before a large painting of a side view of a cow in front of a house. One woman said: "Tell me what you see in this picture." For the fun of it, I began to find all kinds of images painted into the cow, between its head and its tail. It turned into a Surrealist painting. The more we looked at it the more figures began to appear. It became a game – everyone found something – here is a clump of trees on the side of the cow, there is a river running down the cow's neck. All this began to appear, as if the artist had actually painted it.

De Kooning: You mean he didn't paint it there?

Rosenberg: No, they were accidental effects that appeared when you looked at it in a certain way – as if you were watching clouds. A human profile emerges, a cathedral, an animal. We were standing in this idle way and began to see babies and motorcycles on the side of the cow and around the cow. The art teachers behaved as if I had given them a kind of magical lecture, because at first they had seen only a cow and a house.

De Kooning: I know now what you mean. I use that a lot in my work.

Rosenberg: You mean accidental effects?

De Kooning: I don't make an image such as a baby, but I use it. . . .

Rosenberg: That Abstract-Expressionist painting by Perle Fine that's hanging in our bedroom is so loaded with images – Arabs, the painting, but the cast of characters that has come out of it.

De Kooning: You know, those figures are very well drawn. If you asked her to draw a head she couldn't do it that way. That's the strange thing.

Rosenberg: You are absolutely right. No artist could do it.

De Kooning: That's the secret of drawing, because the drawing of a face is not a face. It's the drawing of a face. When you look at a Rembrandt, it's just an association that there is a man standing there that makes it realistic. Next to him there is a black shape. You know it is a man also. But if you look at that spot for a long time, there is no reason to think that it is a man. It happens with so many drawings and paintings – in Chinese art, in all kinds of art – and all the works come together.

Rosenberg: What do you mean by coming together?

De Kooning: That they become separated from their period. Chinese artists did something a thousand years ago, and somebody else today does something very similar.

Rosenberg: They are not divided by history.

De Kooning: No division by history at all.

Rosenberg: What has been going on in the past couple of years? Copying photographs or using actual photographs. Apparently young

artists want to create the feeling of a *mise-en-scène*, a sort of tableau of people looking at pictures in an art gallery, or standing around at a party. What do these activities mean to you? Why should artists make art of photographs, instead of taking photographs for practical purposes, or for the sake of sentiment?

De Kooning: Well, such art has a certain psychological effect. It's almost Minimal Art, as if one said, "Never mind what the meaning is, here it is." This art has a kind of atmosphere, a psychological overtone that is make-believe. You know it is painted and yet it looks like a photograph. I don't understand the meaning. The people look ordinary, and the cars are brand new and look sleeker than the people do, unless they have a beautiful model in front of them, and then the model looks sleeker than the car.

Rosenberg: What's the reason for it? You would expect that works of this sort would advertise something, or on the other hand have a political message to tell.

De Kooning: On television you often see shots, as in scenes televised from Vietnam, that look exactly like painting. If you have that kind of eye, you may say: "That looks like a Manet." Of course it's a coincidence. Sometimes a painted portrait looks like a photograph, and sometimes a photograph looks like a portrait. There is something fascinating for me about photography.

Rosenberg: You don't feel that painting has a particular purpose, or one that you would like to see it have? You don't care why people paint whatever they paint?

De Kooning: The main thing is that art is a way of living – it's the way I live. It's not programmatic. When I read *The Brothers Karamazov*, I liked the father the most.

Rosenberg: I happen to agree that Fyodr Karamazov is the most important character.

De Kooning: In the end he is really all there, and the others couldn't break out of a paper bag by themselves. The father isn't a nice man, but I was painting a picture and all of a sudden it came to me that I liked the father the most.... It came like a revelation. It hung in the air somehow. A novel is different from a painting. I have said that I am more like a novelist in painting than like a poet. But this is a vague comparison because there is no plot in painting. It's an occurrence which I discover by, and it has no message.

Rosenberg: You mean your painting is an event?

De Kooning: It is an event, and I won't say it is kind of empty, but ...

Rosenberg: An event without an interpretation.

De Kooning: Yes. I have no message. My paintings come more from other paintings. Here is *Artnews*, and I become fascinated. I could paint the head of this horse. But that would be an abstract painting. There seems to be something constant for me in painting. This man, you could say, is like a Matisse. But this one is made by a Greek, 3000 years ago, and it looks like a Japanese drawing. I don't know how old these things are – I see them with my eyes. The caption says: "The golden age of Greek painting comes to life in this bucolic scene of a herdsman leading his horses" done between 340 and 320 B. C. That's a long time ago. It's fascinating, isn't it, that this was painted 2,300 years ago and you know right away that this is a tree. I am interested in that. It seems it could only happen in the Impressionist period. But once you have Impressionist eyes, you look at those small Pompeian paintings – not the big classical ones – the little paintings with a tree and a rock, and they are almost the same as Impressionism. This is my pleasure of living – of discovering what I enjoy in paintings.

Rosenberg: Discovering what other people have done, that is like what you have been doing?

De Kooning: Yes, in discovering what other people have done, and that I can do it too. It is like an overtone of my Woman paintings, which are supposed to make me a matricide or a woman hater or a masochist and all sorts of other things. Maybe I am a bit like any other man, but I wouldn't show it off in my paintings...

De Kooning: Why do I live in Springs? To begin with, my friends were already there. But also I was always fascinated with the underbrush ... the entanglement of it. Kind of biblical. The clearing out ... to make a place. Lee Eastman found a large house for me on Lily Pond Lane, but I know it wasn't for me. There was no underbrush – it had been taken away generations ago. I like Springs because I like people who work. Snob Hill is really nice, too, but the trees have already grown up there and it looks like a park – it makes me think of people in costume and Watteau. As I said, I had friends in Springs and visited them and that made me decide to move in.

Rosenberg: Has working in the country affected your work? Everybody seems to think that it has.

De Kooning: Enormously! I had started working here earlier, and I wanted to get back to a feeling of light in painting. Of course you don't have to have it, but every artist has it. Léger has a light. It's another kind of light, I guess; it's hard to go into that. I wanted to get in touch with

nature. Not painting scenes from nature, but to get a feeling of that light that was very appealing to me, here particularly. I was always very much interested in water.

Rosenberg: You were interested in light on Tenth Street, too, where the light is, of course, quite different.

De Kooning: On Fourth Avenue I was painting in black and white a lot. Not with a chip on my shoulder about it, but I needed a lot of paint and I wanted to get free of materials. I could get a gallon of black paint and a gallon of white paint – and I could go to town.... Then I painted the Women. It was kind of fascinating. *Woman I*, for instance, reminded me very much of my childhood, being in Holland near all that water. Nobody saw that particularly, except Joop Sanders. He started singing a little Dutch song. I said, "Why do you sing that song?" Then he said, "Well, it looks like she is sitting there." The song had to do with a brook. It was a gag and he was laughing, but he could see it. Then I said, "That's very funny, because that's kind of what I am doing." He said, "That's what I thought."

Rosenberg: You mean you had the water feeling even in New York?

De Kooning: Yes, because I was painting those women, and it came maybe by association, and I said, "It's just like she is sitting on one of those canals there in the countryside." In Rotterdam you could walk for about 20 minutes and be in the open country. Of course in that time it still looked like the Barbizon School, the idea of farms and...

Rosenberg: But then you did *Gotham News* and those rough looking cityscapes.

De Kooning: I started doing them later. Then slowly I got more and more involved with being here in Easthampton, and it came to me that one has different periods in painting. There was a certain time when I painted that men series...

Rosenberg: In the 1930s?

De Kooning: Yes, but it was all in tone. The *Glazier* was influenced by Pompeian murals. I was often with Gorky when I saw those murals, and he couldn't get over the idea of painting on a terra-cotta wall like the Pompeians were doing. I had that yellow ocher, and I painted a guy on the yellow ocher and the wall was really like the yellow ocher, a flat thing. It was never completely successful, but still it had that feeling. Then slowly I changed, and when I started to make those landscapes, I had the idea of a certain kind of light from nature. The paintings I was doing of men had another idea of light, not like on a wall...

I knew that if I made some kind of shapes with certain tones or values of paints mixed in paint-cans, instead of having ready-made colors from

art-store tubes, that I would be stuck. But if I began arbitrarily, then I would have to find a way to come back with an answer. I don't know if you get what I mean.

Rosenberg: Well, say some more about it.

De Kooning: Arbitrarily, I made those bright flesh colors. All I needed was white and orange to give me an ideal, bizarre flat color, like the color on Bavarian dolls. I made it completely arbitrarily. Then for some reason or other – I forget the details – the idea was that I was going to make a liver color, and the liver color I picked out was the color of the liver when it was cooked and sliced as I remember it from Holland. That was a kind of grey-brownish color and to get it I had to mix about six different colors. It was an uncomfortable color to work with, and I wanted to be kind of stuck with it. It did me a lot of good because it was like a tone; something you can't lay your hands on; almost like a kind of light on a roof. It seems colorless, like a dazed kind of light. It can be a dark color or a light color. You can make it shade in between things. If you have a light of so-called bright colors, you can make them tones in between. It shapes up to the doings of it.

Rosenberg: Was this color one you used in the landscapes?

De Kooning: That's right. I even carried it to the extent that when I came here I made the color of sand – a big pot of paint that was the color of sand. As if I picked up sand and mixed it. And the grey-green grass, the beach grass, and the ocean was all kind of steely grey most of the time. When the light hits the ocean there is kind of a grey light on the water.

Rosenberg: And that was related to the liver?

De Kooning: Well, it came out. I kept forgetting about it, but I was in a state where I could start with that. I had three pots of different lights, instead of working with red, white and blue like Léger or Mondrian...

Rosenberg: Instead of the colors you had tones!

De Kooning: Indescribable tones, almost. I started working with them and insisted that they would give me the kind of light I wanted. One was lighting up the grass. That became that kind of green. One was lighting up the water. That became that grey. Then I got a few more colors, because someone might be there, or a rowboat, or something happening. I did very well with that. I got into painting in the atmosphere I wanted to be in. It was like the reflection of light. I reflected upon the reflections on the water, like the fishermen do. They stand there fishing. They seldom catch any fish, but they like to be by themselves for an hour. And I do that almost every day.

Rosenberg: You do that?

De Kooning: I've done it for years. As in your lecture about the "water gazers," do you remember, in the beginning of *Moby Dick*? When Ishmael felt desperate and didn't know what to do he went to Battery Place. That's what I do. There is something about being in touch with the sea that makes me feel good. That's where most of my paintings come from, even when I made them in New York.

Rosenberg: How does the figure come in? How do you relate it to the light of the landscapes.

De Kooning: I started all over again in the sense of painting those women I painted on Fourth Avenue and on Tenth Street [in 1950–55]. I went back to it here. When I made *Woman Sag Harbor* [1964] I just titled it that, because I go to Sag Harbor and I like the town and I frequently have this association. While I was painting it I said to myself, "That's really like a woman of Sag Harbor, or Montauk, where it's very open and barren." I started to make them more in tone. You can see that; in brightness of light, which makes me think I have some place for her.

Rosenberg: In those tones?

De Kooning: Yes, in those tones. There is a place there. When I say Montauk.... Oh, I could find other places. There is no difference between the ocean beach nearby and at Montauk, but I have an association because I go there quite often. Particularly in the off-season, in the late fall, or even in the wintertime. It would be very hard for me now to paint any other place but here.

Rosenberg: The light of course, is quite different in the wintertime, isn't it?

De Kooning: It gets very pure. Blue skies and very pure light. The haze is gone. Some of my paintings have that light and develop that haze.

De Kooning: If you have nothing to do and want to meditate and have no inspiration, it might be a good idea to make a sphere.

Rosenberg: Out of what?

De Kooning: Out of plaster. It's easy. You can add to it, you can sandpaper it. But you mustn't use calipers or any other instrument. You could never make that sphere because you would never know.

Rosenberg: You mean, you wouldn't know when you had produced a perfect sphere? Or you wouldn't know how to go about making it?

De Kooning: You can imagine yourself doing it. Let's say you make it about 12 inches, but you don't use a ruler. It is very hard to know what 12 inches is without a ruler.

Rosenberg: Do you want it to be a sphere of a certain size or just round?

De Kooning: Well, you could start to make it 12 inches. Then you

turn it around and say, "Gee, I have to sandpaper this a little more." Then the next time you say, "I have to add a little more here." You keep turning it around and it will go on forever because you can only test it by eye.

Rosenberg: If you didn't feel that you had to add or subtract, would you be convinced you had a perfect sphere? I mean, if you got to the point where you felt there was nothing you could do to it. Then it would be a sphere, wouldn't it?

De Kooning: Yes, but that can never happen.

Rosenberg: You don't think one would ever get that feeling?

De Kooning: No, because a sphere is social. If they give you a ball bearing, you know it is absolutely right?

Rosenberg: You would take their word for it.

De Kooning: Most things in the world are absolutes in terms of taking someone's word for it. For example, rulers. But if you yourself made a sphere, you could never know if it was one. That fascinates me. Nobody ever will know it. It cannot be proven, so long as you avoid instruments. If I made a sphere and asked you, "Is it a perfect sphere?" you would answer, "How should I know?" I could insist that it looks like a perfect sphere. But if you looked at it, after a while you would say, "I think it's a bit flat over here." That's what fascinates me – to make something I can never be sure of, and no one else can either. I will never know, and no one else will ever know.

Rosenberg: You believe that's the way art is?

De Kooning: That's the way art is.

DE KOONING OF EAST HAMPTON

Hilton Kramer

SPEAKING OF HIS PREDILECTION for "late art" – for the work that certain artists produce in their later years – Thomas Hardy once remarked: "I prefer late Wagner, as I prefer late Turner ... the idiosyncracies of each master being more strongly shown in these strains. When a man not contented with the grounds of his success goes on and on, and tries to achieve the impossible, then he gets profoundly interesting to me."

For aficionados of such late art, this has already been a festive art season, with spectacular shows of late Matisse and late Cézanne. Now, with the exhibition called "Willem de Kooning in East Hampton," opening today at the Solomon R. Guggenheim Museum (through April 23), we are offered yet another major survey of the late work of an artist universally acclaimed as a master – only in this case, of course, we are seeing the late, or at least the latest, paintings, drawings and sculpture by a living artist still working in a high tide of energy and aspiration.

Mr. de Kooning was 59 when he left New York in 1963 to live and work in East Hampton on Long Island. He is now 73. Except for two paintings that date from 1962, the nearly 100 works that have been assembled here by Dianne Waldman, the curator of exhibitions at the Guggenheim, were all produced in this period of residence on Long Island.

The first question that naturally comes to mind about this work is: What, if any, difference has geographical change brought to Mr. de Kooning's art? The short answer to this question is that the change in locale confirmed, even though it did not initiate, an interest in "landscape" as the area of the painter's primary esthetic focus.

But even this must be immediately modified. Mr. de Kooning has

continued to be much occupied with the figure since his move to East Hampton. It still turns up in his paintings, especially in the 1960's, and all of the drawings in the current show are figure drawings. When the artist turned to sculpture during these years, producing his first bronzes, it was again to depict the figure.

Then too, the concept of "landscape" in Mr. de Kooning's painting is rather special. It has little or nothing to do with the literal representation of what the eye sees in the world "out there," but everything to do with what the artist feels about what he has seen in the landscape when he returns to the studio to face the canvas. Memories of space, light and color are distilled in the abstract gestures traced by a swift-paced, heavily loaded brush. In certain pictures, the observer may discern (or only imagine?) the blue-white "memory" of a swirling sea – as in "Screams of Children Come From Seagulls" (1975) – or a brilliant yellow-red "memory" of a sunset – as in the untitled painting, numbered "III" (1976) – but the result, in any case, is resolutely abstract.

The East Hampton "landscapes" are indeed the most orthodox examples of Abstract Expressionist painting that Mr. de Kooning has ever produced. In writing of the artist's earlier work, Mrs. Waldman observes that "Color, shape, space and tactility as they function in relation to the picture plane are his central concerns," and this remains true of the East Hampton paintings too. Just as in the figure paintings of this period – "Clam Diggers," for example, or "Woman, Sag Harbor" (both 1964) – the subject looks as if it were being devoured by the pigment that defines it, so in the "landscape" abstractions, the land, sea and sky disappear into the high-spirited disorderly gyrations of paint applied and reapplied with great speed and determination to the canvas surface.

To these paintings Mr. de Kooning brings an extraordinary energy and confidence, and a sensibility that is obviously deeply in love with the sheer painterliness of his medium, and very knowing about the delectable effects that this painterliness is capable of achieving. Whether he is evoking the figure or his memories of a landscape, or the memories of other paintings (which one suspects is often the case), there is a visual quality in his work that is arresting and seductive. We are never in doubt that we are in the presence of a superior artist.

Why, then, do I find so much of this large exhibition so dispiriting? The color often sings, the pigment retains its fresh and succulent look, and the characteristic rhythms charm the eye with an appealing kinetic power. In the presence of so much that pleases, and is obviously meant to please, what can be wrong?

Perhaps the answer is to be found in those delectable painterly surfaces, which begin by seducing the eye and end – for this observer, at least – in a suffocating surfeit of sweetness and charm. There is a certain invertebrate quality to Mr. de Kooning's late work that turns soft and mushy under examination, as if it were an organism consisting of flesh without bones.

It is not that the paintings lack structure, but that the structure is often so slack and loose, so utterly feckless in the face of the demands of the painterly energy it is called upon to support, that it seems almost to amount to a failure of will. The surface dances with undiminished energy, but beneath its sensuous charms one senses a kind of esthetic accidie, and intellectual sloth, that yearns to cede everything in the picturemaking process to sensual gratification.

It is characteristic of the late work of certain masters that it represents both a summation of the past and a leap into a new realm of vision. But in Mr. de Kooning's late paintings, the summation tends only to be a reprise of all those surface qualities that so delight the eye, and the leap forward is toward something less serious and weighty.

What this means, in terms of pictorial style, is that Mr. de Kooning's painting has never quite recovered from its attempt to banish Cubism as a governing force. From the balance that was once struck between Cubism and Expressionism in the paintings that earned the artist his first renown in the 1940's, he has moved more and more into a realm where Expressionism dominates. With the loss of a Cubist imperative, a certain element of pictorial "conscience" has also been lost.

Of course, it goes without saying – or ought to – that Willem de Kooning remains one of our best painters, and this is an exhibition that everyone with an interest in modern painting will want to see. But artists of this stature demand to be judged – indeed, to be experienced – in the company of the masters. Any other standard is an implicit denial of the very accomplishment they are said to have achieved. And by that standard, it looks as if Mr. de Kooning's East Hampton period – or this much of it, at least – is not going to enter the annals of the greatest "late art" produced in modern times.

SELECTED CHRONOLOGY

1903	Born New York City.
1920	Studies Art Students League with Robert Henri, John Sloan.
1921	Travels in Europe, studies Académie de la Grand Chaumière, Paris.
1923–9	Returns New York, studies Parsons School of Design, Cooper Union, Educational Alliance Art School.
1930	Two-person show with Konrad Cramer, Dudensing Gallery, New York.
1934	Included, group show, Uptown Gallery, New York.
1934–5	Included, group show, Gallery Secession, New York. (Group forms core of "The Ten.")
1935	Founding member, with others, "The Ten"; joint exhibition, Montross Gallery, New York.
1936–7	Employed by WPA Federal Art Project. Joins Artists Union.
1937	Exhibits with "The Ten," Passedoit Gallery, New York. Signs "Call" and joins American Artists Congress.
1937–9	Lives in Arizona for two years.
1938	Included, "The Ten: Whitney Dissenters," Mercury Gallery, a few doors from the Whitney on Eighth Street. "The Ten" dissent from the Whitney's purported bias toward Regionalism and the American Scene. Included, group show, Passedoit Gallery.
1939	Wins United States Treasury Department Competition to paint mural in post office of Yerrington, Nevada. Final exhibition of "The Ten," Bonestell Gallery, New York. "The Ten" disband.
1940	First solo show, Artists Gallery, New York; again 1942, 1943. Included, Section of Fine Arts, United States

	Treasury Department exhibition of mural designs for federal buildings, Whitney Museum of American Art. Included, "Annual Exhibition of Contemporary American Art," Whitney Museum of American Art; again 1941, 1944–1961, 1963, 1965, 1967.
1943	Included, "Third Annual Exhibition, Federation of Modern Painters and Sculptors," Wildenstein Gallery, New York; also 1944, 1945, 1946. Rothko and Gottlieb discuss their aesthetic theories on WNYC radio.
1944	First Prize, "Annual Exhibition of Brooklyn Society of Artists," Brooklyn Museum. Solo show, Wakefield Gallery, New York. Included, "Abstract and Surrealist Art in America," Mortimer Brandt Gallery, New York, selected by Sidney Janis. Participants include William Baziotes, Willem de Kooning, Mark Rothko.
1944–5	President, Federation of Modern Painters and Sculptors.
1945	Included, "A Painting Prophecy – 1950," David Porter Gallery, Washington, D.C. Included "A Problem for Critics," Gallery 67, New York. Solo shows: Nierendorf Galleries, New York; Gallery 67, New York.
1946	Included, "American Painting from the Eighteenth Century to the Present Day," Tate Gallery, London; "Advancing American Art," Metropolitan Museum of Art; "Annual Exhibition," Pennsylvania Academy of the Fine Arts; also 1949, 1953, 1954. Speaker, forum on "Problems of Art and Artists Today and Tomorrow," sponsored by Art Students League and Federation of Modern Painters and Sculptors.
1947	Two solo shows, Kootz Gallery, New York; also 1950, 1951, 1952, 1954. Included, "Introduction à la peinture moderne américaine," Galerie Maeght, Paris; "Abstract and Surrealist American Art," Art Institute of Chicago.
1948	Speaker, forum "The Modern Artist Speaks," Museum of Modern Art. Included, "Contemporary American Painting," University of Illinois; also 1950, 1951, 1952, 1953, 1955, 1963.
1949	Speaker, forum on "The Schism between Artist and Public," sponsored by Art Students League and Federation of Modern Painters and Sculptors. Solo show, Jaques Seligmann Galleries, New York. Included, "American Painting in Our Century," Institute of Contemporary Art,

	Boston; "The Intrasubjectives," Kootz Gallery; "Juliana Force and American Art," Whitney Museum of American Art; "Contemporary Art in Great Britain, United States, France," Art Gallery of Toronto, Canada.
1950	Solo show, Kootz Gallery; also 1953. Included, "American Painting Today," Florida Gulf Coast Art Center; "American Painting 1950," Virginia Museum of Fine Arts; "American Painting," Walker Art Center, Minneapolis.
1951	Purchase Prize, "Contemporary American Painting," University of Illinois. Included, "Seventeen Modern American Painters," Frank Perls Gallery, Beverly Hills, California; "American Vanguard Art for Paris," Sidney Janis Gallery, New York and Galerie de France, Paris.
1952	Included, "Painters of Expressionist Abstractions," Phillips Gallery, Washington, D.C.; "International Exhibition of Contemporary Painting," Carnegie Institute, Pittsburgh, also 1953, 1955, 1958, 1961, 1967; "International Art Exhibition," Tokyo, also 1955.
1953	Solo show, Area Arts, San Francisco. Included, "Origins and Trends in Contemporary Art," Denver Art Museum, Arts Club of Chicago, Walker Art Center; Biennial, Corcoran Gallery of Art, Washington, D. C., also 1967.
1954	Solo shows: Bennington College, Vermont, and Williams College, Massachusetts.
1955–6	Included, "The New Decade – 35 American Painters and Sculptors," Whitney Museum of American Art; circulated nationally.
1957	Solo shows: Jewish Museum, New York, and Martha Jackson Gallery, New York. Included, "Paintings from the Solomon R. Guggenheim Museum, New York," shown at the Hague, Helsinki, Cologne, Paris. Included, "American Paintings, 1945–1947," Minneapolis Institute of Arts.
1958	Solo show, André Emmerich Gallery, New York; also 1959. Included, "Nature in Abstraction," Whitney Museum of American Art; "Action Painting . . . 1958," Dallas Museum for Contemporary Art.
1958–9	Included, "The New American Painting," organized and circulated by International Council, Museum of Modern Art, to Switzerland, Italy, Spain, West Germany, Holland, Belgium, France, England, and, finally, Museum of Modern Art, New York.

1959	Solo shows: Galerie Rive Droit, Paris; Paul Kantor Gallery, Beverly Hills, California; Institute of Contemporary Art, London. Included, "Documenta II," Kassel, West Germany.
1960	Solo shows: Galerie Handschin, Basel, also 1961; French & Company, New York.
1961	Third Prize, "International Exhibition," Carnegie Institute, Pittsburgh. Solo show, Galleria dell'Ariete, Milan. Included, "American Abstract Expressionists and Imagists," Solomon R. Guggenheim Museum.
1962	Included, "Art Since 1950," Seattle World's Fair; also shown Brandeis University and Institute of Contemporary Art, Boston.
1963	Awarded Grand Premio, VII Bienal de São Paulo, Brazil. Included, "American Section of the VII Bienal de São Paulo," Walker Art Center, Minneapolis.
1964	Solo show, Marlborough-Gerson Gallery, New York; also 1966.
1967	Solo show, Arts Club of Chicago. Included, "Contemporary Americans," Winnipeg Art Gallery, Canada.
1968	Retrospective, organized by Whitney Museum of American Art and Solomon R. Guggenheim Museum, shown at both and also Corcoran Gallery of Art, Washington, D. C., and Brandeis University.
1970	Solo show, Marlborough-Gerson Galleria d'Arte, Rome.
1971–2	Solo shows: Marlborough Galleries in London and Zurich.
1974	Dies New York City.
1975	"Memorial Exhibition: Adolph Gottlieb," American Academy of Arts and Letters, National Institute of Arts and Letters, New York.
1977	Solo show, Emmerich Gallery, New York; also 1978.
1977–8	Solo show, circulated to six museums in Canada.
1979–80	Solo show, circulated to three museums in the United States.
1981	Retrospective, Corcoran Gallery of Art, Washington, D. C.
1982	Solo show, Knoedler & Company, New York.
1986–8	Solo show, works on paper, organized by the Adolph and Esther Gottlieb Foundation and circulated in the United States by American Federation of Arts.
1987	Included, "Abstract Expressionism: the Critical Developments," Albright-Knox Gallery, Buffalo.

MY PAINTING

Adolph Gottlieb

HAVE ALWAYS WORKED on the assumption that if something is valid or meaningful to me, it will also be valid and meaningful to many others. Not to everyone, of course. On the basis of this assumption I do not think of an audience when I work, but only of my own reactions. By the same token I do not worry whether what I am doing is art or not. If what I paint is expressive, if it seems to communicate the feeling that is important to me, then I am not concerned if my work does not have known earmarks of art.

My work has been called abstract, surrealist, totemistic and primitive. To me these labels are not very accurate. Therefore, I chose my own label and called my paintings pictographs. However, I do not think labels are important.

After spending a year in Arizona around 1938, I came back to New York with a series of still lifes. Everyone said my paintings had become very abstract. The thought had never occurred to me whether they were abstract or not abstract. I simply felt that the themes I found in the Southwest required a different approach from that I had used before. I think the same is true of my pictographs. The material I use requires the style I have built around it. If I should find other subjects and forms that interest me more, I shall no doubt find it necessary to use a different method of expression.

People frequently ask why my canvases are compartmentalized. No one ever asks this about a house. A man with a large family would not choose to live in a one room house. It is understood that for convenience and privacy it is desirable a divide a house into compartments and it can at the same time be beautiful.

I am like a man with a large family and must have many rooms. The children of my imagination occupy the various compartments of my

From *Art & Architecture*, September 1951. Reprinted by permission of The Adolph and Esther Gottlieb Foundation.

261

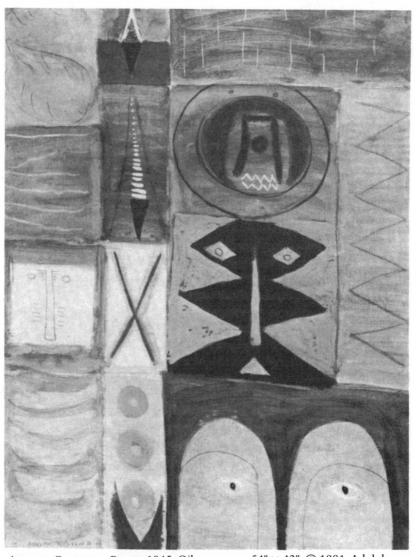

ADOLPH GOTTLIEB, *Beasts*, 1945. Oil on canvas, *54″ × 42″*, © 1981. Adolph and Esther Gottlieb Foundation, Inc. (Photo by Robert E. Mates)

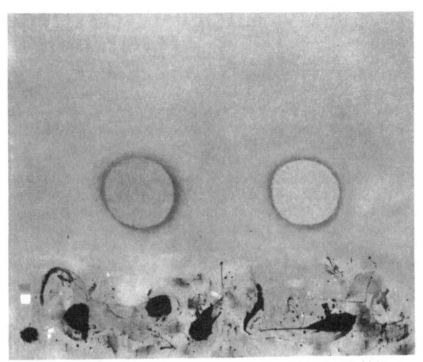

ADOLPH GOTTLIEB, *Two Discs*, 1963. Oil on canvas, 90″ × 108″. Hirshhorn Museum and Sculpture Garden. Smithsonian Institution. Gift of Joseph H. Hirshhorn Foundation, 1966.

painting, each independent and occupying its own space. At the same time they have the proper atmosphere in which to function together, in harmony and as a unified group. One can say that my paintings are like of house, in which each occupant has a room of his own.

ADOLPH GOTTLIEB: AN INTERVIEW

David Sylvester

Sylvester: One of the things that puzzles me about the New York School of Painting is that it isn't exactly a movement. I mean normally with a movement one person's paintings within that movement aren't entirely distinguishable from others. You can confuse a cubist Braque with a cubist Picasso. You can confuse a Monet and a Sisley. But you can't mistake a Pollock for a Rothko, and so on. And yet we talk about the New York School as if it was more than just a generation of painters working in a particular place; we talk as if there were certain common aims. And I wish you could define what it is, if anything, that holds these painters together in spite of their entire differences of style.

Gottlieb: We have to keep in mind that what is called the New York School has been in existence since the early forties, a period of approximately fifteen years, and if you were to examine the work of the cubist group fifteen years after the inception of cubism, I think you would find that painters like Braque and Picasso, and others who were related to some extent with cubism – like Matisse and Derain – ultimately, all these painters seem very different. This is not to say that the American painters of the New York group had a programme such as the cubists had, or that any of them worked as closely as Braque and Picasso; however, I think it is very significant that recently I was at the home of Thomas Hess and he had a painting hanging there and I said to my wife, "Is that one of my paintings?" And she said, "Well, it looks like one of yours from around 1942." But then we realized that it wasn't one of mine but one of Baziotes's paintings. I don't mean to imply that I was influenced by Baziotes or he was influenced by me, but at that time, 1942, the differences in our painting may have seemed very great, but now the difference is not so great apparently. For example, in the early forties Rothko and I decided to

From *Living Arts* (London), June 1963. First broadcast on the BBC Third Programme in October 1960. Reprinted by permission of David Sylvester.

paint a certain subject matter. Perhaps if we saw some of those early paintings now which shared the same subject matter, they might not seem so different as they did at the time. However, at no point was there ever any sort of a doctrine or a programme or anything that would make a School – a conscious common denominator that made all the paintings have relationship. I think it was simply a situation in which all of the painters were at that time; they were trying to break away from certain things. There were also certain destructive impulses.

Sylvester: What, in particular, did you feel you were trying to destroy?

Gottlieb: I felt that what it was necessary for me to destroy was the concept of what constituted a good painting at that time. In other words, the standard which existed, the measuring rod with which paintings were judged. And I felt that it was necessary to destroy this for myself because I felt that it didn't apply to anything that I was interested in. I thought the standards were false and . . .

Sylvester: You are thinking of people like Benton, are you?

Gottlieb: Yes. It was the standard that had been established by people like Benton and others of the American scene and social realist group of painters, and I think that these people established a pattern of what was considered to be good, upright, American painting of that time. Actually it was on its last legs. It was apparent that it had nothing more to offer, but this was a standard that existed in America at the time. Of course, people in the art world did have a high regard for French painting too, but it was felt that American art could exist independently of the international art of Europe and specifically Paris. So therefore I felt that it was a chauvinistic movement and rather ill founded. It was parochial, regional, it did not represent the future of art at all.

Sylvester: You are reacting against two things simultaneously. On the one hand against the parochialism of the American social scene painters, and on the other hand, of the French idea of the well-made picture.

Gottlieb: The French idea of the well-made picture was not so clean-cut as it appears to be today. Whereas today the French seem to have an idea of the well-made picture which to me represents the cuisine type of painting – well-cooked painting with the delicious sauce – during the 40s I didn't think of French painting in that sense. I thought of painting, not as specifically French but as European. Picasso was just as much a Spaniard as a Frenchman. He represented French painting in a sense, true, but nevertheless painters like Picasso and Braque and Matisse and so on represented not only French painting, but painting that functioned on an international level. It wasn't specifically French to me. It was the good painting of my time. And this was a standard that I could very

much respect. And in addition to that, the standards were not only set by individuals but also in terms of movements such as the cubist movement, the surrealist movement and so forth, and these movements seemed to me, as an American, from the distance at which I viewed them – seemed perhaps more organized and planned than they actually were.

Sylvester: The distance at which you viewed them in spite of the fact that you'd previously worked in Europe?

Gottlieb: I hadn't really worked in Europe. I was in Europe when I was merely a boy – I was about eighteen and just beginning to become interested in painting, and then I went for a short trip in 1935 and I didn't work, I just looked while I was there. But I think more significant perhaps was the fact that during the war, many of the surrealists came to America and we were able to see them as just other human beings like ourselves and not as mythical characters who had superhuman capacities and talents. I think that there was a feeling after meeting them personally – well, if these men can do these – have these great achievements, there is hope for us. Prior to that we had accepted a colonial status and felt we could never equal the art which was produced in Europe.

Sylvester: What is it that you felt had to be done: to do something different, or to go further? Did you have any clear idea of what needed to be done?

Gottlieb: I didn't have a clear idea. I was merely groping. I think I had a feeling that it was necessary for me as an individual to find my own identity and establish my own values and find sort of a new honesty, and be able to make some sort of a statement and standard on my own feet with that statement; and that it wasn't even necessary, perhaps, to make art for me but merely to make a statement with paint, because that was the only way that I could express myself. And if I could make some such statement, which was an authentic statement on my part, perhaps this would become art.

Sylvester: Of course, you and your friends succeeded in reconciling a great many tendencies in European art of the first half of the century and using it with extraordinary freedom. I mean Miró and Picasso, Mondrian, perhaps something of expressionism, a lot of surrealism. You seem to manage to use all this in quite a free and uninhibited way and to take what you needed from it. Can you explain how this happened? Because European artists of the same time, European artists of your generation, were in rather a mess after all that had been done by Picasso and Matisse, and yet you here seemed to get out of this mess.

Gottlieb: The only possible explanation I have for it is that the situation was very desperate and everything seemed hopeless and we had

nothing to lose, so that in a sense we were like people condemned to life imprisonment who make a dash for freedom. Nothing could have been worse than the situation in which we were, so we tried desperate things. We revolted in a way against everything – all of the standards – we didn't accept any standards. We were like the people who are nothing but chess players, or tennis bums, and who refuse to do any useful ... painting that's useful, and we felt that we were willing to go all our lives and do this despised kind of painting without any hope of success. That was the way it was, and we accepted that; and most of us refused to assume the normal responsibilities of a respectable citizen. It wasn't completely reasoned out, it was simply something that we all felt a compulsion about and we just had no alternative.

Sylvester: One gets the sense even now, in a remarkable way, that here you are all successful and yet you're still friendly, which is a bit of a miracle among painters, I must say. And one gets this sense of a strong allegiance and a strong sort of corporate spirit. It must have existed then and been more important then than it is now. You said you had no programme but was there a lot of theoretical discussion?

Gottlieb: We had certain common assumptions. We hung around together and we also talked a lot about painting. The one thing we did agree upon was that a certain group of painters respected each other's work and I think that the same group of painters still respect each other's work; and I think that's why we have been able to remain friendly. Even though we may disagree on specific works, or have certain reservations about the other man's point of view, we nevertheless respect his talent and his integrity. That is why a particular group has more or less gone through this period of approximately fifteen years as a group.

Sylvester: But there must have been several things that you agreed on. What were they at the time? How did they change later?

Gottlieb: For example, Rothko and I temporarily came to an agreement on the question of subject matter; if we were to do something which could develop in some direction other than the accepted directions of that time, it would be necessary to use different subjects to begin with and, around 1942, we embarked on a series of paintings that attempted to use mythological subject matter, preferably from Greek mythology. I did a series of paintings on the theme of Oedipus and Rothko did a series of paintings on other Greek themes. Now this is not to say that we were very absorbed in mythology, although at that time a great many writers, more than painters, were absorbed in the idea of myth in relation to art. However, it seemed that if one wanted to get away from such things as the American scene or social realism and perhaps cubism, this offered a

possibility of a way out, and the hope was that given a subject matter that was different, perhaps some new approach to painting, a technical approach might also develop. And as it turned out, such a new approach did develop. At least, it was a different approach than either of us could have arrived at if we hadn't taken a radical departure with respect to subject matter. Well, eventually, of course, we did not remain loyal to the idea of using mythology and ancient fables as subjects because it immediately became apparent that if you are dealing with the Oedipus myth, you're involved with Freud, Surrealism, etc.

Sylvester: Your recent paintings, of course, are freest of all of symbols. This very simple statement of two forms, one above the other. And yet, on the other hand, it might be said, perhaps stupidly, or perhaps this thing has something for you, that there are symbolic suggestions in the relation between these forms – male and female perhaps, or earth and sky, or anything like that. Is there anything of this for you in your recent paintings, or is it just a question of relating two forms on a canvas which is, I suppose, the most difficult of all pictorial problems?

Gottlieb: Well, when I'm painting, of course the problem for me is to relate the two forms and that is the problem with which I have been involved for the last several years. Obviously when I'm finished with a painting and I look at it, I am then a spectator and I can, to a certain extent, see it the way some other spectator will see it. I can see that everyone will have some associations. Now if I were to feel strongly that there shouldn't be any associations, I could then revise my paintings and eliminate anything that would suggest some association, whether it is earth and sky, male or female, or some notion of celestial bodies or sputniks. However, I don't feel strongly about that. I have no impulse to take a doctrinaire position, let us say, in favour of what we call a non-objective sort of painting.

Sylvester: These relations between two forms often have a strong feeling tone – they may be related in one painting in a violent way, in another in a friendly way and another in a rather sexual way. Are you aware of this while you are actually painting?

Gottlieb: Oh no, I'm not aware of it at all. When I'm painting I'm completely preoccupied with the technical problems. Furthermore, before I even start to paint I have to get myself charged, and this is something which I can only feel in a vague way. When I feel that I'm fully charged and ready to let go on the canvas, I'm not in a position to analyse and view myself in an objective way. I have to let my feelings go and it's only afterwards that I become aware of what my feelings really were. And for me this is one of the fascinations and great experiences of painting, that I

become aware of myself and that in the process of painting I become more aware as a person.

Sylvester: In another words, it's painting towards self-discovery, not painting as a means of self-expression?

Gottlieb: I think that's very true.

Sylvester: Coming to New York for the first time, I've had feelings in many ways that the painting of the New York School is as much rooted in the New York landscape and the kind of movement and pattern of New York as impressionist painting is rooted in Argenteuil or Renaissance painting is rooted in Tuscany. And certainly de Kooning has told me how much his painting owes to motives taken from New York. Are you, yourself, conscious in your own painting of owing something to New York life? Do you think that the geographic qualities of New York have made you paint in a different way from what you might have been painting had you been on the West Coast, or in the Middle West, or in Europe? Are you conscious of any such thing?

Gottlieb: Definitely I am. When I was in Paris last spring, my original plan was to go for four months and to paint there, and a number of people urged me to stay. They wanted to see what would happen, how my painting would change. But I felt strongly after being there less than a month that it was necessary for me to come back to New York, because I feel a certain rhythm in New York which I didn't feel in Paris. Everything about life in Paris is conducive to a lowered state of energy. It has a sedative effect, it is seductive. I had a tendency to become like everyone I saw in Paris – to become preoccupied with the excellence of food and drink. In New York, which is barbarous along those lines, I don't mind the poorer quality of material life – our food, which is much worse, and our hard liquor which is not as refined. I think that, aside from those things, there is a tempo in the life of New York which is exhilarating and I feel that this gets into one's painting.

Sylvester: You feel it is the pulse of the city rather than the look?

Gottlieb: It's the pulse, not the look. I'm not involved with the external appearance of the city; it's the vibrations.

ADOLPH GOTTLIEB

Barnett Newman

THE HUMAN FIGURE has been an object of interest to artists through-out history. In the art of the Western world, it has always stayed an object, a grand heroic one, to be sure, or one of "beauty," yet no matter how glorified, an object nevertheless. The artist never dared to contemplate the human figure in terms of body and soul. That he left to the poets and philosophers.

It is a pleasure, then, to see Adolph Gottlieb repudiate, in these studies of bodies and heads, this narcissus attitude, to face the age-old philo-sophic problem of mind and matter, the flesh and the spirit, on equal ground with the philosophers. And he sets it forth with simplicity and dignity.

There are in these headless bodies that compassion, that profound humor, that is the essence of understanding. He has presented the body's frailty lightly. The body is no devil. Rather is it a great imp, ephemeral, unmoral, and mortal – a cloud-like reality. In these burning heads that are the soul, there glows that inner splendor, the "dry-light" of man's eternal quest for salvation.

It is gratuitous to put into a sentence the stirring that takes place in these pictures. But no one has a better right than the ancient Greek philosopher, Heraclitus:

> The perfect soul is a dry light which flies out of the body as lightning breaks from a cloud.

Catalogue introduction, Gottlieb Exhibition, Wakefield Gallery, February 1943. Reprinted courtesy of Mrs. Annalee Newman and The Barnett Newman Foundation insofar as their rights are concerned.

270

ADOLPH GOTTLIEB
AT THE NIERENDORF GALLERY

(Anonymous review)

A DOLPH GOTTLIEB has strengthened his hold on the supernatural and the subterranean in recent gouache and oil "pictographs" at Nierendorf's. His compartments are tighter and shallow, though his range of colour has broadened. Gottlieb's deliberate crudity and primitive symbolism seem not too incongruous to the present-day psyche. *Expectation of Evil*, with its malevolent blacks and whites, has a convincing viciousness. *Mariner's Incantation* conjures up visions of cool underwater magic. *The Alkahest of Paracelsus* dominates this modern sorcerer's cellar, but this reviewer preferred the more innocent mischief of *Naiad*.

From *ARTnews* January 1–14, 1946. By permission of *ARTnews*.

ADOLPH GOTTLIEB

Fairfield Porter

ADOLPH GOTTLIEB, [Jan. 5–25], in an exhibition titled "Imaginary Landscapes and Seascapes," presents a series of pictures that come out of last year's *Frozen Sounds*. This illustration of an imagined sensation was constructed with force. This year's paintings, also divided between a flat ground below and a sky above in which are suspended circles, ellipses and rectangles, carries on the illustrative idea but not its aesthetic one. He has turned to Surrealist abstraction in order to show science fiction subjects, where cosmic forces act. In *Nadir* the ground is strewn like a battlefield with death and destruction. The imbalance of *Sea and Tide* is caused by enormous pressures of gravity between two red ellipses and a black circle. The only painting with repose is *Water and Sound* in which luminous red water lies under a pinkish sky. It is sunny. To this reviewer it seems that this year Gottlieb has given up art in favor of expressing again a strange idea that came to him a year ago. It seems further that he fails in this purpose, as if by stepping outside of himself to hold tight to something, he had irretrievably lost this very thing.

From *ARTnews*, January 1953. Reprinted by permission of *ARTnews* and Mrs. Fairfield Porter.

ADOLPH GOTTLIEB

Clement Greenberg

HARDLY ANOTHER AMONG THE TEN or so American painters who came up during and after the war to take the lead away from Paris has continued in recent years to develop as vigorously as Adolph Gottlieb has. Until about six or seven years ago – when he triumphantly broadened, before relinquishing forever, the "pictograph" style that had become his signature – he seemed a rather narrow if tremendously competent painter. Since then he has become the most adventurous artist in the country: as much so in his readiness to look old-fashioned as in his commitment to innovation. Because being identified with a consistent, recognizable manner seems necessary to an artist's acceptance nowadays, this may have cost him some popularity. Gottlieb is far from being an overlooked artist, but he has become more and more of one for whom no ready-made categories of appreciation are available. The immediacy and diversity of his art leaves the art public at a loss for a "correct" reaction; nothing augurs better for the future of his reputation. The very abundance of Gottlieb's powers has perhaps impeded him in the quest of his particular, most personal ones; his weaknesses are not evident enough to send him straight toward his indisputable, unique strengths. So thoroughly does he possess every technical resource of his art that he could, conceivably, astonish our eyes in any of the going, accepted ways of abstract or, for that matter, representational painting. He could be a great virtuoso. But that would be something less than a great artist. Gottlieb is not interested in that kind of success; or in making pictures that enough people will like. He is out for himself. What makes him the artist I watch with special and concerned attention – and with an interest automatically reserved for major art – is the fact that, at his age, with the achievement already to his credit, and with his equipment, he continues to seek himself with such an utter humility and daring.

Fate plays little tricks on those whose preoccupation with success is

Catalogue essay, "Gottlieb, École de New York," Galerie Rive Gauche, Paris, 1959. Reprinted by permission of Clement Greenberg.

273

not instinctive. Gottlieb has thrown off ideas in passing that others have improved and built upon. When the late Bradley Walker Tomlin set out in 1948 on the all-over, "abstract expressionist" style for which he is now mainly (and too exclusively) known, its derivation from a few pictures Gottlieb had done shortly before, in which small ribbony forms were scattered over an indeterminate background, was patent to those on the spot (as I myself happened to be). Nor did Tomlin then make any bones about his admiration for Gottlieb's art. But when Gottlieb returned to his "ribbons" for a short while some two or three years ago one heard and read in many different quarters that he had been influenced by Tomlin! And no actual mention is made of Gottlieb's decisive influence upon the course of Tomlin's art – a fact of the highest importance to an understanding of its place in recent American painting – in the catalogue for Tomlin's commemorative show at the Whitney Museum this fall. I bring this up not in order to reflect on Tomlin, but to set the record right – and to illustrate. (Picasso himself, when he saw reproductions of Gottlieb's pictographs in 1947, is reported to have been much struck by them; and they do seem to have influenced his large "Kitchen" of 1948.)

I think Gottlieb's later pictures to be his best. They are not the first in which he touches greatness, but they are the first in which there is the sense of a break-through on a wide front. They no longer cross the t's and dot the i's of an assimilated handwriting; they are more self-evidently products of the momentum of inspiration. There was a time when Gottlieb strove consciously against French influence; that issue has disappeared, and now New York influences Paris. Nor, in his very last pictures, does the notion of finish, of a solid completeness, preoccupy him as much as it used to. Clarity and distinctness of parts, lucidity and forthrightness of design remain among the signal virtues of Gottlieb's art, but they have become compatible with a looser, opener structuring of space. The staccato of the flat disks that rise into clear space above the ambiguous horizons of the "Imaginary Landscapes" gave our habits of seeing a jar from which many eyes have not yet recovered. The single, percussive red ball that bounces into narrower space above a disintegrating earth mass in "Burst" deals an even greater shock. What makes such a picture difficult – difficult in the best sense – is its monumental simplicity, which seems more than the conventions of easel painting can tolerate. It is these conventions, in their present frailty, that are at stake in Gottlieb's latest art. They no longer suffice to contain major painting, and that kind of painting in which we feel this strongly has become the only kind which deserves to be called ambitious. The future will appreciate this better than we can.

In a sense, Gottlieb has only begun to show his hand. "Burst" is a masterpiece, but he will do still better. There is also his color. Who else in recent years has been able to attain such an effulgent richness without going off the deep end into confectionery? Yet it is from Gottlieb's color, and his handling of paint texture, that I still await some even less precedented, even more eye-shaking revelation, something utterly unforeseeable and explosive. The centrifugal movement that emerged in his last, large pictographs has been gathering impetus in his work of the past two years; now color, too, thrusts outwards. But his color has yet to shock us to the same extent as his syncopated designed or total image. When it does Gottlieb will have discovered and realized the full measure of himself, and that full measure, the hints of which have already had an unsettling effect, will astound us.

Gottlieb has done more than enough by now to assure his place in the art of our time. If I dwell on his present and future it is because his continuing development provides, to a superior degree, that excitement of which art as an unfolding activity, not as a finished result, is alone capable. His art, as it creates itself from moment to moment, through success, and through failure, offers an experience we cannot get in museums. It is the kind of experience that the future usually envies the past for – because the present usually waits for the ratification of original art, and for the artist himself to finish developing, before it begins to interest itself in the activity that produced the art.

I also dwell on Gottlieb's future because he is one of the handful of artists on whom the immediate future of painting itself depends. He is far more alone as an exploratory artist than he was ten years ago, and he is at the same time more of an explorer than he was then. He is among the very few artists left in New York whose work I can go to in the confident expectation that my sensibility will continue to be challenged and my taste to be expanded. The very difficulty of his art, and that it increases in difficulty, attests to the fact that the heroic age of American art is not yet over.

ADOLPH GOTTLIEB AND ABSTRACT PAINTING

Lawrence Alloway

ABSTRACT PAINTING in the United States was largely separated by the artists of Gottlieb's generation from its geometric base. Mondrian, for instance, was regarded highly, but more as a dedicated or obsessed man than as the exponent of order. This change of focus was symptomatic of an American renewal of the mystique of the artist's vocation and a recovery of confidence in the role of subject matter. The original European abstract painters had been driven towards abstraction by an urge to express great thoughts and mysteries. The artists of Gottlieb's generation were moved by a comparable ambition. It needs to be borne in mind that Gottlieb, for all his professional aplomb, shared this exalted expectation of art. Neither his Pictographs nor the Burst series can be fully grasped outside this context.

Gottlieb's historical position is of the greatest interest. He was the last Abstract Expressionist to arrive at a holistic surface, the whole of which constitutes the visual image, what Clement Greenberg in 1955 called a field.[1] As a result, Gottlieb's paintings after 1957 may seem to lack the prestige of priority as it is built into the theory of the avant garde, but in fact "firstness" is not a stable property of art. Works of art are frequently over-determined in their causes, so that priority becomes a function of which of various contributory factors are being recognized.[2] Thus, there is no reason to think that Gottlieb's historical position put him at a disadvantage to the other artists of his generation. He had their examples to contemplate and to compare with one another; and this, of course, is a critical act. His position in time acted as a vantage point which enabled him to make a special contribution to the mode of field painting. He was able to use in the Burst series (to call them that pragmatically) the lateral

From *Adolph Gottlieb: A Retrospective*, New York: The Arts Publisher, Inc. in association with the Adolph and Esther Gottlieb Foundation, Inc., 1981. Reprinted by permission of Lawrence Alloway and the Gottlieb Foundation.

expansion of color, as in field paintings, especially Mark Rothko's broad tiers of colors. He was able also to use the cutting edge and directional path of gestural painting and to make a personal version of the revision of the figure-ground relation that preoccupied American abstract painting of the period. Gottlieb's balance of surface and mark, field and gesture, has no parallel among his contemporaries. Irving Sandler was the first to note his connection to "both gesture painters and color-field painters."[3] Gottlieb was sensitive to the spread of color and equally responsive to the inventory of forms revealed by a quick brush. Gesture is essentially the linear route of the brush, and field painting essentially has to do with color's immersive properties: Gottlieb reconciled them.

Gottlieb's connection to Abstract Expressionism had an equivocal effect on his reputation. On one hand, he was associated with a powerful group of artists who, like him, were to receive international attention; but, on the other hand, he received less than his full recognition. He knew Barnett Newman very well, and Rothko; his own early work, defining an American subject-matter in small canvases, is parallel to Rothko's. One reason for the slow growth of his reputation is the concept of Abstract Expressionism as a breakthrough that occurs around 1947–48, an ideal historical moment in which a group of men made art fresh. However, this is a deceptive notion, replacing stylistic and social complexities with the vision of sudden change. Several Abstract Expressionists did not produce a consequential body of art until the late forties, and, as a result, they lost nothing by the account of a new start; whereas other artists who reached earlier maturity had their existing work separated from the "new" phase. This happened to Gottlieb, whose Pictographs were never fully integrated into any general view of Abstract Expressionism: ironically their priority isolated them.

This occurred partly because of the emergence of an increasingly formalist reading of Abstract Expressionism which had no use for the myth-raking of the early forties. Evocative imagery, such as that of the Pictographs, was accordingly undervalued, though it can be seen now as part of the substratum of the later work. Thus, not only did Gottlieb lose his developmental lead over his friends, he was sometimes ranked after them. A contributory factor here is his protracted transitional period between the small, complex Pictographs and the large pictorially simplified paintings of 1957 and after. The works of the interim between the Pictographs and the Burst series constitute, in fact, a period of invention not hesitation, as we shall see. The "magic moment" theory of the birth of Abstract Expressionism has been viewed sceptically recently, making it easier to examine both Gottlieb's continuity and priorities.[4] To discuss

his work from the fifties to his death in 1974 therefore involves tracing the logic of the sequence of his work.

Gottlieb's Pictographs explored a broad range of symbolism, but without exceeding the then-traditional small scale of American easel painting. Nonetheless within these limits, he showed an unquenchable inventiveness, accenting the grids and their occupants with a variety closer to Paul Klee's resourcefulness than to Joachim Torres-Garcia's repetitiveness. I visited a warehouse with Gottlieb once and saw the artist standing knee-deep in Pictographs, like the Colossus of Rhodes astride the harbor, and realized that the Pictographs represented a storehouse of culture. He was demonstrating that the world was accessible to the American artist of the forties, an ambition that was resumed in his later works, as we shall see. The grid, for all its flexibility, ceased to satisfy Gottlieb by the late forties. Color expanded without linear intervention, as in *Sounds at Night*, 1948, in which there are no walls to hold the scattered Pictographs. In *Labyrinth I*, 1950, there is a conspicuous grid, but it is in negative, produced by peeling tape from already painted areas; in retrospect we can see this as a part of Gottlieb's increasing interest in continuous planes of color. In other Pictographs, such as *Tournament*, 1951, paint is thickly impasted; this has the effect of dissolving the signifying function of the visual symbols and stressing their decorative character. The all-over composition of the Pictographs is retained, but the surface no longer implies the past or the unconscious mind and their complicities.

A coloristic, all-over web was developed by Gottlieb in a group of paintings in the early fifties that led to *Labyrinth III*, 1954, sixteen feet long, close in size to Pollock's half-dozen large drip paintings. However, despite the evocative title, Gottlieb has curbed the mythological atmosphere rigorously. The painting consists of firmly brushed overlying grids that create a shallow space. Another line of Gottlieb's thought at this time fused the image potential of the Pictographs with massive single forms on a large scale. The first of these, *Black Silhouette*, 1949, is a single dark form that spans the canvas irregularly, reaching to three edges of the painting. It leads to the Unstill Lifes in which the armature of the grid is, as it were, knotted into a central dark image that implies a hefty volumetric mass. The form, somewhere between a table top and a personnage, is seen on a ground squeezed against the edges of the canvas. This group of paintings picks up the ominous mood of some of the Pictographs and embodies it in monumental form. Thus Gottlieb was maximizing the separate elements of his art by concentrating on specific resources in the painting process.

The centered Unstill Lifes turn Braque's *gueridon* into the Rock of Gibraltar. They were accompanied developmentally by the Imaginary Landscapes. This is a series, properly so-called, whereas the number of Labyrinth and Unstill Life paintings is small. The first realized painting is *The Frozen Sounds, I*, 1951, in which a procession of five segmented forms are presented above an emphatic horizon line. It is a sign of Gottlieb's persistent curiosity about figure–ground relationships that he alone of the Abstract Expressionists uses the horizon. The Imaginary Landscapes consist of zones of earth and sky, starkly divided by an horizon parallel to the long top and bottom of the picture, at right angles to the sides. These paintings are schematic in form and luxurious in facture. The terrestrial areas are highly brushy and the solar areas, open and spare by contrast. The firmly painted circular forms are never geometrically neat, but are organically varied, like the silhouette of a fruit or the outline of a glans in cross-section.

The Imaginary Landscapes are considerably larger than the Pictographs, and the images depicted, far fewer. Hence the scale of Gottlieb's brushwork is expanded; it has an amplitude and precision that are new. Some of the painting is improvised in the act of working, but this is a situation of informed process, of control not impulsive hunting. The sequences of disks, ellipses, segments, or blocks of color have a freely inventive character. (Incidentally, we could regard *The Frozen Sounds* as the fate of the Music of the Spheres at the temperature of outer space.) Below the straight-line horizon the lower area is often suggestive of water. Even when the zone is black, brown, and warm, as it is in *The Frozen Sounds I*, the imagery has tidal implications, as if the upper forms were affecting the lower plane, which is always sensuous and sometimes turbulent. This reading is supported by titles, such as *Sea and Tide* and *Eclipse*, both 1952. Gottlieb also used technical terms with a navigational or astronomical reference, such as *Azimuth*, *Equinox*, and *Nadir*, as well as color-based titles, *Red Sky* and *Four Red Clouds*, both 1956. A group exhibition at the Whitney Museum of American Art, arranged by John I. H. Baur, "Nature in Abstraction," 1958, fitted these works admirably. As a matter of fact, the exhibition constituted one of the comparatively few occasions when Gottlieb's current practice coincided with art world patterns from which he felt a certain detachment.

There is a significant change in Gottlieb's choice of color in the early fifties: his use of black and red on white has a readymade look, like enamel from the can or printer's ink. This can be compared with the Abstract Expressionist denial of finesse in favor of directness, like Clyfford Still's color straight from the tube or Franz Kline's use of house-

painters' brushes. For an artist whose work had shown great variety of color in the atmospheric, wide-palette Pictographs, this is a pronounced simplification. In the Imaginary Landscapes these readymade colors add tension to the nature reference of the format. The paintings incorporate both the visual clout of found color and the gradation of invented passages. Gottlieb had not lost his coloristic subtlety as many later paintings show. He was an original colorist, ranging from tender and tonally equivalent hues that conceal their borders to forthright declarations in brown, green, and yellow, colors that are traditionally hard to use on a large scale. We can conclude that black and red were a personal code for the impersonal. It was a knowing, consciously American decision to use vernacular color. It is a crucial part of the series that Gottlieb started in 1957, from the first painting, *Burst*, to a late one like *Crimson Spinning*, 1971.

The multiple heavenly bodies and the textured earth plane, often including sections of broad linear brushwork in black, lead to the Burst series. The sequence is clearly traceable and follows from Gottlieb's decision to transfer the landscape motif to a vertical format. A majority of the paintings in this major group are between six and seven-and-a-half feet high and they tend to be broad, not thin, in the horizontal dimension, a size that relates to human scale: Gottlieb's in painting, the spectator's in viewing. The paintings are a subtle and sustained contribution to the investigation of the visual-physical relationships of image and spectator that is central to the Abstract Expressionists' big pictures.

Let us consider some of the steps leading to *Burst*. In *Solitary* there is a single body in the upper zone and a solid earth plane that spans the canvas almost at midpoint. Though this was painted in 1957, Gottlieb had already arrived at the essential scheme of the Bursts in the preceding year, in *Black, Blue, Red*. The freely painted lower zone more or less spans the canvas but with a solidification of two-thirds of its length which essentially condenses the image on a central axis with two areas, one above another. These two forms relate more to one another in the canvas field than to the edges of the canvas. In the similarly titled *Pink, Blue and Black*, 1957, the forms are aligned on a tighter vertical axis. In both paintings Gottlieb is markedly gestural in handling paint, but the elements imply *Burst*, 1957, the first full statement of the dyadic theme with two freely painted but firmly delimited forms. That this formulation was not easily arrived at is suggested by the fact that in 1958 Gottlieb painted a work like *Argosy*, which can be taken as a version of *Solitary* with its edge-to-edge horizon. He was in possession of the basic format but still experimenting and checking around it: there was nothing facile in the

simple-looking image. He confirmed the importance of *Burst* with two other paintings of the same year, *Blast I* and *II*. The three works can be discussed together for the light they cast on one another and on the long, fruitful period that they initiated.

The decisive painting *Burst* is eight feet high by three-and-a-half wide, narrower than the norm for what I shall call the dyadic paintings. Other paintings led to it, as we saw, a reminder of the false decisiveness of breakthrough theories that presuppose an absolute break between past and present, old and new. *Burst* is different from its predecessors, however, with two forms, roughly equal in area, one above the other; they do not touch, but it feels as if they were bound together, as by planetary forces. The lower form is black and painted in a choppy gestural way; the upper form, red, is smoother in surface and edge, but not closed or measured. It is the product of another type of gesture: the ellipse is freely brushed and surrounded by a tonally graduated halo. (There are red drips, here and there, in two directions, not conspicuous but adding animation to the more contained form.) Associational chains are strong, initiated by Gottlieb's choice of title, as in the Blast pair: the fire ball of the A-bomb, remembered from the end of World War II but kept vivid by postwar testing as at Bikini Atoll. Gottlieb was aware of this association, having solicited it, but he commented that it should not exclude other readings. Like all the Abstract Expressionists, he maintained the greatest confidence in the signifying capacity of art: thus, fire and earth, the solar and the tidal, augment the fireball reading. Gottlieb continued to regard meaning as he had in his Pictographs as open-ended and evocative, a value and not a limited case. Thus *Burst* and the works that followed can be viewed as Pictographs or the scale of field painting.

A field is "an expanse of anything," a "total complex of interdependent factors" (unabridged Random House Dictionary). In painting the term applies to pictures with large areas of monochromatic and spectrally-close color or an allover linear density. Gottlieb's inventory of disks, ellipses, aureoles, and splashes is paired to characterize the field in ways analogous to human thought patterns.[5] He used the technical means of field painting to visualize a mode of thinking, the dyadic. Dyadic means of or consisting of two parts. Pairs likely to have been in Gottlieb's mind, both as a member of our general culture and as the former painter of Pictographs, include sun and earth, male and female, night and day, life and death, Mediterranean and Northern. It will be seen from just these five dyads that such groupings relate to fundamental ideas of order. They are morphological units basic to human communication: us and them, art and life.

In the sixties, a period of proliferating labels and movements, Gottlieb called himself, jokingly in conversation, a trestle painter, the only one. It is a technical fact that many of his field paintings were begun on a trestle table which provides a horizontal surface at a more convenient level than the floor. The wetness of Gottlieb's paint required a flat plane: it would have leaked or poured downward if the picture had been upright at the start. In the horizontal plane, he was free to stir the paint and find the borders of his forms with brush and squeegee. As the paint dried, the canvas could be moved to the traditional upright position, which provides unbeatable opportunities for visual judgment. This is a long way from gestural art interpreted as the swipe or the splash, but it is a good example of the way in which gesture can be a part of planning and thinking, a constructive part of painting, not the sign of a demonstrative physicality. Gottlieb is thinking with paint, not opposing muscular gesture to the act of thought.

We can summarize Gottlieb's position in 1957 on these lines: the immediate source of the Burst series in his own history is the Imaginary Landscapes and the longer-term source is the Pictographs, drawn on for their semantic resonance. In addition, there is Gottlieb's evaluation of his contemporaries' work, particularly Rothko's: his vertical stacks of horizontal forms are echoed by the Burst series. This is not a matter of simple dependency but arises from a critical appraisal of history and abstract art, of Gottlieb's own and his contemporaries' contributions. Robert Motherwell has observed that "the development of the large format" was essential to Abstract Expressionism.[6] To this we can add reduction of the intricacy of the image. It seems clear, looking at *Burst, Blast I,* and *Blast II,* that Gottlieb was exhilarated by the convergence of scale and economy. The pleasures of similitude equalled the beguilement of variety to which he was accustomed. He was an exponent of intricate and subdivided composition who became master of the unified field, a formal shift of enormous range. The first three paintings showed him concerned with the serial image, not as it was to be codified in the 1960s, but in a speculative early form. There is, of course, nuanced differentiation among the paintings, but it occurs behind a screen of identity.

In 1958, Gottlieb broadened the proportion of his canvases in works like *Exclamation,* 90 inches by 72, and *Tan Over Black,* 108 inches by 90. In *Positive* a lighter and freer version of *Tan Over Black,* the canvas measures 90 inches by 60. Gottlieb's interest in repetition and covert variation persists, as is shown by the relation of *Tan Over Black* and *Positive.* His color expanded beyond black and red, but keyed as it was to two large forms, one of them always black, he became a colorist of

large as opposed to compartmented areas. It is not unusual for a third color to be introduced as the tinted ground itself. There is a classic balance to these broad paintings which the agitated edges, pulling apart or merely shifting the weight of the lower form, animate but do not disrupt. The two islands are usually equivalent in area and are characterized as much by their mutuality as their differences. Despite their manual contrast as painted forms, they occupy a continuous spatial plane. The dyadic image should not be interpreted solely in terms of contrasts and opposites. The inter-dependence of the two zones is also important to Gottlieb. Thus he posits a complex exchange between the two parts of the holistic image.

The theme of the Imaginary Landscapes remained in Gottlieb's mind: recurrent horizontal pictures punctuate the verticals of the Burst series. In the Landscapes' development he expanded to a drama of scale that has no equivalent in the upright paintings. Verticality is always keyed to the single human presence in his work, so that the proportionate division of the canvas relates to ourselves. There is a kind of Vitruvian analogy. The later horizontals don't have this intimacy, the scale of the forms, each clearly articulated disk or cursive mass, stays in the body's range, if they are regarded one at a time. The later Imaginary Landscapes from 1960 are influenced by the Burst series in the abolition of the horizon line: the multiple solar and flowing tidal forms are related in horizontal succession and are no longer attached to the edge of the picture field by the horizon. Gottlieb's sculpture belongs to the same train of thought, as it tends to consist of sequences of flat, cut forms at different heights and angles along a central spine. Though fully three-dimensional, this is emphatically painter's sculpture, as it emphasizes form in terms of segments of color seen in their singleness. Gottlieb, incidentally, was an accomplished sailor, and the spatial effect of the Imaginary Landscapes is akin to the low eye-level from a small boat.

The division of Abstract Expressionism into two main directions after the early period of biomorphism, to which the Pictographs contribute as Mary Davis MacNaughton points out, isolates field and gesture. On one hand, there are painters like Newman and Rothko who, whatever gestural components exist in their work, are concerned with color in large planes; and on the other, painters like Kline and Motherwell whose works emphasize the course of the black-loaded brush. Motherwell possesses a keen sense of surface as well as directional inscription, but the retention of black as his prime means reduced the planar potential of forms that might have become fields. It was Gottlieb in particular who showed that the two modes were not antithetical: that is to say,

he reconciled drawing with field painting. The time of his entrance to Abstract Expressionism (the last of the group to paint holistically) put him in a position to align the gestural and coloristic aspects of the movement. His paintings done in 1957 and after make us poignantly aware of the fusion of structural brushwork, from cutting edge to ruffled island, and economical but immersive color, from permeating flood to radiant glow. Gottlieb reconciles color as sensation with form as touch. The pairs in the dyadic paintings act as figures on a ground, but their internal unity and proportion stress the sense of the whole. The holistic image is crucial to the definition of field painting, but Gottlieb is the only painter to achieve it without abandoning the precision of the figure—ground relationships that inhere in gestural handling.

The field painters brought about a change in our expectations of abstract art. The means were simplified, but the content was amplified. Manual emphasis was separated from the decorative and attached to the search for momentous meaning. When Alexander Rodchenko adopted the circle as a canonical form in his paintings of 1918–20, he aimed to reduce the sensuality of easel painting, but, half a century later, Gottlieb's repetition of circular forms became, among other things, a way of preserving manual touch as a positive value. Gottlieb had found a capacious form, a continuous mode, that did not have to be invented every time he painted. It was a shared problem of abstract artists at this time: how to establish an ambitious style within which it was possible to improvise without any slackening of authentic activity. The necessary motif was one that could survive painterly variation without loss of legibility. Gottlieb's early work contributed to his later solution.

Before he approached abstract painting. Gottlieb had painted his Pictographs for ten years and had been a realist for more than fifteen. He was in his late forties when he entered the new phase of his work. His brush work, however, is not retentive of the devices of representation: a large scale, gestural directness and color simplification were brilliantly coordinated, as in the Imaginary Landscapes. There is no formal equivocation between the styles. What happened to subject matter when he was ostensibly no longer using it? It was absorbed in the new imagery and transformed. The Pictographic evocation of mythologies, that is, worlds, is transformed into solar and planetary forms, like a world-landscape. In the Imaginary Landscapes the format of an observed place is transformed into the schemata of earth and void. Titles like *The Frozen Sounds*, *Figuration of Clangor*, and *Cadmium Sound* show that Gottlieb did not present his paintings as pure visual objects in isolation from other experiences. On the contrary, he drew attention to the persistence of

meaning in the new large, simple forms. The reference here is to synesthesia, as in the French Symbolists' correspondence of the senses: the visual and the aural, art and music, are linked in *The Frozen Sounds*, an apt term incidentally for the arresting of music's temporal flow by the spatial tableau of visual art. Gottlieb's painting, like that of the other Abstract Expressionists, was never containable by theories of concreteness and purification. On the contrary, the concrete was replaced by process, so that painterliness became an open source of authentication.

The pace and range of Gottlieb's invention in the late fifties has not been sufficiently recognized, partly because his inventiveness concealed itself in apparently deadpan repetitions. In fact it was an extraordinarily fertile period. The close appearance of the various motifs, which were in full use to the end of his life more than twenty years later, demands that we see them all as part of a total pattern. There are the single-image paintings, which in effect consist of the upper form of the dyadic paintings in isolation, as in *Una*, 1959. There is, too, the first statement of color coding, as it might be called, in which short rows of small tabs of color are compared to the expansive colors of disk and field. The dyadic image of *The Form of the Thing*, 1958, for example, has a third zone along the base, a kind of Morse code in red, black, and white. This work, though at the scale of painting, is on paper which suggests its experimental status; but by 1962 the motif was fully resolved and integrated into single-image paintings such as *Roman Three*. Here three small but decisive rectangles in the lower right seem to summarize the broad yellow field with its high, central, flattened disk. Gottlieb found a way to introduce size-relationships into the unified surface. In the work of the 1970s Gottlieb made a sustained, increasingly free play with all these elements – dyads, single images, and color coding – but with a specifically new stress.

The works from 1971 on were increasingly carried out with the help of assistants, owing to a stroke that immobilized Gottlieb. He had used an assistant before, as many artists do, but now he required more than routine assistance with studio chores. These later works, however, show no loss of personal control, because it had never been *touch* that characterized his work. A conceptual program, anticipating, not simply responsive to, process, was normal in his practice, as the serial nature of the Burst image indicates. Thus, his esthetic and technical decisions were communicable to other people acting on his instructions. The field and the discrete forms upon it were as much the result of prior control as discovery through work. The concept of work itself exceeded the cycle of kinesthetic feedback to incorporate decision making.[7]

The later paintings are continuous with the field paintings but move from the monumental to the lyrical. The scale of the field does not diminish in the seventies, but the forms in the field are often smaller in relation to the whole than before. They convey an impression of mobility, as they flare and fade. Gottlieb's color was always varied and subtle apart from his black-and-red paintings, but it is freshly delicate in the late work. Although the grid is not overt in the Burst format, it is implicitly present in the stability of the motifs bound into the rectangle of the canvas. Like Rothko and Newman, Gottlieb tended to perpetuate the verticality and horizontality of the canvas edges in what he painted. In the late works, however, the smaller forms seem not to be fixed in the same way: they are shaking loose, floating, flying. The fleetingness of the imagery is enhanced by the occasional turning of the canvas during the process of work. This varies the direction of paint splatter, of course, but it also alters the visual impression of the vector of forces implied by the paint. Gottlieb creates a less serene, less restrained field within which the smaller scale of his touch becomes highly animated. The classicism of the earlier works in the series is dissolved by shimmering color and unpredictable form location.

Gottlieb's use of, his feeling for, color is remarkable. In the black paintings of the early fifties color functions like mosaic chips, sparks that arouse the massive planes. In the interwoven paintings that follow, color is similarly firm-bodied, briefer than the grid lines but laid down in similar directions. My sense is that color is used as a relatable solid, as specific area, with less fusion and gradation than are traditionally practiced in painting. Gottlieb's color in the abstract paintings tends to establish a solid surface, but one that is flexible and resilient. It is a brilliant modification of flat color that avoids both schematic two-dimensionality and the full three-dimensional spatiality that a free manual touch engenders. There are numerous paintings and passages in paintings in which color acts as a dimmed or glowing veil, but Gottlieb also expanded the scale of solid, permeable color to the total field of the canvas. These tranquil planes, carefully mixed by the artist, touch on the evocative power of color without violating an essential restraint. All this is compatible with Gottlieb's continued and resourceful use of black as line and color as edge and surface. Only in the last paintings does he experiment with an open and expanding range of atmospheric color as a primary means of painting. The changed facture creates a more volatile surface than is usual but retains the essential characteristics of field painting intact. Gottlieb's commitment to this mode of work after 1957

turned out to be deeply satisfactory; its semantic and pictorial possibilities attuned both to his sensibility and his thinking.

Notes

1. Clement Greenberg, "'American Type' Painting," *Art and Culture* (Boston: Beacon Press, 1961), pp. 208–29. First published in *Partisan Review*, 22, no. 2 (April 1955), pp. 179–96.

2. See "Residual Sign Systems in Abstract Expressionism," in this book.

3. Irving Sandler, *The Triumph of American Painting* (New York: Praeger Publishers, 1970), p. 201.

4. We are indebted to both revisionary art writers, such as Robert Carleton Hobbs (*Abstract Expressionism: The Formative Years*, New York: Herbert F. Johnson Museum of Art and the Whitney Museum of American Art, 1978, pp. 8–26) and graduate departments of art history who rehabilitate neglected pasture by extending the years worth investigating, beyond the artists' first reputations.

5. Field painting is sometimes called Color-field painting, but this over-emphasizes the esthetic and undervalues the semantic potential of the style. We know from statements by Gottlieb, Rothko, and Newman that they were pre-occupied with meaning, which suggests that "Color-field" as a term opposes documentation and intention.

6. Max Kozloff, "Interview with Robert Motherwell," *ArtForum*, 4, no. 1 (September 1965), pp. 33–37.

7. The idea of the creative act as a kinesthetic spectacle was popularized by Hans Namuth's photos of Pollock (Robert Goodnough, "Pollock Paints a Picture," *Art News*, 50 (May 1951), pp. 38–41) which accidentally reinforced the notion of "Action Painting."

SELECTED CHRONOLOGY

1910	Born Wilkes-Barre, Pennsylvania.
1931–5	Student Boston University; studied art.
1937–8	Student Heatherly's Art School, London.
1939	Included, Washington Square outdoor show, New York.
1942	Included, National Academy of Design annual; also 1943, 1944, 1945. Awarded S. J. Wallace Prize 1943, 1944.
1949	Begins first black-and-white paintings.
1950	First solo show, Egan Gallery, New York; also 1951, 1954.
1952	Solo show, Margaret Brown Gallery, Boston. Teaches at Black Mountain College. Included, "Annual Exhibition of Contemporary American Painting," Whitney Museum of American Art; also 1953, 1956, 1957, 1961. Museum of Modern Art Acquires *Chief*.
1953	Teaches at Pratt Institute, New York.
1954	Solo shows: Institute of Design, Chicago; Allan Frumkin Gallery, Chicago. Teaches at Philadelphia Museum School of Art.
1955	Included, "Twelve American Painters and Sculptors," Museum of Modern Art.
1955–6	Included, "The New Decade," Whitney Museum of American Art; circulated nationally. Included, "Modern Art in the United States," Tate Gallery, London; circulated to major cities in Europe.
1956	Solo show Sidney Janis Gallery, New York; also 1958, 1960, 1961, 1963. Included, "XXVII Biennale," Venice. Whitney Museum acquires *Mahoning*.
1957	Included, "Bienal de São Paulo," Brazil, organized by International Council, Museum of Modern Art.
1958	Solo shows: Galleria La Tartaruga, Rome; Galleria del Naviglio, Milan.

1958–9	Included, "The New American Painting," organized by International Council, Museum of Modern Art; shown Switzerland, Italy, Spain, West Germany, Holland, Belgium, France, England, and then the Museum of Modern Art, New York.
1959	Included, "Documenta II," Kassel, West Germany.
1960	Included, "XXX Biennale," Venice; awarded Ministry of Public Instruction prize; Solomon R. Guggenheim International Exhibition, Honorable Mention; "An American Group," Galerie Neufville, Paris.
1961	Included, "American Abstract Expressionists and Imagists," Solomon R. Guggenheim Museum; 64th American Exhibition, Art Institute of Chicago; awarded Flora Mayer Witowsky prize. Solo shows: Collectors' Gallery, New York; New Arts Gallery, Atlanta, Georgia; Arts Club of Chicago.
1961–2	Included, "American Vanguard," organized by United States Information Agency; circulated Austria, Yugoslavia, Poland, England.
1962	Dies in New York. Retrospective, Gallery of Modern Art, Washington, D. C.; circulated to Brandeis University and Museum of Art, Baltimore. Solo show Galeria Lawrence, Paris.
1963	Solo shows: Stedelijk Museum, Amsterdam; Galleria La Tartaruga, Rome; Galleria Civica d'Arte Moderna, Turin; Dwan Gallery, Los Angeles.
1964	Solo shows: Museum des 20 Jahrhunderts, Vienna; Kunsthalle, Basel. Retrospective, Whitechapel Gallery, London (in association with Museum of Modern Art).
1965	Included, "The New York School: The First Generation, Paintings of the 1940s and 1950s," Los Angeles County Museum of Art.
1966	Included, "Two Decades of American Painting," organized by International Council, Museum of Modern Art; circulated in Japan, India, Australia.
1967	Solo show, Marlborough-Gerson Gallery, New York.
1968	Retrospective, Whitney Museum of American Art.
1969	Included, "The New American Painting and Sculpture: The First Generation," Museum of Modern Art.
1969–70	Included, "New York Painting and Sculpture, 1940–1970," Metropolitan Museum of Art; "Painting in

	New York, 1944–1969," Pasadena Art Museum, California.
1974	Solo show, Alan Stone Gallery, New York.
1975	Solo show, David McKee Gallery, New York.
1977	Solo shows: early works, State University at Binghamton and State University at Purchase, New York; works on paper, Mayor Gallery, London.
1979	Solo show, color abstractions, Phillips Collection, Washington D. C.; circulated.
1984	Retrospective, Marisa del Re Gallery, New York.
1986	Solo show, Cincinnati Art Museum, San Francisco Museum of Art.
1987	Included, "Abstract Expressionism: the Critical Developments," Albright-Knox Gallery, Buffalo.
1988	Included, "Postwar Paintings from Brandeis University"; circulated nationally by American Federation of Arts.

FRANZ KLINE RETROSPECTIVE EXHIBITION: INTRODUCTION

Frank O'Hara

AMONG THE AMERICAN ARTISTS to emerge after World War II, Franz Kline occupied a stellar position. Soon after his first one-man exhibition in 1950 at the Charles Egan Gallery in New York, he took a firm, if controversial, place in the consciousness of artists and collectors. Public recognition was slower to come, but his next exhibition a year later placed Kline in the company of Pollock, de Kooning, Gottlieb, Rothko and Still, as one of the formative elements in a cultural development which was later to be unified under the various critical banners of Abstract Expressionism, Action Painting, or more simply "American-type Painting".

To Kline, as to Gertrude Stein, art meant power, power to move and to be moved. (He once said of Josef Albers, "It's a wonderful thing to be in love with The Square.") He is the Action Painter *par excellence*. He did not wish to be "in" his painting, as Pollock did, but to create the event of his passage, at whatever intersection of space and time, through the world. Each painting is a complete and open declaration of feeling. Like a conjurer, and with a similarly self-restricted cast of images, Kline chose to ring the infinite changes of delight, and metamorphosis, and pain. If painting was a wall to him, as several of his titles indicate, it was a wall upon which he, as the mime, would appear in full to reveal the secret of The Dream, that dream of power which shuns domination and subjection and exists purely to inspire love.

Kline had had a thorough academic art training and, unlike many of the artists associated with him, served a long apprenticeship in devotion to traditional forms and styles. He was about thirty-seven when his own personal style began to emerge. As Elaine de Kooning, the painter and his

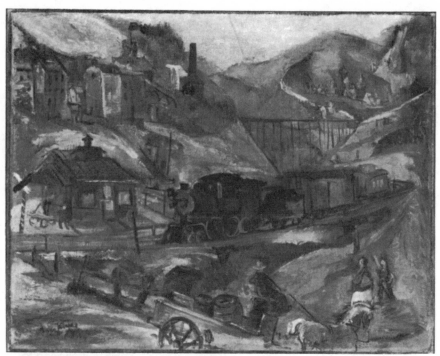

FRANZ KLINE, *Palmerton, PA*, 1941. Oil on canvas, 21″ × 27 ⅛″. National Museum of American Art. Smithsonian Institution. Museum Purchase 1980.52.

close friend, recalls: "While young Americans in the late 'thirties were reacting variously to School of Paris and Mexican art, Franz was in London, poring over the work of English and German graphic artists and cartoonists with their references to Daumier, Blake, Fuseli, Rowlandson, Dürer and Goya, and collecting old prints of the Japanese.

"In the early 'forties, when New York galleries and museums were devoted to Picasso et al., Franz was entranced with Velasquez, Rembrandt, Vermeer, Corot, Courbet, Manet and with the introverted American landscape painters, Ryder, Blakelock and Wyant. When he did yield to twentieth-century styles in the mid-forties, it was with reservations, as though he viewed them through a scrim in a previous style." And of course it was precisely such a scrim which enabled Kline and Pollock to share such a tremendous admiration for a painter like Ryder and find such totally different inspirations in his work.

When Kline returned to America from England in 1939 his career as a serious artist began, and it was as a serious Bohemian artist. Where

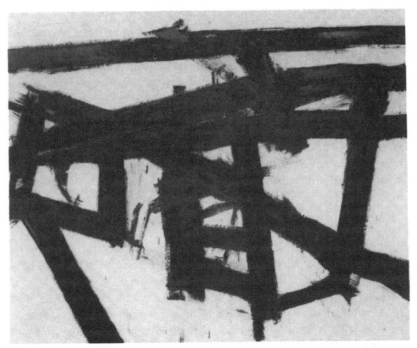

Franz Kline, *Mahoning*, 1956. Oil on canvas, 80″ × 100″. Collection of Whitney Museum of American Art. Purchase, with funds from the Friends of the Whitney Museum of American Art. 57.10. (Photo by Geoffrey Clements)

Gorky and de Kooning had already established a highly intellectual aura of esthetic investigation, discovery and discussion, Kline's temperament and style developed more slowly away from the works of the past he so loved, and he himself was attracted more to the style of the boulevardier, insofar as an artist during the Great Depression could afford to be, frequenting the cafés and bars of Greenwich Village. While most of the artists with whom he would later be associated in the public's mind were employed on one or another of the painting projects of the United States Government, Kline was fortunate in receiving help and support during these years of severe financial struggle from two patrons, Dr. Theodore Edlich, his family's physician, and the industrialist I. David Orr, both of whom purchased and commissioned numerous early figurative works.

During these years Kline exhibited in the twice-yearly shows held on the sidewalks surrounding Washington Square, a Greenwich Village tradition still very much alive today. He painted a series of murals depicting vaudeville and burlesque scenes for the Bleeker Street Tavern,

and drew caricatures of its patrons for the nearby Minetta Tavern. Fortunately many of these works have been preserved and in them, in contrast to the studio paintings of the period, we find the first hints of the Expressionist pace and ready confrontation, and that embrace of vulgarity and drama, which were later to emerge transformed into a new boldness of stance in Kline's abstract work of the 'fifties. In the studio he painted numerous portraits and seated figures, the latter usually in a rocking chair – and memories of the Pennsylvania landscape and of the trains which carried coal from the mines, are among the earliest motifs. Even later, when the transformation from the traditional landscape of Post-Impressionism into a powerful personal vehicle of expression had occurred in his painting, Kline still liked to assign Pennsylvania placenames to abstract paintings (*Lehigh*, *Shenandoah*, or *Hazelton*, for example), or names of locomotives remembered from his youth (*Chief*, *Cardinal*). However, it would be a mistake to read into the forms of the later paintings any significant literary meaning from the titles, applied as they were after the fact of the paintings' creation.

Above all, he drew constantly, whether in a studio, café or street, with whatever materials were available. In his own studio he frequently used the pages of a telephone book to catch an idea or to test a gesture or a motion; elsewhere menus, napkins or scraps of paper would be used and saved for further thought. Drawing for Kline represented not only an activity, but also a diary of plastic notions which might be resumed and developed years later, or acted upon immediately. It follows then that many of the drawings indicated as "studies" are more properly events preceding or related to a given oil painting or mimetic rehearsals of gesture awaiting their ultimate and ideal scale, rather than studies in the traditional sense.

Kline loved paradoxes and theatrics: a great mime, he was fond of parodying, often wordlessly, always amiably, friends, artists, collectors, museum officials, or further afield, literary figures and performers he remembered from vaudeville and the circus. He unerringly, and with great affection, picked upon the precise eccentricity or foible which made his particular subject unique. Alone he was serious, attentive, philosophical within a wonderfully idiosyncratic frame of reference which placed his own conception of The Dream (of art and life) on an equal semantic footing with Existentialism and the Absurd; in public he was gregarious, a marvellous raconteur, and a tremendous fan of Mae West and W. C. Fields. He personally held at bay all possibilities of self-importance, pomposity, mysticism and cant which might have otherwise interfered

with the very direct and personal relation he had to his paintings and their content. He kept himself from being publicly engulfed by his own meanings and the meanings he so well intuited in the life around him. He did not tame his work, but he thus tamed the role which he suspected so correctly society would, if allowed, impose upon him as it had on the unsuspecting Pollock. One of the lessons of our own society, often as opposed to that of Europe in the very recent past, is that for the artist to keep working after initial recognition he must adopt the cleverest devices of Dickens' Artful Dodger. Kline worked publicly to retain his studio privacy. No matter how helplessly he and those around him dissolved in laughter at one of his fantastic anecdotes, underlying it was a nostalgia and longing which reminded one of the early "idealistic" anarchists, and a melancholy recognition of mutability, self-irony singling out the irony of the specific tale.

In a sense the figurative painting of the 'forties, fanatically worked over and over if they did not "make something happen", are his own exhaustions of appearances which haunted him. At this time Kline was teaching himself what he saw and what he could do and what he wanted to see. He loved relationships, if not imitations. He loved commissions as a challenge for his talents, and the more specific the commission the more challenged he felt. "You know I was very hard up one time and this collector was dying to have a Laurencin over his fireplace. He asked me if I could paint him one and I said I'd try. You know, it was terrific working on it, and it turned out to be a terrific picture, all pink and white. I kind of like Laurencin anyway; like Apollinaire said, she was an Amazon".

But once he had found what he wanted to see in his drawings, this fun in art, and this kind of versatility, El Greco and Cézanne in the landscapes, Pascin and Soutine in the figures, were put behind him. The modest quality remained in his conversation, but in his art he was on stage at last with all his own juggler's paraphernalia, and the opportunity for great risks and achievements was fully apparent to him in the harsh light.

Unlike many of his contemporaries, Kline was never consciously avant-garde. He had none of the polemical anxiety which must establish itself for a movement or style and against any or all others. His great admiration for de Kooning did not preclude an intense admiration for Pollock, even in a close-knit artistic society full of partisanship and either/or decisions, which gathered frequently at The Club, an artists-sponsored meeting place, or at a nearby bar, to engage in heated discussions of esthetic right and wrong. His combats were with himself in his art, and were so personal as to defy intellectualization.

His first significant abstract works were done about 1945–47. They evolved naturally from preoccupation with the act of drawing. The "break-through" in style, which seemed to have been signalled in 1950 in his first one-man exhibition, is already foreseen in two works of 1947, *Collage* which prefigures many of the later large horizontal paintings, and *Untitled*, with its strong relationship to both *Chief* and *Clock Face*. The later works, done in black and white, established Kline's originality and strength, but the motifs already existed in the earlier colored ones.

However, the scale marks a change in Kline's self-orientation. In the late 'forties de Kooning had done a series of black and white abstract paintings in enamel with shiny surfaces and the marvellously acute calligraphic cuttings and whippings of line for which he is famous, and Pollock was soon to embark on his series of semi-figurative works done with black paint seeping into unsized canvas, at once sensitive in surface and frequently grotesque in form. Kline's was an entirely different approach to black and white. The forms are stark and simple, the gesture abrupt, rough, passionately unconcerned with finish. All the finesse so ardently acquired from the masters has been set aside for a naked confrontation with the canvas and the image. Where finesse still exists, as in *Cardinal* and *Abstraction* 1950–51, it is commanded by the image totally. The images have become hieratic and undeniable, composed of monumentally angular calligraphic strokes in constant tension with a rough and awkward semi-geometrical stubbornness, like a struggle between Picasso's *Guernica* and the Bauhaus. *Wotan* is an example of the uncompromisingly successful outcome of this impulse.

In the mid-fifties Kline enlarged enormously the scope of his expression without losing any of the immediacy and vigor of his painterly gesture. His blacks and whites took on more and more variety of hue, and their relationships as colors, as in *White Forms* became the vehicle for the introduction of browns and umbers in *The Bridge* and *Shenandoah*, culminating in 1958 in *Mycenae*, where black is entirely absent, and the slashing strokes of reds and yellows interact with the whites in the same intensely opposite way as do the blacks and whites in the earlier paintings.

Paradoxically, the introduction of reds, purples, oranges and browns into the paintings of this period met with as much controversy as had Kline's initial insistence on their absence. Having been assigned the kingdom of black and white, this seemed like abdication. But Kline's greatest efforts were always engaged in pictorial problems, rather than the pursuit of perfection. He was not at all interested in pursuing a style toward the dead-end of expertise. When problems did not exist, he created them.

Even in the black and white paintings of this period we note the increasingly more frequent use of greys, blue-greys, charcoals, altering and complicating the previously clearly defined relationships in a manner which has more to do with chiaroscuro and sfumato than simply with obscured calligraphy. A masterpiece like *Wanamaker Block*, one of his most characteristic black and white paintings, seems the direct and inevitable result of a natural gift, but for Kline it was a hard-won battle, and he distrusted easy victories. To the difficult victories we owe the Kline of *Lehigh* and *Rue*, with their changes from stark opposition of line and mass toward nuances of directional structure and developments of spatial ambiguities within the mass.

To those who had thought the early paintings were influenced by Japanese calligraphy the more complicated hues in the paintings of the mid- and late-fifties were puzzling. But as the density and complexity of Kline's content deepened from embattled clarity to tragic awareness, the means of a previous feeling could not be simply restated in another context. Nor had the earlier work been actually calligraphic in the Oriental sense. The whites and blacks are strokes and masses of entirely relevant intensity to the painting as a whole and to each other. The strokes and linear gestures of the painter's arm and shoulder are aimed at an ultimate structure of feeling rather than at ideograph or writing. Unlike Tobey, Kline did not find a deep spiritual affinity in Japanese art, beyond his appreciation of its pictorial values and perhaps a fondness for the diagonal and for the build-up of unified imagery through exquisite detail also appreciated fully by so many nineteenth-century European painters. His influence on Japanese painters themselves has usually led them directly *away from* their own calligraphic tradition, and we know that one of their leading painters, the late Sabro Hasegawa, admired Kline precisely because his work seemed so uniquely American.

He had always, however, the draughtsman's gift of placement. Forms, strokes, dots and dabs, found unerringly their ideal position in the space of his surfaces. He was very conscious of this quality, and of the vitality and freshness of a slightly "off" positioning. His consciousness of the limits of the canvas was that of the high-diver to his pool, the aerialist to his net. The range of his perception of presences was extraordinary. Some come toward you, advancing as you are beckoned (*Harley Red*), some implacably turn away from your descent (*Charcoal, Black and Tan*), while others float, implacably waiting (*Untitled*, 1960), or speed past in panoramic darkness (*Untitled*, 1961). The huge organic lunge of *Orleans*, the massive gates of *Zinc Door* with the exiled yellow above them, the dignified, impassive guardedness of *Slate Cross* are all aspects of a rigor-

ous confrontation with extreme experiences. These late, great structures of his mind, lucid, tangible, and fiercely humane in their sweeping inclusiveness, find ultimate expression in such a painting as *Shenandoah Wall*, a frontier which fate was to prevent the artist from crossing into who knows what other land of promise?

ART CHRONICLE: FEELING IS ALL (KLINE)

Clement Greenberg

ANOTHER IMPORTANT NEW PAINTER is Franz Kline, who has just had his second show at Egan's. He at least got a better reception from his fellow-artists than Newman did, even if the official and collecting art world is still wary of him (and it would speak little for him if it were not). Kline's large canvases, with their blurtings of black calligraphy on white and gray grounds, are tautness quintessential. He has stripped his art in order to make sure of it – not so much for the public as for himself. He presents only the salient points of his emotion. Three or four of the pictures in his two shows already serve to place him securely in the foreground of contemporary abstract painting, but one has the feeling that this gifted and accomplished artist still suppresses too much of his power. Perhaps, on the other hand, that is exactly the feeling one should have.

From *Partisan Review*, New York, January – February 1952. Reprinted by permission of Clement Greenberg.

FRANZ KLINE

Dore Ashton

AT THE FARTHEST REACHES of esthetics the problem of style can become very complicated. What is style? How is it defined, how is manner different from style, when is it decorous in history to talk about style?

These are questions I pass by. In commonsense terms Franz Kline has a style. Not only is it immediately identifiable (is that a criterion of style?) but it was so almost from the moment he began his reductions to arrive at black and white.

So powerfully apparent is Kline's style that nearly all the commentators on his work have been constrained to discuss it in much the same terms. No matter how desperately the critic would like to find fresh launching sites for his idea, or stirring analogies, he always finishes by discussing the same aspects of Kline's style. I am no exception.

The points generally made are: that Kline is an authentic "action painter" because his image depends on the velocity of skimming lines in white areas. That scale is significant because Kline is not trying to make black figures on white grounds, but paintings in which white is the equal of black. That his work has calligraphic qualities and affinities with Japanese brush paintings. That his is an urban style in which the dynamic, automobile pace of city life is a prominent factor.

I don't like to call Kline an action painter. In its present sense, the term describes a painter who, in the wild crest of his creative passion, performs some rite of ecstasy with his brush to convey the urgency of his emotion.

This is confusing ends and means. It is true that Kline's instinctive "end" is to produce lunging marks that quicken the pulse of the spectator. But Kline's means are rarely those of the stereotyped action painter. He most often works his canvases slowly, adjusting the whites with great care and fashioning black structures precisely. His lines are "action" lines in the sense that Paul Klee's lines meant pictorial action. He is given

From *Cimaise* (Paris), May–June 1961. Reprinted by permission of Dore Ashton and *Cimaise*.

to overpainting whites, for instance, until they fit exactly to his conception of the unity of the entire surface. If Kline's means are ultimately hidden, and if the paintings seem fresh and immediate, credit is to Kline's artistry and not his ecstasy. Ecstasy is in the eye of the beholder (which it certainly is in Kline's case).

Parenthetically, it is not surprising that Kline works over his paintings methodically ("some guys think I just knock them out" he says). He has a solid background in academic painting, studied in Boston for several years, and in London for two years. And such a background is not forgotten – at least not by the hand. It is there forever.

Scale *is* important for Kline, as it is for many of the New York painters who became painting radicals after the war. He partook of the revolution in the late 1940s and kept abreast of de Kooning by reducing his dependence on classical paint-modelling, spreading form in a thin fore-region of his canvases, and working with densely massed lines and skidding lights. I have seen the epithet "image-packed" in several reviews of his pre-1950 painting.

Kline's determined elimination of color, toward 1950, freed him from a bondage to tradition alien to his temperament.

It gave him an absorbing personal problem which still goads him today. The problem was: How to break a profound visual habit of regarding white as background and black as figure. In his struggle to wrench away from his own habitual sight-pattern and then the spectator's, Kline was obliged to exaggerate, to make his white steppes vast and overwhelming. (If the sky seems bluer over Venice, it is because one can see more of it.)

Very soon after the first sharp black signs were registered with the public, talk about calligraphy and Japan got underway. Obviously there is nothing calligraphic in Kline's conception. As he has pointed out to several interviewers, his painting culture derives from Cubism, Mondrian and Western pictorial innovations of the 20th century. In fact, his specific necessity is to prevent the spectator from "reading" his black forms against white. In 1952 he was quoted by Robert Goodnough as saying that "while calligraphy is a matter of writing on an unlimited surface in which the paper acts only as a background to support the writing, his own use of black and white is different since his intention is to create definite positive shapes with the white as well as with the black so that the eye may move easily over the surface."

The main reason Kline's paintings are not calligraphic is that unlike the Japanese sumi painters, Kline doesn't begin with a clearly denoted representation in mind. (Even the so-called abstract calligraphers in Japan

begin with a speciic character to which some meaning adheres.) He speaks of his paintings as personages or structures, and says that sometimes they have an "image", sometimes they don't. But even if they are based on a specific visual experience, Kline's paintings are really the continuation of a single insistent amalgam of all his peculiar experiences. No matter how varied his canvases are, they remain obsessively the same in *impulse*.

The impulse is to shoot out into space, to slam through a wilderness of black and white and reach a climax of total freedom. Anyone who has seen Kline dance will recognize immediately how profoundly instinctual his "thrust" is. He dances as he paints, beating out an idiosyncratic rhythm over sustained periods, and then, suddenly, and with élan, breaks the rhythm dramatically by shooting out one foot in a precipitous *accent grave* movement. (One of his paintings is in fact called *Accent Grave*.)

Since 1950 Kline has held exhibitions every two years and at times I have thought I detected an alteration in his style. But looking back now, I see that essentially, Kline's passion for the most simply defined climactic expression has remained virtually unchanged.

He works with the same idea again, expressed in one of two ways: the intricately balanced structures of black lines and white shapes in which, as Barbara Butler has written, "the concept of gravity and balance is as necessary as it is to a Vermeer or a Titian", and the rumbling masses of blacks and greys that billow up to a theatrically heightened light in an approximation of climax similar to that of a Wagnerian opera, to which Kline is devoted. If any evolutionary trait can be determined, it is only in the slight thickening of line and denser masses of white paint that began to appear around 1952–53.

I think *Corinthian*, painted in 1957, is an excellent example of Kline's black–white, dynamic linear method. It was titled after it was finished because, Kline says, it reminded him of Corinthian columns. The image is placed on a white oblong, a favorite Kline format. The length of a horizontal and relatively narrow canvas inspires Kline because he can give his long line a greater charge.

From one point of view, the black is a pile-driver, forceful shape hastening downward and out of the canvas like an implacable, machine-driven fury. (Kline is given to such colloquialism; that is, he produces shapes that suggest the speed and tempo of machines. His references are often taken to be such city phenomena as subway trestles, unfinished skyscrapers, automobiles, and other images of both speed and urban furniture.)

From another point of view, though, the black in *Corinthian* is set off by the desert of white, grand and spreading and giving off the even

wintery light typical of Kline's work. A smudge and a track in the white field give it scale, make it seem more powerful even than the black structure against which it presses with such energy.

I use this painting to illustrate the complexity residing in the apparently simple. At first glance, the jaws of Kline's black snap-to on the white spaces; the horizontally titled arms seem to circumscribe and appropriate space; the hurtling forms, eating up the miles of his limitless domain, seem linear and black-on-white. But a second glance invariably reveals his solution of the problem he adheres to so stubbornly: that of equalizing two conventionally unequal forces (black and white) and giving them new meanings.

The other, more fretted and tumultuous mode Kline has returned to periodically is typified by *Siegfried* painted in 1958. The image here is not kept strictly on the foreplan, but through graded tones – blue-black, purple-black, brown-black and grays – creeps back behind the surface to give a wealth of dramatic undertones. In essence the painting is baroque. And it is evidence of Kline's descendance from a definite Western tradition. The diagonal at the crest is the track speeding into infinity. The events below are strung along what might seem as supporting trestles, but might also be abstract symbolizations of clashing forces, as in music. In *Siegfried* and numerous other paintings in white, black and gray dominate the whites, and where white is used conventionally to denote light, line deliberately establishes a third dimension. His booming crescendo and avid stroking relate the paintings in this group to other abstract expressionist works.

Also in this category fall Kline's occasional sorties into color. He chooses bright hues in the primary circle usually, and rarely uses intermediary tones. The result is that his color is used in the same way his black is used. I think though that he loses clarity and that few of his larger paintings with color can match his black-and-whites.

I have stressed the homogeneity and immediately identifiable characteristics of Kline's style. When I suggest that there are few mutations in his style, it is not in criticism, but partially in awe, for Kline's extraordinary energy enables him to sustain his force. The reduction he has imposed on himself is certainly no more limiting than that of Mondrian. Each wholly successful painting by Kline evokes a breathless response in his views. Despite the generic similarities in nearly all his canvases, Kline's authentic obsession touches and convinces.

FRANZ KLINE:
PAINTER OF HIS OWN LIFE

Elaine de Kooning

THE MOST INCLUSIVE OF ARTISTS in his attitudes, methods and long development, Franz Kline seems to get rid of everything but immediacy in the momentous black and white image, now internationally recognized as his unmistakable insignia. Its great energy lies in a naked, physical presence. Its time is now, the place is here.

All-American in effect, this final image, disclosed in twelve years' work (1950–62), presents a unity of expression and singleness of purpose that sets it apart. His work is complete, independent; it is all there, in front of you. Any extensions of its visual actuality into history or biography inevitably would appear to be falsifications. Shorn of all reference, association or allusion, his art seems to reject any attempt at explication.

William Faulkner, who died a few months after Franz Kline, maintained that speculations about the methods, the motives or the history of an artist are irrelevant to an understanding and appreciation of the work. Certainly response to art does not involve analysis: there is the revelation made by the artist and there is the recognition by the onlooker: mission completed. Our reaction to Grünewald's *Crucifixion* would not necessarily be amplified by discovering that he was an atheist or a saint. But knowing that an eighty-year-old painter, sitting in a wheelchair, fully aware that he was dying, selected certain colored sheets of paper and made cutouts to be tacked on a wall under his supervision is a piece of information that illuminates the last masterpieces of Henri Matisse.

What we know of any artist's life *may* or *may not* be revelatory. Some artists hide. Others – Michelangelo, Cellini, Delacroix, van Gogh, Dostoyevsky – expose themselves, keep journals, write sonnets. And some, like Franz Kline, talk. For these, nothing they have done or thought or said is irrelevant. Everything helps. For Franz Kline, "talk" was an activity which he always kept going around his art. He was never silent or secret. Everything he said, the wisecracks, the miscellaneous bits

From a catalogue of the Washington (D. C.) Gallery of Modern Art, 1962. Reprinted in *Art News*, November 1962. By permission of Elaine de Kooning.

of lore, the hilarious reminiscences are pertinent to his creation and our understanding.

The authority of Kline's art has nothing to do with authoritarianism; his ideas have nothing to do with ideologies. "Hell," said Franz, "half the world wants to be like Thoreau at Walden worrying about the noise of traffic on the way to Boston; the other half use up their lives being part of that noise. I like the second half. Right?"

His acceptance of things-as-they-are had nothing to do with resignation, but with a rare, panoramic enthusiasm. A great spectator, open to everything, Franz Kline appreciated art, past and present, with passion and perception, as he appreciated the time and place in which he lived. This genius for responding had a humorous, childlike, vulnerable quality – a sense of absolute faith – like that of a Jehovah's Witness who announced to a group of artists some years ago: "This world is a marvelous place. Everything is so convenient. When you get out of bed in the morning, the floor is always there, right under your feet."

His black and white image, with the massive scale, blunt finish, uncaring, unlistening presence of industrial structures, often loomed with an uneasy contemporary sense of the tragic. First exhibited in 1950 at the Egan Gallery, his painting did not reflect the dominant attitudes of the European art that had been shown so widely for the previous decades, nor did they seem to feed on the other new American painting then just gaining its first small acceptance. Certainly the big, automatic canvases of Jackson Pollock had their effect on Franz Kline (as they did on the whole climate of the artists' world), as did his friendship with Willem de Kooning, a dynamic and inspirational relationship (like that of Monet and Renoir, as against the intellectual, collaborative ties that linked Picasso to Braque).

Franz Kline's image found its virile originality in his responses to non-art or life. The shock of original art comes from the form it gives to a consciousness that was there, formless, beforehand. As the poet Frank O'Hara observed, Franz Kline's work both expresses and lives, "by virtue of the American dream of power, that power which shuns domination and subjection and exists purely to inspire love."

Franz Kline recognized the gestures of American Style wherever he looked and had an uncanny ability to project its particularities and breadth through paint. American style, as he saw it – with a fan's zest and expertise – had an element of the comic; the big, brash, breezy gesture that, carried to its extreme, becomes a not-unconscious parody of itself, as in the design of the Cadillac or the cut of the zoot-suit, as in the movie-queen's inevitable role of female impersonator, as in the fanciful sentimentality of Tin Pan Alley songs, as in films based on the lives of

stars, played by the stars themselves (Gloria Swanson in *Sunset Boulevard*), as in the jovial mechanized rhythms, so instantly recognized abroad, of popular dances, from the Charleston, the Black Bottom, the Tango, through the Bunny-Hug, the Lindy, Big Apple, Truckin' to the Twist, the Fly and Mashed Potatoes.

Humor, for Franz, was always a kind of appreciation. Talking about a painter who became a comedian in the Borsht Belt and who never got back to painting, Kline remarked, "He had such marvelous heart. He *cared* so much." Franz had a special love for comedians (particularly the slap-stick that went out with vaudeville) and was himself a magnificent mimic. His anecdotes, told in half-sentences and unfinished gestures, expressed the inexpressible. His jokes, for which, with a helpfully contagious laugh, he was his own best audience, were inimitable. His stories, half-told, half-acted, communicated to a point beyond words. There was always, one felt, a deep message that somehow, a moment later, couldn't be interpreted. But it didn't really matter. "To be right," Franz pointed out, "is the most terrific personal state that nobody is interested in."

"Mirth is the mail of anguish." Franz Kline's favorite comedians were always the helpless ones, "the lost souls," like Laurel and Hardy, W. C. Fields, Buster Keaton, whose acts perpetually meshed into the fatal chain of events of tragic heroes, Ajax, Oedipus, Sisyphus.... In the years when he lived in bleak poverty, one of his jokes was about the Bostonian who defined a bohemian as "someone who could live where animals would die."

Anecdotes were Franz Kline's shop-talk. Literature, religion, philosophy, art theory were subjects to be avoided (too vague, too ponderous). He was in love with the actual and the specific: the time it took Cunningham to run a mile in the Melrose track meet, why they took Jim Thorpe's medals away after he won the Decathlon, how many fights Phainting Phil Scott lost before he retired a rich man, how Ronald Coleman mounted a horse in an old French Foreign Legion film, why Toulouse-Lautrec wanted to draw like Degas who wanted to draw like Ingres ... the stream of Franz Kline's observation was a matter of illuminated fragments, poignant facts, nuggets of insight. A festive man, committed to the moment he was living, ready to dance all night, the last to leave a party, Franz had a paradoxical loyalty to the past. The American rage to discard the "obsolete" was intolerable to him. He never abandoned an enthusiasm and there was no such thing as a passing fancy. Nostalgia played a curious and powerful role in his development. It was as though he proceeded in his life and in his art by looking backward.

While young Americans in the late 1930s were reacting variously to School of Paris and Mexican art, Franz was in London, poring over the work of English and German graphic artists and cartoonists with their references to Daumier, Blake, Fuseli, Rowlandson, Dürer and Goya, and collecting old prints of the Japanese.

In the early 'forties, when New York galleries and museums were devoted to Picasso et al., Franz was entranced with Velasquez, Rembrandt, Vermeer, Corot, Courbet, Manet and with the introverted American landscape painters – Ryder, Blakelock, Wyant. When he did yield to twentieth-century styles in the mid-forties, it was with reservations, as though he viewed them through a scrim in a previous style.

There were artists he admired but kept his distance from – that is, his admiration did not invariably involve the hand that held the brush. "It would take a top kind of egotist to say, 'Velasquez is related to what I'm doing.'" His feelings for other artists as echoed in his work during this period were not sequential but acted in an interplay. A flashily brushed, monotoned oil of a Negro couple is at once reminiscent of Daumier and of Kline's friend, Reginald Marsh. A tiny, glittering portrait of a two-year-old in red overalls, painted in an hour in swirls of bright pigment, evokes both Delacroix and Soutine. El Greco and Cézanne cast their light intermittently over the cramped, industrial landscapes, painted from memory, of Central Pennsylvania, where the artist was born and spent his adolescence before going to Boston to study art. Through this decade, his highly varied studies of women invoke the artists who specialized in painting women: Modigliani, Pascin, Toulouse-Lautrec, Matisse, Rouault and, of course, Picasso. "A great part of every man's life," wrote Sir Joshua Reynolds, "must be employed in collecting materials for the exercise of genius. Invention, strictly speaking, is little more than a new combination of those images which have been previously gathered and deposited in the memory: nothing can come of nothing; he who has laid up no materials can produce no combinations."

An excruciatingly conscious artist, Kline was passive about his erudition. He didn't *apply* it. It imposed itself on his brush.

His relation to his patrons also had an odd, passive quality, like that of artists of past centuries when they used to have patrons. Nowadays, artists are supported (or are not) by collectors who buy their works as objects to be hung among other objects. Patrons, who support the *making* of art, are rare. Franz had two: Dr. Theodore Edlich, whom he met in 1936 and who bought some thirty-five of his works during the lean years, and David Orr, who bought some one-hundred-fifty of his paintings during the 'forties.

Franz Kline had a very close relationship with both of these men who were instrumental in keeping him going in the decade before he became famous. (Edlich was his family doctor and was in attendance during his last illness.) Whenever the artist was more than usually broke – which was constantly – there was always a portrait of a wife or a child to be painted. In 1946, after years of hard work, when Franz hit one of those overwhelming slumps which most disciplined artists experience and make it seem impossible to pick up a brush for months at a time, Dr. Edlich lured him back to his easel by commissioning a portrait of the late Mahatma Gandhi, whom the doctor revered. Franz painted a gentle, impersonal, and uninvolved study as though he had not given the subject much thought, but was willing to empathize with someone else's feelings.

David Orr, who discovered Franz exhibiting in Washington Square in 1939, was an even more active patron, commissioning numerous portraits of himself and of his family and constantly suggesting scenes and subjects to the artist whose work he knew by heart. If someone else bought a landscape or a still-life or a portrait that Orr liked, he often had Franz paint another version – and the later version would always be larger, bolder, freer.

During this period, Franz Kline compulsively returned to the same themes over and over: the figure of a woman seated by a table, an empty rocking chair against a window, a train impacted in a green landscape, a bouquet of big, pale, yellow flowers. And the different versions of one subject would vary drastically in style. Preoccupied with his own ideas of form, the painter could let them cluster around any possibility. André Gide's observation on a Vuillard would be applicable to any of these pictures: "I know of few works where one is brought more directly into communion with the painter. This is due, I suspect, to his emotion never losing its hold on the brush and the outside world always remaining for him a pretext and a handy 'means of expression.'"

Affectionate towards his subjects, he could accept any subject. In fact, a subject was necessary to set his ideas of form in motion. His occasional abstractions of the late 'forties, although graceful and learned, were eclectic to the point of anonymity and lacked the conviction of the representational pictures he was making at the same time.

During this period, Kline would often return to finished paintings, taking them down from Orr's walls and reworking them (he had a studio set up in the household). Sometimes he would get bogged down and paint out the picture. His process was one of constant adjustment, refinement, addition and reduction, as he probed for the image in an approach

closer to that of Ryder than to any other artist. Like Ryder, he painted an interior world, rarely working from life except for his portraits and, even then, the portraits would generally be finished without the presence of the sitter. His self-portraits were the only works completely painted from life. Working painstakingly on small canvases (the average is 18 by 20, the largest 40 by 50), Kline was never finicky as his compact images evolved in dense non-illusionistic space.

Drawing rather than color was Franz Kline's passion in these works. Color was tonal and employed in terms of lights and darks. Even when he used bright color it was arbitrary and ended up in a monochromatic scheme – portraits, landscapes, interiors all might be described as yellow or green or ocher or red paintings as, in each case, the drawing picked up the leading color and ran away with the picture. Drawing was carried not only by the contours, but in the intense, quirky application of pigment as he twisted, pulled, dragged brushes, palette knives, pencils through the wet paint in constantly changing ways, always ending up with a completely coated canvas whether he finished the painting in weeks, months or in a day.

The extraordinary memory for essential gesture, structure, and detail that made him a great mimic, enabled him to reconstruct sweeping cityscapes in his studio – the old Ninth Avenue El, Chatham Square, Hudson Street, the Fulton Fish Market – in characterizations so keen that any New Yorker would immediately recognize the specific neighborhood, from its feel rather than from any circumstantial detail.

Emotions were characterized, too, in the forlorn but jaunty studio-interiors, the lonely seated figures, the lighthearted, preening cats and frolicking horses, the almost invariably melancholy portraits. The pressing sense of bleakness, of isolation, of alienation in the black and white structures were foreshadowed by his preoccupation with the image of Nijinsky in the role of Petrouchka, the clown with the classically lost love. He painted numerous studies of the great dancer, always with the head cocked to one side in a hopeless, disjointed gesture. With the abject, blood-red eyes burning sadly in a pasty white-powdered face, this painting fixes the star's private tragedy on his public image. Like Camus, in *The Artist at Work*, like Henry James in *The Death of the Lion*, like Marilyn Monroe, summing up her own life in the interview published a week before she was "suicided by society" (Artaud's phrase), Franz appreciated how a celebrity's public myth can drain his private blood.

The masterpiece and the last of his serious representational pictures, *Nijinsky* was painted on commission for David Orr in 1950 after Kline had begun working in his new style which is reflected in the radiant

brushwork of the portrait. He painted a few more landscapes, portraits and still-lifes in the early 'fifties, but these were no longer meaningful in his development and were done on commission purely to earn money because his black and white paintings, although widely acclaimed, were not being bought. In fact, Franz Kline had a very short look at his success – six years at most.

A "pro" in a sense that is rare in the art world today, when sanctimonious stands are being taken by so many vanguard artists who apparently were *drawn* to art as a way of life (or a way of preaching), not *driven* to it, as Kline was by the simple need to work, he painted for the joy of the activity itself and used to take on any commission. The 'forties were the interim years, after WPA had vanished and before artists could support themselves with the teaching jobs that are now so numerous, but Kline managed a livelihood, sternly modest though it was, from his art. Purely commercial jobs, like the murals of burlesque queens painted for a Greenwich Village tavern or a panorama painted for the American Legion Hall in Lehighton, reveal an incorruptible effort that kept them from being common potboilers. And the pencil portraits – still scattered on the walls of the Minetta Tavern where the artist drew customers for fifty cents apiece – are direct and exquisite examples of draftsmanship, the result of doing what comes naturally after years of learning how to be natural.

All during the 'forties, while he labored over his paintings, he was making hundreds of tiny sketches in small pads, menus, napkins, envelopes, on the backs of bills, on any scrap of paper around a park, cafeteria or studio. Battered and spattered, smudged and creased, but somehow always saved, these lucid sketches became the key to his self-discovery. Fragmentary jottings of ideas, notations of possible compositions or formalized reductions of finished paintings, Cubistic studies of figures flashing through brittle planes, violent little brush drawings of horses, cats, trains and rocking chairs, fluid pen and ink drawings of friends with the contour skimming around the figures, trapping fantastic resemblances in the fleeting line, these small sketches reveal an astonishing range of invention. Kline carried on his private investigation of his non-verbal thoughts on paper in the same spirit that he "performed" his anecdotes, attempting to fulfill his endless urge to comment, to analyze, to deduce, to combine, to act out – and finally – to amaze, to offer something brand-new. "Art has nothing to do with knowing," Franz said, "it has to do with giving."

Although they seemed to be made in the nature of doodling, these tiny sketches were highly concentrated efforts. Stark and spare, they have

an open, unpremeditated quality not possible to worked-over pictures. Talking with friends or listening to music (Franz was partial to Wagner and Bunk Johnson), he drew with pen or pencil. Alone in his studio, he worked mainly with mixed mediums – crayon, India ink, pastel, water-color, tempera, laying in flat areas of clear color, heavily outlining his forms with black in pencil, crayon, ink or paint.

A crucial element in the evolution of his final concept was the fanatic care he exercised in locating the limits of the rectangle surrounding a sketch. He would never start with a fixed rectangle and compose or expand within it, in the traditional Renaissance manner (still employed, quite unconsciously, by most abstract painters), but would zero in to the final rectangle from changing arrangements and proportions. Sometimes he would draw six different rectangles around a single motif, or he would make several duplicates, each differently delimited.

It was as though his search for a new image had to be pursued on the side and not attacked frontally in a controlled effort where habits of mind could intrude and overwhelm spontaneity and strangle new ideas. Buckminster Fuller once observed that some of the greatest discoveries in the field of engineering came about through the spirit of play.

One day in '49, Kline dropped in on a friend who was enlarging some of his own small sketches in a Bell-Opticon. "Do you have any of those little drawings in your pocket?" the friend asked. Franz always did and supplied a handful. Both he and his friend were astonished at the change of scale and dimension when they saw the drawings magnified bodilessly against the wall. A 4 by 5-inch brush drawing of the rocking chair Franz had drawn and painted over and over, so loaded with implications and aspirations and regrets, loomed in gigantic black strokes which eradicated the image, the strokes expanding as entities in themselves, unrelated to any reality but that of their own existence. He fed in the drawings one after the other and, again and again, the image was engulfed by the strokes that delineated it.

From that day, Franz Kline's style of painting changed completely. It was a total and instantaneous conversion, demanding completely different tools and paints and a completely different method of working with a completely different attitude toward his work. Any allegiance to formalized representation was wiped out of his consciousness. The work, from this moment, contradicts in every way all of the work that preceded it, and from which it had so logically and organically grown.

The artist got hold of large pieces of canvas and tacked them around his walls. He bought housepainters' brushes and enamels in a hardware store since artists' brushes didn't come in large enough sizes and artists'

colors were much too expensive in terms of the quantities he needed, and, more important, they were the wrong consistency – not fluid enough for his new needs. His image was immediately conditioned by the properties of the enamel – the drag on the brush caused by quick drying, the coarse and uneven textures that record the speed and the weight of the stroke, the predictable thickening of the whites and shifts from mat to shiny in the blacks. No matter how simplified his imagery, it was never facile (like that of some of his followers on both sides of the Atlantic). Part of its tension, for the first few years, comes from his fight with intractable materials. Later, when he could afford the best pigment, it took months before the artist, used to struggling with rubbery, stringy paint, could adapt himself to its easy flow and yielding ways. He was appalled when he first began to use good tube whites – titaniums, zincs, permalbas, flakes – with their uniformity of surface and lack of body, and, again, he had to evolve a completely different way of working – this time to avoid slickness and ingratiating effects.

In 1950 his sketches, measuring in feet instead of inches, were slashed out on the pages of telephone books and sheets of newspaper with black enamel. Using these as a kick-off, he would work on several large canvases simultaneously, going from one to another over a period of days or months, hacking away forms, painting over black with white and white with black to carve out or build up his image.

It was Kline's unique gift to be able to translate the character and the speed of a one-inch flick of the wrist to a brush-stroke magnified a hundred times. (Who else but Tintoretto has been able to manage this gesture?) All nuances of tone, sensitivity of contour, allusions to other art are engulfed in his black and white insignia – as final as a jump from the top floor of a skyscraper.

The upheaval in Kline's approach was not accompanied by a verbal mystique, as has been the usual case since Courbet initiated the modern practice of stating revolutionary aims. Since the first appearance of abstract art a half-century ago, its practitioners have been busying themselves with manifestos and ideologies, explaining what their art is and what Art should be. And contemporary painters, more than ever before in history, worry about the interpretation put on their work and are preoccupied with verbalizing its meaning to themselves and to the world. The problem, of course, is that abstract artists often feel that they are going to be misunderstood or that the content of their work is being mis-interpreted somewhere. A curious thing is that the most articulate of the self-explainers from Mondrian, through the Bauhaus, down to Ad Rein-hardt, spend a good deal of their energy laboriously spelling out what

other artists should *not* do. Kline had no desire to explain his work, or to set it up as an Ethos. The painting had its own conviction and that sufficed for the painter. The ideas were all locked in the image and could not be released by words. "The subject has become the problem," Kline said after he had abandoned any representation. "You can say 'painting is the subject,' but you can't just stand by with a shelf full of paint cans."

"Sometimes you do have a definite idea about what you're doing – and at other times, it all just seems to disappear." When he had to give titles to the paintings in his first one-man show, he invited two other artists to his long, narrow studio on East Ninth Street and discussed the possible references. He talked about everything except painting: about his adolescence in a mining town and about the fascination railroads had for him (*Chief* and *Cardinal* were the names of particular trains he remembered); he talked of football games that he played or watched as a child; of the Victorian rosewood furniture designed by John Belter with which his mother furnished the house; of his year in London where he met his wife, Elizabeth, who was then a dancer with the Sadler's Wells Company; of Olympic champions, Pennsylvania Indian tribes, etc. The conversation rambled on for eight hours, animated and directionless, interrupted by one artist or another picking a word out of the discussion as a possible name, which had to be unanimously convincing to be accepted. Its evocation, preferably ambiguous, had to be true to some aspect of Kline's general experience, not to any particular aspect or possible strained resemblance suggested by a painting itself. Titles were identification, not description, and *Caboose* or *Bridge* or *Hoboken* were names that could have been given interchangeably to other paintings. Although he preferred names of places, he occasionally would use one as an homage to a person: *Nijinsky, Elizabeth, Merce C.* (the dancer Cunningham), *Probst* (the painter). And if a private connotation had another implication for the public, that was O. K. too: who would guess that the series called *Mars* was named after a girl he knew in his student days in Boston?

When he had his first show, much was made of a supposed resemblance to Japanese calligraphy, but from the very first, his approach to his large canvases involved an interaction between black and white that was totally alien to calligraphic concepts, techniques and expression. His black forms did not float on a white expanse with the fluency that is a requisite of calligraphy, Japanese or otherwise. Fluency was not the intention or the result as Kline's blacks and whites jostled each other for position in a tense, unrelieved conflict. His way, at that time, of brushing past one color with the other was much closer to the methods of American (as opposed to European) sign-painters who laid in letters in one

color and then cut them with another to achieve a knife-edge impossible through direct application. Although some of the crucial "doodles" of the 1940s were influenced by his long-held admiration for Japanese art, even in these, the forms are straitened and non-calligraphic in expression. Indeed, far from being derivative *from*, his black-and-white image had a wide influence *on* Japanese artists almost immediately after his works were published. The Japanese re-evaluation of the great tradition of Zen calligraphy was, in a way, triggered by their special interpretation of Kline's style.

In his first blacks and whites, Kline often allowed the painting to dry before altering the forms, and the two colors would shear off each other's edges, staying clean and separate. As in the small sketches, the placement of forms in the rectangle was pivotal. Never panoramic, always aggressively close-up, his paintings in the years that follow are like different versions of one immense, complicated machine seen from different angles, from above, from underneath – huge fragments wheeling, rising, toppling, veering, in an always precarious balance. His forms kept becoming more and more massive, the space more dense, as reverberating greys appeared along edges and crashed through blacks and whites, cementing them in increasingly complex structures. Watchful at every moment for the climactic equilibrium, Franz Kline approached his big canvases in a spirit of attack. His gesture of painting might be reckless but was never automatic. From the first carefully aimed sweep to the last, his control was always fiercely evident.

In the middle 'fifties, he began attempting to use color and, at first, it seemed as though his identity was irrevocably caught between black and white. Although his first use of color – great rushes of blue, green, purple – had a marvelous lyrical quality, it lacked the force of his black and white imagery and, over and over, black would get back into the act and solve his problems. Again, he resorted to small sketches, making hundreds of oil studies on large sheets of paper which he would then cut up into smaller rectangles, isolating a flurry of greens here, a flash of purple there, in his search for the scale of color. But on his large canvases, the color seemed to thin out and lose volume and as the paintings developed, color was allowed to remain only in shreds and intermittent washes that acted in terms of value not hue. Then, as he kept struggling, interweaving black and white with weighty blues, oranges, reds, his color made its breakthrough and entered the dynamism of his imagery as an equal actor.

The stage was set, the new action had started.

A recurrent illness forced Franz Kline to stop work in the winter of 1961–62; he died the following May at the age of 50.

The big thing about Franz Kline's art is its inclusiveness. Franz, laughing in front of one of his big black and white paintings, obviously making a wisecrack, in the wonderful photograph printed in *Life* after his death, has the open gesture of his own painting. It is not surprising that this photograph is tacked on the walls, coast to coast, of the studios of artists who never knew him. Franz Kline had an extraordinary gift for establishing intimacy through his art.

KLINE'S ESTATE
Lawrence Alloway

ROBERT GOLDWATER'S INTRODUCTION in the Marlborough-Gerson catalogue to the exhibition continues the differentiation of the so-called Abstract Expressionists from one another that has been going on, a bit at a time, through the 'sixties. One problem in the discussion of the gestural painters is the disentanglement of their open-surfaced paint textures from the simplificatory idea of Action. Towards this end Dr. Goldwater rightly emphasizes the non-athletic character of Kline's art, produced not just by swipes of a house painter's brush in the hands of a coonskinner, but by tarted-up edges and modified paint masses, with small brushes active inside the tracks of big ones. However, Dr. Goldwater retains unintentionally the prestige of an aesthetic of impact in American painting, as when he argues that recognition of "process, that supposed medium of the immediate, only comes much later, ironically introduced by its enemy, contemplation."

The separation of Kline's work into impact and contemplation (first, POW! later a post-impact contemplative phase) makes a false dichotomy. (Dr. Goldwater has confused the first sight of any new work of art which is tough and strange, and its later history when it is familiar and explored.) Kline's works now don't come on strong, even unfamiliar ones from the estates; impact is not an on-going experience. The fact is, process is not revealed merely by seismographic jerks and muscular lunges; it is revealed by degrees of elaboration and Kline acted fully on this notion when he simulated bold marks in paintings that are actually blown-up from drawings, with no more changes introduced than grow technically out of the translation from one medium (and scale) to another.

Thus, looking closely at Kline can free us from the notion that process-record in a painting is a literal account of its execution, free of the duplicity of second-thoughts and effect-getting. On the contrary, process-record is particularly the medium of revision and uncertainty, in Kline as it is in Guston and de Kooning. In all three artists touch, transmitted by

From *Arts* magazine, April 1967. Reprinted by permission of Lawrence Alloway.

the brush to canvas, records respectively, timidity, anxiety, complexity.

Paintings from the estates of successful artists tend to be unrepresentative of the artist's best work, or whole life. The Pollock estate, for example, is over-weighed by early works which are engrossing but not, of course, the works that made the difference. The Kline estate is light on the early 'fifties, the artist's best period, and heavy on later works. (Of course, it is possible that the estate is being husbanded, like the Morris Louis estate, so that not too many works get out and glut the market.) At present revealed, however, are only two early paintings (*Untitled*, c. 1951, *Yellow Square*, c. 1952) and four drawings (c. 1950–52). The thick sparseness of the forms in these works have an authority which is either elaborated (as in an echo chamber) or thinned (like an empire spreading too far from is center) in the later works. To compare *Untitled* c. 1951 with, say, *Riverbed*, 1961, is to see the rigid blacks of the earlier work become more supple, but also softer. An untitled drawing of c. 1959 (55 in the catalogue) repeats the form of the *Untitled* c. 1951 painting very exactly, but the difference between the images is the difference between iron and rubber. The *Yellow Square* c. 1952 with its open field has a pictorial clarity that is abandoned in the later work. From around 1957 his hard signs in a clear white light are pulverised into flecks and planes of color or submerged, as it were, for *Torches Mauve*.

Kline's failure of development seems to derive from the fact that he was basically, despite a swagger that has seemed to many the style of vigour, a timid painter. The relation of his paintings to drawings, for example, seems precautionary in its historical context. It is relevant that though Kline's drawings were well known in the 'fifties, the ones close to particular paintings were discreetly omitted from Action-oriented art criticism, because of the power of the image of heroic improvisation. The revisions and touchings up are present in his early paintings as well as the later, but earlier they stemmed from a strong central monolith or spanning armature, a bare island or a diagram of linear forms in tension. (There seems to be a cross-media link between the latter type of drawing and the early sculptures of Chuck Ginnever and Mark Di Suvero, for instance, of railroad ties and other large scale environmental junk. It may be symptomatic that Kline seems to have had no influence on younger painters, however.)

Kline's early figurative work reveals a nervous reliance on black which never turned into incisive draftsmanship. The extension of his black contour into an all-or-nothing, on-off, black-white kind of abstraction was the best thing he could have done, or ever did. It must be remembered, however, that his early work was a pseudo-realism, in which cliché

overwhelmed perception and in which timidity repressed iconographical invention. (Pollock, on the other hand, transformed his awkward Americana style of the 'thirties into post-Benton rhythms in his work and absorbed the rest into being an *American* artist. That is to say, the early work fed aspects of his later.) Kline, however, had virtually no reserves to call on in his own past art. Thus, when faced with the problem of expanding his reduced vocabulary he re-introduced everything whose exclusion had made him strong. He became tonal, in a cloudy emotive way and the tonality infiltrated his colors so that they usually function merely as tinted half-tones. The blacks themselves become ornamental, either by elaboration or by lack of density. Kline's development thus raises another problem connected with the painters of his generation: the separation of those artists who were capable of extending a reductive art into a major style from those who were only the beneficiaries of a moment of history.

KLINE'S "EFFULGENT ABSTRACTIONS"

John Russell

I T IS QUITE SOME TIME since the art of Franz Kline (1910–62) was considered in depth in a big metropolitan exhibition. A touring show of 92 of his works was seen at the Whitney Museum and elsewhere in 1968, but since then a whole new generation of gallery-goers has come into being. All has been quiet on other fronts. There has been no catalogue raisonne and no fat monograph. There have been no delirious prices at auction and no scandals, financial or emotional, to bring him adventitious publicity. No tyrant of taste has forced him on our attention.

There was a very intelligent show in 1977 called "Franz Kline: The Early Works as Signals" (Albert Boime wrote the catalogue essay) but it didn't get into town. To see Kline in bulk, though on a small scale, the best place has been the David McKee Gallery in New York, which has had work that covered that period from 1945 to 1961. Kline's total achievement stands somewhat apart, therefore, from our everyday experience, though individual black-and-white paintings leave us with an impression of ever-greater power and finality.

We still don't have a major book or a new full-scale retrospective exhibition, but we do have – at the Phillips Gallery in Washington, D.C., through April 8 – a museum show of quite exceptional interest and provocation. It is called "Franz Kline: The Color Abstractions." It includes 54 paintings, ranging in size from "Washington Wall" (1959), which measures 43 by 175 inches, to paintings that measure a mere six inches by eight. The very handsome catalogue (50 color plates, $12 in paperback) has an essay and a chronology by Harry F. Gaugh; and the show will travel later to Houston, Los Angeles and Seattle.

It should be said at once that the impact of the Washington show is one of majestic and fulfilled emotion that finds its natural outlet in color.

We never feel that these are black-and-white paintings with added color. We feel that the color is right and inevitable. What the paintings have to say could not be said in black and white. The color is not a digression. It is not a sign of weakness or sweetening. It fills out, but does not in any way diminish or contradict, our notion of Kline's achievement. Though especially abundant in the year 1959, the color paintings were clearly an important part of Kline's potential through his career as an abstract painter and cannot be seen as freaks or excrescences.

So it is not easy to follow Dr. Gaugh when he suggests that the color abstractions are to Kline's total output as the late black-on-gray paintings are to the total output of Mark Rothko. Dr. Gaugh asks: "Are Kline's color abstractions and Rothko's black-on-gray canvases the sad, desolate manifestations of dead-end styles? Could Kline's physicality of taut planar structure and Rothko's infinite color sensibility survive such problematic shifts in major artistic concern?"

These seem to Dr. Gaugh to be "necessary, if discomforting questions," but they make no sense. No one with an eye in his head could read the consistently voluptuous and on the whole notably successful paintings at the Phillips Gallery as "sad, desolate manifestations of a dead-end style." Many though by no means all of them manifest, moreover, the "taut planar structure" of which Dr. Gaugh speaks. This is as true of the two largest paintings. "Washington Wall" and "Orange and Black Wall" (both of 1959), as it is of the stringent little notations that Kline might or might not have worked up into larger paintings. There is nothing whatever in common between the glorious effulgence of Kline's color abstractions, which everywhere bespeak a creative nature in full evolution, and the sad, pinched, valedictory look of Rothko's black-on-gray moment. This is not an exhibition that needs a factitious antithesis to get itself talked about.

This said, Dr. Gaugh has done us all a great service by his meticulous scavenging of facts and opinions that might otherwise have gone unrecorded. We needed, for instance, to have Robert Motherwell's unpublished comments on the activity that he and Kline had in common: "a contemporary 'black and white' painting that has no intervening middle-tones. An art of opposite weights, and absolute contrast. He really understood ... that modern art's function is to make our present existence known to each other."

It is of great value to have Leo Steinberg's recollection of what Kline said to him in 1956: "I'm always trying to bring color into my paintings, but it keeps slipping away and so here I am with another black show." Dr. Gaugh also has insights of his own: most notably in discussing the

symbiotic relationship between Kline and de Kooning that is apparent in certain paintings in the Washington show. And he is very good at identifying the specific implication of the colors – red, green and yellow – which Kline used to particularly vibrant effect. The relevance of oriental calligraphy is also given its due, and the chronology has new facts to offer, along with some corrections of mistakes that by now have been copied a hundred times over.

The color paintings by definition cannot be reproduced properly in black and white. Kline's color has a direct and evident spontaneity, as if the feeling in question had never found outlet in black and white and was the richer and the riper for the delay. It has to be said that in some of the larger paintings the big girderlike forms do not come off so well in color: what sat like iron on the dead white of the black-and-white paintings here looks like a claw-mark that does not have quite the energy behind it. Once or twice the openness and generosity that are the mark of the color paintings give place to muddle and congestion. But on the whole, and in room after room, what we are given in Washington is a new color painter: and one to cherish.

SELECTED CHRONOLOGY

1905	Born New York City.
1922–6	Studies Art Students League with John Sloan, William Von Schlegel.
1927	Graduates with B. A. from City College of New York.
1931–9	Substitute art teacher, New York high schools.
1941	Graduate student, Cornell University.
1946–9	Included, group shows, Betty Parsons Gallery, New York.
1947	Included, "Abstract and Surrealist American Art," Art Institute of Chicago.
1950	First solo show, Betty Parsons Gallery, New York; also 1951. Included, "American Painting," Walker Art Center, Minneapolis.
1956	Included, "Ten Years," Betty Parsons Gallery.
1957	"American Painting 1945–1957," Minneapolis Institute of Arts.
1958	First retrospective, Bennington College, Vermont.
1958–9	Included, "The New American Painting," organized and circulated by the International Council, Museum of Modern Art, to Switzerland, Italy, Spain, West Germany, Holland, Belgium, France, England, and then Museum of Modern Art, New York. Included, "Bicentennial International Exhibition of Contemporary Painting and Sculpture," Carnegie Institute, Pittsburgh.
1959	Solo show, French & Company, New York. Included, "Neue Amerikanische Malerei," St. Gallen Kunstmuseum, Switzerland; "Group Show," Gallery Kimura, Tokyo; "Moments of Vision," Rome-New York Foundation, Rome; "Documenta II," Kassel, West Germany; "Annual Exhibition of Contemporary Painting," Whitney Museum of American Art; also 1963, 1964, 1965, 1966, 1967, 1971.

1960	Included, "Contemporary American Painting," Columbus Gallery of Fine Arts, Ohio.
1961	Museum of Modern Art purchases *Abraham*. Included, "American Abstract Expressionists and Imagists," Solomon R. Guggenheim Museum.
1961–2	Included, "American Vanguard," organized by United States Information Agency; circulated Austria, Yugoslavia, Poland, England.
1962	Included, "Arts Since 1950," Seattle World's Fair, circulated to Brandeis University and Institute of Contemporary Art, Boston.
1963	"The Dunn International," Beaverbrook Art Gallery, Fredericton, New Brunswick, and Tate Gallery, London.
1963–4	Included, "New Directions in American Painting," Brandeis University, circulated nationally; "Black and White," Jewish Museum, New York.
1964	Included, "The Museum of Our Wishes," Moderna Museet, Stockholm; "Directions in Contemporary Painting," Art Institute of Chicago; "Paintings and Sculpture of a Decade, '54–'64," Tate Gallery, London; "Bilanz International-Mallerei seit 1950," Basel Kunsthalle, Switzerland; "Amerikaane Grafiek," Stedelijk Museum, Amsterdam.
1965	Included, "New York School: The First Generation, Paintings of the 1940s and 1950s," Los Angeles County Museum of Art.
1965–6	Included, "Modern Sculpture U.S.A.," Museum of Modern Art. Organized by the International Council of the Museum of Modern Art; circulated to Paris, Berlin, Baden-Baden.
1966	Solo show, "Stations of the Cross," Solomon R. Guggenheim Museum. Included, "The United States of America," São Paulo VIII Bienal; circulated to Smithsonian Institution, Washington, D. C., and Pasadena Art Museum, California. Included, "Inner and Outer Space," Moderna Museet, Stockholm.
1966–7	Included, "1966 Annual of Sculpture," Whitney Museum of American Art; also 1968.
1967	Included, "Rosc '67: The Poetry of Vision," Royal Dublin Society, Dublin.
1967–8	Included, "Kompas 3," Stedelijk-Van Abbe Museum,

	Eindhoven, Holland; also shown Frankfurt Kunstverein, Germany. Included, "Scale as Content," Corcoran Gallery, Washington, D. C.; "Dada, Surrealism, and Their Heritage," Museum of Modern Art, also shown Los Angeles County Museum and Art Institute of Chicago.
1968	Included, "Documenta IV," Kassel, West Germany.
1968–9	Included, "Art of the Real," Museum of Modern Art; circulated to Paris, Zurich, London.
1969	Included, "The New American Painting and Sculpture: The First Generation," Museum of Modern Art; "The Disappearance and Reappearance of the Image: American Painting Since 1945," Smithsonian Institution, Washington, D. C.; circulated to Rumania, Czechoslovakia, Belgium; "New York 13," Vancouver Art Gallery, Canada; circulated across Canada. Solo shows: lithographs, Basel Kunstmuseum, Switzerland; Knoedler & Company, New York.
1969–70	Included, "American Painting: the 1960s," circulated nationally by American Federation of Arts; "Prints by Four New York Painters: Frankenthaler, Johns, Motherwell, Newman," Metropolitan Museum of Art, New York.
1970	Included, "New York Painting and Sculpture: 1940–1970," Metropolitan Museum of Art; "Painting in New York: 1944 to 1969," Pasadena Art Museum, California. Dies New York City.
1971	Memorial exhibition, Museum of Modern Art. Included, "XII International Biennale of Outdoor Sculpture," Antwerp, Belgium.
1972	Retrospectives: Grand Palais, Paris; Stedelijk Museum, Amsterdam; Tate Gallery, London.
1980	Solo show of complete drawings, Baltimore Museum of Art and Metropolitan Museum of Art.
1985	Solo show of prints, University of California.
1987	Included, "Abstract Expressionism: The Critical Developments," Albright-Knox Gallery, Buffalo.

THE SUBLIME IS NOW

Barnett B. Newman

THE INVENTION OF BEAUTY by the Greeks, that is, their postulate of beauty as an ideal, has been the bugbear of European art and European aesthetic philosophies. Man's natural desire in the arts to express his relation to the Absolute became identified and confused with the absolutisms of perfect creations – with the fetish of quality – so that the European artist has been continually involved in the moral struggle between notions of beauty and the desire for sublimity.

The confusion can be seen sharply in Longinus, who despite his knowledge of non-Grecian art, could not extricate himself from his platonic attitudes concerning beauty, from the problem of value, so that to him the feeling of exaltation became synonymous with the perfect statement – an objective rhetoric. But the confusion continued on in Kant, with his theory of transcendent perception, that the phenomenon is *more* than phenomenon; and with Hegel, who built a theory of beauty, in which the sublime is at the bottom of a structure of *kinds of beauty*, thus creating a range of hierarchies in a set of relationships to reality that is completely formal. (Only Edmund Burke insisted on a separation. Even though it is an unsophisticated and primitive one, it is a clear one and it would be interesting to know how closely the Surrealists were influenced by it. To me Burke reads like a Surrealist manual.)

The confusion in philosophy is but the reflection of the struggle that makes up the history of the plastic arts. To us today there is no doubt that Greek art is an insistence that the sense of exaltation is to be found in perfect form, that exaltation is the same as ideal sensibility, in contrast, for example, with the Gothic or Baroque, in which the sublime consists of a desire to destroy form; where form can be formless.

The climax in this struggle between beauty and the sublime can best be examined inside the Renaissance and the reaction later against the Renaissance that is known as modern art. In the Renaissance the revival of the ideals of Greek beauty set the artists the task of rephrasing an

From *The Tiger's Eye*, December 15, 1948. Reprinted courtesy of Mrs. Annalee Newman and The Barnett Newman Foundation insofar as their rights are concerned.

BARNETT NEWMAN, *Covenant*, 1949. Oil on canvas, 48″ × 60″. Hirshhorn Museum and Sculpture Garden. Smithsonian Institution. Gift of Joseph H. Hirshhorn, 1972.

accepted Christ legend in terms of absolute beauty as against the original Gothic ecstasy over the legend's evocation of the Absolute. And the Renaissance artists dressed up the traditional ecstasy in an even older tradition – that of eloquent nudity or rich velvet. It was no idle quip that moved Michelangelo to call himself a sculptor rather than a painter, for he knew that only in his sculpture could the desire for the grand statement of Christian sublimity be reached. He could despise with good reason the beauty-cults who felt the Christ drama on a stage of rich velvets and brocades and beautifully textured flesh tints. Michelangelo knew that the meaning of the Greek humanities for his time involved making Christ – the man, into Christ – who is God; that his plastic problem was neither the medieval one, to make a cathedral, nor the Greek one, to make a man like a god, but to make a cathedral out of man. In doing so he set a standard for sublimity that the painting of his time could not reach. Instead, painting continued on its merry quest for a voluptuous art until in modern times, the Impressionists, disgusted with its inadequacy, began the movement to destroy the established

326 BARNETT NEWMAN

BARNETT NEWMAN, *Vir Heroicus Sublimus*, 1950–1. Oil on canvas, 7'11⅜" × 17'9¼". Collection, the Museum of Modern Art, New York. Gift of Mr. and Mrs. Ben Heller.

rhetoric of beauty of the Impressionist insistence on a surface of ugly strokes.

The impulse of modern art was this desire to destroy beauty. However, in discarding Renaissance notions of beauty, and without an adequate substitute for a sublime message, the Impressionists were compelled to preoccupy themselves, in their struggle, with the culture values of their plastic history so that instead of evoking a new way of experiencing life they were able only to make a transfer of values. By glorifying their own way of living, they were caught in the problem of what is really beautiful and could only make a restatement of their position on the general question of beauty; just as later the Cubists, by their Dada gestures of substituting a sheet of newspaper and sandpaper for both the velvet surfaces of the Renaissance and the Impressionists, made a similar transfer of values instead of creating a new vision, and succeeded only in elevating the sheet of paper. So strong is the grip of the *rhetoric* of exaltation as an attitude in the large context of the European culture pattern that the elements of sublimity in the revolution we know as modern art, exist in its effort and energy to escape the pattern rather than in the realization of a new experience. Picasso's effort may be sublime but there is no doubt that his work is a preoccupation with the question of what is the nature of beauty. Even Mondrian, in his attempt to destroy the Renaissance picture by his insistence on pure subject matter, succeeded only in raising the white plane and the right angle into a realm of sublimity, where the sublime paradoxically becomes an absolute of perfect sensations. The geometry (perfection) swallowed up his metaphysics (his exaltation).

THE SUBLIME IS NOW 327

The failure of European art to achieve the sublime is due to this blind desire to exist inside the reality of sensation (the objective world, whether distorted or pure) and to build an art within a framework of pure plasticity (the Greek ideal of beauty, whether that plasticity be a romantic active surface, or a classic stable one). In other words, modern art, caught without a sublime content, was incapable of creating a new sublime image, and unable to move away from the Renaissance imagery of figures and objects except by distortion or by denying it completely for an empty world of geometric formalisms – a *pure* rhetoric of abstract mathematical relationships became enmeshed in a struggle over the nature of beauty; whether beauty was in nature or could be found without nature.

I believe that here in America, some of us, free from the weight of European culture, are finding the answer, by completey denying that art has any concern with the problem of beauty and where to find it. The question that now arises is how, if we are living in a time without a legend or mythos that can be called sublime, if we refuse to admit any exaltation in pure relations, if we refuse to live in the abstract, how can we be creating a sublime art?

We are reasserting man's natural desire for the exalted, for a concern with our relationship to the absolute emotions. We do not need the obsolete props of an outmoded and antiquated legend. We are creating images whose reality is self-evident and which are devoid of the props and crutches that evoke associations with outmoded images, both sublime and beautiful. We are freeing ourselves of the impediments of memory, association, nostalgia, legend, myth, or what have you, that have been the devices of Western European painting. Instead of making *cathedrals* out of Christ, man, or "life," we are making it out of ourselves, out of our own feelings. The image we produce is the self-evident one of revelation, real and concrete, that can be understood by anyone who will look at it without the nostalgic glasses of history.

BARNETT NEWMAN
AT THE PARSONS GALLERY

[T.B.H.] Thomas B. Hess

BARNETT NEWMAN AGAIN WINS his race with the avant-garde, literally breaking the tape. This genial theoretician filled a gallery with stripes and backgrounds – a thin white line surrounded by white; a red line surrounded by nothing at all; and a Cecil B. de Mille-size number in Indian-red with five verticals were some of the better ideas presented. In discussing the announcement of his exhibition – a white card printed in white ink – the artist suggested that it was a combination of the *tabula rasa* and Huck Finn's invisible ink. This may also give some idea of the exhibition.

From *ARTnews*, Summer 1951. By permission of *ARTnews*.

ART CHRONICLE: FEELING IS ALL (NEWMAN)

Clement Greenberg

THE FIRST TWO ONE-MAN SHOWS of Barnett Newman, last year and the year before, at Betty Parsons', exhibited both nerve and truth. I mention him at this relatively late date because he has met rejection from a quarter where one had the most right to expect a puzzled judgment to be a suspended one. Newman is a very important and original artist. And he has little to do with Mondrian, even if his pictures do consist of only one or two (sometimes more) rectilinear and parallel bands of color against a flat field. The emphasis falls just as much on the color as the pattern, and the impression is much warmer and more painterly than anything to be gotten from Mondrian or his school. The color itself is broad and easy, sensuous without softness, in a way that is unusual in contemporary abstract painting. People have been bewildered by this art, but there is no question of shock value; Newman simply aimed at and attained the maximum of his truth within the tacit and evolving limits of our Western tradition of painting. Some of his paintings come off, some don't; one can tell the difference. They may not be easel pictures, or murals in any accepted sense, but what do difficulties of category matter? These paintings have an effect that makes one know immediately that he is in the presence of art. They constitute, moreover, the first kind of painting I have seen that accommodates itself stylistically to the demand of modern interior architecture for flat, clear surfaces and strictly parallel divisions. Mondrian aims more at external walls, and at the townscape that replaces the landscape wherever men collect together. Newman – paradoxically, since he is even less of an easel painter than Mondrian – aims at the room, at private rather than public life.

Newman took a chance and has suffered for it in terms of recognition. Those who so vehemently resent him should be given pause, however, by the very fact that they do. A work of art can make you angry only if it

From *Partisan Review*, January–February 1952. Reprinted by permission of Clement Greenberg.

threatens your habits of taste; but if it tries only to take you in, and you recognize that, you react with contempt, not with anger. That a majority of the New York "avant-garde" gave Newman's first show the reception it did throws suspicion on them – and says nothing about the intrinsic value of his art.

THE PHILOSOPHIC LINE
OF B. NEWMAN

E. C. Goossen

J UST SEVEN YEARS AGO Barnett Newman closed shop. That is, he brought his pictures home to the studio from Betty Parsons' gallery after his second one-man show and kept them there. Though a few were subsequently sold and one was allowed to go on exhibition last year in Minneapolis, only visitors to his Front Street studio could refresh their memories of his art. The two Parsons shows in 1950–51 faded into the past.

Meanwhile Newman remained sufficiently in evidence himself, producing a stir occasionally with an open-letter suggesting the incompetence of various members and institutions of the "art-world" and making frequent sorties into vanguard art society where his wit, aggressive concern with principle, and his poetically enigmatic pronouncements seemed to be headed toward placing him permanently as a personality rather than as the fine artist he is. The artist, however, has now been reconfirmed.

The reconfirmation took place at Bennington College where eighteen of his paintings, including the largest he has executed so far, went on view in May; at the same time, four Newman pictures began a tour of Europe in the Museum of Modern Art's "The New American Painting" exhibition.

The most astonishing thing about the Bennington retrospective was the freshness of the pictures. Time often works to an artist's disadvantage, especially if he is an original. The dilution process can work terribly fast, literally almost overnight. But time, in Newman's case, seems to have worked to his advantage. The pictures of 1950–51 might have been painted this morning. Even those of us at the opening who had retained sharp memories of the Parsons shows were suddenly aware that what had seemed then more a matter of the shock of a new image, one stripped to the chassis, had been struck by only half of what Newman was about. The impact was in part due, perhaps, to the new setting – spacious and

From *Art News*, Summer 1958. Reprinted by permission of *Art News* and E. C. Goossen.

yet intimate. But this was primarily a question of opportunity. The real matter in Newman is much deeper than that.

Though Newman has been continuously associated with the generation of painters who have made up what is variously called the New York School, Abstract-Expressionists, Action Painters, etc., his point of view and his own painting represent a kind of personal opposition to the position taken by most of his colleagues. Like many of them he came out of the Surrealist movement in which the important American painting of the 1940s was involved. But the leap he took between the years 1946 and 1948 was perhaps the greatest of any. It certainly landed him in an extreme situation.

In the late 1940s, Mondrian's pure plastic realism was a respected bugaboo, a powerful statement which Newman felt, as did many others, simply had to be challenged. At the same time, he rejected the Expressionist "squiggles" of his colleagues as an inappropriate strategy to correct the "geometricization" of modern art which he traces back to the cult of Cézanne. What he wanted was an art capable of producing the sense of the "sublime" he found in such old masters as Rembrandt and Velasquez, an art whose image would be neither niggardly in its passion nor reduced to a kind of Freudian frenzy, trembling in the face of historical crises.

What he proposed then was that a picture could be made of one unbroken field of color. I say *unbroken* advisedly, for there are those who see his introduction of vertical or horizontal "stripes" as breaking, or at least dividing the rectangle into areas. If this were actually the case, Newman's pictures would simply be enlarged Bauhaus lay-outs, more or less symmetrically and rhythmically organized and just about as emotionally still-born. Or if, despite the character of the color, about which I shall presently speak, he had presented *both* verticals *and* horizontals in the same picture, he would have been pursuing the same kind of purified nature-image, the linear tension-painting Mondrian so excellently exhausted. (Newman's own remarks about Mondrian, related to his abomination of "geometry," are undoubtedly unfair, particularly in the light of the Dutchman's last pictures which suggest that he was ready to enrich his means with more of the material of feeling.)

Newman's "stripe" – perhaps better called "band," a word implying something a little less featured and discrete – must first be studied before it can be eliminated as a divisive form. How does it really act in the picture? What is its role?

On the simplest level it serves to establish the color field for the color that it is. For example, *Vir Heroicus Sublimus*, a vermilion canvas 18 feet

long and 8 high, has five vertical color bands, one of them pure white. The white establishes the vermilion precisely in the scale of reds, lending some of its purity at the same time. Its calculated width, about two inches, also establishes both the length and height of the vermilion plane. The other four verticals are composed basically of the vermilion with the admixture of the near colors in the spectrum, from pale yellow to dark red. Their literal purpose is to adumbrate the scale, energize the field and create a "beat" across the expanse of color. Being close in value, these bands gently provoke the field into wakefulness. Quite the opposite of divisive "stops" in the eternal radiance of the vermilion's light, they act as suggestions, as possibilities and "might-have-beens."

Were the bands "forms," they would appear as either before, behind or in the field discretely. They do not appear this way at all, but catch the eye just enough to allow the expanse of vermilion to sink in (in the Air Force, pilots are trained never to look at anything directly, particularly at light, in order to see it more fully).

Now all the above can sound pretty meager and rationalizing as means and literal effect. It has the ring of the game of formal strategies, such as Henry James applied in the late novels when he isolated the central meaning by establishing points of view in a circle around it. But art is about its formal strategies as much as it is about anything else, and Newman's art is about color in relation to size and shape, which amounts to a strategy of scale. Where he differs from Rothko and Still, who are up to something similar, is in his distaste for any atmospheric illusion and textured paint. And though he associates, in conversation, the Egyptian pyramid with "the death image of geometry," Newman's pictures possess certain Egyptian qualities; they are frontal, static and spaceless (terms which a few years ago would have amounted to the ultimate in damning criticism, but today seem about to return as evidence of admiration).

Though one can trace the evolution of the "band" through Newman's earlier work in the Bennington retrospective where pictures from 1946 on are included, it is not evolution in a straight line. At first, the band ranges across the picture, as in *Genetic Moment*, 1947, a form behind which exists a feeling of space and air. In *Two Edges*, 1948, it has become a slightly wedge-shaped interruption of a picture plane which has come closer to the surface. In *Onement, 1*, of the same year, the band has lost most of its formfulness because all spatial illusion has been abandoned and the field is an admixture of the band's color. In *Be, 1950*, a dark red picture 8 by 9 feet in size, the single, narrow, centered vertical is white. For the first time one feels the field is more important than the

band and that the picture is about *red* in two-count time, like the beat of the heart.

By the time of *Vir Heroicus Sublimis*, 1950–51, the pictures have gained confidence in respect to their reliance on the scale and color of the field, and consequently in passion. *Vir Heroicus Sublimis* seems to me to be one of the truly moving pictures of recent times and strikes into a territory of effectiveness on a level with the large pictures of Picasso, Matisse and the late Monet. Here Newman has thoroughly solved the problem of how to get his energizing, defining colors into the general field without setting up egotistic forms. The muted band obscures itself by continuing from edge to edge, and remaining quietly parallel, avoids any suggestion of directional force. But the picture's power is such that one cannot look at it directly very long.

Another picture with an equivalent but different kind of power is *Day before One*, 1951, 11 feet high by 50 inches wide, shown in the retrospective for the first time. Deep midnight blue, full of pressures, the towering color has to be contained at top and bottom by a thinly-dyed edge about three inches in width. Obviously Newman's stake in bands of color is strictly limited to their usefulness. These giant, but nevertheless man-sized, paintings certainly stir emotional rather than rational reactions, not really turbulent, not really brooding, but rather the cool, rich feelings one has when looking at the vaster natural phenomena, the night sky, the hot desert, a lake of sunlight. It is seeing left unattached to specifications, though controlled by shape and scale and the fact of color.

Whether Newman will have succeeded in creating an incipient universal image or not, seems less important at the moment than the fact that he has produced a number of pictures complete in themselves which can stand with the best of modern art as examples of the infrequent heroism of our awkward times.

BARNETT NEWMAN

The Stations of the Cross
and the Subjects of the Artist
Lawrence Alloway

NEWMAN DID NOT BEGIN these paintings with The Stations in mind. The first two paintings were done early in 1958 in Brooklyn Heights, where he lived from 1956 to 1958. There was some question in his mind of titling them so that they might constitute a pair, such as Adam and Eve, but he decided against this. Then, as he has said, "I knew I would do more" and in 1960 he painted two, the same size, also in pure black on raw canvas, with comparable phasing of the vertical bands. All four have a solid black left edge and a modulated band, rather more than two-thirds across the canvas, to the right. In the first, plumes of dry brush marks expand around a narrow band; in the second a narrow band is outlined in black and set off-center in a wider grey band; in the third a narrow solid and a narrow plumed band adjoin; and in the fourth a narrow band, freely contoured, is set in a flowing black band. It was after the fourth that he realized the number and meaning of the work on which he was engaged. In December 1961 he exhibited what is still the first painting of the Stations as a single work under the title of *Station*. The work was subsequently reproduced as *The Series, 1*,[1] but there can be no doubt that the stations theme was now a definite project in Newman's mind.

The discovery of a subject that proposed fixed limits did not mean that Newman could now work easily by filling in a given schema. In 1962 he produced two more paintings, the *Fifth* and *Sixth*, in 1964 three paintings, in 1965 three, and the two final paintings were begun in 1965 and finished early in 1966. Thus Newman's Stations were arrived at through a process of self-recognition. This fact alone is sufficient to

Catalogue essay in *Barnett Newman, The Stations of the Cross: Lema Sabachtani*, Guggenheim Museum, 1966. Reprinted by permission of Lawrence Alloway and The Guggenheim Museum.

336

separate them from commissioned works on the subject in which the number of Stations and the incidents appropriate to each Station are clearly known in advance. Newman worked, first, without pre-knowledge of group or cycle; then, as a result of developing possibilities within the work itself, he accepted a definition that partially determined the future course of the series. It became a project, a speculative extension into the future, demanding paintings for its realization. This method of learning from the initial stage of work is parallel to the kind of responsiveness that Jackson Pollock revealed in single paintings. He would make a mark and then develop or oppose it by other marks until he reached a point at which he had exhausted the work's cues to him to act further. Newman has demonstrated the possibility of such awareness operating not in terms of visual judgment and touch within one painting, but as a source of structure for a series. A comparable extension of improvisation beyond the formal limits of the single work occurred in Newman's lithographs *18 Cantos* which "really started as three, grew to seven, then eleven, then fourteen, and finished as eighteen."[2]

The production of a series by Newman is an unexpected development in his work. Unlike other artists of his generation, given to numbering their paintings and to production in runs, he has consistently defined his work by separate titles, a verbal statement of the autonomy of each work. Newman has observed: "I think it would be very well if we could title pictures by identifying the subject matter so that the audience could be helped. I think that the question of titles is purely a social phenomenon. The story is more or less the same when you can identify them."[3] Without relegating any of the painting's function to language he indicates a relation of usefulness between verbal and visual elements.

The fact that Newman has now painted a series does not, in fact, dissolve the compactness and solidity on which his earlier work seems predicated. His art has never been the continuous record of the artist's life, in which each work records a unique phase of an artist's sensibility. Under the terms of serial painting the continuity of sequels tends to override the determinate form of each single work. One problem of working in serial form is knowing when to stop. The inventiveness, energy, and, perhaps patience of the artist become the decisive factors. Motherwell's *Elegies for the Spanish Republic*, for example, are open-ended; they constitute a series that does not seem to be bound by any known limits. The proliferation of the series involves us in the personality of the artist. Newman, on the other hand, in *The Stations of the Cross*, is working with a subject which is personal but regulated by number. Although one cannot link his individual works with particular Stations of the Via

Dolorosa, the number fourteen is both an absolute limit and a symbol; more or less than this number would make it impossible to recognize any connections with the declared iconography. Thus Newman's series embodies an order inseparable from the meaning of the work.

The subject of the Stations of the Cross is a late development in Christian iconography. It was not until the seventeenth century that it developed in its modern form, as an expansion of a briefer early theme. From the fifteenth century there are numerous representations of the Way of the Cross, in the form of Seven Falls (a holy number extrapolated from the fullest account of the events in *St. Luke*). These were: Christ carrying the Cross, The First Fall, Christ meets Mary, the Second Fall, Veronica hands Him the face-cloth, The Third Fall, Entombment. In this form Christ, who carries the Cross alone in *St. John*, is aided by Simon and accompanied by a procession, including the grieving women (from *St. Luke*). This theme, with accompanying devotional exercises, spread in Germany, but not elsewhere, in the sixteenth century. Codified in devotional manuals it was doubled in length in the seventeenth century. Pope Innocent XI granted the Franciscans the right to erect Stations in their churches in 1686, and in 1731 Clement XII fixed the number at fourteen. The customary sequence of the Stations is now: Christ condemned to death, Christ carrying the Cross, the First Fall, Christ meets Mary, Simon helps to carry the Cross, Veronica hands Him the face-cloth, the Second Fall, He comforts the women, the Third Fall, He is stripped of His garments, the Crucifixion, the death of Christ, the Deposition, the Entombment.

It may be objected that paintings in which one cannot recognize, for example, Christ condemned to death or Christ carrying the Cross are not Stations of the Cross at all. However, apart from the number symbolism there are other grounds for supporting Newman's title. As Newman said, "the artist's intention is what gives a specific thing form."[4] It is also possible to parallel the paintings with Christ's journey on the basis of an analogy between the events of the subject matter and the event of painting the series. The order of the paintings is the chronological order of their execution. Thus the subject matter is not only a *source* to Newman but, in addition, a parallel with aspects of his own life, so that the original event and the paintings are related like type and antetype in the Testaments. This is an expansion (though on a more ambitious scale than anything earlier) of an idea central to Newman's thought. He has always insisted on the non-functional origins of speech and, hence, of art. "The God Image, not pottery, was the first manual act." "What is the explanation of the seemingly insane drive of man to be painter and poet if it is not

an act of defiance against man's fall and an assertion that he return to the Adam of the Garden of Eden?"[5] The mythic has always been natural to Newman, not only as the subject matter of paintings but assimilated as analogy, as metaphor, in the creative act itself.

Although obviously Newman's Stations are a radical departure from existing Stations by other artists, there is a fundamental connection between them and traditional iconography. Pilgrims tracing the presumed Via Sacra at the original site, the devout who visited chapels spaced as at Jerusalem (for example the early fifteenth-century series of chapels at the Dominican friary, Cordova) or who followed the sequential displays in Franciscan churches were all engaged in a participative experience. Even the Stations in a church constituted an analogic pilgrimage. The worshipper reduced the historical distance between himself and Christ, or to put it another way, Christ's suffering is eternal. As the Stations are outside the Liturgy they were free to be experienced in terms of spectator participation (as in the dramatic and pathetic paintings of Domenico Tiepolo painted for San Polo, Venice, in 1748–49). On the Via Sacra itself, in spatial simulations of Jerusalem, or in condensed sequence, the succession of Stations encouraged identification and parallelism with Christ. The spectator's time and Christ's time coincided. In Newman's Stations what had been the experience of the spectator has become the experience of the artist. Thus the lack of a full panoply of iconographic cues should not allow us to think that Newman's paintings are any fourteen.

Newman has emphasized that he regards the Stations as phases of a continuous agony and not as a series of separate episodes, in which he is basically at one with traditional iconography (although he did not research it beforehand). One consequence of this view is that it would be a serious misreading of the work to consider it in formal terms as a theme and variations. Theme-and-variation readings are applicable neither to the subject matter nor to the restriction of means to black or white paint on raw canvas, because such a form assumes a first statement (giving the theme) accompanied by modifications. In fact, there is no such key to the Stations of the Cross, which have to be experienced as a unit of fourteen continuous parts.

Newman has proposed a modification of traditional iconography beyond that of his reductive imagery.[6] He has added the last words of Christ on the Cross, his last words as a man, to the Stations: Lama Sabachtani (to use the King James version, though Newman prefers James Moffatt's version, Lema Sabachthani).[7] To add "My God, my God, why hast thou forsaken me" (or, as Moffatt has it, "My God, my God, why forsake me") is to emphasize the unity of the Passion and, as it were, to

replace duration by spreading the climax of the Passion over its earlier phases. Indeed so strong is Newman's sense of the unity of the fourteen paintings that he regards the group as a cry. Christ's question is, as it were, the irreducible human content of the Passion, the human cry which has been muffled by official forms of later Church art. In the four years' gap between the *Fourth* and *Fifth* Stations there is a picture which must be linked with this concept of the series as a cry. This is a big painting *Shining Forth* (*To George*), which is painted in black on raw canvas. A slim band on the left, a wide one in the center, and two frayed tracks of black parted to define a narrow open band on the right, echo elements from the Stations. The painting, as the title declares, is commemorative of the artist's brother who died in February 1961. Thus, a personal experience of death occurred soon after Newman had decided what his theme was to be, a confirmation of the universality of Christ's death.

In 1948, an early date for such a statement, Newman published a text on the sublime, a key document for his own intentions and of central relevance to post-war New York painting. He identified his own work with the sublime which, as an esthetic concept, condenses "man's natural desire for the exalted."[8] Rudolf Otto, in *The Idea of the Holy*, proposes the sublime as "the most effective means of representing the numinous."[9] Influenced by sublime esthetics, as well as by religious tradition, he instances "magnitude," "darkness," "silence," and "emptiness" as sublime. These terms apply, with some precision, to aspects of Newman's work, whereas traditional formal analysis (dealing in the balancing of discrete and contrasted units) does not. In the past this iconographic theme of the Stations has not been the occasion of the works that are usually considered to be the high points of Christian art. Newman's series is not being implicitly backed by a tradition of art and iconography which will feed his own paintings. On the contrary, though the Stations have been important devotionally, the processional requirement usually consigned them to the aisles or columns of churches; serviceable function rather than star position (like an altarpiece) was the point. Though Newman is concerned with the Passion of Christ he has taken it in one of its least familiar and least historically prestigious forms.

The celebration of primitive art in the earlier twentieth century assumed a break between modern art and Christian-Hebraic-Classical culture. The affinity of the modern artist and primitive art was used to criticize the complexities and ambivalence of our own tradition in comparison to the primitivist's view of primitive art and culture. Common to Newman and to Northwest Indian or Pre-Columbian artists, about whom he has written, is a concern with the mythic and with cosmogonies. Thus his

appreciation of primitive art is part of the same impulse that led him to use Hebraic and Classical titles for his paintings and, now, a Christian theme. Newman can use the Stations of the Cross as a metaphysical occasion, without sacrificing the intimacy and elaboration of our own tradition or the vividness and impact of other tribes' beliefs. In fact, Newman's viewpoint is sufficiently wide, his independence sufficiently rigorous, for him to consider transformations of Renaissance art as well as parallelisms with primitive art. In fact, the form[s] that his continuities take are often more radical than slogans of revolution and change.

Newman, reflecting on the human figure as a subject, observed: "In the art of the Western world, it has always stayed an object, a grand heroic one, to be sure, or one of beauty, yet no matter how glorified, an object nonetheless."[10] Then, a few years later, he used sculpture as an occasion to argue that the hero having become an unusable image, the gestures he once made, as in the Renaissance, must now be made without the support of the body, as an object. "By insisting on the heroic gesture, and on the gesture only, the artist has made the heroic style the property of each one of us, transforming, in the process, this style from an art that is public to one that is personal."[11] Gesture becomes the artist's act, not that of his subject, and in this form is accessible without the particularities of musculature and drapery. Thus, when Newman paints the Stations of the Cross in terms of his gesture, he is taking possession of the traditional theme on his own terms, but these terms include his homage to the original content. His concern with religious and mythical content never delivers an idol but a presence. The presence is one that the artist shares with any evoked hero or god because it is in his work that the presence is constructed and revealed.

The Stations of the Cross is an iconographic theme that requires a serial embodiment in space. (Matisse's Stations in La Chapelle du Rosaire, Vence, are exceptional in that the episodes are drawn on one surface across the East wall, with the movement of the spectator reduced to a left-right-left reading of numbered scenes.) The spatial structure of the Stations recalls Newman's project for a synagogue in 1963 in which he was necessarily dealing with problems of three-dimensional symbolism. The action of the ritual determines the form of the architecture, so that the worship of the congregation becomes a structure, and not merely an activity within a container. Although Newman's Stations have no obligatory arrangement (something of the flexibility of easel painting is retained), they need to be adjacent, so that repetitions and cross-references can perform identifying and expressive roles. Flexible as the paintings are, their spatial unity, as a group, is essential to their meaning.

Newman's large paintings, such as *Vir Heroicus Sublimis* 1950–51 and *Cathedra* 1951, are relevant here. In a statement written for an early one-man exhibition he stated: "There is a tendency to look at large pictures from a distance. The large pictures in this exhibition are intended to be seen from a short distance."[12] Large, one-color paintings, viewed close up, produce effects of space as magnitude (as external coordinates diminish), of engulfment by color; in short a participative space. This reduction of optimum spectator distance from the work of art is comparable to the reduction of formal elements in his paintings, avoiding diversification and elaboration to preserve the wholistic character of each work. Newman's sense of space explains his great feeling for the Indian Burial Mounds in the mid-West seen in 1949, after he had manifested an interest in working large. It is not that these shapes in the earth initiated his interest, but they coincided with his personal sense of space, simplicity, and the human monument.

The recurrent image in the Stations is of two bands, variously defined, that modulate the field of raw canvas. The canvas is blond in color and slightly flecked and Newman has successfully precipitated the untouched ground into color. It is given color relationally by the black or the white that it carries. In the three white paintings (nine through eleven) the canvas is very different in appearance from the black paintings. The fact that he used oil paint and three different synthetic media reveals his awareness of the function of color in the series, not only in its relational aspects but as a physical property. Different blacks occur from one painting to another and, sometimes, within one painting. Thus the series as a whole, for all its impression of austerity, constitutes a highly nuanced system. Another difference can be seen by comparing a bare black painting, such as the *Fifth Station*, with more extensively covered paintings, such as the *Seventh* or *Thirteenth Station*. The standard size of the series dilates and contracts, rises and falls, according to the proportion and emphasis of the bands. Thus the organization is not restricted to internal divisions of planes and contrasts of forms. All the formal changes, involving as they do areas that cross the total surface, are wholistic in character. It is this largeness and unity in his work, perhaps, that has encouraged notions about the "hypothetical extendability of his areas and bands of color."[13] The Sublime in art may be majestic and vast but this is not the same as continuous and amorphous. Such an idea would link Newman and Mondrian with whose geometry Newman's art demonstrates, in fact, no kinship. Mondrian regarded his lines as bits of a universal grid that ran on beyond the work of art, an image, which, though not literally true, expresses his ,belief in painting as symbolic of universal order. Though

Newman's art raises major issues, of the Passion and Death as in the Stations, for example, he does not do so as the basis of absolutes. Man is the center of Newman's world-picture and it is from man that art originates. Art is, therefore, centrifugal to man and not, as in Mondrian, our glimpse of absolute truth existing separately from us.

Notes

1. Cleve Gray. "The Art in America Show," *Art in America*, New York, vol. 49, no. 4, 1961, p. 94.

2. Barnett Newman. Preface, *18 Cantos: A Volume of Lithographs*. West Islip, New York, 1964.

3. Robert Motherwell, Ad Reinhardt, eds. *Modern Artists in America*. New York, 1951, p. 15.

4. Ibid., p. 18.

5. Barnett Newman. "The First Man Was an Artist." *The Tiger's Eye*, West-port, Conn., vol. 1, no. 1, October 1947, pp. 57–60.

6. One other modification of the form of the Stations is Newman's addition of a fifteenth painting to the group. *Be, II* is a different size and color (solid white field flanked by an orange and a black band). It functions less as a focus, conspicuous because of its differences, than as a supplement; it is a shift and affirmation. It was exhibited earlier under the title *Resurrection* (Allan Stone Gallery 1962). It is a link between the human cry and a state of being, between Christ as a man and Christ as God.

7. *The Bible: A New Translation* (by James Moffatt), New York, Harper Brothers, 1935.

8. "The Ides of Art – Six Opinions on *What Is Sublime in Art*," *The Tiger's Eye*, Westport, Conn., vol. 5, no. 6, December 15, 1948. "The Sublime Is Now," pp. 51–53.

9. Rudolf Otto. *The Idea of the Holy*, Oxford, Oxford University Press, 1923, chapter VII.

10. Barnett Newman. Introduction, *Adolph Gottlieb*. Wakefield Gallery, New York, 1944.

11. Barnett Newman. Introduction. *Herbert Ferber*. Betty Parsons Gallery. New York, 1947.

12. Barnett Newman. Typescript written on the occasion of his 1951 exhibition at Betty Parsons Gallery.

13. Walter Hopps. Introductions, U.S. Pavilion catalogue. VIII Biennale, São Paulo, Brazil, 1965.

NEWMAN:
MEANING IN ABSTRACT ART, II

Harold Rosenberg

Neither man nor nation can exist without a sublime idea.

<div align="right">

DOSTOEVSKY

</div>

The paintings of the late Barnett Newman emerge in triumph out of twenty years of battle, though not without further critical yapping at the heels. As is usual in regard to abstract art, the issue is content: are Newman's areas of color, divided by one or more vertical bands, able to convey the themes indicated by the titles of his pictures and by his public statements? Former detractors now concede that the canvases are attractive and even, to a degree, moving. Paintings such as *Onement I*, *Abraham*, *Cathedra*, which in the fifties were considered "nothing but a stripe down the middle," are found to possess depth and an aura of majesty; in addition, they had inaugurated a new handling of the picture plane. Emily Genauer, hard-crusted foe of expressive abstraction, was plunged by a Newman retrospective at the Museum of Modern Art into "a sea of vivid, resonant color" by which she might, she imagined, have been swept away had it not been for the lifelines provided by Newman's vertical bands. To come close to drowning at the Museum of Modern Art is a rare ordeal, which probably threatens only those who have lived too long in the driest deserts of the imagination. And John Canaday, while readying himself for a new round of insults for Newman, noted that his paintings "looked better than ever before," and was aware of "responding to them as I had never thought could be possible" – which may have been intended to prove how open-minded and aesthetically susceptible Canaday is even to work he cannot abide.

So much for the augmented impact of Newman's paintings on some nervous systems. Yet, despite the improvement in the reception of Newman's work during the past ten years, his spacious themes and his

conception of the metaphysical function of painting have not been welcomed even by those who have become his admirers and followers. The art world has an instinct for what it needs, and it rejects any surplus. Once a work leaves the artist's studio, it is refashioned intellectually to conform to prevailing appetites. It took Newman a long time to convince the art world that he was serious; there is still the problem of what he was serious about. In the fifties, his talk of "awesome feelings" and his evocation of mysteries in the titles of his paintings – *Genesis*, *Primordial Light*, *Day One* – were seen as attempts to disguise his derivations from Mondrian and Neo-Plasticism. Later, when the originality of his work became apparent, his philosophy was condescendingly set aside as an irrelevant verbal accompaniment to his formal innovations. Today, his work is honored on the rebound from the fashionable movements – color-field painting, minimal sculpture – founded upon it. But mention of the emotional substance of his paintings can still arouse indignation. The stirrings of approbation by Genauer and Canaday were but preludes to assaults on what Canaday called Newman's "rapturous philosophizing." Had the canvases at the Museum of Modern Art been presented merely as handsomely surfaced expanses of red, yellow, and blue, a reconciliation with his critics might have been effected under the pressure of art history – or, at least, a truce. Not an inch, however, could be yielded to Newman's posthumous insistence that his paintings have to do with such motifs as the creation of man, the division between night and day, the coalescence of order within chaos, the anguish of man's abandonment: in a word – Newman's word – with the sublime. How could all these grandiloquent dramas be seen in the repeated image of a rectangle with stripes? And, anyway, aren't lofty themes out of date? The trend of modernism is toward mixing art with the commonplace, the matter-of-fact. Those who still speak of "high art" see no connection between it and high thoughts or high states. Our age has been taught that elevated sentiments are composites of less elevated ones, or even of desires that are the opposite of elevated. To espouse lofty ideas is something of a scandal. The art world of the 1960s was personified by Andy Warhol and the pace-setting museum curator. In their attack on Newman's *The Stations of the Cross*, both Canaday and Genauer took steps to dissociate themselves from Newman's solemnity. Canaday headed his column "Mike, Elaine, Woody, Mr. Newman, God and Me," and Genauer compared the work to *Jesus Christ Superstar*. First-name intimacy with popular entertainment establishes the critic, one is led to assume, as a regular guy to whom the philosophizing of a *Mister* Newman is an embarrassment.

Newman's behaving as if the sublime had not been dismantled by the

modern age was a combination of naïveté and defiance. By naïveté I mean pursuing one's own sense of things regardless of prevailing opinion. It is impossible to identify Newman's philosophy as one can the pantheism of Pollock or Hofmann. Though Newman's art is more abstract than theirs, his thinking seems closer to a world of narratives. Newman looked at the art of the aborigines and at Western masterpieces, he read primitive myths, Greek drama, the Old Testament, the Gospels, mystical apothegms as if they depicted things that were still going on; at any rate, he knew they were going on in him. The predicament was that because the imagination could no longer conceive pictures of such happenings one had to paint *ideas* of them. Nevertheless, he labelled the metaphysical subjects of his canvases and sculptures with the literalism of *Woman in a Red Hat* or *Still-Life with Jar*. He argued that the time had come for painting to replace scenes, images, symbols with abstract figures that had the materiality of things and events. The essential was the idea/object, and, to attain that, any suggestion of appearance and even abstractions derived from nature, such as Mondrian's or Kandinsky's, had to be resolutely purged. In Newman's aesthetics, the Burning Bush might resemble a proposition by Euclid, never a Christmas tree.

Newman's total break with natural imagery led to his innovating emphasis on the physical rudiments of works of art – in painting, the size, shape, and color of areas of the canvas; in sculpture, the importance of the base; in lithography, the problem of the border around the print. In its total quantitative presence, a work is the mystical counterpart of the concept denoted by its title. Embodying an idea in exclusively material quantities (for example, *Cathedra* as a ninety-six-inch-by-seventeen-foot-nine-inch sheet of blue) results, ironically, in an exclusively formal construct (*Cathedra* as horizontal, rectangular, ultramarine) from which the idea is visually absent. In his pursuit of absolute content, Newman left nothing on the canvas that might prevent the spectator from perceiving the marked-off space as the reality indicated by the title. On the other hand, there is nothing to prevent him from considering the painting an organization of colored planes and lines and nothing else. Newman's canvases and sculptures invite the spectator to pass beyond the aesthetic into an act of belief. By implication, they define a work of art as any image or feeling that the spectator (including the artist as spectator) introduces; the difference between a Giotto and a Newman would lie in the degree of control exercised by the image. To render his grand themes, Newman made himself the master of an emotional indeterminacy in painting in which all effects depend on tensions of quantity, of size, and of radiance. No one of his paintings stands for anything definite: it is not

a symbol or an emblem, any more than it is pictorial. But, taken all together, the paintings establish an elevated plateau of feeling. Newman was not trying to force Genauer and Canaday to see his fourteen striped white canvases as enactments of *The Stations*. He offered the possibility of sensing, through his whites and blacks, the anguish of the abandoned prophet or artist – his *lama-sabachthani* ("why hast thou forsaken me?") interpretation of *The Stations* affixed to the wall of the Museum. If, instead of responding to the emotional potential of the paintings, the critics sought a visual opera, the paintings left them free to find it.

The catalogue for Newman's retrospective, by Thomas B. Hess, who directed the exhibition, was a heroic attempt to implant Newman's ideas within the substance of his paintings and sculptures, to establish their format and their dimensions and colors as correlatives of exalted experiences. If Hess could succeed in his purpose, Newman's abstractions would communicate as readily as a Pietà or *The Sabines*. Hess studied books on the Talmud and Jewish mysticism that he discovered in Newman's library, and he became convinced that after early immersions in primitive and Greek mythology the artist conceived his creations as equivalents of passages in the Book of Genesis and the Kabbalah. Of *Onement I*, for example, the painting in which Newman settled on his format of the rectangle divided by a vertical stripe, Hess wrote that it "is a complex symbol, in the purest sense, of Genesis itself. It is an act of division, a gesture of separation, as God separated light from darkness, with a line drawn in the void." Hess then interpreted the red-orange stripe in *Onement* as a Kabbalistic metaphor for the fashioning of the first man out of earth, which in turn is represented by the darker red ground that the stripe bisects, and he goes on to quote the Zohar, the Jewish "Book of Splendor," on the meaning of "one" as the conjoining of the male and the female, and of God and Israel.

Equipped with his Kabbalistic hypothesis, Hess discerned in Newman's compositions a system of "secret symmetry," which introduces squares into the middle of rectangles or divides the canvas into proportions suggested, or confirmed, by Kabbalistic formulas; for instance, there is the frequent recurrence of measurements by eighteen and multiples of eighteen, the number whose equivalents in letters of the Hebrew alphabet spell "life." And in Jewish mystical literature Hess encountered the term *Makom*, which means "place" but is also a Kabbalistic name for God; works by Newman such as the *Here* sculptures and the *Be* paintings seem to evoke this concept, and Newman made explicit reference to *Makom* in his statement about his model for a synagogue. Other Kabbalistic in-

fluences include the mysterious notion of *Zim Zum* (the origin of space through God's contracting Himself, which supplies the title of Newman's last sculpture) and reflections on "primordial light," which figure importantly in the rabbinical version of the Creation.

Hess proceeded chronologically through Newman's career, painting by painting, sculpture by sculpture, tacking symbolic meanings to colors ("the man-earth color of cadmium red," "the severe, the grandly formal, the tragic" of black), measuring the placement of the bands (or "zips," as Newman liked to call them) to identify the Kabbalistic proportions, interpreting the works as traditional dramas of spiritual revelation, agony, and salvation. The zips, Hess found, fall into a binary system of symbols: the soft-edged, loosely brushed stripes represent the sensual and the physical; the clean, sharp-edged stripes stand for the intellectual and the transcendental. With a vocabulary of signs distilled from Newman's forms, surfaces, and hues, Hess transmuted *The Stations of the Cross* into a Jewish and humanistic metaphor of the sufferings of mankind, of the artist's own confrontation with death, and of the triumph of life and the act of creation: "Even while committed to the Christian iconography of the Stations of the Cross, he would keep his allusions to the Kabbalah and to its vision of Genesis of the Torah."

Hess's catalogue is an extraordinary document, unique in this genre of writing for its insights, its personal devotion, and its intellectual diligence. It is an essay in poetic criticism, designed to create a crystallization of ideas, feelings, and images in which Newman's paintings are fully reflected. It combines illuminated thinking of the sages with events of Newman's biography, lengthy passages from essays by Newman, incidents of the history of art in New York since the last war, and formalistic analyses of Newman's paintings, sculptures, and prints. Inspired by the works, their titles, the writings, and Newman's personality, Hess conceived a hitherto partly hidden artist, a kind of rabbinical though non-religious New Yorker who reasons in red, yellow, white, and blue and in the carpentry of stretchers about arcane events and trends in the art world, as if divine miracles and the change from oil paint to acrylics were subject to the same logic. With Hess's Newman, metaphysics and art materials have achieved a common lexicon. Such a portrait is bound to contain exaggerations, but – as Plato remarked about one of his myths – though the details may not be accurate, one who sees this picture will not be far from the truth. To think of *Onement I* in terms of Adam, of Adam in terms of *adamah* (earth), to think of the red stripe in the field of red as the first man arising out of the primal ooze, is genuinely to see Newman's painting as a creation, beyond merely looking at it as an object.

In sum, Hess has plunged headfirst into the scandal of Newman's lofty thoughts; he has even been willing to intensify it. To follow him in grasping the content of Newman's paintings and sculptures, spectators would have to become adept in divine emanations. No wonder critics are indignant; in their view, Hess has compounded Newman's crime of polluting paintings with words.

I doubt whether the Zohar must become required reading for visitors to the museums. As Hess himself acknowledges, "it is possible that I am pushing the Kabbalist interpretation too far. Certainly Newman never spoke about such a basis for his art." Hess has converted Newman into a Jewish icon-maker, disregarding the fact that icons cannot be Jewish. Newman's philosophy was a private fabrication; in it, the Kabbalistic *Makom* became synonymous with Indian burial mounds in Ohio and the pitcher's mound at Yankee Stadium. Analogies of this sort do not constitute an idea but are an aspect of sensibility, any component of which – for example, Newman's fondness for (to use his favorite phrase) "raising the issue," or his becoming a bird- or weight-watcher – has as much to do with individual paintings as any other. In interpreting specific paintings in terms of Kabbalistic and mystical passages, Hess makes the mistake of isolating them from Newman's intellectual physiognomy. Regardless of their sacred sources, the meaning of Newman's concepts is a secular one and needs to be restated in the pragmatic language of secular and contemporary experience. Newman's concept of the Hebrew God as "one" is less pertinent to his paintings, despite his reflections on the Scriptures and Commentaries, than his passionate continuation of the tradition in modernism – from Emerson to Mondrian – that declares both inward unity and unity of effect to depend upon concentration, reduction, and repetition. When Hess writes that Newman's *Vir Heroicus Sublimis* "refers to a man who, in working to reestablish the unity and harmony of a universe coexistent with God, acts as God in the here and now and aids in the coming of the ultimate reunion," he is presenting Newman's paintings not in the rhetoric of the artist's sensibility but in that of religious philosophy – moreover, in terms that are eroded and vague. I do not believe that *Vir Heroicus* "refers" to any such aims or could have been inspired by any such thoughts. Newman's enthusiasm for Jewish mystics and their sayings was a matter of intellectual delight rather than of religious belief or philosophical programs – a facet of his charming, childlike response to wonders and poetic phrases, whatever their source. As with other modern artists, his readings provided not an organized outlook but a kind of *metaphysical hum* that surround his mental operations. His thinking was truly systematic only when it dealt with achieving

the reality of the art object as a "creation out of nothing," which was a common theme in New York art after the last war and the break with the European past. His *Here I* sculpture, which consists of a vertical two-by-four covered with plaster and a white one-by-two, both stuck into mounds of plaster as shapeless as mud pies and mounted on a beat-up wooden box, calls attention exclusively to its own being as a creation extracted from the "chaos" not of primal night but of the inexhaustible junk pile of the present day.

Hess's catalogue expands the range of potentiality of Newman's rigorously restricted format, but it does not settle the problem of what the rectangles and zips mean. For Newman, painting was a way of practicing the sublime, not of communicating it. In the last analysis, all his works are, as he said of *The Stations*, "a single event" – in effect, one painting, though it manifests itself in a surprising sweep of variations, including sculpture. It combines the heroic (*Achilles*), the pathetic (*The Stations*), the metaphysical (the *Be* series), the religious (*The Way*), and the aesthetic (*Who's Afraid of Red, Yellow, and Blue*), which grew dominant in his last years. In its multiple inward shifts, Newman's art must remain partly inaccessible. It belongs to a one-man culture, which as it becomes more integrated becomes more estranged from shared ideas. As Kierkegaard kept repeating, the sublime in our time identifies itself only through "indirect communication."

SELECTED CHRONOLOGY

1912	Born Cody, Wyoming.
1929–31	Studies Art Students League with Thomas Benton.
1935	Included, "Eighth Exhibition of Watercolors, Pastels, and Drawings by American and French Artists," Brooklyn Museum.
1935–42	Employed by WPA Federal Arts Project. Joins Artists Union.
1937	Included, "Federal Art," Federal Art Gallery, New York.
1942	Included, "American and French Paintings," McMillen Gallery, New York; "Artists for Victory," Metropolitan Museum of Art.
1943	First solo show, Art of this Century, New York; also 1945, 1946, 1947. Three group exhibitions: "Exhibition of Collage," "Spring Show," "Natural, Insane, Surrealist Art," Art of this Century.
1944	Museum of Modern Art purchases *She-Wolf*. Included, "Abstract and Surrealist Art in the United States," Cincinnati Art Museum, circulated nationally; "Abstract and Surrealist Art in America," Mortimer Brandt Gallery, New York; "First Time in America," Art of this Century, New York; "Twelve Contemporary Painters," organized and circulated by Museum of Modern Art.
1945	Solo shows: Arts Club of Chicago, San Francisco Museum of Modern Art. Included, "A Problem for Critics," 67 Gallery, New York; "The Critic's Choice of Contemporary American Painting," Cincinnati Art Museum; "Contemporary American Painting," California Palace of the Legion of Honor, San Francisco.
1946–7	Included, "Annual Exhibition of Contemporary American

	Painting," Whitney Museum of American Art; also 1947, 1948, 1949, 1950, 1951, 1952.
1947	Included, "Large-Scale Modern Paintings," Museum of Modern Art; "Fifty-eighth Annual Exhibition of American Paintings and Sculpture, Abstract and Surrealist American Art," Art Institute of Chicago; also 1951, 1954.
1948	Solo show, Betty Parsons Gallery; also 1949, 1950, 1951. Included, "XXIV Biennale," Venice, also 1950, 1956; "Third Annual Exhibition of Contemporary Painting," California Palace of the Legion of Honor, San Francisco.
1949	Included, "The Guggenheim Collection," Strozzi Palace, Florence, and Palazzo Reale, Milan; "Contemporary American Painting," University of Illinois, also 1950, 1951, 1953; "The Intrasubjectives," Kootz Gallery, New York; "Sculpture by Painters," Museum of Modern Art, circulated nationally.
1950	Solo show, Museo Correr, Venice and Galleria d'Arte del Naviglio, Milan. Included, "Amerika Schildert," Stedelijk Museum, Amsterdam.
1951	Included, "Surrealism and Abstraction from the Peggy Guggenheim Collection," Stedelijk Museum, Amsterdam, circulated to Belgium and Switzerland; "Abstract Painting and Sculpture in America," Museum of Modern Art; "First Bienal de São Paulo," Museu de Arte Moderna, São Paulo, Brazil, also in 1957; "Ben Shahn, Willem de Kooning, Jackson Pollock," Arts Club of Chicago.
1951–3	Included, "Modern Relief," organized and circulated nationally and in Canada by Museum of Modern Art.
1952	Solo show, Sidney Janis Gallery; also 1954, 1955, 1957, 1958. First retrospective, Bennington College, Vermont. Included, "International Exhibition of Contemporary Painting," Carnegie Institute, Pittsburgh; "Fifteen Americans," Museum of Modern Art.
1953	Included, "Abstract Expressionists," Baltimore Museum of Art; Solo show, Kunsthaus, Zurich.
1953–4	Included, "Twelve Modern American Painters and Sculptors," organized by Museum of Modern Art, circulated France, Germany, Sweden, Finland, Norway.
1954	Included, "Younger American Painters: A Selection," Solomon R. Guggenheim Museum; Guggenheim purchases *Ocean Greyness*.

1955	Included, "The New Decade," Whitney Museum of American Art; "Tendences Actuelles," Berne Kunsthalle, Switzerland.
1955–6	Included, "Selections from the Collections of the Museum of Modern Art," organized by MOMA and shown in France, Switzerland, Spain, Germany, England, Holland, Austria, Yugoslavia.
1956	Dies in Spring, New York. Included, "Abstract Art 1910 to Today," Newark Museum.
1956–7	Memorial Exhibition, Museum of Modern Art.
1957	Solo show organized by Museum of Modern Art at "IV Bienal de São Paulo," São Paulo, Brazil.
1958	Included, "Nature in Abstraction," Whitney Museum of American Art; "Sculpture by Painters," Galerie Chalette, Paris.
1958–9	Solo show, organized by International Council, Museum of Modern Art, circulated to Brazil, Italy, Switzerland, Holland, West Germany, England, France. Included, "The New American Painting," organized and circulated by International Council, Museum of Modern Art, to Switzerland, Italy, Spain, West Germany, Holland, Belgium, France, England, and then Museum of Modern Art, New York.
1959	Included, "Documenta II," Kassel, West Germany.
1961	Solo shows: Kunsthaus, Zurich; Kunsthalle, Dusseldorf, West Germany; Marlborough Fine Arts, Ltd., London. Included, "American Abstract Expressionists and Imagists," Solomon R. Guggenheim Museum, New York.
1961–2	Included, "Vanguard American Painting," organized by United States Information Agency, shown in Austria, Yugoslavia, Poland, England.
1962	Solo shows: Marlborough Galleria d'Arte, Rome and Toninelli Arte Moderna, Milan.
1963	Solo show, Moderna Museet, Stockholm. Included, "Idole and Dämonan," Museum des 20 Jahrhunderts, Vienna.
1963–4	Included, "United States Government Art Projects: Some Distinguished Alumni," organized and circulated nationally by Museum of Modern Art.
1964	Included, "Painting and Sculpture of a Decade, '54–'64," Tate Gallery, London; "Within the Easel Convention: Sources of Abstract Expressionism," Fogg Art Museum.

	Solo show, Marlborough-Gerson Gallery, New York, also 1969.
1965	Included, "The New York School: The First Generation Paintings of the 1940s and 1950s," Los Angeles County Museum of Art; "The Peggy Guggenheim Collection," Tate Gallery, London.
1966	Included, "Federal Art Patronage 1933–1943," University of Maryland.
1967	Retrospective, Museum of Modern Art, also shown at Los Angeles County Museum. Included, "Kompass 3," Stedelijk-Van Abbe Museum, Eindhoven, Holland.
1968	Included, "Dada, Surrealism, and Their Heritage," Museum of Modern Art; "The 1930s: Painting and Sculpture in America," Whitney Museum of American Art.
1968–9	Solo show, works on paper, Museum of Modern Art, circulated United States and Canada.
1969–70	Included, "New York Painting and Sculpture 1940–1970," Metropolitan Museum of Art; "Painting in New York, 1944–1969," Pasadena Art Museum.
1971	Included, "Von Picasso bis Warhol," Kunsthalle, Cologne, West Germany.
1974–5	Included, "Surrealität-Bildrealität," Städtliche Kunsthalle, Düsseldorf and Städtliche Kunsthalle, Baden-Baden.
1975	Included, "Subjects of the Artists," Whitney Museum of American Art (Downtown branch).
1977	Included, "Paris-New York," Musée national d'art moderne, Paris; "Kunst aus U.S.A. nach 1950: Amerikaner," Kunstsammlung Nordrhein-Westfalen, Düsseldorf.
1978	Included, "Abstract Expressionism: The Formative Years," Whitney Museum of American Art and Herbert F. Johnson Museum of Art, Cornell University, circulated nationally; "Dada and Surrealism Reviewed," Hayward Gallery, London; "The Subjects of the Artist," National Gallery of Art, Washington, D.C. Solo show, Yale University.
1979	Solo show, Musée d'art contemporain, Montreal.
1980	Solo shows: "Drawing into Paintings," Museum of Modern Art; "The Black Pourings," Institute of Contemporary Art, Boston. Included, "Amerika Traum

	und Depression 1920–1940," Akademie der Künste, Berlin.
1981	Included, "Paris-Paris: Créations en France 1937–1957," Musée national d'art moderne, Paris; "Westkunst," Museum der Stadt, Cologne.
1982	Two-person show, "Krasner/Pollock: A Working Relationship," Guild Hall Museum, East Hampton, New York. Solo show, Musée national d'art moderne, Centre Beauborg, Paris.
1987	Included, "Abstract Expressionism: The Critical Developments," Albright-Knox Art Gallery, Buffalo.
1987–8	Included, "Two Hundred Years of American Art," Munson-Williams-Proctor Institute of Art; circulated nationally.

MY PAINTING
Jackson Pollock

MY PAINTING does not come from the easel. I hardly ever stretch my canvas before painting. I prefer to tack the unstretched canvas to the hard wall or the floor. I need the resistance of a hard surface. On the floor I am more at ease. I feel nearer, more a part of the painting, since this way I can walk around it, work from the four sides and literally be *in* the painting. This is akin to the method of the Indian sand painters of the West.

I continue to get further away from the usual painter's tools such as easel, palette, brushes, etc. I prefer sticks, trowels, knives and dripping

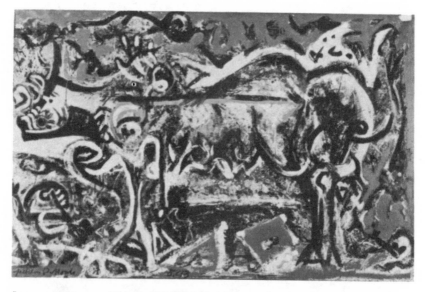

JACKSON POLLOCK, *The She-Wolf*, 1943. Oil, gouache, and plaster on canvas, 41⅞" × 67". Collection, the Museum of Modern Art, New York. Purchase.

From *Possibilities I*, Winter 1947–48. Reprinted by permission of Wittenborn Art Books, Inc. and ARS N.Y./Pollock-Krasner Foundation, 1988.

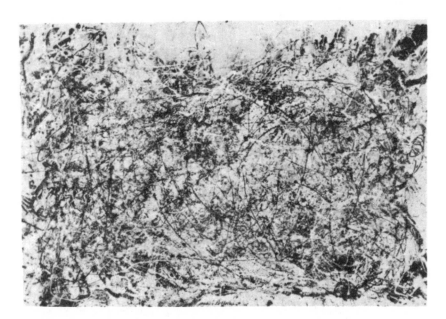

JACKSON POLLOCK, *Number 1, 1948,* 1948. Oil on canvas, 68″ × 8′8″.
Collection, the Museum of Modern Art, New York. Purchase.

fluid paint or a heavy impasto with sand, broken glass and other foreign
matter added.

When I am *in* my painting, I'm not aware of what I'm doing. It is only
after a sort of "get acquainted" period that I see what I have been about.
I have no fears about making changes, destroying the image, etc., because
the painting has a life of its own. I try to let it come through. It is only
when I lose contact with the painting that the result is a mess. Otherwise
there is pure harmony, an easy give and take, and the painting comes out
well.

AN INTERVIEW
WITH JACKSON POLLOCK

William Wright

W. W.: Mr. Pollock, in your opinion, what is the meaning of modern art?

J. P.: Modern art to me is nothing more than the expression of contemporary aims of the age that we're living in.

W. W.: Did the classical artists have any means of expressing their age?

J. P.: Yes, they did it very well. All cultures have had means and techniques of expressing their immediate aims – the Chinese, the Renaissance, all cultures. The thing that interests me is that today painters do not have to go to a subject matter outside of themselves. Most modern painters work from a different source. They work from within.

W. W.: Would you say that the modern artist has more or less isolated the quality which made the classical works of art valuable, that he's isolated it and uses it in a purer form?

J. P.: Ah – the good ones have, yes.

W. W.: Mr. Pollock, there's been a good deal of controversy and a great many comments have been made regarding your method of painting. Is there something you'd like to tell us about that?

J. P.: My opinion is that new needs need new techniques. And the modern artists have found new ways and new means of making their statements. It seems to me that the modern painter cannot express this age, the airplane, the atom bomb, the radio, in the old forms of the Renaissance or of any other past culture. Each age finds its own technique.

W. W.: Which would also mean that the layman and the critic would have to develop their ability to interpret the new techniques.

J. P.: Yes – that always somehow follows. I mean, the strangeness will wear off and I think we will discover the deeper meanings in modern art.

W. W.: I suppose every time you are approached by a layman they ask you how they should look at a Pollock painting, or any other modern painting – what they look for – how do they learn to appreciate modern art?

J. P.: I think they should not look for, but look passively – and try to receive what the painting has to offer and not bring a subject matter or preconceived idea of what they are to be looking for.

W. W.: Would it be true to say that the artist is painting from the unconscious, and the – canvas must act as the unconscious of the person who views it?

J. P.: The unconscious is a very important side of modern art and I think the unconscious drives do mean a lot in looking at paintings.

W. W.: Then deliberately looking for any known meaning or object in an abstract painting would distract you immediately from ever appreciating it as you should?

J. P.: I think it should be enjoyed just as music is enjoyed – after a while you may like it or you may not. But – it doesn't seem to be too serious. I like some flowers and others, other flowers I don't like. I think at least it gives – I think at least give it a chance.

W. W.: Well, I think you have to give anything that sort of chance. A person isn't born to like good music, they have to listen to it and gradually develop an understanding of it or liking for it. If modern painting works the same way – a person would have to subject himself to it over a period of time in order to be able to appreciate it.

J. P.: I think that might help, certainly.

W. W.: Mr. Pollock, the classical artists had a world to express and they did so by representing the objects in that world. Why doesn't the modern artist do the same thing?

J. P.: H'm – the modern artist is living in a mechanical age and we have a mechanical means of representing objects in nature such as the camera and photograph. The modern artist, it seems to me, is working and expressing an inner world – in other words – expressing the energy, the motion, and other inner forces.

W. W.: Would it be possible to say that the classical artist expressed his world by representing the objects, whereas the modern artist expresses his world by representing the effects the objects have upon him?

J. P.: Yes, the modern artist is working with space and time, and expressing his feelings rather than illustrating.

W. W.: Well, Mr. Pollock, can you tell us how modern art came into being?

J. P.: It didn't drop out of the blue; it's part of a long tradition dat-

INTERVIEW WITH JACKSON POLLOCK 359

ing back with Cézanne, up through the cubists, the post-cubists, to the painting being done today.

W. W.: Then, it's definitely a product of evolution?

J. P.: Yes.

W. W.: Shall we go back to this method question that so many people today think is important? Can you tell us how you developed your method of painting, and why you paint as you do?

J. P.: Well, method is, it seems to me, a natural growth out of a need, and from a need the modern artist has found new ways of expressing the world about him. I happen to find ways that are different from the usual techniques of painting, which seems a little strange at the moment, but I don't think there's anything very different about it. I paint on the floor and this isn't unusual – the Orientals did that.

W. W.: How do you go about getting the paint on the canvas? I understand you don't use brushes or anything of that sort, do you?

J. P.: Most of the paint I use is a liquid, flowing kind of paint. The brushes I use are used more as sticks rather than brushes – the brush doesn't touch the surface of the canvas, it's just above.

W. W.: Would it be possible for you to explain the advantage of using a stick with paint – liquid paint rather than a brush on canvas?

J. P.: Well, I'm able to be more free and to have greater freedom and move about the canvas, with greater ease.

W. W.: Well, isn't it more difficult to control than a brush? I mean, isn't there more a possibility of getting too much paint or splattering or any number of things? Using a brush, you put the paint right where you want it and you know exactly what it's going to look like.

J. P.: No, I don't think so. I don't – ah – with experience – it seems to be possible to control the flow of the paint, to a great extent, and I don't use – I don't use the accident – cause I deny the accident.

W. W.: I believe it was Freud who said there's no such thing as an accident. Is that what you mean?

J. P.: I suppose that's generally what I mean.

W. W.: Then, you don't actually have a preconceived image of a canvas in your mind?

J. P.: Well, not exactly – no – because it hasn't been created, you see. Something new – it's quite different from working, say, from a still life where you set up objects and work directly from them. I do have a general notion of what I'm about and what the results will be.

W. W.: That does away, entirely, with all preliminary sketches?

J. P.: Yes, I approach painting in the same sense as one approaches

drawing; that is, it's direct. I don't work from drawings, I don't make sketches and drawings and color sketches into a final painting. Painting, I think, today – the more immediate, the more direct – the greater the possibilities of making a direct – of making a statement.

W. W.: Well, actually every one of your paintings, your finished canvases, is an absolute original.

J. P.: Well – yes – they're all direct painting. There is only one.

W. W.: Well, now, Mr. Pollock, would you care to comment on modern painting as a whole? What is your feeling about your contemporaries?

J. P.: Well, painting today certainly seems very vibrant, very alive, very exciting. Five or six of my contemporaries around New York are doing very vital work, and the direction that painting seems to be taking here – is – away from the easel – into some sort, some kind of wall – wall painting.

W. W.: I believe some of your canvases are of very unusual dimensions, isn't that true?

J. P.: Well, yes, they're an impractical size – 9 × 18 feet. But I enjoy working big and – whenever I have a chance, I do it whether it's practical or not.

W. W.: Can you explain why you enjoy working on a large canvas more than a small one?

J. P.: Well, not really. I'm just more at ease in a big area than I am on something 2 × 2; I feel more at home in a big area.

W. W.: You say "in a big area." Are you actually on the canvas while you're painting?

J. P.: Very little. I do step into the canvas occasionally – that is, working from the four sides I don't have to get into the canvas too much.

W. W.: I notice over in the corner you have something done on plate glass. Can you tell us something about that?

J. P.: Well, that's something new for me. That's the first thing I've done on glass and I find it very exciting. I think the possibilities of using painting on glass in modern architecture – in modern construction – terrific.

W. W.: Well, does the one on glass differ in any other way from your usual technique?

J. P.: It's pretty generally the same. In this particular piece I've used colored glass sheets and plaster slabs and beach stones and odds and ends of that sort. Generally it's pretty much the same as all of my paintings.

W. W.: Well, in the event that you do more of these for modern buildings, would you continue to use various objects?

J. P.: I think so, yes. The possibilities, it seems to me are endless, what one can do with glass. It seems to me a medium that's very much related to contemporary painting.

W. W.: Mr. Pollock, isn't it true that your method of painting, your technique, is important and interesting only because of what you accomplish by it?

J. P.: I hope so. Naturally, the result is the thing – and – it doesn't make much difference how the paint is put on as long as something has been said. Technique is just a means of arriving at a statement.

ART CHRONICLE: JACKSON POLLOCK

Clement Greenberg

THERE ARE BOTH SURPRISE and fulfilment in Jackson Pollock's not so abstract abstractions. He is the first painter I know of to have got something positive from the muddiness of color that so profoundly characterizes a great deal of American painting. It is the equivalent, even if in a negative, helpless way, of that American chiaroscuro which dominated Melville, Hawthorne, Poe, and has been best translated into painting by Blakelock and Ryder. The mud abounds in Pollock's larger works, and these, though the least consummated, are his most original and ambitious. Being young and full of energy, he takes orders he can't fill. In the large, audacious *Guardians of the Secret* he struggles between two slabs of inscribed mud (Pollock almost always *inscribes* his purer colors); and space tautens but does not burst into a picture; nor is the mud quite transmuted. Both this painting and *Male and Female* (Pollock's titles are pretentious) zigzags between the intensity of the easel picture and the blandness of the mural. The smaller works are much more conclusive: the smallest one of all, *Conflict*, and *Wounded Animal*, with its chalky incrustation, are among the strongest abstract paintings I have yet seen by an American. Here Pollock's force has just the right amount of space to expand in; whereas in larger format he spends himself in too many directions at once. Pollock has gone through the influences of Miró, Picasso, Mexican painting, and what not, and has come out on the other side at the age of thirty-one, painting mostly with his own brush. In his search for style he is liable to relapse into an influence, but if the times are propitious, it won't be for long.

From *The Nation*, November 27, 1943. Reprinted by permission of Clement Greenberg.

JACKSON POLLOCK
AT ART OF THIS CENTURY
(Anonymous Review)

J ACKSON POLLOCK UNEXPECTEDLY comes from Wyoming and in
the deep, dark past was a Benton pupil. A favorite find of Peggy
Guggenheim, who has given him four shows within a few years,
he characteristically works in surging serpentines, thickly intertwined
but transparent, thanks to a limited color range dominated by white,
yellow, and black. Latest pictures such as *The Key*, being broader and
more colorful, make it easier to assimilate the basic energy which flows
through all his canvases.

From *ARTnews*, February 1947. By permission of *ARTnews*.

JACKSON POLLOCK: THE INFINITE LABYRINTH

Parker Tyler

TO COMPREHEND THE PAINTING of Jackson Pollock, one must appreciate in full measure the charm of the paradox: the apparent contradiction that remains a fact. His work has become increasingly complex in actual strokes, while it has been simplified in formal idea. This is a convenient paradox with which to begin. Even more fundamental is the painter's almost entire abandonment of the paint-stroke, if by "stroke" is meant the single gesture by which the fingers manipulate the handle of a brush or the palette knife to make a mark having beginning and end. The paint, scattered sometimes in centrifugal dots, is primarily poured on his surfaces (sometimes canvas, sometimes board) and poured in a revolving continuity, so that the thin whorls of color not only form an interlacing skein but also must endure the imposition of an indefinite number of skeins provided by other colors. Thus the paint surface becomes a series of labyrinthine patinas – refined and coarse types intermingling, save in the case of small and simple works which resemble large oriental hieroglyphs. The relief resulting from the physical imposition of one color on another is important to the visual dimension of these works and unfortunately is almost totally lost in reproduction.

The relation of Pollock's "paint stream" to calligraphy supplies another paradox. For it has the continuity of the joined letters and the type of curve associated with the Western version of Arabic handwriting – yet it escapes the monotony of what we know as calligraphy. It is as though Pollock "wrote" non-representational imagery. So we have a paradox of abstract form in terms of an alphabet of unknown symbols. And our suspense while regarding these labyrinths of color is heightened by the awareness that part of the point is that this is a cuneiform or impregnable language of image, as well as beautiful and subtle patterns of pure form.

From the *Magazine* of *Art*, March 1950. Reprinted by permission of The American Federation of Arts.

On ancient stelae, sometimes defaced by time, certain languages have come down to us whose messages experts have labored to interpret. The assumption is that every stroke is charged with definite if not always penetrable meaning. But in these works of Pollock, which look as fresh as though painted last night, a definite meaning is not always implicit. Or if we say that art always "means something," Pollock gives us a series of abstract images (sometimes horizontally extended like narrative murals) which by their nature can never be read for an original and indisputable meaning, but must exist absolutely, in the paradox that any system of meaning successfully applied to them would at the same time not apply, for it would fail to exhaust their inherent meaning.

Suppose we were to define these paintings, as already indicated, as "labyrinths"? The most unprepared spectator would immediately grasp the sense of the identification. But a labyrinth, from that of Dedalus in the myth of the Minotaur to some childish affair in a comic supplement, is a logically devised system of deception to which the creator alone has the immediate key, and which others can solve only through experiment. But even if the creator of these paintings could be assumed to have plotted his fantastic graphs, the most casual look at the more complex works would make it evident that solution is impossible because of so much superimposition. Thus we have a deliberate disorder of hypothetical hidden orders, or "multiple labyrinths."

By definition, a labyrinth is an arbitrary sequence of directions designed, through the presentation of many alternatives of movement, to mislead and imprison. But there is one true way out – to freedom. A mere unitary labyrinth, however, is simple, while in the world of Pollock's liquid threads, the color of Ariadne's affords no adequate clue, for usually threads of several other colors are mixed with it, and the same color crosses itself so often that alone it seems inextricable. Thus, what does the creator tell us with the images of his multiple labyrinths like so many rhythmic snarls of yarn? He is conveying a paradox. He is saying that his labyrinths are by their nature insoluble; they are not to be threaded by a single track as Theseus threaded his, but to be observed from the outside, all at once, as a mere spectacle of intertwined paths, in exactly the way that we look at the heavens with their invisible labyrinths of movement provided in cosmic time by the revolutions of the stars and the infinity of universes.

The perspective that invites the eye: this is the tradition of painting that Pollock has totally effaced; effaced it not as certain other pure-abstract painters have done, such as Kandinsky and Mondrian, who present a lucid geometry and define space with relative simplicity, but deliberately,

arbitrarily and extravagantly. In traditional nature-representation, the world seen *is this* one; the spectator's eye is merely the precursor of his body, beckoning his intelligence to follow it in as simple a sense as did the axial symmetry of renaissance perspective. But the intelligence must halt with a start on the threshold of Pollock's rectangularly bounded visions, as though brought up before a window outside which there is an absolute space, one inhabited only by the curving multicolored skeins of Pollock's paint. A Pollock labyrinth is one which has no main exit any more than it has a main entrance, for every movement is automatically a liberation – simultaneously entrance and exit. So the painter's labyrinthine imagery does not challenge to a "solution," the triumph of a physical passage guided by the eye into and out of spatial forms. The spectator does not project himself, however theoretically, into these works; he recoils from them, but somehow does not leave their presence: he clings to them as though to life, as though to a wall on which he hangs with his eyes.

In being so overwhelmingly non-geometrical, Pollock retires to a locus of remote control, placing the tool in the hand as much apart as possible from the surface to be painted. In regularly exiling the brush and not allowing any plastically used tool to convey medium to surface, the painter charges the distance between his agency and his work with as much *chance* as possible – in other words, the fluidity of the poured and scattered paint places maximum pressure against conscious design. And yet the design *is* conscious, the seemingly uncomposable, composed.

Pollock's paint flies through space like the elongating bodies of comets and, striking the blind alley of the flat canvas, bursts into frozen visibilities. What are his dense and spangled works but the viscera of an endless non-being of the universe? Something which cannot be recognized as any part of the universe is made to represent the universe in totality of being. So we reach the truly final paradox of these paintings: being in non-being.

THE MONTH IN REVIEW: JACKSON POLLOCK

Hilton Kramer

THE JACKSON POLLOCK EXHIBITION at the Museum of Modern Art has presented us with a double spectacle: a moment of history and at the same time a selection of works from the career of an artist who died last summer at the age of forty-four. It is a matter of some importance that a distinction between the two be maintained, even (or especially) in the face of the prevailing tone of art criticism with its tendency to dissolve all discrete objects and events in a headlong historical continuum, which, by purely rhetorical transformations, is itself made the new fulcrum of artistic meaning. This tendency has nowhere been so quintessentially embodied in overwrought rhetorical sophistries as in Mr. Hunter's brief monograph on Pollock for the exhibition which he has organized. It is a monograph which claims for Pollock the heroism of history to a degree which is absolute and unequivocal, and which then goes on to claim for this historical heroism an artistic sovereignty equally unqualified and immeasurable. It is a neat trick, and it does not lack for brilliance or verbal audacity. It lacks only the clarity and intellectual candor which should be the first principles of criticism.

Let me quote two examples – by no means the most flagrant – to underscore the point: "The dynamics of the development of Pollock's abstract painting style which was germinating in the thirties would seem to have sprung from a strong tension of renunciation, as if in the role of the revolutionary he had constantly to remind himself of his spiritual chains in order to spur his progress towards freedom"; and "[Pollock's] first exhibited work looked somewhat like a battlefield after a heated engagement, strewn in this case with the corpses of Picasso, the Surrealists, Miró, Kandinsky perhaps, and fragments of American Indian art." There is nothing to be said about the first sentence except that it is pretentious, but of the second, one must insist that there be a simpler way of saying that a painting is a pastiche – no small matter with Pollock,

From *Arts magazine*, February 1957. Reprinted by permission of Hilton Kramer.

but not in any event a matter of dishonor or embarrassment in an artist's first exhibited work. In Mr. Hunter's commentary every phase of Pollock's career is invoked with the same hyperbolic claims and treated to the same historical dramatization. Even in the artist's "mature" period, it is the *role* of the picture and not its intrinsic, artistic factuality which commands the writer's high-flown periods.

The logic of this approach is all too clear: when the artist has been recast as a hero of history, his real achievements have equal weight with his most horrendous blunders as episodes in the unfolding spectacle. The singular interest of a particular work is utterly irrelevant. By such means is art thus sold out to history whose contingencies it seeks at its highest moments to modify and transcend.

The issue is a serious one and not irrelevant to the exhibition at hand. Pollock *was* involved in history to an extreme degree, a history which is still ours and from which we shall not easily disengage ourselves. But out of *his* involvement came specific pictures which have, presumably, an interest beyond the sheer fact that he made them. If they have nothing to say to us beyond that, then they are of less than no interest and all the rhetorical resources of the language will not make them otherwise.

The critical problem, then, is not to rehash the drama of history but to ascertain what sort of artistic *oeuvre* Pollock has left us. My own impression of that *oeuvre* is that it is dominated by an anarchic sensibility whose characteristic modes of expression were a vehement and sometimes nullifying pastiche and, for a short period, a decorative style in which the most intractable problems of his paintings were given over to design for their solution.

The anarchic and the decorative: these are the primary impulses which make themselves felt in Pollock's work, and whatever pictorial tensions they may claim derive from their confrontation, juxtaposition, or displacement in one degree or another. They form, in fact, Pollock's special dialectic – and, incidentally, help to explain why his imitators have generally produced either unspeakable messes or shallow interior decoration, depending on which term of the dialectic they have seized upon. In the early forties, in such works as *Guardians of the Secret*, *The She-Wolf*, and *Totem I*, this anarchic impulse vented itself on the stylistic pastiche which Pollock was simultaneously creating and nullifying – creating out of the milieu which Mr. Hunter describes: a milieu in which Picasso, Miró, Mexican painting, Kandinsky, Surrealism, but above all Picasso, were available for emulation and as counter-elements to the tepid American abstraction of the thirties; and nullifying by means of surfaces, structures, and a progressive derangement of *matière* which

disavowed the felicities which Pollock obviously felt were expendable in the art of painting. Yet even in some of these pictures the decorative side of his talent performs important functions in lieu of a more far-reaching structural principle; thus in *Guardians of the Secret* the rectangular forms whose planes denote the picture's shallow spaces give the effect of a house of cards whose walls are furiously stitched together by the desperate "calligraphy" which everywhere attempts to draw these planes into a pictorial coherence. It fails to do so, I believe, and in its place substitutes the action of the stitching itself as the picture's dominant expressive means. The rectangular planes remain inert and lifeless. (If one wants to count corpses in Pollock's painting, that is a good place to start.) Where the decorative impulse is held in abeyance – as in *Totem I*, for example – Pollock's proclivities as a pasticheur have full control and in this case produce a small anthology of Picassoisms, albeit somewhat ravaged and played off against other elements.

It is in *Shimmering Substance* (1946) that we have a suggestion of that plateau in Pollock's career – roughly, from 1947 to 1950 – during which he temporarily purged this tendency for wild anthologizing and transmuted the anarchic impulse into the decorative style which has become his best-known signature. I find *Shimmering Substance* superior to any of the "drip" paintings which follow it: it remains a painting rather than a decorative simulacrum of painting, and it really does bring us a fresh imagery in its swirling, shimmering light. A decade after its execution it still looks very fresh, vigorous, and – surprisingly – even-tempered, and one can't say that about many of Pollock's works. And yet . . . all one can feel in its presence is a suggestion of the pleasure the artist must have felt in the physical act of painting, and even that is of short duration and, at best, a vicarious satisfaction, really a secondhand emotion for the spectator. One's initial delight in the picture turns out to be one's whole experience of it. Soon the small arcs and swirls, which are its basic formal motif, begin to reveal a cloying consistency; they do not have the variety of feeling they promise at first sight. Instead of an infinitude of sensation, there is ultimately only a closed world of tedium.

At that, however, the strokes by which the work is composed have a felicity which separates them from the continuous, linear skeins of duco, oil, and aluminum paint which characterize the work of 1947–50. In *Shimmering Substance* Pollock's art was poised precariously between the vehemence of his anarchic energy and his penchant for the decorative. It was clearly a painting which "promised" something. (I think it promises something still: an overall, *painted* imagery which, independently of Cubism – though possibly not of Impressionism – may yet restore a

kind of subtlety, variety, and nuance which our painting now lacks.) In the face of this promise he chose simply to enlarge the tedium which was already explicit in *Shimmering Substance*, projecting it onto larger and larger canvases until his painting became a kind of architecture for the creation of which he invented a new technique – the famous "drip" – which finally disavowed all connection with the measured unit of feeling which is, after all, the brushstroke's decisive contribution to easel painting.

This "architecture," with its interweaving networks of linear arabesques, is not at all the Dionysian orgy of paint-splattering which people make it out to be. If anything, pictures like *Number 2* (1949) and *Lavender Mist* (1950) are overelegant and precious in the regularity of their effects. But in the "drip" technique Pollock found his perfect instrument: a means which, in execution, would give expression to the athleticism of his sensibility, but which in final result would provide that athleticism with a semblance of taste which it lacked as a native gift. In the "drip" paintings the anarchic was, temporarily, domesticated by the decorative.

I have spoken of this period as a plateau in Pollock's career. What followed was an abyss from which he retrieved, in my opinion, only one work of abiding interest: *Easter and the Totem* (1953), a surprising confrontation of the Matissean style which momentarily disarmed the appalling taste which dominates the pictures painted in the last four years of his life. Since Mr. Hunter makes much of Pollock's "lyricism," I am surprised to find that he doesn't mention this picture at all. But then, in claiming that this lyicism is "epic in its sweep" – a remark in which Mr. Hunter reaches, semantically, something comparable to that total freedom he attributes to Pollock's art – he confirms that lyricism is now a term invoked to bridge disparities between an artist's feeling and his achievement. By and large, the last gallery in the Pollock exhibition was a dismaying experience, revealing an artist driven by aspirations which cruelly outdistanced his talents. But under the aegis of history, I suppose such judgments are unwelcome and dispensable, and it is in the name of history that the official rhetoricians have now claimed him.

DE KOONING ON POLLOCK: AN INTERVIEW

James T. Valliere

Valliere: In 1942 you and Pollock exhibited along with others in a show called "French and American Painters." It was held at the McMillen Gallery.

De Kooning: Yes. It was a very little show – not outstanding. The critics liked it and were sympathetic so it was written up nicely. The Americans looked very good; they were different from one another, but nobody paid attention. It was not like today. People just weren't buying American painting.

Valliere: But why were a group of almost completely unknown Americans like yourself, Pollock and Lee Krasner shown with highly recognized Europeans – Picasso, Braque, Rouault, etc.?

De Kooning: Because of John Graham. The owner of the McMillen Gallery asked him to arrange an exhibition and he picked us. Graham was very highly regarded. He had written a book called the *Dialectics of Art*. Also, Graham, Stuart Davis and Arshile Gorky at that time were known as the Three Musketeers. They were the three outstanding modern artists. Graham was very important and he discovered Pollock. I make that very clear. It wasn't anybody else, you know.

Valliere: You think Graham discovered Pollock?

De Kooning: Of course he did. Who the hell picked him out? The other critics came later – much later. Graham was a painter as well as a critic. It was hard for other artists to see what Pollock was doing – their work was so different from his. It's hard to see something that's different from your work. But Graham could see it.

Valliere: Had you ever seen any of Pollock's work before the McMillen exhibition?

De Kooning: No. That was the first time. Pollock was about nine or ten years younger than I. I knew Graham as early as 1927 and through

From *Partisan Review*, Vol. 34, No. 4, Fall 1967. Reprinted by permission of Willem de Kooning.

him met Gorky and Davis; but I got to know Pollock only after the group show at McMillen.

Valliere: After you knew him did you speak about painting very often?

De Kooning: No, not much conversation. He didn't like to talk. I remember that Mercedes Matter once told me a story of how Pollock and her husband Herbert met when Lee and Jackson had them to dinner. Jackson and Herbert spoke a little to each other upstairs and when they came down they just sat for the rest of the night. Not a word was said. When they left, Jackson told Lee that Herbert was a "nice man, a nice fellow." Mercedes said Herbert said the same thing about Jackson. They were each taken with the other – they had a nice feeling between them. They didn't have to talk.

Valliere: What about the Club? Was Pollock involved in that?

De Kooning: No. That started after Pollock had moved out to East Hampton. He was very suspicious of it.

Valliere: Why was he suspicious of it?

De Kooning: The Club was always misunderstood. We always wanted not exactly to start a club but to have a loft and for years I had it in mind. The Greeks and Italians each have their own social clubs along Eighth Avenue. We didn't want to have anything to do with art. We just wanted to get a loft, instead of sitting in those god damned cafeterias. One night we decided to do it – we got up twenty charter members who each gave ten dollars and found a place on Eighth Street. We would go there at night, have coffee, a few drinks, chew the rag. We tried but couldn't get a name so we called it the Club.

Valliere: Pollock didn't like that.

De Kooning: He was suspicious of any intellectual talk. He couldn't do it – at least not while he was sober. But he was smart though – oh boy – because when he was half-loaded, that in-between period, he was good, very good, very provocative. But he had contempt for people who talked – people who taught.

Valliere: But don't you think that might have been part of his belief that art could not be taught and only phonies tried?

De Kooning: Maybe. He never taught, although many of us had to, and he felt superior about that. He felt that he was a very important artist and that most of us weren't so hot.

Valliere: He tried to make it known that he was *the* painter?

De Kooning: Oh yes. He was it. A couple of times he told me, "You know more, but I feel more." I was jealous of him – his talent. But he was a remarkable person. He'd do things that were so terrific.

After a while we only used the Club on Friday and Saturday nights. The rest of the time we'd all go to the Cedar Bar as we were drinking more then. So when Pollock was in town he'd come to the Cedar too. He had this way of sizing up new people very quickly. We'd be sitting at a table and some young fellow would come in. Pollock wouldn't even look at him, he'd just nod his head – like a cowboy – as if to say, "fuck-off." That was his favorite expression – "Fuck-off." It was really funny, he wouldn't even look at him. He had that cowboy style. It's an American quality with artists and writers. They feel that they have to be very manly.

Valliere: I've heard that you wrestled with him at the Cedar Bar.

De Kooning: Oh yes. It was a joke, very friendly. He'd go berserk – like a child – a small boy. We'd run, fight, jump on each other. Such joy, such desperate joy.

But there was another side of him too. When he had money he spent it and he began to dress with a great style. He had a nice physique – tall with muscular arms that hung away from his body. Tweed suits looked very good on him.

Franz Kline told me a story about one day when Pollock came by all dressed up. He was going to take Franz to lunch – they were going to a fancy place. Half-way through the meal Pollock noticed that Franz's glass was empty. He said, "Franz have some more wine." He filled the glass and became so involved in watching the wine pour out of the bottle that he emptied the whole bottle. It covered the food, the table, everything. He said, "Franz have some more wine." Like a child he thought it was a terrific idea – all that wine going all over. Then he took the four corners of the table cloth – picked it up and set it on the floor. In front of all those people! He put the goddamn thing on the floor – paid for it and they let him go. Wonderful that he could do that. Those waiters didn't take any shit and there was a guy at the door and everything. It was such an emotion – such life.

Another time we were at Franz's place. Fantastic. It was small, very warm and packed with people drinking. The windows were little panes of glass. Pollock looked at this guy and said, "You need a little more air" and he punched a window out with his fist. At the moment it was so delicious – so belligerent. Like children we broke all the windows. To do things like that. Terrific.

THE MYTHIC ACT
Harold Rosenberg

JACKSON POLLOCK'S CHIEF PUBLIC STATEMENT about his work, a three-paragraph note written in 1947, is devoted entirely to method; it contains no reference to the paintings or to what he was trying to achieve through them. Apparently, he assumed that the value of what he did lay in his way of doing it – an assumption common to scientists and to celebrants of sacred rites. He had found the means, he believed, to generate content beyond what the mind might supply. A work could be initiated without idea or subject by a simple act of will – the will to make a painting. Any gesture with paint or crayon was sufficient to set up a situation that would then engage the artist's latent impulses. Once reciprocating action had begun between the artist and the canvas, an image laden with meaning for both the painter and his public would be brought into being; Pollock, who had been psychoanalyzed, often spoke of "reading" a painting. What was essential in creation, he declared, was to maintain "contact" with the totality that was in the course of being formed. So long as the contact was sustained, the picture would take care of itself. "I have no fears about making changes, destroying the image, etc., because the painting has a life of its own. I try to let it come through. It is only when I lose contact with the painting that the result is a mess." The action of the artist thus blends into the "activity" of the canvas in a kind of feedback process that excludes error. Later, Pollock claimed that his method also excluded chance or accident – a claim that is logical if one conceives of a painting as an invisible being, a kind of demonic form, that uses the artist and his strokes or casts of paint to materialize itself in the visible word. Correcting mistakes and abolishing chance, "contact" also eliminates conflict. As long as the silver cord holds, "there is pure harmony, an easy give and take, and the painting comes out well." As Kierkegaard might have put it, the teleology or destiny of the painting suspends the ethics of the

painter and his need for a principle of choice. For Pollock, the aim of painting was to achieve not a balance of antagonistic factors, as in de Kooning, but a state of grace.

Pollock's way of working raises the problem of the role of consciousness in art. "When I'm *in* my painting," he wrote, "I'm not aware of what I'm doing." As an inhabitant of the alienated realm of the canvas in progress, the artist exercises his craft, as it were, blindly, like a woodcarver working from inside the wood. More abstractly, he resembles an organic force; Pollock's wife quotes him as saying in reply to an observation about working from nature, "I *am* Nature." The implication is of being almost completely obedient to automatic impulses (though miraculously beneficent ones), like a person caught in the sweep of an event or moving under the influence of drugs. Pollock is thus an ancestor of Happenings and of psychedelic art. He himself provided the basis for derivations of that sort by declaring that "the source of my painting is the unconscious." Since, to those who accept the Freudian theory, all art originates in the unconscious, this could only be his way of repeating that he painted without being aware of what he was doing. One is invited to see his paintings as gigantic doodles. Or, in more romantic terms, as direct products of being carried away or inspired. The element of involuntarism, of being possessed by the work as by a fetish with a "life of its own," cannot be excluded from Pollock's art without violating the artist's purpose and falsifying the content and meaning of his creations. To picture Pollock as the solver of certain formal "problems" of art history is precisely to blur his part in the history of painting and the desperate efforts of artists in the twentieth century to revive art's ancient powers. The concept of the doodle as the "model" of Pollock's paintings is, naturally, an over-simplification: doodles are not done in a condition of alert intentionality, any more than ideas are conceived in a state of narcosis. But even a doodle ought not to be mistaken for a product of pure automatism. Automatic drawing by a person who is wide-awake inevitably absorbs into itself some degree of imitation and judgment. If the doodler is an artist, his image-forming will draw upon the whole range of his experience of art. Moreover, the longer one "works" on a doodle the more one sees in it and the more possibilities arise for conscious intervention. Disturbed children, encouraged to let themselves go in drawing, were soon found to be painstakingly copying examples of spontaneity presented to them by their teachers.

Pollock designed his method as a means for resisting mental calculation. With him, automatism served in the first place to unlock the activity of painting and release it from dependence upon concepts. Once the artist

had entered into motion, his transaction with the canvas would carry him through varying stages of awareness. Though his painting began with random gestures, his consciousness of it would grow as the work progressed. "After a sort of 'get acquainted' period," Pollock explained, "... I see what I have been about." But to maintain spontaneity as a power of continual refreshment, it was necessary to hold himself aloof from rational or aesthetic decisions. Only in the arena of the action could the artist's psyche be wound up to the unrealized demands of the picture. Thus, having declared that in his painting "there is no accident," Pollock completes his credo by adding, "Just as there is no beginning and no end." In photographs of the artist at work, he wears an expression of extreme concentration, on occasion almost amounting to anguish, and his body is poised in nervous alertness as if he were expecting signals from above or behind. He seems about to dart into movement; in the most eloquent of the photographs (one by Hans Namuth) his feet are crossed and his right arm is flexed to fling the paint in a gesture that belongs unmistakably to dance. With his paint-saturated wand, he will draw lines in the air, letting flecks of color fall on the canvas as traces of his occult gesticulations. His consciousness is directed not toward an effect determined by notions of good painting but toward the protraction and intensification of the doing itself, of the current that flows between the artist and his marked-out world and whose pauses, drifts, detours, and tides lift him into "pure harmony."

Obviously, Pollock was an artist with a secret. He knew how to make magic – a peer of the Navajo sand painters (invoked in the statement I have been quoting), who rolled their patrons in their glittering compositions as a cure for disease. His colleagues talked; Pollock had, as he liked to put it, "something to say." Being a painter was to this medicine man to some degree a masquerade. He preferred to play the laconic cowboy – a disguise that both protected him from unwanted argument and hid his shamanism behind the legendary he-man of the West.

To conceive of art as a form of incantation is not unusual in modern thinking – especially since the Symbolists, *The Golden Bough* and the writings of Freud. Why Pollock's magical procedures should upset people, including those of his admirers who wish to transform him into a hero of technological progress in painting, is a problem not of art criticism but of the deficiencies of American education. The notion of the artist as a "seer" guided by outside forces is implicit in the classical conception of the madness of the creator – a conception resurrected by Rimbaud in his celebrated axiom "I is another." Pollock read Rimbaud in translation, and a quotation from (if my memory is correct) *A Season*

in Hell appeared in large letters on the wall of his wife's studio in the early forties. The principle of the displaced ego of the creator, adopted by the Surrealists as a primary article of belief and disseminated by them in New York in the years before the war, provided sufficient hints for Pollock's "When I'm *in* my painting, I'm not aware of what I'm doing."

The originality of Pollock lay in the literalness with which he converted theoretical statements into painting practice. What to others was philosophy or metaphor he dealt with as material fact. Since in his view the driving force in painting was "contact" between the artist and his canvas, he concluded that creation could be dissociated from the formal history of European art and brought about through concentrating on techniques for making that contact more immediate and complete. In order to be literally "*in* the painting," Pollock renounced the easel and tacked his canvas to the floor. His other innovations stem from a similar substitution of contact for tradition. Pouring the paint from the can or dribbling or throwing it off the end of a stick was a means for gaining closer touch with the medium than was possible through applying paint with a brush. Refusing to work from preliminary drawings or sketches was an assertion of the primacy of directness in each individual composition. From the desire to be totally encompassed by the work came the wall-size dimensions of the drip canvases, so suggestive to later "environmental" painters and sculptors.

Leonardo, the Surrealists liked to point out, had called the attention of painters to the significant shapes evoked from the unknown by cracks in plaster and water stains on paper. Yet painting had lagged behind poetry in resorting to free association. Words, in their immateriality, are more responsive to psychic states than are mediums requiring the use of tools. Pollock's modifications of painting tend toward an emulation of writing. In throwing, dribbling, and blotting his pigments, he brought paint into closer approximation of the resiliencies of verbal utterance. The essential form of drip painting is calligraphy. In tying to the picture surface color layers of different depths, Pollock produced the visual equivalent of a play on words – a standard feature of oracular pronouncements. Masterworks like *Full Fathom Five* and *Lavender Mist* transform themselves from sheer sensuous revels in paint into visionary landscapes, then back again into contentless agitations of materials. Their immediate derivation is not the work of any painter but Pollock's favorite readings, from Rimbaud to *Finnegans Wake*. The thought of being influenced by other artists made Pollock uneasy, and he shook off his teachers with an impressive degree of success, but he eagerly identified himself with Hart Crane and with Joyce and Dylan Thomas.

378 HAROLD ROSENBERG

Pollock's most spectacular accomplishment is his large drip paintings. Since they almost go over the brink into non-art, these works have provided a bonanza for post-Dada critics engaged in shuffling paintings into various patterns of aesthetic evolution. Thus the drip paintings have been separated from the inner continuity of Pollock's creation and the drama of his adventure with mythic powers. Happily, the exhibition at the Museum of Modern Art, the biggest ever assembled of Pollock (or of any American painter there), restored the drip paintings to the context of Pollock's effort. That the core of this effort lies in the tradition of art as ritual is made explicit by the titles of the chief works of Pollock's early maturity – *The Guardians of the Secret, The She-Wolf, Night Ceremony, The Night Dancer, The Totem,* all done in the first half of the forties; also among the paintings of this period are *Masqued Image, Magic Mirror, Circumcision, The Key.* Typical of most of these paintings is a curious rectangular or circular structure suggestive of plaques or medallions. The paintings tend to be crowded with incomplete shapes, vanishing faces, and arbitrary emblems, and are sprinkled with inchoate writings, signs, and numbers. Forms are contoured or cut by thick black lines, and the dark and heavy pigment upon a ground of rather sinister gray creates an atmosphere of primitivism and psychological disturbance not unlike that in some of Klee's last paintings. For an artist just turned thirty in the wartime United States, these paintings show a remarkable inner sophistication and sense of purpose; they emanate from a region of Pollock's imagination to which he was to return in his last years.

The totems, masked mirrors, and night ceremonies adapted from Mexican mural painting and the Left Bank poetic kitchen are replaced in 1946, a year after Pollock moved to East Hampton, by the nature mysticism of compositions like *Sounds in the Grass: Shimmering Substance, Sounds in the Grass: The Blue Unconscious* and *Eyes in the Heat,* in which hidden creatures peer out between ridges of high-pitched yellow and blue paint. From these apprehensions of presences and energies in nature Pollock passed into union with them through releasing paint in fluids that directly record his physical movements. In the drip paintings, his striving toward an overwhelming symbol is lessened and breaks down into the rise and fall of rhythms rebounding from the canvas on the floor. He has discovered the harmony of the "easy give and take" and has condensed it into a style belonging exclusively to him. The state of abstraction into which Pollock has entered, as well as the origin of that state in the flowing of natural energies, is, as before, conveyed by his titles; with a few exceptions, like *Autumn Rhythm* and *Lavender Mist,* which look back to the intuitions of 1946, the drips are identified only by

numbers or are called simply *Painting* or *Black and White*.

Bringing the drip paintings into focus with the earlier totemic compositions provides a measure of both their strength and their weakness. What was radically new about the method of the drips was that the method was all there was to them. By discarding all traces of symbolism or visual mythology, exemplified by Surrealist dream pictures and the abstract figures of Gorky and Klee, Pollock pushed toward a purging of the imagination – or even its elimination. The catharsis implied by this technique establishes a connection between the matted undergrowths of *Blue Poles* and *Full Fathom Five* and the expansive vacancies of the work of Pollock's friends Barnett Newman and Tony Smith or the unyielding surfaces of Clyfford Still. It was myth without myth content – a pure *state*. It joined painting to dance and to the inward action of prayer, as Cubism had joined it to architecture and city planning.

What proves most remarkable is Pollock's range, an effect of temperament, physical ebullience, and integrity of purpose. For this "sand painter," the painting was medicine for the artist himself, not for a patient brought out of his tent to be cured for a fee of two goats. Contact was Pollock's salvation, and he tried to make it appear afresh in each painting. Whatever slackness and repetition occur are attributable less to Pollock's character than to his method. In its "easy give and take" the artist could only win or lose, without struggle. Its goal of "harmony" induced a settling down of psychic method into aesthetic process; this is clear in the work of Pollock's followers, for most of whom relaxed floatings or daubings of paint produce a mere simulation of the master's outer-controlled tension. Drip-painting contact contains no principle of resistance. It offers the temptation to roller-coaster thrills. A painting like Pollock's *Number Seven, 1950*, analyzed layer by layer, amounts to a record of glides and turns whose major quality is headiness. Lacking Pollock's magical mission, such paintings fulfill themselves exclusively in the aesthetic and represent his jazz music for the avant-garde art world.

Pollock himself, after the first excitement of his plunge into the abstract world of liberated pigment, found its harmonies less than satisfying. Already in 1949, only two years after lighting upon his new method, he deliberately defaces a typical drip painting with cutouts of flat, sharp-edged shapes and entitles the work *Out of the Web*, intimating an escape from the tangle of unmitigated responsiveness; in two other works executed in the same year – *Cutout*, a painting distinguished by his peculiar gracefulness, and *Shadows* – he repeats the motif with human shapes emerging out of the jungle of interwoven vines of paint. Turning to the rigors of black and white, to collage and massive drawings of classical

heads, he signals his awareness of the limits of visual "gorgeousness" as represented by *Lavender Mist* and other joyous isles gleaming with shreds of blue and aluminum. By 1953, the year of *Blue Poles*, a painting attractive because of a degree of naturalistic grossness, Pollock is in full swing back to the denser intuitions and more refractory images of his early-forties paintings. The flow of paint gradually dries up; his works take on references to paintings of contemporaries; execution becomes tighter and more tentative. He begins consciously to display skill – a necessary preliminary to a new departure but bound at the start to act as a handicap. Abstract titles like *Number Twelve* and *Black and White Painting* give way to a new set of riddles: *Four Opposites, Easter and the Totem, Portrait and a Dream*, until the list ends, with uncanny appropriateness, in *Search* – apparently the last oil painting he completed before his death.

TO INTERPRET
OR NOT TO INTERPRET
JACKSON POLLOCK

Donald B. Kuspit

In place of a hermeneutics we need an erotics of art.

SUSAN SONTAG, "Against Interpretation"

Since the time of the German romantics . . . the task of hermeneutics has been defined as avoiding misunderstanding.

HANS-GEORG GADAMER, "Aesthetics and Hermeneutics"

THE MEANING OF Jackson Pollock's paintings, particularly the all-over pictures, has always been in question. But the real question is whether we want them to have a meaning, or more precisely, whether they need a meaning to make sense. In 1947 Clement Greenberg insisted that Pollock's work had, in their "very abstractness and absence of assignable definition, a more reverberating meaning." Even earlier, in 1944, Robert Motherwell wrote that Pollock's "principal problem is to discover what his true *subject* is. And since painting is his thought's medium, the resolution must grow out of the process of painting itself." But the resolution does not seem to have emerged, at least with any clarity, from the process. The true subject seems uncertain, although, as Thomas Hess wrote in 1964, it has to be a "Big Subject." And yet this, too, may be a false subject, for as long as any subject remains uncertain there is no way we can be certain of its quality. The sense that something important is happening in Pollock's paintings does not tell us that they are about important things.

In 1962, writing in *Encounter* on "How Art Writing Earns Its Bad Name," Greenberg attacked the problem more directly. Rather than trying to impose still another interpretation on Pollock's paintings, he argued that their only possible meaning grew out of the fact that they

From *Arts* magazine, March 1979. Reprinted by permission of Donald B. Kuspit.

were made as art. Any approach which ignored their meaning as art gave Pollock's paintings a cultural determination which interfered with our aesthetic experience of them. The point was to see their power and importance as art, and not locate them culturally, for to do so neutralized them aesthetically. Thus, noting that Harold Rosenberg's conception of "Action Painting" originated "late in the same year as Pollock's Paris show," Greenberg writes:

> Transposing some notions from Heidegger's and Sartre's Existentialism, Mr. Rosenberg explained that these painters (Abstract Expressionists) were not really seeking to arrive at art, but rather to discover their own identities through the unpremeditated and more or less uncontrolled acts by which they put paint to canvas.... The covered canvas was left over as the unmeaning aftermath of an "event," the solipsistic record of purely personal "gestures," and belonged therefore to the same reality that breathing and thumbprints, love affairs and war belonged to, but not works of art.

Susan Sontag, in her 1964 essay "Against Interpretation," has picked up and in fact dogmatized this idea. Its logical outcome is in the first quotation that heads this article. The point is to "reveal the sensuous surface of art without mucking about in it." What is needed, writes Sontag, are "acts of criticism" which "would supply a really accurate, sharp, loving description of the appearance of a work of art." Such acts would witness "transparence ... the highest, most liberating value in art.... Transparence means experiencing the luminousness of the thing in itself, of things being what they are." Any art and its criticism should show "a directness that entirely frees us from the itch to interpret." "The sensory experience of the work of art cannot be taken for granted, now," and since interpretation takes it for granted, "and proceeds from there," it overlooks the essential nature of the work of art, i.e., its living presence in immediate experience. We must "experience more immediately what we have, but interpretation, because of its insistence on abstract schemes of meaning as mediators for what we have, undoes the notion of immediate experience. For Sontag, "to interpret is to impoverish, to deplete the world – in order to set up a shadow world of 'meanings'."

In her attack on interpretation Sontag insists that she doesn't "mean interpretation in the broadest sense, the sense in which Nietzsche (rightly) says, 'There are no facts, only interpretations.' By interpretation, I mean here a conscious act of the mind which illustrates a certain code, certain 'rules' of interpretation." In other words, she is against interpretation which reduces art, or the world, to an example of the general principle,

the case in point which "proves" an idea. But she is in fact more absolutely against interpretation than she admits, for she regards it as "the revenge of the intellect upon the world" and art. Interpretation does more than force experience into a Procrustes bed of consciousness. Interpretation analytically dismembers experience so that it cannot be reconstituted as a whole. Instead, it permanently reduces to a number of themes, sometimes logically, sometimes illogically related, but never recovering the original intense unity of the experience. This reduction is epitomized in the idea that there is a content to experience, separable from its form. Aesthetic experience is particularly susceptible to such nihilistic reduction to content, which becomes a convenient way of showing, as Greenberg puts it, that works of art belong "to the same reality" as other things. As Sontag says, "the habit of approaching works of art in order to *interpret* them . . . sustains the fancy that there really is such a thing as the content of a work of art." For her, "the idea of content is today mainly a hindrance, a nuisance, a subtle or not so subtle philistinism," which distracts from "what is needed, first," i.e., "more attention to form in art." Only form can convey "the naked power of . . . art": can show whether the art is "real" enough "to make us nervous," as all truly "real" art does. Thus, interpretation of art, revealing "a wish to replace it by something else," in effect represses its power and form, the source of that power. Interpretation, by emphasizing content, makes the art comfortable rather than nerve-racking. Interpretation, by eliminating the art in art, pulls out its sting. In her 1965 essay "On Style," a kind of follow-up on her essay "Against Interpretation," Sontag defines content as "the pretext, the goal, the lure which engages consciousness in essentially *formal* processes of transformation." It is not the theme we discover after the work of art is complete, but the catalyst that triggers its existence. But by this explanation content reduces to "metaphysical" nonsense, to a tautological affirmation of the work's formal power, which is exactly where Sontag wants it to be.

Now Pollock's all-over pictures seem eminently suitable to be the subject of an erotics of art. With their painterly directness, they seem unqualifiedly immediate in impact – ungraspable by any instruments of mediation. All the interpretations of them, which range from the art historical to psychoanalytic and autobiographical, seem to leave the works untouched. They remain as fresh as ever, their immediacy unchallenged, their directness unmitigated, their sensuous reality unsullied by ratiocinative machinations. They seem to be made to be lovingly described. Yet one wonders whether loving description will do justice to their freshness, bring out their apparent transparence and luminosity. A general

consideration emerges in the course of description: does it not fail – blur – the work as much as interpretation? With more irremediable damage? Description, because it does not expect to lose contact with the work, because it does not doubt its sense of the work's immediacy – because it does not suspect itself – misleads more than interpretation. Worse yet, because it is unaware of the inherent inadequacy of language to its task, description cannot prepare us for misunderstanding. It cannot avoid misunderstanding because it is so sure of its object and so unselfconscious about its methods.

A hermeneutics of art begins self-consciously and uncertain. It is acutely aware of the contingency of its results and gambits – acutely aware of possible misunderstanding at the finish as well as start of its investigations. And so it is cautious and self-critical in a way unimaginable to the "erotic" – loving – formal approach to art. In its effort to transcribe, even embrace the work of art in its direct presence, formalist erotics falls back on the ineffable, after it has worn itself out with terms which reduce the work to matter-of-factness. After a futile effort at freshness, the formalist is left with the facticity of both his words and the work. One might say that description, forced back on naive indication (excited pointing) after using naive language (denotative clichés), banalizes or over-objectifies itself as well as the work of art. Both reduce to a simple, facile objectivity, to a barren terrain of purposeless fact, and so to an inertia which is altogether antithetical to any sense of immediacy, any freshness. Formalist erotics reduces to a description which is neither spirited nor philosophic.

Description, then, can as little render the freshness and immediacy of the work of art as interpretation. These are apparent only under certain subjective conditions of consciousness, which neither description nor interpretation can create, at least with any completeness and guarantee that they will endure. But interpretation, because it is more aware than description of the difficulty and deviousness of establishing, however tenuously, a sense of the work's immediacy and freshness – and such qualities are always tenuous and fragile, idiosyncratic and unstable – is in a better position than description for gaining access to the work. Interpretation expects nothing from it; above all, it does not assume that it is necessarily experiencing the work directly. This in itself generates a certain freshness, a certain sense of immediacy. Moreover, interpretation recognizes the indirectness of its language – of any language, including that of description. This gives it a certain advantage over description, since it can avoid that straining for effect that reduces so much description to concrete poetry – that intense effort to evoke the work which all

too often becomes a form of self-parody. Description, in fact, just when it thinks it is most in touch with the work, and so almost poetry, tends to be most prosaic.

Formalism, then, is not only indifferent to the misunderstanding it arouses with its myth of immediacy, but seems to court misunderstanding. Above all, it thinks that because words will ultimately fail us, because, as Sontag says, the most elementary "translation" of the work of art will ultimately prove inadequate, distort the work grotesquely, words must be used simply and directly, as markers – as directly as the work of art presents itself to us. Yet such linguistic directness is impossible, and fraught with misunderstanding; the pragmatics of language alone should tell us that. Interpretation is willing to acknowledge the difficulty of language, its inability to pin the work down – the very absurdity of the enterprise, and what that "down" implies for our sense of the work – and work with that difficulty, by using language dialectically. Interpretation does something more like cornering the work – or else show that it can dance, with a step even surprising to itself, over an unexpected terrain – than pinning it down, than marking it with milestone words. Whatever the failings of its efforts, interpretation does not succumb to the futility about the work of art embodied in the notion of its supposed ineffability, which implies its permanent evasiveness. This notion, which is supposed to acknowledge the "eternal present" of the work, the undying freshness of its presence, is in fact description's compensation for its inability to pin the work down decisively, to be exact enough about it to hold it fast for contemplation. The work is never made completely clear and distinct – let alone fresh and immediate – by description, which is why it is reduced to insisting upon the work's ineffability. The supposed charm of its evasiveness only masks the inadequacy of the methods used to grasp it.

Much formalist description, when it is not secretly celebrating the ineffability of the work of art, articulates the clichés of some doctrine about art – or rather, turns its ideas into clichés. Just when it thinks it is most precise and objective, it is in fact most propagandistic. Thus Michael Fried's use of Greenberg's idea of Pollock. Fried's description of Pollock's *Number One* in *Three American Painters* (1965), with its emphasis on Pollock's "opticality," is more concerned to articulate, in as nuanced a way as possible, a general criterion of modernist criticism than to give full play and weight to the values evoked by the picture. These cry out for mediation – however difficult they may be to mediate – but they will be ignored because they are presumably not immediate in the art, i.e., not art values. But Fried does not risk articulating them because his method is unable to, and because he is concerned to establish that

method's exclusive claim on the picture, as though, as its conquistador, it had the first right to the best pickings. A limited perspective on the picture is made into an irrefutable fact about it, as though now that the picture was firmly in one kind of focus all its richness was disclosed. In fact, that richness goes unmined. There is no reason why *Number One's* "new kind of space ... in which conditions of seeing prevail" should preclude exploration of all that we are conscious of when we subject ourselves to those conditions.

We can get at the problem more generally, as well as in relation to Pollock, through a quotation from *Modes of Thought* by A. N. Whitehead. Discussing how "language is always relapsing into the generality of this intermediate stage between animal habit and learned precision," Whitehead notes that:

> Coleridge, in his *Biographia Literaria*, objects to a party of tourists who gazed at a torrent and ejaculated "How pretty!" as a vague characterization of an awe-inspiring spectacle. Undoubtedly, in this instance, the degenerate phrase "How pretty!" lets down the whole vividness of the scene. And yet there is a real difficulty in the way of verbal expression. Words, in general, indicate useful particularities. How can they be employed to evoke a sense of that general character on which all importance depends?

Whitehead's reference to the "general character on which all importance depends" goes to the heart of the critic's problem. How can one articulate that general character? If one doesn't do so, one doesn't know the importance of what one is describing; one can't even begin to describe it with any cogency. One's sense of the work of art's power depends upon one's sense of its importance, and that depends upon one's sense of its general character. The work's "immediacy," sensuous "directness," "freshness" – the urgency of its presence – qualify its power and are perceived through our conception of its importance. The language with which we describe the work gets its power through its ability to evoke the general character of the work. Is "opticality" much better than "prettiness" when it comes to evoking general character? Can this evocation ever be a matter of such simple-minded verbal ejaculation, in which a monolithic word is supposed to do the whole work and carry the full weight of understanding?

Sontag has no cognizance of any of this. Or if she does, like all formalists she buries it in her incapacity to deal adequately with the general. There are two errors in her formalism, which show just how facile it is.

First, her emphasis on the immediate preempts the general character of the important. By insisting that the critic simply describe what is immediately given, she assumes that all description will be self-evidently verifiable and coherent, when in fact its verifiability and coherence depend upon a general understanding that transcends the art's givenness. Second and more important, Sontag's separation of description and interpretation as irreconcilable opposites at cross-purposes repeats a pattern of bifurcation, serving reductionist purpose, that can be traced back at least to Descartes. Where in Descartes cognitive experience was given priority to sense or visceral experience, in Sontag the priorities are reversed, but with the same resulting hierarchization, and above all, with the same devaluation of the lower to the higher – the same effort to bring the lower under control of the higher. The disintegration of experience that results from this approach makes it easier to argue for the absoluteness of one or the other of its factors, at the expense of the other. Thus it is Sontag, by her insistence on formalist description of the work of art, that impoverishes our experience of it, as much as any attempt to make it exclusively the illustration of a certain code. Sontag's version of description is as inadequate to the work of art as her version of interpretation. Missing in both accounts is a sense of the importance that determines description or interpretation. This sense of importance is, as Whitehead says, an "expression" or "instrument" of "some large generality of understanding" characteristic of the way "civilized beings . . . survey the world." Clearly, Sontag's "generality of understanding" is not "large, adequate." For Whitehead, "one characteristic of the primary mode of conscious experience is its fusion of a large generality with an insistent particularity." For Sontag, insistent particularity is sufficient, which is why her experience of art cannot be said to be fully conscious. Her presumption, at one point, in evoking the Kantian "thing in itself," as though it was accessible through sense experience, shows her naiveté. [She gives sense experience a power it never had for Kant, and rarely has for any thinker. She does not seem to think error is possible in sensing, and so she accepts it without qualification.] The hermeticism of her formalist empiricism altogether belies the power of the work of art. Reduced to its insistent particularity – its sheer facticity – it does not so much make us nervous as bore us. The ennui that overtakes us in experiencing without generality of understanding testifies to the absurdity of pure fact. As Whitehead says, "A single fact in isolation is the primary myth required for finite thought, that is to say, for thought unable to embrace totality." Sontag reduces the work of art to a single fact in isolation, altogether unable to evoke totality – the large absence which

388 DONALD B. KUSPIT

surrounds and qualifies its small presence, giving it a good deal of its character and importance.

What is the significance of this line of thinking for Pollock's art, especially his all-over paintings? First, it must be recognized that the reason for the importance of Pollock's all-over paintings has not yet been firmly established, for their general character has not yet been made clear. Neither the art historical nor psychoanalytic approaches are sufficiently general. Whitehead has said that "perspective is gradation of relevance," and it may be that, because they are fact-obsessed and not sufficiently general, neither the art historical nor psychoanalytic perspectives can measure Pollock's relevance. They do not reach for Pollock's generality, and perhaps never can, given their character. For the visual generality of the all-over paintings seems to vehemently transcend their material factuality, however much the generality originates in the factuality. The properly general perspective can emerge only from an adequate account of what Pollock's art does for consciousness – what horizon the art suggests to it. This would be a true, phenomenological hermeneutics – a true aesthetic hermeneutics. No doubt it would begin by recurring to the "original definition of hermeneutics," which, in Hans-Georg Gadamer's words, is "the art of clarifying and mediating by our own effort of interpretation what is said by persons we encounter in tradition." Thus, we would examine the art historical and psychoanalytic approaches to Pollock, but with an eye for the kinds of meaning they find in his art rather than with a trust in their description of its particularity. In fact, the fact that such description tends to become poetically tongue-tied or aborts in simplistic, stereotypical references to the materiality of the art, or the person of the artist, becomes another kind of meaning of the art – one which will ultimately open us to the generality it empowers.

Indeed the power of Pollock's all-over pictures is that they embrace generality, evoke totality. Their transcendence of the finite perspectives on them testifies to this, shows that they exist in the direction of totality, as the first inkling of its horizon, as it were. The ease with which they can be characterized by such Whiteheadean categories as "creative flux" and "creative impulsiveness" also shows their direct grasp of generality. They have, as it were, concretized totality by overcoming traditional pictorial dichotomies. Fried says as much when he says that Pollock's "all-over line does not give rise to positive and negative areas," that "there is no inside or outside to Pollock's line or to the space through which it moves." What is missing in Fried is the acknowledgment that this transcendence of finite contrasts gives rise not simply to the optical illusion of infinity but to a sense of the "concrete universal," the literal presence of

generality, a graspable totality. In Gadamer's words, the all-over paintings transcend both their sources and vestiges, to "follow an old definition from Droysen's hermeneutics":

> Vestiges are fragments of a past world that have survived and assist us in the intellectual reconstruction of the world of which they are a remnant. Sources, on the other hand, constitute a linguistic tradition, and they thus serve our understanding of a linguistically interpreted world.

Thus, Pollock's all-over paintings transcend not only the "purely personal 'gestures'" they solipsistically record – even the artist's self-referencing image of his own hand in some of his works – but also their art historical location, the conventions of Impressionism and automatism with which, among others, they have been identified. And even the conventions of perception, as Fried has shown. Personal and public history – handmark and trademark – become excrescences on the work, denying its transcendence to totality, its general role for consciousness.

Does this mean that Pollock's art can never be adequately described, that the conventions of language, which depend on finite distinctions, fail it? Are the all-over paintings at last truly ineffable art – pure painting picturing nothing, inaccessible to formal analysis as well as interpretative codification? Gadamer has said that "being that can be understood is language," and Pollock's art, since it can be understood as generality and totality, is language. To identify being and language is, for Gadamer, not a "metaphysical assertion," but "describes, from the medium of understanding, the unrestricted scope possessed by the hermeneutical perspective." As Gadamer says:

> In the last analysis, Goethe's statement "Everything is a symbol" is the most comprehensive formulation of the hermeneutical idea. It means that everything points to another thing.

What other thing does Pollock's all-over painting point to? What is it a symbol of? The transcendence toward totality and generality is self-transcendence. Pollock's art reminds us that all art, all being tends to transcend itself – *must* transcend itself, if it is to be. This is perhaps why art that is really art makes us nervous, as Sontag says. It reminds us that we must change ourselves. Pollock's art epitomizes the hermeneutical idea that everything must point to another thing to be. Pollock's art, in its generality, seems to point to everything else, and so exists powerfully. As Gadamer says:

For the distinctive mark of the language of art is that the individual art work gathers into itself and expresses the symbolic character that, hermeneutically regarded, belongs to all beings. In comparison with all other linguistic and nonlinguistic tradition, the work of art is the absolute present for each particular present, and at the same time holds its word in readiness for every future. The intimacy with which the work of art touches us is at the same time, in enigmatic fashion, a shattering and a demolition of the familiar. It is not only the "This art thou!" disclosed in a joyous and frightening shock; it also says to us, "Thou must alter thy life!"

So immersed has Sontag been in the absolute present – abbreviated into material immediacy – the work of art implies, that she ignores the ready future it wills. Clearly, to interpret means to transcend all the descriptions that bog the work down in the present, that deny it future life. Pollock's art, perhaps more than any other in recent times, restores us to this future – restores the generality which conditions all finite perspectives that give importance, the totality which embraces possibility, and so permits us, as well as itself, to have a future, to alter.

SELECTED CHRONOLOGY

1903	Born Dvinsk, Russia.
1913	Family emigrates to Portland, Oregon.
1921–3	Attends Yale University, leaves without degree.
1924–6	Studies Art Students League with George Bridgeman and Max Weber.
1928	Included, group exhibition, Opportunity Galleries, New York.
1929–52	Teaches art to children, part time, Brooklyn Jewish Center.
1933	First solo show, Museum of Art, Portland, Oregon. Solo show, Contemporary Arts, New York.
1934	Included, three group shows, Uptown Gallery, New York. Joins Artists Union.
1934–5	Included, group exhibition, Gallery Secession. (Group forms core of "The Ten.")
1935–6	Exhibits with "The Ten," Montross Gallery, New York.
1936	Included, "The Ten," Municipal Art Galleries, New York; "The Ten," Galerie Bonaparte, Paris. Joins American Artists Congress.
1936–7	Employed by WPA Federal Art Project. Included, "The Ten," Montross Gallery, New York; also 1938.
1937	Included, "The Ten," Passedoit Gallery; also 1938.
1938	Included, "The Ten: Whitney Dissenters," Mercury Gallery, a few doors from the Whitney Museum on Eighth Street. "The Ten" dissent from the Whitney's purported bias toward Regionalism and the American Scene. Included, "Second Annual Members Exhibit," American Artists Congress, New York.
1939	Final exhibition of "The Ten," Bonestell Gallery, New York. The group disbands.

1940	Included, group show, Neuman-Willard Gallery, New York. Resigns from American Artists Congress, joins in forming Federation of Modern Painters and Sculptors. Included, group show, Federation of Modern Painters and Sculptors, New York World's Fair.
1941	Included, "First Annual Exhibition," Federation of Modern Painters and Sculptors, Riverside Museum, New York.
1942	Included, group show selected by Samuel Kootz, R. H. Macy's, New York.
1943	Included, "Third Annual Exhibition," Wildenstein Gallery, New York, and "As We See Them," 460 Park Avenue Galleries, New York, both sponsored by the Federation of Modern Painters and Sculptors. Rothko and Gottlieb discuss their aesthetic theories on WNYC radio.
1944	Included, "Abstract and Surrealist Art in America," Mortimer Brandt Gallery, New York.
1945	First solo show, Art of This Century, New York. Included, "A Painting Prophecy," David Porter Gallery, Washington, D. C.; "A Problem for Critics," 67 Gallery, New York.
1945–6	Included, Annual Exhibition of Contemporary Painting, Whitney Museum of American Art; also 1947–8, 1949–50, 1950.
1946	Solo shows: oils and watercolors, San Francisco Museum of Art; watercolors, Mortimer Brandt Gallery, New York. Included, "141st Annual," Pennsylvania Academy of the Fine Arts, Philadelphia; "Annual Exhibition of Contemporary American Sculpture, Watercolors and Drawings," Whitney Museum of American Art; also 1948, 1949.
1947	Solo show, Betty Parsons Gallery, New York; also 1948, 1949, 1950, 1951. Instructor, California School of Fine Arts, San Francisco; also 1949.
1948	Founder, with William Baziotes, David Hare, Robert Motherwell, and others, of school called "The Subjects of the Artist."
1949	Included, "The Intrasubjectives," Samuel Kootz Gallery, New York.
1951	Included, "Abstract Painting and Sculpture in America," Museum of Modern Art; "1951 Annual Exhibition:

Contemporary Painting in the United States," Los Angeles County Museum; "Seventeen Modern American Painters," Frank Perls Gallery, Beverly Hills, California.

1951–4	Assistant Professor, Department of Design, Brooklyn College.
1952	Included, "Fifteen Americans," Museum of Modern Art. MOMA purchases *Number 10, 1950*.
1953	Solo show, Art Institute of Chicago.
1955	Solo show, Sidney Janis Gallery, New York. Teaches in summer program, University of Colorado.
1957	Visiting artist, Tulane University. Solo show, Contemporary Arts Museum, Houston. Included, "Eight Americans," Sidney Janis Gallery, New York.
1958	Included, "XXIX Biennale," Venice. In lecture at Pratt Institute asserts he is not associated with abstract expressionism. Refuses "Guggenheim International Award" of $1000 from Solomon R. Guggenheim Museum.
1958–9	Included, "The New American Painting," organized and circulated by International Council, Museum of Modern Art, to Switzerland, Italy, Spain, West Germany, Holland, Belgium, France, England, and then Museum of Modern Art, New York.
1959	Included, "Documenta II," Kassel, West Germany.
1960	Solo show, Phillips Collection , Washington, D. C. Included, "Contemporary American Painting," Columbus Gallery of Fine Arts, Columbus, Ohio; "An American Group," Galerie Neufville, Paris.
1961	Included, "American Abstract Expressionists and Imagists," Solomon R. Guggenheim Museum.
1961–2	Included, "American Vanguard Painting," United States Information Agency, shown in Austria, Poland, Yugoslavia, England.
1961–3	First retrospective, Museum of Modern Art. Circulated by International Council of MOMA to London, Rome, Paris, Basel.
1962	Included, "Art Since 1950," Seattle World's Fair; also shown Brandeis University and Institute of Contemporary Art, Boston.
1964	Included, "Painting and Sculpture of a Decade, '54–'64," Tate Gallery, London.

1965	Award in creative arts, Brandeis University. Included, "The New York School: The First Generation, Paintings of the 1940s and 1950s," Los Angeles County Museum of Art.
1966	Included, "Two Decades of American Painting," organized and circulated by International Council, Museum of Modern Art, to Japan, India, Australia.
1967	Included, "Kompass III," Stedelijk Museum, Eindhoven, and Frankfurt. Included, "Six Painters," selected by Dominique de Menil, University of St. Thomas, Houston. Teaches summer program, University of California.
1968	Included, "Dada, Surrealism and Their Heritage," Museum of Modern Art; also shown Chicago and Los Angeles. Elected to National Institute of Arts and Letters.
1969	Honorary doctorate, Yale University. Included, "The Development of Modernist Painting: Jackson Pollock to the Present," Washington University, St. Louis; "The New American Painting and Sculpture: The First Generation," Museum of Modern Art.
1969–70	Included, "Painting in New York: 1944–1969," Pasadena Art Museum, California; "New York Painting and Sculpture: 1940–1970," Metropolitan Museum of Art.
1970	Dies a suicide, New York. Retrospective, Museum of Modern Art. Solo show, Museo d'Arte Moderna, organized by XXXV Venice Biennale.
1971	Solo shows: Galleria Martano, Turin; Kunsthaus, Zurich; Galleria Lorenzelli, Bergamo; Yale University, New Haven.
1974	Solo show, Newport Harbor Museum, Newport Beach, California.
1976	Included, "The Golden Door: Artist-Immigrants of America, 1876–1976," Hirshhorn Museum and Sculpture Garden, Smithsonian Institution.
1977	Solo show, Galleria Civica d'Arte Moderna, Mantua, Italy.
1978	Solo show, Pace Gallery, New York.
1978–9	Retrospective, Solomon R. Guggenheim Museum.
1981	Solo show, Pace Gallery, New York.
1983	Solo show, Walker Art Center, Minneapolis; Pace Gallery, New York.
1983–4	Solo show, High Museum of Art, Atlanta.
1984	Solo show, San Francisco Museum of Modern Art.

1984–6	Solo show, circulating exhibit of works on paper, Mark Rothko Foundation and American Federation of Arts.
1985	Solo show, Pace Gallery, New York.
1987	Included, "Abstract Expressionism: The Critical Developments," Albright-Knox Gallery, Buffalo.

THE ROMANTICS WERE PROMPTED

Mark Rothko

THE ROMANTICS WERE PROMPTED to seek exotic subjects and to travel to far off places. They failed to realise that, though the transcendental must involve the strange and unfamiliar, not everything strange or unfamiliar is transcendental.

The unfriendliness of society to his activity is difficult for the artist to accept. Yet this very hostility can act as a lever for true liberation. Freed from a false sense of security and community, the artist can abandon his plastic bank-book, just as he has abandoned other forms of security. Both the sense of community and of security depend on the familiar. Free of them, transcendental experiences become possible.

I think of my pictures as dramas: the shapes in the pictures are the performers. They have been created from the need for a group of actors who are able to move dramatically without embarrassment and execute gestures without shame.

Neither the action nor the actors can be anticipated, or described in advance. They begin as an unknown adventure in an unknown space. It is at the moment of completion that in a flash of recognition, they are seen to have the quantity and function which was intended. Ideas and plans that existed in the mind at the start were simply the doorway through which one left the world in which they occur.

The great cubist pictures thus transcend and belie the implications of the cubist program.

The most important tool the artist fashions through constant practice is faith in his ability to produce miracles when they are needed. Pictures must be miraculous: the instant one is completed, the intimacy between the creation and the creator is ended. He is an outsider. The picture must

From *Possibilities I*, Winter 1947–8. Reprinted by permission of Wittenborn Art Books, Inc., and Copyright © 1947 by Kate Rothko Prizel and Christopher Rothko. Reproduced with their kind permission.

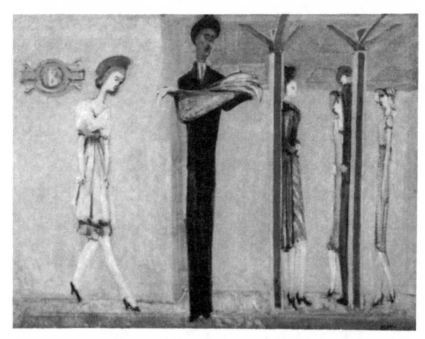

MARK ROTHKO, *Subway (Subterranean Fantasy)*, ca. 1936. Oil on canvas, 33¾″ × 60″. Copyright © 1978 by Kate Rothko Prizel. Collection, Solomon R. Guggenheim Museum, New York. (Photo by Robert E. Mates and Mary Donlon.)

be for him, as for anyone experiencing it later, a revelation, an unexpected and unprecedented resolution of an eternally familiar need.

On shapes:
 They are unique elements in a unique situation.
 They are organisms with volition and a passion for self-assertion.
 They move with internal freedom, and without need to conform with or to violate what is probable in the familiar world.
 They have no direct association with any particular visible experience, but in them one recognizes the principle and passion of organisms.

The presentation of this drama in the familiar world was never possible, unless everyday acts belonged to a ritual accepted as referring to a transcendent realm.
 Even the archaic artist, who had an uncanny virtuosity found it necessary to create a group of intermediaries, monsters, hybrids, gods and

Mark Rothko, 1903–1970,
Vessels of Magic, 1946.
Watercolor (38^{15}/$_{16}$" × 26").
The Brooklyn Museum,
47.106. Museum Collection
Fund.

demigods. The difference is that, since the archaic artist was living in a more practical society than ours, the urgency for transcendent experience was understood, and given an official status. As a consequence the human figure and other elements from the familiar world could be combined with, or participate as a whole in the enactment of the excesses which characterize this improbable hierarchy. With us the disguise must be complete. The familiar identity of things has to be pulverized in order to destroy the finite associations with which our society increasingly enshrouds every aspect of our environment.

Without monsters and gods, art cannot enact our drama: art's most profound moments express this frustration. When they were abandoned as untenable superstitions, art sank into melancholy. It became fond of the dark, and enveloped its objects in the nostalgic intimations of a half-lit world. For me the great achievements of the centuries in which the artist accepted the probable and familiar as his subjects were the pictures of the single human figure – alone in a moment of utter immobility.

MARK ROTHKO, *Red, Brown, and Black,* 1958. Oil on canvas, 8′10⅝″ × 9′9¼″. Collection, the Museum of Modern Art, New York. Mrs. Simon Guggenheim Fund.

But the solitary figure could not raise its limbs in a single gesture that might indicate its concern with the fact of mortality and an insatiable appetite for ubiquitous experience in face of this fact. Nor could the solitude be overcome. It could gather on beaches and streets and in parks only through coincidence, and, with its companions, form a *tableau vivant* of human incommunicability.

I do not believe that there was ever a question of being abstract or representational. It is really a matter of ending this silence and solitude, of breathing and stretching one's arms again.

MARK ROTHKO
AT ART OF THIS CENTURY

(Anonymous Review)

MARK ROTHKO APPLIES PAINT on canvas so that forms and areas have a vague, tenuous interlocking relationship. His work is abstract. Although his language derives from the world of the subconscious, he does not use orthodox Surrealist symbols. Instead he has evolved his own eloquent and suggestive idiom. This he has rendered in chalky paint, with color so subdued and subtle that it has a rather hypnotic effect. Indeed, the canvases themselves have the curious quality of first claiming the spectator by their quietness, and then suddenly startling him by the intricacy and power of their images. In some the manipulation to suggest swirling motion in counterbalance with static forms is masterfully achieved. Rothko is especially successful in the less ambitious medium-and-small-sized paintings where integration is more assured. Show is at Art of this Century.

From *ARTnews* January 1–14, 1945. By permission of *ARTnews*.

ART: MARK ROTHKO

Dore Ashton

MARK ROTHKO'S IMAGE has found its mute way with increasing ease during the past three years, impressing itself not only on the American art scene but on the European as well. Of all the temperaments which together make up the American vanguard acknowledged as such abroad, Rothko's is perhaps the most pondered, the most constructively disturbing. Although he obviously shares certain attitudes with other New York painters, Rothko, in a sense, stands alone. He is the transcendentalist of the group. He, more than the others, has minimized reference to the daily minutiae of experience in his work in his effort to reach exalted summary.

This is not to say that he is not speaking of "la condition humaine." On the contrary, he is speaking through his humanity, through his amplitude of emotions, of the highest point of human experience. He is speaking in the various voices of pain, joy, perplexity and exaltation, familiar to us all. But he is speaking metaphorically. Just as the good poet who writes of the sea, or who gives a tongue to stone, is writing of his own humanity. By calling Rothko a transcendentalist, I mean to say that he tends to go beyond phenomena, beyond the effect of many small sense impressions in order to find universals.

But if he is a transcendentalist in tendency, Rothko is no absolutist. Like the poets, he understands that an absolute cannot be a human life-giving expression. No matter how vast the figure of speech in a good poet, no matter how abstract, he will always find a finite measure. He will use a simple concrete noun or a familiar verb to show us how we can partake of the vastness, to lead us into the greater reality of the poem. Shakespeare in his Sonnet LXV, for instance, gave us both the concrete and the abstract:

Since brass, nor stone, nor earth, nor boundless sea,
But sad mortality o'er-sways their power,

From *Arts & Architecture*, Vol. 75, April 1958. Reprinted by permission of Dore Ashton.

How with this rage shall beauty hold a plea
Whose action is no stronger than a flower?...

Vastness (boundless sea) is made conceivable through the solidity of nouns (brass, stone). And beauty, a transcending abstraction, is made conceivable through the familiar image of the flower.

Rothko, in painter's terms, does the same. It is through his zones of ambiguity – those shivering bars of light between the major forms – that Rothko can move us. Through those tremulous passages creep our finite but infinitely nuanced emotions, finding their expression.

There are few clues to Rothko's philosophy, and the effects of the paintings themselves are almost beyong the reach of the word. Rothko himself has become increasingly silent concerning his work. It seems that artists retreat from the word the nearer they come to the truths they feel sure of. Yet, something Rothko wrote, together with Adolph Gottlieb, fifteen years ago is probably valid still. He said: "There is no such thing as a good painting about nothing. We assert that the subject is crucial and only that subject-matter is valid which is tragic and timeless ..."

This statement, which speaks for the whole New York group of that period, is important in that it reverses a tendency, since Maurice Denis, Roger Fry, Clive Bell, to regard the canvas as a field for the play of form and color and little more. Rothko, though revered now as a colorist, still endows his paintings with subjects. True, the subjects are not readily catalogued, but their validity is unquestionable. These paintings are *about* emotions as well as being, in a mysterious transference, the emotions themselves.

The subjects for the paintings in his recent show at the Sidney Janis Gallery range far, but they are in a different mood from the paintings before them. With what can only be called an overwhelming prescience, these large, resounding paintings embody Rothko's deeply developed sense of the tragic. I suspect that in part, Rothko struck out with exasperation at the general misinterpretation of his earlier work – especially the effusive yellow, orange and pinks of three years back. He seems to be saying in these new foreboding works that he was never painting *luxe*, *calme* and *volupté* if we had only known it! Most of these paintings are in the great tragic voice (though one borders on irritable despair.) They are, in their own way, equivalents to the "machine" paintings of earlier periods, those large scale, ambitious canvases in which great painters tried to give form to great truths.

I can't avoid thinking of these paintings in concert. The gradations of feeling, pressed one above the other in tissue-thin layers, are different in

each painting, but yet seem related to feeling in other paintings much as the parts of a Mozart mass are inseparable, yet can stand alone, esthetically complete.

I cannot tell you the names of the subjects painted. ("There are no names for things among which one is quite alone." – Valery) At best, I can suggest that color, for Rothko, is in one sense symbolic. His black, which is never black but a seething mass of deep, rich hues, is almost certainly intended to be on expression of a forbidding and wracking emotion. His purples the same. When, through the interstices a glimpse of pale light is seen, it is color-light, holding the mood.

The paintings are in no sense two-dimensional. It is true that they are plotted in similar divisions: often, the long rectangle, that brief bar, then the somewhat more squared form below and sometimes the framelike border. But what Rothko has done with these basic shapes is – well, there is no other word for it – magical. He has, by laying on one unspeakably thin plane above another, created an uncanny effect of recession. The surface, in fact, is scarcely important. It is what happens behind each successive scrim, so closely matched. In the night-like center of several paintings here, the eye strains to penetrate behind, and finally it can. Behind – the shadowy world, the whispers, the sobs, the restlessness indicated through the most subtle brushing, through actual strokes. Never before has Rothko so clearly warned us that his paintings are not what Hubert Crehan once called "walls of light." Far from being walls, they are stages for an internal drama that must be seen, must absolutely be seen through the eye and mind which must expend a consuming effort of attention to "see" the image.

There are those who will say that Rothko had no place to go with his simplified schema; that the shadows which play behind these newer works are the beginning of a return to figuration. To my eye, these new paintings are simply more accented. The shadows were always the paradoxical substance of his work.

Parenthetically, I would like to suggest that the paling edges, the quavering areas of light, the completely ambiguous extremities of Rothko's forms – present for the past five years at least – are the crucial carriers of Rothko's complex expression. Think of a painting by, say, Albers, in which the form superficially can be said to resemble Rothko's. There neatly, opaquely arranged are the rectangles. But between them, nothing but hard colored surface. There is no area of ambiguity and the bald geometry remains just that. There is a greater difference between Rothko and Albers (or any painter using squared forms) than there is between Rothko and Guston or Rothko and Tobey.

404 DORE ASHTON

To get back to the paintings, I must speak of how precisely they are executed. For Rothko is a precise painter. His green in one painting is deep like a tarn, and black phantoms stir in its depth. White below is a silvery film, escaping pressure from above. A ragged purple edge supports the major dark red field (built up with red ground below, and green and pink stealing from its edges). They are all held, in this painting, by the framelike band of Fra Angelico jewel blue. But that blue is also varied, though scarcely visible so that it creeps in deeper at parts and returns to the surface when needed for containment purposes. Bled into the canvas, all the colors fuse, yet their identities are never lost.

There is precision, too, in the postulation of mood. One of the paintings most penetratingly melancholy, called I think *Purple and Brown*, pends heavily on its horizontal axes and pulls against any upward thrust of feeling. The somber purple-browns above resting heavily on a bar of mulberry are brought to a depressive climax at the very bottom of the canvas. There, the brownish rectangle is filled with downward strokes, the last filtering out of melancholy – the indescribable melancholy which drinks up all light and dully shines with it. The same is felt in the mournful brown painting where a dead tan center is played about by silver grays and blackish shadows. There are shadows in all the paintings, sometimes in an echoing edge, darkened and pushing over the plane, sometimes behind the picture plane.

Several red and black impressions burn and quicken the senses and bespeak, possibly, anger. One enormous essay in exasperation is a red border painting in which a great, deliberately endless and blank white field is a rude expression of intense anxiety. I found this to be more polemic in value, less rich in imaginative innuendo. It is in the subtly built-up, greatly nuanced paintings that Rothko is at his best, and in these last paintings, he has provided an orchestration on a heroic scale.

THE NEW
NEW YORK SCENE

Anita Brookner

"**P**AINTINGS TO BE VIEWED through dark glasses" was the subtitle I longed to append to "The New New York Scene," an exhibition of American abstract art at the Marlborough New London Gallery. I rest my case on the immense blue rectangle of Ellsworth Kelly, the same artist's double rectangle *(Peru, 1959)*, of which the catalogue thoughtfully published a detail, and Raymond Parker's two irregular rectangles placed one above the other *(Untitled)*. Lee Krasner paints rather more spontaneously: the man [*sic*] is clearly a romantic. Helen Frankenthaler splashes with some idea of style, and I particularly liked Lee Bontecou's relief contrived from an old cabin trunk, part of a gas-stove, fragments of nail-studded asbestos, and a sprinkling of chicken wire.

Is this all as silly as it sounds? Or rather, at what point of inversion do we cease to pay our respects? The highly dramatic exhibition of Mark Rothko's paintings at Whitechapel poses the same problem. These huge impassive areas of colour, which Stuart Preston has compared in this Journal to "tinted steam," are at the very opposite pole from the excitable and egocentric works of the New York abstract expressionists. They are undeniably more serious and more meaningful. Mr Bryan Robertson, in his preface to the catalogue, tells us that ". . . their conclusion is so massive in its registration, so purged of extraneous detail, so relentlessly single-minded in its pursuit of plastic self-sufficiency, that we are carried beyond the end into a new and transcendent being." Not me. I was carried to a sort of spiritual Stonehenge, obliged to concede some strange premonitory power to vast expanses of dark blue or dark red, especially if the colour appears to shift slightly or blur towards the edges, but unwilling or unable to project more into these paintings than a feeling

From *Burlington Magazine*, Vol. 103, November 1961. Reprinted by permission of *Burlington Magazine* and Anita Brookner.

that I had been here before in another medium. Electronic music, perhaps. Baudelaire's theory of correspondences. This is not to denigrate Mr Rothko's gifts as a painter but to isolate the mild hysteria that his pictures are apt to induce. The soft cunning abstracts of the 1940's prove that Rothko is a painter of high seriousness and subtlety, and the almost monochrome works of the 1960s that he is a contemplative who contemplates on a vast scale. His dark paintings are particularly beautiful; the lighter ones seemed to me less interesting. It is when Mr Rothko explores the peculiar powers of the colours he calls "maroon" and "plum" that he touches some nerve in us all. But to claim "transcendence" for an *oeuvre* that seems to have evolved to a point not only of no return but of no advance may be to anticipate greatness a little too easily.

MARK ROTHKO'S NEW RETROSPECTIVE

Max Kozloff

MARK ROTHKO'S PAINTINGS at the Museum of Modern Art have been received immediately as the most problematical works shown this year. Even those most unhappy about Rothko do not deny him a certain historical importance or overlook the radical position he holds in modern painting – an extreme which thus far, apparently, has allowed no middle-of-the-road reactions. It is good that we are offered this inclusive look at Rothko, germinal as he has been for a host of contemporary and younger painters, because it provides us with the best chance yet to judge both him and his influence.

An obvious asset of the recent show is its broad presentation of the artist's development from 1946 to the present. Rothko's path emerges very clearly, from the delicate early watercolors with their Surrealist transparent organisms to the enormous, light-filled rectangles of the Fifties, and ending, finally, with work completed only last year, the extremely dark-keyed studies for his 1958–59 mural project. The shifts in his vision have been so consistent and gradual that the earliest work already contains an inevitable forecast of his latest. Yet the differentiations are far greater than one had imagined – of color and texture, if not of concept. This exhibition establishes once and for all, if this was necessary, how drastically Rothko's art is one of theme and variations. With their horizontal layers, their once or twice divided zones of color, his paintings are far more like continuing nuances of one major idea than individual statements meant to be apprehended in their own right. What is more, the impression is strong that Rothko has arrived at this exposition of his work as much through programmatic reasons as through a sensual response to certain forms and colors.

One would have expected, therefore, that his show would hold together, for good or for bad, each painting deriving its coherence from the

From *The Art Journal*, Vol. XX, No. 3, 1961. Reprinted by permission of Max Kozloff and *The Art Journal*.

overall display of his artistic will. But this has not happened. Despite their common frontality or mutual restrictions of space and movement, the separate paintings are not served by the abundant presence of their own kind. Chronologically the arrangement makes sense, but aesthetically there is an exasperating struggle found throughout the exhibition. The spectator simply has no room or freedom from distraction with which to contemplate a Rothko painting, and this is necessary because, with a fabulous aristocracy, its subtleties tend not to yield themselves in this crowded, marketlike situation. Not merely does a Rothko painting require a special consideration in the manner by which it is displayed; it imperiously demands total concentration from the beholder. For his works to intrude upon each other as they do here is as intolerable as to see a room full of Prometheuses competing for the theft of fire. As an idea, admittedly, any painting by Rothko is quickly exhausted by the knowing of its abstract framework, but as an actual physical presence, it is always imponderable and, often, an overwhelming experience.

It is for this reason that one ought to disregard the rhetoric of an exhibition that has literally covered all walls in an attempt to impose a Rothko cosmology upon the viewer. In this respect, a single one of the mature paintings will do as much.

What impresses at once is the quality of its color. For Rothko to but choose a color means to annex it and to make it inimitably his own. Whether this be a persimmon orange, an indefinable rose yellow, or a rusty violet, its resonance, intensity, and value have been totally reinvestigated by the artist. For all the imageless impersonality of its context, then, Rothko's color strikes a highly personal note. Of course, the reduction of all elements to color itself is not sufficient to explain this paradox. Rather, the pictorial format illuminates the singular color impression very much. Fragile transitions and faded edges constantly set up a delicate "aesthetic" atmosphere, reminding many critics of Whistler. Indeed, Rothko's surfaces have a studied look that tries to conceal itself — the deadpan, as it were, rather than the dead — very reminiscent of Whistler's muted handling. Then, too, Rothko's color selection has its ultimate sources in late nineteenth-century French Symbolism. Like Gauguin, Rothko explores deliberately unlikely hues (they suggest rare tropical birds or flowers) but magnifies them to such an enormous extent by the expanse of his areas that a merely lush sensation turns into a terrible luxuriance. Just as through the intensity of his perception even a primary can be used as a secondary color (red), so also he can exceed the complementary relationship he has given one to expect: the blue has too much green and the orange too much yellow in his 1954 *Homage to*

Matisse, for instance, for an equilibrium to exist. So, the deceptive modesty of his textures, coupled with a desire to avoid sweetness through color a trifle too strange to be agreeable, reveals a considerable tension in a Rothko painting, as well as perhaps lending his work a certain irony.

Rothko has forged a crucial position for himself in the American avant-garde, however, not by what he owes to French tradition but by the absolutism of his conceptions. Monet turned the aquatic vision of his late *Nymphéas* into violet because that color could recall the exquisiteness of his visual reverie; Rothko is addicted to a color quite before any emotional mood or association may present itself. With him, the possibility of a new harmony comes before everything. As indication of this, we can examine the show's revelation of Rothko's celebrated "close" painting. Avoiding as much as possible light-dark contrasts, Rothko concentrates exclusively on the visual distinctions that colors alone can make. The result is a series of paintings in which structure is discriminated only by differences of the immaterial wavelengths emitted by colors. But these very differences are reduced intransigently so that the spectator is forced, with each Rothko painting, to judge anew his own perceptions of color. With the juxtaposition of, say, a warm with a cold yellow, Rothko can make visible a chromatic attenuation of unprecedented fineness. Even with a post-Fauve palette, starting in luminosity where Dufy, for one, left off, Rothko creates color relations worthy of the tonal washes in Sung painting. Yet he paints with all the mobility and radiance of a discoverer.

Thus, Rothko might be a somehwat authoritarian artist, but rarely a "pure" one. One hardly feels, no matter how uncompromising his renunciation of imagery, that he is out to "purify" what he explores. On the contrary, Rothko's sense of possibility has even allowed him to treat cool and relatively deep colors, such as in *White and Greens in Blue* (1957), with all the disciplined extravagance he previously reserved for the warm edge of the spectrum. Had Mondrian turned to curves, the change could not have been more enticing.

When we come to those profoundly dark mural sections of 1958, though, we find Rothko examining the alternate convention, so to speak, and making, too, his first major mistake. It might be argued that these works have a monumental somberness about them (it could not have been otherwise as this artist plunged himself so deeply into the negation of color) and that they embody a new mystique of shadow. But, optically, darks do not permit very much resonance at all – a discovery the Impressionists made long ago. We observe the "events" in Rothko's murals about as readily as we can make out objects in a room so dark it defies

the maximum enlargement of our pupils. Because of this technical limitation, Rothko has found himself, temporarily, one hopes, in an expressive dilemma. His brownish-purple mural paintings are ultimately flat, dark, and opaque; whatever color variations operate at their low range tend to cancel each other out. So, far from extending the level of chromatic visibility, these late works move toward the exact opposite – invisible painting.

It is an irony that his latest canvases should run counter to the whole meaning of Rothko's exhibition. Not the least peculiar is the fact that the more invisible his murals become as paintings, the more tangible they appear as mere objects. In the end, we have nothing further than rather brackish arrangements of dark tones, blinding us, to be sure, by their impermeability to light but remaining all too measurable and material. Oddly enough, while these colored walls are enormous, they seem less large than the actually smaller canvases of the middle Fifties. This is because the eye associates light more freely than darkness with overall space and, further, because warm–cool contrasts, even though extremely delicate, initiate advances and recessions into space. With Rothko, high luminosity makes of the picture surface a kind of osmotic membrane allowing molecules of color to thread back and forth, to recompose themselves, as it were, on huge, palpitating screens. For all aesthetic purposes the plane does not exist, and as soon as the spectator himself, growing more intent on the color vibrations, learns to discount the surface, the whole painting ceases to *be*, as a concrete thing. A breakthrough has then been reached, and the apprehensions are flooded or saturated with one or two extremely vivid but disembodied chromatic sensations. Only when his paintings can be "entered" in this way does he belie the suspicion that he is but the creator of pigmented containers of emptiness. To find that lever or consciousness which will change a blank painted fabric into a glow perpetuating itself into the memory is the immediate aim of his art and the fulcrum for experiencing it. The murals stop the viewer short and confine his attention to a few diminishing nuances on their façades; the paintings encourage him to balk stubborn matter, as they give off the illusion that their very flesh is transparent.

Needless to say, such effects might be labeled romantic, even somewhat mystical. To these accusations Rothko eventually proves himself vulnerable. That single luminous block or band that lies across so many of his canvases is like a sky by Odilon Redon. And then, the vapory, almost substanceless paint gives the impression of being totally unconditioned by the human hand; prosaic brushstrokes would indeed be an intolerable intrusion. His *No. 22* (1960), with its three inexplicable horizontal

scratches, proves this by bringing the spectator down to earth quite unceremoniously. Thus, Rothko paints with a kind of Olympian disdain for the merely circumstantial, or anything that might define his work in an objectively perceived here and now. Inevitable but not totally palpable, Rothko's masses occupy an unspecified limbo in the viewer's mind between the joys of dreaming and the freshness of primitive sensation.

All the same, his aspiration toward the infinite is not accompanied by the posture of a visionary. Nor are his paintings the testimony of facile lyrical effusions. Rather, he practices a brinkmanship whereby his mists are kept from becoming too introspective or nebulous by the austerity of the format. This in turn is nothing more than a sign of an intellectual control Rothko will tend either to impose or release, depending upon the progress each picture is taking. (One further reason his murals, with their inscribed rectangles, are not successful is that they are the most thoroughly "designed" of his works but the least pictorial in execution.) That he is lonely in his ambition can be seen by comparing him to those painters whose work resembles his own. Stamos, Still, and Baziotes, for instance, represent the more sensuous, unabashedly poetic side of the Rothko style, and Reinhardt, Newman, and Josef Albers express an affinity with its rigorous conceptualizing. In either case, however, the ramifications are fewer than in the paintings exhibited at the Museum of Modern Art. While sporadically creative, painting that parallels his slides either into the illustrative or the overly calculated. It is an exceptionally hard style to profit by, and rare are the crystallizations of energy that are able to bring a work out from the realm of affectation. In Rothko, on the contrary, what matters is not the ineffable adjustments of one color and its edge to another – these are only the mechanics of his art. Rather, the ignition that results from the impact of a fierce palette upon an aloof and fastidious temperament flusters exhaustion and begins to hold the haunted spectator longer than he intended. Rothko's stunning combination of puritanic restrictions and lavish self-indulgence produces a drama that often ruffles the serenity of his canvases – almost from within, as it seems, like a young girl blushes. He emerges, in those many paintings where the balance between his impulses is always precarious but awesome too, as one of the loftiest sensibilities of his generation.

ROTHKO

Harold Rosenberg

MARK ROTHKO, who committed suicide in February 1970, belonged to a wing of Abstract Expressionism whose art was based on the idea of one idea. This was an aspiration toward an aesthetic essence, which the group of artists to whom Rothko was close sought to attain not through acts of intuition but by calculating what was irreducible in painting. The movement began in the middle forties, as an accompaniment and antithesis to Action painting, with its psychological and formal openness; it is ironic that the two movements should have emerged together under one label – Abstract Expressionism. The one-idea painters excluded both nature and self, as manifested in the randomness, induced accidents, and associationism of Gorky, de Kooning, and Pollock. Seeking a universal principle, most of them looked back to Mondrian, though not for the quality of his sensibility, which they found too mathematical, but for the rigorousness of his aesthetics of exclusion – as remote as could be from Kandinsky's early improvisations, which beguiled Gorky and Hofmann. One might say that Rothko and his friends constituted the theological sector of Abstract Expressionism. Together with Still, Newman, Reinhardt, Gottlieb (the names suddenly translate themselves into characters of a miracle play), Rothko sought to arrive at an ultimate sign. To this end, he and the other theologians conceived painting as a kind of marathon of deletion – one of them got rid of color, another of texture, a third of drawing, and so on. By the mid-forties, Rothko was able to dramatize the crumbling of subject matter in a succession of compositions suggesting jungles and submerged landscapes, whose creatures, habitations, and implements had been scraped or washed away. His blanched surfaces and unidentifiable biomorphic shapes conveyed an effect of the archaic that in its effect of distance corresponded to Gottlieb's pictographs and Newman's cosmic spheres of the same period. Pictorial content had been reduced to vague psychic reverberations.

Rothko's next move was to obliterate subject matter entirely. This was done through a series of acts of subtraction, to which he devoted four or five years. During this development, drawing vanished, horizons melted into diffused masses – Rothko's *No. 24* done in 1947, has much in common with *Moonlight Marine*, by that other seeker after "something out there beyond," Albert Pinkham Ryder – and movement finally came to a standstill. But Rothko would not rest with simplifications of observed phenomena, as exemplified by the paintings of Milton Avery, which he admired, or with projections of the unconscious, like those of Gorky or his own earlier work. Even simplifications so extreme as to make their models unrecognizable violated the ideal of an absolute art. The idea of one idea demands a format that can stand for the inexpressible through being denuded of all particulars and associations and detached from the contingencies of nature, like Mondrian's "unchangeable right angle."

By 1950, Rothko had conceived his conclusive insigne of a disembodied absolute. This icon consisted of the rectangle of the canvas as a one-color ground visible along the edge of – and occasionally through an opening between – three or four horizontal blocks of color with brushed surfaces and furry borders. For the next twenty years, Rothko's work consisted of reanimating this pattern with the substance of his emotional life. It was as if he had conceived a latter-day, visual version of the sonnet or the *haiku*. Except that (and this is decisive in regard to the situation of the one-idea painter) his format was private – almost, one might say, the framework of another self, or of himself in another form – and unavailable to others.

Rothko had reduced painting to volume, tone, and color, with color as the vital element. His paintings, many of them huge and intended for display in public places, range from floating masses of tinted air, like influxes of breath, to closely packed slabs of dense, glowing pigment, resembling segments of metal or stone tablets that once carried inscriptions (the latter canvases reawaken the archaic overtones of Rothko's submerged cities of the early forties). With the overall figuration kept intact from canvas to canvas, emotional content is determined by the hue, pitch, weight, and expansion and contraction of his oblongs of color, as these are affected by the shape and size of the whole. The psychic tensions evoked by Rothko are at once extreme and featureless, mythical without mythic personages or events. An upward drift, as of levitation or the weightlessness of grace, stimulates a flux of inhalation and opening out, and draws the spectator into the orbit of the artist's inward flights. Materiality is overcome – at least, until the walls reassert their presence –

an effect that had led some observers to speak of Rothko's paintings as enveloping the onlooker or transforming his environment. In contrast, his brooding, dark reddish-brown canvases, which had emerged as early as the fifties but appeared more frequently, and growing blacker, in his last years, tower over the spectator in a blank foreboding, like ancient testaments kept intact in a shrine or a grotto of some dour barbaric cult. Both the uplifting and the heavy, dark nights of Rothko's compositions have been identified as embodying religious experiences. Peter Selz has said that his paintings "really seem to ask for a special place apart, a kind of sanctuary, where they may perform what is essentially a sacramental function." Rothko's last commission was for an ecumenical chapel in Houston.

Whether or not Rothko's paintings require a "sanctuary," the artist found his own sanctuary in his studio. His reductive idea closed its door against the world and sanctified the studio as a site for rituals of death and rebirth. There he carried on his program, announced in 1943 in a joint communiqué with Gottlieb, of making his art "an adventure into an unknown world," an adventure of which his suicide in the studio was the concluding act. Rothko's art was "escapist" in the deepest traditional sense – rich in the romance of self-estrangement and of nostalgia for communion. Emotionally, he took less away from painting than any of his early companions. Compared to Newman's, his canvases are passionate rediscoveries of a state of being rather than detached affirmations of an objective truth. It can be argued that Rothko was never "really abstract," in the sense of canceling subjective qualities in favor of his idea. He deleted the particulars of which a human self is made, but he did not exclude the sentiment of his own absence. Restrained and sedate, his art was essentially soft, that is to say, humanly susceptible, with a susceptibility that his color-area imitators of the sixties did their best to banish. His were the first "empty" paintings by an American to make an impact on the public, perhaps because his emotionally charged reds, blues, browns, black-greens succeeded in stirring up feelings – awe, anguish, release – too deeply buried to be brought to the surface by visual metaphors.

Rothko spoke often of tragedy, Greek and Shakespearean, and of myth and ritual. It is not easy to grasp the connection he had in mind between his mats of color and Orestes or Macbeth. It must be presumed that the very blankness of his canvases vis-à-vis persons and things carried the reference to torment and purgation. It was another self that Rothko sought – the kind of illuminated, memoryless alter ego that emerges out of conversion rites. But it was an anonymous self, identified with a hero,

saint, or god not yet named. In his genial, matter-of-fact manner, he whispered to me at a party, most likely because the subject of Expressionism had been raised, "I don't express myself in my painting. I express my not-self." I had long had the impression that he was not much attracted to what he had found in his personality. On the other hand, he had no wish to put his wounds on parade, like some of the Middle European Expressionists. It was in transcending himself that his hopes lay, in building a life independent of day-to-day facts. He decided that he could do most for his art by evicting himself from it, and that art could do most for him by providing occasions for acts of catharsis that he could have before him later. Compressing his feelings into a few zones of color, he was at once dramatist, actor, and audience of his self-negation.

The drama of purgation was not, of course, visible in each of his paintings; often the spectator saw only combinations of pinks, whites, and purples. Something similar is true of van Gogh: yellows and greens that for him were imbued with sinister drama have aroused pleasure in onlookers. The emotional effects of color cannot be calculated precisely – except, possibly, in the art of century-old cults, in which their meaning has been fixed by tradition and doctrine, such as the Hindu Tantric designs. Yet an artist's intended emotional content need not communicate itself in every painting; if it comes across once, the spectator is justified in accepting something like it as the potential content of all the artist's works. With Rothko, the poetry and agony of self-displacement established itself as the note of his paintings, and if some of them failed to speak, one felt that they might at some other time.

As against the self-creators among his contemporaries – de Kooning, Hans Hofmann – Rothko posed the anti-self. His purged paintings affirmed the purged ego – or, rather, the act of purging. Each work was an evidence of the mind's approximation to zero, an image of the not-seen. The effectiveness of such cleansing events lay in their reiteration. Rothko was not deterred by the realization that for two decades visitors to his exhibitions would know in advance what they could expect to see. Theoretically, the artist who has attained his ultimate image ought to reproduce it without change, like the order of a ceremony. Reinhardt, a drier logician than Rothko, advanced to this practice in the all-black paintings of his last period. The glint of color below his unchanging squares of silence emphasize that all differences in individual sensibility amount to nothing more than a scarcely perceptible nuance against the massive truth of death and nothingness. Rothko, for whom reductionist aesthetics was also the vehicle of primordial moods, avoided the finality of Reinhardt's summation. With him, too, however, the drift was toward

black, as representing both heaviness of feeling and the fading of the visible world.

No doubt Rothko drew much strength from practicing painting as a ritual of self-purification. Yet the art of one idea is full of painful contradictions. It transforms the studio into a sanctuary but also into an isolation cell. The symbolism of a cult unites its members, though it separates them from nonbelievers. The symbolism of the contemporary artist-theologian is that of a one-man cult, and it separates its creator as its sole communicant. The absolute images of Rothko, Newman, Gottlieb, Still, Reinhardt can coexist in a picture collection but could not coexist in the minds of their originators. Each was the proprietor of a sacred enigma, whose authority had to exceed that of all others. The fate of Rothko's original group of artist-companions was to disperse and become in most instances implacably hostile to one another. Nor could Rothko, whose passionate anti-self engaged him so totally in his paintings, win the devotion of the bland professionals who in the sixties adopted some of his technical innovations. To the reductive theologian of painting, his work represents ultimate meaning. To others, its appeal is to taste. His all-embracing symbolic format was arrived at by difficult routes; once conceived, it could be reproduced at will – Rothko was one of the first to declare, no doubt ironically, that he could order his paintings made over the telephone. Nullifying himself was his discipline of exaltation; fame surrounded him with himself in countless mirrors. In the end, his anguish was loneliness and the thought that his poetry had not been received. In this loneliness and sense of futility, he achieved the universal that was his ambition as an artist. But he was compelled to experience this universal as a single individual, without consolation. He had been depressed for at least five years, yet no one knows why he took his life. Like his paintings, his act of self-annihilation is a deeply affecting blank. The art world turned out en masse for his funeral.

MARK ROTHKO

Robert Carleton Hobbs

WHEN MARK ROTHKO WROTE "The Romantics Were Prompted" for publication in *Possibilities* in 1947,[1] he was ending a period he later termed Surrealist, and beginning to develop his art along more abstract lines, occasioned first by dropping mythic titles and later by creating multiforms. In this essay, which marks the shift between his earlier and later Abstract Expressionist styles, his attitude is generally retrospective. He used the theatrical metaphor to explain the appearance of hybrids in his work of the forties: "I think of my pictures as dramas; the shapes in the pictures are the performers." His references to the impossibility of presenting his drama in the everyday world rely heavily on Nietzsche's theories on the origins of tragedy: the emphasis on the chorus of satyrs is paralleled in Rothko's hybrids, and the effect of creating an atmosphere to break down individual differences and establish a primordial unity is crystallized in his term "transcendent experience."

Rothko must have thought of the theatrical metaphor often when he worked. Brian O'Doherty recounts that Rothko sometimes said he had acted when he was young.[2] And Thomas Hess refers to his training as a scenery painter,[3] which he connects to Rothko's later use of "scenery paints cooked over a hot-plate" to stain his canvases. Robert Motherwell remembers that Rothko, who was so secretive about his methods of painting and usually worked from 5:00AM until 10:00AM, in a moment of weakness admitted to him that he painted under lights of high intensity that were arranged like stage lights.[4] Intense lighting would naturally have the effect of making every nuance blaringly evident. Also, it would bleed out the richness of his colors making them more opaque and less jewel-like when he was working. Perhaps this is the reason why Rothko once stated that the completed painting is as much a revelation to the artist as it is to the viewer, and once finished it begins an existence separate from its creator.[5] It is unknown exactly when Rothko began to

Reprinted from *Abstract Expressionism: The Formative Years* by Robert Carleton Hobbs and Gail Levin, © 1978 by permission of the Whitney Museum of American Art and the Herbert F. Johnson Museum of Art.

418

paint in this manner, but we do know that for years he insisted on having his works viewed under dim lighting, a request with theatrical overtones that would have the effect of decreasing focused vision and intensifying peripheral scanning. Subtle changes in tone that were greatly exaggerated under stage lights would, under dimmed conditions, create an entirely different sensation. His chalky, generally pale colors of the forties – mostly conceived within a narrow range of values – would become richer. And the entire composition would subtly vibrate, creating the effect of an incipient presence hesitantly beginning to stir.

In his works of the forties, Rothko played on the theatrical idea even to arranging his biomorphic forms on a shallow stage, making them participants in some inexplicable drama. And the titles – such titles as *Implements of Magic, Tantalus, Vessels of Magic, The Entombment* and *Nocturnal Drama* – reinforce the mood of mystery and the distant past. Years after he created these works, Rothko told Peter Selz, "As I have grown older, Shakespeare has come closer to me than Aeschylus, who meant so much to me in my youth." Aeschylus, it should be mentioned, is the tragedian Nietzsche selected to examplify the merits of tragedy in contradistinction to Euripides, who diminished its importance by stressing unnecessary realistic elements. Rothko's hybrids affirm the mystery of his work and keep it from being marred by prosaic elements. These beings have their origins in a microscopic world that serves as an analogue to man's inner realm; some forms call to mind ciliated protozoa, others flowing protoplasmic entities with pseudopods, and still others flagella. Among the Abstract Expressionists, Rothko was one of the few who consistently appreciated the early work of Salvador Dali and Max Ernst.[6] Some of his figures, which are much more abstract than various Surrealist forms, are vaguely reminiscent in terms of their contours of the profiles defined by ingenious confluent figures in Dali's paintings. But Rothko follows more closely in the tradition of Max Ernst. Ernst's *Stratified Rocks,* 1920, with its elemental shapes and encompassing fluids, is the type of work that prefigures many of Rothko's biological entities. Ultimately, Rothko's use of the biological metaphor may have a source in his studies at Yale University where he matriculated as a science major, taking courses mainly in biology, math, and physics.[7]

Of all the qualities of Rothko's work, his lighting has occasioned the most discussion. In the forties he placed his ambiguous shapes in an ambient fluid that at first appears penetrable but on closer inspection is restricting and almost claustrophobic. Most of Rothko's paintings depend on the contradictoriness of both light and space. It is highly possible that Rothko's presentation of ambivalent light, which is both dark and glow-

ing, muted and intense, and space, which is both airy and constraining, has a source in his infancy and childhood. The constricting qualities of his work – shallow stages with figures encased in fluids – might stem from the fact of his being bound in swaddling clothes for such a length of time that he remembered it with resentment throughout his life.[8] This feeling of enclosure would certainly engender in him a desire for transcendence as it might well have reinforced the idea that one is forever constrained within one's own body as well as within one's own internal prison, one's mind. Another experience from his childhood that might have had a direct bearing on his concern with light is the glorious sunsets that he remembered in Russia[9] and the equally dazzling ones occurring in Portland, Oregon, where he later moved. While Rothko's special feeling for light may have stemmed from profoundly moving childhood circumstances, it could also have evolved from his intimate knowledge of Milton Avery's art with which his work shares an interest in flat muted forms with diffused edges, or from his own psychic automatist concerns in which he would start with a liquid medium that would naturally lead to the idea of underwater imagery. Also his light could have stemmed from his wife's costume jewelry plant that occupied the same space as his studio in the early forties.[10] Whatever the source or sources may have been for his "cheerful" light, Rothko used it to communicate both ecstasy and tragedy. In view of this, it is of interest to note that Rothko regarded Mozart, his favorite musician, as a tragic artist.[11]

Rothko's assessment of his biomorphic hybrids as the actors in the drama that is his painting indicates a reliance on Nietzsche's theory espoused in his *Birth of Tragedy*. Only in Rothko's work the tragedy takes place on a stage that is the pictorial counterpart of the darkened passages of the mind, the unconscious. His light is both a symbolic and necessary ingredient in his art. By analogy the dim glow of his light serves as the little understood pathways of the mind, those areas approached only by indirection: by Dionysian empathetic intuition, not Apollonian reason. Deliberately vague and shrouded in semidarkness, his art causes the viewer to rely heavily on peripheral vision and thus his own unconscious reactions. Primitive drama, as Nietzsche conceived it, was similar to Rothko's paintings; it was an event with the precise aim of focusing a viewer's attention on himself. The spectator imagined himself a part of the chorus, and according to Nietzsche "the chorus in its primitive form, in proto-tragedy [was] the mirror image in which the Dionysian man contemplates himself."[12] By extension Rothko's paintings with their satyric hybrid choruses and darkened stages are mirrors in which the Dionysus in modern man is reflected.

420 ROBERT CARLETON HOBBS

Notes

1. *Possibilities 1*, eds. Robert Motherwell, Harold Rosenberg, Pierre Chareau, John Cage (New York: Wittenborn, Schultz, 1947), p. 84.

2. Brian O'Doherty, "The Rothko Chapel," *Art in America* 61 (January 1973): 15.

3. Thomas B. Hess, "Editorial: Mark Rothko, 1903–1970," *Art News* 69 (April 1970): 29.

4. Robert Motherwell, conversation with Hobbs, Greenwich, Conn., November 1975.

5. This idea also parallels Baudelaire's statement, "Next to the pleasure of being surprised, there is no greater pleasure than to cause surprise" (taken from Marcel Raymond, *From Baudelaire to Surrealism*, Documents of Modern Art 10, [New York: Wittenborn, Schultz, 1950], p. 214), meaning the most pleasurable aspect of art for the creator is being surprised when he takes his actions on faith while working and reserves judgment for a later time in order to encourage chance to enter and free him from the constraints of reason.

6. Herbert Ferber, conversation with Hobbs, New York, April 1977. Gottlieb also was interested in Dali's early work. Mary R. Davis, "The Pictographs of Adolph Gottlieb: A Synthesis of the Subjective and the Rational," *Arts Magazine* 52 (November 1977): 142, 146.

7. I am indebted to Debbie Gee for this information. I would like to thank Ms. Gee and also Mollie McNickle, students in a seminar I was teaching at Yale University, who met with me regularly in 1975 and 1976 and who always came with searching questions that have helped me enormously in analyzing this period.

8. Motherwell, conversation with Hobbs. Motherwell has recalled that Rothko would speak with rage whenever he repeated the story of his infancy.

9. Ibid.

10. Joseph Liss, "Portrait by Rothko," n.d., typescript in Artist's File, Library of Whitney Museum of American Art, New York.

11. Ferber and Motherwell, conversations with Hobbs.

12. Friedrich Nietzsche, *The Birth of Tragedy* in *The Birth of Tragedy and The Case of Wagner*, trans. by Walter Kaufmann (New York: Vintage Books, 1967), pp. 62–63.

SELECTED BIBLIOGRAPHY

Ackerman, James S. "The Demise of the Avant-garde: Notes on the Sociology of Recent American Art." *Comparative Studies in Society and History,* October 1969.

Albright, Thomas. "A Conversation with Clifford Still." *Art News.* March 1976.

Alloway, Lawrence. "Gorky." *Artforum,* March 1963.

– *William Baziotes.* New York: Guggenheim Museum, 1965.

– *Topics in American Art Since 1945.* New York: Norton, 1975.

– *The Interpretive Link: Abstract Surrealism and Abstract Expressionism 1938–1948.* Newport Beach, Cal.: Newport Harbor Art Museum, 1980.

– *Network: Art and the Complex Present.* Ann Arbor, Mich.: UMI Research Press, 1984.

Arb, Renée. "Spotlight on De Kooning." *Art News,* April 1948.

Arnason, H. Harvard. *Sixty American Painters 1960: Abstract Expressionist Painting in the Fifties.* Minneapolis: Walker Art Center, 1960.

– *American Abstract-Expressionists and Imagists.* New York: Solomon R. Guggenheim Museum, 1961.

– *Philip Guston.* New York: Guggenheim Museum, 1962; Los Angeles: Los Angeles County Museum, 1963.

Arts Club of Chicago. *Exhibition of Ben Shahn, Willem de Kooning, Jackson Pollock.* Chicago: Arts Club, 1951.

Ashton, Dore. *The Unknown Shore: A View of Contemporary Art.* Boston: Little, Brown, 1962.

– *Yes, But. . . .* New York: Viking, 1976.

– *The New York School: A Cultural Reckoning.* New York: Penguin, 1979.

– *Out of the Whirlwind: Three Decades of Arts Commentary.* Ann Arbor, Mich.: UMI Research Press, 1987.

Auping, Michael, ed. *Abstract Expressionism: The Critical Developments.* New York: Abrams, 1987.

Baigell, Matthew. "American Abstract Expressionism and Hard Edge: Some Comparisons." *Studio International* (London), January 1966.

Barker, Virgil. "Seven Americans Open in Venice: Gorky, de Kooning, Pollock." *Art News,* Summer 1950.

– *From Realism to Reality in Recent American Painting.* Lincoln: University of Nebraska, 1959.

Barzun, Jacques. "Artist Against Society: Some Articles of War." *Partisan Review,* January 1952.

Battcock, Gregory. "Willem de Kooning." *Arts Magazine,* November 1967.

Baur, John I. H. *Revolution and Tradition in Modern Art.* Cambridge, Mass.: Harvard University Press, 1951.

– *Bradley Walker Tomlin.* New York: Whitney Museum of American Art, 1957.

– *Nature in Abstraction.* New York: Whitney Museum of American Art, 1958.

Baziotes, William. "I Cannot Evolve Any Concrete Theory." *Possibilities* I, Winter 1947–48.

– "Notes on Painting." *It Is,* Autumn 1959.

423

Berger, John. "The White Cell." *New Statesman*, 22 November 1958.

Berkson, William. "Dialogue with Philip Guston." *Art and Literature*, Winter 1965.

– "The New Gustons." *Art News*, October 1970.

Boswell, Peyton. "Too Many Words." *Art Digest*, 15 February 1950.

Bowness, Alan. "The American Invasion and the British Response." *Studio International (London)*, June 1967.

Braden, Thomas W. "I'm Glad the CIA Is Immoral." *Saturday Evening Post*, 20 May 1967.

Breton, André. "The Eye-Spring: Arshile Gorky." *It Is*, Autumn 1959.

Brooks, James. "Interview." *Scrap*, 20 January 1961.

Brustein, Robert. "The Cult of Unthink." *Horizon*, September 1958.

Burrows, Carlyle. "Early to Modern." *New York Herald Tribune*, 15 January 1950.

– "Gottlieb Abstracts." *New York Herald Tribune*, 11 April 1954.

Butcher, G. M. "Gottlieb and the New York School." *Art News and Review* (London), 9 June 1959.

Butler, J. T. "De Kooning Retrospective." *Connoisseur* (London), January 1970.

Calas, Elena. "The Peggy Guggenheim Collection: Some Reflections." *Arts*, December 1968–January 1969.

Calas, Nicolas. "Subject Matter in the Work of Barnett Newman." *Arts*, November 1967.

– "Venus: De Kooning and the Woman." *Arts*, April 1969.

Canaday, John. *Embattled Critic: Views on Modern Art.* New York: Farrar, Straus & Giroux, 1962.

– *Culture Gulch.* New York: Farrar, Straus & Giroux, 1969.

Cavaliere, Barbara. "An Introduction to the Methods of William Baziotes." *Arts*, April 1977.

– and Robert Hobbs. "Against a Newer Laocoon." *Arts*, April 1977.

Celantano, Francis. "The Origins and Development of Abstract Expressionism in the United States." Unpublished Master's thesis, New York University, 1957.

Chaet, Bernard. "Concept of Space and Expression: An Interview with James Brooks." *Arts*, January 1959.

Chave, Anna. *Mark Rothko's Subjects.* Atlanta, Georgia: High Museum of Art, 1983.

Clark, Kenneth. "The Blot and the Diagram: An Historian's Reflection on Modern Art." *Art News*, December 1962.

Clarke, T. J. "Clement Greenberg's Theory of Art." *Critical Inquiry*, 9 September 1982.

Coates, Robert. "Art." *The New Yorker*, 29 May 1943.

– "Art." *The New Yorker*, 20 November 1943.

– "Art." *The New Yorker*, 17 January 1948.

– "Art." *The New Yorker*, 22 November 1952.

– "Art." *The New Yorker*, 20 February 1954.

Cockcroft, Eva. "Abstract Expressionism, Weapon of the Cold War." *Artforum*, June 1974.

Collier, Oscar. "Mark Rothko." *Iconograph*, Fall 1947.

Colt, Priscilla. "Notes on Ad Reinhardt." *Art International* (Lugano), October 1964.

Cook, Blanch Wieser. *The Declassified Eisenhower.* Garden City, N.Y.:

Doubleday, 1981.

Cox, Annette. *Art-as-Politics: The Abstract Expressionist Avant-garde and* *Society.* Ann Arbor, Mich.: UMI Research Press, 1982.

Crehan, Hubert. "Clyfford Still: Black Angel in Buffalo." *Art News,* December 1959.

Davis, Stuart. "Arshile Gorky in the 1930s: A Personal Recollection." *Magazine of Art,* February 1951.

De Kooning, Elaine. "Jackson Pollock." (Review roundup: Reviews.) *Art News,* December 1949.

– "Hans Hofmann Paints a Picture." *Art News,* February 1950.

– "Gorky: Painter of His Own Legend." *Art News,* January 1951.

– "Inclining to Exultation." *Art Digest,* 1 May 1954.

– "Subject: What, How or Who?" *Art News,* April 1954.

– "Pure Paints a Picture." *Art News,* Summer 1957.

– "Two Americans in Action: Kline and Rothko." *Art News Annual,* 1958.

– "Is There a New Academy?" *Art News,* June 1959.

Devree, Howard. "Adolph Gottlieb." *The New York Times,* 13 February 1944.

– "Of Words and Art." *The New York Times,* 19 July 1953.

Donnell, Radka Zagaroff. "Space in Abstract Expressionism." *Journal of Aesthetics,* Winter 1964.

Doty, Robert, and Diane Waldman. *Adolph Gottlieb.* New York: Praeger/ Whitney Museum of American Art/Solomon R. Guggenheim Museum, 1968.

Egbert, Donald Drew. "The Idea of the Avant-Garde in Art and Politics." *American History Review,* No. 2, 1967.

Eliot, Alexander. *Expressionism in American Painting.* Buffalo, N. Y.: Albright Art Gallery, 1952.

Ferren, John. "Epitaph for an Avant-garde." *Arts,* November 1958.

Finklestein, Louis. "Marin and De Kooning." *Magazine of Art,* October 1950.

– "New York: Abstract Impressionism." *Art News,* March 1956.

Firestone, Evan R. "Color in Abstract Expressionism: Sources and Background for Meaning." *Arts,* March 1981.

Forge, Andrew. "De Kooning in Retrospect." *Art News,* March 1969.

Foster, Stephan C. *The Critics of Abstract Expressionism.* Ann Arbor, Mich.: UMI Research Press, 1981.

Frascina, Francis, ed. *Pollock and After: The Critical Debate.* New York: Harper & Row, 1985.

Fried, Michael. "Jackson Pollock." *Artforum,* September 1965.

Friedman, B. H., ed. *School of New York: Some Younger Artists.* New York: Grove, 1959.

Friedman, Martin. "Private Symbols in Public Statements." *Art News,* May 1963.

Fuller, Peter. "American Painting Since the Last War." *Art Monthly* (London), July–August 1979.

Geldzhaler, Henry. *New York Painting and Sculpture.* New York: Dutton/ Metropolitan Museum of Art, 1969.

Genauer, Emily. "Art and Artists." *New York Herald Tribune,* 6 May 1951.

– "Abstract Painters Exhibit." *New York Herald Tribune,* 13 January 1952.

– "Barnett Newman." *New York Herald Tribune,* 23 April 1966.

Getlein, Frank. "The Same Old Schmeerkunst." *The New Republic,* 26 February 1959.

– "Franz Kline: Retrospective Memorial Exhibition," *Burlington Magazine*, December 1962.

Gibson, Ann. "Regression and Color in Abstract Expressionism: Barnett Newman, Mark Rothko, and Clyfford Still." *Arts*, March 1981.

Goldin, Amy. "Harold Rosenberg's Magic Circle." *Arts*, November 1965.

Goldwater, Robert. "Willem de Kooning." *Magazine of Art*, February 1948.

– "A Symposium: The State of American Art." *Magazine of Art*, March 1949.

– "Reflections on the Rothko Exhibit." *Arts*, March 1961.

– "Art and Criticism." *Partisan Review*, May–June 1961.

– "Franz Kline: Darkness Visible." *Art News*, March 1967.

Goodnough, Robert. "Pollock Paints a Picture." *Art News*, May 1951.

– "Kline Paints a Picture." *Art News*, December 1952.

Goodrich, Lloyd. "Notes on Eight Works by Arshile Gorky." *Magazine of Art*, February 1951.

Goossen, Eugene C. "The Big Canvas." *Art International* (Lugano), November 1958.

– "Robert Motherwell and the Seriousness of Subject." *Art International* (Lugano), Nos. 1 & 2, 1959.

– "Painting as Confrontation: Clyfford Still." *Art International* (Lugano), No. 1, 1960.

– "Rothko: The Omnibus Image." *Art News*, January 1961.

Gordon, John. *Franz Kline 1910–1962*. New York: Whitney Museum of American Art, 1968.

Gottlieb, Adolph. "Letter to the Art Editor." *The New York Times*, 22 July 1945.

– "The Artist and the Public." *Art in America*, December 1954.

– "Artist and Society: A Brief Case History." *College Art Journal*, Winter 1955.

Gowans, Alan. "A-humanism, Primitivism, and the Art of the Future." *College Art Journal*, Winter 1952.

Gray, Francine du Plessix, and Cleve Gray. "Who Was Jackson Pollock?" *Art in America*, May–June 1967.

Greenberg, Clement. "Art: Reviews." *The Nation*, 7 April, 1945.

– "Most Important Art Teacher of Our Time." *The Nation*, 21 April 1945.

– "The Present Prospects of American Painting and Sculpture." *Horizon*, Nos. 93–94, 1947.

– *De Kooning Retrospective*. Boston: Boston Museum School, 1953.

– "Abstraction and Representational." *Art Digest*, November 1954.

– *An Exhibition of Oil Paintings by Adolph Gottlieb*. New York: Jewish Museum, 1957.

– *Barnett Newman: First Retrospective Exhibition*. Bennington, Vt.: Bennington College, 1958.

– "Hans Hofmann: Grand Old Rebel," *Art News*, January 1959.

– *Art and Culture: Critical Essays*. Boston: Beacon Press, 1961.

– "How Art Writing Earns Its Bad Name." *Encounter*, December 1962.

– "The 'Crisis' of Abstract Art." *Arts Yearbook*, 1964.

– "America Takes the Lead, 1945–1965." *Art in America*, August 1965.

Greene, Balcomb. "The Artist's Reluctance to Communicate." *Art News*, January 1957.

Guilbaut, Serge. "The New Adventures of the Avant-Garde in America." *October*, Winter 1980.

– *How New York Stole the Art World from Paris*. Chicago: University of Chicago, 1983.

Guston, Philip. "Faith, Hope, and Possibility." *Art News Annual*, October 1965.

Hadler, Mona. "The Art of William Baziotes." Ph.D. dissertation, Columbia University, 1977.

Hamilton, Robert B. "Painting in Contemporary America." *Burlington Magazine* (London), May 1960.

Hare, David, and Thomas B. Hess. "William Baziotes, 1912–1963." *Location*, Summer 1964.

Hauptman, William. "The Suppression of Art in the McCarthy Decade." *Artforum*, October 1973.

Henning, Edward B. *Fifty Years of Modern Art, 1906–1966*. Cleveland: Cleveland Museum of Art, 1966.

Herbert, James D. "The Political Origins of Abstract Expressionist Criticism." *Telos*, Winter 1984–85.

Heron, Patrick. "Americans at the Tate Gallery: Abstract Expressionism the Most Provocative." *Arts*, 1956.

– "A Kind of Cultural Imperialism." *Studio International* (London), February 1968.

– "Barnett Newman." *Studio International* (London), September 1970.

Hess, Thomas B. *Abstract Painting: Background and American Phase*. New York: Viking, 1951.

– "Is Abstraction Un-American?" *Art News*, February 1951.

– "De Kooning Paints a Picture." *Art News*, March 1953.

– "Reinhardt: The Position and Perils of Purity." *Art News*, December 1953.

– *Willem de Kooning*. New York: Museum of Modern Art, 1954.

– "The Phony Crisis in Amercan Art." *Art News*, Summer 1963.

– *Barnett Newman*. New York: Museum of Modern Art, 1971.

Hodin, Josef P. "The Fallacy of Action Painting." *Art News and Review* (London), 20 December 1958.

Hofmann, Hans. "Statement." *Search for the Real and Other Essays*. Andover, Mass.: Addison Gallery of American Art, Phillips Academy, 1948.

– "Hofmann Explains His Paintings." *Bennington College Alumnae Quarterly*, Fall 1955.

Hopkins, Henry T., ed. *Philip Guston*. New York: Braziller/San Francisco Museum of Modern Art, 1980.

Hudson, Andrew. "The Case for Exporting Nation's Avant-garde Art." *Washington Post*, 27 March 1966.

– "Scale as Content." *Artforum*, December 1967.

Hunter, Sam. *Modern American Painting and Sculpture*. New York: Dell, 1959.

– *James Brooks*. New York: Whitney Museum of American Art, 1963.

– "Abstract Expressionism – Then and Now." *Canadian Art*, September–October 1964.

– *Hans Hofmann*. New York: Abrams, 1964.

Janis, Harriet, and Rudi Blesh. *De Kooning*. New York: Grove, 1960.

Janis, Sidney. *Abstract and Surrealist Art in America*. New York: Reynal & Hitchcock, 1944.

Janson, H. W. "Philip Guston." *Magazine of Art*, February 1957.

Jarrell, Randall. "The Age of the Chimpanzee." *Art News*, Summer 1957.

Jewell, Edward Alden. "In the Realm of Art: A New Platform, 'Globalism' Pops into View." *The New York Times*, 13 June, 1943.

Jordan, Jim, and Robert Goldwater. *The Paintings of Arshile Gorky: A Critical Catalogue*. New York: New York University, 1982.

Judd, Donald. "Adolph Gottlieb." (In the Galleries). *Arts*, December 1960.
– "Jackson Pollock." *Arts*, April 1967.
– "Barnett Newman." *Studio International* (London), February 1970.
Kaprow, Allan. "The Legacy of Jackson Pollock." *Art News*, October 1958.
Kavolis, Vytautus. "Abstract Expressionism and Puritanism." *Journal of Aesthetics and Art Criticism*, Spring 1963.
Kingsley, April. "Adolph Gottlieb in the Fifties: Different Times Require Different Images." *Arts*, September 1985.
Kline, Franz. "Is Today's Artist with or against the Past?" *Art News*, September 1958.
Kozloff, Max. "Matta: An Interview." *Artforum*, September 1965.
– *Renderings: Critical Essays on a Century of Modern Art*. New York: Simon & Schuster, 1969.
– "American Painting During the Cold War." *Artforum*, May 1973.
– *Twenty-five Years of American Painting, 1948–1973*. Des Moines: Des Moines Art Center, 1973.
Kramer, Hilton. *The Age of the Avant-garde: An Art Chronicle 1956–1972*. New York: Farrar, Straus & Giroux, 1973.
Krasne, Belle. "The Bar Vertical on Fields Horizontal." *Art Digest*, 1 May 1951.
Krauss, Rosalind E. "Gottlieb." *Artforum*, May 1966.
– "The New de Koonings." *Artforum*, January 1968.
– "Robert Motherwell's New Paintings." *Artforum*, May 1969.
– "Contra Carmean: The Abstract Pollock." *Art in America*, Summer 1982.
Kuh, Katherine. *The Artist's Voice*. New York: Harper & Row, 1962.
Kuspit, Donald. "Meyer Schapiro's Marxism." *Arts*, November 1978.
– *Clement Greenberg: Art Critic*. Madison, Wis.: University of Wisconsin Press, 1979.
– *The Critic Is Artist: The Intentionality of Art*. Ann Arbor, Mich.: UMI Research Press, 1984.
Lader, Melvin P. "David Porter's Personal Statement: A Painting Prophecy." Archives of American Art *Journal*, Vol. 28, No. 1, 1988.
Langsner, Jules. "More About the School of New York." *Arts & Architecture*, May 1951.
Lasch, Christopher. "The Cultural Cold War." *The Nation*, 11 September 1967.
Leider, Philip. "The New York School in Los Angeles." *Artforum*, September 1965.
Levin, Gail. "Miró, Kandinsky, and the Genesis of Abstract Expressionism," in Robert Carleton Hobbs and Gail Levin, *Abstract Expressionism: The Formative Years*. New York: The Whitney Museum of American Art/Ithaca: Johnson Museum, Cornell University, 1978.
Levine, Neil. "The New York School Question." *Art News*, September 1965.
Lippard, Lucy. "Three Generations of Women: De Kooning's First Retrospective." *Art International* (Lugano), 20 November 1965.
– *Changing*. New York: Dutton, 1971.
– *Ad Reinhardt*. New York: Abrams, 1981.
Longren, Lillian. "Abstract Expressionism in America." *Art International* (Lugano), April 1958.
Loucheim, Aline B. "Betty Parsons: Her Gallery, Her Influence." *Vogue*, October 1951.

Lucie-Smith, Edward. "An Interview with Clement Greenberg." *Studio International*, January 1968.

Lyotard, J. F. "Sublime and the Avant-Garde." *Artforum*, April 1984.

MacAgy, Douglas. "Mark Rothko." *Magazine of Art*, January 1949.

McBride, Henry. "Review: Jackson Pollock." *New York Sun*, 29 December 1949.

– "Abstract Report for April." *Art News*, April 1953.

McChesney, Mary Fuller. *A Period of Exploration: San Francisco 1945–1950*. Oakland, Cal.: Oakland Museum, 1973.

MacLeish, Archibald. *Imaginary Landscapes and Seascapes*. New York: Kootz Gallery, 1953.

MacNaughton, Mary Davis. "The Paintings of Adolph Gottlieb, 1923–1974." Ph.D. dissertation, Columbia University, 1981.

Mark Tobey: Retrospective Exhibition. New York: Whitney Museum of American Art, 1951.

Matter, Mercedes. "Hans Hofmann." *Arts & Architecture*. May 1946.

Matthews, Jane. "Art and Politics in Cold War America." *American Historical Review*, October 1976.

Mellow, James R. "On Art: A Passion for Destruction." *The New Leader*, 31 March 1969.

Menkert, Jörn. *Willem de Kooning: Drawings, Paintings, Sculpture*. New York: Whitney Museum of American Art, 1984.

Miller, Dorothy, ed. *Twelve Americans*. New York: Museum of Modern Art, 1956.

Mitchell, W. J. T., ed. *The Politics of Interpretation*. Chicago: University of Chicago, 1983.

Motherwell, Robert. "The Modern Painter's World." *Dyn*, November 1944.

– "Painter's Objects." *Partisan Review*, Winter 1944.

– *The School of New York*. Beverly Hills, Cal.: Perls Gallery, 1951.

– "The Painter and the Audience." *Perspectives USA*, Autumn, 1954.

Motherwell, Robert, and Ad Reinhardt, eds. *Modern Artists in America*. New York: Wittenborn, Schultz, 1951.

Newman, Barnett. "The First Man Was an Artist." *Tiger's Eye*, October 1947.

– *On My Art*. New York: Betty Parsons Gallery, 1950.

– "For Impassioned Criticism." *Art News*, Summer 1968.

O'Brian, John, ed. *Clement Greenberg: The Collected Essays and Criticism*. 2 vols. Chicago: University of Chicago, 1986.

O'Connor, Francis. *Jackson Pollock*. New York: Museum of Modern Art, 1967.

O'Connor, Francis, and Eugene Thaw, eds. *Jackson Pollock: A Catalogue Raisonné of Paintings, Drawings and Other Works*. 4 vols. New Haven: Yale University, 1978.

O'Doherty, Brian. *Objects and Ideas: An Art Critic's Journal*. New York: Simon & Schuster, 1967.

O'Hara, Frank. *Jackson Pollock*. New York: Braziller, 1959.

– *Robert Motherwell*. New York: Museum of Modern Art, 1965.

O'Neill, John P., ed. *Clyfford Still*. New York: Metropolitan Museum of Art, 1979.

Orton, Fred, and Griselda Pollock. "*Avant-gardes* and Partisans Reviewed." *Art History*, September 1981.

"Our Country and Its Culture: A Symposium." *Partisan Review*, May–June 1952.

Paalen, Wolfgang. *Form and Sense*. New York: Wittenborn, 1959.

Pavia, Phillip, and Irving Sandler, eds. "The Philadelphia Panel." *It Is*, Spring 1960.

Poggioli, Renato. *The Theory of the Avant-Garde*. Cambridge: Harvard University, 1968.

Pohl, Francis K. "An American in Venice: Ben Shahn and United States Foreign Policy at the 1954 Venice Biennale." *Art History*, March 1981.

Polcari, Stephen. "The Intellectual Roots of Abstract Expressionism: Mark Rothko." *Arts*, September 1979.

Pollock, Jackson. "Letter to the Editor." *Time*, 11 December 1950.

Pomeroy, Ralph. *Stamos*. New York: Abrams, 1974.

Ponente, Nello. *Modern Painting: Contemporary Trends*. Lausanne: Skira, 1960.

Poor, Henry Varnum. "Painting Is Being Talked to Death." *Reality*, Spring 1953.

Porter, Fairfield. "Review: Pollock." *Art News*, December 1951.

— "Adolph Gottlieb." *Art News*, January 1952.

— "Class Content in American Abstract Painting." *Art News*, April 1962.

Porter, Robert Fulton. "A Critique of Criticism: The Mature Paintings of Mark Rothko." Ph.D. dissertation, University of North Carolina, 1974.

Preston, Stuart. "Brooks Retrospective at the Whitney Museum." *Burlington Magazine* (London), March 1963.

Rand, Harry. *Arshile Gorky, the Implications and Symbols*. Montclair, N.J.: Allenheld & Schram; London: George Prior, 1981.

Rasmussen, Waldo. *Two Decades of American Painting*. New York: Museum of Modern Art, 1966.

Raynor, Vivien. "Guston." *Arts*, September 1962.

Read, Herbert. "An Art of Internal Necessity." *Quadrum* (Brussels), No. 1, 1956.

— "Social Significance in Abstract Art." *Quadrum* (Brussels), No. 9, 1960.

Reiff, Robert. *A Stylistic Analysis of Arshile Gorkey's Art from 1943–1948*. New York: Garland, 1977.

Reinhardt, Ad. "The Artist in Search of an Academy." *College Art Journal*, Spring 1953.

— "Who Are the Artists?" *College Art Journal*, Summer 1954.

— "The Art–Politics Syndrome: A Project in Integration." *Art News*, November 1956.

— "Twelve Rules for a New Academy." *Art News*, May 1957.

— "Art-as-Art." *Art International* (Lugano), December 1962.

— "The Next Revolution in Art: Art-as-Dogma." *Art International* (Lugano), March 1964.

Reise, Barbara M. "Greenberg and the Group." *Studio International* (London), May and June 1968.

— "The Stance of Barnett Newman." *Studio International* (London), February 1970.

Robbins, Daniel, and Eugenia Robbins. "Franz Kline: Rough Impulsive Gesture." *Studio* (London), May 1964.

Robertson, Bryan. *Jackson Pollock*. New York: Abrams, 1960.

Rodman, Selden. *Conversations with Artists*. New York: Devin-Adair, 1957.

Romanow, A. "Mister Barr's Abstract Souvenir." *Art News*, January 1962.

Rose, Barbara. *American Art Since 1900: A Critical History*. New York: Praeger, 1967.

- ed. *Art as Art: The Selected Writings of Ad Reinhardt.* New York: Viking, 1975.
- "Hans Namuth's Photographs and the Jackson Pollock Myth: Media Impact and the Failure of Criticism." *Arts,* March, 1979.
Rose, Berenice. *Jackson Pollock: Works on Paper.* New York: Museum of Modern Art, 1969.
Rosenberg, Bernard, and Norris Fliegel. *The Vanguard Artist: Portrait and Self-Portrait.* Chicago: Quadrangle, 1965.
Rosenberg, Harold. "After Next, What?" *Art in America,* April 1964.
- *The Anxious Object: Art Today and Its Audience.* New York: Horizon, 1966.
- *Arshile Gorky: The Man, The Time, The Idea.* New York: Horizon, 1966.
- *Art Works and Packages.* New York: Dell, 1971.
- *The De-Definition of Art.* New York: Horizon, 1972.
- *Discovering the Present.* University of Chicago, 1973.
- *De Kooning.* New York: Abrams, 1974.
- *Art on the Edge: Creators and Situations.* New York: Macmillian, 1975.
- *Barnett Newman.* New York: Braziller, 1978.
- *The Case of the Baffled Radical.* Chicago: University of Chicago Press, 1985.
- *Art and Other Serious Matters.* Chicago: University of Chicago Press, 1985.
Rosenblum, Robert. "The Abstract Sublime." *Art News,* February 1961.
- "The Fatal Women of Picasso and De Kooning." *Art News,* October 1985.
Rothko, Mark. "Introduction to the Clyfford Still Exhibition." New York: Art of This Century Gallery, 1946.
Rothko, Mark, et al. "The Ides of Art: The Attitudes of Ten Artists on Their Art and Contemporaneousness." *Tiger's Eye,* December 1947.
Rubin, William. "The New York School: Then and Now." *Art International* (Lugano), March-April and May–June 1958.
- *Jackson Pollock and the Modern Tradition.* New York: Abrams, 1967.
Russell, John. "The New American Painting Captures Europe." *Horizon* (London), November 1959.
Sandler, Irving. "Robert Motherwell." *Art International* (Lugano), 1961.
- "James Brooks and the Abstract Inscape." *Art News,* February 1963.
- "Baziotes: Modern Mythologist." *Art News,* February 1965.
- "Clyfford Still: Emerging from the Eclipse." *The New York Times,* 21 December 1969.
- *The Triumph of American Painting.* New York: Harper & Row (Icon), 1975.
- ed. "Discussion: Is There a New Academy?" *Art News,* Summer and September 1959.
Sandler, Irving, and Amy Newman, eds. *Defining Modern Art: Selected Writings of Alfred H. Barr, Jr.* New York: Abrams, 1986.
Schapiro, Meyer. "The Younger American Painters of Today." *The Listener* (London), 26 January 1956.
- "The Liberating Quality of Avant-Garde Art." *Art News,* Summer 1957.
Schjeldahl, Peter. "Barnett Newman: Aspiration Toward the Sublime." *The New York Times,* 6 September 1970.
Schulze, Franz. *Fantastic Images: Chicago Art Since 1945.* Chicago: Follet, 1972.
Schwabacher, Ethel. *Arshile Gorky Memorial Exhibition.* New York: Whitney Museum of American Art, 1957.
Seckler, Dorothy. "Artist in America: Victim of the Culture Boom?" *Art in America,* December 1963.

— "Interview: James Brooks Talks with Dorothy Seckler." *Archives of American Art Journal*, Vol. 16, No. 1, 1979.

Seitz, William. *Mark Tobey*. New York: Museum of Modern Art, 1962.

— *Arshile Gorky*. New York: Museum of Modern Art, 1962.

— "The Rise and Dissolution of the Avant-garde." *Vogue*, September 1963.

— *Hans Hofmann*. New York: Museum of Modern Art, 1963.

— *Abstract Expressionist Painting in America*. Washington, D. C.: National Gallery of Art and Harvard University, 1983.

Selz, Peter. *Mark Rothko*. New York: Museum of Modern Art, 1961.

Sharpless, Ti-Grace. *Clyfford Still: Thirty-three Paintings in the Albright-Knox Art Gallery*. Buffalo: Albright-Knox Art Gallery, 1966.

Siegel, Jeanne. "Adolph Gottlieb at 70: I Would Like to Get Rid of the Idea That Art Is for Everybody." *Art News*, December 1973.

Sivard, Susan. "The State Department 'Advancing Modern Art' Exhibition of 1946 and the Advance of American Art." *Arts Magazine*, April 1984.

Sloane, J. C. "On the Resources of Non-objective Art." *Journal of Aesthetics and Art Criticism*, Summer 1961.

Solomon, Alan. *The New Art Scene*. New York: Holt, Rinehart & Winston, 1967.

Spaeth, Eloise. "America's Cultural Responsibilities Abroad." *College Art Journal*, Winter 1951–52.

Steinberg, Leo. "De Kooning's Woman." *Arts Magazine*, November 1955.

— "Month in Review . . . : Fifteen Years of Jackson Pollock." *Arts*, December 1955.

— *Other Criteria: Confrontations with Twentieth-Century Art*. New York: Oxford University Press, 1972.

Still, Clyfford. *Paintings by Clyfford Still*. Buffalo: Albright-Knox Art Gallery, 1959.

— "An Open Letter to an Art Critic." *Artforum*, December 1963.

Sutton, Denys. "The Challenge of American Art." *Horizon* (London), October 1949.

Sweeney, James Johnson. "Recent Trends in American Painting." Bennington College *Alumnae Quarterly*, Fall 1955.

Sylvester, David. "Painting as Existence: An Interview with Robert Motherwell." *Metro* (Milan), No. 7, 1962.

— *Modern Art: From Fauvism to Abstract Expressionism*. New York: Watts, 1965.

Tillim, Sidney. "Jackson Pollock: A Critical Evaluation." *College Art Journal*, Spring 1957.

Townsend, J. Benjamin. "An Interview with Clyfford Still." *Gallery Notes*, No. 2, 1961. Buffalo: Albright-Knox Art Gallery.

Tuchman, Maurice. *The New York School: The First Generation: Paintings of the 1940s and 1950s*. Los Angeles: Los Angeles County Museum, 1965.

Tyler, Parker. "Nature and Madness Among Younger Painters." *View*, May 1945.

Wagner, Geoffrey. "The New American Painting." *Antioch Review*, March–June 1954.

Waldman, Diane. *De Kooning in East Hampton*. New York: Solomon R. Guggenheim Museum, 1978.

— *Mark Rothko: A Retrospective*. New York: Abrams and Solomon R. Guggenheim Foundation, 1978.

Ward, James. "The Function of Science as Myth in the Evolution of Mark Rothko's Abstract Style." Ph.D. dissertation, Institute of Fine Arts, New York University, 1979.

Wechsler, Jeffrey. *Surrealism and American Art, 1931–1937*. Exhibition catalogue, New Brunswich; Rutgers University Art Gallery, 1977.

Wind, Edgar. *Art and Anarchy*. London: Faber & Faber, 1963.

Yard, Sally. "Willem de Kooning's Women." *Arts*, November 1978.

Young, Mahonri Sharp. "The Metropolitan Museum of Art Centenary Exhibition I: The New York School." *Apollo* (London), November 1969.

abstract art: as academic, 87; conventions of, 185–6; historical justification for, 73–4; post-painterly, 169, 180; School of Paris, 1, 52, 127, 129, 135 (roots in, 72–3, 76; source of modernism, 76)

"Abstract Expressionism, Weapon of the Cold War" (Cockcroft), 175, 193

Abstract Expressionist(s), 2, 3, 8, 9, 28, 50, 52, 54, 77, 89, 91, 99, 109, 113, 116, 117, 135, 150, 152, 157, 162, 163, 166, 170, 171, 172, 176, 178, 183, 197, 198, 200–6, 238, 247, 279, 316, 333, 383, 419; common assumptions of, 267; critical history of, 141–50; European critics' reactions to, 102–6; Existential aesthetic, 140, 153–4; as Existential hero, 133; in federal programs, 14–15, 38, 48, 79, 127, 128, 129, 171, 172, 310; Freud and, 199; history of, 5–25, 96–100, 127–31, 169–81; as History Painters, 166; influences on, 2, 45, 46, 127–35, 141–50, 198–205; John Graham, assistance of, 372; motives, 123; as Myth Makers, 161; mythology of, 10, 131, 159, 267–8; new interpretations of, 29–30; private myths, 80, 130; resistance to interpretation, 195–6; and Russian Formalism, 198, 202–5; as school, 127; School of Paris and, 1, 130; societal attitudes of, 155; subject matter of, 4, 65–6, 134; supportive critics, 51

Abstract Painting: Background and American Phase (Hess), 148

Abstraction-Création, 99

Action Painting, 1, 25, 97, 109, 113, 117, 133, 142, 143; art as action, 76–80; Freudian edge and, 142;

Kline as action painter, 291, 316

"Against Interpretation" (Sontag), 383–90

Albers, Josef, 291, 404, 412

Albert Gallatin Collection of Living Art, 6

Alloway, Lawrence, 150; new definitions for art, 25

American Abstract Artists (AAA), 12, 48, 99, 130

"American Action Painters" (Rosenberg), 19, 204

"American Art Today, 1950" (Metropolitan Museum of Art), 52

American Artists Congress, 16, 79

American Federation of Art, 21

American scene painting, 1, 12, 18, 134

American violence, expression in art of, 45

Arp, Hans, 49, 72–3, 99

art: as academic, 115; as action, 76–80; avant-garde, 16–18, 66–70; as commodity, 82; communication in, 3, 121, 195–6, 205; crisis in, 144, 169, 244; function of order, 111–12; moral bases of, 165; private myths, and, 80; as reflection of society, 182; as regression, 140; speculation in, 175

Art Digest, 89, 91, 92

Art News, 19, 21, 22, 54, 55, 89, 92, 94, 125, 238, 249

Art Nouveau, 90

Art of this Century (gallery), 51, 99, 126, 130, 167n, 203, 401

artist: as commodity, 82; isolated, 142; marginal, 128

artists, black, 155

Artists Union, 46

automatism, 38, 40, 44, 45, 96–7, 145, 150, 197–8, 376

"Avant-garde and Kitsch" (Greenberg), 16–19

Avery, Milton, 414, 420

Barnes, Dr. Albert, 149
Barr, Alfred Jr., 108, 123, 175, 178, 196; *Cubism and Abstract Art*, 26n; European reviews quoted by, 102–8; *see also* McCray, Porter
Baur, John I. H.: "Nature in Abstraction," 279
Baziotes, William, 37, 38, 39, 44, 45, 49, 53, 98, 106, 213, 412; on communication, 141, 196; and Gottlieb, parallels with, 264; statement quoted, 96
Beardsley, Monroe C. ("Intentional Fallacy"), 201
Bell, Clive, 197, 403
Bennington College, 332, 334
Benton, Thomas Hart, 42, 129, 172, 191, 192, 265, 318, 364; rejected, 11; standards, 265
Berger, Arthur, 34
Berger, John, 172, 185
Bernini, 244
Betty Parsons (gallery), 51, 99, 130, 164, 330, 332
Bewley, Marius, 196
Bischoff, Elmer, 199
Bishop, Isabel, 125n
Blok (Warsaw), 203
Bloom, Hyman, 98
Bohemia, 142; as sanctuary, 65
Boime, Albert, "Franz Kline: The Early Works as Signals," 319
Bonnard, Pierre, 76
Bontecou, Lee, 406
Boston Museum of Contemporary Art, 52
Bourgeois, Louise (Mrs. Robert Goldwater), 196, 202
Braden, Thomas W., 175
Braque, Georges, 1, 7, 42, 264, 265, 305, 372
Breton, André, 99, 197; Freudian and Marxian sanctions, 97; "Manifesto," 15–16, "Surrealism in the Service of the Revolution," 15
Brooks, Cleanth, *The Well-Wrought Urn*, 200, 202, 203
Brooks, James, 100, 106, 124, 213; statement quoted, 95
Browne, Byron, 12

Brussels Fair, 105, 110
Brustein, Robert, 140
Burchfield, Charles, 13
Burke, Edmund, 162–3, 325
Burliuk, David, 203
Burrows, Carlyle, 22
Busa, Peter, 37, 38, 39

Cage, John, 49, 54
Cahiers d'art (Paris), 129
Calas, Nicholas, 49, 54
California School of Fine Arts, 199
Callery, Mary, 43
Canaday, John, 22, 23, 122–3, 344–5; letter opposing, 122–3 (signers, 123–5; supporters, 125n)
Castelli, Leo, 57
Castelli (gallery), 178
Cedar Bar, 47, 203, 374; as Cedar Street Tavern, 56, 130
Cézanne, Paul, 7, 21, 76, 129, 132, 244, 254, 307, 333
Chagall, Marc, 7
Clark, Kenneth, 140
Clark, T. J., 197
"Club, The," 47, 48–57, 130, 295, 373–4; charter members, 49–50; founders, 49; misunderstood, 373; 9th Street Show, 57; proceedings, 46–7; programs and speakers, 52–4
Cobra movement, 171
Cockcroft, Eva: "Abstract Expressionism, Weapon of the Cold War," 174–5, 193
Cold War, 15, 174
Colin, Paul, 202
Columbia University, 34
Commentary, 21
Communist Party, 15, 16, 189
Conceptualism, 169
Constructivism, 222
Cornell, Joseph, 42, 49
Corot, Jean-Baptiste-Camille, 64, 292
Courbet, Gustave, 66, 67, 120, 312
Craven, Thomas, 11
Croce, Benedetto, 145
Cubism, 72, 79, 137, 139, 145, 146, 147, 192, 224, 233, 243, 256, 301, 370, 380
Cubism, "synthetic," 147

Cubism and Abstract Art (Barr), 26n
Cubist(s), 137, 139, 146, 148, 173, 226, 229, 266, 327
Curry, John Steuart, 11, 129
Curt Valentin (gallery), 39

Dada, 99, 114, 137, 145, 170, 178, 327
Dali, Salvador, 7, 34, 197, 419
Daumier, Honoré, 64
David McKee (gallery), 319
Davis, Stuart, 98, 110, 124, 372; de Kooning, influence on, 241
de Chirico, 7
de Kooning, Elaine (Mrs. Willem de Kooning), 53, 112, 291
de Kooning, Willem, 4, 5, 46, 57, 109, 135, 144, 145, 148, 149, 204–5, 293, 295, 305, 316, 320–1, 376; as abstract painter, 229–30; black-and-white paintings of, 234; chronology, 215–27; collage, 227–8; color, 251–2; on crisis, 144; on Cubism, 224, 233, 243–4; early articles on, 21; on feeling American, 225; landscapes, 255; late paintings, 254–6; meaning, 240, 249; MOMA symposium and, 21; on Mondrian, 246; on Newman, 244–5; on photo-realism, 248; on Pollock, 372–4; retrospective of, 238–40; on Rubens, 240–2; Sartre in relation to, 231; space in, 232–3; Springs (L.I.), living in, 249–50; statement quoted, 95; unity, 239; "Women" series, 225–7, 234–5, 236, 239, 249; works cited, 173, 225–8, 233, 234, 235, 239, 244, 250, 252, 255
De Stijl (Holland), 7
Dehner, Dorothy (Mrs. David Smith), 203
Delacroix, Eugene, 33, 64, 86, 120, 307
Devree, Howard, 22
Di Suvero, Mark, 317
Dialectics of Art (Graham), 372; *see also* Graham, John, *System and Dialectics of Art*
Dove, Arthur, 13, 99
Dubuffet, Jean, 91

Duchamp, Marcel, 99, 114, 129, 224
Dufy, Raoul, 7

Egan, Charles, 59, 99
Egan (gallery), 51, 99, 130, 229, 291, 299, 305
Eliot, T. S., 197, 199
emigré artists in New York, 7–8, 128–9
Empson, William, 201
Encounter (London), 20, 382
Ernst, Max, 7, 39, 41, 42, 93, 97, 99, 129, 419
European critics quoted, 102–8
Evergood, Philip, 11, 87
Existentialism, 4, 96, 153–4, 198, 203–5, 294, 383
Expressionism, 139, 145, 256; German, 97, 106
Expressionist, 139

Fauves, 137
Fauvism, 106, 146
Federal Art Project, 48, 127, 128, 129, 171, 172; Abstract Expressionists on, 14; Public Works of Art Project (PWAP), 13–14; Treasury Art Project (TRAP), 14; Works Progress Administration (WPA), 38, 79, 127, 129, 310
Federation of Modern Painters and Sculptors, 8, 16
Ferber, Herbert, 49, 100, 157, 200
Ferren, John, 29n, 51, 53, 54, 57, 89
field painting, 192, 276–7, 281–6, 287n
Fiene, Ernest, 12
Fine, Perle, 53, 247
Fitzsimmons, James, 54, 89, 91, 93
Formalism, Russian, 198, 203, 205
Fortune, 175
Fragonard, Jean-Honoré, 239
Francis, Sam, 100, 103, 106, 109
Frankenthaler, Helen, 153, 180, 406
French Salon, 120
Freud, Sigmund, 199, 268, 377
Fried, Michael, 386
Fry, Roger, 197, 403
Fuller, Peter, 182–7, 188, 193
Futurists, Russian, 203

Gabo, Naum, 93
galleries: Art of this Century, 51, 99,
126, 130, 167n, 203, 401; Betty
Parsons, 51, 99, 130, 159, 164,
330, 332; Castelli, 178; Curt
Valentin, 39; David McKee, 319;
Egan, 51, 99, 130, 229, 291, 299,
305; Howard Putzel, 51; Julien
Levy, 37, 99, 130; McMillen, 372,
373; Marlborough-Gerson, 316;
Marlborough New London
(England), 406; Nierendorf, 271;
Peridot, 130; Pierre Matisse, 39,
204; Samuel Kootz, 51, 54, 59,
Stable, 130; subsidies, 44; Tenth
Street, 130; Whitechapel (London),
406
Gaugh, Harry F., "Franz Kline: The
Color Abstractions," 319–20
Gauguin, Paul, 121, 132, 191
Geldzahler, Henry, 152–5; *New York
Painting and Sculpture: 1940–
1970*, 152
Genauer, Emily, 22, 344–5
Géricault, 64
Getlein, Frank, 64, 140
Giocometti, Alberto, 91–2, 94, 203,
232
Glarner, Fritz, 49
Glasco, Joseph, 92
Godamer, Hans-George, 382, 389–91
Goldwater, Robert, 20, 31, 51, 52, 53,
55–6, 92
Gombrich, Ernst, 140
Goodnough, Robert, 49, 301
Goossen, E. C., 160
Gorky, Arshile, 21, 40, 43, 99, 106,
126, 131, 141–2, 171, 173, 177,
178, 190, 213, 229–30, 241, 250,
293, 372, 379, 380, 413, 414;
influence on de Kooning, 40;
suicide, 173; underground
reputation, 44
Gottlieb, Adolph, 4, 5, 8, 10, 139, 141,
148, 160, 195, 229, 291; and
Baziotes, 264; chronology, 257–9;
color, 278–80, 283–6; color field,
276–7, 281–6; desperation of,
266–7; "Imaginary Landscapes,"
272, 274, 284; MOMA
symposium, 21; on myth and

symbol, 159, 199, 267–8, 278; and
Picasso, 274; pictographs, 199,
261–2, 271, 273, 276, 277–9; and
Rothko, 267, 277, 413, 417; scale,
279, 282; standards, 9, 25, 265–7;
subject matter, 3, 99, 267, 276;
Surrealism, 272; and Tomlin, 274;
works cited, 271, 272, 274, 276,
278–86
Graham, John, 40; aid to Abstract
Expressionists, 372; influence on de
Kooning, 241; Russian Formalism,
link to, 203; *System and Dialectics
of Art*, 8, 372
Graves, Morris, 98
Gray, Cleve, 125n
Greenberg, Clement, 26, 51, 99, 111,
159–60, 178, 190, 197, 205, 276;
"Avant-garde and Kitsch," 16–19;
and Cold War, 15; "Cubist
trauma," 146–7; emotion in art,
147; flatness, 179–81; "How Art
Writing Earns Its Bad Name,"
382–3; metaphysical content, 148;
MOMA symposium, 21; on New
York School, 146; on subject
matter, 65–6, 178, 200–1; as
tastemaker, 177; theory, 141–50
Greene, Balcomb, 12
Gropper, William, 11
Guggenheim, Peggy, 39, 41, 42, 44,
45, 49, 51, 99, 364; *see also* Art of
This Century (gallery)
Guggenheim, Solomon R., Museum,
see Solomon R. Guggenheim
Museum
Guilbaut, Serge, 197
Guston, Philip, 5, 53, 100, 106, 213,
316, 404; statement quoted, 96

Hare, David, 100
Hartigan, Grace, 53, 100, 101, 103,
106
Hartley, Marsden, 7
Harvard University, 33
Hess, Thomas, 51, 94, 144, 244, 382,
418; *Abstract Painting:
Background and American Phase*,
148; Newman derided by, 22, 329;
Newman retrospective, 347–50;
theory, 141, 148–9; *Willem de*

Hess, Thomas (*cont.*)
 Kooning, 149, 238–40
Hofer, Karl, 40
Hofmann, Hans, 7, 99, 100, 110, 111,
 133, 136, 143, 145–6, 173, 203,
 213, 413, 416; Hans Hofmann
 School, 48
Holty, Carl, 12
Holtzman, Harry, 49, 53
Hopper, Edward, 13, 98, 125n
Howard Putzel (gallery), 51
humanists, 88
Hunter, Sam, 150, 368–9, 371
Hurd, Peter, 12

Impressionism, 67, 102, 119, 243,
 326, 370
Ingres, Jean-Auguste-Dominique, 64
"Intentional Fallacy, The" (Beardsley
 and Wimsatt), 200
"Intrasubjectives, The" (catalogue
 essay, Rosenberg), 54
It Is, 51

Jakobson, Roman, 202
Janson, H. W., 21
Jaspers, Karl, 96
Jewell, Edward Alden, 22; letter from
 Gottlieb and Rothko, 10
Jewish Museum, 238
Johns, Jasper, 178, 238
Joyce, James, 116, 378
Julien Levy (gallery), 37, 99, 130
Jung, Carl, 97; *Modern Man in Search
 of a Soul*, 198–9; *see also* Pollock,
 Jackson, Jungian analysis

Kamrowski, Gerome, 37, 38, 40
Kandinsky, Wassily, 43, 44, 76, 97,
 101, 119, 146, 190, 222, 223, 346,
 366, 368, 413; color, 202; early
 New York showings, 6; as
 influence, 2, 43, 190, 202, 222, 369
Kaprow, Allan, 25
Kelly, Ellsworth, 162, 169, 406
Kierkegaard, Soren, 80, 96, 375
Klee, Paul, 6, 41, 73, 92, 103, 106,
 300, 379, 380
Kline, Franz, 109, 136, 148, 165, 374;
 black-and-white paintings, 296,
 299, 300–3, 304–5, 309–10,

313–15, 317–18, 320–1;
 calligraphy, 297, 299, 300–2,
 313–14; chronology, 288–9; The
 Club and, 295; color, 97, 309, 314,
 319–21; copying, 295; drawing,
 294, 297, 309, 310, 312; drinking,
 173; influences, 307, 311; patrons,
 293–4, 307–8, 309; portraits,
 308, 310; scale, 300–1; tavern
 decorations, 293–4, 310; works
 cited, 292–4, 296, 297, 298,
 302–3, 308–10, 313, 317, 320
Knaths, Karl, 7, 87, 125n
Kozloff, Max, 24, 176
Kramer, Hilton, 20, 140
Krasner, Lee (Mrs. Jackson Pollock),
 39, 372, 406
Kuspit, Donald, 197, 199

Lassaw, Ibram, 100
League for Cultural Freedom and
 Socialism, 8, 16
Lee, Doris, 12
Léger, Fernand, 7, 12, 99, 249, 251
Levine, Jack, 98
Life, 20, 21
Lipton, Seymour, 100, 196
Louis, Morris, 180, 240, 317
Lovejoy, Arthur, 33
Lynes, Russell, 175

McCarthy, Senator Joseph, 23
McCray, Porter, 101
McMillen (gallery), 372, 373
Magazine of Art, 21, 116, 134
Malevich, Kasimir, 160
Man Ray, 7
Manet, Edward, 67, 121, 129, 141,
 229, 241, 248, 292
Mangold, Robert, 169
"Manifesto: Toward a Free
 Revolutionary Art" (Breton), 15;
 see also Rivera, Diego; Trotsky,
 Leon
Marca-Relli, Corrado, 57
Marden, Brice, 169
Margo, Boris, 203
Margolis, David, 203
Marin, John, 13, 98, 99
Marinetti, Fillipo, 84
Marisol, Escobar, 155

Marlborough-Gerson (gallery), 316
Marlborough New London (gallery) (England), 406
Marsh, Reginald, 307
Marxist Quarterly, 15
"Marxists," 79
Masson, André, 99, 106, 129, 147; collage, 43; influence, 7, 43
Mathieu, Georges, 90, 91
Matisse, Henri, 7, 46, 102, 106, 127, 226, 230, 249, 254, 264–5, 304, 307, 335, 341; influence, 1, 2, 145
Matta (Roberto Echaurren Matta), 99, 106; collage, 42; Exquisite Corpse, 41; influence, 7, 33, 35–7, 40–2, 147
Matter, Mercedes, 373
Mayakovsky, Vladimir, 203
Metropolitan Museum of Art, 21, 52; Centennial exhibition, 152, 155
Michelangelo, 77, 116
Minimalism, 155–6, 169, 244, 248
Miró, Joan, 73, 76, 93, 99, 230; influence, 2, 41, 45, 142, 147, 266, 363, 368, 369
Modern Man in Search of a Soul (Jung), 198–9
modernism, 5, 82–4, 142
Modigliani, Amadée, 7, 307
Mondrian, Piet, 7, 83, 99, 129, 223, 226, 230, 242, 246, 251, 266, 276, 301, 303, 312, 327, 330, 333, 342, 343, 345–6, 366, 410, 413; early New York showing, 6
"Monster Painting," 171
Morris, George L. K., 7
Mortimer, Raymond, 21
Motherwell, Robert, 4, 31, 49, 51, 53, 57, 99, 103, 104, 106, 109, 124, 141, 173, 175, 185, 197, 198, 213, 282, 283, 337, 382, 418; automatism, 197–8; on becoming artist, 33–5; collage, 42; early articles on, 21; Matta, influence of, 36–44; Schapiro, influence of, 34; Seligmann, influence of, 35; statement quoted, 95; works cited, 104, 197, 337
Museum of Modern Art (MOMA), 5, 52, 123, 158, 178, 179, 196, 238, 344, 345, 368, 379, 408, 412; accused of bias, 87–8; admission to, 7; American abstraction, attitude toward, 12; Aquisitions Committee, 21; cultural imperialism, 175–6; *The New American Painting*, tour of, 95, 101, 332; symposium, Abstract Expressionism, 21
Museum of Non-objective Art, 6; *see also* Solomon R. Guggenheim Museum

Namuth, Hans, 377
Nation, The, 21
"Nature of Abstract Art" (Schapiro), 10, 15
Neo-Plasticists, 222, 242
Nevelson, Louise, 155
New Criticism, 198–9, 200–4
New York Herald Tribune, 22
New York Painting and Sculpture, 1940–1970 (Geldzahler), 152
New York School, 1, 33, 126, 130, 132, 133, 135, 138, 144, 264, 269, 281
New York Times, 10, 22–3, 122, 125n, 152
New York Times Magazine, 175
New York University, 7, 49
Newman, Barnett, 3, 27n, 97, 148, 158, 160–1, 166, 201, 205, 244–5, 299, 380, 412, 413, 417; artist's intention, 338; on beauty and sublime, 325–8, 345–56; chronology, 322–3; color, 334–5; color field, 333, 345; on Constructivism, 203; "The First Man Was an Artist," 165; on Gottlieb, 195; on hero, 157, 335; heroic gesture, 341; *The Ideographic Picture*, 158–9; imagery, 338, 346; Kabbalah, 244, 347–50; Mondrian, relation to, 330–1, 333, 342; "stripe," "band," or "zip", 97, 333, 334, 344, 348; subject matter, 10, 140, 336–42; sublime, 340, 345–6, 350; symbolism, 99, 159; theory, 157–8; work in series, 164–5, 336–7, 341; works cited, 161, 163, 164, 165, 333, 334–5, 336–7,

Newman, Barnett (*cont.*)
340, 342, 334–50
Nierendorf (gallery), 271
Noland, Kenneth, 180

O'Doherty, Brian, 418
O'Hara, Frank, 305
O'Keeffe, Georgia, 13
Oldenburg, Claes, 25
Olitski, Jules, 180
Onslow-Ford, Gordon, 36
Oriental art, 63, 117, 118, 247, 297,
301–2, 313–14, 360, 410; Eastern
calligraphy, 116; Hsieh Ho, 117;
"wild men," 116, Wu Tao-tzu, 113
Orozco, Jose Clemente, 42
Orton, Fred, 197
Osborn, Peggy, 40
Ozenfant, Amédée, *Foundations of
Modern Art*, 7–8

Paalen, Wolfgang, 36
Parker, Raymond, 406
Parks, David, 199
Partisan Review, 16, 20, 21, 177
Pavia, Phillip, 50–2, 54, 57
Peridot (gallery), 130
Phillips (gallery), 319, 320
photo-realism, 179, 248
Picasso, Pablo, 1, 2, 5, 7, 42, 46, 92,
93, 99, 106, 149, 230, 236, 264–5,
274, 292, 305, 307, 327, 335, 363,
368, 369, 372; *Guernica*, 172
Pierce, Waldo, 12
Pierre Matisse (gallery), 39, 204
Pollock, Griselda, 197
Pollock, Jackson, 37, 39, 46, 109, 136,
205, 229, 291, 295, 351–91;
accidents, 173, 360, 367, 375–6;
alcoholism, 43, 172; apocalyptic,
190–3; and Cedar Bar, 374;
character, 43, 144, 186–9, 374;
chronology, 351–5; and The Club,
373–4; collage, 42; color, 364;
decorative art, 114–15, 369–70;
Formalism, 386; Happenings, 376;
imagery, 365–7, 368, 370–1;
influences, 5, 42, 43, 172, 318, 364,
368, 377, 379; Jungian analysis,
199; McMillen Gallery, 372–3;
and meaning of his art, 358,

365–6, 382–91; MOMA
symposium, 21; scale, 45, 361;
technique, 42–4, 99–100, 132,
140, 150, 153, 172; 178, 185–6,
356–7, 358, 360, 362, 365; ugly
art, 143; works cited, 190, 196,
363, 364, 369, 370, 371, 377, 378,
379, 380, 381, 386
Pop art, 25, 169, 179, 191
Porter, David, 196
Possibilities, 418
post-Cubist, 148
Post-Impressionism, 79
Pound, Ezra, 104
Prall, David, 33
Preston, Stuart, 406
"Problem for Critics, A" (Putzel), 147
Proust, Marcel, 116
purists, 61
purity and music, 69
Putzel, Howard, 51; "A Problem for
Critics," 147

Quadrum (Belgium), 52, 56

Rauschenberg, Robert, 144, 238
Ray, Man, 7
Read, Herbert, 110, 140
Reality, 86–8; letter to MOMA,
87–8; signers, 87; statement, 86–7
Rebay, Baroness Hilla, 6
Regionalism, 18, 98
Regionalists, 172
Reinhardt, Ad, 49, 53, 54, 94, 154,
158, 177, 199, 203, 213, 412, 413,
417; against interpretation, 202
Reis, Bernard, 36
Rembrandt, 73, 77, 325
Renaissance, 93, 120, 325
Renoir, Auguste, 116, 122, 127, 305
Riopelle, 90
Rivera, Diego, 16, 191, 192; *see also*
"Manifesto: Toward a Free
Revolutionary Art"
Robertson, Bryan, 406
Rodchenko, Alexander, 284
Rodman, Selden, 200
Romanticism, 64–5, 111
Rose, Barbara, 178
Rose, Berenice, 173, 178
Rosenberg, Harold, 21, 24, 49, 51, 53,

54, 57, 58, 97, 113, 115–16, 124, 152, 154, 159, 189, 205; "American Action Painters," 19, 204; theory, 141–50, 383
Roszak, Theodore, 100
Rothko, Mark, 8, 9, 10, 50, 136, 148, 149, 160, 166, 180, 191, 195–6, 205, 291, 334; automatism, 44; Chapel, 164; chronology, 392–6; color, 403, 405, 406–7, 408, 409–11, 414–15, 416, 419; credo, 139, 200, 397–400; and Gottlieb, 267; imponderable, 409; letter to, Jewell, 10; lighting, 418–20; murals, 163–5, 410–12; mythology, 159, 161; reductive qualities, 158, 413–15; scale, 45, 411; statement quoted, 95; subject matter, 3, 403–4; suicide, 173, 413; Surrealism, influence of, 44, 401, 408, 419; transcendentalism of, 402–3; works cited, 163–4, 196, 398–400, 405, 409, 410, 411, 419
Rousseau, Theodore, 64
Rubens, 240, 241, 242
Rubin, William, 24, 150, 178, 190
Russell, Alfred, 91
Ryder, Albert Pinkham, 42, 99, 292, 307, 309, 363, 414

Sample, Paul, 12
Samuel Kootz (gallery), 51, 54; subsidies, 44
Sandler, Irving, 29n, 31, 197, 277; "The Triumph of American Painting," 173
Sapir, Edward, 195
Sartre, Jean-Paul, 4, 145, 198, 203, 234, 383; de Kooning in relation to, 231; La Nausée, 204; The Words, 231
scale as factor in art, 45, 97–8, 104, 166, 282, 301
Schapiro, Meyer, 21, 34, 150; American Artists Congress, 16; as influence, 8, 34; "The Nature of Abstract Art," 10, 15
Schreiber, George, 125n
Schwitters, Kurt, 42
Seitz, William, 117, 150
Seligmann, Kurt, 8, 35, 36, 53

Selz, Peter, 419
Serra, Richard, 169
Sert, Jose Maria, 241, 242
Seurat, Georges, 7
Sewanee Review, 201
Shahn, Ben, 11, 98
Siqueiros, David Alfaro, 172, 191, 192
Smith, David, 100, 173, 195, 199, 202, 203
Social Realism, 1, 18, 38, 197
Social Realists, 11, 15, 186
Socialist Realism, 98, 174
Solomon R. Guggenheim Museum, 5, 59, 89, 254
Sontag, Susan, "Against Interpretation," 383–90
Soulages, Pierre, 90
Soutine, Haim, 76, 147, 307
Stable (gallery), 130
Stalinism, 15, 19
Stamos, Theodore, 100, 159, 412
Stein, Gertrude, 227, 291
Steinberg, Leo, 24, 150, 320
Stella, Frank, 162, 180
Sternberg, Harry, 125n
Sterne, Hedda, 202
Stevens, Wallace, 78
Still, Clyfford, 4, 44, 45, 78, 99, 100, 109, 133, 136, 143, 148, 159, 160, 162, 163, 164, 175, 199, 205, 213, 279, 291, 334, 380, 382, 412, 413, 417; Abstract Expressionists, influence on, 45; reductive renunciation of, 158; statement quoted, 95
Studio 35, 49, 51, 52
"Subjects of the Artist" School, 57; faculty, 49; founders, 49; Modern Artists in America, 49
sublime: as aesthetic category, 162–3; social responsibility and the, 165
Surrealism, 2, 15, 36, 97, 100, 116, 130, 131, 133, 139, 150, 233, 266, 268, 333, 369, 401; Exquisite Corpse, 41, 132; literary, 197; motifs, 101
Surrealism in the Service of the Revolution, 15
Surrealists, 99, 132, 139, 325, 378; as bohemians, 129; influence of, 34, 41, 127, 131, 170–1, 368

Sweeney, James Johnson, 20, 54
Sylvester, David, 135

Tachisme, 101
Tanguy, Yves, 197–8
Tate Gallery, 107, 163
Taylor, Francis Henry, 21
Tchelitchew, Pavel, 7, 197
Tenth Street, 47, 176–7
Tenth Street (gallery), 130
Thomas, Dylan, 52
Tiger's Eye, 20, 161, 196, 201–2
Time, 20
Times Literary Supplement (London),
 179
Tobey, Mark, 97, 98, 404
Tomlin, Bradley Walker, 100, 104,
 106, 274
Trilling, Lionel, 199
"Triumph of American Painting, The"
 (Sandler), 173
Trotsky, Leon: art theory, 15; as
 influence, 8, 18; "Manifesto,"
 15–20
Tworkov, Jack, 53, 56, 100, 106

Unit One, 99
Utrillo, Maurice, 7

Van Doesburg, Theo, 7

Van Gogh, Vincent, 121, 127
Venice Biennale, 196
Venturi, Lionello, 73
Vermeer, Jan, 83

Waldman, Diane, 254, 255
Warhol, Andy, 345
Warren, Robert Penn, 202
Weber, Max, 98
Well-Wrought Urn, The (Brooks), 200
Wescher, Herta, 92
Whitechapel (gallery) (London), 406
Whitman, Walt, 81, 143
Whitney Museum of American Art,
 274, 279, 319; Whitney Biennial,
 169
Willem de Kooning (Hess), 238–40
Wimsatt, W. K. ("The Intentional
 Fallacy"), 200, 201
Wollheim, Richard, 199
Wood, Grant, 11, 121, 129
World War II, 20, 170, 172

Xcéron, John, 7

Zadkine, Ossip, 8
Zarnower, Theresa, 203
Zen, 96
Zirmunskij, Victor, 202
Zorach, William, 7, 125n